W9-BRF-839

Henry M. Sayre
Oregon State University

The Humanities
Culture, Continuity & Change

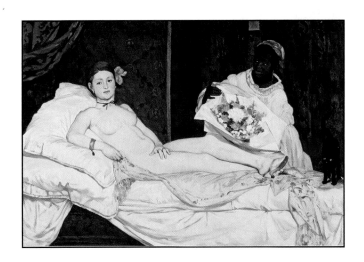

BOOK 5

ROMANTICISM, REALISM, AND EMPIRE:

1800 TO 1900

PEARSON
Prentice
Hall

Upper Saddle River, New Jersey 07458

Library of Congress Cataloging-in-Publication Data

Sayre, Henry M.

The humanities : culture, continuity & change / Henry M. Sayre.

p. cm.

Includes index.

ISBN 0-13-086264-9

1. Civilization—History. 2. Humanities—History. 3. Social change—History. I. Title.

CB69.S29 2008

909—dc22 2007016065

For Bud Therien, art publisher and editor par excellence, and a good friend

Editor-in-Chief: Sarah Touborg
Senior Editor: Amber Mackey
Editor-in-Chief Development: Rochelle Diogenes
Senior Development Editor: Roberta Meyer
Development Editor: Karen Dubno
Assistant Editor: Alexandra Huggins
Editorial Assistant: Carla Worner
Media Editor: Alison Lorber
Director of Marketing: Brandy Dawson
Executive Marketing Manager: Marissa Feliberty
Senior Managing Editor: Mary Rottino
Project Manager: Barbara Marttine Cappuccio
Production Editor: Assunta Petrone
Production Assistant: Marlene Gassler
Senior Operations Specialists: Sherry Lewis and Brian Mackey
Senior Art Director: Nancy Wells
Interior and Cover Design: Ximena Tamvakopoulos
Layout Specialists: Gail Cocker-Bogusz and Wanda España
Line Art and Map Program Management: Gail Cocker-Bogusz and Mirella Signoretto
Fine Line Art: Peter Bull Art Studio
Cartographer: Peter Bull Art Studio
Line Art Studio: Precision Graphics

Pearson Imaging Center
Site Supervisor: Joe Conti
Project Coordinator: Corin Skidds
 Scanner Operators: Corin Skidds, Robert Uibelhoer,
 Ron Walko
Photo Research: Image Research Editorial Services/Francelle
 Carapetyan and Rebecca Harris
Director, Image Resource Center: Melinda Reo
Manager, Rights and Permissions: Zina Arabia
Manager, Visual Research: Beth Brenzel
Manager, Cover Visual Research and Permissions:
 Karen Sanatar
Image Permissions Coordinator: Debbie Latronica
Text Permissions: Warren Drabek, ExpressPermissions
Text Research: John Sisson
Copy Editor: Karen Verde
Proofreaders: Barbara DeVries and Nancy Stevenson
Composition: Preparé, Inc.
Cover Printer: Phoenix Color Corp.
Printer/Binder: Courier Kendallville
Cover Photo: *Olympia*, 1863 (oil on canvas), Manet, Édouard
 (1832–83)/Musée d'Orsay, Paris, France, Giraudon/
 The Bridgeman Art Library.

Credits and acknowledgments borrowed from other sources and reproduced, with permission, in this textbook appear on appropriate pages within text and beginning on page Credits-1.

Pearson Education LTD.
Pearson Education Singapore, Pte. Ltd.
Pearson Education, Canada, Ltd.
Pearson Education–Japan
Pearson Education, Upper Saddle River, New Jersey

Pearson Education Australia PTY, Limited
Pearson Education North Asia Ltd
Pearson Educación de Mexico, S.A. de C.V.
Pearson Education Malaysia, Pte. Ltd

10 9 8 7 6 5 4 3 2 1
ISBN 10: 0-13-086268-1
ISBN 13: 978-0-13-086268-6

Series Contents

Contents

36 Revolution and Civil War
The Conditions of Modern Life 1153

37 The Rise of Bourgeois Culture
Living the Good Life 1187

Dear Reader,

You might be asking yourself, why should I be interested in the Humanities? Why do I care about ancient Egypt, medieval France, or the Qing Dynasty of China?

I asked myself the same question when I was a sophomore in college. I was required to take a year long survey of the Humanities, and I soon realized that I was beginning an extraordinary journey. That course taught me where it was that I stood in the world, and why and how I had come to find myself there. My goal in this book is to help you take the same journey of discovery. Exploring the humanities will help you develop your abilities to look, listen, and read closely; and to analyze, connect, and question. In the end, this will help you navigate your world and come to a better understanding of your place in it.

What we see reflected in different cultures is something of ourselves, the objects of beauty and delight, the weapons and wars, the melodies and harmonies, the sometimes troubling but always penetrating thought from which we spring. To explore the humanities is to explore ourselves, to understand how and why we have changed over time, even as we have, in so many ways, remained the same.

About the Author

Henry M. Sayre is Distinguished Professor of Art History at Oregon State University–Cascades Campus in Bend, Oregon. He earned his Ph.D. in American Literature from the University of Washington. He is producer and creator of the 10-part television series, *A World of Art: Works in Progress,* aired on PBS in the fall of 1997; and author of seven books, including *A World of Art, The Visual Text of William Carlos Williams, The Object of Performance: The American Avant-Garde since 1970;* and an art history book for children, *Cave Paintings to Picasso.*

See Context and Make Connections...

The Humanities: Culture, Continuity, and Change shows the humanities in context and helps readers make connections—among disciplines, cultures, and time periods. Each chapter centers on a specific geographic location and time period and includes integrated coverage of all disciplines of the humanities. Using an engaging storytelling approach, author Henry Sayre clearly explains the influence of time and place upon the humanities.

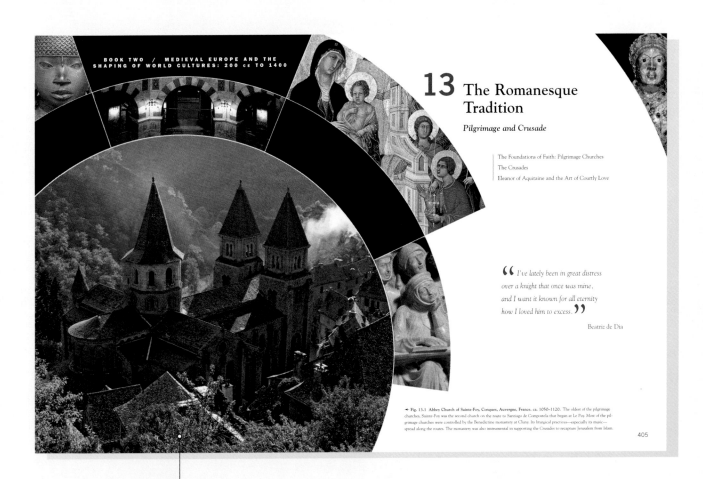

BOOK TWO / MEDIEVAL EUROPE AND THE
SHAPING OF WORLD CULTURES: 200 CE TO 1400

13 The Romanesque Tradition

Pilgrimage and Crusade

The Foundations of Faith: Pilgrimage Churches
The Crusades
Eleanor of Aquitaine and the Art of Courtly Love

" *I've lately been in great distress over a knight that once was mine, and I want it known for all eternity how I loved him to excess.* "

Beatriz de Dia

◄ Fig. 13.1 Abbey Church of Sainte-Foy, Conques, Auvergne, France. ca. 1050–1120. The oldest of the pilgrimage churches, Sainte-Foy was the second church on the route to Santiago de Compostela that began at Le Puy. Most of the pilgrimage churches were controlled by the Benedictine monastery at Cluny. Its liturgical practices—especially its music—spread along the routes. The monastery was also instrumental in supporting the Crusades to recapture Jerusalem from Islam.

405

CHAPTER OPENERS Each chapter begins with a compelling chapter opener that serves as a snapshot of the chapter. These visual introductions feature a central image from the location covered in the chapter. Several smaller images represent the breadth of disciplines and cultures covered throughout the book. An engaging quote drawn from one of the chapter's readings and a brief list of the chapter's major topics are also included.

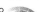

Across the Humanities

CONTINUITY & CHANGE

Full-page essays at the end of each chapter illustrate the influence of one culture upon another and show cultural changes over time.

Egyptian
and Greek Sculpture

Continuity & Change

Freestanding Greek sculpture of the Archaic period—that is, sculpture dating from about 600–480 BCE—is notable for its stylistic connections to 2,000 years of Egyptian tradition. The Late Period statue of *Montuemhet* [men-too-em-het] (Fig. 6.18), from Thebes, dating from around 2500 BCE, differs hardly at all from Old Kingdom sculpture at Giza (see Figs. 3.8–3.9), and even though the *Anavysos* [ah-NAH-vee-sus] *Kouros* (Fig. 6.19), from a cemetery near Athens, represents a significant advance in relative naturalism over the Greek sculpture of just a few years before, it still resembles its Egyptian ancestors. Remarkably, since it follows upon the *Anavysos Kouros* by only 75 years, the *Doryphoros* [dor-IF-uh-ros] (*Spear Bearer*) (Fig. 6.20) is significantly more naturalistic. Although this is a

Roman copy of a lost fifth-century BCE bronze Greek statue, we can assume it reflects the original's naturalism, since the original's sculptor, Polyclitus [pol-ih-KLY-tus], was renowned for his ability to render the human body realistically. But this advance, characteristic of Golden Age Athens, represents more than just a cultural taste for naturalism. As we will see in the next chapter, it also represents a heightened cultural sensitivity to the worth of the individual, a belief that as much as we value what we have in common with one another—the bond that creates the city-state—our *individual* contributions are at least of equal value. By the fifth century BCE, the Greeks clearly understood that individual genius and achievement could be a matter of civic pride. ■

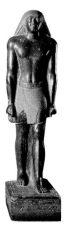 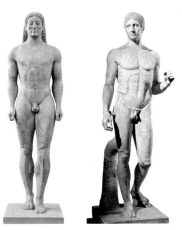

Fig. 6.18 *Montuemhet*, from Karnak, Thebes. ca. 660 BCE. Granite, height 54″. Egyptian Museum, Cairo.

Fig. 6.19 *Anavysos Kouros*, perhaps young Kroisos, from a cemetery at Anavysos [ah-NAH-vee-sus], near Athens. ca. 525 BCE. Marble with remnants of paint, height 6′ 4″. National Archaeological Museum, Athens; Fig. 6.20 *Doryphoros* (*Spear Bearer*), Roman copy after the original bronze by Polyclitus of ca. 450–440 BCE. Marble, height 6′ 6″. Museo Archeologico Nazionale, Naples.

185

Fig. 18.6 Donato Bramante, *Tempietto*. 1502. San Pietro in Montorio, Rome. This chapel was certainly modeled after a classical temple. It was commissioned by King Ferdinand and Queen Isabella of Spain, financiers of Christopher Columbus's voyages to America. It was undertaken in support of Pope Alexander VI, who was himself Spanish.

In his plan for a new Saint Peter's (Fig. 18.7a), Bramante adopted the Vitruvian square, as illustrated in Leonardo's drawing, placing inside it a **Greek cross** (a cross in which the upright and transverse shafts are of equal length and intersect at their middles) topped by a central dome purposely reminiscent of the giant dome of the Pantheon (see Fig. 8.25). The resultant central plan is essentially a circle inscribed within a square. In Renaissance thinking, the central plan and dome symbolized the perfection of God. Construction began in 1506.

Julius II financed the project through the sale of **indulgences**, dispensations granted by the Church to shorten an individual's stay in purgatory. This was the place where, in Catholic belief, individuals temporarily reside after death as punishment for their sins. Those wanting to enter heaven faster than they otherwise might could shorten their stay in purgatory by purchasing an indulgence. The Church had been selling these documents since the twelfth century, and Julius's building campaign intensified the practice (see *Voices*, page 588). (In protest against the sale of indulgences, Martin Luther would launch the Protestant Reformation in Germany in 1517; see chapter 21.) The New Saint Peter's would be a very expensive project, but there were also very many sinners willing to help pay for it. With the deaths of both pope and architect, in 1513 and 1514 respectively, the project came to a temporary halt. Its final plan would be developed in 1546 by Michelangelo (Fig. 18.7b).

Continuity & Change

p. 260

The Pantheon

CONTINUITY & CHANGE references provide a window into the past. These eye-catching icons enable students to refer to material in other chapters that is relevant to the topic at hand.

CRITICAL THINKING questions at the end of each chapter prompt readers to synthesize material from the chapter.

Critical Thinking Questions

1. What was the relationship of the Anglo-Saxon lord or chief to his followers and subjects?

2. How does the *Song of Roland* reflect feudal values? How do these values differ from those found in *Beowulf*?

3. What is the Rule of St. Benedict and how did it affect monastic life?

4. What role did music play in Charlemagne's drive to standardize the liturgy?

See Context and Make Connections...

Focus

The Stained Glass at Chartres

The stained glass at Chartres covers more than 32,000 square feet of surface area. Although the illustration below lacks detail, we can imagine the overall effect of so many windows. The windows were donated by the royal family, by noblemen, and by merchant guilds. On an average day, the light outside the cathedral is approximately 1,000 times greater than the light inside. Thus the windows, backlit and shining in the relative darkness of the nave, seem to radiate with an ethereal and immaterial glow, suggesting a spiritual beauty beyond the here and now.

Rose window and lancets, north transept, Chartres. ca. 1150–80.
A **rose window** is a round window with mullions (framing elements) and traceries extending outward from its center in the manner of the petals of a rose. It is symbolic of the Virgin Mary in her role as the Mystic Rose—the root plant, it was believed, of the Jesse Tree. This rose window measures 42 feet in diameter. The small windows between the lancets and the rose window contain the French royal coat of arms. They remind the viewer that the windows decorating the north transept were donated by Blanche, the queen mother.

Incarnation window, Chartres Cathedral. ca. 1150.
The program for this window reads left to right, bottom to top, beginning with the Annunciation at bottom left. Next is the Visitation, showing Mary meeting her cousin Elizabeth. In the next row up, shepherds view the Star of Bethlehem on the left; on the right are the three wise men. The life of Christ continues up the window.
Just below the arch at the top, Christ enters Jerusalem on a white donkey. The window culminates in the arch with an enthroned Mary and the Christ child in a mandorla, with angels on each side.

Charlemagne window, see Figure 12.11.

Tree of Jesse window, see Fig. 14.8.

Notre-Dame de la Belle Verrière (Our Lady of the Beautiful Window), see Figure 14.7.

The Labyrinth
Actually not a maze, but a continuous path that winds back and forth, the so-called labyrinth on the floor of the nave was designed for the pilgrim to recreate a pilgrimage—it was commonly called the Road to Jerusalem—by moving along the path while saying prayers.

441

FOCUS Highly visual Focus features offer an in-depth look at a particular work from one of the disciplines of the humanities. These annotated discussions give students a personal tour of the work—with informative captions and labels—to help students understand its meaning.

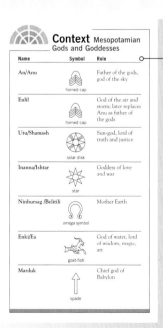

Context Mesopotamian Gods and Goddesses

Name	Symbol	Role
An/Anu	horned cap	Father of the gods, god of the sky
Enlil	horned cap	God of the air and storm; later replaces Anu as father of the gods
Utu/Shamash	solar disk	Sun-god, lord of truth and justice
Inanna/Ishtar	star	Goddess of love and war
Ninhursag/Belitili	omega symbol	Mother Earth
Enki/Ea	goat-fish	God of water, lord of wisdom, magic, art
Marduk	spade	Chief god of Babylon

CONTEXT boxes summarize important background information in an easy-to-read format.

MATERIALS AND TECHNIQUES boxes explain and illustrate the methods artists and architects use to produce their work.

Materials & Techniques
Tapestry

Tapestries are heavy textiles hand-woven on looms. The looms range in size from small, hand-held models to large, freestanding structures. They serve as frames, holding in tension supporting threads, called the **warp**, so that striking threads, called the **weft**, can be interwoven between them. Warp threads are made of strong fibers, usually wool or linen, while weft threads are brightly colored strands of silk or wool, spun gold, or spun silver. Once the warp threads are stretched on the loom, the weaver places a **cartoon**, or full-scale drawing, below or behind the loom. The weaver then works on the back side of the tapestry, pushing the weft threads under and over the warp threads, knotting alternating colors together in a single strand, to match the cartoon's design. So the front side of the tapestry reproduces the design in reverse. The design can approach painting in its compositional complexity, refinement, and the three-dimensional rendering of forms.

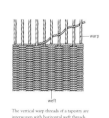
warp
weft
The vertical warp threads of a tapestry are interwoven with horizontal weft threads

Through Special Features and Primary Sources

Each chapter of *The Humanities* includes **PRIMARY SOURCE READINGS** in two formats. Brief readings from important works are included within the body of the text. Longer readings located at the end of each chapter allow for a more in-depth study of particular works. This organization offers great flexibility in teaching the course.

END-OF-CHAPTER READINGS

BRIEF READINGS

READINGS

READING 17.4

from Baldassare Castiglione, *The Book of the Courtier*, Book 1 (1513–18; published 1528)

Castiglione spent his life in the service of princes, first in the courts of Mantua and Urbino, and then in Rome, where he served the papacy. His Book of the Courtier was translated into most European languages and remained popular for two centuries. It takes the form of a series of fictional conversations between the courtiers of the duke of Urbino in 1507 and included the duchess. In the excerpt below, the separate speakers have not been identified to facilitate ease of reading. The work is a celebration of the ideal character of the Renaissance humanist and the ethical behavior associated with that ideal.

[The Perfect Courtier]

Within myself I have long doubted, dearest messer Alfonso, which of two things were the harder for me: to deny you what you have often begged of me so urgently, or to do it. For while it seemed to me very hard to deny anything (and especially a thing in the highest degree laudable) to one whom I love most dearly and by whom I feel myself to be most dearly loved, yet to set about an enterprise that I am not sure of being able to finish, seemed to me ill befitting a man who esteems just censure as it ought to be esteemed. . . .

You ask me then to write what is to my thinking the form of Courtiership most befitting a gentleman who lives at the court of princes, by which he may have the ability and knowledge perfectly to serve them in every reasonable thing, winning from them favor, and praise from other men; in short, what manner of man he ought to be who may deserve to be called a perfect Courtier without flaw. . . .

So now let us make a beginning of our subject, and if possible let us form such a Courtier that any prince worthy to be served by him, although of but small estate, might still be called a very great lord.

I wish then, that this Courtier of ours should be nobly born and of gentle race; . . . for noble birth is like a bright lamp that manifests and makes visible good and evil deeds, and kindles and stimulates to virtue both by fear of shame and by hope of praise. . . . And thus it nearly always happens that both in the profession of arms and in other worthy pursuits the most famous men have been of noble birth, because nature has implanted in everything that hidden seed which gives a certain force and quality of its own essence to all things that are derived from it, and makes them like itself: as we see not only in the breeds of horses and of other animals, but also in trees, the shoots of which nearly always resemble the trunk; and if they sometimes degenerate, it arises from poor cultivation. And so it is with men, who if rightly trained are nearly always like those from whom they spring, and often

It is true that, by favor of the stars or of nature, some men are endowed at birth with such graces that they seem not to have been born, but rather as if some god had formed them with his very hands and adorned them with every excellence of mind and body. So too there are many men so foolish and rude that one cannot but think that nature brought them into the world out of contempt or mockery. Just as these can usually accomplish little even with constant diligence and good training, so with slight pains those others attain the highest summit of excellence. . . .

Besides this noble birth, then, I would have the Courtier favored in this regard also, and endowed by nature not only with talent and beauty of person and feature, but with a certain grace and (as we say) air that shall make him at first sight pleasing and agreeable to all who see him; and I would have this an ornament that should dispose and unite all his actions, and in his outward aspect give promise of whatever is worthy the society and favor of every great lord.

But to come to some details, I am of opinion that the principal and true profession of the Courtier ought to be that of arms; which I would have him follow actively above all else, and be known among others as bold and strong, and loyal to whomsoever he serves. And he will win a reputation for these good qualities by exercising them at all times and in all places, since one may never fail in this without severest censure. And just as among women, their fair fame once sullied never recovers its first lustre, so the reputation of a gentleman who bears arms, if once it be in the least tarnished with cowardice or other disgrace, remains forever infamous before the world and full of ignominy. Therefore the more our Courtier excels in this art, the more he will be worthy of praise . . .

. . . And of such sort I would have our Courtier's aspect; not so soft and effeminate as is sought by many, who not only curl their hair and pluck their brows, but gloss their faces with all those arts employed by the most wanton and unchaste women in the world; and in their walk, posture and every act, they seem so limp and languid that their limbs are like to fall apart; and they pronounce their words so mourn-

The poem, in short, demonstrates that traditional chivalric virtues—those that Castiglione was outlining in *The Book of the Courtier* (see chapter 17) even as Ariosto was writing his poem—had little or no relevance to the modern Italian court, just as armor, swords, and lances had been made irrelevant by the invention of gunpowder. On the subject of gunpowder, the poem makes the following lament (**Reading 19.2b**):

READING 19.2b from Ludovico Ariosto, *Orlando Furioso*, Canto XI

XXVI

How, foul and pestilent discovery,
Didst thou find place within the human heart?
Through thee is martial glory lost, through thee
The trade of arms become a worthless art;
And at such ebb are worth and chivalry,
That the base often plays the better part.
Through thee no more shall gallantry, no more
Shall valour prove their prowess as of yore.

Love is never ennobling in the poem—and rarely chivalric—but leads only to insult, rejection, madness, and death. The only way to save oneself is not to love at all. But however unsympathetic the poem is to the chivalric code, Ariosto's ability to create an exciting narrative of nonstop action that moves across the globe in large part accounts for his poem's extraordinary success. Throughout the sixteenth century, new readers discovered the poem as the printing press (see chapter 21) made it more widely available, especially to a popular audience that had little use for the conventions of chivalry.

Lucretia Marinella's *The Nobility and Excellence of Women*

Not surprisingly, Renaissance women also attacked the chivalric, or rather pseudo-chivalric, attitudes and behavior of Renaissance males. One such attack was *The Nobility and Excellence of Women and the Defects and Vices of Men* by the Venetian writer Lucretia Marinella [loo-CREE-sha mah-ree-NEL-lah] (1571–1653), published in Venice around 1600 and widely circulated. (See **Reading 19.3a**.) Marinella was one of the most prolific writers of her day. She published many works, including a pastoral drama, musical compositions, religious verse, and an epic poem celebrating Venice's role in the Fourth Crusade, but her sometimes vitriolic polemic against men is unique in the literature of the time. *The Nobility and Excellence of Women* is a response to a contemporary diatribe, *The Defects of Women*, written by her Venetian contemporary, Giuseppe Passi [PAHS-see].

It is clear enough to Marinella, who had received a humanistic education, that any man who denigrates women

is motivated by such reasons as anger and envy (see **Reading 19.3**, pages 631–632, for an extended excerpt).

READING 19.3a from Lucretia Marinella, *The Nobility and Excellence of Women*

When a man wishes to fulfill his unbridled desires and is unable to because of the temperance and continence of a woman, he immediately becomes angry and disdainful, and in his rage says every bad thing he can think of, as if the woman were something evil and hateful. . . . When a man sees that a woman is superior to him, both in virtue and in beauty, and that she is justly honored and loved even by him, he tortures himself and is consumed with envy. Not being able to give vent to his emotions in any other way, he resorts with sharp and biting tongue to false and specious vituperation and reproof. . . . But if with a subtle intelligence, men should consider their own imperfections, oh how humble and low they would become! Perhaps one day, God willing, they will perceive it.

From Marinella's point of view, Renaissance women possess the fullest measure of Castiglione's moral virtue and humanist individualism, not the courtiers themselves. The second part of the book, on the defects and vices of men, is a stunning and sometimes amusing reversal of Passi's arguments, crediting men with all the vices he attributes to women.

For Marinella, Ariosto's *Orlando Furioso*, with its many exemplary female characters, was a rich mine of opinions, episodes, and characters that suggest women's moral and intellectual eminence. She makes use of the Neoplatonic argument that beauty is a reflection of goodness, arguing that women's souls must be preeminent because of "the beauty of their bodies." But perhaps Marinella's most important distinction is her insistence that women are autonomous beings, who should not be defined only in relation to men. (See *Voices*, page 627.)

Music of the Venetian High Renaissance

Almost without exception, women of literary accomplishment in the Renaissance were musically accomplished as well. As we have seen, Isabella d'Este played both the lute and the *lira da braccio*, the precursor to the modern violin (see Fig. 18.18). Through her patronage, she and her sister-in-law Lucrezia Borgia, duchess of Ferrara, competed for musicians and encouraged the cultivation of the *frottola*, (see chapter 17). Courtesans such as Veronica Franco could both sing and play. And both Isabella and Elisabetta Gon-

Included in every chapter, **VOICES** features offer vivid first person accounts of the experiences of ordinary people during the period covered in the chapter. These primary source readings offer a glimpse of what life was like in the past and help students understand the social context of a particular culture.

))) Voices (((

A Young Woman's Perspective on Venetian Society

Against her will, the parents of Arcangela Tarabotti (1604–1652) sent her to a Benedictine convent near Venice for her education. Here she expresses her passionate anger at her family, the convent system, and the hierarchy of Venetian society. This excerpt is from her first work, Parental Tyranny. *Her next work was an even more searing indictment (never published) entitled* Convent Hell.

Compares the plight of young girls in the convent to captured birds:

Whenever I see one of these hapless young girls, betrayed by their very own parents, I am reminded of what happens to a pretty little bird: from within the tree's foliage or along riverbanks, it delights the ear with sweet chirping and charming song, soothing the hearts of its audience—when suddenly it's trapped in a treacherous net, robbed of precious liberty.

Discussing education, Tarabotti focuses on her own experiences:

So shameless are you that while reproaching women for stupidity you strive with all your power to bring

"As soon as you men catch sight of a woman with pen in hand, you start ranting and raving; you order them under penalty of death to put aside their scribbling and attend to "feminine" tasks like needlework and spinning. . . ."

them up and educate them as if they were witless and insensitive. You give them as a governess another woman, also unlettered, who can barely instruct them in the rudiments of reading, to say nothing of anything to do with philosophy, law, and theology. In short, they learn nothing but the ABC, and even that is poorly taught. (I know from experience, so I can bear witness at length.)

As soon as you men catch sight of a woman with pen in hand, you start ranting and raving; you order them under penalty of death to put aside their scribbling and attend to "feminine" tasks like needlework and spinning. . . . (As if our intellects could find no more appropriate occupation than spinning!)

A **CD ICON** calls out musical selections discussed in the text that are found on the supplemental CDs available for use with *The Humanities*.

zaga, duchess of Urbino, were well known for their ability to improvise songs. By the last decades of the sixteenth century, we know that women were composing music as well. The most famous of these was the Venetian Madalena Casulana [mah-dah-LAY-nah kah-soo-LAH-nah].

Madalena Casulana's Madrigals

Madalena Casulana was the first professional woman composer to see her own compositions in print. In 1566, her anthology entitled *The Desire* was published in Venice. Two years later, she dedicated her first book of songs to Isabella

chapter 17), the madrigal was **through-composed**—that is, each line of text is set to new music. This allows for **word painting**, where the musical elements imitate the meaning of the text in mood or action. Anguish, for example, is conveyed with an unusually low pitch, as in Casulana's *Morir non puo'il mio cuore* [muh-REER nohn pwo eel MEE-oh KWOR-eh] ("My Heart Cannot Die") (**CD-Track 19.1**). The song laments a relationship gone bad, and the narrator contemplates driving a stake through his heart because it is in so much pain. When she says that her suicide might kill her beloved—*so che morreste voi [so keh mor-EH-stay VOY]* ("I know that you would die")—

See Context and Make Connections...
Across Cultures

The Humanities: *Culture, Continuity, and Change* provides the most comprehensive coverage of various cultures including Asia, Africa, the Americas, and Europe.

Included in every chapter, **CULTURAL PARALLELS** highlight historical and artistic developments occurring in different locations during the period covered in the chapter. This feature helps students understand parallel developments in the humanities across the globe.

Detailed **MAPS** in each chapter orient the reader to the locations discussed in the chapter.

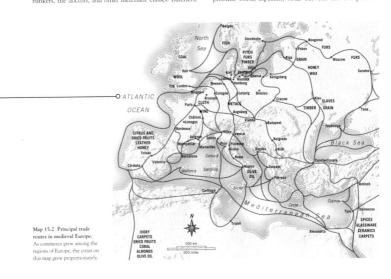

464 BOOK TWO MEDIEVAL EUROPE AND THE SHAPING OF WORLD CULTURES

CULTURAL PARALLELS

Textiles in Florence and Peru
Florence was the center of textile production in the West, but 7,000 miles farther west, the Inca culture of the Peruvian highlands also produced abundant supplies of high-quality textiles. The Inca valued these woolen products even more than gold, and weavers encoded complex symbolism into the fabric (see chapter 16).

The Guilds and Florentine Politics Only two other cities in all of Italy—Lucca and Venice—could boast that they were republics like Siena and Florence, and governing a republic was no easy task. As in Siena, in Florence the guilds controlled the commune. By the end of the twelfth century there were seven major guilds and fourteen minor ones. The most prestigious was the lawyers' guild (the Arte dei Giudici), followed closely by the wool guild (the Arte della Lana), the silk guild (the Arte di Seta), and the cloth merchants' guild (the Arte di Calimala). Also among the major guilds were the bankers, the doctors, and other merchant classes. Butchers,

bakers, carpenters, and masons composed the bulk of the minor guilds.

As in Siena, too, the merchants, especially the Arte della Lana, controlled the government. They were known as the *Popolo Grasso* (literally, "the fat people"), as opposed to *Popolo Minuto*, the ordinary workers, who comprised probably 75 percent of the population and had no voice in government. Only guild members could serve in the government. Their names were written down, the writing was placed in leather bags (*borse*) in the Church of Santa Croce, and nine names were drawn every two months in a public ceremony. (The period of service was short to reduce the chance of corruption.) Those *signori* selected were known as the *Priori*, and their government was known as the *Signoria*—hence the name of the Piazza della Signoria, the plaza in front of the Palazzo Vecchio. There were generally nine Priori—six from the major guilds, two from the minor guilds, and one standard-bearer.

The Florentine republic might have resembled a true democracy except for two details: First, the guilds were very close-knit so that, in general, selecting one or the other of their membership made little or no political difference; and second, the available names in the *borse* could be easily manipulated. However, conflict inevitably arose, and throughout the thirteenth century other tensions made the problem worse, especially feuds between the Guelphs and

Map 15.2 Principal trade routes in medieval Europe. As commerce grew among the regions of Europe, the cities on this map grew proportionately.

See Context and Make Connections...
with Teaching and Learning Resources

THE PRENTICE HALL DIGITAL ARTS LIBRARY contains every image in *The Humanities* in the highest resolution and pixellation possible for optimal projection. Each image is available in jpeg format and as a customizable PowerPoint® slide with an instant download function. Available to instructors upon adoption of *The Humanities*, the Digital Arts Library also includes video and audio clips for use in classroom presentations.

DVD Set: 978-0-13-615298-9
CD Set: 978-0-13-615299-6

MYHUMANITIESLAB is a dynamic online resource that provides opportunities for practice, assessment, and instruction—including digital flashcards of every image in the text. Easy to use and easy to integrate into the classroom, it engages students as it builds confidence and enhances students' learning experience.

Visit **www.myhumanitieslab.com** to begin.

Instructor's Manual and Test Item File
978-0-13-182727-1

Test Generator
978-0-13-182730-1
www.prenhall.com/irc

Companion Website
www.prenhall.com/sayre

Student Study Guide
Volume I: 978-0-13-615316-0
Volume II: 978-0-13-615317-7

VangoNotes Audio Study Guides
www.vangonotes.com

Music CDs
Music CD to Accompany Volume I: 978-0-13-601736-3
Music CD to Accompany Volume II: 978-0-13-601737-0

The Prentice Hall Atlas of the Humanities
978-0-13-238628-9

Package Penguin titles at a significant discount
Visit **www.prenhall.com/art** for information.

Developing *The Humanities*

The Humanities: Culture, Continuity, and Change is the result of an extensive development process involving the contributions of over one hundred instructors and their students. We are grateful to all who participated in shaping the content, clarity, and design of this text. Manuscript reviewers and focus group participants include:

Kathryn S. Amerson, *Craven Community College*
Helen Barnes, *Butler County Community College*
Bryan H. Barrows III, *North Harris College*
Amanda Bell, *University of North Carolina, Asheville*
Sherry R. Blum, *Austin Community College*
Edward T. Bonahue, *Santa Fe Community College*
James Boswell Jr., *Harrisburg Area Community College–Wildwood*
Diane Boze, *Northeastern State University*
Robert E. Brill, *Santa Fe Community College*
Daniel J. Brooks, *Aquinas College*
Farrel R. Broslawsky, *Los Angeles Valley College*
Benjamin Brotemarkle, *Brevard Community College–Titusville*
Peggy A. Brown, *Collin County Community College*
Robert W. Brown, *University of North Carolina –Pembroke*
David J. Califf, *The Academy of Notre Dame*
Gricelle E. Cano, *Houston Community College–Southeast*
Martha Carreon, *Rio Hondo College*
Charles E. Carroll, *Lake City Community College*
Margaret Carroll, *Albany College of Pharmacy of Union University*
Beverly H. Carter, *Grove City College*
Michael Channing, *Saddleback Community College*
Patricia J. Chauvin, *St. Petersburg College*
Cyndia Clegg, *Pepperdine University*
Jennie Congleton, *College Misericordia*
Ron L. Cooper, *Central Florida Community College*
Similih M. Cordor, *Florida Community College*
Laurel Corona, *San Diego City College*
Michael W. Coste, *Front Range Community College–Westminster*
Harry S. Coverston, *University of Central Florida*
David H. Darst, *Florida State University*
Gareth Davies-Morris, *Grossmont College*
James Doan, *Nova Southeastern University*
Jeffery R. W. Donley, *Valencia Community College*
William G. Doty, *University of Alabama*
Scott Douglass, *Chattanooga State Technical Community College*
May Du Bois, *West Los Angeles College*
Tiffany Engel, *Tulsa Community College*
Walter Evans, *Augusta State University*
Douglas K. Evans, *University of Central Florida*
Arthur Feinsod, *Indiana State University*
Kimberly Felos, *St. Petersburg College–Tarpon Springs*
Jane Fiske, *Fitchburg College*
Brian Fitzpatrick, *Endicott College*
Lindy Forrester, *Southern New Hampshire University*
Barbara Gallardo, *Los Angeles Harbor College*
Cynthia D. Gobatie, *Riverside Community College*
Blue Greenberg, *Meredith College*
Richard Grego, *Daytona Beach Community College–Daytona*
Linda Hasley, *Redlands Community College*

Dawn Marie Hayes, *Montclair State University*
Arlene C. Hilfer, *Ursuline College*
Clayton G. Holloway, *Hampton University*
Marion S. Jacobson, *Albany College of Pharmacy of Union University*
Bruce Janz, *University of Central Florida*
Steve Jones, *Bethune-Cookman College*
Charlene Kalinoski, *Roanoke College*
Robert S. Katz, *Tulsa Community College*
Alice Kingsnorth, *American River College*
Connie LaMarca-Frankel, *Pasco-Hernando Community College*
Leslie A. Lambert, *Santa Fe Community College*
Sandi Landis, *St. Johns River Community College–Orange Park*
Vonya Lewis, *Sinclair Community College*
David Luther, *Edison Community College, Collier*
Michael Mackey, *Community College of Denver*
Janet Madden, *El Camino College*
Ann Marie Malloy, *Tulsa Community College–Southeast*
James Massey, *Polk Community College*
John Mathews, *Central Florida Community College*
Susan McClung, *Hillsborough Community College–Ybor City*
Joseph McDade, *Houston Community College, Northeast*
Brian E. Michaels, *St. Johns River Community College*
Maureen Moore, *Cosumnes River College*
Nan Morelli-White, *St. Petersburg College–Clearwater*
Jenny W. Ohayon, *Florida Community College*
Beth Ann O'Rourke, *University of Central Florida*
Elizabeth Pennington, *St. Petersburg College–Gibbs*
Nathan M. Poage, *Houston Community College–Central*
Jay D. Raskin, *University of Central Florida*
Sharon Rooks, *Edison Community College*
Douglas B. Rosentrater, *Bucks County Community College*
Grant Shafer, *Washtenaw Community College*
Mary Beth Schillaci, *Houston Community College–Southeast*
Tom Shields, *Bucks County Community College*
Frederick Smith, *Lake City Community College*
Sonia Sorrell, *Pepperdine University*
Jonathan Steele, *St. Petersburg Junior College*
Elisabeth Stein, *Tallahassee Community College*
Lisa Odham Stokes, *Seminole Community College*
Alice Taylor, *West Los Angeles College*
Trent Tomengo, *Seminole Community College*
Cordell M. Waldron, *University of Northern Iowa*
Robin Wallace, *Baylor University*
Daniel R. White, *Florida Atlantic University*
Naomi Yavneh, *University of South Florida*
John M. Yozzo, *East Central University*
James Zaharek, *Rio Hondo College*
Kenneth Zimmerman, *Tallahassee Community College*

Acknowledgments

No project of this scope could ever come into being without the hard work and perseverance of many more people than its author. In fact, this author has been humbled by a team at Pearson Prentice Hall that never wavered in its confidence in my ability to finish this enormous undertaking (or if they did, they had the good sense not to let me know); never hesitated to cajole, prod, and massage me to complete the project in something close to on time; and always gave me the freedom to explore new approaches to the materials at hand. At the down-and-dirty level, I am especially grateful to fact checker, George Kosar; to historian Frank Karpiel, who helped develop the timelines, the Cultural Parallels, and the Voices features of the book; to Mary Ellen Wilson for the pronunciation guides; as well as the more specialized pronunciations offered by David Atwill (Chinese and Japanese); Jonathan Reynolds (African); Nayla Muntasser (Greek and Latin); and Mark Watson (Native American); to John Sisson for tracking down the readings; to Laurel Corona for her extraordinary help with Africa; to Arnold Bradford for help with critical thinking questions; and to Francelle Carapetyan and her assistant Rebecca Harris for their remarkable photo research. The maps and some of the line art are the work of cartographer and artist, Peter Bull, with Precision Graphic drafting a large portion of the line art for the book. I find both in every way extraordinary.

In fact, I couldn't be more pleased with the look of the book, which is the work of Leslie Osher, associate director of design, Nancy Wells, senior art director, and Ximena Tamvakopoulos, designer. The artistic layout of the book was created by Gail Cocker-Bogusz and Wanda España. Gail Cocker-Bogusz coordinated the map and line art program with the help of Mirella Signoretto. The production of the book was coordinated by Barbara Kittle, director of operations; Lisa Iarkowski, associate director of team-based project management; Mary Rottino, senior managing editor; and by Barbara Cappuccio, project manager; who oversaw with good humor and patience the day-to-day, hour-to-hour crises that arose. Brian Mackey, operations manager, ensured that this project progressed smoothly through its production route.

The marketing and editorial teams at Prentice Hall are beyond compare. On the marketing side, Brandy Dawson, director of marketing; Marissa Feliberty, executive marketing manager; and Irene Fraga, marketing assistant; helped us all to understand just what students want and need. On the editorial side, my thanks to Yolanda de Rooy, president of the Humanities and Social Science division; to Sarah Touborg, editor-in-chief; Amber Mackey, senior editor; Bud Therien, special projects manager; Alex Huggins, assistant editor; and Carla Worner, editorial assistant. The combined human hours that this group has put into this project are staggering. Deserving of special mention is my development team, Rochelle Diogenes, editor-in-chief of development; Roberta Meyer, senior development editor; Karen Dubno; and Elaine Silverstein. Roberta may be the best in the business, and I feel extremely fortunate to have worked with her.

Finally, I want to thank, with all my love, my beautiful wife, Sandy Brooke, who has supported this project in every way. She continued to teach, paint, and write, while urging me on, listening to my struggles, humoring me when I didn't deserve it, and being a far better wife than I was the husband. I was often oblivious, and might at any moment disappear into the massive pile of books beside my desk that she never made me pick up. To say the least, I promise to pick up.

The nineteenth century is dominated by two crucial social transformations—the emergence of industrial society, supplanting the predominantly agricultural way of life that had defined Western society for centuries, and the extension of European and American control over the native cultures of Africa, Asia, and the Americas. These two forces—industrialization and imperialism—gave rise, especially in the last half of the century, to many of the characteristics that still define Western culture today. More people began living in cities than in the country. Big business emerged, and trade unions organized to resist them. Liberals, recognizing that labor was consistently mistreated by industry, worked for reform, laying the foundations of the welfare state. Socialism, which decried the control of production by the wealthy few, became a central force in the political life of the West. Seeking work, literally millions of workers emigrated, especially from Eastern Europe to the United States, where, by 1890, fully three-quarters of the population was foreign-born. In Europe, the working class increasingly found itself pushed out of the city, as in Paris, or removed to one side, as in London. Where tenements had

Claude Monet, detail of *The Regatta at Argenteuil*, ca. 1872. Oil on canvas, 19″ × 29½″. Musée d'Orsay, Paris. (See Fig 37.6)
(right) Jacques-Louis David, *The General Bonaparte*. (See Figure 34.2).

Romanticism, Realism, and Empire: 1800 to 1900

once stood, the new bourgeois middle class gentrified the cityscape, creating parks, wide streets, and shopping districts. For the first time in history, a large percentage of the population had the time and money to indulge in leisure entertainment and activities, like sailing on the Seine, painting in the open air, or strolling on the island of La Grande Jatte outside Paris on a Sunday afternoon. Increasingly, the populations of the West began to assert their ethnic, linguistic, and cultural identities, and the nation-state as we know it began to take shape. Italy and Germany were unified. France, England, Germany, Russia, and even Belgium all competed to assert their national supremacy by gaining control of vast reaches of Africa and Asia. This was taking place even as, in the Americas, the United States moved to assert its supremacy over the American continent, driving the Native American population into reservations and its own Southern states, who tried to assert their own national identity by seceding from the Union, into subjugation. All this required great military expenditure, and the foundations of modern warfare were laid in place.

In the arts, such developments were not received uncritically. Reacting against the Neoclassical quest for order and control that was epitomized by the figure of Napoleon Bonaparte, the Romantic movement in art and literature sought to broaden its understanding of human experience, to recognize the tumultuous power of human emotion and imagination. Sentimentality, melancholy, and longing, as well as triumph and joy, all were symptomatic of the Romantic cast of mind. The darker side of the imagination also revealed itself—one tormented by the horrors of war, the destructive power of the human will, and the frightening prospects of nightmare and fantasy. In poetry, in painting, and in music, this new investigation into the subjective reaches of the self opened new realms of feeling and experience.

To some, such investigations were merely self-indulgent, especially given the sordid realities of working-class life that would lead, in 1848, to over a hundred revolutions across the European continent. Some writers chose to parody the Romantic frame of mind. Painters and writers celebrated the quiet heroism of the working class, even as they lambasted the ruling class and the blind eye it turned toward suffering. Idealism came to seem something of a sham, a retreat from the human condition—or what one author called the "human comedy." Forces larger than the self—biological and social—seemed to determine the course of existence. But art could also turn its eye to the bourgeoisie and celebrate its good life, as the Impressionist painters would come to paint not work but leisure.

Beginning in the 1880s, artists and thinkers begin to believe in the necessity of pushing aside previous norms and standards entirely, instead of merely revising past knowledge in light of current techniques, a process that suggests a nascent, burgeoning modernism. As one writer remarked, "It is essential to be thoroughly modern in one's tastes." The drive to be "modern" involved the self-conscious rejection of tradition, which very often asserted itself at major art exhibitions. In literature, the Symbolist movement would have a tremendous influence on the development of modernist poetry, and the first great modernist painters of the next century would develop directly out of a Symbolist tradition in painting. And philosophers and intellectuals in their abandonment of convention and tradition announced the liberation of modern consciousness.

Timeline Book Five: 1800 to 1900

	1770–1825	1825–1850
HISTORY AND CULTURE	**1796:** death of Catherine the Great of Russia **1799–1815:** Napoleon rules France **1807:** Napoleon invades Spain **1814–1815:** Congress of Vienna	**1830:** revolutions in France, Belgium **1833:** Britain bans employment of children under age 9 **1845–1849:** Irish Potato Famine **1848:** revolutions in France, Austria, Italy, Germany **1848:** French king Louis-Philippe deposed **1848–1860s:** Jews gain rights of citizenship in Western Europe **1849:** gold discovered in California
RELIGION AND PHILOSOPHY	**1790:** Immanuel Kant's *Critique of Judgment* **1806:** Georg Wilhelm Friedrich Hegel's *The Philosophy of History* **1820s:** Charles Fourier and Robert Owen plan utopian communities	**1848:** Karl Marx and Friedrich Engels write *The Communist Manifesto*
TECHNOLOGY AND SCIENCE		**1836:** London's first railway **1839:** first photographs; Charles Darwin's *The Voyage of the Beagle*
ART AND ARCHITECTURE	**1774–1840:** Caspar David Friedrich, German Romantic painter **1776–1837:** John Constable, English Romantic landscape painter **1793:** Kitagawa Utamaro's *Utamaro's Studio* **1796–1798:** Francisco Goya's *The Sleep of Reason Produces Monsters* **1814–1815:** Goya's *Third of May, 1808* **1818:** Théodore Géricault's *The Raft of the "Medusa"* Utamaro, *Utamaro's Studio*	**1826–1900:** U.S. Hudson River School painter Frederic Edwin Church **1829–1831:** Katsushika Hokusai's *Thirty-Six Views of Mount Fuji* **1830:** Eugene Delacroix's *Liberty Leading the People* **1836:** Thomas Cole's *The Oxbow (View from Mount Holyoke, Northampton, Massachusetts, After a Thunderstorm)* **1836–1837:** A.W.N. Pugin designs interiors for London's Houses of Parliament **1844:** J.M.W. Turner's *Rain, Steam, and Speed—The Great Western Railway* **1849:** Rosa Bonheur's *Plowing at the Nivernais* **1849–1850:** Gustave Courbet's *A Burial at Ornans* **1850:** Jean-François Millet's *The Sower*
LITERATURE AND MUSIC	**1774:** Johann Wolfgang von Goethe's novel *The Sorrows of Young Werther* **1798:** Samuel Taylor Coleridge's and William Wordsworth's *Lyrical Ballads* **1798:** Friedrich von Schlegel coins the term "Romanticism" **1804:** Ludwig van Beethoven's *Eroica* symphony **1815–1850s:** Franz Schubert and Robert and Clara Schumann set poetry to music in *lieder* form **1812:** Lord Byron's poem *Childe Harold's Pilgrimage* **1818:** Mary Shelley's novel *Frankenstein* **1819:** John Keats's *Ode to a Nightingale* and *Ode on a Grecian Urn*; Percy Bysshe Shelley's *Ode to the West Wind* **1824:** Beethoven's Ninth Symphony Stieler, *Beethoven*	**1826:** James Fenimore Cooper's novel *The Last of the Mohicans* **1827–1838:** John James Audubon's *Birds of America* **1830:** Hector Berlioz's *Symphonie Fantastique* **1832:** Goethe's play *Faust* **1833–1845:** Honoré de Balzac's 92-novel series *The Human Comedy* **1834:** Ralph Waldo Emerson (1803–1882) moves to Concord, Massachusetts, writes *Nature* (1836), helps found the "Transcendental Club" **1834:** F Chopin (1810–1849) composes *Fantasie impromptu* **1836:** Charles Dickens (1812–1870) writes *Sketches by Boz*, followed by *The Old Curiosity Shop* (1840) **1836:** Russian realist Nikolai Gogol (1809–1852) writes *The Inspector General*, followed by *Dead Souls* (1842) **1843:** Thomas Carlyle (1795–1881) writes *Past and Present* contrasting lives of workers with those of the prosperous **1845:** Frederick Douglass (1817–1895) writes *Narrative of the Life of Frederick Douglass: An American Slave* **1846:** French poet Charles Baudelaire (1821–1867) writes "To the Bourgeoisie," recognizing the power of the middle class **1849:** Henry David Thoreau (1817–1862) writes *Civil Disobedience*

1850–1875	1875–1900	
1850s: Florence Nightingale establishes nursing as honored profession **1852–1870:** Emperor Napoleon III rules France **1853:** Commodore Matthew Perry initiates contact with Japan **1861–1865:** U.S. Civil War **1868:** Meiji Restoration ends rule of shoguns, begins modernization of Japan **1870–1871:** Franco–Prussian War **1871:** Paris Commune	**1870s–1900:** Russian Westernizers battle Slavophiles **1880s–1890s:** European "Scramble for Africa" **1882:** United States prohibits Chinese immigration **1883:** U.S. Supreme Court nullifies Civil Rights Act, enabling Jim Crow laws in South **1890–1900:** fin de siècle era characterized by prosperity, opulence, decadence	HISTORY AND CULTURE
1872: Friedrich Nietzsche's *The Birth of Tragedy*	**1883–1886:** Nietzsche's *Beyond Good and Evil*, *Thus Spoke Zarathustra*, calling for society of *ubermenschen* ("higher men")	RELIGION AND PHILOSOPHY
1851: "Crystal Palace" exhibition in London **1853–1870:** Baron Haussmann redesigns Paris **1855:** municipal sewage system established in London **1859:** Darwin's *The Origins of Species* **1871:** Darwin's *The Descent of Man* **1872:** first long-distance railway in Japan	**1880s–1890s:** electricity introduced to commercial buildings, residences **1889:** Eiffel Tower erected for Paris Exposition **1893:** Chicago's Columbian Exhibition	TECHNOLOGY AND SCIENCE
1856–1870s: Frederick Law Olmsted and Calvert Vaux design Central Park, in New York City **1860–1875:** Paris Opera constructed, designed by Charles Garnier **1863:** Édouard Manet's *Le Déjeuner sur l'Herbe* **1867:** Manet's *The Execution of Maximilian* **1874:** first Impressionist exhibition in Paris **1874:** Edgar Degas's *Dance Class*; James McNeill Whistler's *Nocturne in Black and Gold: The Falling Rocket* Manet, Le *Déjeuner sur l'Herbe*	**1875:** Thomas Eakins's *The Gross Clinic* **1879:** Paul Cézanne's *Gulf of Marseilles, seen from l'Estaque* **1880s:** Art Nouveau movement **1881–1882:** Manet's *Bar at the Folies-Bergère* **1886:** Auguste Rodin's statue *The Kiss*; Georges Seurat's *Sunday Afternoon on the Island of La Grand Jatte* **1889:** Vincent van Gogh's *Starry Night* **1893:** Edvard Munch's *The Scream* **1894:** Paul Gauguin's *Mahna no Atua (Day of the Gods)* **1896–1897:** Louis Sullivan designs the Bayard Building in New York **1901–1902:** Gustav Klimt's *Judith, Portrait of Emilie Floge*	ART AND ARCHITECTURE
1851: Herman Melville's novel *Moby Dick*; Giuseppe Verdi's opera *Rigoletto* **1851–1853:** John Ruskin's *The Stones of Venice* **1852:** Harriet Beecher Stowe's novel *Uncle Tom's Cabin* **1854:** Henry David Thoreau's *Walden, or Life in the Woods* **1854:** Charles Dickens's novel *Hard Times* **1856:** Gustave Flaubert's novel *Madame Bovary* **1857:** Charles Baudelaire's poems *Les Fleurs du mal* **1866:** Jacques Offenbach's operetta *La Vie Parisienne*; Fyodor Dostoyevsky's novel *Crime and Punishment* **1869:** Leo Tolstoy's novel *War and Peace*; John Stuart Mill's essay *The Subjection of Women* argues for women's rights **1874:** Richard Wagner completes *Der Ring des Nibelungen* cycle of operas	**1877:** Tolstoy's novel *Anna Karenina* **1879:** Henrik Ibsen's play *A Doll's House* **1881:** Henry James's novel *Portrait of a Lady* **1885:** Mark Twain's novel *Huckleberry Finn* **1888–1889:** Gustav Mahler composes *Symphony No. 1* **1890s:** birth of jazz in New Orleans **1891:** first collection of poems by Emily Dickinson published **1892:** Walt Whitman's final edition of *Leaves of Grass* **1899:** Scott Joplin composes *Maple Leaf Rag*; Kate Chopin's novel *The Awakening* **1905:** Claude Debussy composes *La Mer*	LITERATURE AND MUSIC

BOOK FIVE / ROMANTICISM, REALISM, AND EMPIRE: 1800 TO 1900

33 The Self in Nature

The Rise of Romanticism

The Early Romantic Imagination

The Romantic Landscape

Transcendentalism and the American Romantics

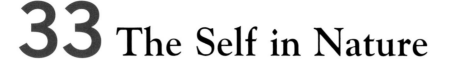

❝ *A motion and a spirit, that impels*
All thinking things, all objects of all thought,
And rolls through all things. . . . ❞

Wordsworth, "Tintern Abbey"

◄ **Fig. 33.1 Tintern Abbey, Wye Valley, Gwent Monmouthshire.** Robert Harding Picture Library. The abbey was founded in the twelfth century, but gradually fell to ruin after Henry VIII dissolved the monasteries in 1536. Ruins such as the abbey and the surrounding woodlands fueled the Romantic imagination.

T

INTERN ABBEY IS A RUINED MEDIEVAL MONASTERY ON THE banks of the Wye River north of Bristol in South Wales, England (Fig. **33.1**). Its roofless buildings were open to the air and its skeletal Gothic arches overgrown with weeds and saplings (Fig. **33.2**). In the late eighteenth century, it was common for

British travelers to tour the beautiful Wye River, and the final destination of the journey was the Abbey (Map **33.1**). In 1798, a British magazine writer assigned a degree of importance to the *Wye Tour* (as it was known) that might surprise the modern reader:

> The enchanting beauties of the River Wye are by this time pretty generally known among the lovers of the picturesque . . . [C]uriosity has been inflamed by poetry and by prose, by paintings, prints, and drawings. . . . An excursion on the Wye has become an essential part of the education . . . of all who aspire to the reputation of elegance, taste, and fashion.

That a "tour" of English scenery should be "essential" to one's education suggests that there is more to the picturesque than just the "view" it offers. The River Wye offered larger lessons.

This chapter surveys the growing taste for the natural world in the late eighteenth and first half of the nineteenth centuries in Europe, particularly England and Germany, and in America, where a loosely knit group known as the Transcendentalists sought to discover the "transcendent" order of nature. Unifying principles could be found in the natural world, which became a sacred space that pointed to the imminent presence of the divine. During this period, poets and painters, essayists and composers increasingly came to view nature itself as the greatest teacher, the defining center of culture, and the pivotal force that determined and guided human experience. London and New York might well have been the Western hubs of commerce, Washington, D.C. and Paris the focal points of political life, but it was to nature that artists turned for inspiration.

Romantic artists revolted against the classical values of order, control, balance, and proportionality championed by Neoclassical artists, many of whom—Jacques-Louis David, for instance (see chapter 32)—were their contemporaries. They approached the world instead with an outpouring of feeling and emotional intensity that came to be called *Romanticism* [roh-MAN-tih-siz-um]. Originally coined in 1798 by the German writer and poet Friedrich von Schlegel [SHLAY-gul] (1772–1829), "Romanticism" was an overt reaction against the Enlightenment and classical culture of the eighteenth century. For Schlegel, Romanticism refers mainly to his sense that the common cultural ground of

Europe—the Classical past from which it had descended, and the values of which it shared—was disintegrating, as Europeans formed new nation-states based on individual cultural identities.

Schlegel's own thinking was deeply influenced by the philosopher Immanuel Kant [kahnt] (1724–1804). In his *Critique of Judgment* (1790), Kant defined the pleasure we derive from art as "disinterested satisfaction." By this he meant that contemplating beauty, whether in nature or in a work of art, put the mind into a state of free play in which things that seemed to oppose each other—subject and object, reason and imagination—are united. Schlegel was equally influenced by Johann Winckelmann's perspective on Greek art (see chapter 31). What the Greeks offered were not works of art to be slavishly imitated, in the manner of Neoclassical artists. For Winckelmann, and for Schlegel, the Greeks provided a new way for the Romantic artist to approach nature: The Greeks studied nature in order to discover its essence. Nature only occasionally rises to moments of pure beauty. The lesson taught by the Greeks, Winckelmann argued, was that art might capture and hold those rare moments.

Dedicated to the discovery of beauty in nature, the Romantics rejected the truth of empirical observation, which John Locke and other Enlightenment thinkers had championed. The objective world mattered far less to them than their subjective experience of it. The poet Samuel Taylor Coleridge, one of the founders of the Romantic movement, offered a pithy summary in a letter to a friend: "My opinion is this—that deep Thinking is attainable only by a man of deep Feeling, and that all Truth is a species of Revelation." Knowing the exact distance between the earth and the moon mattered far less than how it *felt* to look at the moon in the dark sky. And it must be remembered that for Romantics, the night was incomparably more appealing, because it was more mysterious and unknowable, than the daylight world.

Nor did they believe that the human mind was necessarily a thinking thing, as Descartes had argued, when he wrote, "I think, therefore I am." For the Romantics, the mind was a feeling thing, not distinct from the body as Descartes had it, but intimately connected to it. Feelings, they believed, led to truth, and most of the major writers

and artists of the early nineteenth century used their emotions as a primary way of expressing their imagination and creativity. Indeed, since nature stimulated the emotions as it did the imagination, the natural world became the primary subject of Romantic poetry, and landscape the primary genre of Romantic painting. Because nurturing one's feelings restored human beings to their own true nature, examining the emotional life of the self in relation to the world characterized Romantic fiction. In nature the Romantics discovered not just the wellspring of their own creativity, but the very presence of God, the manifestation of the divine on earth.

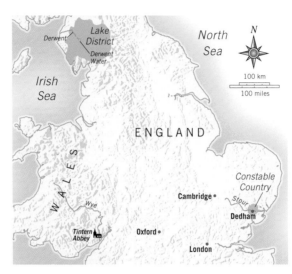

Map 33.1 Romantic England.

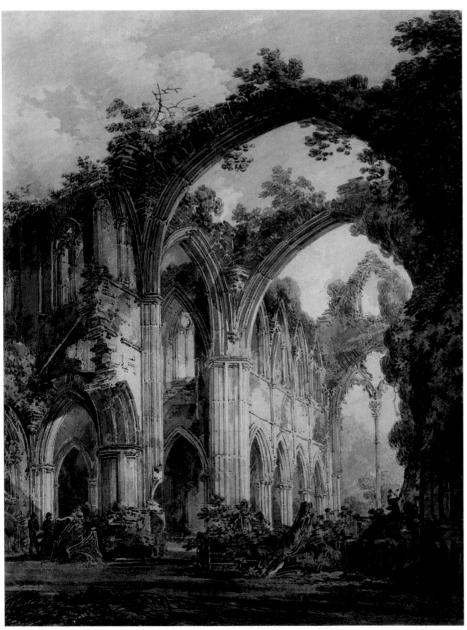

Fig. 33.2 J. M. W. Turner. *Interior of Tintern Abbey.* 1794. Watercolor, $12\frac{5}{8}$" × $9\frac{7}{8}$". The Trustees of the Victoria and Albert Museum, London, Art Resource, NY. Turner toured South Wales and the Wye Valley in 1792, when he was 19 years old. This watercolor is based on a sketch made on that trip.

The Early Romantic Imagination

In July 1798, the same year the British writer claimed that the Wye Tour was essential to everyone's education, the 28-year-old poet William Wordsworth (1770–1850) visited Wye Valley, accompanied by his sister Dorothy. There he composed a poem that for his entire generation would come to embody the very idea of the Romantic.

The Idea of the Romantic: William Wordsworth's "Tintern Abbey"

The Wordsworth poem that had such a major impact is generally known by the shortened title "Tintern Abbey." Its complete title is "Lines Composed a Few Miles above Tintern Abbey, on Revisiting the Banks of the Wye during a Tour, July 13, 1798" (see **Reading 33.1**, pages 1074–1075, for the complete poem). The poet had visited the valley five years before, and he begins his poem by thinking back to that earlier trip:

> Five years have passed; five summers, with the length
> Of five long winters! and again I hear
> These waters, rolling from their mountain-springs
> With a soft inland murmur. —Once again
> Do I behold these steep and lofty cliffs,
> That on a wild secluded scene impress
> Thoughts of more deep seclusion; and connect
> The landscape with the quiet of the sky.

The implication is that the scene evokes thoughts "more deep" than mere appearance, thoughts in which landscape and sky—and perhaps the poet himself—are all connected, united together as one.

After describing the scene before him at greater length, the poet then recalls the solace that his memories of the place had brought him in the five intervening years as he had lived "in lonely rooms, and 'mid the din / Of towns and cities." His memories of the place, he says, brought him "tranquil restoration," but even more important "another gift," in which "the weary weight / Of all this unintelligible world, / Is lightened" by allowing the poet to "see into the life of things."

Wordsworth does not completely comprehend the power of the human mind here. What the mind achieves at such moments remains to him something of a "mystery." But it seems to him as if his breath and blood, his very body—that "corporeal frame"—is suspended in a "power / Of harmony" that informs all things.

Wordsworth next describes how he reacted to the scene as a boy. The scene, he says, was merely "an appetite." But now, as an adult, he looks on the natural world differently. He finds in nature a connection between landscape, sky, and thought that is intimated in the opening lines of the poem. Humankind and Nature are united in total harmony:

> A motion and a spirit, that impels
> All thinking things, all objects of all thought,
> And rolls through all things.

In this perception of the unity of all things, Wordsworth is able to define nature as his "anchor" and "nurse," "The guide, the guardian of my heart, and soul / Of all my mortal being." Wordsworth's vision is informed not just by the scene itself, but by his memory of it, and by his imagination's understanding of its power. As the poem moves toward conclusion, Wordsworth turns to his sister beside him, praying that she too will know, as he does, that "Nature never did betray / The heart that loved her." Indeed, Wordsworth's prayer for his sister Dorothy is really intended as a prayer for us all. We should each of us become, as he is himself, "a worshiper of Nature."

"Tintern Abbey" can be taken as one of the fullest statements of the Romantic imagination. In the course of its 159 lines, it argues that in experiencing the beauty of nature, the imagination dissolves all opposition. Wordsworth suggests that the mind is an active participant in the process of human perception rather than a passive vessel. There is an ethical dimension to aesthetic experience, a way to stand above, or beyond, the "dreary intercourse of daily life," both literally and figuratively on higher ground. Perhaps most of all, the poem provides Wordsworth with the opportunity for communion, not merely with the natural world, but with his sister beside him, and by extension his readers as well. In individual experience, Wordsworth makes contact with the whole.

A Romantic Experiment: *Lyrical Ballads*

On his way to Tintern Abbey and the River Derwent [DUR-wunt] in 1798, Wordsworth had stopped in Bristol to drop off a book of poems at Joseph Cottle's publishing house. He had co-written the book, *Lyrical Ballads*, with his friend, Samuel Taylor Coleridge [KOLE-rij] (1772–1834). Coleridge had published with Cottle already, but *Lyrical Ballads* was published anonymously. As Coleridge put it, "Wordsworth's name is nothing—[and] to a large number of persons mine stinks." At the last moment, on his way back from South Wales, Wordsworth added "Tintern Abbey" to the volume.

For its next editions, in 1800 and 1802, the book was significantly revised and augmented, and Wordsworth included an important preface that discussed why poetry should attempt to reflect what he called "the language of conversation" (**Reading 33.2**):

READING 33.2 **from William Wordsworth, "Preface" to *Lyrical Ballads* (1800)**

The principal object ... proposed in these Poems was to choose incidents and situations from common life, and to relate or describe them, throughout, as far as was possible, in a selection of language really used by men. ... Humble and rustic life was generally chosen, because, in that condition, the essential passions of the heart find a better soil in which they can attain their maturity, are less under restraint, and speak a plainer and more emphatic language; because in that condition of life our elementary feelings co-exist in a state of greater simplicity, and, consequently, may be more accurately contemplated, and more forcibly communicated; because the manners of rural life germinate from those elementary feelings; and, from the necessary character of rural occupations, are more easily comprehended, and are more durable; and lastly, because in that condition the passions of men are incorporated with the beautiful and permanent forms of nature. The language, too, of these men is adopted ... because such men hourly communicate with the best objects from which the best part of language is originally derived; and because ... they convey their feelings and notions in simple and unelaborated expressions.

Although the Wordsworth of "Tintern Abbey" is no humble rustic, the aim of the poem is precisely that of the *Lyrical Ballads* as a whole, to discover that moment when "the passions of men are incorporated with the beautiful and permanent form of nature." Wordsworth further defines poetry as "the spontaneous overflow of powerful feelings" resulting from "emotion recollected in tranquility," emotions like those he recollected overlooking Tintern Abbey. The poet, Wordsworth writes, "considers man and nature as essentially adapted to each other, and the mind of man as naturally the mirror of the fairest and most interesting qualities of nature."

In 1799 Wordsworth and his sister moved to the northern Lake District, where they had grown up. Over the course of the next seven years, he wrote some of his greatest poems, such as "The Rainbow," published in 1807 as *Poems in Two Volumes* (see *Focus*, pages 1058–1059). Much of the remainder of his life was dedicated to completing two long poems, *The Recluse*, a meditation on the relationship between humanity, nature, and society that he never completed, and a book-length autobiographical poem, tracing, as he says, "the growth of a poet's mind," and published after his death in 1850 under the title of *The Prelude*.

Romanticism as a Voyage of Discovery: Samuel Taylor Coleridge

Wordsworth's statements in the Preface to *Lyrical Ballads* could not be further from the mind-sets of the characters created by his friend Coleridge. In fact, the Mariner in Coleridge's "Rime of the Ancient Mariner," a long narrative poem which opened *Lyrical Ballads*, is a man wholly at odds with nature. In Part I of the poem, the Mariner senselessly kills the albatross that had been his shipmates' companion at sea (see **Reading 33.3**, pages 1076–1077). He and his shipmates come to see this act as bringing them the worst luck a ship can have, to be floating in the middle of the ocean until they run out of food and water (**Reading 33.3a**):

READING 33.3a **from Samuel Taylor Coleridge, "Rime of the Ancient Mariner," Part II (1797)**

Day after day, day after day,
We stuck, nor breath nor motion;
As idle as a painted ship
Upon a painted ocean.

Water, water, everywhere,
And all the boards did shrink;
Water, water, everywhere,
Nor any drop to drink.

In fact, a death ship arrives in this unnatural sea, taking all the crew but leaving the Mariner alone in a kind of living death (**Reading 33.3b**):

READING 33.3b **from Samuel Taylor Coleridge, "Rime of the Ancient Mariner," Part IV (1797)**

Alone, alone, all, all alone,
Alone on a wide wide sea!
And never a saint took pity on
My soul in agony.

Focus

Wordsworth's "The Rainbow"

William Wordsworth wrote "The Rainbow" in 1802, while he was working on the first draft of *The Prelude*, his book-length autobiographical poem, in which he traced "the growth of a poet's mind." So, despite its shortness—only nine lines—"The Rain- bow" has packed into it much of the thinking that went into *The Prelude*. Both poems express the idea that his poetic occupation had been foreordained in his childhood. In "The Rainbow," the poet is reaching back into his childhood in order to begin his quest for the unity of self.

The poem's first line brings together feeling ("my heart leaps up") and vision ("when I behold"), the subjective and objective are unified in a single moment.

Past, present, and future are united here in a parallel phrasing that is reminiscent of prayer.

Wordsworth's covenant is not between God and humanity, but between himself and nature. This is what he means by "natural piety," a reverence for nature of which he longs to be reminded each and every day.

The Rainbow

My heart leaps up when I behold
A rainbow in the sky:
So was it when my life began,
So is it now I am a man,
So be it when I shall grow old,
Or let me die!
The child is the father of the man;
And I could wish my days to be
Bound each to each by natural piety.

The rainbow is a traditional symbol of renewal, a renewal founded in Judeo-Christian tradition, where God says to Noah after the Flood: "I do set my bow in the cloud, and it shall be a covenant between me and the earth." It symbolizes the bridge between the secular world and the spiritual realm.

This line echoes lines from the 1799 first version of *The Prelude* asking of the River Derwent if it inspired his love of nature when, as a baby, his nurse first walked him along its banks:

For this didst thou,
O Derwent, traveling over the
 green plains
Near my "sweet birthplace," didst
 thou, beauteous stream. . .
[Give me] A knowledge, a dim
 earnest, of the calm
That nature breathes among her
 woodland haunts?

Rhyme Scheme and Meter

The rhyme scheme and meter are simple, but Wordsworth takes advantage of this simplicity to achieve surprising effects. The standard measure (or "foot") is iambic (short-long).

Rhyme	Meter	Rhyme	Meter
a	4 feet	*b*	2 feet
b	3 feet	*c*	4 feet
c	4 feet	*d*	4 feet
c	4 feet	*d*	5 feet
a	4 feet		

Only the first foot of line 7—"The child is"—is not iambic. It is, instead, a **dactyl** [DAK-tul], composed of one short and two long units. Thus Wordsworth emphasizes his theme, the presence of the child in the man, rhythmically, by drawing attention to the word "child." The five beats of the last line, and the final couplet rhyme, draw attention to the phrase "natural piety."

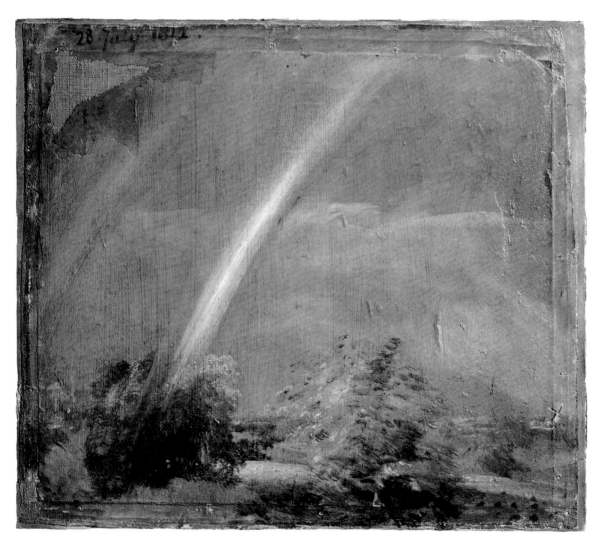

John Constable. *Landscape and Double Rainbow.* **1812.** Oil on paper mounted on canvas, 13 1/4″ × 15″. Victoria and Albert Museum, London/Art Resource, NY. 328-1888. Near the end of his life, Constable would copy Wordsworth's poem into his notebooks. Constable himself wrote: "Nature in all the varied aspects of her beauty exhibits no feature more lovely nor any that awakens a more soothing reflection than the rainbow."

His salvation comes only when he recognizes that even the water-snakes that surround him are "living things" (**Reading 33.3c**):

READING 33.3c **from Samuel Taylor Coleridge, "Rime of the Ancient Mariner," Part IV (1797)**

A spring of love gushed from my heart,
And I blessed them unaware:
Sure my kind saint took pity on me,
And I blessed them unaware. . . .

The self-same moment I could pray;
And from my neck so free
The Albatross fell off, and sank
Like lead into the sea.

Although the Mariner still faces many trials, this is the turning point of his life. His redemption seems possible.

The supernatural and mystical character of Coleridge's imagination—fueled not incidentally by his addiction to opium—helped to define Romantic art as a voyage of discovery.

Indeed, Coleridge's poem contains a clear moral lesson. The Mariner's killing of the albatross is an act of bad faith, an attack on the natural world that puts him at odds with it. Only after he blesses the water-snakes, creatures even more monstrous than the albatross, can he redeem himself, reuniting himself with nature as a whole.

Classical versus Romantic: The Odes of John Keats

The odes of John Keats (1795–1821) represent the essence of Romantic poetry. An **ode** is a poem of exaltation, exhibiting deep feeling. Keats's life was tragically short. Most of his greatest poems were written in one year (September 1818 to September 1819) when he was deeply in love with a young woman and was simultaneously diagnosed with tuberculosis, the disease that had killed his mother. All of his great odes were written during this period (Fig. **33.3**).

Keats's "Ode to a Nightingale" is typical of the Romantic's contemplation of nature. "My heart aches, and a drowsy numbness pains / My sense, as though of hemlock I had drunk," it begins, but the song of the Nightingale awakens his senses. Still, he says, "I have been half in love with easeful Death, / Call'd him soft names in many a mused rhyme." But he recognizes something eternal in the song of the nightingale (**Reading 33.4**):

READING 33.4 **from John Keats, "Ode to a Nightingale" (1819)**

Thou wast not born for death, immortal Bird!
No hungry generations tread thee down;
The voice I hear this passing night was heard
In ancient days by emperor and clown:
Perhaps the self-same song that found a path
Through the sad heart of Ruth, when, sick for home,
She stood in tears amid the alien corn;[1]
The same that oft-times hath
Charm'd magic casements,[2] opening on the foam
Of perilous seas, in faery lands forlorn. . . .

[1] In proclaiming the immortality of the nightingale, Keats alludes to the biblical Ruth. As a widow, she relocated to Bethlehem to care for her mother-in-law, Naomi, and ended up tending fields of grain in an alien land. She ultimately married the landowner, Boaz, and was great-grandmother to King David of Israel. Ruth attained immortality through her good deeds.

[2] Casements are windows.

Fig. 33.3 Joseph Severn. *John Keats*. 1821. Oil on canvas, 22 1/4″ × 16 1/2″. National Portrait Gallery, London. Severn would later describe the scene recreated in this posthumous portrait: "This was the time he first fell ill & had written the Ode to the Nightingale on the morning of my visit to Hampstead. I found him sitting with the two chairs as I have painted him & was struck with the first real symptoms of sadness in Keats so finely expressed in that poem."

Keats comes to an awareness here of the eternal beauty and continuity of the nightingale's song. This is also the clear implication of Keats's "Ode on a Grecian Urn"—the beauty of art lives on. In the poem, Keats contemplates a Greek vase covered with figures whose joy in the fleeting pleasures of life is, paradoxically, permanently immortalized in the design of the vase (**Reading 33.5**):

READING 33.5 John Keats, "Ode on a Grecian Urn" (1819)

Thou still unravish'd bride of quietness,
Thou foster-child of silence and slow time,
Sylvan historian, who canst thou express
A flowery tale more sweetly than our rhyme:
What leaf-fring'd legend haunt about thy shape
Of deities or mortals, or of both,
In Tempe or the dales of Arcady?
What men or gods are these? What maidens loth?
What mad pursuit? What struggle to escape?
What pipes and timbrels? What wild ecstasy?

Heard melodies are sweet, but those unheard
Are sweeter: therefore, ye soft pipes, play on;
Not to the sensual ear, but, more endear'd,
Pipe to the spirit ditties of no tone:
Fair youth, beneath the trees, thou canst not leave
Thy song, nor ever can those trees be bare;
Bold lover, never, never canst thou kiss,
Though winning near the goal—yet, do not grieve;
She cannot fade, though thou hast not thy bliss,
For ever wilt thou love, and she be fair!

Ah, happy, happy boughs! that cannot shed
Your leaves, nor ever bid the spring adieu;
And, happy melodist, unwearied,
For ever piping songs for ever new;
More happy love! more happy, happy love!
For ever warm and still to be enjoy'd,
For ever panting, and for ever young;
All breathing human passion far above,
That leaves a heart high-sorrowful and cloy'd,
A burning forehead, and a parching tongue.

Who are these coming to the sacrifice?
To what green altar, O mysterious priest,
Lead'st thou that heifer lowing at the skies,
And all her silken flanks with garlands drest?
What little town by river or sea shore,
Or mountain-built with peaceful citadel,
Is emptied of this folk, this pious morn?
And, little town, thy streets for evermore
Will silent be; and not a soul to tell
Why thou art desolate, can e'er return.

O Attic shape! Fair attitude! with brede
Of marble men and maidens overwrought,

With forest branches and the trodden weed;
Thou, silent form, dost tease us out of thought
As doth eternity: Cold Pastoral!
When old age shall this generation waste,
Thou shalt remain, in midst of other woe
Than ours, a friend to man, to whom thou say'st,
"Beauty is truth, truth beauty,"—that is all
Ye know on earth, and all ye need to know.

Contemplating a Greek vase—probably a composite "ideal" vase made up of scenes derived from those in the collection of the British Museum—Keats admits ignorance about the symbolism of the decorative motifs and what "deities or mortals, or both" are painted on it. Yet the vase's scenes come alive in his imagination and are all the more poignant for being eternal, unchangeable, and silent. The melodies being played by the musicians illustrated on the vase, if anyone were to hear them, would, of course, be beautiful, "but those unheard / Are sweeter." The trees can never lose their leaves. And though the lover will never succeed in kissing his love, thus painted, he can take solace in the fact that she "cannot fade" and will be forever fair. He imagines that the people who populate the vase have been drawn out of some "little town," the streets of which are now forever silent. Then, to conclude, the poet addresses the vase directly: "O Attic shape," he says, when we are dead, you shall remain a "friend to man." The vase imparts an important message to humankind:

"Beauty is truth, truth beauty,"—that is all
Ye know on earth, and all ye need to know.

These last two lines are possibly the most discussed and debated in English poetry. They suggest that the vase, and by extension the poem itself, is a higher form of nature than mortal life. This is, of course, a traditional theme of poetry—think of Shakespeare's sonnets (see chapter 24)—but in the context of Keats's own tragic struggle with tuberculosis and his imminent death, it takes on a stunningly poignant and deeply Romantic tone. Rather than being terrified by the prospect of mortality, the individual contests death and exalts in the confrontation. Perhaps the poem's greatest achievement is that it dissolves the greatest opposition of them all, uniting life and death in the circularity of the "leaf-fring'd legend" that draws the viewers' eyes around the vase's shape. In February 1821, a few months after his twenty-fifth birthday, Keats died in Rome, survived only by his posthumously published poems.

The Romantic Landscape

The most notable landscape painting in Europe had developed in Italy and the Netherlands 200 years earlier. Even the term "landscape" derives from the Dutch word "landschap," meaning a patch of cultivated ground. Although influenced by Italian artists' use of light and color, the great seventeenth-century

Continuity & Change
p. 845

View of Haarlem

Dutch landscape painters, including Jacob van Ruisdael (see chapter 26), were also inspired by a dramatically changing physical geography sparked by the reclamation of hundreds of thousands of acres of land along the coasts. The Dutch landscape painters in turn influenced later English landscape painters. Two seventeenth-century French painters, Nicolas Poussin and Claude Lorrain, also influenced the British artists (see Figs. 27.8, 29.13). Lorrain's use of light and color, in particular, inspired the young John Constable, among the most popular of the English Romantic painters.

John Constable: Painter of the English Countryside

Tension between the timeless and the more fleeting aspects of nature deeply informs the paintings of John Constable (1776–1837). Constable focused most of his efforts on the area around the valley of the Stour River in his native East Bergholt, Suffolk. Like Wordsworth, he felt his talents depended on "faithful adherence to the truth of nature." In 1802, he complained that he had been too busy looking at the work of others: "I have been running after pictures, and seeking the truth at second hand." He acknowledged that "one's mind may be elevated, and kept up to what is excellent, by the works of the great masters," but believed that he needed to look to nature, for "Nature is the fountain's head, the source from which all originally must spring." To this end,

Constable sketched endlessly. His drawing of *Willy Lott's House, East Bergholt* is typical (Fig. 33.4). Lott, a farmer, lived in this house his entire 80 years, spending only four nights of his life away from it. For Constable, the house symbolized a stability and permanence that contrasts dramatically with the impermanence of the weather, the constant flux of light and shadow, sun and cloud.

Like Wordsworth, Constable believed that his art could be traced back to his childhood on the Stour, to places that he had known his whole life. "I should paint my own places best," he wrote to a friend in 1821, "I associate my 'careless boyhood' to all that lies on the banks of the Stour. They made me a painter (& I am grateful)." A painting like *The Stour Valley and Dedham Village* could almost illustrate the opening lines of Wordsworth's "Tintern Abbey," with its "plots of cottage grounds," "orchard tufts," "hedge rows," and "pastoral farms" (Fig. **33.5**). Like Wordsworth, Constable also wished to depict incidents and situations from common life, including villages, churches, farmhouses, and cottages. But most of all, the painting captures Constable's sense that he was, like Wordsworth, "a worshipper of Nature," a religious sentiment underscored by the presence of the Dedham parish church in the distance. As Constable wrote in a letter of May 1819, "Every tree seems full of blossom of some kind & the surface of the ground seems quite living—every step I take & on whatever object I turn my Eye that sublime expression of the Scripture 'I am the resurrection and the life' &c, seems verified about me." In fact, the cathedral at the center of so many Constable landscapes symbolizes the permanence of God in nature.

From 1819 to 1825, Constable worked on a series of what he referred to as his "six-footers," all large canvases depicting scenes on the Stour painted in his London studio from sketches and drawings done earlier. *The Hay Wain* (Fig. **33.6**) is based on a number of studies, including the drawing of *Willy Lott's House* (see Fig. 33.4). Constable felt that a sketch reflected just one emotion. "A sketch," he wrote, "will not serve more than one state of mind & will not serve to drink at it again & again—in a sketch there is nothing but one state of mind—that which you were in at the time." This critique of the sketch goes a long way toward explaining the power of Constable's painting. It contains more than one state of mind—the passing storm, indicated by the darkened clouds on the left, contrasts with the brightly lit field below the billowing clouds at the right, the longevity of the tree behind the house with its massive trunk contrasts with the freshly cut hay at the right, the gentleman fisherman contrasts with the hardworking cart drivers.

Fig. 33.4 John Constable. *Willy Lott's House, East Bergholt.* ca. 1820. Graphite on paper (drawing made up of three sheets of paper), $9\frac{7}{8}'' \times 11\frac{1}{8}''$. Sir Robert Clermont Witt bequest; 1952. Copyright: © Courtauld Institute Gallery of Art, London. For Constable, this farmhouse symbolized a stability and permanence that contrasted dramatically with the unpredictability of weather, the constant flux of light and shadow, sun and cloud.

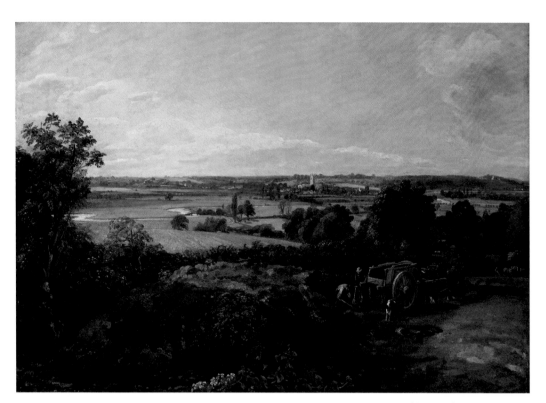

Fig. 33.5 John Constable. *The Stour Valley and Dedham Village.* **1814.** Oil on canvas, 21 ³/₄″ × 30 ³/₄″. Photograph © 2008 Museum of Fine Arts, Boston. William W. Warren Fund, 1948 (48.226). The workers in the foreground are loading manure onto a cart for spreading in the fields.

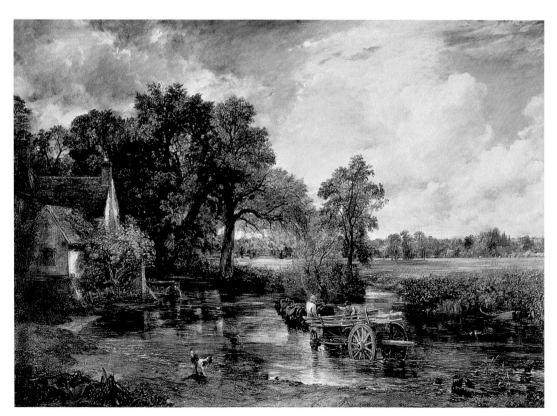

Fig. 33.6 John Constable. *The Hay Wain.* **1821.** Oil on canvas, 51 ³/₈″ × 73″. The National Gallery, London. Constable failed to sell *The Hay Wain* when it was exhibited at the Royal Academy in 1821, though he turned down an offer of £70 for it.

When the painting was first exhibited at the Royal Academy in 1821, Londoners could not accept that this was a "finished" painting because it had been painted in economic, almost abstract terms. Constable used short, broken strokes of color in a variety of shades and tints to produce a given hue (the green of foliage, for example). Nor did they understand how such a common theme deserved such a monumental canvas. Constable subsequently complained to a friend, "Londoners with all their ingenuity as artists know nothing of the feeling of a country life (the essence of Landscape)—any more than a hackney coach horse knows of pasture."

Joseph Mallord William Turner: Colorist of the Imagination

The other great English landscape painter of the day, Joseph Mallord William Turner (1775–1851), was closer in temperament to Coleridge than to Wordsworth. He freely explored what he called "the colors of the imagination." Even his contemporaries recognized, in the words of the critic William Hazlitt (1778–1830), that Turner was interested less in "the objects of nature than . . . the medium through which they are seen." In Turner's paintings earth and vegetation seem to dissolve into light and water, into the very medium—gleaming oil or translucent watercolor—with which he paints them. In *The Upper Falls of the Reichenbach* [RY-khun-bahk], for instance,

Turner's depiction of the falls, among the highest in the Swiss Alps, seems to animate the rocky precipice (Fig. **33.7**). Turner draws our attention, not to the rock, cliff, and mountain, but to the mist and light through which we see them.

Perhaps the best way to understand the difference between Constable and Turner is to consider the *scale* of their respective visions. Constable's work is "close," nearby and familiar, with an abundance of human associations. Turner's is exotic, remote, and even alienating. The human figure in Constable's paintings is an essential and elemental presence, uniting man and nature. The human figure in Turner's paintings is minuscule, almost irrelevant to the painting except insofar as its minuteness underscores nature's very indifference. Not only is *The Upper Falls of the Reichenbach* removed from the close-at-hand world of Constable's paintings, but the cowherd and his dog, barely visible at the lower left of the painting, are dwarfed by the immensity of the scene. Cattle graze on the rise at the bottom middle, and another herd is on the ridge across the gorge. The effect is similar to that described by Wordsworth in "Tintern Abbey":

> And I have felt
> A presence that disturbs me with the joy
> Of elevated thought; a sense sublime
> Of something far more deeply interfused,
> Whose dwelling is the light of setting suns,

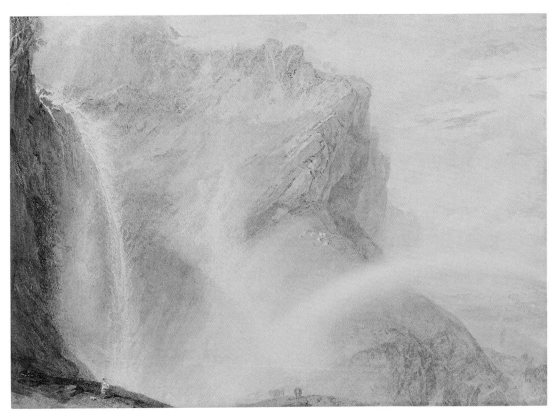

Fig. 33.7 J. M. W. Turner. *The Upper Falls of the Reichenbach.* ca. 1810–1815. Watercolor, $10\frac{7}{8}'' \times 15\frac{7}{16}''$. Yale Center for British Art, Paul Mellon Collection. The Bridgeman Art Library. Turner achieved the transparent effect of the rainbow and the spray rising from the falls by scraping away the watercolor down to the white paper beneath.

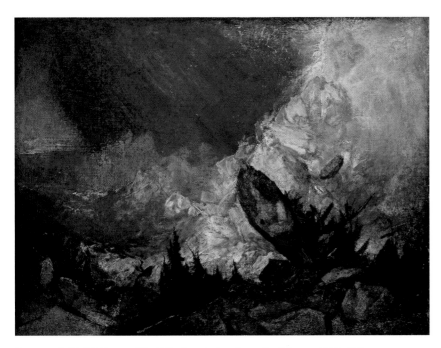

Fig. 33.8 J. M. W. Turner. *The Fall of an Avalanche in the Grisons.* **1810.** Oil on canvas, 35⅝″ × 47¼″. Clore Collection, Tate Gallery, London/Art Resource, NY. This and Fig. 33.7 were influenced by Turner's tour of the Alps in 1802.

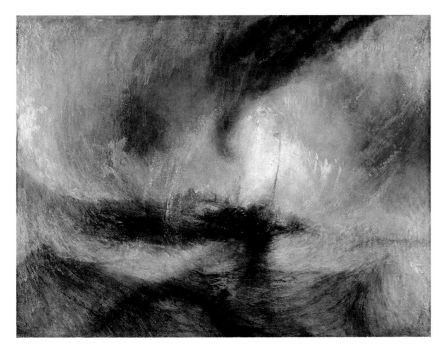

Fig. 33.9 J. M. W. Turner. *Snow Storm—Steam-Boat off a Harbour's Mouth.* **1842.** Oil on canvas, 36″ × 48″. Clore Collection, Tate Gallery, London/Art Resource, NY. Turner bequeathed 19,049 drawings and watercolors to the British nation. Many of these works anticipate the gestural freedom of this painting, with its sweeping linear rhythms.

And the round ocean and the living air
And the blue sky, and in the mind of man:
A motion and a spirit, that impels
All thinking things, all objects of all thought,
And rolls through all things.

We must keep in mind, though, the sublime is never altogether benign or kind. In *The Fall of an Avalanche in the Grisons* [gree-SOHNZ], for example, (Fig. **33.8**), there is no human figure, only a mountain hut about to be crushed beneath a giant thumb of rock and debris. The viewer has nowhere to stand, except in the path of this mammoth demonstration of nature's force. Turner himself wrote lines to accompany the painting in the exhibition catalogue:

> The downward sun a parting sadness
> gleams,
> Portentous lurid thro' the gathering
> storm'
> Thick drifting snow on snow,
> Till the vast weight bursts thro' the rocky
> barrier;
> Down at once, its pine clad forests,
> And towering glaciers fall, the work of
> ages
> Crashing through all! extinction
> follows,
> And the toil, the hope of man—
> o'erwhelms.

The painting suggests the "extinction" of the very "hope of man"—a sentiment far removed from Constable's pastoral landscapes or Wordsworth's "natural piety." Turner had never been to the Grisons, and this painting seems to have been inspired by an avalanche that occurred there in 1808, crushing a chalet beneath huge rocks propelled by a giant mass of snow. The painting is a pure act of imagination. It anticipates his great paintings of the 1840s, in which he focused on the immersion of the self (and the viewer) into the primal forces of nature.

One of the most daring of these later masterpieces was *Snow Storm—Steam-Boat off a Harbour's Mouth* (1842), originally subtitled *The author was in this storm on the night the Ariel left Harwich* (Fig. **33.9**). "I wished to show," Turner said, "what such a scene was like. I got the sailors to lash me to the mast to observe it . . . and I did not expect to escape: but I felt bound to record it if I did." We have no evidence confirming a ship named *Ariel*. Most likely, Turner imagined this scene of a maelstrom of steam and storm that deposits us at its very heart. Turner's depiction of the raw experience of nature in its most elemental form clearly represents a Romantic view of the world. This view is the opposite of the Enlightenment ideal of the natural world characterized by clarity, order, and harmony.

The Romantic in Germany: Friedrich and Kant

Although Constable and Turner's approaches are very different, both believed that nature provoked their imaginations. In the German Romantic tradition, the imagination is also the fundamental starting point. The painter Caspar David Friedrich [FREED-rikh] (1774–1840) represents the imaginative capacities of the Romantic mind by placing figures, often solitary ones, before sublime landscapes. In *Monk by the Sea* (Fig. **33.10**), a figure stands alone, engulfed in the vast expanse of sand and storm, as if facing the void. His is a crisis of faith. How do I know God? he seems to ask. And how, in the face of this empty vastness, do I come to belief? Can I even believe?

These sentiments echo the philosopher Immanuel Kant's *Critique of Pure Reason* (1781), in which Kant had argued that the mind is not a passive recipient of information—not, that is, the "blank slate" that Locke had claimed. For Kant, the mind was an active agent in the creation of knowledge. He believed that the ways we understand concepts like space, time, quantity, the relations among things, and, especially, quality, are innate from birth. We come to understand the world through the operation of these innate mental abilities as they perceive the various aspects of experience. Each of our experiences is various as well, and so each mind creates its own body of knowledge, its own world. No longer was the nature of reality the most important question. Instead, the mind confronting reality was paramount. Kant shifted the basic question of philosophy, in other words, from What do we know? to How do we know?—even to How do we know that we know?

The theme of doubt is a constant in Friedrich's paintings, but more as a stimulant to the imagination than a source of anxiety and tension. In his *Wanderer above the Mists*, Friedrich pictures a lone man with windblown hair positioned directly in front of the viewer on a rocky promontory (Fig. **33.11**). Like the monk, we can view him as a projection of ourselves. His view is interrupted by the vast expanse of mist just as ours is cut off by the outcropping of rock. The full magnificence of the scene is only hinted at, a vague promise of eventual revelation. Friedrich, in fact, had this to say about the value of uncertainty:

> If your imagination is poor, and in fog you see nothing but gray, then an aversion to vagueness is understandable. All the same, a landscape enveloped in mist seems vaster, more sublime, and it animates the imagination while also heightening suspense—like a veiled woman. The eye and the imagination are generally more intrigued by vaporous distances than by a nearby object available to the eye.

The viewer's imagination is further stimulated by the contrast between near and far, between the rock in the foreground and the ethereal atmosphere stretching into the distance—that is, between the earthly and spiritual realms.

The American Romantic Landscape

In America, the Romantic landscape was literally shaped by the presence of vast tracts of wilderness. One of the foremost American landscape painters of the time was an Englishman, Thomas Cole (1801–1848). Cole immigrated to the United States when he was 18 years old, and he returned to London 10 years later, where he studied the paintings of Constable and Turner. Traveling on to Paris and Florence,

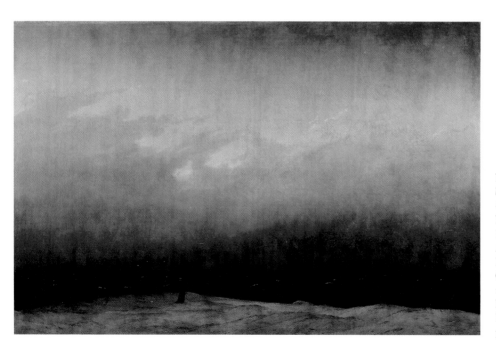

Fig. 33.10 Caspar David Friedrich. *Monk by the Sea*. 1809–1810. Oil on canvas, 47 $\frac{1}{2}$" × 67". Inv.: NG 9/85. Nationalgalerie, Staatliche Museen zu Berlin, Berlin, Germany. Joerg P. Anders/Bildarchiv Preussischer Kulturbesitz/Art Resource, NY. Schloss Charlottenburg, Berlin. Bildarchiv reussischer Kulturbesitz. Some art historians believe that the monk is Friedrich himself, which makes this a self-portrait.

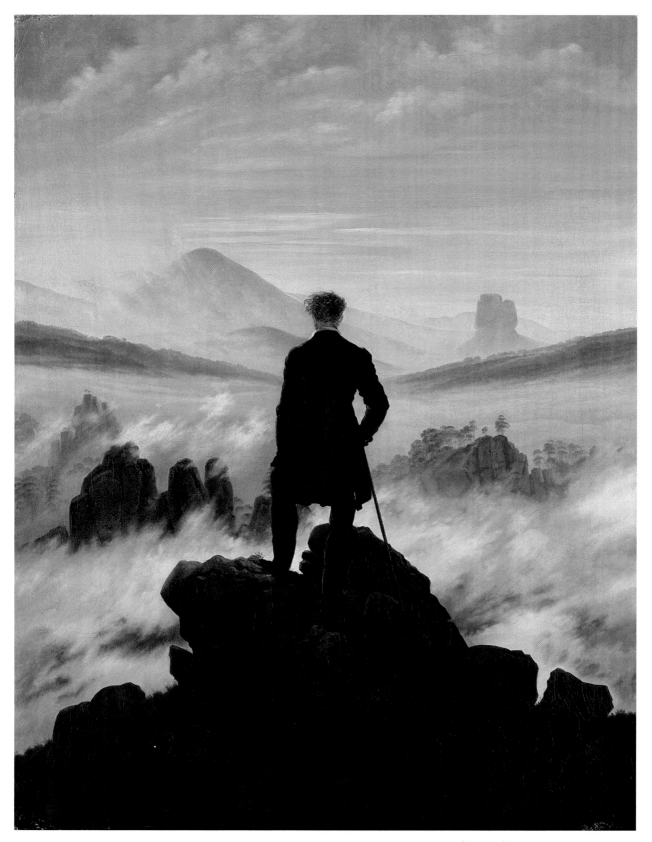

Fig. 33.11 Caspar David Friedrich. *The Wanderer above the Mists.* **ca. 1817–1818.** Oil on canvas, $37\frac{1}{4}''\times29\frac{1}{2}''$.
Inv.: 5161. On permanent loan from the Foundation for the Promotion of the Hamburg Art Collections. Photo: Elke
Walford. Hamburger Kunsthalle, Hamburg, Germany. Bildarchiv Preussischer Kulturbesitz/Art Resource, NY. The artist's
identification with nature is underscored by the analogy Friedrich establishes between the figure's head and the distant
rock at the right.

he came to recognize that "in civilized Europe the primitive features of scenery have long since been destroyed or modified." In America, on the other hand,

> ... nature is still predominant, and there are those who regret that with the improvements of cultivation the sublimity of the wilderness should pass away; for those scenes of solitude from which the hand of nature has never been lifted, affect the mind with a more deep toned emotion than aught which the hand of man has touched. Amid them the consequent associations are of God the creator—they are his undefiled works, and the mind is cast into the contemplation of eternal things.

Cole's painting, *The Oxbow*, of a famous bend in the Connecticut River in Massachusetts, describes the boundary between those lands "which the hands of man has touched" and the "undefiled" wilderness (Fig. **33.12**). Cole paints himself into the scene—he is at his easel below the rocks to the left of his pack and umbrella—where he acts as mediator between the neatly defined fence rows and sunny fields of the valley below and the rugged wilderness behind him, symbolized by the blasted tree stump and the dark clouds of the thunderstorm in the distance.

Cole painted most often in the Catskill Mountains up the Hudson River halfway between Albany and New York. He was the most prominent artist in what became known as the Hudson River School. His pupil, Frederic Edwin Church (1826–1900), began construction of his own home, Olana, in 1860, overlooking the Hudson River and the Catskills from a ridge high over Hudson, New York.

By then Church had taken two trips to South America, which resulted in a number of enormous paintings of the Andes Mountains. After seeing these canvases, one British reviewer commented that "the mantle of our greatest painter [i.e., Turner] appears to us to have fallen" on Church. But for what many consider to be his masterpiece, Church turned to

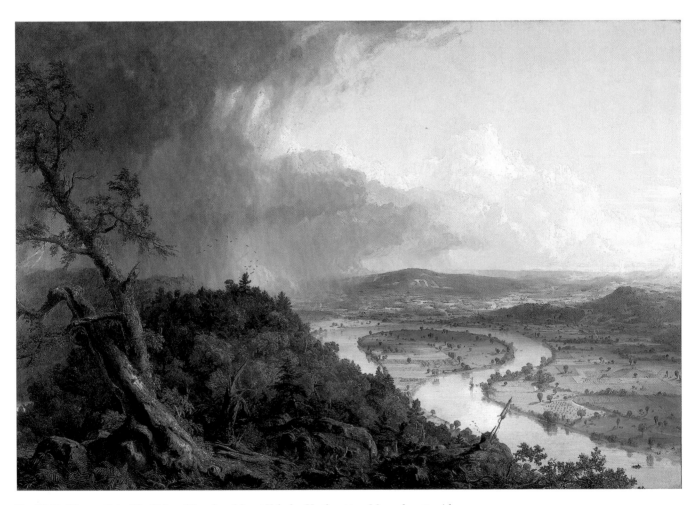

Fig. 33.12 Thomas Cole. *The Oxbow (View from Mount Holyoke, Northampton, Massachusetts, After a Thunderstorm).* **1836.** Oil on canvas, 4′3¹⁄₂″ × 6′4″. The Metropolitan Museum of Art, NY. Gift of Mrs. Russell Sage, 1908 (08.228). The painting suggests, as the storm departs to the left, that civilization will eventually overwhelm the wilderness, a prospect Cole anticipated with distress.

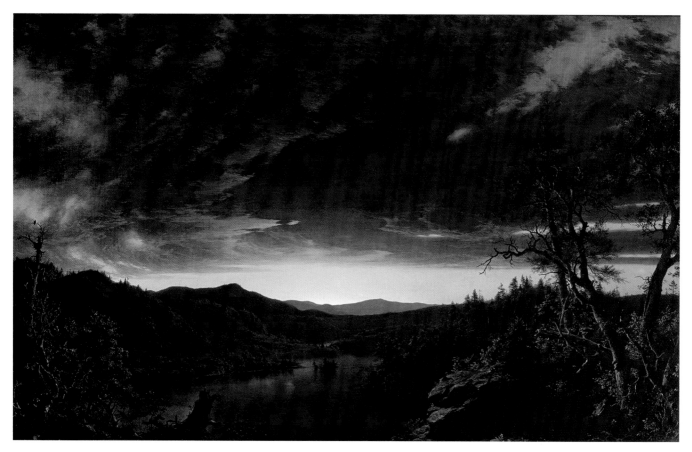

Fig. 33.13 Frederic Edwin Church. *Twilight in the Wilderness.* **1860.** Oil on canvas, 40″ × 60″. The Cleveland Museum of Art, Mr. and Mrs. William H. Marlatt Fund. The Bridgeman Art Library. As was true of almost all Church's major paintings of the era, this one was exhibited by itself as a paid-entrance event in New York City, where it became enormously popular.

his native land. *Twilight in the Wilderness* lacks any human presence (Fig. **33.13**). The painting suggests that its subject is not merely twilight *in* the wilderness, but twilight *of* the wilderness. This spot, above the glassy lake, might be among the last such places on the continent. Indeed, there was a growing interest in preserving such spaces. In 1864 President Lincoln signed an act which declared that Yosemite Valley in California "be held for public use, resort, and recreation . . . inalienable for all time." Eight years later, in 1872, Congress established Yellowstone as the nation's first national park.

Transcendentalism and the American Romantics

Just as the American landscape inspired the Romantic sensibilities of artists, it provoked in the minds of writers what Cole had described as "the contemplation of eternal things." American writers of a Romantic sensibility shared with the painters like Church a wonder at the natural world with which they felt an ecstatic communion. In many ways, they were shaped by the nation's emphasis on individualism and

individual liberty. Free to think for themselves, their imaginations were equally free to discover the self in nature.

The Philosophy of Romantic Idealism: Emerson and Thoreau

In 1834, a 31-year-old minister, disenchanted with institutionalized religion and just back from England, where he had encountered Coleridge and heard Wordsworth recite his poetry, moved to the village of Concord, Massachusetts. Over the next several years, Ralph Waldo Emerson (1803–1882), a Unitarian minister, wrote his first book, *Nature*, published anonymously in 1836. The book became the intellectual beacon for a group of Concord locals, mostly ministers, that became known as the "Transcendental Club." It took its name from the *System of Transcendental Idealism*, written by Freidrich Schelling [SHELL-ing] (1775–1854), which argued that scientific observation and artistic intuition were complementary, not opposed, modes of thought. "Nature," Schelling wrote, "is visible Spirit; Spirit is invisible Nature."

This sense of the spirit's oneness with nature informs the most famous passage of *Nature*, when Emerson outlines the fundamental principle of transcendental thought: In the

direct experience of nature the individual is united with God, thus transcending knowledge based on empirical observation (**Reading 33.6**):

READING 33.6 **from Ralph Waldo Emerson,** *Nature*, **Chapter 1 (1836)**

Crossing a bare common, in snow puddles, at twilight, under a clouded sky, without having in my thoughts any occurrence of special good fortune, I have enjoyed a perfect exhilaration. Almost I fear to think how glad I am. In the woods too a man casts off his years, as the snake his slough, and at what period soever of life, is always a child. In the woods, is perpetual youth. Within these plantations of God, a decorum and sanctity reign, a perennial festival is dressed, and the guest sees not how he should tire of them in a thousand years. In the woods, we return to reason and faith. There I feel that nothing can befall me in life,— no disgrace, no calamity (leaving me my eyes,) which nature cannot repair. Standing on the bare ground,— my head bathed by the blithe air, and uplifted into infinite space,—all mean egotism vanishes. I become a transparent eye-ball. I am nothing. I see all. The currents of the Universal Being circulate through me; I am part or particle of God. The name of the nearest friend sounds then foreign and accidental. To be brothers, to be acquaintances,—master or servant, is then a trifle and a disturbance. I am the lover of uncontained and immortal beauty. In the wilderness, I find something more dear and connate [i.e., congenial] than in streets or villages. In the tranquil landscape, and especially in the distant line of the horizon, man beholds somewhat as beautiful as his own nature.

The sense of the self at the center of experience—the "eye/I" is also the sense of individualism and self-reliance fundamental to transcendental experience. In fact, in one of his most famous essays, "Self-Reliance," Emerson would declare, "Whoso would be a man must be a nonconformist. . . . Nothing is at last sacred but the integrity of your own mind." Of all Emerson's contemporaries, none fits this description better than Henry David Thoreau [thor-OH] (1817–1862). Educated at Harvard, Thoreau was fiercely independent. He resigned his first job as a schoolteacher in Concord because he refused to inflict corporal punishment on his students. He became one of the nation's most vocal abolitionists and was briefly jailed for refusing to pay a poll tax to a government that tolerated slavery. But most famously, for two years, from 1845 to 1847, he lived in a small cabin that he built himself, on Emerson's property at Walden Pond. This experience spawned *Walden, or Life in the Woods*, a small book published in 1854, dedicated to teaching the satisfactions and virtues of living simply and wisely in communion with nature (Fig. **33.14**). Thoreau's woods are the same woods that Emerson extols in *Nature*. Thoreau writes (**Reading 33.7**):

READING 33.7 **from Henry David Thoreau,** *Walden, or Life in the Woods*, **Chapter 2 (1854)**

I went to the woods because I wished to live deliberately, to front only the essential facts of life, and see if I could not learn what it had to teach, and not, when I came to die, discover that I had not lived. . . . I wanted to live deep and suck out all the marrow of life, to live so sturdily and Spartan-like as to put to rout all that was not life. . . . Time is but the stream I go a-fishing in. I drink at it; but while I drink I see the sandy bottom and detect how shallow it is. Its thin current slides away, but eternity remains.

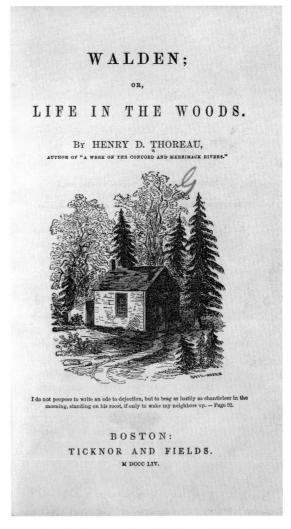

Fig. 33.14 Original title page to the 1854 edition of *Walden*, by Henry David Thoreau. This is as accurate a depiction of Thoreau's cabin at Walden Pond as we have.

The eccentricities of Thoreau's life are matched by the inventiveness of his prose, and in the end Thoreau's argument is for what he calls "the indescribable innocence and beneficence of Nature."

As powerful and as transformative as nature was, Thoreau viewed it as vulnerable to human encroachment, an insight that proved him far ahead of his time. He worried, for instance, that the railroad had destroyed the old scale of distances, a complaint shared by many of his contemporaries. His understanding of the environment's vulnerability and humanity's role in conserving or degrading it illustrates Thoreau's other enduring influence on American literature culture—as a powerful social conscience and spokesman for unpopular causes. Rebelling against unjust war in his essential essay "Civil Disobedience," against slavery as an active supporter of the Underground Railroad, and against conformism in his work as a writer and educator, Thoreau was both highly individualistic as well as a committed social activist. In his essay "Life without Principle," drawn from a series of lectures in 1854, Thoreau pondered "the way we spend our lives," and the negative effect it had on the natural world as well as our human nature (**Reading 33.8**):

READING 33.8 **from Henry David Thoreau, "Life without Principle" (1854)**

This world is a place of business. What an infinite bustle! I am awaked almost every night by the panting of the locomotive. It interrupts my dreams. . . . It would be glorious to see mankind at leisure for once. It is nothing but work, work, work. I cannot easily buy a blank-book to write thoughts in; they are commonly ruled for dollars and cents. . . . If a man was tossed out of a window when an infant, and so made a cripple for life, or scared out of his wits by the Indians, it is regretted chiefly because he was thus incapacitated for— business! I think that there is nothing, not even crime, more opposed to poetry, to philosophy, ay, to life itself, than this incessant business. . . . If a man walk in the woods for love of them half of each day, he is in danger of being regarded as a loafer; but if he spends his whole day as a speculator, shearing off those woods and making earth bald before her time, he is esteemed an industrious and enterprising citizen. As if a town had no interest in its forests but to cut them down!

Thoreau's sense of individualistic conscience is most evident in his 1849 essay "Civil Disobedience," written after his brief imprisonment for refusing to pay a poll tax (a tax levied on every male adult voter) as a protest against the Mexican-American war and slavery:

Must the citizen ever for a moment, or in the least degree, resign his conscience to the legislator? Why has every man a conscience, then? I think that we should be men first, and subjects afterward. It is not desirable to cultivate

a respect for the law, so much as for the right. The only obligation which I have a right to assume is to do at any time what I think right. . . . Under a government which imprisons any unjustly, the true place for a just man is also a prison. The proper place to-day, the only place which Massachusetts has provided for her freer and less desponding spirits, is in her prisons. . . . It is there that the fugitive slave, and the Mexican prisoner on parole, and the Indian come to plead the wrongs of his race, should find them; on that separate, but more free and honorable ground, where the State places those who are not *with* her, but *against* her—the only house in a slave State in which a free man can abide with honor.

Herman Melville: The Uncertain World of *Moby Dick*

Nothing could be further from Thoreau's belief in the "innocence and beneficence of Nature" than the sensibility of Herman Melville [MELL-vill] (1819–1891). Melville had worked as a ship's cabin-boy, and later as a crew member on a whaler bound for the South Pacific. His experiences at sea led him to view the natural world (and the humans who inhabited it) as a severe challenge rather than a calm gateway to inspiration. After abandoning the whaling ship because of its intolerable conditions, Melville was taken prisoner by cannibals in the Marquesa islands. Once rescued, he survived by taking menial jobs in Tahiti and Hawaii in the 1840s.

Melville's hardscrabble years as a sailor would inform his great novel, *Moby Dick*. Published in 1851, the novel tells the story of Captain Ahab's [AY-hab] vengeful quest across the vast reaches of the Pacific Ocean for an elusive white whale to whom he had lost his leg.

Melville knew and appreciated Turner's work, collecting engravings of *Snow Storm—Steam-Boat off a Harbour's Mouth* (see Fig. 33.9). He was also aware that Turner had painted a number of whaling pictures, based on Thomas Beale's *Natural History of the Sperm Whale* (1839), which he himself used as a source for the novel. Among them is the 1845 *Whale Ship*, depicting a whale breaching in a fury of foam and spray, harpoonists approaching from its right (Fig. **33.15**). In fact, early in *Moby Dick*, its narrator, Ishmael [ISH-me-el], having decided to go to sea, arrives at the Spouter Inn in New Bedford, Massachusetts, where he encounters a picture hanging in the entry (**Reading 33.9**):

READING 33.9 **from Herman Melville, *Moby Dick*, Chapter 3, "The Spouter Inn" (1851)**

. . . a very large oil painting so thoroughly besmoked, and every way defaced, that in the unequal crosslights by which you viewed it, it was only by diligent study

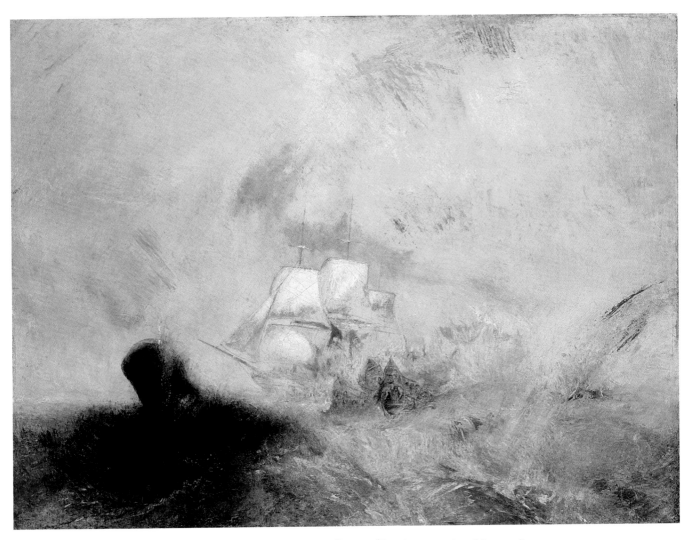

Fig. 33.15 J. M. W. Turner. *The Whale Ship*. ca. 1845. Oil on canvas, $36\frac{1}{8}'' \times 48\frac{1}{4}''$. The Metropolitan Museum of Art, NY. Catharine Lorillard Wolfe Collection, Wolfe Fund, 1896 (96.29). Image copyright © The Metropolitan Museum of Art. This painting was exhibited at the Royal Academy in 1845 with the caption "Vide Beale's Voyage p. 175." This refers to a passage in a book written by Thomas Beale, describing the harpooning of a large sperm whale off Japan in 1832.

and a series of systematic visits to it, and careful inquiry of the neighbors, that you could any way arrive at an understanding of its purpose.

. . .What most puzzled and confounded you was a long, limber, portentous, black mass of something hovering in the centre of the picture over three blue, dim, perpendicular lines floating in a nameless yeast. A boggy, soggy, squitchy picture truly, enough to drive a nervous man distracted. Yet was there a sort of indefinite, half-attained, unimaginable sublimity about it that fairly froze you to it. . . . Ever and anon a bright, but, alas, deceptive idea would dart you through.—It's the Black Sea in a midnight gale.—It's the unnatural combat of the four primal elements.—It's a blasted heath.—It's a Hyperborean [hy-pur-BOR-ee-un] winter scene.—It's the breaking-up of the icebound stream

of Time. But at last all these fancies yielded to that one portentous something in the picture's midst. . . . But stop; does it not bear a faint resemblance to a gigantic fish? even the great leviathan himself?

In fact, the artist's design seemed this. . . .The picture represents a Cape-Horner in a great hurricane; the half-foundered ship weltering there with its three dismantled masts alone visible; and an exasperated whale, purposing to spring clean over the craft, is in the enormous act of impaling himself upon the three mast-heads.

As long as the painting is mysterious, as long as its meaning escapes definition, then, like Friedrich's mist, "it animates the imagination." It is alive with sublime possibility. In this sense, the painting is analogous to Ahab's white whale, possessed of a whiteness that is at once "innocent"

and "pure" and like Coleridge's albatross, "pale dread . . . that white phantom [that] sails in all imaginations." (See **Reading 33.3**, pages 1078–1079) Readers have interpreted the white whale in countless ways since *Moby Dick* was published. It symbolizes both good and evil, as well as elements of the natural world that cannot be controlled by humans— that are truly wild.

As much as it reflects a Romantic sensibility, in many ways Melville's book is a challenge to American transcendentalism and the Romantic imagination. This is most evident in his chapter entitled, "The Mast-Head," in which Ishmael describes his first watch from the top of the ship's mast looking for whales. "There," he says, "you stand, lost in the infinite series of the sea, with nothing ruffled but the waves. The tranced ship indolently rolls; the drowsy trade winds blow; everything resolves you into languor." It is, he says, the perfect place for a young man with a Romantic sense of melancholy to find himself, even if it means that no whales will be spied on account of the watchman's reverie (**Reading 33.10**):

Here Melville indicates sensibly that the precarious sailor's perch on the mast of a ship is no place for deep thoughts of "romantic, melancholy, and absent-minded young men." They are lost "in the round ocean and the living air / And the blue sky" that Wordsworth describes in "Tintern Abbey," and risk falling to their death. In *Moby Dick*, Ishmael's Romantic vision is definitely limited. It cannot grasp the complexity of experience, just as Ahab cannot grasp the meaning of the whale that he longs to destroy. There is, as the next chapter suggests, a darker side to the Romantic imagination.

READING 33.10 **from Herman Melville,**
Moby Dick, Chapter 35,
"The Mast-Head" (1851)

And let me in this place movingly admonish you, ye ship-owners of Nantucket! Beware of enlisting in your vigilant fisheries any lad with lean brow and hollow eye; given to unseasonable meditativeness. . . . Beware of such an one, I say: your whales must be seen before they can be killed; and this sunken-eyed young Platonist will tow you ten wakes round the world, and never make you one pint of sperm the richer. Nor are these monitions at all unneeded. For nowadays, the whale-fishery furnishes an asylum for many romantic, melancholy, and absent-minded young men . . .

Very often do the captains of such ships take those absent-minded young philosophers to task, upbraiding them with not feeling sufficient "interest" in the voyage; half-hinting that they are so hopelessly lost to all honorable ambition, as that in their secret souls they would rather not see whales than otherwise" . . . Why, thou monkey," said a harpooneer to one of these lads, "we've been cruising now hard upon three years, and thou hast not raised a whale yet. Whales are scarce as hen's teeth whenever thou art up here." Perhaps they were; or perhaps there might have been shoals of them in the far horizon; but lulled into such an opium-like listlessness of vacant, unconscious reverie is this absent-minded youth by the blending cadence of waves with thoughts, that at last he loses his identity; takes the mystic ocean at his feet for the visible image of that deep, blue, bottomless soul, pervading mankind and nature . . .

READINGS

from William Wordsworth, "Lines Composed a Few Miles above Tintern Abbey, on Revisiting the Banks of the Wye during a Tour, July 13, 1798" (1798)

"Tintern Abbey" is the product of Wordsworth's visit to the medieval abbey's ruins on the banks of the Wye River in 1798. The 159-line poem is typical of Wordsworth's poetry in the way that it swings back and forth between his observation of an external scene and his contemplation of the feelings generated by that scene, between the past and the present, and between his personal experience ("I") and more universal and general experience ("we").

Five years have passed; five summers, with the length
Of five long winters! and again I hear
These waters, rolling from their mountain-springs
With a soft inland murmur.—Once again
Do I behold these steep and lofty cliffs,
That on a wild secluded scene impress
Thoughts of more deep seclusion; and connect
The landscape with the quiet of the sky.
The day is come when I again repose
Here, under this dark sycamore, and view 10
These plots of cottage-ground, these orchard-tufts,

Which at this season, with their unripe fruits,
Are clad in one green hue, and lose themselves
'Mid groves and copses. Once again I see
These hedge-rows, hardly hedge-rows, little lines
Of sportive wood run wild: these pastoral farms,
Green to the very door; and wreaths of smoke
Sent up, in silence, from among the trees!
With some uncertain notice, as might seem
Of vagrant dwellers in the houseless woods, 20
Or of some Hermit's cave, where by his fire
The Hermit sits alone.
 These beauteous forms,
Through a long absence, have not been to me
As is a landscape to a blind man's eye:
But oft, in lonely rooms, and 'mid the din
Of towns and cities, I have owed to them
In hours of weariness, sensations sweet,
Felt in the blood, and felt along the heart;
And passing even into my purer mind, 30
With tranquil restoration:—feelings too
Of unremembered pleasure: such, perhaps,
As have no slight or trivial influence
On that best portion of a good man's life,
His little, nameless, unremembered, acts
Of kindness and of love. Nor less, I trust,
To them I may have owed another gift,
Of aspect more sublime; that blessed mood,
In which the burthen of the mystery,
In which the heavy and the weary weight 40

Of all this unintelligible world,
Is lightened:—that serene and blessed mood,
In which the affections gently lead us on,—
Until, the breath of this corporeal frame
And even the motion of our human blood
Almost suspended, we are laid asleep
In body, and become a living soul:
While with an eye made quiet by the power
Of harmony, and the deep power of joy,
We see into the life of things. 50
 If this
Be but a vain belief, yet, oh! how oft—
In darkness and amid the many shapes
Of joyless daylight; when the fretful stir
Unprofitable, and the fever of the world,
Have hung upon the beatings of my heart—
How oft, in spirit, have I turned to thee,
O sylvan Wye! thou wanderer thro' the woods,
How often has my spirit turned to thee!
And now, with gleams of half-extinguished thought, 60
With many recognitions dim and faint,
And somewhat of a sad perplexity,
The picture of the mind revives again:
While here I stand, not only with the sense
Of present pleasure, but with pleasing thoughts
That in this moment there is life and food
For future years. And so I dare to hope,
Though changed, no doubt, from what I was when first
I came among these hills; when like a roe
I bounded o'er the mountains, by the sides 70
Of the deep rivers, and the lonely streams,
Wherever nature led: more like a man
Flying from something that he dreads, than one
Who sought the thing he loved. For nature then
(The coarser pleasures of my boyish days,
And their glad animal movements all gone by)
To me was all in all.—I cannot paint
What then I was. The sounding cataract
Haunted me like a passion: the tall rock,
The mountain, and the deep and gloomy wood, 80

Their colours and their forms, were then to me
An appetite; a feeling and a love,
That had no need of a remoter charm,
By thought supplied, nor any interest
Unborrowed from the eye.—That time is past,
And all its aching joys are now no more,
And all its dizzy raptures. Not for this
Faint I, nor mourn nor murmur, other gifts
Have followed; for such loss, I would believe,
Abundant recompense. For I have learned 90
To look on nature, not as in the hour
Of thoughtless youth; but hearing oftentimes
The still, sad music of humanity,
Nor harsh nor grating, though of ample power
To chasten and subdue. And I have felt
A presence that disturbs me with the joy
Of elevated thoughts; a sense sublime
Of something far more deeply interfused,
Whose dwelling is the light of setting suns,
And the round ocean and the living air, 100
And the blue sky, and in the mind of man;
A motion and a spirit, that impels
All thinking things, all objects of all thought,
And rolls through all things. Therefore am I still
A lover of the meadows and the woods,
And mountains; and of all that we behold
From this green earth; of all the mighty world
Of eye, and ear,—both what they half create,
And what perceive; well pleased to recognise
In nature and the language of the sense, 110
The anchor of my purest thoughts, the nurse,
The guide, the guardian of my heart, and soul
Of all my moral being.
 Nor perchance,
If I were not thus taught, should I the more
Suffer my genial spirits to decay:
For thou art with me here upon the banks
Of this fair river; thou my dearest Friend,
My dear, dear Friend; and in thy voice I catch
The language of my former heart, and read 120
My former pleasures in the shooting lights
Of thy wild eyes. Oh! yet a little while
May I behold in thee what I was once,
My dear, dear Sister! and this prayer I make,

Knowing that Nature never did betray
The heart that loved her; 'tis her privilege,
Through all the years of this our life, to lead
From joy to joy: for she can so inform
The mind that is within us, so impress
With quietness and beauty, and so feed 130
With lofty thoughts, that neither evil tongues,
Rash judgments, nor the sneers of selfish men,
Nor greetings where no kindness is, nor all
The dreary intercourse of daily life,
Shall e'er prevail against us, or disturb
Our cheerful faith, that all which we behold
Is full of blessings. Therefore let the moon
Shine on thee in thy solitary walk;
And let the misty mountain-winds be free
To blow against thee: and, in after years, 140
When these wild ecstasies shall be matured
Into a sober pleasure; when thy mind
Shall be a mansion for all lovely forms,
Thy memory be as a dwelling-place
For all sweet sounds and harmonies; oh! then,
If solitude, or fear, or pain, or grief,
Should be thy portion, with what healing thoughts
Of tender joy wilt thou remember me,
And these my exhortations! Nor, perchance—
If I should be where I no more can hear 150
Thy voice, nor catch from thy wild eyes these gleams
Of past existence—wilt thou then forget
That on the banks of this delightful stream
We stood together; and that I, so long
A worshipper of Nature, hither came
Unwearied in that service: rather say
With warmer love—oh! with far deeper zeal
Of holier love. Nor wilt thou then forget,
That after many wanderings, many years
Of absence, these steep woods and lofty cliffs, 160
And this green pastoral landscape, were to me
More dear, both for themselves and for thy sake! ■

Reading Question

At the heart of Wordsworth's poem is his sense that nature is not merely a scene but that it is infused with a moral value comparable to divinity itself. In what ways does he describe his growing realization that this is so?

READING 33.3

from Samuel Taylor Coleridge, "Rime of the Ancient Mariner," Part I (1798)

Coleridge's poem in seven parts is set on the foreboding ocean. It reveals truths about nature that seem, at first, the total opposite of Wordsworth's nurturing landscapes. In Coleridge's poem, nature is an indomitable force, a ruthless power. Yet, even in its most horrific aspects, it possesses an inherent value and beauty. In the first book of the poem, which sets up the tragic tale, the Mariner's destructive act in killing the albatross symbolizes humanity's destructive relation to the natural world as a whole. In the subsequent parts, the Mariner's regeneration and salvation come as he accepts responsibility for his actions.

Argument

How a Ship having passed the Line was driven by storms to the cold Country towards the South Pole; and how from thence she made her course to the tropical Latitude of the Great Pacific Ocean; and of the strange things that befell; and in what manner the Ancyent Marinere came back to his own Country.

Part I

An ancient Mariner meeteth three Gallants bidden to a wedding-feast, and detaineth one.

It is an ancient Mariner,
And he stoppeth one of three.
'By thy long beard and glittering eye,
Now wherefore stopp'st thou me?

The Bridegroom's doors are opened wide, 10
And I am next of kin;
The guests are met, the feast is set:
May'st hear the merry din.'

He holds him with his skinny hand,
'There was a ship,' quoth he.
'Hold off! unhand me, grey-beard loon!'
Eftsoons his hand dropt he.

The Wedding-Guest is spell-bound by the eye of the old seafaring man, and constrained to hear his tale.

He holds him with his glittering eye—
The Wedding-Guest stood still,
And listens like a three year's child: 20
The Mariner hath his will.

The Wedding-Guest sat on a stone:
He cannot choose but hear;
And thus spake on that ancient man,
The bright-eyed Mariner.

'The ship was cheered, the harbour cleared,
Merrily did we drop
Below the kirk, below the hill,
Below the lighthouse top.

The Mariner tells how the ship sailed southward with a good wind and fair weather, till it reached the Line.

The Sun came up upon the left, 30
Out of the sea came he!
And he shone bright, and on the right
Went down into the sea.

Higher and higher every day,
Till over the mast at noon—'
The Wedding-Guest here beat his breast,
For he heard the loud bassoon.

The Wedding-Guest heareth the bridal music; but the Mariner continueth his tale.

The bride hath paced into the hall,
Red as a rose is she;
Nodding their heads before her goes 40
The merry minstrelsy.

The Wedding-Guest he beat his breast,
Yet he cannot choose but hear;
And thus spake on that ancient man,
The bright-eyed Mariner.

The ship driven by a storm toward the south pole.

'And now the STORM-BLAST came, and he
Was tyrannous and strong:
He struck with his o'ertaking wings,
And chased us south along.

With sloping masts and dipping prow, 50
As who pursued with yell and blow
Still treads the shadow of his foe,
And forward bends his head,
The ship drove fast, loud roared the blast,
The southward aye we fled.

And now there came both mist and snow,
And it grew wondrous cold:
And ice, mast-high, came floating by,
As green as emerald.

The land of ice, and of fearful sounds where no living thing was to be seen.

And through the drifts the snowy cliffs 60
Did send a dismal sheen:
Nor shapes of men nor beasts we ken—
The ice was all between.

The ice was here, the ice was there,
The ice was all around:
It cracked and growled, and roared and howled,
Like noises in a swound!

Till a great sea-bird, called the Albatross, came through the snow-
fog, and was received with great joy and hospitality.

At length did cross an Albatross,
Through the fog it came;
As if it had been a Christian soul, 70
We hailed it in God's name.

It ate the food it ne'er had eat,
And round and round it flew.
The ice did split with a thunder-fit;
The helmsman steered us through!

And lo! the Albatross proveth a bird of good omen, and followeth
the ship as it returned northward through fog and floating ice.

And a good south wind sprung up behind;
The Albatross did follow,

And every day, for food or play,
Came to the mariner's hollo!

In mist or cloud, on mast or shroud, 80
It perched for vespers nine;
Whiles all the night, through fog-smoke white,
Glimmered the white Moon-shine.'

The ancient Mariner inhospitably killeth the pious bird of good
omen.

'God save thee, ancient Mariner!
From the fiends, that plague thee thus!—
Why look'st thou so ?'—With my cross-bow
I shot the ALBATROSS. ∎

Reading Question

**The Mariner narrates his tale to a wedding guest, who in the
fourth stanza "listens like a three years' child." Why do you
suppose Coleridge wants the Mariner's audience to listen
with child-like attentiveness?**

Summary

■ **The Early Romantic Imagination** William Wordsworth's poem "Tintern Abbey" embodies the growing belief in the natural world as the source of inspiration and creativity that marks the early Romantic imagination. The Romantics were dedicated to the discovery of beauty in nature through their subjective experience of it. Wordsworth's poem was included in *Lyrical Ballads*, a book he coauthored with Samuel Taylor Coleridge in 1798 as a self-conscious experiment dedicated to presenting "incidents and situations from common life . . . in a selection of language really used by men." That said, Coleridge's "Rime of the Ancient Mariner" reflects the supernatural and mystical character of Coleridge's imagination, very different from Wordsworth's adherence to what he called "the truth of nature." Of all Romantic poetry, perhaps the odes of John Keats most fully embody the Romantic imagination's ability to transcend even death, which Keats faced when he realized at age 23 that he was dying of tuberculosis. In a nightingale's song or a Grecian urn, Keats discovers the essence of a beauty that represents a form of nature higher than mortal life itself.

■ **The Romantic Landscape** Landscape painters in the nineteenth century saw the natural world around them as the emotional focal point or center of their own artistic imaginations. John Constable, painting in the valley of the Stour River in his native Suffolk, considered himself "a worshipper of Nature," and in his paintings, especially his large canvases like *The Hay Wain*, he tried to capture nature in all its variety, thus reflecting the many states of mind in which he contemplated it. J. M. W. Turner specialized in capturing light, not the objects of nature so much as the medium through which they are seen. The scale of Turner's paintings is usually very large, dwarfing the human presence. And nature is never altogether benign or friendly—avalanches and storms constantly threaten the viewer. In Germany, the painter Caspar David Friedrich often places solitary figures before sublime landscapes that constantly raise the theme of doubt. Doubt—the inability to determine with certainty the meaning of the world before him—excites Friedrich's imagination. In America, the Romantic imagination found itself at home in the vast and sublime reaches of the untamed wilderness. The paintings of Thomas Cole and Frederic Edwin Church often confront the tension between the imaginative freedom offered by the wilderness and the impinging threat of civilization.

■ **Transcendentalism and the American Romantics** American writers of a Romantic sensibility were, like the painters, free to discover the self in nature. Ralph Waldo Emerson codified their thinking in his 1836 treatise *Nature*. His contemporary, Henry David Thoreau, sought to experience nature firsthand by retreating to a small cabin in the woods on Emerson's property, where he wrote *Walden, or Life in the Woods*, first published in 1854. Romantic thinking was more problematic for the novelist Herman Melville. While many of the characters in his *Moby Dick* reflect a deeply Romantic sensibility, Melville challenges their way of approaching the world as overly simplistic and even dangerously so.

Glossary

dactyl A metrical measure (or "foot") composed of one short and two long units.

ode A lyric poem of exaltation, exhibiting deep feeling.

Critical Thinking Questions

1. What is the "transcendence" that Wordsworth and Constable find in nature?

2. What is Turner's conception of the "sublime"?

3. How is the Romantic "self" different from other forms of individualism?

4. Compare Emerson's "transparent eyeball" and Thoreau's "stream of time" as metaphors for the Romantic experience in nature.

The Romantics and Napoleon

On February 8, 1807, during a fierce blizzard near the town of Eylau, Russia's General Bennigsen, with an army of 74,500 men engaged Napoleon Bonaparte and his much smaller army of less than 50,000 in battle. Napoleon struck first, knowing that he had reinforcements in the wings. But the blizzard hampered both sides. The Russians withdrew, and Bonaparte claimed victory. There were 23,000 Russian casualties who had died for their emperor, Alexander I, but the battlefield was also strewn with 22,000 dead and wounded French.

Five weeks after Napoleon's "victory" a competition was announced in France for a painting commemorating the great day. The director of French museums declared that it should depict "The moment . . . when, His Majesty visiting the battlefield at Eylau in order to distribute aid to the wounded, a young Lithuanian hussar, whose knee had been shot off, rose up and said to the Emperor, 'Caesar, you want me to live. . . . Well, let them cure me and I will serve you as faithfully as I did Alexander!'" Antoine Jean Gros [groh] (1771–1835) won the competition with the painting illustrated here (Fig. 33.16). The painting made an odd piece of official propaganda. The larger than life-size pile of bodies, frozen blue, at the bottom of the painting is so terrifying and so openly hostile to the idea of victory that it seems impossible Napoleon would have approved it. Yet he did, just as he would ignore the advice of his aides in the fall of 1812 not to push into Russia, where his army "took" the city of Moscow, even as the Russians burned it. Napoleon abandoned his troops to return to Paris. He had begun his march into Russia with over 1 million men. Only about 100,000 returned. Never before had the term "heroism" seemed more hollow.

The promise of Napoleon—his ability to impose classical values of order, control, and rationality upon a French society that had been wracked with revolution and turmoil—was thus undermined by a darker reality. The Romantics, whose fascination with the powers of individual intuition and creativity had led them to lionize Napoleon, would react to his failure and to the ensuing disorder that marked the first half of the nineteenth century. Artists, composers, and writers would express in their works a profound pessimism about the course of human events. The optimistic spirit we find in Wordsworth and Constable, Emerson and Thoreau, would be challenged, not merely by the sense of darkness and foreboding expressed by Coleridge and Melville, but by a pessimism that undermined the Romantics' faith in the powers of nature to heal and restore humanity's soul. ∎

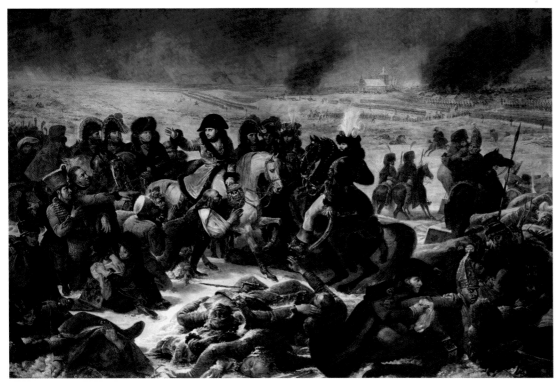

Fig. 33.16 Antoine Jean Gros. *Napoleon at Eylau.* **1808.** Oil on canvas, 17'5 ½" × 26'3". Musée du Louvre, Paris. RMN Reunion des Musees Nationaux, France. Erich Lessing/Art Resource, NY

34 A Darker World

Napoleon and the Romantic Imagination

Napoleon and the Romantic Hero

Beethoven and the Rise of Romantic Music

Goya's Tragic Vision

French Painting after Napoleon: The Classic and Romantic
 Revisited

“ *And this is all that I have found—*
The impossibility of knowledge! ”

Goethe, *Faust*

◄ **Fig. 34.1 *View of Vienna from the Josephstadt.*** Colored engraving by Carl Schütz. 1785. Historisches Museum der Stadt Wien. Vienna was a city obsessed with leisure and entertainment, perhaps never more so than in 1815, when Europe's dignitaries gathered there for the Congress of Vienna, a peace conference that was, in essence, also a celebration of the defeat of Napoleon Bonaparte, at once the greatest hero of the day and the embodiment of Romanticism's darkest side.

VIENNA WAS A CITY OF CONTRADICTIONS IN THE EARLY YEARS of the nineteenth century (Fig. **34.1**). In 1827 it still had not expanded beyond its medieval walls (Map **34.1**), but in the 1840s, its population would approach 400,000. Although smaller than both London (with nearly 1 million inhabitants in 1800)

and Paris (with about half that), it was one of the fastest-growing cities in the world. This growth coincided with Vienna's new position as the capital of the Austrian-Hungarian Empire.

Vienna's extraordinary growth and accompanying breakdown in infrastructure—its water system was probably the worst in Europe—contrasted sharply with the city's fondness for leisure and entertainment. As the century progressed, the city dismantled its elaborate system of defensive walls and constructed gardens, parks, and broad boulevards that allowed for urban expansion and a gradual transition to the surrounding suburbs. Yet even before the medieval walls came down, the streets of Vienna were lined with dance halls, theaters, coffeehouses, and wine bars. An English traveler, John Owen, reported in 1792, "good

cheer is, indeed, pursued here in every quarter, and mirth is worshiped in every form."

For 14 months, from September 1814 until November 1815, the city was especially lively and was in every way the center of European culture. All of Europe's heads of state gathered there for the Congress of Vienna, a conference called to guarantee peace in Europe both by treaty and other political tools after the defeat of Napoleon. This peace involved dividing Napoleon's empire and redrawing Europe's political map (Map **34.2**). The Habsburg emperor Franz I (1768–1835) appointed a festivals committee to entertain the visiting monarchs, their enormous entourages, and the continuing stream of dignitaries that flooded the city's streets. There were banquets and balls, tournaments and hunts, sleighing expeditions, torchlight parades, balloon ascents, theatricals, ballets, operas, and musical performances of every type.

Especially popular was a new orchestral work by Ludwig van Beethoven [BAY-toh-ven], Vienna's greatest composer, celebrating the June 1813 British victory over Napoleon at the Battle of Vittoria in Spain. Today the *Wellingtons Sieg* [seeg] (*Wellington's Victory*), a raucous noisemaker of a composition, is rarely performed. Beethoven himself later declared the work a "folly," but in a Vienna celebrating the defeat of the French, it was a sensation and was performed repeatedly. As minor as the composition is considered in retrospect, it illustrates how attractive the popular musical genre termed "battle music" was to Europeans of every social rank at this critical historical moment. Beethoven took full advantage of the unexpected acclaim, appearing in more public concerts in 1815 than in any other year of his

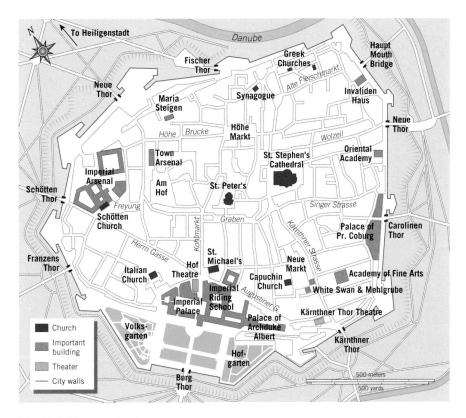

Map 34.1 Vienna ca. 1827.

lifetime. In fact, his late masterpieces were largely financed by *Wellingtons Sieg*.

While Vienna's great composer had sensed a commercial opportunity, the years immediately following Napoleon's final defeat also led to the rapid spread of a new nationalist political ideology despite the Congress of Vienna's attempt to restore a conservative political order in Europe. A blend of ethnic pride and cultural identity based on shared history and a sense of destiny, **nationalism** was the justification for the creation of many new nineteenth-century nation-states. Ironically, although it was Napoleon's defeat that triggered the spread of nationalism throughout his previously conquered territories, it was the French leader's political innovations that made nationalism so appealing.

Indeed, 11 years earlier, in 1803, before Napoleon had embarked on his monumentally destructive effort to conquer Europe, Beethoven had dedicated a symphony to the emperor whose defeat he now celebrated. And Beethoven had not been alone in his admiration for Napoleon. So stunningly successful were Napoleon's military campaigns, so fierce was his dedication to the principles of liberty, fraternity, and equality (abolishing serfdom throughout much of Europe), and so brilliant was his reorganization of the government, the educational system, and civil law, that in the first years of the nineteenth century, he seemed to many a savior. Ultimately,

Napoleon was the very personification of the Romantic hero as well as a French national icon, a man of common origin who had risen, through sheer wit and tenacity, to dominate the world stage.

But as everyone at the Congress of Vienna in 1814–1815 knew, there was a darker side to Napoleon. He was, for instance, a man of such ego that he led his armies on an endless series of military campaigns as if immune to defeat. He was a man with so great a desire for personal glory that he crowned himself emperor and established a royal dynasty to rule his various conquests. And in imposing his reforms, he brought war to many nations and suppressed their national identity. His reputation as a Romantic nationalist figure came to a crashing end in the midst of the Congress of Vienna in June 1815, when he was defeated once and for all at the battle of Waterloo—by Wellington once again—giving rise to a new flurry of *Wellingtons Sieg* performances. How the Romantics in various centers of culture throughout Europe reconciled their need for heroes of epic proportion with the inevitable human failings of heroic figures such as Napoleon is the subject of this chapter. The nature of the heroic is a constant theme in Romantic literature, music, and art. Many of the European artists who challenged the moral and aesthetic values of their time and championed their own and others' liberty self-consciously defined themselves as heroes.

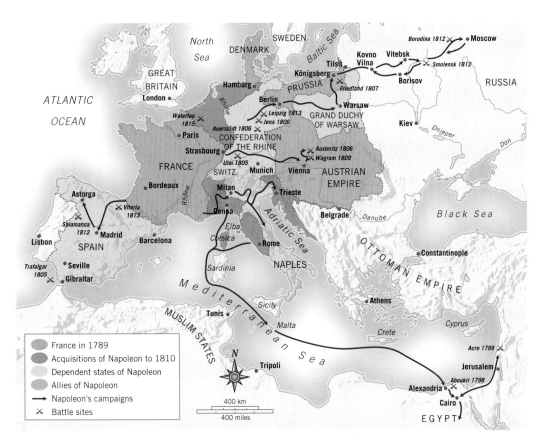

Map 34.2 Post-Napoleonic Europe 1815. The Congress of Vienna created the territorial borders shown here.

Continuity & Change
p. 211

CULTURAL PARALLELS

Volcanic Eruption

At the same time that the Congress of Vienna convened during the spring and summer of 1815, 7,000 miles away in the Dutch East Indies (Indonesia), Mount Tambora erupted, ejecting enormous quantities of volcanic dust into the atmosphere. The next year, 1816, was dubbed "the year without a summer" or "the Poverty year" across the globe because of plunging temperatures and disruption in agricultural production worldwide.

Napoleon and the Romantic Hero

Napoleon's relative success at creating stability in France (see chapter 32) fueled his desire to establish stability across Europe, by force. To this end, in 1800 he crossed into Italy, establishing firm control of Piedmont and Lombardy. That same year, Jacques-Louis David celebrated the event in a painting (see Fig.

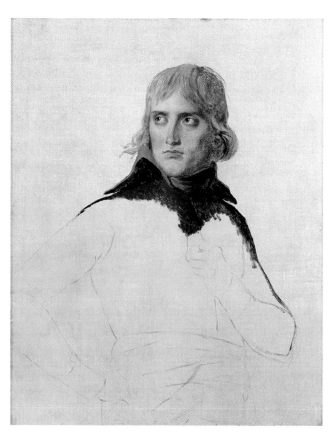

Fig. 34.2 Jacques-Louis David. *The General Bonaparte.* ca. 1797–1798. Unfinished oil on canvas, 31⅞" × 25⅝". Photo: R.G. Ojeda. Musée du Louvre/RMN Réunion des Musées Nationaux, France. SCALA/Art Resource, NY. David, who years earlier had created the epitome of the tribute to a French revolutionary with his painting of Marat, would claim to everyone, "Bonaparte is my hero!"

Alexander the Great

32.14) that is pure propaganda, designed to create a proper myth for the aspiring general. However, David's vision of Napoleon as a Romantic hero was evident years earlier in a sketch celebrating the emperor's peace treaty with Austria (Fig. **34.2**). Here Napoleon's penetrating eyes are meant to evoke the ancient Greek sculptor Lysippus's famous image of Alexander the Great (see Fig. 7.21) as the dashing young warrior about to dominate the world. One of the most influential early expressions of the Napoleonic myth came from German philosopher Georg Wilhelm Friedrich Hegel [HAY-gul] (1770–1831) in 1806: "I have seen the emperor, that world soul, pass through the streets of the town on horseback. It is a prodigious sensation to see an individual like him who, concentrated at one point, seated on a horse, spreads over the world and dominates it."

Extending his sights beyond the Continent, and financed in no small part by the sale of the Louisiana Territory to the United States in 1803 for 80 million francs (roughly $15 million), Napoleon prepared to invade England, his chief enemy. He assembled over 100,000 troops and 1,000 landing craft on the straits of Dover, but Vice Admiral Lord Nelson, commander of the British fleet, thwarted his tactics. Napoleon dispatched the French fleet to the West Indies in order to draw Nelson away from the English Channel, instructing the fleet to return secretly in order to escort the French troops across the channel. Instead, the British admiral caught up with the French ships off Cape Trafalgar [truh-FAL-gar] near the southwest corner of Spain and defeated them at the cost of his own life. Nelson destroyed nearly half the French fleet as well as Napoleon's dream of conquering England without the loss of any of his own ships.

Napoleon nevertheless remained undaunted and launched a succession of campaigns against Britain's continental allies, Austria and Prussia. By mid-October 1805, French forces occupied Vienna. Then on December 2, 1805, in one of Napoleon's greatest victories, his army of 73,000 defeated a combined Austrian and Russian force of 86,000, under the command of the tsar and the emperor of Austria, at Austerlitz [OH-ster-litz]. The resulting treaty left Napoleon in control of all of Italy north of Rome. By 1807, the only European countries outside Napoleon's sphere of influence were Britain, Sweden, and Portugal (see Map 32.2).

The Hegelian Dialectic and the "Great Man" Theory of History

For German philosopher Georg Wilhelm Friedrich Hegel, Napoleon was the force driving the world toward an absolute freedom embodied in the laws and institutions of a great European nation-state. From Hegel's point of view, the entire world is governed by a single divine nature, which he alternately called "absolute mind" or "world-spirit." Napoleon, whom Hegel termed "that world soul," personi-

fied this "absolute mind," which in seeking to know its own nature initiates a process known as the **dialectic**. At any given moment, the prevailing set of ideas, which Hegel termed the "thesis," finds itself opposed by a conflicting set of ideas, the "antithesis." For instance, chaotic revolutionary forces in France found themselves opposed by the call for order and rule of law embodied by Napoleon. This conflict resolves itself in a "synthesis," which inevitably establishes itself as the new thesis, generating its own new antithesis, with the process always moving forward, ever closer to the ultimate goal—spiritual freedom. Each period in history is necessary to the next, driven by conflict, which Hegel viewed as a positive and productive force rather than a damaging or destructive one.

Hegel, along with English philosopher-historian Thomas Carlyle, is also responsible for what is commonly called the **"Great Man" theory**, which asserts that human history is driven by the achievement of men (and men only) who lead humankind forward because they have sensed by intuition the "world-spirit" (**Reading 34.1**):

READING 34.1 **from Georg Wilhelm Friedrich Hegel, *Philosophy of History* (1805–1806)**

Such are all great historical men ... they may be called Heroes, inasmuch as they have derived their purposes and their vocation, not from the calm, regular course of things, sanctioned by the existing order, but from a concealed fount—one which has not attained to phenomenal, present existence—from that inner Spirit, still hidden beneath the surface, which, impinging on the outer world as on a shell, bursts it in pieces. . . . Such individuals had no consciousness of the general Idea they were unfolding ... but at the same time they were thinking men, who had an insight into the requirements of the time—what was ripe for development.

Hegel's primary emphasis here is the same as that of the Romantic writers and philosophers—history is driven by the spiritual rather than the material—but unlike the Romantics, he believed that world history revealed a rational process. "Reason is the Sovereign of the World," declared Hegel, and it was only through men such as Alexander, Charlemagne, or Napoleon that the world-spirit could manifest itself in an orderly process. The "Great Man" theory has many shortcomings, the most obvious being that women have no political or historical role. Neither do the common people and workers, a deficiency that one of Hegel's astute students, Karl Marx, would address several decades later when he revised Hegel's "dialectic" by contending that the struggle between social classes moves history forward (see chapter 36).

The Promethean Hero in England

The "Great Man" approach to history is part of the more general Romantic fascination with the powers of individual intuition and creativity. The literary manifestation of this fascination found its most compelling expression in the ancient Greek myth of Prometheus [pro-MEE-thee-us]. A member of the race of deities known as Titans [TY-tunz], Prometheus stole fire, the source of wisdom and creativity, from the sun and gave it to humankind, to whom Zeus [zoos], ruler of the Gods, had denied it. For this crime Zeus chained him to a rock, where an eagle fed daily on his liver, which was restored each night. The English Romantic poets embraced Prometheus. He was, for them, the all-suffering but ever noble champion of human freedom. The vulnerability and continued suffering of Prometheus, along with his bold and reckless ambition to achieve his goals by breaking the laws imposed by supreme authority, endeared him to generations of Romantically inclined artists.

The Promethean Idea in England: Lord Byron and the Shelleys For poet George Gordon, Lord Byron (1788–1824), Prometheus was the embodiment of his own emphatic spirit of individualism. Byron was a prodigious traveler to foreign countries, a sexual experimenter, and a champion of oppressed nations. In his 1816 ode "Prometheus," Byron rehearses the myth as described in Aeschylus' play *Prometheus Bound*, and then addresses his mythical hero (**Reading 34.2**):

READING 34.2 **from George Gordon, Lord Byron, "Prometheus" (1816)**

Thou art a symbol and a sign
To Mortals of their fate and force;
Like thee, Man is in part divine,
A troubled stream from a pure source;
And Man in portions can foresee

His own funereal destiny;
His wretchedness, and his resistance,
And his sad unallied existence:
To which his Spirit may oppose
Itself—an equal to all woes,

And a firm will, and a deep sense,
Which even in torture can descry
Its own concentred recompense,
Triumphant where it dares defy,
And making Death a Victory.

Byron balances the poem's sense of almost hopeless resignation by his defiant insistence on the power of the human spirit to overcome any and all troubles it encounters—even death.

Prometheus's daring to oppose the Olympian gods was, for Byron, the same daring that he saw in Napoleon. In

Childe Harold's Pilgrimage, the long narrative poem that established his reputation, Byron addressed Napoleon directly (**Reading 34.3a**):

READING 34.3a **from George Gordon, Lord Byron, *Childe Harold's Pilgrimage*, Canto III, stanzas 37, 42 (1812)**

Conqueror and captive of the earth art thou!
She trembles at thee still. . . .
 there is a fire
And motion of the soul which will not dwell
In its own narrow being, but aspire
Beyond the fitting medium of desire;
And, but once kindled, quenchless evermore,
Preys upon high adventure . . .

Childe Harold's Pilgrimage is written what in what is known as the *Spenserian stanza*, a nine-line stanza with the rhyme scheme *ababbcbcc* (see below). The meter of the stanza's first eight lines is iambic pentameter, and the ninth is iambic hexameter (known as an Alexandrine meter). This stanza was common to poetic travel literature at the time and is perfectly suited to a poem about a "Childe" (a medieval word for a young noble awaiting knighthood) setting out on a pilgrimage or journey of discovery. Harold is an outsider with a complex personality, loving Nature, hating crowds, never contented but forever seeking new experiences. He is the archetypical Romantic hero (**Reading 34.3b**):

READING 34.3b **from George Gordon, Lord Byron, *Childe Harold's Pilgrimage*, Canto II (1812)**

25 To sit on rocks, to muse o'er flood and fell,
 To slowly trace the forest's shady scene,
 Where things that own not man's dominion dwell,
 And mortal foot hath ne'er, or rarely been;
 To climb the trackless mountain all unseen,
 With the wild flock that never needs a fold;
 Alone o'er steeps and foaming falls to lean;
 This is not solitude; 'tis but to hold
 Converse with Nature's charms, and view her stores unroll'd.

26 But midst the crowd, the hum, the shock of men,
 To hear, to see, to feel, and to possess,
 And roam along, the world's tir'd denizen,
 With none who bless us, none whom we can bless;
 Minions of splendour shrinking from distress!
 None that, with kindred consciousness endued,
 If we were not, would seem to smile the less
 Of all that flatter'd, follow'd, sought and sued;
 This is to be alone; this, this is solitude!

Childe Harold's Pilgrimage essentially recounts Byron's own Grand Tour, his own restless travels through Spain, Portugal, Greece, Turkey, and Albania, where he purchased the costume in which he posed for Thomas Phillips (Fig. **34.3**). Barely distinguishable from his chief character, Byron in succeeding years would add new cantos to the poem, relating his travels through Belgium, Switzerland, the Alps, and Italy.

In Italy, Byron met up with the English poet Percy Bysshe Shelley (1792–1822) and his wife Mary Godwin Shelley (1797–1851), daughter of the philosopher and writer William Godwin and author Mary Wollstonecraft (see chapter 32). Shelley was also working on a Prometheus project, a four-act play entitled *Prometheus Unbound*. It concerns Prometheus's final release from captivity, and in it Shelley departs from tradition in choosing to have that release follow the overthrow of Zeus rather than precede a reconciliation between the hero and his tyrannical oppressor. A revolutionary text that champions free will, goodness, and idealism in the face of oppression, *Prometheus Unbound* is Shelley's answer to the mistakes of the French Revolution and its cycle of replacing one tyrant with another. Shelley declares his beliefs as a poet and revolutionary in the epilogue (**Reading 34.4**):

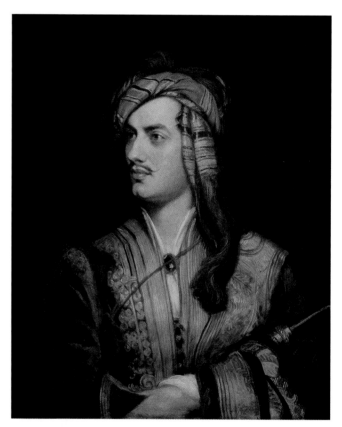

Fig. 34.3 Thomas Phillips. *Lord Byron Sixth Baron in Albanian Costume*. 1835. Oil on canvas, 29½″ × 24½″. National Portrait Gallery, London, UK. The Bridgeman Art Library. This is Phillips's own copy of the original 1813 painting, which hangs in the British Embassy in Athens. Bryon's dashing good looks and his exotic costume, the Albanian shawl wrapped round his head like a turban, underscore the poet's Romantic individualism.

READING 34.4 from Percy Bysshe Shelley, *Prometheus Unbound* (1820)

To suffer woes which Hope thinks infinite;
To forgive wrongs darker than death or night;
To defy Power, which seems omnipotent;
To love, and bear; to hope till Hope creates
From its own wreck the thing it contemplates;
Neither to change, nor falter, nor repent;
This, like thy glory, Titan, is to be
Good, great and joyous, beautiful and free;
This is alone Life, Joy, Empire, and Victory.

Shelley also shared with Byron a deep belief in the immortality of art. In his 1819 "Ode to the West Wind" a five-stanza lyric poem in which the Wind is the vehicle for spreading the word of reform and change, Shelley addressed the Wind as the enduring power of human expression (**Reading 34.5a**):

READING 34.5a from Percy Bysshe Shelley, "Ode to the West Wind" (1819)

Be thou, spirit fierce,
My spirit! Be thou me, impetuous one!

Drive my dead thoughts over the universe
Like withered leaves to quicken a new birth!
And, by the incantation of this verse,

Scatter, as from an unextinguished hearth
Ashes and sparks, my words among mankind!

For Shelley, poets were, as he wrote in *A Defense of Poetry*, "the unacknowledged legislators of the world" who sought to change the world with their writing. In the lines above, he exhorts the Wind to give life to his message of reform and revolution by spreading his words over the world.

Mary Shelley was as galvanized by the Prometheus myth as her husband and Byron, but her attitude toward it was more ambivalent. When Byron arrived in Italy, she had already begun her novel *Frankenstein; or the Modern Prometheus*. The novel is narrated by an English explorer in the Arctic, whose ice-bound ship takes on a man in terrible condition named Victor Frankenstein, and reports the passenger's story. Dr. Frankenstein had learned the secret of endowing inanimate material with life.

Dr. Frankenstein subsequently created a monster of giant proportion and supernatural strength from assembled body parts taken from graveyards, slaughterhouses, and dissecting rooms. But as soon as the creature opened his eyes, the scientist realized that he had not so much created a miracle as a horror, a creature doomed to a miserable existence of exile from normal society. Dr. Frankenstein flees his laboratory

(Fig. **34.4**), leaving the creature to fend for himself (see **Reading 34.5**, page 1108 for this episode). What follows is the story of the monster's revenge—a series of murders that adversely affect Frankenstein and his family. So, like Prometheus, Dr. Frankenstein is punished for the acquisition of powerful knowledge. Promethean ambition and power, Mary Shelley tells us, can step beyond the bounds of reason and the human capacity to manage the consequences—as Napoleon had demonstrated.

In July 1823, Byron sailed to Greece to aid the Greeks in their War of Independence from the Ottoman Turks. Greece was for Byron a Promethean country, longing to be "unbound." Now he would come to its aid himself. But he never did face any action. Instead, he died in 1824 of fever and excessive bleeding, the result of his doctor's mistaken belief that bleeding would cure him. He was buried in his family vault in England, except for his heart and lungs, which were interred at Missolonghi, where he had perished. Keats had died of tuberculosis in 1821, Shelley had drowned in a boating accident in 1822. Of all the great English Romantic poets, only Wordsworth and Coleridge were still alive by the mid-1820s.

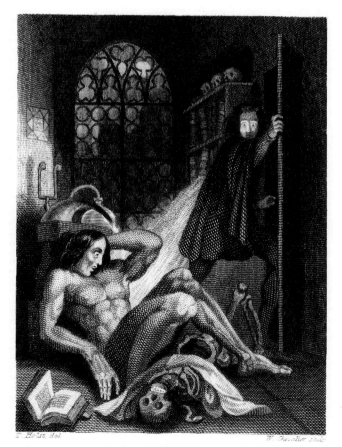

Fig. 34.4 Theodor M. von Holst. Illustration from *Frankenstein* by Mary Shelley. 1831. Engraving. Private Collection. The Bridgeman Art Library.

The Romantic Hero in Germany: Johann Wolfgang von Goethe's *Werther* and *Faust*

One of the great ironies in the development of Romanticism is that two of its greatest heroes, Werther [VER-tur] and Faust (rhymes with "oust"), were the creation of an imagination that defined itself as classical. The creator of these two heroes, Johann Wolfgang von Goethe [GUH-tuh] (1749–1832), had strong classical tastes and is often categorized as a "classical" author. He had moved to Weimar [VY-mar], one of the great cultural centers of Europe, in 1775, and later filled his house there with Greek and Roman statuary. His most famous portrait, painted by J. H. W. Tischbein [TISH-bine] in 1787, presents him in a pilgrim's garb before an array of Roman ruins (Fig. **34.5**), and, indeed, he found Romanticism abhorrent. In a famous letter of 1829, Goethe wrote a friend, "The classical I call healthy, the Romantic sick . . . [the Romantic] is weak, sickly, ill, and the [classical] is strong, fresh, cheerful . . ."

Goethe himself occasionally descended into what he called these "other darker places." As he admitted, the German poet Friedrich Schiller (1759–1805) had "demonstrated to me that I myself, against my will, was a Romantic." This ill-defined border between Goethe's "classical" and "Romantic" approaches to literature reminds us that labeling artistic and literary styles is helpful in gaining some basic understanding of their context, but does not produce iron-clad, fixed categories.

Goethe's Romantic Novel: *The Sorrows of Young Werther*

Early in his career, Goethe had written what was, for the age, the quintessential Romantic novel, *The Sorrows of Young*

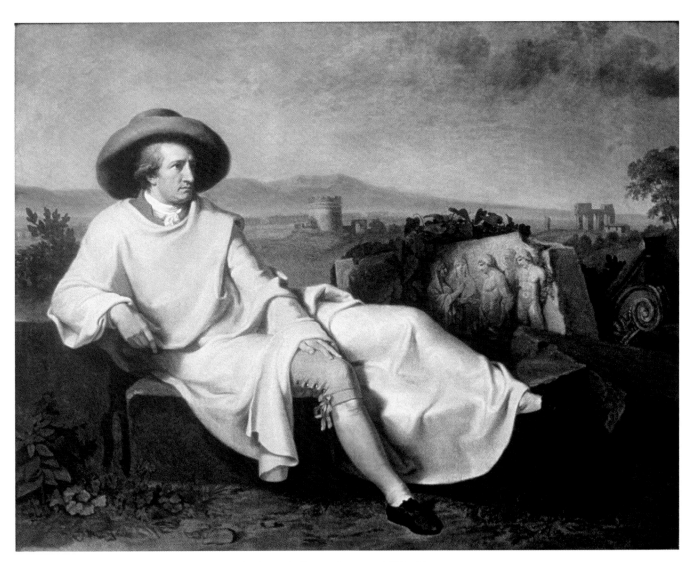

Fig. 34.5　J. H. W. Tischbein, *Johann Wolfgang von Goethe in the Roman Campana*. 1787. Oil on canvas, 64$\frac{1}{2}$″ × 81″. Location: Staedelsches Kunstinstitut, Frankfurt am Main, Germany. Kavaler/Art Resource, NY. Tischbein painted this portrait during Goethe's first visit to Rome, which lasted from September 1786 until June 1788, during which time the two shared an apartment.

Werther. It told the story of a young man who feels increasingly disillusioned with life, even as he finds himself hopelessly in love with a happily married woman. This much was semiautobiographical—Goethe had fallen in love with his law partner's fiancée. But where Goethe's Werther ends his life by committing suicide, Goethe simply left town and turned his experiences into a best-selling novel, establishing a precedent for alienated, ambitious young artists for the next two centuries.

Werther is happiest when by himself, in nature: "I am so happy, my friend," he writes in one of the first letters in the book, ". . . when the lovely valley surrounds me in mist, and the sun at noon lingers on the surface of the impenetrable darkness of my woods, and only a few rays steal into the inner sanctum. . . . [then] the entire heavens come to rest in my soul, like the form of a beloved." But when he actually falls in love, he finds nothing but torment (**Reading 34.6**):

READING 34.6 **from Johann Wolfgang von Goethe, *The Sorrows of Young Werther* (1774)**

When I have spent several hours in her company, till I feel completely absorbed by her figure, her grace, the divine expression of her thoughts, my mind becomes gradually excited to the highest excess, my sight grows dim, my hearing confused, my breathing oppressed as if by the hand of a murderer, and my beating heart seeks to obtain relief for my aching senses.

Such sentiments were a revelation for readers at the time. Even Napoleon later admitted to Goethe that he had enthusiastically read *Young Werther* several times. Across Europe, young men began to wear the blue jacket and yellow trousers that Goethe describes as Werther's habitual dress, and some of these, disappointed like their hero, committed suicide, copies of the book in their pockets. It is, no doubt, these young men to whom Goethe refers when he says that the Romantic is "sick."

Goethe well understood that the Romantic aspirations of his fictional hero Werther represented the same feelings described by his friend, the poet Georg Friedrich Philipp von Hardenberg (1772–1801), who wrote under the pen-name Novalis [noh-VAH-lis]. Novalis defined the process of creating art from the Romantic perspective: "Insofar as I give the common an elevated meaning, the usual a secret perspective, the known the value of the unknown, the finite an infinite appearance—I thus romanticize." Goethe expanded on this theme, arguing that "Great works of art are comparable to the great works of nature; they have been created by men according to true and natural laws. Everything arbitrary,

imaginary collapses. Here is necessity, here is God." While great art is transcendent, Goethe suggests, it is ultimately, subject to God's grand design and the natural laws that govern the universe, a point of view similar to that of the Enlightenment *philosophes*.

Goethe's *Faust* and the Desire for Infinite Knowledge
Goethe conceived his greatest character and hero, Faust, in the 1770s, but did not start writing the work until 1800, and completed it just before his death in 1832. It is a 12,000-line verse play based on a sixteenth-century German legend about an actual traveling physician named Johann or Georg Faust, who was reputed to have sold his soul to the devil in return for infinite knowledge. To Goethe, he seemed an ideal figure for the Romantic hero—driven to master the world, with dire consequences.

Faust is a man of great learning and breadth of knowledge—like Goethe himself—but bored with his station in life and longing for some greater experience. He wants the kind of knowledge that does not always come from books (**Reading 34.7a**):

READING 34.7a **from Johann Wolfgang von Goethe, *Faust*, Part I (1808)**

FAUST Here stand I, ach, Philosophy
Behind me and Law and Medicine too
And, to my cost, Philosophy—
All these I have sweated through and through
And now you see me a poor fool
As wise as when I entered school!
They call me Master, they call me Doctor,
Ten years now I have dragged my college
Along by the nose through zig and zag
Through up and down and round and round
And this is all that I have found—
The impossibility of knowledge!
. . .
Besides, I have neither goods nor gold,
Neither reputation nor rank in the world;
No dog would choose to continue so! . . .
Oh! Am I still stuck in this jail?
This God-damned dreary hole in the wall
Where even the lovely light of heaven
Breaks wanly through the painted panes!

In essence, Faust is profoundly bored, suffering from one of the great afflictions of the Romantic hero, **ennui** [ahn-wee], a French term that denotes both listlessness and a profound melancholy. He longs for something that will challenge the limits of his enormous intellect. That challenge appears, not long after, in the form of Mephistopheles [mef-ih-STOFF-uh-leez]—the devil—who arrives in Faust's study dressed as a

city square from the inn was Mehlgrube [MEHL-groo-beh] Hall, where, on April 2, 1800, Beethoven premiered his First Symphony. Mozart had performed a series of six concerts in the Mehlgrube in 1785. Yet in Beethoven's First and Second Symphonies, completed in 1802, there is a sense that he consciously intended to recapitulate and summarize the Classical tradition, preparing to move on to more exciting breakthroughs. A personal crisis, brought on by his increasing deafness, instigated an extraordinary period of creativity for Beethoven over the next decade, in which he produced six symphonies, four concertos, and five string quartets, leaving the Classical tradition behind.

The Heroic Decade: 1802–1812

In April 1802, Beethoven left Vienna for the small village of Heiligenstadt [HY-lig-en-shtaht], just north of the city. Though his hearing had been deteriorating for some time, what had started as humming and buzzing was becoming much worse. Moody and temperamental by nature, his deafness deeply depressed him. His frustrations reached a peak in early October as he contemplated ending his life. His feelings are revealed in a remarkable document found among his papers after his death, a letter to his brothers today known as the *Heiligenstadt Testament* (**Reading 34.8**):

READING 34.8 **from Ludwig van Beethoven,** *Heiligenstadt Testament* (1802)

From childhood on, my heart and soul have been full of the tender feeling of goodwill, and I was ever inclined to accomplish great things. But, think that for six years now I have been hopelessly afflicted, made worse by senseless physicians, from year to year deceived with hopes of improvement, finally compelled to face the prospect of a lasting malady . . . Though born with a fiery, active temperament, even susceptible to the diversions of society, I was soon compelled to withdraw myself, to live life alone . . . It was impossible for me to say to people, "Speak louder, shout, for I am deaf." Ah, how could I possibly admit an infirmity in the one sense which ought to be more perfect in me than in others. . . . I must live almost alone, like one who has been banished . . . If I approach near to people a hot terror seizes upon me, and I fear being exposed to the danger that my condition might be noticed. . . . What a humiliation for me when someone standing next to me heard a flute in the distance and I heard nothing, or someone heard a shepherd singing and again I heard nothing. Such incidents drove me almost to despair; a little more of that and I would have ended my life—it was only my art that held me back . . .

Beethoven soon reconciled himself to his situation, recognizing that his isolation was, perhaps, the necessary condition to his creativity. His sense of self-sufficiency, of an imagination turned inward, guided by an almost pure state of subjective feeling, lies at the very heart of Romanticism. Beethoven's post-Heiligenstadt works, often called "heroic" because they so thoroughly evoke feelings of struggle and triumph, mark the first expression of a genuinely Romantic musical style. When composer and author E. T. A. Hoffmann said, in 1810, that Beethoven's music evokes "the machinery of awe, of fear, of terror, of pain"—he meant that it evokes the *sublime* (see chapter 33). To this end, it is much more emotionally expressive than its Classical predecessors. In Beethoven's ground-breaking compositions, this expression of emotion manifests itself in three distinct ways: long, sustained *crescendos* that drive the music inexorably forward; sudden and surprising key changes that always make harmonic sense; and both loud and soft repetitions of the same theme that are equally, if differently, poignant.

The *Eroica* Beethoven's Third Symphony, the *Eroica*, is the first major expression of this new style in his work. Much longer than any previous symphony, the 691 measures of the first movement alone take approximately 19 minutes to play compared to 8 minutes for the first movement of Mozart's Symphony No. 40 in G minor (see **CD-Track 29.2**). In fact, the first movement is almost as long as an entire Mozart symphony! Dramatically introducing the main theme and recapitulating it after elongated melodies, this movement ends in a monumental climax, establishing the Romantic, Promethean mood of the piece. The second movement (see **CD-Track 34.1**), with its strong, repetitive beat of double basses imitating military drums, signals the start of the main theme, a solemn funeral march. At the end of the movement, the clockwork sound of the violins suggests the passing of time, while the return of the solemn theme in fragmented form suggests to many listeners the sighing of a dying man. This movement expresses despair with a few hints of consolation. For the third movement, Beethoven relaxed the tension and substituted a **scherzo** [SKER-tso]—an Italian term meaning "joke," denoting a type of musical composition, especially one that is fast and vibrant and presents a surprise—for the courtly measures of the traditional minuet, which had faded in popularity. The finale brings together the themes and variations of the first movement in a broad, triumphant conclusion featuring a majestic horn. Ultimately, this symphony dramatizes Beethoven's own descent into despair at Heiligenstadt (figured in the second movement), his inward struggle, and his ultimate triumph through art.

The Fifth Symphony Beethoven's Fifth Symphony, like the *Eroica*, brings musical form to the triumph of art over death, terror, fear, and pain. Premiering on December 22, 1808, the symphony's opening four-note motif, with its short-short-short-long rhythm, is in fact the basis for the entire symphony (for the first movement, see **CD-Track 34.2**):

Here we descry;
Eternal Womanhead
Leads us on high.

In the end, Goethe's Faust is an extremely ambiguous figure, a man of enormous ambition and hence enormous possibility, and yet, like Frankenstein, his will to power is self-destructive. We see these ambiguities in the poem's high seriousness countered by ribald comedy, and in Faust's great goodness countered by deep moral depravity.

Beethoven and the Rise of Romantic Music

Fascination with the Promethean hero was not limited to literature. It was reflected in music, and especially that of Ludwig van Beethoven (1770–1827), the key figure in the transition from the Classical to the Romantic era. His Third Symphony, which came to be known as the *Eroica* [eh-ROH-ee-kah]—Italian for the "Heroic"—was originally dedicated to Napoleon because of the composer's admiration for the French leader as a champion of freedom. But when, on December 2, 1804, Napoleon had himself crowned as emperor, Beethoven changed his mind, saying to a friend: "Is he then, too, nothing more than an ordinary human being? Now he, too, will trample on all the rights of man and indulge only his ambition. He will exalt himself above all others, become a tyrant!" Thus, on the title page of the symphony he crossed out the words "*Intitulata* [in-tee-too-LAH-tah] *Bonaparte*," "Entitled Bonaparte."

Beethoven remained ambivalent about the emperor. Even as Napoleon occupied Vienna in 1809 in his second taking of the city (the first had been in 1805 without a battle when the citizens greeted him with interest), Beethoven had chosen to conduct the *Eroica* at a charity concert for the theatrical poor fund, probably in hopes of attracting the emperor to the performance. (Napoleon, it turns out, had left town the day before.) And as late as October 1810, he wrote a note to himself: "The Mass [in C, op. 86] could perhaps be dedicated to Napoleon." Bonaparte thus embodied the type of contradiction that always fueled Beethoven's imagination. The composer viewed the emperor as at once the enlightened leader and tyrannical despot, as did most of Europe.

Early Years in Vienna: From Classicism to Romanticism

Beethoven's music is a direct reflection of his life's journey, his joys and sorrows, and, in turn, an indication of the shift from the formal structural emphases of Classical music to the expression of more personal, emotional feelings in Romantic music. Other, earlier composers had expressed emotion in their works, but not in the personal, autobiographical way that Beethoven did. Arriving in Vienna from Bonn, Germany, in November 1792, just a month before his twenty-second birthday, Beethoven gained wide acclaim for his skills as a pianist.

The city of Mozart and Haydn was deeply aware of its musical preeminence. In fact, Haydn would serve as the young Beethoven's teacher during his first 14 months in the city. Although their relationship was stormy, Haydn's emphasis on formal inventiveness within the framework of Classical clarity guided Beethoven's development as an artist in his first decade in Vienna.

In Vienna, Beethoven began every day at his desk, working until midday. After his noontime dinner, he took a long walk around the city, often spending the entire afternoon in the streets until, in the early evening, he made his way to a favorite tavern like the White Swan Inn (Fig. **34.7**). Located across the

Fig. 34.7 Neuer Markt ("New Market"), Vienna. Colored engraving by Carl Schütz. ca. 1785. Location: Wien Museum Karlsplatz, Vienna, Austria. Erich Lessing, Art Resource, NY. The building at the far end is the Schwarzenberg Palace, where, among other works, Beethoven would premier his String Quintet in C, op. 29, in 1801. To the left of it is the Mehlgrube, literally "flour store," so-called because it had served that function in the Middle Ages. Here, Beethoven premiered his Symphony No. 1, on April 2, 1800. Beethoven's favorite tavern, the White Swan Inn, is at the right.

city square from the inn was Mehlgrube [MEHL-groo-beh] Hall, where, on April 2, 1800, Beethoven premiered his First Symphony. Mozart had performed a series of six concerts in the Mehlgrube in 1785. Yet in Beethoven's First and Second Symphonies, completed in 1802, there is a sense that he consciously intended to recapitulate and summarize the Classical tradition, preparing to move on to more exciting breakthroughs. A personal crisis, brought on by his increasing deafness, instigated an extraordinary period of creativity for Beethoven over the next decade, in which he produced six symphonies, four concertos, and five string quartets, leaving the Classical tradition behind.

The Heroic Decade: 1802–1812

In April 1802, Beethoven left Vienna for the small village of Heiligenstadt [HY-lig-en-shtaht], just north of the city. Though his hearing had been deteriorating for some time, what had started as humming and buzzing was becoming much worse. Moody and temperamental by nature, his deafness deeply depressed him. His frustrations reached a peak in early October as he contemplated ending his life. His feelings are revealed in a remarkable document found among his papers after his death, a letter to his brothers today known as the *Heiligenstadt Testament* (**Reading 34.8**):

READING 34.8 **from Ludwig van Beethoven,**
***Heiligenstadt Testament* (1802)**

From childhood on, my heart and soul have been full of the tender feeling of goodwill, and I was ever inclined to accomplish great things. But, think that for six years now I have been hopelessly afflicted, made worse by senseless physicians, from year to year deceived with hopes of improvement, finally compelled to face the prospect of a lasting malady . . . Though born with a fiery, active temperament, even susceptible to the diversions of society, I was soon compelled to withdraw myself, to live life alone . . . It was impossible for me to say to people, "Speak louder, shout, for I am deaf." Ah, how could I possibly admit an infirmity in the one sense which ought to be more perfect in me than in others. . . . I must live almost alone, like one who has been banished . . . If I approach near to people a hot terror seizes upon me, and I fear being exposed to the danger that my condition might be noticed. . . . What a humiliation for me when someone standing next to me heard a flute in the distance and I heard nothing, or someone heard a shepherd singing and again I heard nothing. Such incidents drove me almost to despair; a little more of that and I would have ended my life—it was only my art that held me back . . .

Beethoven soon reconciled himself to his situation, recognizing that his isolation was, perhaps, the necessary condition

to his creativity. His sense of self-sufficiency, of an imagination turned inward, guided by an almost pure state of subjective feeling, lies at the very heart of Romanticism. Beethoven's post-Heiligenstadt works, often called "heroic" because they so thoroughly evoke feelings of struggle and triumph, mark the first expression of a genuinely Romantic musical style. When composer and author E. T. A. Hoffmann said, in 1810, that Beethoven's music evokes "the machinery of awe, of fear, of terror, of pain"—he meant that it evokes the *sublime* (see chapter 33). To this end, it is much more emotionally expressive than its Classical predecessors. In Beethoven's ground-breaking compositions, this expression of emotion manifests itself in three distinct ways: long, sustained *crescendos* that drive the music inexorably forward; sudden and surprising key changes that always make harmonic sense; and both loud and soft repetitions of the same theme that are equally, if differently, poignant.

The *Eroica* Beethoven's Third Symphony, the *Eroica*, is the first major expression of this new style in his work. Much longer than any previous symphony, the 691 measures of the first movement alone take approximately 19 minutes to play compared to 8 minutes for the first movement of Mozart's Symphony No. 40 in G minor (see **CD-Track 29.2**). In fact, the first movement is almost as long as an entire Mozart symphony! Dramatically introducing the main theme and recapitulating it after elongated melodies, this movement ends in a monumental climax, establishing the Romantic, Promethean mood of the piece. The second movement (see **CD-Track 34.1**), with its strong, repetitive beat of double basses imitating military drums, signals the start of the main theme, a solemn funeral march. At the end of the movement, the clockwork sound of the violins suggests the passing of time, while the return of the solemn theme in fragmented form suggests to many listeners the sighing of a dying man. This movement expresses despair with a few hints of consolation. For the third movement, Beethoven relaxed the tension and substituted a **scherzo** [SKER-tso]—an Italian term meaning "joke," denoting a type of musical composition, especially one that is fast and vibrant and presents a surprise—for the courtly measures of the traditional minuet, which had faded in popularity. The finale brings together the themes and variations of the first movement in a broad, triumphant conclusion featuring a majestic horn. Ultimately, this symphony dramatizes Beethoven's own descent into despair at Heiligenstadt (figured in the second movement), his inward struggle, and his ultimate triumph through art.

The Fifth Symphony Beethoven's Fifth Symphony, like the *Eroica*, brings musical form to the triumph of art over death, terror, fear, and pain. Premiering on December 22, 1808, the symphony's opening four-note motif, with its short-short-short-long rhythm, is in fact the basis for the entire symphony (for the first movement, see **CD-Track 34.2**):

Werther. It told the story of a young man who feels increasingly disillusioned with life, even as he finds himself hopelessly in love with a happily married woman. This much was semiautobiographical—Goethe had fallen in love with his law partner's fiancée. But where Goethe's Werther ends his life by committing suicide, Goethe simply left town and turned his experiences into a best-selling novel, establishing a precedent for alienated, ambitious young artists for the next two centuries.

Werther is happiest when by himself, in nature: "I am so happy, my friend," he writes in one of the first letters in the book, ". . . when the lovely valley surrounds me in mist, and the sun at noon lingers on the surface of the impenetrable darkness of my woods, and only a few rays steal into the inner sanctum. . . . [then] the entire heavens come to rest in my soul, like the form of a beloved." But when he actually falls in love, he finds nothing but torment (**Reading 34.6**):

READING 34.6 **from Johann Wolfgang von Goethe, *The Sorrows of Young Werther* (1774)**

When I have spent several hours in her company, till I feel completely absorbed by her figure, her grace, the divine expression of her thoughts, my mind becomes gradually excited to the highest excess, my sight grows dim, my hearing confused, my breathing oppressed as if by the hand of a murderer, and my beating heart seeks to obtain relief for my aching senses.

Such sentiments were a revelation for readers at the time. Even Napoleon later admitted to Goethe that he had enthusiastically read *Young Werther* several times. Across Europe, young men began to wear the blue jacket and yellow trousers that Goethe describes as Werther's habitual dress, and some of these, disappointed like their hero, committed suicide, copies of the book in their pockets. It is, no doubt, these young men to whom Goethe refers when he says that the Romantic is "sick."

Goethe well understood that the Romantic aspirations of his fictional hero Werther represented the same feelings described by his friend, the poet Georg Friedrich Philipp von Hardenberg (1772–1801), who wrote under the pen-name Novalis [noh-VAH-lis]. Novalis defined the process of creating art from the Romantic perspective: "Insofar as I give the common an elevated meaning, the usual a secret perspective, the known the value of the unknown, the finite an infinite appearance—I thus romanticize." Goethe expanded on this theme, arguing that "Great works of art are comparable to the great works of nature; they have been created by men according to true and natural laws. Everything arbitrary,

imaginary collapses. Here is necessity, here is God." While great art is transcendent, Goethe suggests, it is ultimately subject to God's grand design and the natural laws that govern the universe, a point of view similar to that of the Enlightenment *philosophes.*

Goethe's *Faust* and the Desire for Infinite Knowledge
Goethe conceived his greatest character and hero, Faust, in the 1770s, but did not start writing the work until 1800, and completed it just before his death in 1832. It is a 12,000-line verse play based on a sixteenth-century German legend about an actual traveling physician named Johann or Georg Faust, who was reputed to have sold his soul to the devil in return for infinite knowledge. To Goethe, he seemed an ideal figure for the Romantic hero—driven to master the world, with dire consequences.

Faust is a man of great learning and breadth of knowledge—like Goethe himself—but bored with his station in life and longing for some greater experience. He wants the kind of knowledge that does not always come from books (**Reading 34.7a**):

READING 34.7a **from Johann Wolfgang von Goethe, *Faust*, Part I (1808)**

FAUST Here stand I, ach, Philosophy
Behind me and Law and Medicine too
And, to my cost, Philosophy—
All these I have sweated through and through
And now you see me a poor fool
As wise as when I entered school!
They call me Master, they call me Doctor,
Ten years now I have dragged my college
Along by the nose through zig and zag
Through up and down and round and round
And this is all that I have found—
The impossibility of knowledge!
. . .
Besides, I have neither goods nor gold,
Neither reputation nor rank in the world;
No dog would choose to continue so! . . .
Oh! Am I still stuck in this jail?
This God-damned dreary hole in the wall
Where even the lovely light of heaven
Breaks wanly through the painted panes!

In essence, Faust is profoundly bored, suffering from one of the great afflictions of the Romantic hero, **ennui** [ahn-wee], a French term that denotes both listlessness and a profound melancholy. He longs for something that will challenge the limits of his enormous intellect. That challenge appears, not long after, in the form of Mephistopheles [mef-ih-STOFF-uh-leez]—the devil—who arrives in Faust's study dressed as a

Fig. 34.6 Eugène Delacroix. *Mephistopheles Appearing to Faust in His Study.* **Illustration for Goethe's *Faust*.** 1828. Lithograph, $10\frac{3}{4}'' \times 9''$. Private Collection. The Stapleton Collection. The Bridgeman Art Library. Delacroix's illustrations were Goethe's favorite representations of his work.

dandy, a (Fig. **34.6**) nineteenth-century man of elegant taste and appearance:

READING 34.7b **from Johann Wolfgang von Goethe, *Faust*, Part I (1808)**

MEPHISTOPHELES . . . We two, I hope, we shall be good friends . . .
I am here like a fine young squire today,
In a suit of scarlet trimmed with gold
And a little cape of stiff brocade,
With a cock's feather in my hat
And at my side a long sharp blade,
And the most succinct advice I can give
Is that you dress up just like me,
So that uninhibited and free
You may find out what it means to live.

Mephistopheles makes a pact with Faust: He promises Faust "ravishing samples of my arts" which will satisfy his greatest yearnings, but in return, if Faust agrees that he is satisfied, Mephistopheles will win Faust's soul. As Faust leaves to prepare to accompany Mephistopheles, the fiend contemplates the doctor's future:

MEPHISTOPHELES . . . We just say go—and skip.
But please get ready for this pleasure trip.
[Exit Faust]
 Only look down on knowledge and reason,
The highest gifts that men can prize,
Only allow the spirit of lies
To confirm you in magic and illusion,
And then I have you body and soul.
Fate has given this man a spirit
Which is always pressing onwards, beyond control,
And whose mad striving overleaps
All joys of the earth between pole and pole.
Him I shall drag through the wilds of life
And through the flats of meaninglessness,
I shall make him flounder and gape and stick
And to tease his insatiableness
Hang meat and drink in the air before his watering lips;
In vain he will pray to slake his inner thirst,
And even had he not sold himself to the devil
He would be equally accursed.

Mephistopheles recognizes Faust as the ultimate Promethean hero, a man "always pressing onwards, beyond control," whose insatiable ambition will inevitably lead him to "overleap" his limitations. After a tumultuous love affair with a young woman named Gretchen—"Feeling is all!" he proclaims—he abandons her, which causes her to lose her mind and murder their illegitimate child. For this she is condemned to death, but the purity of her love wins her salvation in the afterlife.

In Book Two, Faust follows Mephistopheles into the "other dark worlds" of the Romantic imagination, a nightmare world filled with witches, sirens, monsters, and heroes from the distant past, including Helen of Troy, with whom he has a love affair. But, in Goethe's ultimately redemptive story, Faust is unsatisfied with this unending variety of experiences. What begins to quench his thirst, ironically, is good works, namely putting knowledge to work in a vast land-reclamation project designed to provide good land for millions of people. (This reminds us of Prometheus's desire to benefit humanity through the gift of fire.) Before achieving his dream, Faust dies, but without ever having actually declared his satisfaction. So, despite Mephistopheles's attempt to grab Faust's soul as it leaves his body, a band of angels carry Faust to heaven with the divine Gretchen at their head. She is what Goethe calls the "Eternal Womanhead"—both nature itself and the redeeming power of love—and so the poem ends as follows (**Reading 34.7c**):

READING 34.7c **from Johann Wolfgang von Goethe, *Faust*, Part II (1832)**

All that is past of us
Was but reflected;
All that was lost in us
Here is corrected;
All indescribables

Throughout the symphony's four movements, this rhythmic unit is used again and again, but never in a simple repetition. Rather, the rhythm seems to grow from its minimal opening phrasings into an expansive and monumental theme by the symphony's end.

A number of startling innovations emerge as a counterpoint to this theme: an interruption of the opening motif by a sudden oboe solo; the addition of piccolo and double bassoons to the woodwind sections and of trombones in the finale; the lack of a pause between the last two movements; the surprising repetition of the scherzo's theme in the finale; and the ending of the piece in a different key than it began—a majestic C major rather than the original C minor. In fact, the Fifth Symphony ends with one of the longest, most thrilling conclusions Beethoven ever wrote. Over and over again it seems as if the symphony is about to end, but instead it only gets faster and faster, until it finally comes to a rest on the single note C, played *fortissimo* [for-TISS-eh-moh] by the entire orchestra.

The Late Period: The Romantic in Music

Although initially Beethoven's musical innovations startled his public, by the end of the Heroic decade Beethoven was the most famous composer of instrumental music in Europe. His prominence in the Viennese musical scene always attracted an audience to see him perform or conduct (see *Voices*, page 1094). In 1815, during the Congress of Vienna when his *Wellingtons Sieg* was so popular and as he seemed to be rebounding from a hopeless romantic affair with a friend's wife, his brother Casper Carl died of tuberculosis, leaving a widow, Johanna [yoh-HAHN-uh], and a nine-year-old son, Karl, under Beethoven's protection. For five years, Johanna and Beethoven contested in court the guardianship of young Karl, which Beethoven finally won in 1820. During this time the composer was at first unproductive, but beginning in 1818, even as the court battle raged, he composed 23 of the Diabelli [dee-ah-BEH-lee] Variations for piano, brought the *Missa Solemnis* [MIS-sah soh-LEM-nis] a long way toward completion (Fig. **34.8**), and began sketching what would be his final great symphony, the Ninth. Once again, out of the chaos of his personal life, Beethoven gained new energy and artistic vision.

One of the most remarkable of Beethoven's last works is the Piano Sonata No. 30 in E Major, op. 109, which he completed in 1820 (see **CD-Track 34.3**). Beethoven's 32 piano sonatas are almost uniformly original, and many of them have acquired nicknames: the *Moonlight* Sonata, so named by a critic who was reminded of moonlight on a lake; *Les Adieux* ("The Farewell"), so named by Beethoven himself to commemorate the exile and return of his pupil and patron the Archduke Rudoph; and the *Appassionata,* which derives its name from the passionate tone of the first and last movements. The Piano Sonata No. 30 in E Major, one of three he composed in his late period, lacks a nickname but, like the other sonatas, is completely original and untraditional in

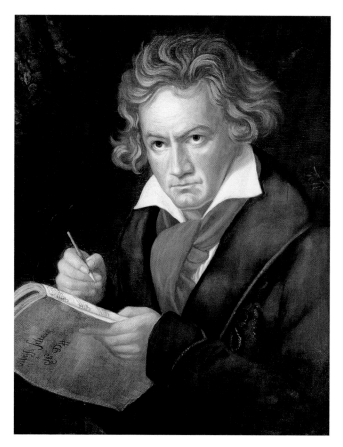

Fig. 34.8 Joseph Carl Stieler. *Beethoven*. 1820. Oil on canvas, 24³⁄₈″ × 19³⁄₈″. Beethoven Haus, Bonn, Germany. The Bridgeman Art Library. This portrait shows Beethoven writing the *Missa Solemnis* and was commissioned by Antonie Brentano, who kept a miniature copy of it on ivory.

form. In this sonata Beethoven alters the standard number and order of movements. In contrast to the traditional four-movement fast-slow-minuet-fast sonata form, he presents only three movements: *Vivace* ("Lively"), *Prestissimo* ("Very Fast"), and *Andante molto cantabile ed espressivo* ("Quite slow, lyrical, and expressive"). In addition to its Italian tempo marking, the last movement has a direction in German: *Gesangvoll mit innigster Empfundung* ("Songlike with the innermost feeling"). The animated but quiet first movement is interrupted by a slow passage that culminates in an explosive and passionate outburst. The short second movement creates a sense of powerful and dramatic tension. But the long third movement—at nearly 15 minutes nearly twice as long as the other two movements combined—is completely unanticipated. In the form of a theme and variations, it moves between extreme simplicity and profound, almost dreamlike feeling, culminating in a sense of peace and harmony.

The Ninth Symphony returns to the heroic style of the first decade of the nineteenth century. Simply put, it is a statement of faith in humanity, an utopian vision. The great innovation of the symphony is that in its finale it turns to song, introducing a vocal chorus into the symphonic form

Voices

An Englishman in Vienna Attends a Beethoven Premier

During a brief residence in Vienna early in the nineteenth century, the young English physician Henry Reeve had the good fortune of witnessing Beethoven conduct the second performance of Fidelio, *Beethoven's only opera. Circumstances were tense: Napoleon, in his war with Austria and Russia in late 1805, had just occupied the city, and French military officers claimed a substantial number of seats in the theater.* Fidelio, *with its themes of heroism and the quest for political liberty, was highly relevant to the situation. Reeve recorded his observations of that evening in his journal:*

"Beethoven presided at the pianoforte and directed the performance himself."

Thursday, November 21—Went to the Wieden Theater to see the new opera "Fidelio" the music composed by Beethoven. The story and the plan of the piece are a miserable mixture of low manners and romantic situations; the airs, duets, and choruses equal to any praise. The several overtures, for there is an overture for each act, appeared to be too artificially composed to be generally pleasing, especially on

being first heard. Intricacy is the characteristic of Beethoven's music and it requires a well-practised ear or a frequent repetition of the same piece to understand and distinguish its beauties. This was the first opera he ever composed and it was much applauded; a copy of the complimentary verses was showered down from the upper gallery at the end of the piece. Beethoven presided at the pianoforte and directed the performance himself. He is a small dark, young-looking man, wears spectacles and is like Mr. Koenig. Few people present, though the house would have been crowded in every part but for the present state of public affairs [the French military occupation].

(see **CD-Track 34.4**). For this reason the work is also known as the *Choral Symphony.* For the text, Beethoven used Friedrich Schiller's 1785 poem "An die Freude" [ahn dee FROY-duh] ("To Joy"), known to English-speaking audiences as the "Ode to Joy," a celebration of the joy of universal brotherhood:

Freude, schöner	Joy, beauteous spark
Götterfunken . . .	of divinity . . .
Alle Menschen werden Brüder	All men become brothers
Wo dein sanfter Flügel weilt.	Where your gentle
	wing abides.

Ninety voices performed the piece at its May 7, 1824, premiere. This, Beethoven's final expansive gesture, was designed to explore the full, expressive, and Romantic possibilities of the symphonic form.

Romantic Music after Beethoven

Beethoven's musical explorations of individual feelings were immensely influential on the Romantic composers who succeeded him. They strove to find new ways to express their own emotions. Some focused on the symphony as the vehicle for their most important statements. Others found a rich vehicle in piano music and song.

Hector Berlioz and Program Music French composer Hector Berlioz [BER-lee-ohz] (1803–1869) was the most star-

tlingly original of Beethoven's successors, both musically and personally. His compositions were frankly autobiographical; Berlioz attracted attention with new approaches to symphonic music and instrumentation. He wrote three symphonies: the *Symphonie fantastique* [SAM-foh-nee FAHN-tahss-teek] (1830); *Harold en Italie* [AH-rold ahn EE-tah-lee] (1834), based on Byron's *Childe Harold;* and *Roméo et Juliette* [ROH-may-oh ay joo-lee-ET] (1839). All are notable for their inventiveness and novelty, and especially for the size of the orchestras Berlioz enlisted to play them. The enormity of the sound could be deafening. The symphonies are also instances of program music, which suggests a sequence of images or incidents and may be prefaced with a text identifying these themes (see chapter 25). As large as the orchestras were and as intricate as their narrative structure was, Berlioz was able to unify his symphonies by introducing recurring themes that provided continuity through the various movements.

The *Symphonie fantastique,* subtitled "Episode in the Life of an Artist," was inspired by the composer's passionate love affair with Irish Shakespearean actress Harriet Smithson. In the notes for the first movement, entitled "Reveries, Passions," Berlioz joyously describes the infatuation of young lovers (see **CD-Track 34.5**). Berlioz insisted on the importance of his written program notes. He believed it essential that the audience read the text in advance of the performance "in order," he wrote, "to provide an overview of the dramatic structure of this work." Here is his description of the first movement's dramatic structure:

The author imagines that a young musician . . . sees for the first time a woman who embodies all the charms of the ideal being of his dreams, and he falls hopelessly in love with her. By bizarre peculiarity, the image of the beloved always presents itself to the soul of the artist with a musical idea that incorporates a certain character he bestows to her, passionate but at the same time noble and shy.

This melodic image pursues the young musician ceaselessly as a double *idée fixe* [EE-day feex] ("fixed idea"), the term Berlioz gave to the leading theme or melody in his work. This is the reason for the persistent appearance, in every movement of the symphony, of the melody that begins the opening Allegro. The transition from this state of melancholic reverie (interrupted by a few spasms of unfounded joy) to one of delirious passion (with its animations of fury, jealousy, its return to tenderness, and tears) is the theme of the first movement.

As Berlioz's *idée fixe* changes appearance through the course of the symphony, it mirrors the progress of the composition. In the second movement, "A Ball," the composer sees his beloved dancing a concert waltz. The third movement, "Scene in the Country," mixes hope and fear, as the artist seeks the solace of nature. In the fourth movement, "March to the Scaffold," the artist hallucinates on opium, dreaming that he kills his beloved and is witness to his own execution. Finally, in the symphony's last movement, "Dream of a Witches' Sabbath," his beloved appears on her broomstick, accompanied by a virtual pandemonium of sound and a symphonic shriek of horror, echoing Faust's adventures with Mephistopheles (Fig. **34.9**). The emphasis on overwhelming emotion, passion, and otherworldly scenes

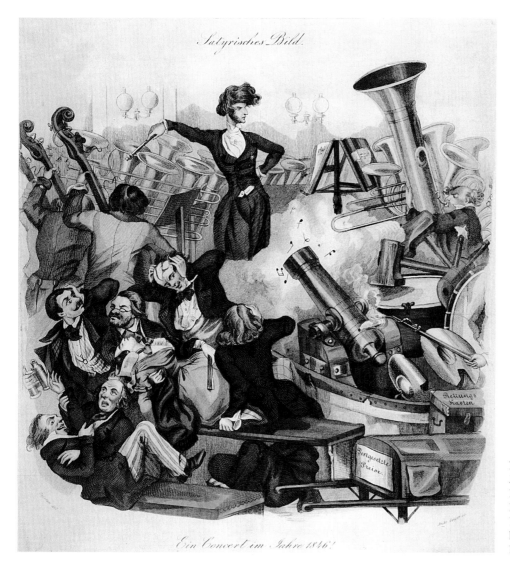

Fig. 34.9 Andrew Geiger. *A Concert of Hector Berlioz in 1846*. 1846.
Engraving. Musée de l'Opera, Paris, France. The Bridgeman Art Library. Berlioz was famous for his extraordinary hairstyle, which was as audacious as the loudness of his orchestras.

marks Berlioz as a key figure in the Romantic movement of the nineteenth century.

Felix Mendelssohn and the "Meaning" of Music Program music was an important part of the work of another Romantic composer after Beethoven. As a young man, Felix Mendelssohn [MEN-dul-zohn] (1809–1847) was befriended by Goethe, and their great friendship convinced the composer, who was recognized as a prodigy, to travel widely across Europe from 1829 to 1831. These travels inspired many of his orchestral compositions. These include the *Italian* Symphony (1833), which with its program has become his most popular work; the *Scottish* Symphony (1842), which is the only symphony he allowed to be published in his lifetime; and the *Hebrides* (1832), also known as *Fingal's Cave*. The last is a **concert overture**, a form that grew out of the eighteenth-century tradition of performing opera overtures in the concert hall. It consists of a single movement and is usually connected in some way with a narrative plot known to the audience, and in this sense is programmatic. The *Hebrides* overture, however, does not tell a story. Rather, it sets a scene—one of the first such compositions in Western music—the rocky landscape and swell of the sea that inspired Mendelssohn when he visited the giant cave carved into basalt columns on an island off the Scottish coast.

Mendelssohn himself played both piano and violin. For the piano he composed 48 "Songs without Words," published in eight separate books that proved enormously popular. The works challenge the listener to imagine the words that the compositions evoke. When asked by a friend to provide descriptive titles to the music, he replied:

> I believe that words are not at all up to it [the music], and if I should find that they were adequate I would stop making music altogether. . . . So if you ask me what I was thinking of, I will say: just the song as it stands there. And if I happen to have had a specific word or specific words in mind for one or another of these songs, I can never divulge them to anyone, because the same word means one thing to one person and something else to another, because only the song can say the same thing, can arouse the same feelings in one person as in another—a feeling that is not, however expressed by the same words.

The meaning of music, in other words, lies for Mendelssohn in the music itself. It cannot be expressed in language. The music creates a feeling that all listeners share, even if no two listeners would interpret it in the same terms.

One of Mendelssohn's most beautiful and popular works is the Concerto in E minor for Violin and Orchestra, composed in 1844 (see **CD-Track 34.6**). Its lyrical beauty is matched by the dazzling virtuosity Mendelssohn's score demands of the soloist. Throughout the composition, the violinist is required to finger and bow two strings simultaneously, a technique known as "double-stopping." This allows performers not only to demonstrate their skill but

also to assert, in a manner consonant with Romantic individualism, their own expressive genius. The work is also innovative compositionally. Most notably, each movement follows the previous one without break, and in contrast to the Classical concerto, the violin states each melody first instead of the orchestra.

Song: Franz Schubert and the Schumanns Not all Romantic composers followed Beethoven in concentrating on the symphonic form to realize their most important innovations and to communicate most fully their personal emotions. Beginning in about 1815, German composers became intrigued with the idea of setting poetry to music, especially the works of Schiller and Goethe. Called **lieder** [LEE-der] (singular *lied* [leet]), these songs were generally written for solo voice and piano. Their popularity reflected the growing availability and affordability of the piano in middle-class households and the composers' willingness to write compositions that were within the technical grasp of amateur musicians. This early expansion of the market for music freed composers from total reliance on the patronage of the wealthy.

The *lieder* of Franz Schubert [SHOO-burt] (1797–1828) and Robert (1810–1856) and Clara Schumann [SHOO-mahn] (1819–1896) were especially popular. Schubert's life was a continual struggle against illness and poverty, and he worked feverishly. In his brief career, he composed nearly 1,000 works, 600 of which were *lieder*, as well as 9 symphonies and 22 piano sonatas. Schubert failed to win international recognition in his lifetime, for which his early death by typhoid was partially to blame. But his melodies, for which he had an uncanny talent, seemed to capture, in the minds of the many who discovered him after his death, the emotional feeling and depth of the Romantic spirit.

Before he married Clara in 1840, Robert Schumann had permanently damaged his hands by constant over-practice. He turned from performance to composition and journalism, founding and editing one of the most important journals of its kind, still published today, the *Neue Zeitschrift für Musik* [NOY-uh TSITE-shrift fure MOO-zeek] (*New Journal of Music*), even as he struggled to write music. His success was directly tied to his moods. In the decade before marrying Clara, he never wrote more than five pieces in a given year. In the year of his marriage, however, he composed 140 songs, including his wedding gift to Clara, the poem *Du bist wie eine Blume* [doo beest vee EYE-nuh BLOO-muh], "You are like a Flower," and another song performed at their wedding, *Widmung* [VEED-moong], "Dedication," which begins "You are my soul, / you are my heart," and ends with a brief musical quotation from Schubert (see **CD-Track 34.7**). So Clara was the inspiration for much of her husband's most moving music.

By the age of 20, Clara Schumann was so well known as a piano virtuoso that the Viennese court had given her the title Royal and Imperial Virtuosa. She was one of the most

famous and respected concert pianists and composers of her day, despite her difficult marriage to Robert Schumann. She specialized in performing piano works known as **character pieces**, works of relatively small dimension that explore the mood or "character" of a person, emotion, or situation, including her husband's 1835 *Carnaval*. After Robert's death she supported her family by performing lengthy concert tours and was among the first artists to do this on a regular basis.

Piano Music: Frédéric Chopin Performance of character pieces often occurred at **salon concerts**, in the homes of wealthy music enthusiasts. Among the most sought-after composer/performer pianists of the day was the Polish-born Frédéric Chopin [SHOH-pan] (1810–1849). He composed almost exclusively for the piano. Among his most impressive works are his *études* [ay-TOOD], or "studies," which address particular technical challenges on the piano; *polonaises* [poh-loh-NEZ], stylized versions of the Polish dance; **nocturnes** [NOK-turns], character pieces related to the tradition of the serenade performed outside a loved one's window; and larger-scale works, particularly the four *ballades* [bah-LAHD], dramatic narrative forms that are among his most famous works. Focusing on melodramatic romance, supernatural events, and stormy emotion, Chopin's ballades are rich and complex, synthesizing contemporary poetry and diverse moods.

The *Fantasie impromptu* [fahn-tah-ZEE em-prohm-TOO] showcases the expressive range Chopin was capable of even in a brief composition (**see CD-Track 34.8**). Like other pianists of the day, Chopin enhanced the emotional mood of the piece by using *tempo rubato* [TEM-poh roo-BAH-toh] (literally "robbed time"), in which the tempo of the piece accelerates or decelerates in a manner "akin to passionate speech" as described by one of his students. While the word *fantasie* connotes creativity, imagination, magic, and the supernatural, the word *impromptu* suggests spontaneous improvisation, though, of course, the piece was written down. Combining impulsive, spur-of-the-moment creativity and imaginary and fantastical effects, Chopin's work is the very definition of Romanticism.

Goya's Tragic Vision

The impact of Napoleon's Promethean ambition, and the human tragedy associated with it, extended not only to Beethoven's Austria but also into Spain. Like Beethoven, the Spanish painter Francisco Goya [GOY-ah] (1746–1828) was, at first, enthusiastic about Napoleon's accession to power in France. Yet he, too, came to see through the idealistic veil of the emperor's ostensible desire to establish a fair and efficient government in a still-feudal country that was debased, corrupt, and isolated from the rest of Europe. Indeed, Goya's feelings for Napoleon were far less ambivalent than Beethoven's. Goya came to simply hate the emperor, as most Spaniards did.

When Napoleon decided to send a French army across the Iberian Peninsula to force Portugal to abandon its alliance with Britain, he did not foresee a problem since Spain had been his ally since 1796 (see Map 32.2). At first, Napoleon's army was unopposed, but by the time the troops reached Saragossa, the Spanish population rose up against the invaders in nationalistic fervor. For the next five years, the Spanish conducted a new kind of warfare, engaging the French in innumerable *guerrillas* [gay-REEL-yah], or "little wars," from which derives the concept of guerrilla warfare.

In March 1808, Napoleon made a fatal error. Maneuvering the Spanish royal family out of the way through bribery, he named his brother, Joseph Bonaparte (r. 1808–1814), to the Spanish throne. This gesture infuriated the Spanish people. The crown was *their* crown, after all, not Napoleon's. Even as the royal family was negotiating with Napoleon, rumors had spread that Napoleon was planning to execute them. On May 2, 1808, the citizens of Madrid rose up against Napoleon's troops, resulting in hundreds of deaths in battle, with hundreds more executed the next day on a hill outside Madrid. Six years later, in 1814, after Napoleon had been deposed and Ferdinand reinstated as king, Goya commemorated the events of May 2 and 3 in two paintings, the first depicting the battle and the second the executions of the following day.

The Third of May, 1808: Napoleon's Spanish Legacy

The Third of May, 1808 is one of the greatest testaments to the horrors of war ever painted (Fig. **34.10**). The night after the events of May 2, Napoleon's troops set a firing squad and executed hundreds of Madrilenos—anyone caught bearing weapons of any kind. The only illumination comes from a square stable lantern that casts a bright light on a prisoner with his arms raised wide above his head in a gesture that seems at once a plea for mercy and an act of heroic defiance. Below him the outstretched arms of a bloody corpse mirror his gesture. To his left, in the very center of the painting, another soon-to-be casualty of the firing squad hides his eyes in terror, and behind him stretches a line of victims to follow. Above them, barely visible in the night sky, rises a solitary, darkened church steeple.

Much of the power of the painting lies in its almost Baroque contrast of light and dark and its evocation of Christ's agony on the cross, especially through the cruciform pose of the prisoner. The soldier-executioners represent the grim reality of loyalty to one's state, as opposed to loyalty to one's conscience. Goya documented the realities of war in other works, including *The Disasters of War*, a series of etchings begun in 1810 and completed about the same time as *The Third of May, 1808*. These prints testify to the brutality of Napoleon's army, which, by all accounts, saw the Spanish people as little better than animals. In one of these prints, satirically entitled *Great courage! Against corpses!* Goya shows

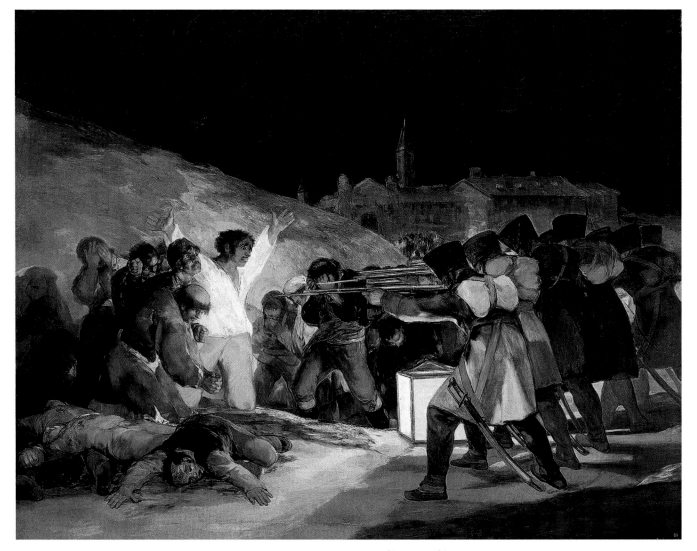

Fig. 34.10 Francisco Goya. *The Third of May, 1808.* 1814–1815. Oil on canvas, 8'9$\frac{1}{2}$" × 13'4$\frac{1}{2}$". Museo del Prado, Madrid. Goya was later asked why he had painted the scene with such graphic reality. His reply was simple: "To warn men never to do it again."

that in the hands of the French troops, the human body is no longer human (Fig. **34.11**).

Goya before Napoleon: Social Satire

The Napoleonic invasion of Spain certainly galvanized Goya's imagination, but even such shocking and satiric images as *Great courage! Against corpses!* are anticipated in his earlier work. Both patriotic and antiwar, Goya embodies the two sides of Romanticism that are often contradictory since nationalism in the nineteenth century almost always led to the need for armed conflict. Under the rule of Charles III, from 1759 to 1788, Spain had instituted many liberal reforms, but the French Revolution frightened his successor, Charles IV. This monarch reinstated the Inquisition and went so far as to ban the importation of books from France.

Goya was angered at this abandonment of reform, and between 1796 and 1798 he executed a series of prints, called the *Caprichos* [kah-PREE-chohss], or *Caprices*, that expressed this sentiment. *The Sleep* [or Dream] *of Reason Produces Monsters* was originally designed as a title page to the series (Fig. **34.12**). According to biographers, it shows Goya himself asleep at his work table as winged creatures swarm in the darkness behind him. An owl, a symbol of wisdom, takes up Goya's pen as if urging him to depict the monsters of his dreams. Throughout the series, Goya shows the follies of Spanish society—social injustice, prostitution, vanity, greed, snobbery, and superstition (accounting for the many images depicting witches and monsters). Goya's criticism of Spanish society included the ruling class, but wisdom required him to take a more restrained yet still satirical approach in portraits of the royal family (see *Focus*, pages 1100–1101). In Goya's

Fig. 34.11 Francisco Goya. *Grande hazara! Con muertos! (Great courage! Against corpses!)*, from *The Disasters of War*, No. 39. 1810–1814. Etching. Private Collection. The Bridgeman Art Library. The series was not published in Goya's lifetime—and not until 1863—probably because the government in Spain persecuted liberals after the return of Ferdinand VII in 1815.

Grande hazaña! Con muertos!

view, Spanish society, although in no way Promethean in its ambition, similarly steps beyond the bounds of reason without any capacity to manage the consequences. For this reason, he presents it as a parody of the Promethean myth, in the same way that Miguel de Cervantes's delusional Don Quixote (see chapter 22) is a parody of the ideal knight.

The Black Paintings

Goya's sense that his world had abandoned reason dominated his final works. In 1819, when Goya was 72 years old, he moved into a small two-story house outside Madrid. The move was inspired at least in part by his relationship with his 30-year-old companion, Leocadia Weiss, which scandalized more conservative elements of Madrid society. It was also a more general expression of Goya's growing preference for isolation.

Goya spent the next four years executing a series of 14 oil paintings directly on the plaster walls of this house, Quinta del sordo. Today they are known as the "black paintings." There is no record that Goya ever explained them to any friend or relative, nor did he title them in any written form. Among these works are a painting of a woman who is evidently Leocadia, leaning on a tomb; two men dueling with cudgels; a pilgrimage

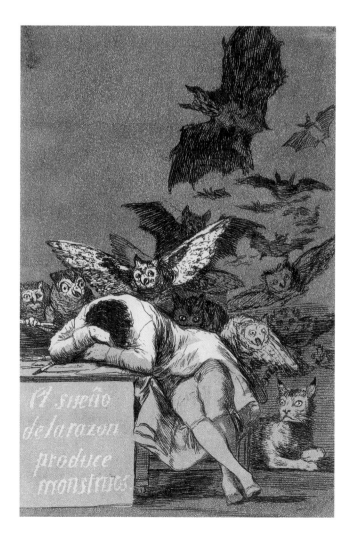

El sueño de la razon produce monstruos

Fig. 34.12 Francisco Goya. *The Sleep of Reason Produces Monsters*, from the *Caprichos*. 1796–1798. Etching and aquatint on paper, $8\frac{1}{2}'' \times 6''$. The Hispanic Society of America, NY. Goya offered 300 sets of the *Caprichos* series for sale in 1799, only to withdraw them two days later, presumably because the Church, which he portrayed in unflattering ways throughout, threatened to bring him before the Inquisition.

Focus

Goya's *The Family of Charles IV*

In 1789, Francisco Goya was appointed painter to Charles IV of Spain. As court painter he was responsible for producing portraits of the royal family and of courtiers. This may seem surprising given Goya's disapproval of Charles IV's Spain, but the position resulted mostly from Goya's great skill as a portraitist. In 1798, he was asked to produce a monumental portrait of the royal family. In its frank reference to Velázquez's *Las Meninas* (see Focus, chapter 27), which was in the royal collection, *The Family of Charles IV* is a sort of parody of greatness. Goya portrays himself standing at the back of the work at his easel, in the same position as Velázquez in *Las Meninas*. Queen Maria Luisa assumes the exact pose of the Infanta Margarita in the Velázquez work, but unlike the delicate infanta she is a giant presence, pudgy and grotesque. And Goya does nothing to hide the giant wart above the right eye of the king's sister, Maria Josepha. Nineteenth-century French writer Théophile Gautier (1811–1872) noted that Goya's royal couple resembles "the corner baker and his wife after they won the lottery."

How could the royal family accept such an unflattering work? The answer must lie in their own egotism, which Goya had anticipated in the *Caprichos*. In the image *Till Death*, an old woman tries on a new hat, primping herself before her mirror, as her maid barely suppresses a laugh. Two gentlemen share in her amusement, as one gazes up to the heavens as if in mock prayer. Vanity blinds the old woman, and so, presumably, does it blind the royal family, who, given Goya's position behind them, must be looking at their reflections in a mirror the painter had set up in front of them.

Caught up in their own self-admiration, the royal family evidently admired Goya's portrait of them immensely. In a letter to Manuel Godoy, the prime minister and her long-time lover, the queen pronounced it "the best of all paintings." Still, it turned out to be Goya's last royal commission. A recent cleaning of the painting has revealed on the wall behind the queen's head a lecherous scene, perhaps the biblical story of Lot and his daughters. It is possible that this story of incest upset the king and queen, who were, after all, first cousins, and caused them to request it be painted out.

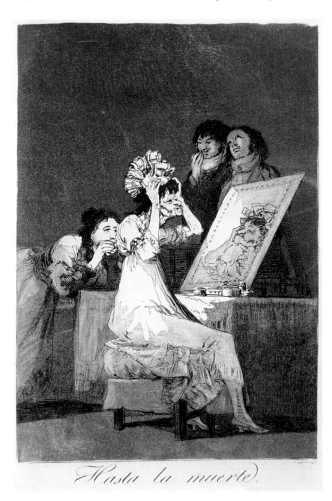

Francisco Goya. *Hasta la muerte (Till Death)*. **1797–1798.** Etching, aquatint, and drypoint on paper, $8\frac{3}{4}'' \times 6''$. Private Collection. The Bridgeman Art Library. The title implies the marriage vow "Till Death Do Us Part," as if we are faithful to our own image—and perhaps blind to its faults—until we die.

Charles IV's grotesquely deformed sister, **Maria Josepha**.

Queen Maria Luisa at forty-eight years of age with two children: the Infanta Maria Isabelle, aged eleven, and the Infante Francisco de Paula, aged six. It was widely believed that both children had been fathered by Manuel Godoy, who rose to the position of prime minister at the queen's insistence.

Charles IV's eldest daughter, the **Infanta Carlota Joaquina**, 25 and already Queen of Portugal, was severely hunchbacked as a result of a hunting accident.

Goya at his easel presumably looking in a mirror to paint the group portrait.

The Prince of Asturias, the future king Ferdinand VII. Behind him is his brother Don Carlos, who after Ferdinand's death in 1833 would plunge Spain into civil war as he tried to assert his right to the throne as Charles V.

The identity of the woman turning away is not known, but lends an air of distraction to the work as a whole.

The king decked out in military regalia and a white wig. Behind him is his uncle, Don Antonio.

Another daughter, **Maria Luisa Jospeha**, holding her child beside her husband, Don Luis, prince of Parma.

Francisco Goya. *The Family of Charles IV*. 1800. Oil on canvas, 9'2" × 11'. Museo del Prado, Madrid. Arixiu Mass, Barcelona/Derechos reservados © Museo Nacional Del Prado, Madrid. Goya subsequently painted Charles IV's successor, Joseph Bonaparte, Napoleon's brother, who ascended to the Spanish throne in 1808. When Ferdinand VII, son of Charles IV, returned to power in 1814, after Napoleon's defeat, he unleashed a wave of repression aimed at liberals and dissenters but spared Goya, allowing him to remain as court painter. He declared: "I ought to hang you, but you are a great artist, and I'll forgive everything."

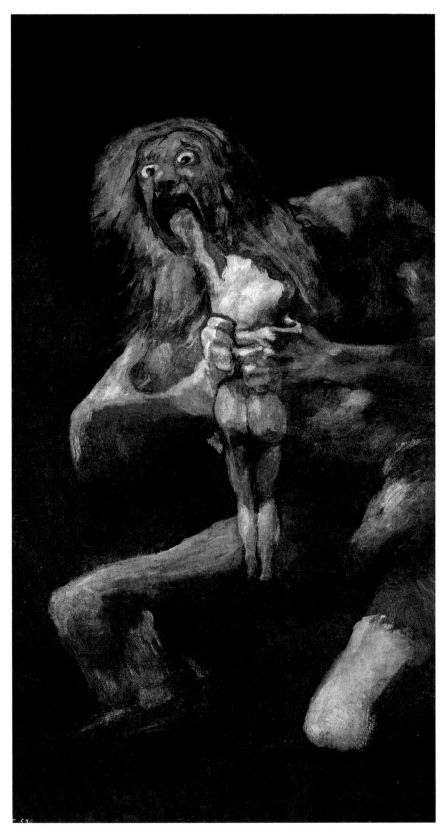

Fig. 34.13 Francisco Goya. *Saturn Devouring One of His Children.* 1820–1823. Oil on plaster transferred to canvas, 57⅞″ × 32⅝″. Derechos reservados © Museo Nacional Del Prado, Madrid. The painting reflects Goya's increasing disgust with Spanish politics. In 1824, he finally gave up on Ferdinand VII's Spain and, under the pretense of needing to visit the thermal baths, moved to Bordeaux, France, where he remained in self-exile until his death in 1828.

of terrifying and hideous figures through a nocturnal landscape; a convocation of these same figures in a witch's sabbath around a giant he-goat; two skeletal old people eating soup; and most terrifying of all, the painting today known as *Saturn Devouring One of His Children* (Fig. **34.13**). Derived from the story of Kronos [KROH-noss] eating his children, it is among the legends associated with the pre-Olympian Titans. *Saturn* is the Latin form of the Greek *Kronos*.

At the Quinta del sordo, the *Saturn* faced the main door, and it seems likely that Goya did not intend the Saturn myth as a "welcoming" image. His horrific giant with skinny legs, massive shoulders, wild hair, and crazed eyes is perhaps more an image of society as a whole, the social order, even Spain itself, devouring its own people. It is worth recalling that even as Goya was painting the *Saturn*, Beethoven was completing the Ninth Symphony. These works represent two sides of the Romantic imagination. Both share a profound sense of despair, isolation, and loneliness, but where Beethoven overcomes this condition and rises to a statement of hope and affirmation, Goya descends into a world of near madness and fear.

French Painting after Napoleon: The Classic and Romantic Revisited

After the fall of Napoleon in 1815, the battle between Classicism and Romanticism raged within France, fueled by political factionalism. Bourbon rule had been restored when Louis XVIII (r. 1814–1824), the deposed Louis XVI's brother, assumed the throne. Royalists, who favored this return of the monarchy, championed the more conservative Neoclassical style. Liberals identified with the new Romantic style, which from the beginning had allied itself with the French Revolution's radical spirit of freedom and independence.

The new king could not ignore the reforms implemented by both the revolution and Napoleon. His younger brother,

the count of Artois [AR-twah], disagreed, and almost immediately a so-called Ultraroyalist movement, composed of families who had suffered at the hands of the revolution, established itself. Advocating the return of their confiscated estates and the abolition of revolutionary and Napoleonic reforms, the Ultraroyalists imprisoned and executed hundreds of revolutionaries, Bonaparte's sympathizers, and Protestants in southern France. (David, who had supported Napoleon, was in exile during this period.) In order to solidify his control, Louis dissolved the largely Ultraroyalist Chamber of Deputies and called for new elections, which resulted in a more moderate majority.

Relative calm prevailed in France for the next four years, but in February 1820 the son of the count of Artois, who was the last of the Bourbons and heir to the throne, was assassinated, initiating ten years of repression. The education system was placed under the control of Roman Catholic bishops, press censorship was inaugurated, and "dangerous" political activity banned. At the death of Louis XVIII, the count of Artois assumed the throne as Charles X (r. 1824–1830).

Théodore Géricault: Rejecting Classicism

Against this political backdrop, the young painter Théodore Géricault [ZHAY-ree-koh] (1791–1824) inaugurated his career. Trained in Paris in a Neoclassical style, by the last years of Napoleon's reign he was painting largely military subjects that reflected a growing recognition of the emperor's limitations (see Fig. 32.18). In *The Wounded Cuirassier Leaving the Field*, the heroic ideal still finds expression in the rigid diagonals of the officer's and horse's legs and officer's sword—echoing the rigid poses of David's *Horatii* (see Fig. 32.4)—and in the painting's monumental size (Fig. **34.14**). But the cavalry officer's backward glance, the fear in the horse's eyes, and the fiery destruction in the background, all speak of the hollowness of heroism on the battlefield.

In fact, perhaps seeking some way to retrieve what was evidently lost, Géricault joined the Royal Musketeers soon after he completed this painting, assigned to protect the

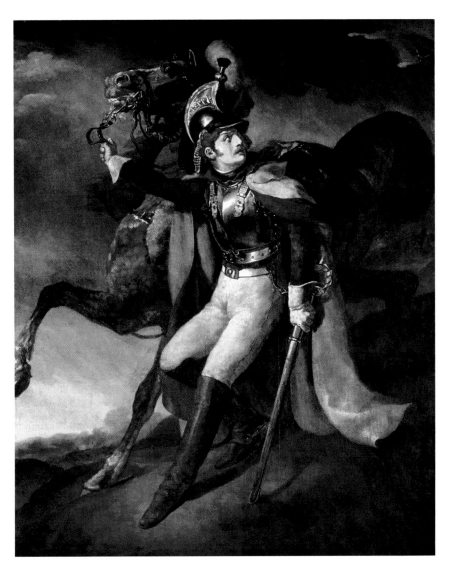

Fig. 34.14 Théodore Géricault. *The Wounded Cuirassier Leaving the Field.* 1814. Oil on canvas, 11'3/4" × 115'3/4". Musée du Louvre/RMN Réunion des Musées Nationaux, France. Bridgeman Art Library, NY. The emotional turbulence of the scene is underscored by the officer's apparent lack of balance.

future Louis XVIII from Napoleon. But events quickly overcame Géricault's brief royalist career. On July 2, 1816, a government frigate named the *Medusa*, carrying soldiers and settlers to Senegal, was shipwrecked on a reef 50 miles off the coast of West Africa. The captain and crew saved themselves, leaving 150 people, including a woman, adrift on a makeshift raft. Only 15 survived the days that followed, days marked by insanity, mutilation, famine, thirst, and finally cannibalism. Géricault was outraged. An inexperienced captain, commissioned on the basis of his noble birth and connections to the monarchy, saved himself, providing a profound indictment of aristocratic privilege.

Géricault set himself the task of rendering the events. He interviewed survivors, and painted mutilated bodies in the Paris morgue. The enormous composition of *The Raft of the*

"*Medusa*" is organized as a double triangle (Fig. **34.15**). The mast and the two ropes supporting it form the apex of one triangle, and the torso of the figure waving in the direction of the barely visible *Argus*, the ship that would eventually rescue the castaways, the apex of the other. The opposing diagonals form a dramatic "X" centered on the kneeling figure whose arm reaches upward in the hope of salvation. Ultimately, however, the painting makes a mockery of the idea of deliverance, just as its rigid geometric structure parodies the ideal order of Neoclassicism. Like Byron, Géricault's Romanticism assumed a political dimension through his art. He had himself become a Promethean hero, challenging the authority of the establishment.

The Aesthetic Expression of Politics: Delacroix versus Ingres

When Géricault's *The Raft of the "Medusa"* was exhibited at the French Academy of Fine Arts Salon of 1819, it was titled simply *A Shipwreck Scene*, in no small part to avoid direct confrontation with the Bourbon government. Royalist critics dismissed it. The conservative press wrote that the painting was "not fit for moral society. The work could have been done for the pleasure of vultures." But its sense of immediacy, its insistence on depicting current events (but not how the castaways actually looked after 13 days adrift), made an enormous impression on another young painter, Eugène Delacroix (1798–1863), who actually had served as the model for the facedown nude in the bottom center of the *Raft*. Soon after Géricault's accidental death, Delacroix exhibited his *Scenes from the Massacres at Chios* at the Salon of 1824 (Fig. **34.16**).

The full title of the painting—*Scenes from the Massacres at Chios; Greek Families Awaiting Death or Slavery, etc.*— *See Various Accounts and Contemporary Newspapers*— reveals its close association with journalistic themes. It depicts events of April 1822, after the Greeks had initiated a War of Independence from Turkey, a cause championed by all of liberal Europe. In retaliation, the sultan sent

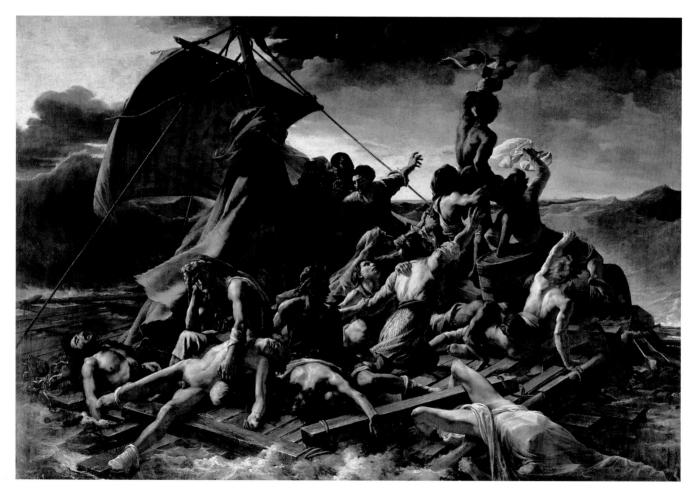

Fig. 34.15 Théodore Géricault. *The Raft of the "Medusa".* **1818.** First oil sketch. Oil on canvas, 16′1″ × 23′6″. Musée du Louvre, Paris. Photo: Herve Lewandowski. Inv.: RF 2229. © Réunion des Musées Nationaux/Art Resource, NY. The painting today is much darker than it was originally because Géricault used bitumin, an organic carbon-based material, in his pigment.

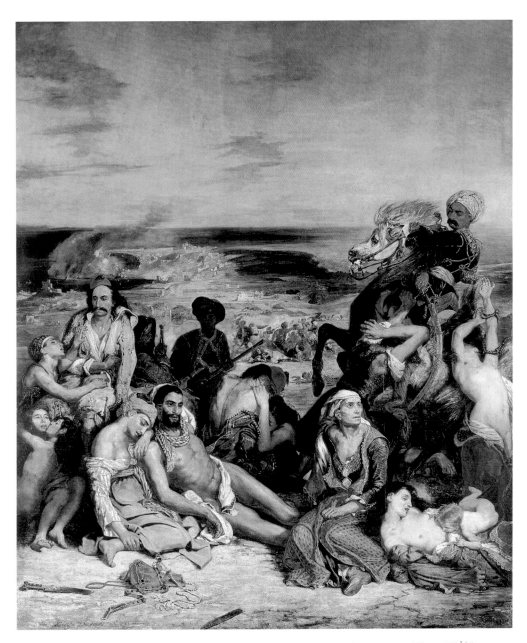

Fig. 34.16 Eugène Delacroix. *Scenes from the Massacres at Chios.* 1824. Oil on canvas, 165″ × 139′ ¹⁄₄″. Musée du Louvre, Paris. Photo: Le Mage. © Réunion des Musées Nationaux/Art Resource, NY. Delacroix relied on the testimony of a French volunteer in the Greek cause for the authenticity of his depiction.

an army of 10,000 to the Greek island of Chios [KY-oss], just several miles off the west coast of Turkey. The troops killed 20,000 and took thousands of women and children into captivity, selling them into slavery across North Africa. In the left foreground, defeated Greek families await their fate. To the right a grandmother sits dejectedly by what is perhaps her dead daughter, even as her grandchild tries to suckle at its dead mother's breast. A prisoner vainly tries to defend a Greek woman tied to a triumphant Turk's horse. The vast space between the near foreground and the far distance is startling, almost as if the scene transpires before a painted tableau.

The stark contrast between Delacroix's *Scenes from the Massacres at Chios* and a traditional painting by Ingres entitled *The Vow of Louis XIII* (Fig. **34.17**) at the Salon of 1824 emphatically underscored Delacroix's Romanticism. Especially in the context of the times, Ingres's painting is a deeply royalist work. It depicts Louis XIII placing France under the protection of the Virgin in February 1638 in order to end a Protestant rebellion. The painting is divided into two distinct zones, the religious and the secular, or the worlds of church and state. The king kneels in the secular space of the foreground, painted in almost excruciating detail. Above him, the Virgin, bathed in a spiritual light, is

Fig. 34.17 Jean-Auguste-Dominique Ingres. *The Vow of Louis XIII.* 1824. Oil on canvas, 165³/₄″ × 103¹/₈″. Montauban Cathedral, Montauban, France, Lauros. Giraudon/The Bridgeman Art Library, NY. The plaque in the hands of the putti reads "Louis XIII puts France under the protection of the Virgin, February 1638."

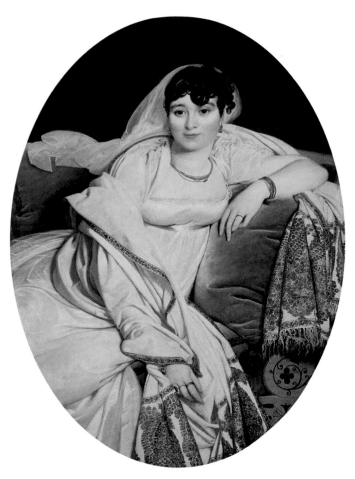

Fig. 34.18 Jean-Auguste-Dominique Ingres. *Madame Rivière,* (born Marie Françoise Jacquette Bibiane Blot de Beauregard). 1806. Oil on canvas, 46″ × 32¹/₄″. Musée du Louvre/RMN Réunion des Musées Nationaux, France. SCALA/Art Resource, NY. Ingres exhibited this portrait as well as portraits of Philibert Rivière and the couple's 15-year-old daughter, Caroline, in the Salon of 1806.

a monument to Renaissance classicism, directly referencing the Madonnas of Raphael. In every way, the painting is a monument to tradition, to the traditions of the Bourbon throne, the Catholic Church, and classical art.

In his paintings, Ingres never hesitated to adjust the proportions of the body to the overall composition. A good example is his 1806 portrait of Madame Rivière [ree-vee-AIR] (Fig. **34.18**), wife of one of his earliest and most important patrons. The oval shape of her face almost perfectly mirrors the oval format of the frame, both echoed again in the long curve of Madame Rivière's right arm. But what a long curve it is! It is an arm of almost apelike proportion, disguised by flowing fabric. The rhythmic harmonies of the painting determine its length, not any anatomical precision.

In many ways, Delacroix's *Arab on Horseback Attacked by a Lion* (Fig. **34.19**) mirrors, in its circular flow of line, the composition of Ingres's *Madame Rivière*. But its emotional impact is radically different. In 1854, Delacroix wrote in his journal, "I pity those who work tranquilly and coldly. I am convinced

that everything they do can only be cold and tranquil." Delacroix preferred what he called "the fury of the brush," a fury especially evident in paintings such as this one. His brushwork, described by a contemporary as "plunged deep like sword thrusts," is indeed almost violent, rising like the spiral forms of the entangled horse and lion in a swift and energetic motion that culminates in the flowing red cape flying off the back of the horseman. Such gestural expression is a hallmark of Romantic painting.

So Delacroix and Ingres reenact the aesthetic debate that had marked French painting since the time of Louis XIII, the debate between the intellect and emotion, between the school of Poussin and the school of Rubens (see chapter 27). But now, Ingres's Neoclassicism and Delacroix's Romanticism entered into this debate not merely as expressions of aesthetic taste but as a political struggle, which by 1830 would happen again in a revolution that Delacroix would celebrate in his monumental painting *Liberty Leading the People* (see Fig. 35.12).

Fig. 34.19 Eugène Delacroix. *Arab on Horseback Attacked by a Lion.* 1849. Oil on canvas, $17\frac{1}{4}''$ × $15''$. Potter Palmer Collection. 1922.403, The Art Institute of Chicago. Photograph © 2008, The Art Institute of Chicago. All Rights Reserved. Delacroix shared a fascination with the power of horses with his mentor Géricault, who died as a result of falling from one.

READINGS

from Mary Shelley, *Frankenstein*, chapter 5 (1818)

Mary Shelley's Frankenstein *was begun in 1816 at a villa in Switzerland after the English poet Lord Byron proposed to his companions that they compete in writing ghost stories.* Frankenstein *is an epistolary novel, a series of letters written by an English explorer in the Arctic whose ice-bound ship takes on a man in terrible condition, Victor Frankenstein, who narrates his own story to the explorer. Here, Frankenstein describes the horror he felt after creating a monster when he had dreamed of creating a creature of unparalleled beauty.*

It was on a dreary night of November that I beheld the accomplishment of my toils. With an anxiety that almost amounted to agony, I collected the instruments of life around me, that I might infuse a spark of being into the lifeless thing that lay at my feet. It was already one in the morning; the rain pattered dismally against the panes, and my candle was nearly burnt out, when, by the glimmer of the half-extinguished light, I saw the dull yellow eye of the creature open; it breathed hard, and a convulsive motion agitated its limbs.

How can I describe my emotions at this catastrophe, or how delineate the wretch whom with such infinite pains and care I had endeavoured to form? His limbs were in proportion, and I had selected his features as beautiful. Beautiful!—Great God! His yellow skin scarcely covered the work of muscles and arteries beneath; his hair was of a lustrous black, and flowing; his teeth of a pearly whiteness; but these luxuriances only formed a more horrid contrast with his watery eyes, that seemed almost of the same colour as the dun white sockets in which they were set, his shriveled complexion and straight black lips.

The different accidents of life are not so changeable as the feelings of human nature. I had worked hard for nearly two years, for the sole purpose of infusing life into an inanimate body. For this I had deprived myself of rest and health. I had desired it with an ardour that far exceeded moderation; but now that I had finished, the beauty of the dream vanished, and breathless horror and disgust filled my heart. Unable to endure the aspect of the being I had created, I rushed out of the room, and continued a long time traversing my bedchamber, unable to compose my mind to sleep. At length lassitude succeeded to the tumult I had before endured; and I threw myself on the bed in my clothes, endeavouring to seek a few moments of forgetfulness. But it was in vain: I slept, indeed, but I was disturbed by the wildest dreams. I thought I saw Elizabeth, in the bloom of health, walking in the streets of Ingolstadt. Delighted and surprised, I embraced her; but as I imprinted the first kiss on her lips, they became livid with the hue of death; her features appeared to change, and I thought that I held the corpse of my dead mother in my arms; a shroud enveloped her form, and I saw the grave-worms crawling in the folds of the flannel. I started from my sleep with horror; a cold dew covered my forehead, my teeth chattered, and every limb became convulsed: when, by the dim and yellow light of the moon, as it forced its way through the window shutters, I beheld the wretch—the miserable monster whom I had created. He held up the curtain of the bed; and his eyes, if eyes they may be called, were fixed on me. His jaws opened, and he muttered some inarticulate sounds, while a grin wrinkled his cheeks. He might have spoken, but I did not hear; one hand was stretched out, seemingly to detain me, but I escaped, and rushed down stairs. I took refuge in the courtyard belonging to the house which I inhabited; where I remained during the rest of the night, walking up and down in the greatest agitation, listening attentively, catching and fearing each sound as if it were to announce the approach of the demoniacal corpse to which I had so miserably given life.

Oh! no mortal could support the horror of that countenance. A mummy again endued with animation could not be so hideous as that wretch. I had gazed on him while unfinished; he was ugly then; but when those muscles and joints were rendered capable of motion, it became a thing such as even Dante could not have conceived.

I passed the night wretchedly. Sometimes my pulse beat so quickly and hardly that I felt the palpitation of every artery; at others, I nearly sank to the ground through languor and extreme weakness. Mingled with this horror, I felt the bitterness of disappointment; dreams that had been my food and pleasant rest for so long a space were now become a hell to me; and the change was so rapid, the overthrow so complete!

Morning, dismal and wet, at length dawned, and discovered to my sleepless and aching eyes the church of Ingolstadt, its white steeple and clock, which indicated the sixth hour. The porter opened the gates of the court, which had that night been my asylum, and I issued into the streets, pacing them with quick steps, as if I sought to avoid the wretch whom I feared every turning of the street would present to my view. I did not dare return to the apartment which I inhabited, but felt impelled to hurry on, although drenched by the rain which poured from a black and comfortless sky.

I continued walking in this manner for some time, endeavouring, by bodily exercise, to ease the load that weighed upon my mind. I traversed the streets, without any clear conception of where I was, or what I was doing. My heart palpitated in the sickness of fear; and I hurried on with irregular steps, not daring to look about me: . . . ■

Reading Questions

Why does Frankenstein reject his creation? Why does his dream turn to nightmare? Why did Mary Shelley leave so many questions unanswered?

Summary

■ **Napoleon and the Romantic Hero** When all of Europe's heads gathered for the Congress of Vienna in 1814–1815, called to guarantee peace in Europe after the defeat of Napoleon Bonaparte, the city was the focus of European culture. Almost everyone there recognized that even if Napoleon personified the Romantic hero, he also possessed a darker side. In many eyes, he was a modern Prometheus, what Hegel called a "Great Man," who sensed the "world-spirit" and in his singular action brought the dialectic of history closer to its utopian conclusion. Prometheus was the archetypal Romantic hero, celebrated by many cultural figures, including Lord Byron, Percy Bysshe Shelley, and Mary Shelley (whose Dr. Frankenstein was punished, like Prometheus, for acquiring knowledge beyond that of ordinary mortals). While the hero of Johann Wolfgang von Goethe's *The Sorrows of Young Werther* is self-absorbed and disillusioned with life, the hero of his later work, *Faust*, is a full-blown Promethean figure of almost insatiable drive for knowledge and experience.

■ **Beethoven and the Rise of Romantic Music** Like other Romantics of his era, Ludwig van Beethoven was fascinated by Napoleon, whose heroic deeds he celebrated in his Third Symphony, the *Eroica*, even as he began to recognize him as a tyrannical despot. Beethoven's musical career can be divided into three eras. In the early years he was deeply influenced by the classical music of Mozart and Haydn. In the so-called "Heroic Decade," after coming to the brink of suicide in 1802 due to his increasing deafness, he was guided by an almost pure state of subjective feeling. In great symphonies like the *Eroica* and the Fifth, he defined the Romantic style in music. After undergoing much personal anguish related to his family, Beethoven entered his late period, during which he completed three uniquely structured piano sonatas and his triumphal Ninth Symphony in 1824.

Beethoven's approach to the Romantic style in music required innovation and originality. Succeeding generations of composers followed his lead by expanding the musical vocabulary of orchestras and developing new symphonic forms. Hector Berlioz's autobiographical epic *Symphonie fantastisque* describes a passionate love affair through inventive melodies and harmonies and an enormous orchestra. Felix Mendelssohn composed orchestral compositions inspired by his travels; nevertheless, he believed that the meaning of music lies in the music itself. It cannot be expressed in language. Other composers, such as Franz Schubert and Robert and Clara Schumann set the poems of Romantic poets such as Schiller and Goethe to music in compositions called *lieder*. Frédéric Chopin composed almost solely for the piano and was famous especially for his *études*, studies that address particular technical challenges.

■ **Goya's Tragic Vision** Like Beethoven, the Spanish painter Francisco Goya was at first enthusiastic about Napoleon, but quickly changed his mind after the emperor's invasion of Spain in 1808. Goya would commemorate the Spanish rebellion against Napoleon's army in his *Third of May, 1808*, and narrate the horrors of Napoleonic occupation in his series of prints *The Disasters of War*. Goya was no less critical of Spanish leadership. In the *Caprichos*, he depicts the follies of Spanish society, and in a monumental painting commissioned by the crown, he satirizes the pretensions of the royal family. Late in life his vision became even darker in a series of works on the plaster walls of his house known as the "black paintings," which include the so-called *Saturn Devouring One of His Children*.

■ **French Painting after Napoleon: The Classic and Romantic Revisited** After Napoleon's defeat, the monarchy was restored in France. Painters like Théodore Géricault became increasingly disenchanted with the monarchy and rejected their classical training. Géricault's *The Raft of the "Medusa,"* based on the wreck of a government frigate and the abandonment of its passengers, represents a new direction in Romantic painting by depicting with a sense of urgency and immediacy a disturbing contemporary event. Géricault's student Eugène Delacroix followed with another painting on a controversial contemporary subject, *Scenes from the Massacres at Chios*, illustrating the genocide of thousands of Greeks revolting against Ottoman rule.

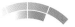

Glossary

ballade A highly dramatic narrative form.

character piece A piano work of relatively small dimension that explores the mood or "character" of a person, emotion, or situation.

concert overture A programmatic form that grew out of the eighteenth-century tradition of performing opera overtures in the concert hall and that consists of a single movement usually connected in some way with a narrative plot known to the audience.

dialectic An evolutionary process in which the prevailing set of ideas, called the "thesis," finds itself opposed by a conflicting set of ideas, the "antithesis." This conflict resolves itself in a "synthesis," which inevitably establishes itself as the new thesis.

ennui A French term that denotes both listlessness and a profound melancholy.

étude In music, a study that addresses particular technical challenges.

"Great Man" theory A theory asserting that human history is driven by the achievement of men who lead humankind forward because they have sensed by intuition the "world-spirit."

idée fixe A French term meaning "fixed idea," or an idea that dominates one's mind for a prolonged period.

lieder Songs, generally written for solo voice and piano.

nationalism A blend of ethnic pride and cultural identity based on shared history and a sense of destiny.

nocturne In music, a character piece related to the tradition of the serenade performed outside a loved one's window.

polonaise A stylized version of the Polish dance.

salon concert A concert held in the homes of wealthy music enthusiasts.

scherzo An Italian term meaning "joke" denoting a type of musical composition, especially one that is fast and vibrant and presents a surprise.

Critical Thinking Questions

1. Are the "darker" romantic qualities in Prometheus, Frankenstein's monster, and Faust attractive in any way? How so?

2. What is the "romantic style in music" that Beethoven defined, as opposed to Romantic musical themes or genres? Think of Mozart to contrast.

3. Describe the darker side of war and of the aristocracy as seen in the works of Goya, Géricault, and Delacroix.

From Romanticism to Realism

The Romantic imagination as embodied in the works of Beethoven, Goethe, and Goya is profoundly subjective, the product of an interior world that was intent, like Faust, on developing itself to the fullest. Beethoven spoke regretfully on his deathbed of his failure to set Goethe's *Faust* to music not because he approved of Faust as a man, but because he recognized in the sweep of the character's ambition something of his own expansive spirit.

However, it was not to the subjective imagination alone that the nineteenth-century imagination turned. In paintings like Géricault's *Raft of the "Medusa"* or Delacroix's *Scenes from the Massacres at Chios*, we are witness to the reality of contemporary events. In such works, the painter accepts the role of a newspaper reporter and attempts to convey, if not the actuality, then the emotional reality of events. In the years just before his death in 1824, Géricault had, in fact, produced a series of paintings, none of which were discovered until a half century after his death, that are today known as his portraits of the insane (Fig. **34.20**). What motivated Géricault to paint these portraits remains a mystery, but they reveal an interest in the most intimate side of human emotion, depicting their subjects with something approaching deep reverence for their psychological fragility. These are not subjective paintings, but they are *about* subjectivity—or more precisely, about the subjective mind's inability to come to grips with its world. And they suggest, in the isolation of each figure within the confined dark space of traditional portraiture, that we are not witness to personalities—the traditional subject of portraiture—but to figures emptied of their personalities.

These paintings amount to an extended study of the impact of nineteenth-century society on the downtrodden, the forgotten, and the all-too-often-alienated masses. They are one of the first expressions of what would in the coming years be a redirection of artistic attention away from the personal turmoil and dramas of the Romantic self and toward the plight of those unable to manage for themselves in a quickly changing industrial world. Reacting to images like these—and there would soon be others—the arts would come to the service of those demanding social reform. And the reformists themselves, impatient for change, would foment revolution. A new realism would be born, one dedicated to righting social wrongs. ■

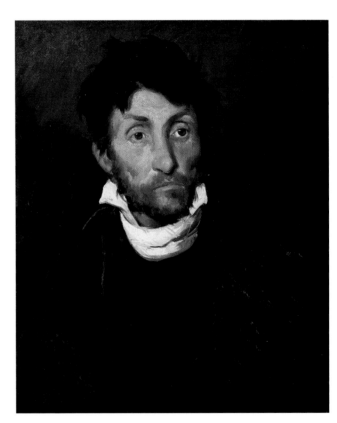

Fig. 34.20 Théodore Géricault. *Portrait of an Insane Man.* 1822–1823. Oil on canvas, 24″ × 19³⁄₄″. Museum voor Schone Kunsten, Ghent, Belgium. The Bridgeman Art Library.

BOOK FIVE / ROMANTICISM, REALISM,
AND EMPIRE: 1800 TO 1900

35 Industry and the Working Class

A New Realism

❝ *The filthy and miserable appearance of this part of London can hardly be imagined . . . men and women, in every variety of scanty and dirty apparel, lounging, scolding, drinking, smoking, squabbling, fighting, and swearing.* **❞**

Charles Dickens, *Sketches by Boz*

◄ **Fig. 35.1 Anonymous. *Old Hetton Colliery, Newcastle.* ca. 1840.** Beamish, North of England Open Air Museum, Durham, UK. The Bridgeman Art Library. The industrialization of Europe changed the nature of work and with it the nature of society, especially in England. While it created vast wealth for a few, industrialization forced the vast majority of men and women to work in factories where conditions were grim, the workday long, and wages low.

D
URING THE LIFE OF THE GREAT ENGLISH NOVELIST CHARLES

Dickens (1812–1870), London was both the capital of a nation of ever-increasing wealth and international preeminence and a city mired in poverty, crime, and urban blight. In part, Dickens saw London through the lens of a trained reporter. He had

covered endless, unproductive debates in Parliament about social reform that left him impressed only by that august body's inability to act in any meaningful way. But he also viewed the vast city from the perspective of his harsh childhood, details of which were so awful that he kept them secret his entire life. Two days after his twelfth birthday, he went to work in a boot-blacking factory, from 8:00 AM to 8:00 PM, for a wage of 6 shillings a week. (Twenty shillings equaled a British pound—worth approximately $5 at the time—so Dickens earned less than $2 per week.) Shortly afterward, his father was arrested and committed to debtors' prison. The family moved into the prison cell with him, as was common at the time. These events so indelibly marked young Charles that, later in life, he would become one of the English reform movement's most active speakers. As a novelist, he portrayed the lives of children whose suffering mirrored his own. These novels, published in serialized chapters in the London press beginning when Dickens was in his twenties, attracted hundreds of thousands of readers. In depicting the lives of the English lower classes with intense sympathy and great attention to detail, Dickens became a leading creator of a new type of prose fiction, **literary realism**.

Dickens's novels illuminated the enormous inequities of class that existed in nineteenth-century England, with his heroes and heroines, villains and scoundrels, often approaching the point of caricature. While his sentimentalism sometimes verged on the maudlin, Dickens also had an unparalleled ability to vividly describe England. Take, for instance, his description of industrial Birmingham in his 1840 novel *The Old Curiosity Shop*, a scene very much like the one depicted in the anonymous *Old Hetton Colliery, Newcastle* (Fig. **35.1**) painted at about the same time that Dickens wrote these words:

> A long suburb of red brick houses—some with patches of garden-ground, where coal-dust and factory smoke darkened the shrinking leaves, and coarse rank flowers, and where the struggling vegetation sickened and sank under the hot breath of kiln and furnace, making them by its presence seem yet more blighting and unwholesome than in the town itself—a long, flat, straggling suburb passed . . . where not a blade of grass was seen to grow, where not a bud put

forth its promise in the spring, where nothing green could live. . . . On every side, and far as the eye could see into the heavy distance, tall chimneys, crowding on each other, and presenting that endless repetition of the same dull, ugly form, which is the horror of oppressive dreams, poured out their plague of smoke, obscured the light, and made foul the melancholy air. On mounds of ashes by the wayside, sheltered only by a few rough boards, or rotten pent-house roofs, strange engines spun and writhed like tortured creatures; clanking their iron chains, shrieking in their rapid whirl from time to time. . . . Dismantled houses here and there appeared, tottering to the earth, propped up by fragments of others that had fallen down, unroofed, windowless, blackened, desolate, but yet inhabited.

> Men, women, children, wan in their looks and ragged in attire, tended the engines, fed their tributary fire, begged upon the road, or scowled half-naked from the doorless houses. Then came more of the wrathful monsters, whose like they almost seemed to be in their wildness and their untamed air, screeching and turning round and round again; and still, before, behind, and to the right and left, was the same interminable perspective of brick towers, never ceasing in their black vomit, blasting all things living or inanimate, shutting out the face of day, and closing in on all these horrors with a dense dark cloud.

As the number of factories in and around cities such as London exploded over the course of the century (see Map **35.1**), not just the landscape, but the nature of work and with it the nature of human society, changed dramatically. Although industrialization created wealth for a few, it forced the vast majority of men and women into jobs as low-paid laborers. In the southern United States, where work was conducted by slaves, conditions in rural areas were equally horrifying. In England, France, Russia, and the United States, many artists and writers called for social reform. Some depicted the actual conditions of the working class in increasingly realistic works of art and literature; others demanded the reinvention of society itself. The new medium of photography allowed uniquely accurate representations of people, objects, and landscapes. The increasing emphasis on realism in the arts—depicting the world as it actually was rather than idealizing it—was mirrored by the growing popularity of the

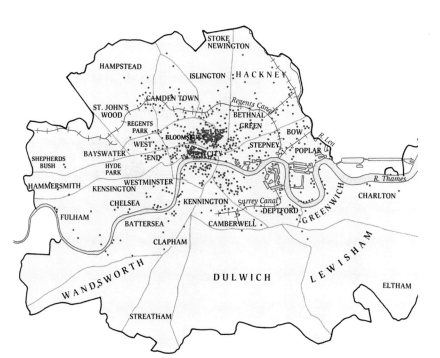

Map 35.1 London in 1898: Factories with over 100 workers.

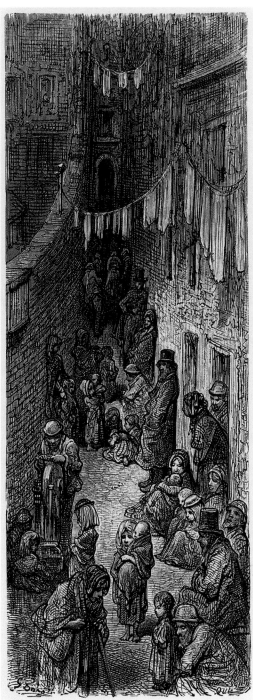

Fig. 35.2 **Gustave Doré.** *Orange Court—Drury Lane.* **1869.** Illustration for Gustave Doré and Blanchard Jerrold. *London: A Pilgrimage,* 1872. Accompanied by policemen from Scotland Yard, Doré went around the city, including the East End and Whitechapel, making sketches on the spot. Though executed some 36 years after Dickens penned *Sketches by Boz,* Doré's drawings capture the poverty that Dickens describes, at the same time proving how enduring poverty was.

scientific methodology to rigorously investigate every facet of human experience and the natural world. In fact, Auguste Comte (1798–1857), an enormously influential French thinker, elevated science to a kind of religion, developing the philosophy of "positivism." According to Comte, society passes through three successive stages in its quest for knowledge of any subject—theological (religious), metaphysical (abstract, philosophical), and positive (scientific). It was only through the application of the scientific method that truth could be obtained about the natural world, technology, or human society. This chapter ends by summarizing the achievements of one of the century's most creative scientists, Charles Darwin. By challenging established theories, Darwin set the stage for viewing nature and the universe as part of a dynamic, ever-changing process.

The Industrial City: Conditions in London

In his earliest published book, writing under the pen name Boz, Dickens describes one of the worst slums in London, on Drury Lane (**Reading 35.1**). A century earlier, it had been a good address, but by the beginning of the 1800s it was dominated by prostitution and gin houses (Fig. **35.2**):

READING 35.1 from Dickens, *Sketches by Boz* (1836)

The filthy and miserable appearance of this part of London can hardly be imagined by those (and there are many such) who have not witnessed it. Wretched houses with broken windows patched with rags and paper; every room let out [rented] to a different family, and sometimes two or even three—fruit and "sweet stuff" manufacturing in the cellars, barners and red-herring vendors in the front parlours, cobblers in the back; a bird fancier in the first floor, three families on the second, starvation in the attics, Irishman in the passage, a "musician'" in the front kitchen, and a char-woman and five hungry children in the back one—filth everywhere—a gutter before the houses and a drain behind—clothes drying, and slops emptying from the windows, girls of fourteen or fifteen, with matted hair, walking about barefoot, and in white great-coats, almost their only covering; boys of all ages, in coats of all sizes and no coats at all; men and women, in every variety of scanty and dirty apparel, lounging, scolding, drinking, smoking, squabbling, fighting, and swearing.

The writing style is pure Dickens. Descriptions pile up in detail after detail, in one long sentence, so that the reader, almost breathless at its conclusion, feels overwhelmed, as the author tries to make the unimaginable real. His aim is not simply to entertain, but to advocate reform. Dickens was hardly alone in criticizing the fruits of "progress" of Western civilization. The plight of the poor, coupled with the indolence of the wealthy, was a matter of great concern for many writers and artists in mid-nineteenth-century England. Thomas Carlyle (1795–1881), the foremost essayist and social critic of the day, put it this way (**Reading 35.2**):

READING 35.2 from Thomas Carlyle, *Past and Present* (1843)

The condition of England . . . is justly regarded as one of the most ominous, and withal one of the strangest, ever seen in this world. England is full of wealth, of multifarious produce, supply for human want in every kind; yet England is dying of inanition [exhaustion, lack of social, moral vigor]. With unabated bounty the land of England blooms and grows; waving with yellow harvests; thick-studded with worskhops, industrial implements, with fifteen millions of workers, understood to be the strongest, the cunningest and the willingest our Earth ever had; these men are here; the work they have done, the fruit they have realised is here, abundant, exuberant on every hand of us: and behold, some baleful fiat as of Enchantment has gone forth, saying, "Touch it not, ye workers, ye master-workers, ye master-idlers; none of you can touch it, no man of you shall be the better for it; this is enchanted fruit!". . . Of these successful skilful workers some two millions, it is now counted, sit in Workhouses, Poor-Law Prisons; or have "out-door relief" flung over the wall to them,—the workhouse Bastille [referring to the infamous Paris prison that triggered the French revolution in 1789] being filled to bursting, and the strong Poor-law broken asunder by a stronger. They sit there, these many months now; their hope of deliverance as yet small. In workhouses, pleasantly so-named, because work cannot be done in them. Twelve-hundred-thousand workers in England alone; their cunning right-hand lamed, shut in by narrow walls. They sit there, pent up, as in a kind of horrid enchantment; glad to be imprisoned and enchanted, that they may not perish starved. . . .

Carlyle argued that while the natural guardians of the poor, the English aristocracy, were out fox hunting and shooting game, poverty was exploding around them. The upper classes and much of the government were blind to the horrors that were everywhere evident if they bothered to look. Those horrors penetrated all aspects of urban living: water, housing, labor, and family life.

Water and Housing

Carlyle and Dickens saw, every day, that the river Thames was little more than an open sewer. A petition of 1827 to the House of Commons advised against its use:

The water taken from the River Thames at Chelsea, for the use of the inhabitants of the western part of the metropolis, [is] being charged with the contents of the great common sewers, the drainings from dunghills, and laystalls [collections of human waste], the refuse of hospitals, slaughter houses, colour, lead and soap works, drug mills and manufactures, and with all sorts of decomposed animal and vegetable substances, rendering the said water offensive and destructive to health, ought no longer to be taken up by any of the water companies from so foul a source.

Among the lethal bacteria that thrived in this water was cholera, and its principal victims were the poor. Where they lived, one in three children died before the age of one. After several devastating cholera epidemics in the 1830s and 1840s, a municipal waterworks was finally established in London in 1855, charged with the construction of "a system of sewerage which should prevent . . . any part of the sewage

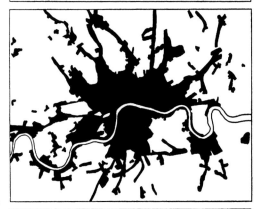

At the end
of the 18th
century.

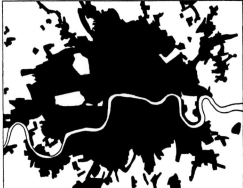

In the 1830s.

In the 1870s.

Map 35.2 The growth of London, 1800–1880. After Roy Porter, *London: A Social History* (New York: Penguin Books, 1994). London's population in 1800 was about 1 million. By 1881, the population had more than quadrupled, growing to 4.5 million, dwarfing the industrial cities to the north. Social services were unable to keep up with this rapid growth.

within the metropolis from passing into the Thames in or near the metropolis." Contributing to London's water pollution problem was the extraordinarily rapid growth of the population (Map **35.2**). As the city's boundaries expanded, high-density neighborhoods grew as well. Because laborers needed to walk to their jobs in urban factories, living in the countryside was no longer possible. As the poor crowded into buildings already stressed by age and disrepair, whole neighborhoods turned into slums. Map 35.1 shows factories employing more than 100 workers in London in 1898, with most of them concentrated in the inner city. Rent for an entire house cost about 7 shillings 6 pence a week, around $2.00, though most working families could afford only to rent a single room in a central London house. The 1841 census found 27 houses in Goodge Place, a poor neighborhood but no slum, occupied by 485 people, many practicing their trade in the same room where they lived!

Labor and Family Life

As a result of industrialization, the British workforce increasingly became **proletariat**—a class of workers who neither owned the means of production (tools and equipment) nor controlled their own work. Trades such as clothing and shoemaking that had flourished in the West End of London, close to the homes of wealthy customers in the eighteenth century, were replaced by factories, producing goods for the proletariat itself. The introduction of machine manufacture into the textile industry, especially, required fewer skilled workers, and more unskilled workers, mostly single young women and widows, who worked for lower wages than men (Fig. **35.3**).

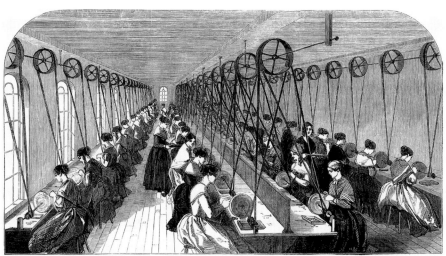

THE PEN GRINDING ROOM.

Fig. 35.3 A pen-grinding factory. ca. 1845. *The Illustrated London News* Picture Library. After 1840, mailing a letter anywhere in England cost just one penny. In just one year, the volume of mail rose from 76 million letters to 168 million. Letter-writers needed pens, and production in factories rose to meet the demand. The labor force in the pen industry was almost entirely female.

Voices

A Recipe for Domestic Harmony

French as well as English family life was profoundly altered during the first quarter of the nineteenth century as a result of transformations in working conditions, new industries, and a growing bourgeois class. Mme. Elizabeth Celnart's widely published manuals on domestic economy (many were translated into English) during the 1820s and 1830s offered detailed instructions to family members on how to behave in public and in private. In the passage below, she offers advice on the proper tone and manner of conversation between husbands and wives.

Care should be taken with the honors of the dinner table not only when you have guests but also for your husband's sake, in order to make life at home more civilized. I use the word "civilized" advisedly, for the mark of civilization is the ability to bestow pleasure and dignity on the satisfaction of all our needs. This must be done because the occupations of social life, especially for men, leave almost no time for family life except mealtimes, and because experience and what we know about prolonging life suggest that this time be devoted to gaiety so as to make digestion easy and unobtrusive. Here, then, is ample reason to enliven your meals with gentle conversation. . . .

> "If at any time the society of your husband or wife should cause you *ennui* [weariness or boredom], you ought neither to say so, nor give any suspicion of the cause by abruptly changing the conversation."

The conversation of a husband and wife cannot be elegant and sustained in the same manner it is in society . . . but it should be free from all impoliteness and indelicacy. If at any time the society of your husband or wife should cause you *ennui* [weariness, boredom, lack of interest], you ought neither to say so, nor give any suspicion of the cause by abruptly changing the conversation. In all discussions you should watch yourself attentively lest domestic familiarity raise itself by degrees to the pitch of a quarrel. It is especially to females that this advice is addressed, since [according to] Scripture "woman was not created for wrath" and [we may add] "she was created for gentleness."

This in turn encouraged prostitution as a way to supplement a woman's meager wage income. In addition, the sexual exploitation of low-paid, uneducated women workers by their male supervisors was commonplace.

Children of poor families often worked as assistants in the factories. The English Factory Act of 1833 banned employment of children under the age of nine. Children 9 to 13 years of age could work a 9-hour day (down from 12 hours), and employers had to provide 2 hours of education to child-workers each day. Not surprisingly, these conditions radically altered family life. Before the nineteenth century, families had often worked together in textile production, usually at home. But as married women were displaced from the workforce and their husbands' wages allowed families to live on a single income, wives became solely responsible for domestic life—child-rearing, food preparation, and housekeeping. Gender-determined roles, which had previously been the rule only among the relatively small middle class and the aristocracy, now characterized the working-class family as well (see *Voices*, above).

Reformists Respond: Utopian Socialism, Medievalism, and Christian Reform

Faced with the reality of working-class life, reformist thinkers and writers across Europe reacted by writing polemical works that are meant to be understood as critiques of industrial society. Chief among its targets are the economic engine of the industrial state—its desire to reap a profit at whatever human cost—and the unbridled materialism that, in turn, seemed to drive industrialism's economic engine. This world seemed life-consuming and soul-destroying, a world in which the pulse of machinery was supplanting the pulse of the human heart.

For many humanist thinkers, London's social conditions were directly tied to economics. Ever since Adam Smith's *Wealth of Nations* (see chapter 31), economists had argued that a nation achieved economic growth by free enterprise and a marketplace unimpeded by governmental regulation. Competition would naturally result in the marketplace governing itself. By the 1820s, however, many began to question the free-market system, especially its low wages, unequal distribution of goods, and hollow materialism. Social critics deplored a system that permitted the factory owners, the "haves," to enjoy leisure and comfort at the expense of the impoverished working class who "had not." They argued that human society could be better organized as a cooperative venture, with each person working for the good of the whole.

Utopian Socialism

Among the critics of free enterprise were those who envisioned ideal communities, where production would be controlled by society as a whole rather than owned by individuals. In France, for instance, Charles Fourier [sharl foo-ree-AY] (1772–1837) argued for the establishment of phalanxes, communities that would liberate individuals to live freely rather than follow the drudgery of industrial life. Phalanxes would be located in the countryside, where no person performed the same kind of work for the entire day, where there was sexual freedom for the young (marriage was to be reserved for later life), and where all residents would be free to pursue pleasure. Scholars have come to call Fourier and those who sought to create such communities *utopian socialists*.

British industrialist Robert Owen (1771–1858), owner of one of the largest British cotton factories, developed a more practical scheme. At his factory at New Lanark, Scotland, he provided his workers with good quarters, recreational opportunities, education for their children, and classes for adults. In 1824, Owen left England for the United States, where he intended to found a series of communities in which factory and farm workers might live and work together. After purchasing the town of New Harmony, Indiana, for $135,000, Owen hired architect Stedman Whitwell to design a city plan, and invited people to apply for the 800 spaces that were available. Although New Harmony attracted hundreds of settlers, most found themselves unable to adapt to life in the community, and most lacked the skills to either farm or otherwise contribute meaningfully to the economy. By 1828, Owen's New Harmony experiment had failed.

A.W. N. Pugin, Architecture, and the Medieval Model

In 1836 (the same year that Dickens published his *Sketches by Boz*), the architect Augustus Welby Northmore Pugin

[PYOO-jin] (1812–1852) published a book called *Contrasts*. Pugin compared medieval and modern buildings, aiming to show the decay of taste over time. He contrasted a contemporary poor house to a medieval one, run with compassion by the Church (Fig. **35.4**). The rag-clad, miserable tenants of the nineteenth-century poorhouse were subjected to a whip-carrying master, a meager diet of bread and gruel, barren cells, and a sense of imminent death. In contrast, medieval tenants had had a beneficent master, a garden setting, and a bountiful supply of mutton, beef, bread, and ale. Such nostalgia for medieval life was rooted in the Romantic taste for Gothic ruins—Turner's view of the *Interior of Tintern Abbey* (Fig. 33.2), for instance, or Friedrich's *Abbey in the Oakwood*. Tales of adventure and love set in medieval times such as Sir Walter Scott's historical novel *Ivanhoe*, which described the late twelfth-century Crusades, also inspired the Romantics.

Yet Pugin found such Romantic medievalism shallow, even vacuous. He saw in medieval architecture not so much a style to be imitated as the expression of a way of life that would help reform nineteenth-century English society. "We do not want to revive a facsimile of the works of style of any particular individual or even period," he wrote—*but it is the devotion, majesty, and repose of Christian art, for which we are contending; it is not a style, but a principle.*" For the Catholic Pugin, the advantage of medieval society was that it was guided by Christian principles. These principles had long since been lost to English society. The problems inherent in industrialization, mechanization, and materialism, he believed, were created by society's lack of the ethical foundations provided by the Church. Pugin believed that architecture served not just a functional purpose, but also a moral one. The building itself embodied a spirit of ethical conduct.

Many found Pugin's ideas attractive, but his most celebrated commission came when architect Sir Charles Barry (1795–1860) asked him to design the interiors and ornamentation for London's new Houses of Parliament. (A fire had destroyed the old buildings in 1834.) To be consistent with Westminster Abbey, which it abutted, the new Parliament needed Gothic ornamentation (Fig. **35.5**). Barry's basic plan is classical—a symmetrical layout meant to suggest the balance of powers inherent in the British system of government. Pugin's ornamentation follows from what he called the "two great rules" of architecture: "first that there should be no features about a building which are not necessary for convenience, construction, or propriety; second, that all ornament should consist of enrichment of the essential structure of the building." Nevertheless, Pugin's scheme for decorative ornament was hardly restrained, as he also believed that legislators surrounded by "glorious" and elaborate ornament would deliberate with "the faith, the zeal, and, above all, the unity, of our ancestors."

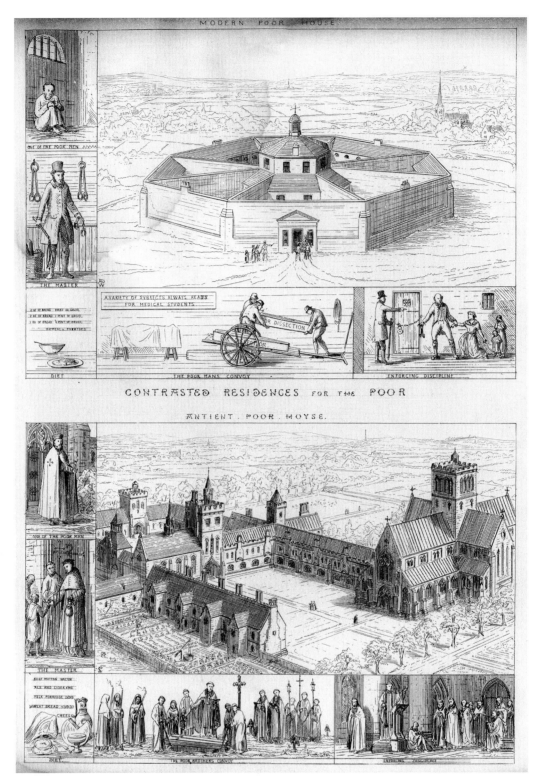

Fig. 35.4 A. W. N. Pugin. *Contrasted Residences for the Poor,* from *Contrasts: or, a Parallel Between the Noble Edifices of the Fourteenth and Fifteenth Centuries, and similar Buildings of the Present Day; showing the Present Decay of Taste: Accompanied by Appropriate Text.* **1836.** Pugin contrasts the harsh treatment of the Poor Law to the charitable good works of the medieval church.

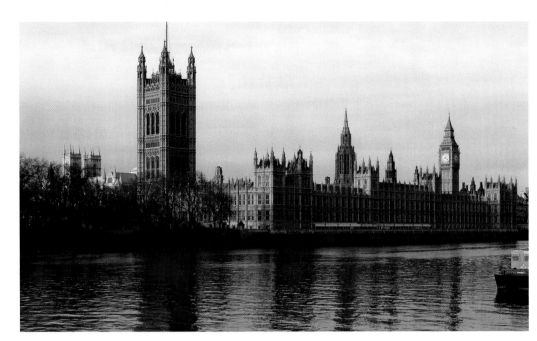

Fig. 35.5 Charles Barry and
A. W. N. Pugin. Houses of
Parliament, London. 1836–1860.
Length 940′. Barry was in charge
of the structural floor plan while
Pugin took care of the decorative
plan. The tower of Westminster
Abbey is at the far left.

Literary Realism

Faced with the reality of working-class life, reformist thinkers and writers across Europe reacted by writing polemical works that criticized industrial society. Chief among their targets were the economic engine of the industrial state—its desire to reap a profit at whatever human cost—and the unbridled materialism that seemed to drive industrialism's economic engine. Industrialized society seemed life-consuming and soul-destroying, a society in which the pulse of machinery was supplanting the pulse of the human heart. Even while essayists like Carlyle argued forcefully for social reforms in the new industrialized economic system, most reformists felt some ambivalence toward the Industrial Revolution. It seemed to promise both hope and despair. Probably nothing embodied this uncertainty more than the steam locomotive. London's first railway began operating in December 1836, with the London & Greenwich running 4 miles southeast from London Bridge. A virtual railroad mania followed as company after company vied to build new and competing lines. For Charles Dickens, writing in *Dombey and Son*, which appeared at the height of the mania between 1846 and 1848, the steam engine offered untold potential even as he imaged it as a kind of monster (**Reading 35.3**):

READING 35.3 **from Dickens, *Dombey and Son* (1846–1848)**

The miserable waste ground, where the refuse matter had been heaped of yore, was swallowed up and gone, and in its frowsy [ill-smelling] stead were tiers of warehouses, crammed with rich goods and costly merchandise. . . . The carcasses of houses, and beginnings of new thoroughfares, had started off upon the line at steam's own speed, and shot away into the country in a monster train. To and from the heart of this great change, all day and night, throbbing currents rushed and returned incessantly like its life's blood. Crowds of people and mountains of goods, departing and arriving scores upon scores of times in every four-and-twenty hours, produced a fermentation in the place that was always in action. The very houses seemed disposed to pack up and take trips. Wonderful Members of Parliament, who, little more than twenty years before, had made themselves merry with the wild railroad theories of engineers . . . [now] went . . . north with their watches in their hands, and sent on messages before by the electric telegraph, to say that they were coming. . . .

Night and day the conquering engines rumbled at their distant work, or, advancing smoothly to their journey's end, and gliding like tame dragons into the allotted corners grooved out to the inch for their reception, stood bubbling and trembling there, making the walls quake, as if they were dilating with the secret knowledge of great powers yet unsuspected in them, and strong purposes not yet achieved.

Even as the coming of the railroad transformed the "waste ground" of the inner city into "warehouses crammed with rich goods" and "costly merchandise," clearing out the "carcasses of houses" to make way for new rails, Dickens knew there was a

price to pay. Its "monstrous" effect was to displace thousands, perhaps as many as 100,000, of the poor from their homes.

"The poor are displaced," *The Times* of London warned in 1861, "but they are not removed. They are shovelled out of one side of the parish, only to render more overcrowded the stifling apartments in another part." In fact, construction of the London and Blackwall Railway caused almost 3,000 homes to be destroyed in 1836 alone, and the railway companies had no obligation to provide alternate housing for any of their residents.

The price of progress is the subject of J. M. W. Turner's 1844 painting *Rain, Steam, and Speed—The Great Western Railway* (Fig. **35.6**). We stare over the river Thames across the Maidenhead Bridge, the Great Western Railway barreling toward us. To the left, a boat floats gently on the river before an arched bridge on the far shore. To the right of the boat, strokes of white paint suggest a group of bathers. To the left lies the pre-industrial world, to the right post-industrial modernity. Rain and fog and machine-made vapor combine with a new factor, the blurring effects of speed, to leave the landscape largely undefined and indefinable. The rational architecture of the bridge and the railway—the very images of progress rendered in a strict two-point, linear perspective—are consumed in a Romantic light that renders the world at once beautiful and murky. "What price progress?" the painting ultimately asks.

Dickens's *Hard Times*

This question dominates the work of the writers whose novels probed the realities of life in the new industrial world. Nothing exasperated Dickens more than the promise of the Industrial Revolution to improve life and its ability to do just the opposite—to make life miserable for so many. None of his novels so openly address this issue as *Hard Times*, which appeared during the spring and summer of 1854 in weekly segments in *Household Words*, a periodical edited by Dickens himself.

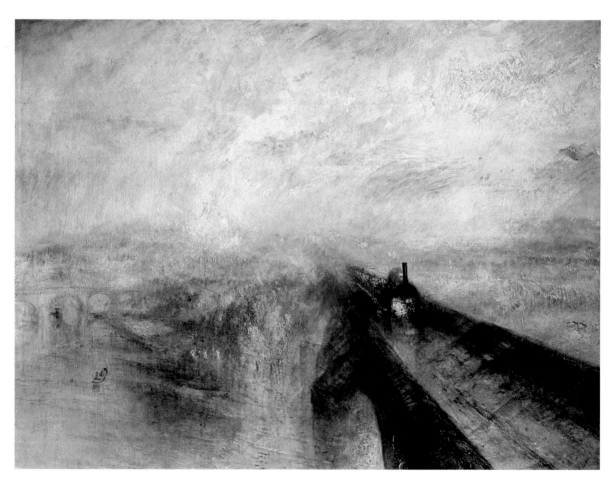

Fig. 35.6 J. M. W. Turner. *Rain, Steam, and Speed—The Great Western Railway*. 1844. Oil on canvas, 33¾″ × 48″. National Gallery, London, Great Britain. Erich Lessing/Art Resource, NY. Although not easily seen in reproduction, a hare races down the tracks in front of the train. A traditional symbol of natural speed, the hare is about to be overcome by the train speeding at 50 miles per hour.

Designed to satirize industrialists known as Utilitarians, who sought to create the greatest good for the greatest number of people, the novel portrayed them as aiming to create wealth for the upper and middle classes at the expense of the majority—the poor working class. Dickens describes Utilitarians as "those who see figures and averages, and nothing else." In *Hard Times*, they are represented by the "eminently practical" Mr. Thomas Gradgrind, who views literature as "destructive nonsense," emotion as "unmanageable thought," and "Fact"—statistics in particular—as the only truth. Dickens resolved to "strike the heaviest blow in my power" for those who worked in the inhuman conditions created by Utilitarian-endorsed industries.

Probably no passage in the novel better summarizes Dickens's beliefs about the social consequences of Utilitarianism than his description of the novel's fictional Coketown, an industrial wasteland that is an amalgam of his observations of all British industrial cities (**Reading 35.4**):

READING 35.4 from Dickens, *Hard Times* (1854)

It was a town of red brick, or of brick that would have been red if the smoke and ashes had allowed it; but as matters stood it was a town of unnatural red and black like the painted face of a savage. It was a town of machinery and tall chimneys, out of which interminable serpents of smoke trailed themselves for ever and ever, and never got uncoiled. It had a black canal in it, and a river that ran purple with ill-smelling dye, and vast piles of buildings full of windows where there was a rattling and a trembling all day long, and where the piston of the steam-engine worked monotonously up and down like the head of an elephant in a state of melancholy madness. It contained several large streets all very like one another, and many small streets still more like one another, inhabited by people equally like one another, who all went in and out at the same hours, with the same sound upon the same pavements, to do the same work, and to whom every day was the same as yesterday and tomorrow, and every year the counterpart of the last and the next.

In this setting, Gradgrind, a retired wholesale hardware dealer, runs a Utilitarian school. His closest friend is Josiah Bounderby, manufacturer, banker, and mill owner, "a man perfectly devoid of sentiment." As is often the case in Dickens's fiction, their lack of feeling is contrasted sharply with that of another character, Sissy, partially educated but also the irrepressible product of her life in the circus, a young woman full of imagination and hope.

Their story is told in three parts, "Sowing," "Reaping," and "Garnering," ironic references to agriculture rather than industry as well as to the biblical verse, "Whatever a man

sows, this he will also reap." Given what Gradgrind and Bounderby have sown in creating Coketown, Dickens must have delighted in manufacturing their demise: Gradgrind abandons his Utilitarian philosophy, which draws the wrath of his fellow members of Parliament whom he so admires, while Bounderby dies in a fit in the street one day, having squandered his fortune. Yet in the end, Dickens never really questions the ultimate wisdom of industrialization. Rather, the novel seems to argue that in the hands of more humane industrialists, who cared about the well-being of their workers, the industrialization of England might be good for everyone.

French Literary Realism

Literary realism was not restricted to England, although elsewhere in Europe writers rarely confronted the effects of the Industrial Revolution as forcefully as Dickens had. As in England, the work of French novels often appeared in serial form, designed to appeal to a growing middle-class audience. However, French authors aimed at creating fully rounded characters and were less inclined to caricature than Dickens was. French realists claimed to examine life scientifically, without bias, and to describe what they saw in a straightforward manner. The writings of Honoré de Balzac and Gustave Flaubert [floh-BAIR] are the foremost examples.

Balzac's *Human Comedy* "I am not deep," the novelist Honoré de Balzac (1799–1850) once said, "but very wide." In 1833, he decided to link together his old novels so that they would reflect the whole of French society. He would come to call this series of books *The Human Comedy*. Balzac's plan eventually resulted in 92 novels, which include more than 2,000 characters. Among the masterpieces are *Eugénie Grandet* [er-ZHEN GRAHN-deh] (1833), *Père Goriot* [pair GOH-ree-oh] (1834), *Father Goriot*, the trilogy *Lost Illusions* (1837–1843), and *Cousin Bette* [koo-ZEHN bet] (1846). The primary setting is

Paris, with its old aristocracy, new wealth, and the rising culture of the **bourgeoisie** (middle-class shopkeepers, merchants, and business people, as distinct from laborers and wage-earners). The novel is populated by characters from all levels of society—servants, workers, clerks, criminals, intellectuals, courtesans, and prostitutes. Certain individuals make appearances in novel after novel, for instance Eugène Rastignac [eh-ZHEN RAH-steen-yak], a central figure in *Father Goriot*, who comes from an impoverished provincial family to Paris to seek his fortune, and Henri de Marsay [ahn-REE deh mar-ZAY], a dandy who appears in 25 of the novels.

Balzac drew his characters from direct observation: "In listening to these people," he wrote of those he encountered in the Paris streets, "I could espouse their lives. I felt their rags on my back. I walked with my feet in their tattered shoes; their desires, their wants—everything passed into my soul." The story goes that he once interrupted one of his friends, who was telling about his sister's illness, by saying, "That's all very well, but let's get back to reality: to whom are we going to marry Eugénie Grandet?"

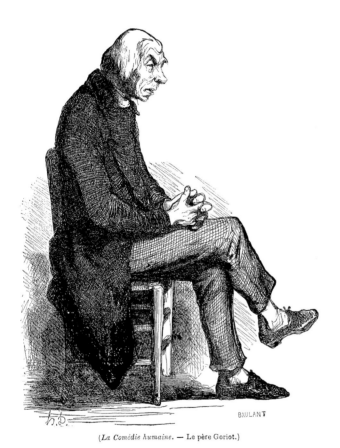

(*La Comédie humaine.* — Le père Goriot.)

Fig. 35.7 Honoré Daumier. *Father Goriot*. 1843. From *Œuvres illustrées de Balzac. La comédie humaine*, Volume 3. Imp. Schneider/ Imp. Simon Raçon et Cie. Paris : MM. Marescq et Cie. et J. Bry aîné. 1851. Daumier captures Père Goriot's isolation and loneliness.

Father Goriot is an adaptation of Shakespeare's play *King Lear*. Rastignac falls in love with Delphine [DEL-feen], one of two daughters of old Goriot (Fig. **35.7**), a father who has sacrificed everything for his children. Both daughters have married into the French aristocracy, but they rely on their father's excessive paternal love to bail them out of the financial crises that constantly confront them through their husbands' profligacy. The novel contrasts the poverty of the boarding house, where both Goriot and Rastignac live, to their daughters' glittering social world, to which Rastignac aspires. Goriot dies penniless, and Rastignac is forced to pay for his funeral. (See **Reading 35.5**, page 1144, for the final scene.) When the funeral is over, Rastignac contemplates the possibilities that Paris offers:

> He went a few paces further, to the highest point of the cemetery, and looked out over Paris and the windings of the Seine; the lamps were beginning to shine on either side of the river. His eyes turned almost eagerly to the space between the column of the Place Vendome [plahss vahn-DOME] and the cupola of the Invalides [en-vah-LEED]; there lay the shining world that he had wished to reach. He glanced over that humming hive, seeming to draw a foretaste of its honey, and said magniloquently:
> "Henceforth there is war between us."

This comment ends the novel and is the very heart of serialization. It is the bone Balzac throws to his audience to create a sense of anticipation of more to come, another novel, and then another and another, in which Rastignac declares that he will take on French society. He will, as it turns out, have many lovers and a gambling problem of his own, before becoming a successful politician.

Flaubert's *Madame Bovary* The novel *Madame Bovary*, written by Gustave Flaubert [floh-BAIR] (1821–1880) at mid-century, is at its core a realist attack on Romantic sensibility. But Flaubert had a strong Romantic streak as well, for which his Parisian friends strongly condemned him. They suggested that he should write a "down-to-earth" novel of ordinary life, and further, that he base it on the true story of Delphine Delamare [del-MAR], the adulterous wife of a country doctor who had died of grief after deceiving and ruining him. Flaubert agreed, and *Madame Bovary*, first published in magazine installments in 1856, is the result.

The realism of the novel is born of Flaubert's struggle not to be Romantic. He would later say, "Madame Bovary—*c'est moi!*" [say- mwah] ("Madame Bovary—that's me!) in testament to his deep understanding of the bourgeois, Romantic sensibility that his novel condemns. Toward the middle of the novel, Emma imagines she is dying. She has been ill for two months, since her lover Rodolphe ended their affair. Now, she romanticizes what she thinks are her last moments, experiencing a rapturous ecstasy of the kind portrayed by Bernini in *The Ecstasy of St. Teresa* (**Reading 35.6**; also see Fig. 25.6):

from Flaubert, *Madame Bovary* (1856)

One day, when at the height of her illness, she had thought herself dying, and had asked for the communion; and, while they were making the preparations in her room for the sacrament, while they were turning the night table covered with syrups into an altar, and while Felicite was strewing dahlia flowers on the floor, Emma felt some power passing over her that freed her from her pains, from all perception, from all feeling. Her body, relieved, no longer thought; another life was beginning; it seemed to her that her being, mounting toward God, would be annihilated in that love like a burning incense that melts into vapour. The bed-clothes were sprinkled with holy water, the priest drew from the holy pyx [small box containing the sacrament] the white wafer . . . The curtains of the alcove floated gently round her like clouds, and the rays of the two tapers burning on the night-table seemed to shine like dazzling halos. Then she let her head fall back, fancying she heard in space the music of seraphic harps, and perceived in an azure sky, on a golden throne in the midst of saints holding green palms, God the Father, resplendent with majesty.

In an 1852 letter describing a dinner conversation between Leon and Emma earlier in the book, Flaubert wrote: "I'm working on a conversation between a young man and a young lady on literature, the sea, the mountains, music—in short, every poetic subject there is. It could be taken seriously and I intend it to be totally absurd." The same could be said of Emma's faint in which her paroxysm of religious experience is as staged as her illness itself. Words and phrases such as "an azure sky, on a golden throne" are examples of what Flaubert called *le mot juste* [leh moh joost], "the right word," exactly the precise usage to capture the essence of each situation, in this case a level of cliché that underscores the dramatic absurdity of Emma's experience. Flaubert felt he was proceeding like the modern scientist, investigating the lives of his characters through careful and systematic observation.

The Russian Realists under Nicholas I

In Russia, realism developed from a different social reality than it had in England and France. The serf system, with its entrenched rural poverty, had not changed since medieval times. After the death of Catherine the Great (1729–1796), Russia was ruled by first her son, Paul, and then by two of her grandsons, Alexander I (r. 1801–1825) and Nicholas I (r. 1825–1855). Alexander suppressed any vestiges of liberalism and reform remaining from the reign of his grandmother, when French *philosophes* were highly influential. Nicholas understood the need for reform, but was afraid of losing the support of the aristocracy. "There is no doubt," he told his State Council in 1842, "that serfdom, in its present form, is a flagrant evil which everyone realizes, yet to attempt to remedy it now would be, of course, an evil more disastrous."

Neoclassical Saint Petersburg By the time Nicholas came to the throne, the nation's capital, Saint Petersburg, was as grand as any city in Europe. Tsar Peter the Great, who ruled Russia from 1682 to 1725, literally pointed Russia toward the West by creating a new capital city at the mouth of the River Neva. The area was a swamp, frozen from November to March, but even a partially open harbor would support Russia's economic development and gave Russia permanent access to the Baltic Sea. Emulating the three-pronged design of the approaches to Versailles (see Fig. 27.4), its three broad avenues crossed a network of canals to meet at a giant parade-ground square in front of the Admiralty (Map **35.3**). Half Venice and half Classical Baroque, the city had grown to a population of 192,000 under the rule of Catherine the Great. Catherine, a German princess, had married the nephew of Tsar Peter the Great's daughter Elizabeth, murdered him when he became tsar, and then proclaimed herself empress. Dedicated to creating a city to rival both Rome and Paris, she declared Neoclassicism the official court style, sensing that it symbolized her own power. "Decency requires that affluence and magnificence should surround the throne," she said in 1769. She sought the advice of both Diderot and Voltaire to expand her art collection to some 3,000 works—installed in the Neoclassical Hermitage Palace in 1796—and was so influenced by the *philosophes* that she made French the official language of her court.

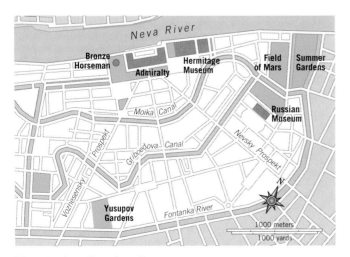

Map 35.3 Saint Petersburg, Russia.

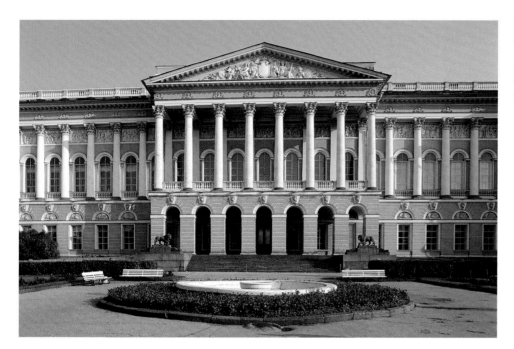

Fig. 35.8 Carlo Rossi. Mikhailovsky Palace, Saint Petersburg, Russia. 1819–1825. The yellow facade punctuated by white columns was designed to impart a sense of classical calmness to the whole.

Saint Petersburg's citizens seemed always to feel that it was an unnatural place. Darkness filled its winter months, but in the summer, for nearly three weeks in June, during the so-called White Nights, the city was bathed in round-the-clock daylight. The regularity, balance, and proportion of its Neoclassical architecture was consciously designed to counter the irregularity of its seasons and light. One of the great examples is the Mikhailovsky

 Continuity & Change p. 1042

La Madeleine

[mi-KILE-uv-skee] Palace (today the Russian Museum), designed by Carlo Rossi, an Italian-born architect who was brought to Russia by his ballerina mother as a young man (Fig. **35.8**). The palace is perfectly symmetrical, its central facade of eight free-standing Corinthian columns bracketed on each side by eight engaged columns. Completed just as Nicholas I assumed the throne, it represents the culmination of the Neoclassical design in Saint Petersburg.

Aleksandr Pushkin Nicholas was particularly frightened of the intellectuals and writers living in his capital, the *intelligentsia*, as they were called. Chief among these was the poet Aleksandr Pushkin (1799–1837). Great-grandson of a black Ethiopian slave, whom Peter the Great had purchased in Constantinople and who rose to prominence in the tsar's court, Pushkin was a great champion of liberal causes. Among his most admired works is *The Bronze Horseman*, a poem written in 1833 commemorating both Peter the Great, whose bronze equestrian statue still stands in Saint Petersburg, and the devastating flood of the Neva that hit the city in November 1824. Pushkin opens the poem rhapsodizing on the beauty of the city (**Reading 35.7**):

READING 35.7 **from Pushkin, *The Bronze Horseman* (1833)**

I love you, Peter's creation, I love your stern
Harmonious look, the Neva's majestic flow,
Her granite banks, the iron tracery
Of your railings, the transparent twilight and
The moonless glitter of your pensive nights . . .
I love the motionless air and frost of your harsh winter,
The sledges coursing along the solid Neva,
Girls' faces brighter than roses, and the sparkle
And noise and sound of voices at the balls,
And, at the hour of the bachelor's feast, the hiss
Of foaming goblets. . . .

The poem goes on to describe the tragic fate of Yevgeni [yiv-GAYN-yee], a young man who goes insane imagining that the bronze horseman is chasing him through the streets of the city after his fiancée dies in the flood. He is the victim of both the great tsar's socially irresponsible and arrogant construction of the city on a floodplain, and the indifference of its nameless inhabitants to his plight. Because of its ambiguous attitude toward the tsar, the poem was banned from publication in Pushkin's lifetime. In its attention to the beauty of the city and its light, the poem is Romantic in tone, but its sense of social responsibility anticipates the new realism that will soon dominate Russian literature. The primary force for realism was Nikolai Gogol (1809–1852).

Nikolai Gogol In 1831, Nikolai Gogol, a young writer from the Ukraine, had the good fortune to meet Aleksandr Pushkin.

They became good friends, and Pushkin suggested ideas that would lead to Gogol's comic masterpiece of 1836, the play *The Inspector General*, and the novel *Dead Souls*, which inaugurated Russian realist fiction in 1842. In the former a young civil servant, Khlestakov, finds himself stranded in a small provincial town where the local officials assume he is a government inspector, visiting incognito. Khlestakov happily adapts to his new role and exploits the situation. The play is a not-so-subtle attack on the graft and corruption of the Russian bureaucracy, but its humor saved it. Even the tsar was said to have laughed at it. Gogol's novel *Dead Souls* is based on the fact that owners of serfs paid a tax on every "soul" registered to them. Chichikov, Gogol's hero-villain, travels through Russia to buy the "souls" of dead serfs, for whom their owners were required to pay taxes until a new census could eliminate them from the tax rolls. Chichikov thus acquires, very cheaply, a list of serfs that he, in turn, mortgages to a bank for a handsome profit. His plan is to buy an estate with his profits and populate it with real serfs. The novel was meant to be comic, but Pushkin found it all too real. On hearing it read aloud, he is said to have cried out at Gogol, "God! What a sad country Russia is!" He said later, "Gogol invents nothing; it is the simple truth, the terrible truth."

Literary Realism in the United States: The Issue of Slavery

It was, in fact, the "terrible truth" of slavery that most haunted American realist writers. They were inspired largely by the abolitionist movement. While the movement had been active in both Europe and America ever since the 1770s (see chapter 30), it didn't gain real momentum in the United States until the establishment of the American Anti-Slavery Society in 1833. The Society organized lecture tours by abolitionists, gathered petitions, and printed and distributed anti-slavery propaganda. By 1840, it had 250,000 members in 2,000 local chapters and was publishing more than 20 journals.

Frederick Douglass When William Lloyd Garrison (1805–1879), head of the Anti-Slavery Society, heard a speech delivered by a 24-year-old former slave in Nantucket in 1841, he was so impressed that he immediately enlisted him as a lecturer. The young man's name was Frederick Douglass (1817–1895) (Fig. **35.9**). He never knew his father, a white man, and was separated from his mother, a slave, while still very young. His account of life under slavery was so compelling that the society helped him publish his autobiography, *Narrative of the Life of Frederick Douglass: An American Slave*, in 1845.

The book moves from Douglass's first clear memory, the whipping of his Aunt Hester, which he describes as his "entrance into the hell of slavery" (see **Reading 35.8**, page 1146), to the book's turning point, when he resolves to stand up and fight his master. "From whence came the spirit I don't know," Douglass writes. "You have seen how a man was made a slave; you shall see how a slave was made a man," he says before summing up the fight's outcome" (**Reading 35.8a**):

This battle with Mr. Covey was the turning point in my career as a slave. It rekindled the few expiring embers of freedom, and revived within me a sense of my own manhood. It . . . inspired me again with a determination to be free. The gratification afforded by the triumph was a full compensation for whatever else might follow, even death itself. . . . I felt as I never felt before. It was a glorious resurrection, from the tomb of slavery, to the heaven of freedom. My long-crushed spirit rose, cowardice departed, bold defiance took its place; and I now resolved that, however long I might remain a slave in form, the day had passed forever when I could be a slave in fact. I did not hesitate to let it be known of me, that the white man who expected to succeed in whipping, must also succeed in killing me.

Douglass guesses at the reason Covey spares him being beaten at the whipping post for raising his hand against a white man: "Mr. Covey enjoyed the most unbounded reputation for being a first-rate overseer and negro-breaker," he

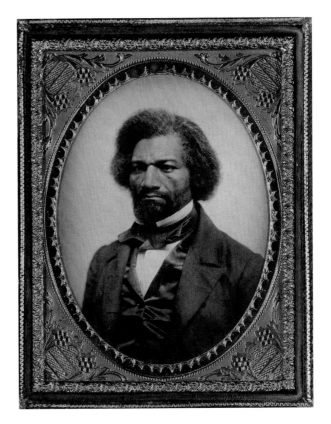

Fig. 35.9 Portrait of Frederick Douglass. 1847. Daguerreotype. National Portrait Gallery, Smithsonian Institution, Washington, D.C. Collection William Rubel. After publishing his *Narrative*, Douglass lectured in England and Ireland for 2 years, fearing recapture under the Fugitive Slave Act.

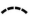

Fig. 35.10 Sojourner Truth Seated with Knitting. 1864. Sophia Smith Collection, Smith College Archives, Northampton, Massachusetts. In 1863, it occurred to Truth to earn money by selling photographs of herself. As she explained, "I'll sell the Shadow to support the Substance."

35.10) was born Isabella Baumfree to slave parents in Ulster County, New York, and was sold four times before she was 30 years old. In 1843, inspired by a spiritual revelation, she changed her name to Sojourner Truth and became a preacher advocating "God's truth and plan for salvation." She often tied her lessons to her own experiences as a slave, and she championed both abolition and the woman's suffrage movement.

Because Olive Gilbert tells Truth's story in the third person, occasionally quoting her subject's much more colloquial speech, it is hard to say just how much of the work is Gilbert's and how much Truth's. This question also surrounds Truth's most famous speech, "Ain't I a Woman?" delivered to a Women's Convention in Akron, Ohio in 1851. Unpublished until 1863, it still offers evidence of the rhetorical persuasiveness of Truth—and her undeniable wit (**Reading 35.9**):

READING 35.9 **from Sojourner Truth, "Ain't I a Woman?" (1851)**

Well, children, where there is so much racket there must be something out of kilter. I think that 'twixt the negroes of the South and the women at the North, all talking about rights, the white men will be in a fix pretty soon. But what's all this here talking about?

That man over there says that women need to be helped into carriages, and lifted over ditches, and to have the best place everywhere. Nobody ever helps me into carriages, or over mud-puddles, or gives me any best place! And ain't I a woman? Look at me! Look at my arm! I have ploughed and planted, and gathered into barns, and no man could head me! And ain't I a woman? I could work as much and eat as much as a man—when I could get it—and bear the lash as well! And ain't I a woman? I have borne thirteen children, and seen most all sold off to slavery, and when I cried out with my mother's grief, none but Jesus heard me! And ain't I a woman? . . .

Obliged to you for hearing me, and now old Sojourner ain't got nothing more to say.

says, ". . . so, to save his reputation, he suffered me to go unpunished." The rest of the book recounts Douglass's escape to New York, and then to New Bedford, Massachusetts, up to the moment that he meets Garrison in Nantucket.

Douglass eventually broke with the Anti-Slavery Society because "its doctrine of 'no union with slaveholders,' carried out, dissolves the Union, and leaves the slaves and their masters to fight their own battles, in their own way. This I hold to be an abandonment of the great idea . . . to free the slave. It ends by leaving the slave to free himself." Douglass argued the issue with Abraham Lincoln in print during the early phases of the Civil War. Initially Lincoln was reluctant to emancipate the slaves, because he feared that emancipation would divide the Union. Lincoln finally agreed with Douglass, whom he welcomed to the White House several times, and issued the Emancipation Proclamation at the end of 1862.

Slave Narratives More than 100 book-length slave narratives were published in the 1850s and 1860s. Besides Douglass's, one of the other most important of these was the *Narrative of Sojourner Truth*, dictated by an illiterate former slave to her friend Olive Gilbert. Sojourner Truth (ca. 1797–1883) (Fig.

Like so many others in the abolitionist movement, Truth saw the cause of women's rights as part of the effort to end slavery. The growing conviction that women—white and black—endured a brand of slavery of their own is one of the most important subtexts of the Civil War.

In fact, the Anti-Slavery Society was a leader in this effort. Sarah Grimke (1792–1873), daughter of a slaveholding judge from Charleston, South Carolina, publicly called for women "to rise from that degradation and bondage to which the faculties of our minds have been prevented from expanding." With help from some in the Society, she published the ground-breaking *Letters on the Equality of the Sexes* in 1838. Other members were not at all pleased by the society's advocacy of women's rights, and when three women

were elected to the executive committee, many withdrew, contending that "To put a woman on the committee with men is contrary to the usages of civilized society."

Harriet Beecher Stowe's *Uncle Tom's Cabin* The daughter of a minister and reformer who spoke out against slavery, Harriet Beecher Stowe (1811–1896) was raised with strong abolitionist convictions. She would write the best-selling anti-slavery novel of the day, *Uncle Tom's Cabin*, becoming the symbol of the abolitionist movement in America. Writing to a woman who admired the book, she connects its themes to the grief she endured after her young son died of cholera in 1849 (**Reading 35.10**):

READING 35.10 **letter from Harriet Beecher Stowe to Eliza Cabot Follen, December 16, 1852**

My Dear Madam,
So you want to know what sort of woman I am! . . . To begin, then, I am a little bit of a woman,—somewhat more than forty, about as thin and dry as a pinch of snuff—never very much to look at in my best days and looking like a used up article now.

I was married when I was twenty-five years old to a man rich in Greek and Hebrew and Latin and Arabic, and alas, rich in nothing else. . . . But then I was abundantly furnished with wealth of another sort. I had two little curly headed twin daughters to begin with and my stock in this line has gradually increased, till I have been the mother of seven children, the most beautiful and the most loved of whom lies buried near by our Cincinnati residence. It was at his dying bed and at his grave that I learned what a poor slave mother may feel when her child is torn away from her. In those depths of sorrow which seemed to me immeasurable, it was my only prayer to God that such anguish might not be suffered in vain. There were circumstances about his death of such peculiar bitterness, of what seemed almost cruel suffering that I felt that I could never be consoled for it unless this crushing of my own heart might enable me to work out some great good to others.

I allude to this here because I have often felt that much that is in that book had its root in the awful scenes and bitter sorrow of that summer. It has left now, I trust, no trace on my mind except a deep compassion for the sorrowful, especially for mothers who are separated from their children. . . .

I suffer exquisitely in writing these things. It may truly be said that I write with my heart's blood. Many times in writing "Uncle Tom's Cabin" I thought my health would fail utterly; but I prayed earnestly that God would help me till I got through, and still I am pressed beyond measure and above strength.

This horror, this nightmare abomination! Can it be in my country! It lies like lead on my heart, it shadows my life with sorrow; the more so that I feel, as for my own brothers, for the South, and am pained by every horror I am obliged to write, as one who is forced by some awful oath to disclose in court some family disgrace. Many times I have thought that I must die, and yet pray God that I may live to see something. . . .
Yours affectionately,
H. B. Stowe

Uncle Tom's Cabin is a narrative concerning the differing fates of three slaves—Tom, Eliza, and George—whose life in slavery begins together in Kentucky. Although Eliza and George are married, they are owned by different masters. In order to live together they escape to free territory with their little boy. Tom meets a different fate. Separated from his wife and children, he is sold by his first owner to a kind master, Augustine St. Clare, and then to the evil Simon Legree, who eventually kills him. Serialized in 1851 in the abolitionist newspaper *The National Era*, and published the year after, the book sold 300,000 copies in the first year after its publication. Stowe's depiction of the plight of slaves like Tom roused anti-slavery sentiment worldwide and it eventually became the best-selling novel of the nineteenth century. Only the Bible could compete, although it could be argued that Stowe's book was equally pious. The scene of Little Eva reading from the Bible to Tom (Fig. **35.11**) as Stowe sets it up in chapter 22 of the novel is deeply romanticized (**Reading 35.11**):

READING 35.11 **from Harriet Beecher Stowe, *Uncle Tom's Cabin* (1852)**

It is now one of those intensely golden sunsets which kindles the whole horizon into one blaze of glory, and makes the water another sky. The lake lay in rosy or golden streaks, save where white-winged vessels glided hither and thither, like so many spirits, and little golden stars twinkled through the glow, and looked down at themselves as they trembled in the water. . . .

At first, she read to please her humble friend; but soon her own earnest nature threw out its tendrils, and wound itself around the majestic book; and Eva loved it, because it woke in her strange yearnings, and strong, dim emotions, such as impassioned, imaginative children love to feel.

This passage points to a central mission of the abolitionist movement. Abolitionists felt the duty to enlighten the darkened souls of slaves by asserting Christian beliefs. Notice how light is used as a metaphor in the passage. But the condescension apparent to the modern reader—both Tom and Eva are

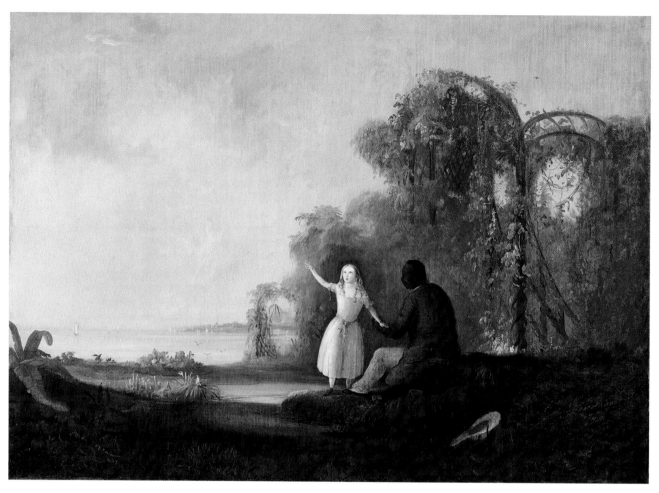

Fig. 35.11 Robert S. Duncanson. *Uncle Tom and Little Eva.* **1853.** Oil on canvas, 27 $\frac{1}{4}$″ × 38 $\frac{1}{4}$″. The Detroit Institute of Arts, USA. The Bridgeman Art Library. MI. Duncanson was the first African American artist to receive international fame.

depicted as children—together with Tom's sentimental attachment to both Eva and her pious Christianity—would eventually make the term "Uncle Tom" a derogatory label referring to anyone who is servile or deferential to white people.

Mark Twain's *Adventures of Huckleberry Finn* A patronizing tone dominates representations of African Americans by whites in the nineteenth and twentieth centuries, and it informs *Adventures of Huckleberry Finn*, arguably one of the greatest American novels. Published in 1885 by Samuel L. Clemens (1835–1910), whose pen name was Mark Twain, the novel tells the story of a young boy, Huck Finn, and Jim, an escaped slave, as they make their way by raft down the Mississippi River from Hannibal, Missouri. They intend to turn north at the juncture of the Ohio River so that Jim might reach freedom in Cincinnati. (Ohio was a slave-free state.) Set in the years just before the Civil War, the book is vigorously opposed to slavery, and portrays those who supported it in a uniformly unflattering light, designed precisely to expose them. When, for instance,

Huck and Jim are anticipating arriving at Cairo, where the Ohio meets the Mississippi, Huck is anguished by his role in helping Jim escape (**Reading 35.12**):

READING 35.12 **from Mark Twain,** *Huckleberry Finn* **(1885)**

Jim said it made him all over trembly and feverish to be so close to freedom. Well, I can tell you it made me all over trembly and feverish, too, to hear him, because I begun to get it through my head that he was most free—and who was to blame for it? Why, me. I couldn't get that out of my conscience, no how nor no way. It got to troubling me so I couldn't rest; I couldn't stay still in one place. It hadn't ever come home to me before, what this thing was that I was doing. But now it did; and it stayed with me, and

scorched me more and more. I tried to make out to myself that I warn't to blame, because I didn't run Jim off from his rightful owner; but it warn't no use, conscience up and says, every time, "But you knowed he was running for his freedom, and you could a paddled ashore and told somebody." That was so—I couldn't get around that noway. That was where it pinched. Conscience says to me, "What had poor Miss Watson done to you that you could see her nigger go off right under your eyes and never say one single word? What did that poor old woman do to you that you could treat her so mean? Why, she tried to learn you your book, she tried to learn you your manners, she tried to be good to you every way she knowed how. That's what she done." I got to feeling so mean and so miserable I most wished I was dead. I fidgeted up and down the raft, abusing myself to myself, and Jim was fidgeting up and down past me. We neither of us could keep still. Every time he danced around and says, "Dah's Cairo!" it went through me like a shot, and I thought if it was Cairo I reckoned I would die of miserableness.

storms, and we a-floating along, talking and singing and laughing. But somehow I couldn't seem to strike no places to harden me against him, but only the other kind. I'd see him standing my watch on top of his'n, 'stead of calling me, so I could go on sleeping; and see him how glad he was when I come back out of the fog. . . . and how good he always was; and at last I [remember] I saved him by telling the men we had small-pox aboard, and he was so grateful, and said I was the best friend old Jim ever had in the world, and the *only* one he's got now; and then I happened to look around and see that paper [the note informing his owner of his whereabouts].

It was a close place. I took it up, and held it in my hand. I was a-trembling, because I'd got to decide, forever, betwixt two things, and I knowed it. I studied a minute, sort of holding my breath, and then says to myself:

"All right, then, I'll *go* to hell"—and tore it up.

It was awful thoughts and awful words, but they was said. And I let them stay said; and never thought no more about reforming.

Huck is torn between the tenets of his upbringing, in which, of course, slaves were the legal property of their owner, and his affection for Jim as a human being. In helping Jim, he believes he is stealing from Miss Watson, one of the two sisters who have adopted him.

Twain put words into the mouths of his characters that are realistic for the time but offensive today. Thus, when Aunt Sally asks if anyone was hurt in a steamboat accident, Huck replies, "No'm. Killed a nigger." Twain fully intends the word to signify racist dehumanization of African Americans by whites, but Huck is speaking exactly as a young boy raised in the slaveholding South would. Part of Twain's great achievement is to allow his readers the chance to see the specter of racism rise up in otherwise basically good people, and along with Huck discover that presence in themselves. The triumph of *Huckleberry Finn*, then, lies in the fact that the reader joins Huck in coming to understand and appreciate Jim's humanity. Huck's realization occurs as he contemplates redeeming himself, becoming "washed clean of sin" by informing Miss Watson of his whereabouts, seeking the posted reward, and therefore returning "property" to its rightful owner (**Reading 35.13**):

READING 35.13 **from Mark Twain,**
Huckleberry Finn (1885)

. . . And Got to thinking over our trip down the river; and I see Jim before me all the time: in the day and in the night-time, sometimes moonlight, sometimes

Thus Mark Twain, in a fictional setting, follows the path set by Thoreau in *Civil Disobedience* a quarter century earlier, forcefully rejecting the conventional morality of society that saw slaves as legal property. Rather than conforming to the law, Huck followed the dictates of his conscience, thinking "no more about reforming" and vowing to steal Jim out of slavery again if necessary because "as long as I was in, and in for good, I might as well go the whole hog."

The New French Realism in Painting

Perhaps the most down-to-earth, if not exactly realistic, description of nineteenth-century Paris came from Mark Twain, who was also America's master humorist. Ever the contrarian, Twain's satirical broadside in 1880 offers an unaffectionate remembrance of the "City of Light": ". . . anywhere is better than Paris. Paris the cold, Paris the drizzly, Paris the rainy, Paris the damnable. More than a hundred years ago somebody asked Quin, 'Did you ever see such a winter in all your life before?' 'Yes,' said he, 'Last summer.' I judge he spent his summer in Paris. Let us change the proverb; Let us say all bad Americans go to Paris when they die. No, let us not say it for this adds a new horror to Immortality" (from Clemens's letter to Lucius Fairchild, April 28, 1880, reprinted in *Mark Twain, The Letter Writer*).

However, events more dramatic than Paris's miserable weather inspired French Realist painting. We've seen such realist works as Géricault's *Raft of the "Medusa"* (see Fig. 34.15) and Delacroix's *Massacres at Chios* (see Fig. 34.16), but

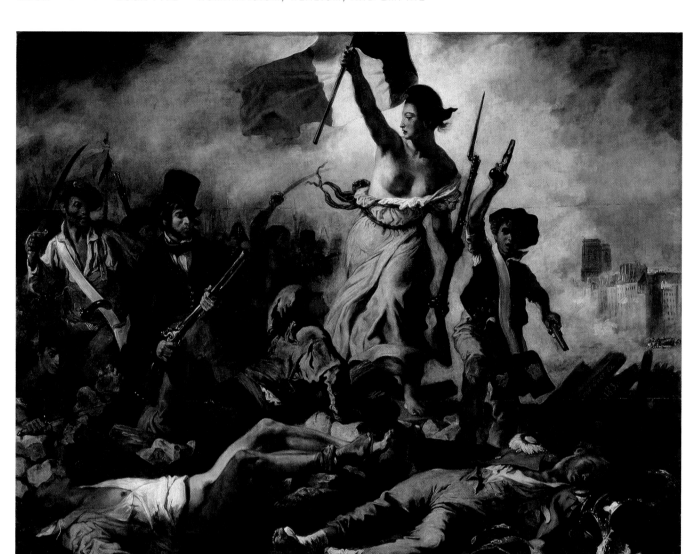

Fig. 35.12 Eugène Delacroix. *Liberty Leading the People.* 1830. Oil on canvas, 8′ 6″ × 10′ 7″. Photo: Hervè Lewandowski. Musée du Louvre/RMN Réunion des Musées Nationaux, France. SCALA/Art Resource, NY. Note one of the towers of Notre Dame Cathedral in the right background of the painting, which contributes to the realism of the image.

realism in art gained new prominence after the summer of 1830. Three years earlier, after liberals won a majority in the Chamber of Deputies, King Charles X responded by relaxing censorship of the press and government control of education. But these concessions irked him, and in the spring of 1830 he called for new elections. The liberals won a large majority, but Charles was not to be thwarted. On July 25, he dissolved the new Chamber, reinstituted censorship of the press, and restricted the right to vote to the wealthiest French men. The next day, rioting erupted as workers took to the streets, erected barricades, and confronted royalist troops. In the following days, 1,800 people died. Soon after, Charles abdicated the throne and left France for England. In his place, the Chamber of Deputies named the duke of Orléans, Louis-Philippe [loo-

EE-fee-LEEP], king of their new constitutional monarchy. The two-century-old Bourbon dynasty had fallen.

In the end, the French workers may have overthrown the Bourbon dynasty, but their new king, Louis-Philippe, was hardly an improvement. He instructed the workers that if they displayed sufficient energy, they need not fear being poor, but he did nothing concrete to help them. As early as 1831, he ordered troops to suppress a worker's revolt in Lyons, and a year later he ordered the army to do the same in Paris, where they killed or wounded more than 800 workers. And in 1834, he crushed a silkworkers' strike, again in Lyons.

Eugène Delacroix's version of the events of July 1830, *Liberty Leading the People* (Fig. **35.12**) is an allegorical repre-

sentation with realistic details, an emotional call to political action. A bare-breasted Lady Liberty, symbolic of freedom's nurturing power, strides over a barricade, the tricolor flag of the revolution in hand, accompanied by a young street ruffian waving a pair of pistols. On the other side is a middle-class gentleman in his top hat and frock coat, a self-portrait of Delacroix, and beside him a man wielding a sabre. A worker, dressed in the colors of the revolution, rises from below the barricade. The whole triangular structure of the composition rises from the bodies of two French royalist guards, both stripped of their shoes and one of his clothing by the rioting workers. These figures purposefully recall the dead at the base of both Gros's *Napoleon at Eylau* (see Fig. 33.16) and Géricault's *Raft of the "Medusa"* (see Fig. 34.15).

To the middle-class liberals who had fomented the 1830 revolution, the painting was frighteningly realistic. The new king, Louis-Philippe, ordered that it be purchased by the state, and then promptly put it away so that its celebration of the commoners would not prove too inspiring. In fact, the painting was not seen in public again until 1848, when Louis-Philippe was himself deposed by yet another revolution, this one ending the monarchy in France forever.

Caricature and Illustration: Honoré Daumier

Despite strict censorship, the press quickly made king Louis-Philippe an object of ridicule. Honoré Daumier [DOH-mee-ay] (1808–1879), an artist known for his political satire, regularly submitted cartoon drawings to daily and weekly newspapers. The development of the new medium of **lithography** (see *Materials and Techniques*, page 1135), made Daumier's regular appearance in newspapers possible. He could literally create a drawing and publish it the same day. In a cartoon that appeared in the weekly paper, *La Caricature*, Daumier depicted the king—recognizable due to his pear-shaped head—as Gargantua (Fig. **35.13**), the sixteenth-century character created by the French writer Rabelais, who had a giant body and an equally gigantic appetite (see chapter 21). The drawing shows the king gorging himself with taxes that are carried up a ramp to his waiting mouth. The poor offer up their last coins to the corrupt king while an impoverished woman at the far right tries to breast-feed her baby. As the king digests the taxes, he evacuates a series of laws and regulations.

Louis-Philippe was not amused. Daumier, his publisher, and their printer were charged with inciting contempt and hatred of the French government and with insulting the king. Daumier was sentenced to six months in jail and fined 100 francs, but he continued to publish political cartoons. His *Rue Transnonain* [roo trahns-noh-NAN] is not a caricature but direct reportage of the killings committed by government troops during an insurrection by Parisian workers in April 1834 (Fig. **35.14**). After a sniper's bullet killed one of their officers, the police claimed it had come from 12 rue

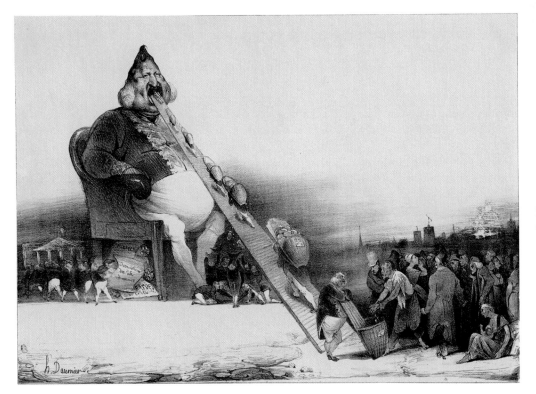

Fig. 35.13 Honoré Daumier. *Gargantua.* **1831.** Lithograph, $10\frac{3}{8}'' \times 12''$. Fine Arts Museums of San Francisco, Museum purchase, Herman Michels Collection, Vera Michels Bequest Fund, 1993.48.1. Daumier produced over 4,000 lithographs for Paris newspapers and journals over the course of his career, often publishing as many as three images a week.

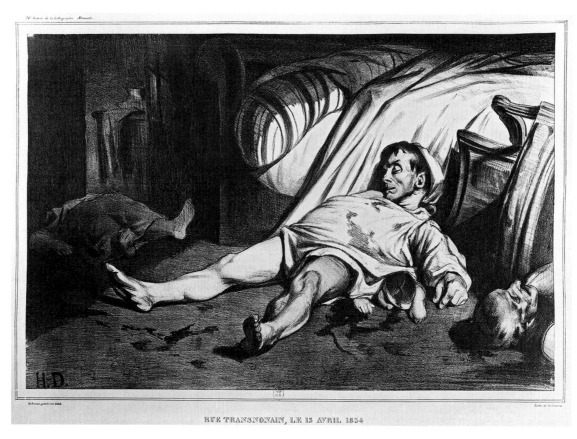

Fig. 35.14 Honoré Daumier. *Rue Transnonain, April 15, 1834*. 1834. Lithograph, $11\frac{1}{2}$" × $17\frac{5}{8}$". Inv. A 1970-67. Kupferstichkabinett, Staatliche Kunstsammlungen, Dresden, Germany Erich Lessing / Art Resource, NY. A few days after the police killed the residents of 12 Rue Transnonain, Daumier exhibited this image in the window of a Paris store, drawing huge crowds.

Continuity & Change
p. 1104

The Raft of
The "Medusa"

Transnonain and they killed everyone inside. Daumier's illustration shows the father of the family, who had been sleeping, lying dead by his bed, his child crushed beneath him, his dead wife to his right and an elder parent to his left. The strong diagonal of the scene draws us into its space, a working-class recasting of Géricault's *Raft of the "Medusa"* (see Fig. 34.15). The impact of such images on the French public was substantial, as the king clearly understood. Louis-Philippe eventually declared that freedom of the press extended to verbal but not pictorial representation.

Realist Painting: The Worker as Subject

In his focus on ordinary life, Daumier openly lampooned the idealism of both Neoclassical and Romantic art. No longer was the object of art to reveal some "higher" truth. What mattered instead was the truth of everyday experience. In his paintings, such as *The Third-Class Carriage* (Fig. **35.15**), Daumier clearly demonstrates his interest in the daily lives of working people. The painting conveys a sense of unity and continuity with the men gathered in the back-ground apparently engaged in conversation, while a young mother breast-feeds her child, her own mother beside her, a basket (presumably of food) on her lap, and her young son asleep beside his grandmother.

The subject of Daumier's painting is typical of French realist painting as a whole. By focusing on laborers and common country folk rather than on the Parisian aristocracy and bourgeoisie, the painting is implicitly political. It reflects the social upheaval that in 1848 rocked almost all of Europe (see chapter 36).

One of the most successful painters of the working class was Rosa Bonheur [BUN-ur] (1822–1899). A student of zoology, she made detailed studies of animals in the Paris slaughterhouses and dressed in men's suits because women's clothing interfered with her work. After she won a medal at the 1848 Salon, the French government commissioned Bonheur to paint *Plowing in the Nivernais: The Dressing of the Vines* (Fig. **35.16**).

It was not only this new subject matter that was transforming the idea of what was beautiful in art. It was the new and rapid methods artists used as well—Daumier with his crayon in lithography, for instance, and Jean-François Millet [mee-YAY] (1814–1875) with his brush. In *The Sower*, Millet's broad brushstrokes of dark paint mirror the physical exhaustion of the peasant in the fields, working until

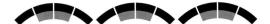

Materials & Techniques Lithography

Lithography, which literally means "stone writing," is a printing process that depends on the fact that oil and water do not mix. The process was discovered accidentally by a young German playwright named Alois Senefelder [AH-lo-us zay-nuh-FEL-dur]. Senefelder published his plays by writing them backward on a copper plate and then etching the text. But seeking a less expensive material, he chose a piece of Kelheim [KEL-hime] limestone, the material used to line the Munich streets and abundantly available. One day his laundry woman arrived to pick up his clothes and, with no paper or ink on the premises, he jotted down what she had taken in wax on the prepared limestone. It dawned on him to bathe the stone with nitric acid and water, and when he did so, he found that the acid had etched the stone and left his writing raised in relief above its surface. Here, at last, was an extraordinarily cheap—and quick—reproductive process.

Recognizing the commercial potential of his invention, by 1798 he had discovered that if he drew directly on the stone with a greasy crayon and then treated the entire stone with nitric acid, water, and gum arabic (a very tough substance obtained from the acacia tree that attracts and holds water), then ink, applied with a roller, would stick only to the greasy drawing. He also discovered that the acid and gum arabic solution did not actually *etch* the limestone. As a result, the same stone could be used again and again. So it would be possible to pull multiple prints from one stone.

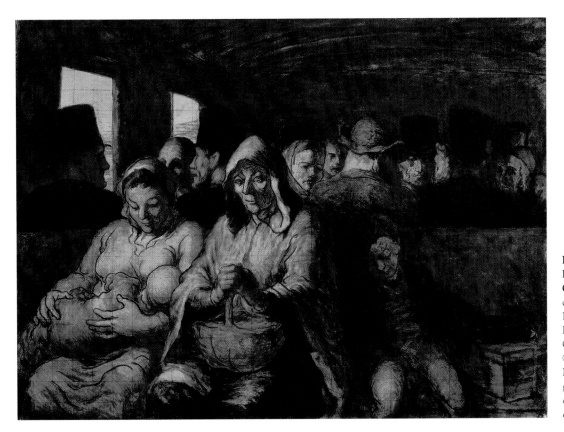

scraper paper inked stone moving bed

In the lithographic process, the prepared stone is rolled with ink that sticks only to the crayon image. Then a layer of damp paper is placed over the stone and both are pressed together with a scraper, later replaced by a press. This transfers the image from the stone to the paper, thereby creating the lithograph. Lithography became an important commercial reproduction process and a popular artists' medium. The French artists Daumier, Géricault, and Delacroix dominated the early history of lithography.

Fig. 35.15 Honoré Daumier. *The Third-Class Carriage.* **ca. 1862.** Oil on canvas, $25\frac{3}{4}'' \times 35\frac{1}{2}''$. Bequest of Mrs. H. O. Havemeyer, 1929. The Ho. O. Havemeyer Collection. © 1922 The Metropolitan Museum of Art, NY. Without glass windows, third-class carriages were open to smoke, cinders, and the cold.

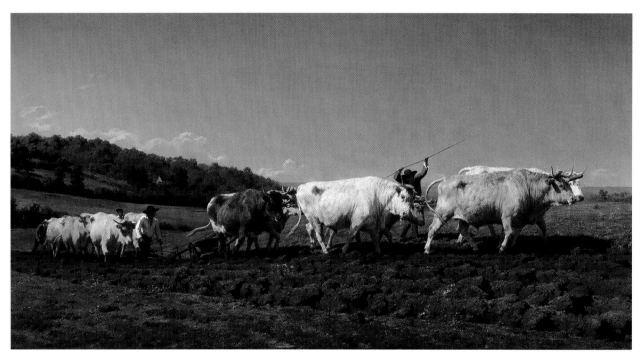

Fig. 35.16 Rosa Bonheur. *Plowing in the Nivernais: The Dressing of the Vines.* **1849.** Oil on canvas, 5′ 9″ × 8′ 8″. Musée d'Orsay, Paris, Gerard Blot/Reunion des Musées Nationaux. Art Resource, NY. Perhaps the most revolutionary feature of Bonheur's painting, given its humble subject, is its very large size.

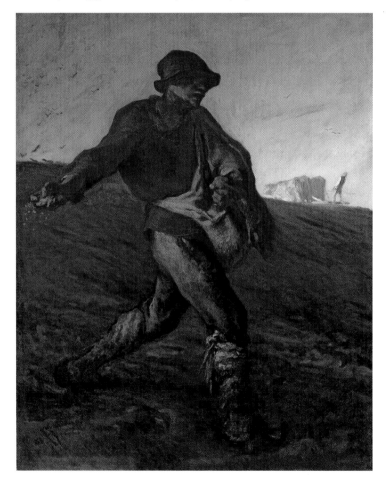

daylight is completely gone (Fig. **35.17**). On the horizon, a yoke of oxen till the field, bathed in the light of the setting sun. Following the tiller, the sower, cast in shadow, seems to emerge out of the very soil he sows, almost literally a "man of the earth." Birds flock behind the sower, eating his seed, allowing us a glimpse into the hard and futile work of the rural poor. When they were first exhibited, Millet's paintings were interpreted as political statements, in part because of the massive scale of his figures, which fill most of the picture frame. Objectionable to many aristocratic and bourgeois viewers was his apparent desire to romanticize his rural subjects. In *The Sower* and in Millet's most famous painting, *The Gleaners* (1857), he renders them in such heroic terms that they seem to rise to the level of poetry.

Fig. 35.17 Jean-François Millet. *The Sower.* **1850.** Oil on canvas, 40″ × 32 ¹/₂″. Museum of Fine Arts, Boston. Gift of Quincy Adams Shaw through Quincy A. Shaw, Jr., and Mrs. Marian Shaw Haughton, 17.1485. Photograph © 2008 Museum of Fine Arts, Boston. Millet painted in the village of Barbizon, south of Paris. An artists' colony there was known for its nostalgic view of the simplicity and innocence of rural life. Millet was far less sentimental.

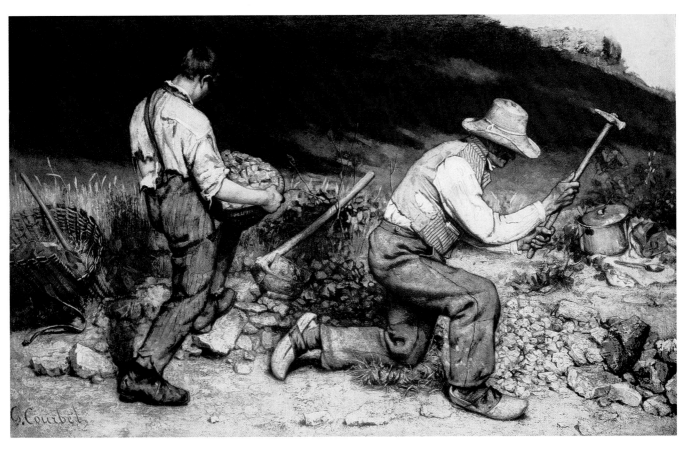

Fig. 35.18 Gustave Courbet. *The Stonebreakers*. 1849. (Salon of 1850–1851). Oil on canvas, 5′ 3″ × 8′ 6″.
(Destroyed in 1945), Galerie Neue Meister, Dresden, Germany, © Staatliche Kunstsammlungen Dresden. The Bridgeman
Art Library. The painting is believed to have been destroyed during the American fire-bombing of Dresden in World War II.

Gustave Courbet: Against Idealism

The leading realist painter of the era was undoubtedly
Gustave Courbet (1819–1877). A farmer's son and self-
taught artist, Courbet's goal was to paint the world just as
he saw it, without any taint of Romanticism or idealism.
"To know in order to be able to create," Courbet wrote in
his Realist Manifesto of 1855, "that was my idea. To be in
a position to translate the customs, the ideas, the appear-
ance of my epoch, according to my own estimation; to be
not only a painter, but a man as well; in short, to create
living art—this is my goal." In fact, he rejected the tradi-
tional political and moral dimensions of realism in favor of
a more subjective and apolitical approach to art. This new
brand of realism would dominate the art of the following
generations.

But when the public first saw his work at the Salon of
1850–1851, they were astonished by the monumental scale of
his paintings. Such a grand size was usually reserved for paint-
ings of historical events, but Courbet's subjects were the

mundane and the everyday. Both *The Stonebreakers* (Fig.
35.18) and *A Burial at Ornans* (see *Focus*, pages 1138–1139)
are enormous paintings, all the figures in each life-size. In *The
Stonebreakers*, Courbet depicts two workers outside his native
Ornans, a town at the foot of the Jura Mountains near the
Swiss border. They are pounding stones to make gravel for a
road. Everything in the painting seems to be pulled down by
the weight of physical labor—the strap pulling down across
the boy's back, the basket of stones resting on his knee, the
hammer in the older man's hand descending downward, the
stiff, thick cloth of his trousers pressing against his thigh,
even the shadows of the hillside behind them descending
toward them. Only a small patch of sky peeks from behind
the rocky ridge in the upper right-hand corner, the ridge itself
following the same downward path as the hammer. Together,
the older man and his younger assistant seem to suggest the
unending nature of their work, as if their backbreaking work
has afflicted generation after generation of Courbet's rural
contemporaries—"a complete expression of human misery,"
as Courbet explained it.

Focus

Courbet's *A Burial at Ornans*

Perhaps Courbet's most daring effort to address ordinary life without expressing sentimentalism of any kind is a nearly 22-foot-wide painting of 1849–1850, *A Burial at Ornans*. Critics disliked Courbet's monumental treatment of a common country burial. The scene depicts the actual residents of Courbet's hometown in northeastern France, at the funeral of a local farmer, the painter's great uncle, Claude-Etienne Teste. Such a vast canvas was traditionally reserved for depicting historical events, considered the highest form of painting. By using a broad horizontal composition, with rows of 52 life-size mourners arranged without a hierarchy of importance, Courbet presents the scene in a matter-of-fact way. The crucifixion rises above the scene with no more authority than another spectator. No eye meets any other. In fact, like the dog who turns to look at something outside the frame, the entire work is a study in collective distraction. Even as the town gathers together in ritual mourning, each individual seems alone. Just as there is no single focal point in the painting, the community as a whole lacks focus. It is as if all unifying feelings, all shared beliefs, have been lost. As Courbet explained, his new realism was "the negation of the ideal . . . [and] *A Burial at Ornans* was in reality the burial of Romanticism."

A portrait of Courbet's beloved Grandfather Oudot, who had died in August 1848, just a month before the burial of his great-uncle, is represented here.

These are the same cliffs of Ornans which form the background for Courbet's *Stonebreakers*.

The funeral procession of pallbearers, choirboys, and priests on the left side of the painting is headed by two beadles (lay church officers), one a vine-grower and the other a shoemaker. Dressed in red, they add a comic air to the scene, and their flushed faces suggest that they have recently been sampling the vintner's wine.

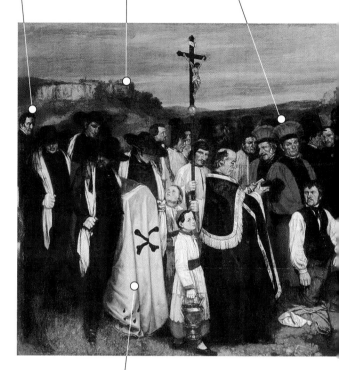

Courbet's black-and-white color scheme was meant, at least in part, to evoke the realist medium of photography. The shroud over the coffin, with its black crossbones and tears, is an imaginative transformation of the usual coffin shroud design of black with gold or white crossbones and tears.

Gustave Courbet. *A Burial at Ornans*, 1849–1850 (Salon of 1850–1851). Oil on canvas, 10′ 3 1/2″ × 21′ 9″. Hervè Lewandowski/Musée d'Orsay, Paris, France. RMN Réunion des Musées Nationaux/Art Resource, NY.

Courbet's father stands at almost the center of the painting in a tall, silk hat.

Courbet's three sisters contrast with the older women in white bonnets behind them. His sister Zoë, in the middle, covers her face with a handkerchief.

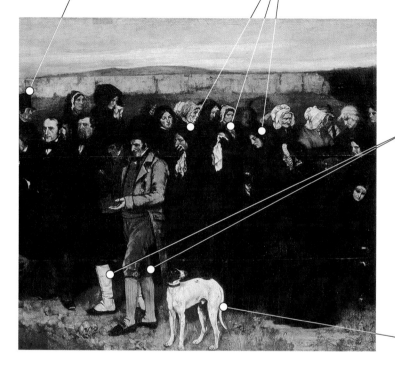

To the right of the open grave stand two older men. One wears white spatterdashes, typically used by soldiers, farmers, and others who were regularly exposed to rain and mud to prevent water from getting into walking boots. The old-fashioned culotte (knee-breeches), long coat, and blue gaiters (knee-socks) of the second figure identify him as a survivor of the French Revolutionary era.

The contrast here between the white dog and the black mourning dresses of the funeral attendees underscores the dominant contrast between black and white in the painting, as well as its other tensions—between the green gaiters of the veteran and the red robes of the beadles, between the sky at the top of the painting and the hard reality of the earth at its bottom, between the idea of transcendence implied by the crucifix rising above the horizon and the matter-of-factness of burial imaged in the open grave.

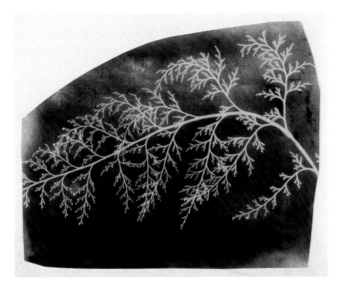

Fig. 35.19 William Henry Fox Talbot. _Wrack._ 1839. Photogenic drawing (salted paper print), $8\frac{11}{16}'' \times 8\frac{7}{8}''$. Harris Brisbane Dick Fund, 1936 (36.37.20). Image copyright © The Metropolitan Museum of Art / Art Resource, NY. Fox Talbot discovered that by placing an image, such as that of the wrack (or seaweed) shown here, on sensitized paper and exposing both to sunlight, a latent image was etched onto the paper and could be brought out by dipping the paper in gallic acid. This calotype process is the basis of modern photography.

Photography: Realism's Pencil of Light

It is no coincidence that the invention of photography coincides with the rise of realism in the arts. The scientific principles required for photography had been known in Europe since at least 1727 when Johann Heinrich Schulze (1684–1744), a German physician, showed that certain chemicals, especially silver halides, turn dark when exposed to light. And the optical principle employed in the camera is essentially the same as that used in the _camera obscura_, which Leonardo da Vinci described and Johannes Vermeer used in his paintings (see Fig. 26.7). While the _camera obscura_ could capture an image, it could not preserve it. But in 1839, inventors in England and France discovered a means to fix the image. It was as if the world could now be drawn by a pencil made of light itself.

In England, William Henry Fox Talbot presented a process for fixing negative images on paper coated with light-sensitive chemicals, which he called **photogenic drawing** (Fig. 35.19). In France, a different process, which yielded a positive image on a polished metal plate, was named the **daguerreotype** [duh-GAIR-oh-type], after one of its inventors, Louis-Jacques-Mandé Daguerre [dah-GAIR] (1789–1851). Wildly enthusiastic public reaction followed, and the French and English presses reported each advance in great detail.

When the French painter Paul Delaroche [deh-lah-ROSH] saw his first daguerreotype, he exclaimed, "From now on, painting is dead!" Delaroche overreacted, but he understood the potential of photography to seize painting's historical role of representing the world. Photographic portraiture quickly became a successful business, with daguerreotype images of individuals costing 15 francs in Paris. This new medium made personalized pictures available not only to the wealthy but to the middle and working classes. By 1849, a decade after the process was discovered, 100,000 daguerreotype portraits were sold in Paris each year.

At the time Daguerre first announced his discovery, imprinting an image on a metal plate took 8 to 10 minutes in bright summer light. His photo of _Le Boulevard du Temple_ was exposed for so long that none of the people or traffic moving in the street left any impression, except for one solitary figure at the lower left who is having his shoes shined (Fig. **35.20**). By 1841, the discovery of so-called chemical "accelerators" had made it possible to expose the plate for only 1 minute, but a sitter, such as Daguerre himself (Fig. **35.21**), could not move for fear of blurring the image. The process remained cumbersome, requiring considerable time to prepare, expose, and develop the plate. Iodine was vaporized on a copper sheet to create light-sensitive silver iodide, and the picture developed by suspending it face down in heated mercury, The unexposed silver iodide was dissolved with salt and the plate was then carefully rinsed and dried.

The daguerrotype process resulted in a single, unreproducible image, but the invention of lithography had demonstrated that there was a market for mass-produced prints. Fox Talbot, whose photogenic drawings utilized paper instead of a metal plate, led the way to making multiple prints of an image. Talbot also discovered that sensitized paper, exposed for even a few seconds, held a latent image that could be brought out and developed by dipping the paper in gallic acid. This **calotype** [KAL-uh-type] process is the basis of modern photography. In 1843, Talbot's picture, which he called _The Open Door_ (Fig. 35.22), made it apparent that calotypes could become works of art in their own right. The power of the image rests in the contrast between light and dark, the visible and the unseen. Talbot published the image in _The Pencil of Nature_ (1844–1845), the first book fully illustrated by photographs. It was accompanied by the following caption: "A painter's eye will often be arrested where ordinary people see nothing remarkable. A casual gleam of sunshine, or a shadow thrown across his path, a time-withered oak, or a moss-covered stone may awaken a train of thought and feelings. . . ." Thus, for Talbot, photography was a realist medium that might evoke Romantic sentiment. But the medium's ability to document current events quickly overshadowed its more artistic possibilities in the public mind.

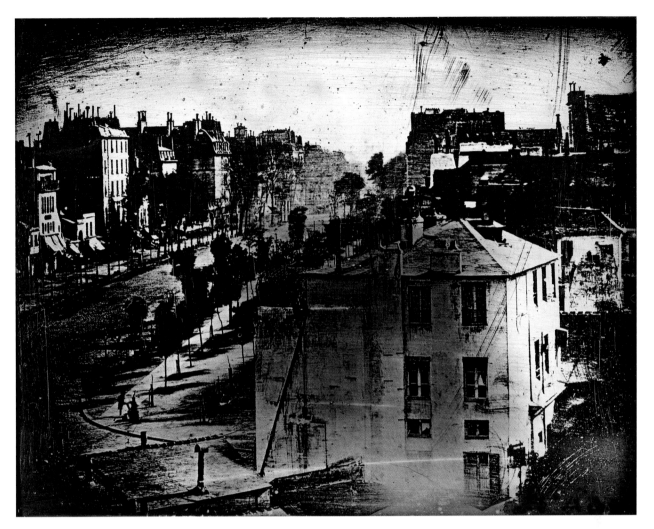

Fig. 35.20 Louis-Jacques-Mandé Daguerre. *Le Boulevard du Temple.*
1839. Daguerrotype. Bayerisches National Museum, Munich. Daguerre was
a painter who made his living producing panoramic dioramas, room-size
backlit paintings that appeared to change from daylight to dusk as the
illumination behind them decreased. Daguerre composed these large
painted scenes with a camera obscura, a tedious process requiring hours of
tracing. His interest in photography stemmed from his desire to speed up his
painting process. This daguerrotype was taken from the roof of the building
that housed his diorama attraction.

Fig. 35.21 Charles Richard Meade. Portrait *Louis-Jacques-*
Mandé Daguerre. **1848.** Daguerreotype, hand-colored half-
plate, 8′ 11/16″ × 7′. The J. Paul Getty Museum, Los Angeles.
84.XT.953. Unaware that Daguerre very much disliked
having his own portrait made, Charles Richard Meade
traveled to France in 1848 to make a photograph that
would show American audiences what Daguerre looked
like. Meade visited Daguerre at his country home, where he
finally succeeded in making five portraits of the inventor.

Fig. 35.22 William Henry Fox Talbot. *The Open Door.* **1843.** Salted paper print from a calotype negative 5⅝″ × 7⅝″. Museum of Modern Art, NY. Gilman Paper Company Collection (L.1995.2.7). Talbot's experiments with photography were sparked by the fact that he drew poorly and yet he wanted to record his impressions of landscape.

Charles Darwin: The Science of Objective Observation

The emphasis on direct observation and the objective reporting of real conditions that is so evident in realist literature and painting is reflected as well in the science of the nineteenth century, especially in the work of Charles Darwin (1809–1882). In December 1831, the 22-year-old Darwin, grandson of Josiah Wedgwood and Erasmus Darwin, founding members of the Lunar Society (see chapter 28), set sail on the HMS *Beagle* (Fig. **35.23**), to serve as naturalist on the ship's survey of South America. On his 5-year journey he kept a daily diary, the basis for his *Journal of Researches into the Geology and Natural History of the Various Countries Visited by H. M. S. Beagle* (1839), commonly known as *The Voyage of the Beagle*. There he recorded his detailed observations of the geology, flora, and fauna of the region, from the rainforests of Brazil, "undefaced by the hand of man," to the barren landscape of Tierra del Fuego, and finally, the volcanic islands of Galapagos, just below the equator off the South American coast. Darwin was astonished at what he found there (**Reading 35.14**):

READING 35.14 from Darwin, *Voyage of the Beagle* (1839)

The natural history of these islands is eminently curious, and well deserves attention. Most of the organic productions are aboriginal creations, found nowhere else; there is even a difference between the inhabitants of the different islands; yet all show a marked relationship with those of America, though separated from that continent by an open space of ocean, between 500 and 600 miles. . . . The archipelago is a little world within itself, or rather a satellite attached to America, whence it has derived a few stray colonists. . . . Considering the small size of the islands, we feel the more astonished at the number of their aboriginal beings, and at their confined range. . . .

The circumstance, that several of the islands possess their own species of the tortoise, mocking-thrush, finches, and numerous plants, these species having the same general habits, occupying analogous situations, and obviously filling the same place in the natural

Fig. 35.23 Conrad Martens. *The Beagle Laid Ashore for Repairs,* **from Charles Darwin,** *Journal of Researches into the Geology and Natural History of the Various Countries Visited by H. M. S. Beagle,* **Henry Colburn Publishers, London, 1839.** The artist Conrad Martens sailed for South America from England in May 1833. When his ship docked at Rio de Janeiro, he heard that the *Beagle,* refitting at Montevideo, needed an artist. Martens was hired and served as the artist on board the *Beagle* until July 1834.

economy of this archipelago, that strikes me with wonder. . . . Reviewing the facts here given, one is astonished at the amount of creative force, if such an expression may be used, displayed on these small, barren, and rocky islands; and still more so, at its diverse yet analogous action on points so near each other. I have said that the Galapagos Archipelago might be called a satellite attached to America, but it should rather be called a group of satellites, physically similar, organically distinct, yet intimately related to each other, and all related in a marked, though much lesser degree, to the great American continent.

Twenty years later, Darwin would publish his analysis of the vast amount of data he had collected. In *The Origin of the Species by Means of Natural Selection, or the Preservation of the Favored Races in the Struggle for Life* (1859), he concluded that similar flora and fauna, in similar habitats, but isolated from each other, developed in a relatively brief period of time—geologically speaking—into distinct species. Darwin was on the way to understanding the "mystery of mysteries," the origin of life itself.

In the *Origin of Species,* Darwin argued that through the process of natural selection, certain organisms are able to increase rapidly over time by retaining traits conducive to their survival and eliminating those that are less favorable to survival. A given species' ability to *adapt to its environment,* then, is fundamental to its survival. A species' ability to repel predators—including environmental challenges such as drought or flood—enhances its chances for procreation and determines its "fitness" to survive. And, in the end, only the "fittest" survive, an idea that, misunderstood and misapplied, would have an enormous impact on social theory later in the century.

Darwin's theory met with instant resistance. In its picture of nature as a theater of competition and struggle, a process of local adaptation with no intrinsic drive toward a higher state or greater good, propelled not by some higher force but by sexual instinct, the theory was profoundly alienating, especially to Christians. Yet by 1862, when Darwin published a paper on the fertilization of orchids by insects and hummingbirds, he had convinced many that his theories were correct. Today, the science of molecular genetics—the study of the information stored in our DNA—provides biological confirmation of Darwin's theories, although no one has as yet fully explained the origins of life itself.

READINGS

READING 35.5

from Balzac, *Father Goriot* (1834)

Balzac published his first successful piece of fiction in 1829 at the age of 30, and for the next 20 years, he led an astonishingly active life. Writing and editing a number of journals, along with some 92 novels, he often worked for as many as 18 hours at a stretch, beginning at midnight and lasting until the late afternoon. Perhaps his greatest talent lies in his ability to link the material and psychological worlds of his characters so that readers feel, as he describes the furnishings of a room, or clothing, that they are delving into the soul of a real individual. But above all, it is his understanding of the passions and desires of every level of French society that makes The Human Comedy *such an extraordinary achievement. Excerpted below is part of the last chapter of* Father Goriot, *as Rastignac buries the penniless Goriot, the father of the woman whom he loves.*

They laid Father Goriot upon his wretched bed with reverent hands. Thenceforward there was no expression on his face, only the painful traces of the struggle between life and death that was going on in the machine; for that kind of cerebral consciousness that distinguishes between pleasure and pain in a human being was extinguished; it was only a question of time—and the mechanism itself would be destroyed.

"He will lie like this for several hours, and die so quietly at last, that we shall not know when he goes; there will be no 10 rattle in the throat. The brain must be completely suffused."

As he spoke there was a footstep on the staircase, and a young woman hastened up, panting for breath.

"She has come too late," said Rastignac.

But it was not Delphine; it was Therese, her waiting-woman, who stood in the doorway.

"Monsieur Eugene," she said, "monsieur and madame have had a terrible scene about some money that Madame (poor thing!) wanted for her father. She fainted, and the doctor came, and she had to be bled, calling out all the 20 while, 'My father is dying; I want to see papa!' It was heart-breaking to hear her—"

"That will do, Therese. If she came now, it would be trouble throwaway. M. Goriot cannot recognize any one now."

"Poor, dear gentleman, is he as bad at that?" said Therese.

"You don't want me now, I must go and look after my dinner; it is half-past four," remarked Sylvie. The next instant she all but collided with Mme. de Restaud on the landing outside.

There was something awful and appalling in the sudden apparition of the Countess. She saw the bed of death by the 30 dim light of the single candle, and her tears flowed at the sight of her father's passive features, from which the life had almost ebbed. Bianchon with thoughtful tact left the room.

"I could not escape soon enough," she said to Rastignac.

The student bowed sadly in reply. Mme. de Restaud took her father's hand and kissed it.

"Forgive me, father! You used to say that my voice would call you back from the grave; ah! come back for one moment to bless your penitent daughter. Do you hear me? Oh! this is fearful! No one on earth will ever bless me henceforth; every 40 one hates me; no one loves me but you in the entire world. My own children will hate me. Take me with you, father; I will love you, I will take care of you. He does not hear me . . . I am mad . . ."

She fell on her knees, and gazed wildly at the human wreck before her.

"My cup of misery is full," she said, turning her eyes upon Eugene. "M. de Trailles has fled, leaving enormous debts behind him, and I have found out that he was deceiving me. My husband will never forgive me, and I have left my fortune 50 in his hands. I have lost all my illusions. Alas! I have forsaken the one heart that loved me (she pointed to her father as she spoke), and for whom? I have held his kindness cheap, and slighted his affection; many and many a time I have given him pain, ungrateful wretch that I am!"

"He knew it," said Rastignac.

Just then Goriot's eyelids unclosed; it was only a muscular contraction, but the Countess' sudden start of reviving hope was no less dreadful than the dying eyes.

"Is it possible that he can hear me?" cried the Countess. 60 "No," she answered herself, and sat down beside the bed. As Mme. de Restaud seemed to wish to sit by her father, Eugene went down to take a little food. The boarders were already assembled.

"Well," remarked the painter, as he joined them, "it seems that there is to be a death-orama upstairs."

"Charles, I think you might find something less painful to joke about," said Eugene.

"So we may not laugh here?" returned the painter. "What harm does it do? Bianchon said that the old man was quite 70 insensible."

"Well, then," said the employee from the Museum, "he will die as he has lived."

"My father is dead!" shrieked the Countess.

The terrible cry brought Sylvie, Rastignac, and Bianchon; Mme. de Restaud had fainted away. When she recovered they carried her downstairs, and put her into the cab that stood waiting at the door. Eugene sent Therese with her, and bade the maid take the Countess to Mme. de Nucingen.

Bianchon came down to them.

"Yes, he is dead," he said.

"Come, sit down to dinner, gentlemen," said Mme. Vauquer, "or the soup will be cold."

The two students sat down together.

"What is the next thing to be done?" Eugene asked of Bianchon.

"I have closed his eyes and composed his limbs," said Bianchon. "When the certificate has been officially registered at the Mayor's office, we will sew him in his winding sheet and bury him somewhere. What do you think we ought to do?"

"He will not smell at his bread like this any more," said the painter, mimicking the old man's little trick.

"Oh, hang it all!" cried the tutor, "let Father Goriot drop, and let us have something else for a change. He is a standing dish, and we have had him with every sauce this hour or more. It is one of the privileges of the good city of Paris that anybody may be born, or live, or die there without attracting any attention whatsoever. Let us profit by the advantages of civilization. There are fifty or sixty deaths every day; if you have a mind to do it, you can sit down at anytime and wail over whole hecatombs of dead in Paris. Father Goriot has gone off the hooks, has he? So much the better for him. If you venerate his memory, keep it to yourselves, and let the rest of us feed in peace."

"Oh, to be sure," said the widow, "it is all the better for him that he is dead. It looks as though he had had trouble enough, poor soul, while he was alive."

And this was all the funeral oration delivered over him who had been for Eugene the type and embodiment of Fatherhood.

The fifteen lodgers began to talk as usual. When Bianchon and Eugene had satisfied their hunger, the rattle of spoons and forks, the boisterous conversation, the expressions on the faces that bespoke various degrees of want of feeling, gluttony, or indifference, everything about them made them shiver with loathing. They went out to find a priest to watch that night with the dead. It was necessary to measure their last pious cares by the scanty sum of money that remained. Before nine o'clock that evening the body was laid out on the bare sacking of the bedstead in the desolate room; a lighted candle stood on either side, and the priest watched at the foot. Rastignac made inquiries of this latter as to the expenses of the funeral, and wrote to the Baron de Nucingen and the Comte de Restaud, entreating both gentlemen to authorize their man of business to defray the charges of laying their father-in-law in the grave. He sent Christophe with the letters; then he went to bed, tired out, and slept.

Next day Bianchon and Rastignac were obliged to take the certificate to the registrar themselves, and by twelve o'clock the formalities were completed. Two hours went by, no word came from the Count nor from the Baron; nobody appeared to act for them, and Rastignac had already been obliged to pay the priest. Sylvie asked ten francs for sewing the old man in his winding-sheet and making him ready for the grave, and Eugene and Bianchon calculated that they had scarcely sufficient to pay for the funeral, if nothing was forthcoming from the dead man's family. So it was the medical student who laid him in a pauper's coffin, despatched from Bianchon's hospital, whence he obtained it at a cheaper rate.

"Let us play those wretches a trick," said he. "Go to the cemetery, buy a grave for five years at Pere-Lachaise, and arrange with the Church and the undertaker to have a third-class funeral. If the daughters and their husbands decline to repay you, you can carve this on the headstone—'Here lies M. Goriot, father of the Comtesse de Restaud and the Baronne de Nucingen, interred at the expense of two students.'"

Eugene took part of his friend's advice, but only after he had gone in person first to M. and Mme. de Nucingen, and then to M. and Mme. de Restaud—a fruitless errand. He went no further than the doorstep in either house. The servants had received strict orders to admit no one.

"Monsieur and Madame can see no visitors. They have just lost their father, and are in deep grief over their loss."

Eugene's Parisian experience told him that it was idle to press the point. Something clutched strangely at his heart when he saw that it was impossible to reach Delphine.

"Sell some of your ornaments," he wrote hastily in the porter's room, "so that your father may be decently laid in his last resting-place."

He sealed the note, and begged the porter to give it to Therese for her mistress; but the man took it to the Baron de Nucingen, who flung the note into the fire. Eugene, having finished his errands, returned to the lodging-house about three o'clock. In spite of himself, tears came into his eyes. The coffin, in its scanty covering of blackcloth, was standing there on the pavement before the gate, on two chairs. A withered sprig of hyssop was soaking in the holy water bowl of silver-plated copper; there was not a soul in the street, no passer-by had stopped to sprinkle the coffin; there was not even an attempt at a black drapery over the wicket. It was a pauper who lay there; no one made a pretence of mourning for him; he had neither friends nor kindred—there was no one to follow him to the grave.

Bianchon's duties compelled him to be at the hospital, but he had left a few lines for Eugene, telling his friend about the arrangements he had made for the burial service. The house student's note told Rastignac that a mass was beyond their means, that the ordinary office for the dead was cheaper, and must suffice, and that he had sent word to the undertaker by Christophe. Eugene had scarcely finished reading Bianchon's scrawl, when he looked up and saw the little circular gold locket that contained the hair of Goriot's two daughters in Mme. Vauquer's hands.

"How dared you take it?" he asked.

"Good Lord! is that to be buried along with him?" retorted Sylvie. "It is gold."

"Of course it shall!" Eugene answered indignantly; "he shall at any rate take one thing that may represent his daughters into the grave with him."

When the hearse came, Eugene had the coffin carried into 190 the house again, unscrewed the lid, and reverently laid on the old man's breast the token that recalled the days when Delphine and Anastasie were innocent little maidens, before they began "to think for themselves," as he had moaned out in his agony.

Rastignac and Christophe and the two undertaker's men were the only followers of the funeral. The Church of Saint-Etienne du Mont was only a little distance from the Rue Nueve-Sainte-Genevieve. When the coffin had been deposited in a low, dark, little chapel, the law student looked 200 round in vain for Goriot's two daughters or their husbands. Christophe was his only fellow-mourner; Christophe, who appeared to think it was his duty to attend the funeral of the man who had put him in the way of such handsome tips. As they waited there in the chapel for the two priests, the chorister, and the beadle, Rastignac grasped Christophe's hand. He could not utter a word just then.

"Yes, Monsieur Eugene," said Christophe, "he was a good and worthy man, who never said one word louder than another; he never did any one any harm, and gave nobody 210 any trouble."

The two priests, the chorister, and the beadle came, and said and did as much as could be expected for seventy francs in an age when religion cannot afford to say prayers for nothing. The ecclesiastics chanted a psalm, the *Libera nos* and the *Deprofundis*. The whole service lasted about twenty minutes. There was but one mourning coach, which the priest and chorister agreed to share with Eugene and Christophe.

"There is no one else to follow us," remarked the priest, "so we may as well go quickly, and so save time; it is half-past five." 220

But just as the coffin was put in the hearse, two empty carriages, with the armorial bearings of the Comte de Restaud and the Baron de Nucingen, arrived and followed in the procession to Pere-Lachaise. At six o'clock Goriot's coffin was lowered into the grave, his daughters' servants standing round the while. The ecclesiastic recited the short prayer that the students could afford to pay for, and then both priest and lackeys disappeared at once. The two grave diggers flung in several spadefuls of earth, and then stopped and asked Rastignac for their fee. Eugene felt in vain in his pocket, and was 230 obliged to borrow five francs of Christophe. This thing, so trifling in itself, gave Rastignac a terrible pang of distress. It was growing dusk, the damp twilight fretted his nerves; he gazed down into the grave and the tears he shed were drawn from him by the sacred emotion, a single-hearted sorrow. When such tears fall on earth, their radiance reaches heaven. And with that tear that fell on Father Goriot's grave, Eugene Rastignac's youth ended. He folded his arms and gazed at the clouded sky; and Christophe, after a glance at him, turned and went—Rastignac was left alone. 240

He went a few paces further, to the highest point of the cemetery, and looked out over Paris and the windings of the Seine; the lamps were beginning to shine on either side of the river. His eyes turned almost eagerly to the space between the column of the Place Vendome and the cupola of the Invalides; there lay the shining world that he had wished to reach. He glanced over that humming hive, seeming to draw a foretaste of its honey, and said magniloquently:

"Henceforth there is war between us."

And by way of throwing down the glove to Society, Rasti- 250 gnac went to dine with Mme. de Nucingen. ■

Reading Question

The central concern of these last pages of the novel is not so much Father Goriot's death as it is money. What does Balzac mean us to understand?

READING 35.8

from the *Narrative of the Life of Frederick Douglass: An American Slave,* Chapter 1 (1845)

There are over 6,000 narratives recounting the pre–Civil War experience of slaves, many of them interviews and essays, and nearly 100 of them book-length works. Frederick Douglass's Narrative of the Life of Frederick Douglass, An American Slave, *is generally considered the greatest of these. In Chapter 1, Douglass recounts his witnessing, as a young boy, of the beating of his Aunt Hester by Mr. Plummer, the overseer of a small plantation in Maryland. The story inaugurates the first half of the book, what he refers to as his descent into "the hell of slavery."*

Chapter 1

was born in Tuckahoe, near Hillsborough, and about twelve miles from Easton, in Talbot county, Maryland. I have no accurate knowledge of my age, never having seen any authentic record containing it. By far the larger part of the slaves know as little of their ages as horses know of theirs, and it is the wish of most masters within my knowledge to

keep their slaves thus ignorant. I do not remember to have ever met a slave who could tell of his birthday. They seldom come nearer to it than planting-time, harvest-time, cherry-time, spring-time, or fall-time. A want of information concerning my own was a source of unhappiness to me even during childhood. The white children could tell their ages. I could not tell why I ought to be deprived of the same privilege. I was not allowed to make any inquiries of my master concerning it. He deemed all such inquiries on the part of a slave improper and impertinent, and evidence of a restless spirit. The nearest estimate I can give makes me now between twenty-seven and twenty-eight years of age. I come to this, from hearing my master say, some time during 1835, I was about seventeen years old.

My mother was named Harriet Bailey. She was the daughter of Isaac and Betsey Bailey, both colored, and quite dark. My mother was of a darker complexion than either my grandmother or grandfather.

My father was a white man. He was admitted to be such by all I ever heard speak of my parentage. The opinion was also whispered that my master was my father; but of the correctness of this opinion, I know nothing; the means of knowing was withheld from me. My mother and I were separated when I was but an infant—before I knew her as my mother. It is a common custom, in the part of Maryland from which I ran away, to part children from their mothers at a very early age. Frequently, before the child has reached its twelfth month, its mother is taken from it, and hired out on some farm a considerable distance off, and the child is placed under the care of an old woman, too old for field labor. For what this separation is done, I do not know, unless it be to hinder the development of the child's affection toward its mother, and to blunt and destroy the natural affection of the mother for the child. This is the inevitable result.

I never saw my mother, to know her as such, more than four or five times in my life; and each of these times was very short in duration, and at night. She was hired by a Mr. Stewart, who lived about twelve miles from my home. She made her journeys to see me in the night, travelling the whole distance on foot, after the performance of her day's work. She was a field hand, and a whipping is the penalty of not being in the field at sunrise, unless a slave has special permission from his or her master to the contrary—a permission which they seldom get, and one that gives to him that gives it the proud name of being a kind master. I do not recollect of ever seeing my mother by the light of day. She was with me in the night. She would lie down with me, and get me to sleep, but long before I waked she was gone. Very little communication ever took place between us. Death soon ended what little we could have while she lived, and with it her hardships and suffering. She died when I was about seven years old, on one of my master's farms, near Lee's Mill. I was not allowed to be present during her illness, at her death, or burial. She was gone long before I knew any thing about it. Never having enjoyed, to any considerable extent, her soothing presence, her tender and watchful care, I received the tidings of her death with much the same emotions I should have probably felt at the death of a stranger.

Called thus suddenly away, she left me without the slightest intimation of who my father was. The whisper that my master was my father, may or may not be true; and, true or false, it is of but little consequence to my purpose whilst the fact remains, in all its glaring odiousness, that slaveholders have ordained, and by law established, that the children of slave women shall in all cases follow the condition of their mothers; and this is done too obviously to administer to their own lusts, and make a gratification of their wicked desires profitable as well as pleasurable; for by this cunning arrangement, the slaveholder, in cases not a few, sustains to his slaves the double relation of master and father.

I know of such cases; and it is worthy of remark that such slaves invariably suffer greater hardships, and have more to contend with, than others. They are, in the first place, a constant offence to their mistress. She is ever disposed to find fault with them; they can seldom do any thing to please her; she is never better pleased than when she sees them under the lash, especially when she suspects her husband of showing to his mulatto children favors which he withholds from his black slaves. The master is frequently compelled to sell this class of his slaves, out of deference to the feelings of his white wife; and, cruel as the deed may strike any one to be, for a man to sell his own children to human flesh-mongers, it is often the dictate of humanity for him to do so; for, unless he does this, he must not only whip them himself, but must stand by and see one white son tie up his brother, of but few shades darker complexion than himself, and ply the gory lash to his naked back; and if he lisp one word of disapproval, it is set down to his parental partiality, and only makes a bad matter worse, both for himself and the slave whom he would protect and defend.

Every year brings with it multitudes of this class of slaves. It was doubtless in consequence of a knowledge of this fact, that one great statesman of the south predicted the downfall of slavery by the inevitable laws of population. Whether this prophecy is ever fulfilled or not, it is nevertheless plain that a very different-looking class of people are springing up at the south, and are now held in slavery, from those originally brought to this country from Africa; and if their increase do no other good, it will do away the force of the argument, that God cursed Ham, and therefore American slavery is right. If the lineal descendants of Ham are alone to be scripturally enslaved, it is certain that slavery at the south must soon become unscriptural; for thousands are ushered into the world, annually, who, like myself, owe their existence to white fathers, and those fathers most frequently their own masters.

I have had two masters. My first master's name was Anthony. I do not remember his first name. He was generally called Captain Anthony—a title which, I presume, he acquired by sailing a craft on the Chesapeake Bay. He was not considered a rich slaveholder. He owned two or three farms, and about thirty slaves. His farms and slaves were under the care of an overseer. The overseer's name was Plummer. Mr.

Plummer was a miserable drunkard, a profane swearer, and a savage monster. He always went armed with a cowskin and a heavy cudgel. I have known him to cut and slash the women's heads so horribly, that even master would be enraged at his cruelty, and would threaten to whip him if he did not mind himself. Master, however, was not a humane slaveholder. It required extraordinary barbarity on the part of an overseer to affect him. He was a cruel man, hardened by a long life of slave-holding. He would at times seem to take great pleasure in whipping a slave. I have often been awakened at the dawn of day by the most heart-rending shrieks of an own aunt of mine, whom he used to tie up to a joist, and whip upon her naked back till she was literally covered with blood. No words, no tears, no prayers, from his gory victim, seemed to move his iron heart from its bloody purpose. The louder she screamed, the harder he whipped; and where the blood ran fastest, there he whipped longest. He would whip her to make her scream, and whip her to make her hush; and not until overcome by fatigue, would he cease to swing the blood-clotted cowskin. I remember the first time I ever witnessed this horrible exhibition. I was quite a child, but I well remember it. I never shall forget it whilst I remember any thing. It was the first of a long series of such outrages, of which I was doomed to be a witness and a participant. It struck me with awful force. It was the blood-stained gate, the entrance to the hell of slavery, through which I was about to pass. It was a most terrible spectacle. I wish I could commit to paper the feelings with which I beheld it.

This occurrence took place very soon after I went to live with my old master, and under the following circumstances. Aunt Hester went out one night,—where or for what I do not know,—and happened to be absent when my master desired her presence. He had ordered her not to go out evenings, and warned her that she must never let him catch her in company with a young man, who was paying attention to her belonging to Colonel Lloyd. The young man's name was Ned Roberts, generally called Lloyd's Ned. Why master was so careful of her, may be safely left to conjecture. She was a woman of noble form, and of graceful proportions, having very few equals, and fewer superiors, in personal appearance, among the colored or white women of our neighborhood.

Aunt Hester had not only disobeyed his orders in going out, but had been found in company with Lloyd's Ned; which circumstance, I found, from what he said while whipping her, was the chief offence. Had he been a man of pure morals himself, he might have been thought interested in protecting the innocence of my aunt; but those who knew him will not suspect him of any such virtue. Before he commenced whipping Aunt Hester, he took her into the kitchen, and stripped her from neck to waist, leaving her neck, shoulders, and back, entirely naked. He then told her to cross her hands, calling her at the same time a d–d b–h. After crossing her hands, he tied them with a strong rope, and led her to a stool under a large hook in the joist, put in for the purpose. He made her get upon the stool, and tied her hands to the hook. She now stood fair for his infernal purpose. Her arms were stretched up at their full length, so that she stood upon the ends of her toes. He then said to her, "Now, you d—d b—h, I'll learn you how to disobey my orders!" and after rolling up his sleeves, he commenced to lay on the heavy cowskin, and soon the warm, red blood (amid heart-rending shrieks from her, and horrid oaths from him) came dripping to the floor. I was so terrified and horror-stricken at the sight, that I hid myself in a closet, and dared not venture out till long after the bloody transaction was over. I expected it would be my turn next. It was all new to me. I had never seen any thing like it before. I had always lived with my grandmother on the outskirts of the plantation, where she was put to raise the children of the younger women. I had therefore been, until now, out of the way of the bloody scenes that often occurred on the plantation. ■

Reading Question

Near the end of this chapter, Douglass makes the somewhat startling claim, "It was all new to me." How does this claim help the reader to identify with Douglass's plight?

Summary

■ **The Industrial City: Conditions in London** During much of the nineteenth century, industrialization created wealth for a few but left the vast majority of men and women living bleak and unhealthy lives. They worked long hours for low wages in an environment plagued by smoke and soot. In London, their drinking water was taken from the river Thames, which was little better than an open sewer. Cholera and other contagious diseases thrived in the rapidly growing urban areas of Britain, Europe, and the United States, causing millions of deaths. Housing was cramped at best, owing to the fact that workers needed to live near the factories in which they worked. As single women increasingly entered the workforce—their low wages often encouraging them to supplement their income by means of prostitution—married women were driven out, leaving men as the sole breadwinners for the family.

■ **Reformers Respond: Utopian Socialism, Medievalism, and Christian Reform** In France and England, the horrific conditions brought about by industrialization led socialist thinkers such as Charles Fourier and Robert Owen to argue for the creation of utopian communities where work and wealth would be shared by all. Other humanists called for a return to medieval values. Augustus Pugin was chief among those who argued that restoring Christian values to art and architecture would instill those principles into the social fabric of nations. Art and architecture served a moral as well as a functional purpose, exemplified in the ornamentation he designed for the new Houses of Parliament in London.

■ **Literary Realism** Humanist writers attacked the problems afflicting the working class by addressing their plight in realistic terms, describing in minute detail the material conditions and psychological impact wrought by unhealthy surroundings. Such Charles Dickens works as *Hard Times* reflected both the promise and the human cost of industrialization. Writers like Dickens argued that the workers' plight could be improved if industrialists treated the workforce more humanely.

In France, realist writers such as Honoré de Balzac depicted the full breadth of French society, from its poor to its most wealthy. In the 92 novels that make up Balzac's *Human Comedy*, some 2,000 characters come to life for the reader. In the novel *Madame Bovary*, Gustave Flaubert attacked the Romantic sensibilities to which he was himself strongly attracted. In Russia, writers reacted especially strongly to the social conditions brought about by the survival of a serf economy. Poet Aleksandr Pushkin was a great champion of social causes, condemning the indifference of the modern Neoclas-

sical city of Saint Petersburg to the plight of its citizens in *The Bronze Horseman*. His friend, novelist Nikolai Gogol, attacked the Russian bureaucracy in his masterful comedy *The Inspector General*, and took on the serf economy explicitly in his novel *Dead Souls*.

In the United States, slavery was the chief target of realist writers. Slaves themselves recounted the horrors of their lives in autobiographical narratives such as those by Frederick Douglass and Sojourner Truth. Truth saw the cause of women's rights to be intimately connected with the effort to end slavery. One of the most important attacks on the institution, the most widely read novel of the era, was Harriet Beecher Stowe's *Uncle Tom's Cabin*. Even so, Stowe's novel adopts a patronizing tone in its treatment of African Americans, an attitude that becomes one of the chief themes of Mark Twain's great novel *Huckleberry Finn*, although Huck comes to understand and appreciate the slave Jim's humanity.

■ **The New French Realism in Painting** French realist painting could be said to have begun in 1830 with Eugène Delacroix's *Liberty Leading the People*, which was received by the public as both a threat to the aristocracy and an attack on the middle class. In his cartoon work for daily and weekly newspapers, Honoré Daumier constantly held the French court of King Louis-Philippe up to ridicule, even as he depicted the plight of working people in a series of paintings not exhibited until near the end of his life. Working-class life became an increasingly popular subject, in the illustrations and prints of Gustave Doré, and the monumental agricultural paintings of Rosa Bonheur and Jean-François Millet.

■ **Photography: Realism's Pencil of Light** The new art of photography arose in the context of the rise of realism in the arts. In England, William Henry Fox Talbot developed a process for fixing a negative image on paper at the same time that in France Louis-Jacques Mandé Daguerre invented the daguerreotype, a process yielding a positive image on a metal plate. Daguerre's process, which produced single images that could not be reproduced, quickly revolutionized the art of portraiture, while Fox Talbot's calotype process offered a way of making multiple prints.

■ **Charles Darwin: The Science of Objective Observation** Realist artists tried to look at the world with objective eyes. This same objectivity defined the scientific method of Charles Darwin, whose voyage on the HMS *Beagle* led him, in the Galapagos Islands off the South American coast, to develop his theory of evolution, published in 1859 as *The Origin of the Species*.

Glossary

bourgeoisie Middle-class merchants, shopkeepers, and businessmen.

calotype An early photographic process in which sensitized paper, exposed for a few seconds, holds a latent image that is brought out and developed by dipping the paper in gallic acid.

daguerreotype A photographic process developed in the early 1800s that yielded a positive image on a polished metal plate; named after one of its two inventors, Louis-Jacques-Mandé Daguerre.

literary realism The depiction of contemporary life emphasizing fidelity to everyday experience and the facts and conditions of everyday life.

lithography Literally "stone writing," this printing process depends on the fact that oil and water do not mix.

photogenic drawing A process for fixing negative images on paper coated with light-sensitive chemicals, developed by William Henry Fox Talbot in the early 1800s.

proletariat A class of workers lacking ownership of the means of production (tools and equipment) and control over both the quality and price of their own work.

Critical Thinking Questions

1. What does Dickens seek to reform through the use of literary realism? How does he do it? Do French and Russian authors have similar goals?

2. The bare-breasted allegorical figure of Liberty, by Delacroix, and the caricatures or cartoons by Daumier, are both considered part of a "realist" style. Why?

3. How is photography a threat to painting's role of representing the world? Think of some examples among early photographs.

4. What do Darwin's nonfiction works have in common with the fiction of Dickens, Flaubert, and Twain?

In July 1864, the French painter Édouard Manet [mah-NAY] traveled from Paris to Boulogne-sur-Mer [boo-LOHN ser mair] on the English Channel expressly to paint the U.S.S. *Kearsarge* [KEER-sarj], a small warship ideal for coastal defense. *The Kearsarge* had sunk the Confederate sloop-of-war *Alabama* off Cherbourg [shair-BOOR], on the Norman coast, on June 19. The *Alabama* had been fitted with supplies and repaired at Cherbourg after nearly two years of roving the seas, from Brazil to Singapore. During that time it had sunk 65 Union merchant ships. The *Kearsarge* patiently waited for the *Alabama* to leave French waters, and then attacked, sinking it.

Manet relied on newspaper accounts to paint *The Battle of the "Kearsarge" and the "Alabama"* (Fig. **35.24**), exhibiting it only 26 days after the battle. Soon after, he traveled to Boulogne-sur-Mer to see the victorious ship in person.

Manet was, above all, the painter of a new, self-consciously modern bourgeois France. Under Napoleon III, the emperor who had come to power after the revolution of 1848, France, and England too, openly sympathized with the Confederacy. Both the French and English textile industries depended on Southern cotton, and the Union blockade of the Confederate ports had crippled them. Manet felt differently. He did not believe in placing economic self-interest above the cause of human equality and freedom. *The Battle of the "Kearsarge" and the "Alabama"* is, thus, a deeply political statement. Manet's painting challenges the complicity of the French government and the bourgeois culture supporting it with the Southern cause.

The painting, finally, epitomizes the dawning modern age, an age of revolution and civil war when tensions surrounding questions of freedom and equality, self-determination and national identity, erupted in violence. As revolution threatened, the bourgeoisie tightened its control of European society, and the attitudes and tastes of modern bourgeoisie culture are the constant targets of Manet's art. ■

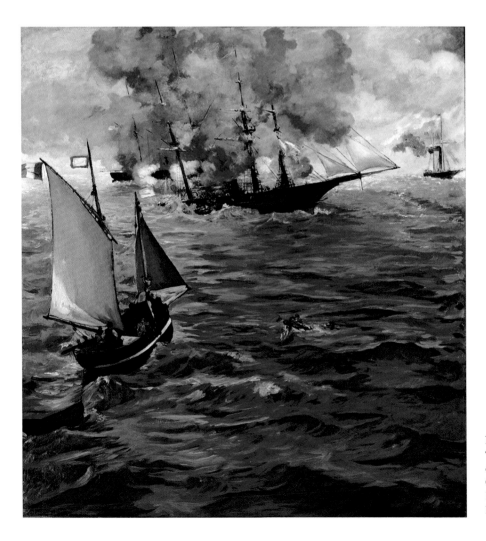

Fig. 35.24 **Édouard Manet.** *The Battle of the "Kearsarge" and the "Alabama."* **1864.** Oil on canvas, 54$\frac{1}{4}$" × 50$\frac{3}{4}$". John G. Johnson Collection, 1917. Philadelphia Museum of Art, Philadelphia, Pennsylvania, U.S.A. Art Resource, NY.

B ETWEEN 1800 AND 1848, THE CITY OF PARIS DOUBLED IN size, to nearly 1 million people. Planning was nonexistent. The streets were a haphazard labyrinth of narrow, stifling passageways, so clogged with traffic that pedestrians were in constant danger. The gutters were so full of garbage and raw sewage

that cesspools developed overnight in low-lying areas. The odor they produced was often strong enough to induce vomiting. And they bred rats and fleas, and the diseases they carried, such as cholera, dysentery, typhus, and typhoid fever. One epidemic in Paris during 1848 and 1849 killed more than 19,000 people. Further complicating the situation, no accurate map of the streets existed prior to 1853, so to venture into them was to set out into unknown and dangerous territory.

By 1848, these conditions prevailed throughout urban areas in Europe, made worse by food shortages and chaos in the agricultural economy. The potato famine in Ireland that killed a million people was merely the worst of a widespread breakdown. The agricultural crisis in turn triggered bankruptcies and bank closings, particularly in places where industrial expansion had not been matched by the growth of new markets. In France, prices plummeted, businesses failed, and unemployment was rampant. The situation was ripe for revolution. Soon the streets of Paris were filled with barricades (Fig. 36.1), occupied by workers demanding the right to earn a livelihood and determine their own destiny. In other European capitals, workers quickly followed the Parisians' lead (Map 36.1).

This chapter explores the revolutions of 1848 in Europe and their aftermath. At the heart of these conflicts were two ideologies that were sometimes compatible and sometimes not: liberalism and nationalism. Liberal belief was founded in Enlightenment values—the universal necessity for equality and freedom at the most basic level. The nationalist agenda, however, focused on regional autonomy, cultural pride, and freedom from monarchical control, especially that of the Habsburgs, who controlled much of central, eastern, and southern Europe. Liberal politics were transnational; nationalism rested upon claims of distinct regional, even local, ethnic and linguistic identity.

While liberal and nationalist politics dominated all of Europe after 1848, Paris remained the center of revolutionary activity, a focus of world attention, as well as the center of European culture. The realist approach to art that developed in the 1830s and 1840s was integrated into an effort to define the term *modern*, which, after the revolutions of 1848, became a popular characterization of contemporary life. Writers and painters presented the conditions of life in France's new bourgeois (middle class) society in sometimes shockingly direct terms, interested not so much in revealing the physical realities, as their predecessors had done in describing the working class, but in examining the social condi-

tions and prejudices of their subjects. And in America, the Civil War—interpreted by Europeans primarily as a contest between liberal and nationalist politics—resulted in a new realism that demythologized the antebellum-era Romantic view of slavery in art and music while also depicting the horrors of war with brutal directness.

The Revolutions of 1848: From the Streets of Paris to Vienna

Although the working classes suffered most from the miserable living conditions in cities, they were not the initial cause of the revolutionary turmoil of 1848. It was the middle-class (bourgeois) political thinkers who most strongly argued for representative government and civil liberties. They considered themselves to be *liberal*, espousing legal equality, religious toleration, and freedom of the press. They generally believed, like Enlightenment writers John Locke and Thomas Jefferson, that government emanated from the people, who freely consented to its rule and had the power to

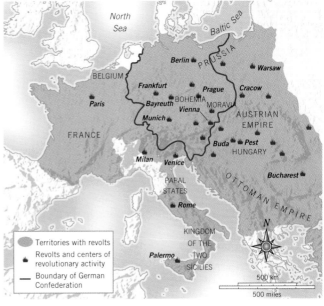

Map 36.1 Revolutionary activity in Europe in 1848.

36 Revolution and Civil War

The Conditions of Modern Life

> *There are, in my opinion, two elements in a work: the element of reality, which is nature, and the personal element, which is man. The element of reality, nature, is fixed, always the same; it is given equally to all men. . . . The personal element, man, is, on the other hand, infinitely variable; there are as many possible works as there are different minds. . . .*
>
> Émile Zola, *The Moment in Art*

◄ Fig. 36.1 *The Barricade at the Church of la Madeleine.* February 1848. This photograph, one of the first to be printed on paper, looks down rue de la Concorde (now rue Royale) toward Place de la Concorde and across the Seine to the National Assembly. The dome in the distance is Les Invalides, burial place of Napoleon I. The photo captures the reality of the revolutions that swept Europe in 1848 (see Map 36.1) when workers and middle-class liberals united to assert their right to democratic rule and civil liberty. It also prefigures the civil war that would soon consume the United States, itself fueled by the issue of slavery.

BETWEEN 1800 AND 1848, THE CITY OF PARIS DOUBLED IN size, to nearly 1 million people. Planning was nonexistent. The streets were a haphazard labyrinth of narrow, stifling passageways, so clogged with traffic that pedestrians were in constant danger. The gutters were so full of garbage and raw sewage

that cesspools developed overnight in low-lying areas. The odor they produced was often strong enough to induce vomiting. And they bred rats and fleas, and the diseases they carried, such as cholera, dysentery, typhus, and typhoid fever. One epidemic in Paris during 1848 and 1849 killed more than 19,000 people. Further complicating the situation, no accurate map of the streets existed prior to 1853, so to venture into them was to set out into unknown and dangerous territory.

By 1848, these conditions prevailed throughout urban areas in Europe, made worse by food shortages and chaos in the agricultural economy. The potato famine in Ireland that killed a million people was merely the worst of a widespread breakdown. The agricultural crisis in turn triggered bankruptcies and bank closings, particularly in places where industrial expansion had not been matched by the growth of new markets. In France, prices plummeted, businesses failed, and unemployment was rampant. The situation was ripe for revolution. Soon the streets of Paris were filled with barricades (Fig. **36.1**), occupied by workers demanding the right to earn a livelihood and determine their own destiny. In other European capitals, workers quickly followed the Parisians' lead (Map **36.1**).

This chapter explores the revolutions of 1848 in Europe and their aftermath. At the heart of these conflicts were two ideologies that were sometimes compatible and sometimes not: liberalism and nationalism. Liberal belief was founded in Enlightenment values—the universal necessity for equality and freedom at the most basic level. The nationalist agenda, however, focused on regional autonomy, cultural pride, and freedom from monarchical control, especially that of the Habsburgs, who controlled much of central, eastern, and southern Europe. Liberal politics were transnational; nationalism rested upon claims of distinct regional, even local, ethnic and linguistic identity.

While liberal and nationalist politics dominated all of Europe after 1848, Paris remained the center of revolutionary activity, a focus of world attention, as well as the center of European culture. The realist approach to art that developed in the 1830s and 1840s was integrated into an effort to define the term *modern*, which, after the revolutions of 1848, became a popular characterization of contemporary life. Writers and painters presented the conditions of life in France's new bourgeois (middle class) society in sometimes shockingly direct terms, interested not so much in revealing the physical realities, as their predecessors had done in describing the working class, but in examining the social condi-

tions and prejudices of their subjects. And in America, the Civil War—interpreted by Europeans primarily as a contest between liberal and nationalist politics—resulted in a new realism that demythologized the antebellum-era Romantic view of slavery in art and music while also depicting the horrors of war with brutal directness.

The Revolutions of 1848: From the Streets of Paris to Vienna

Although the working classes suffered most from the miserable living conditions in cities, they were not the initial cause of the revolutionary turmoil of 1848. It was the middle-class (bourgeois) political thinkers who most strongly argued for representative government and civil liberties. They considered themselves to be *liberal*, espousing legal equality, religious toleration, and freedom of the press. They generally believed, like Enlightenment writers John Locke and Thomas Jefferson, that government emanated from the people, who freely consented to its rule and had the power to

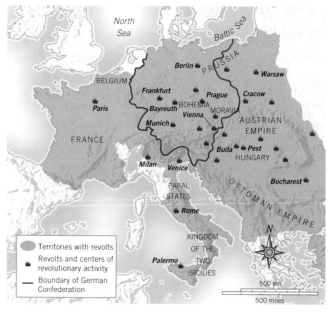

Map 36.1 Revolutionary activity in Europe in 1848.

I n July 1864, the French painter Édouard Manet [mah-NAY] traveled from Paris to Boulogne-sur-Mer [boo-LOHN ser mair] on the English Channel expressly to paint the U.S.S. *Kearsarge* [KEER-sarj], a small warship ideal for coastal defense. *The Kearsarge* had sunk the Confederate sloop-of-war *Alabama* off Cherbourg [shair-BOOR], on the Norman coast, on June 19. The *Alabama* had been fitted with supplies and repaired at Cherbourg after nearly two years of roving the seas, from Brazil to Singapore. During that time it had sunk 65 Union merchant ships. The *Kearsarge* patiently waited for the *Alabama* to leave French waters, and then attacked, sinking it.

Manet relied on newspaper accounts to paint *The Battle of the "Kearsarge" and the "Alabama"* (Fig. 35.24), exhibiting it only 26 days after the battle. Soon after, he traveled to Boulogne-sur-Mer to see the victorious ship in person.

Manet was, above all, the painter of a new, self-consciously modern bourgeois France. Under Napoleon III, the emperor who had come to power after the revolution of 1848, France, and England too, openly sympathized with the Confederacy. Both the French and English textile industries depended on Southern cotton, and the Union blockade of the Confederate ports had crippled them. Manet felt differently. He did not believe in placing economic self-interest above the cause of human equality and freedom. *The Battle of the "Kearsarge" and the "Alabama"* is, thus, a deeply political statement. Manet's painting challenges the complicity of the French government and the bourgeois culture supporting it with the Southern cause.

The painting, finally, epitomizes the dawning modern age, an age of revolution and civil war when tensions surrounding questions of freedom and equality, self-determination and national identity, erupted in violence. As revolution threatened, the bourgeoisie tightened its control of European society, and the attitudes and tastes of modern bourgeoisie culture are the constant targets of Manet's art. ■

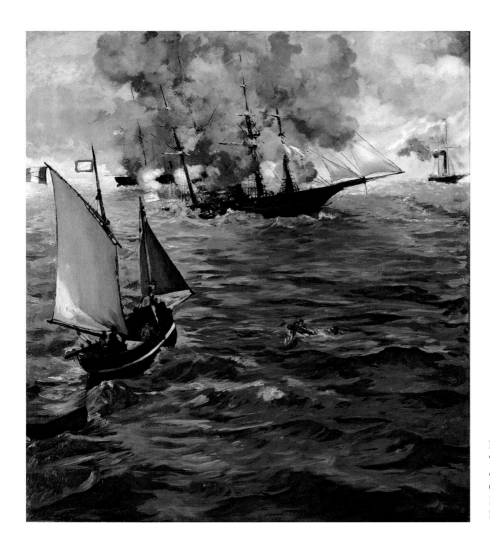

Fig. 35.24 Édouard Manet. *The Battle of the "Kearsarge" and the "Alabama."* 1864. Oil on canvas, 54$\frac{1}{4}$" × 50$\frac{3}{4}$". John G. Johnson Collection, 1917. Philadelphia Museum of Art, Philadelphia, Pennsylvania, U.S.A. Art Resource, NY.

oust unwanted leaders. The people expressed this consent through the election of representatives, and they protected their rights through written constitutions. Many liberals supported the ideas of Adam Smith, who argued (see chapter 31) that government should keep its nose out of economics and trade. Many were, in fact, self-serving capitalists, partisans of unregulated economic life, and opponents of tyranny of any government that threatened their self-interest. When they allied themselves with the working classes—generally more predisposed to violence—it was more a matter of convenience than conviction. Nineteenth-century liberalism thus expressed the French Revolution's principle, *"Liberté, Égalité, Fraternité,"* in less strident terms, but with the same concern for individual rights and common morality.

Marxism

There were, however, more radical thinkers whose convictions were untarnished by self-interest and who, furthermore, did not shy away from proposing violence to attain their goals. Karl Marx (1818–1883) and Friedrich Engels [EN-gulz] (1820–1895) were two young, middle-class Germans who believed that since the conditions in which one earns a living determined all other aspects of life—social, political, and cultural—capitalism must be eliminated because of its inherent unfairness. Reform was pointless—only a revolution of the working people would succeed in achieving meaningful change. In fact, Marx and Engels believed revolution was inevitable, following the logic of the philosopher Georg Wilhelm Friedrich Hegel's dialectic (see chapter 34). The struggle between the bourgeoisie—which Engels defined as "the class of modern capitalists, owners of the means of production and employers of wage labor"—and the proletariat (working class) amounted to the conflict between thesis and antithesis. (The term bourgeoisie generally referred to the capitalist or merchant class.) The resolution lay in the synthesis of a classless society, a utopian society at "the end of history," since the dialectic forces that drive history would be finally and permanently resolved.

The collaboration of Marx and Engels would ultimately help shape nineteenth- and twentieth-century history across the globe. Their epochal partnership began rather simply in a Parisian café in August 1844, where Marx first met Engels. Marx had been editing a German newspaper and Engels was the heir to his father's textile factory in Manchester, England. The following year Engels published his *Conditions of the Working Class in England*, a scathing indictment of industrial life, and in early 1848 the two had coauthored and published a manifesto for the newly formed Communist League in London. The term *communist* at the time suggested a more radical approach to communal politics than *socialist*. In the *Communist Manifesto* (see **Reading 36.1**, page 1179, for Part I, "Bourgeois and Proletarians"), Marx and Engels argued that class struggle characterized all past societies and that industrial society simplified these class antagonisms. "Society as a whole is splitting up more and more into two great hostile camps, into two great classes directly facing each other: Bourgeoisie and Proletariat."

In its most controversial phrases, the *Communist Manifesto* called for "the forcible overthrow of all existing social conditions," and concluded, "The proletarians have nothing to lose but their chains. They have a world to win. WORKING MEN OF ALL COUNTRIES, UNITE." This simplistic call-to-arms would gain support steadily through the ensuing decades, even though Marx and Engels failed to anticipate capitalism's ability to adapt to change and slowly improve the lot of "the proletariat." However, the *Manifesto*, as well as Marx's later *Das Kapital (Capital)*, offered an important testament of the living conditions of the proletariat and an incisive interpretation of the way capitalism operated. Ironically, this forceful critique of the effects of the free market became an influential factor in advancing reforms in working conditions, as well as providing higher wages and greater social equality.

The Streets of Paris

In February 1848, rioters overthrew Louis-Philippe, who had ruled since 1830. Tension between the bourgeoisie, the intellectual liberals, and the working people who fought beside them was evident from the first. In his *History of the Revolution of 1848*, writer and politician Alphonse de Lamartine [lah-mar-TEEN] (1790–1869) describes the scene just before the overthrow (**Reading 36.2**):

READING 36.2 **from Alphonse de Lamartine, *History of the Revolution of 1848* (1849)**

These two classes exhibited a characteristic difference of air and costume. The one was composed of young men belonging to the rich and refined mercantile classes, to the schools, to trade . . . to literature, and . . . to the periodical press. These harangued the people, inflamed popular indignation against the king, the minister, and the chambers; spoke of the humiliation of France before the foreigner, of the diplomatic treasons of the court, and the insolent corruption and servility of deputies, who had sold themselves to the sovereign will of Louis-Philippe. . . . The numerous promenaders and bystanders, whose curiosity was excited by whatever was new, crowded around these orators, and applauded their expressions. The other class was composed of the lower orders [workers], summoned within the last two days, from their shops, by the sound of firing; clad in their working dress, with their blue shirts open, and their hands still blackened with the smoke of the forge. These came down in silence, in little knots. . . . One or two workmen, better dressed than the rest, with long skirted cloth coats, walked before them, addressed them in a low tone, and seemed to be giving them the word of command. These were the heads of the sections of the Rights of Man and of Families [a reference to the French Revolution of the 1790s].

Within several days King Louis-Philippe fled to exile in England. A provisional government for the Second French Republic was installed by voice vote of a crowd that shouted its judgment for each name read by Alphonse de Lamartine.

The June Days in Paris: Worker Defeat and Rise of Louis-Napoleon

The mob that day had made one thing clear—it demanded the "right to work." The provisional government quickly acted to form *Ateliers Nationaux* [ah-tuh-lee-AY nah-see-oh-NOH], "National Workshops," to provide employment. Enrollment in these workshops quickly jumped from 10,000 in March to 120,000 in June. Unable to provide useful employment for such numbers, the government discovered it had inadvertently created a vast army eager to support almost every radical cause. On June 22, the National Workshops were officially terminated and disillusioned workers took up arms in response. The so-called June Days—three days of the bloodiest street fighting in nineteenth-century European history—followed, as workers built and occupied barricades in the streets (see Fig. 36.1). The army quickly overcame the workers at the cost of 10,000 dead and wounded. Eleven thousand more so-called leaders of the revolution were deported to France's new colony of Algiers [al-JEERZ], in North Africa. The brutal street fighting was so disturbing to Parisians that even such a traditional Salon painter as Ernst Meissonier (me-saw-NYEY) (1815–1891), who spent his entire career celebrating French military history, was moved, for once, to depict the truth of war (Fig. **36.2**).

Many members of the middle class were convinced that they had barely survived the complete collapse of social order. What came to be known as the Red Fear, an almost paranoid distrust of the working class, gripped France. Conservatives succeeded in passing legislation that curbed freedom of the press and limited political association. A new constitution provided for the election of a president who could deal with any future rebellions without interference.

In the December 1848 election for president, Charles-Louis-Napoleon Bonaparte (1808–1873) was the victor. Known as Louis-Napoleon [loo-EE-nah-poh-lay-OHN], this nephew of Napoleon I was awkward and spoke French with a German accent, but his name proved attractive to the electorate. When, in 1851, the assembly refused to amend the constitution to allow the president to run for a second term, Louis-Napoleon staged a *coup d'état* [koo day-TAH] (sudden, unlawful overthrow of a government). On December 2 of that year, the anniversary of his uncle's great victory at Austerlitz, he ordered his troops to disperse the assembly. Hundreds were killed resisting the coup, 26,000 people were arrested, and 10,000 deported to Algeria. A year later, Louis-Napoleon was proclaimed Emperor Napoleon III, again approved by an overwhelming popular plebiscite (a "yes" or "no" vote). The conservative bourgeoisie, or as Marx would term them, the capitalists, were firmly entrenched in power. An autocrat, Louis-Napoleon was popular with monarchists and the middle class as a force

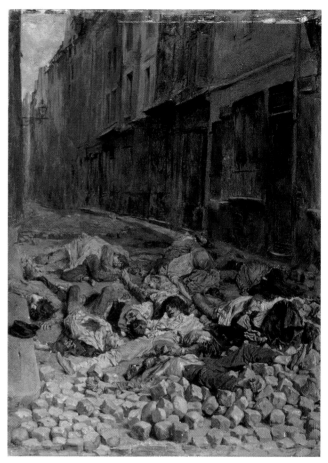

Fig. 36.2 Ernest Meissonier. *Memory of Civil War (The Barricades)*. 1849 (Salon of 1850–1851). Oil on canvas, $11\frac{1}{2}" \times 8\frac{1}{4}"$. Inv. RF1942-31. Location: Louvre, Paris, France. Musée du Louvre/RMN Réunion des Musées Nationaux, France. SCALA/Art Resource, NY. Meissonier served as a captain of the Republican Guard defending the Hôtel de Ville in the June Days and witnessed the bloodshed with his own eyes. The result is this painting, which a contemporary called an "omelette of men." It is Delacroix's *Liberty Leading the People* (see Fig. 35.12) stripped bare of all its glory.

for restoring order. To the working class, he promised economic progress for all, while the rural population revered him as Napoleon Bonaparte's nephew.

No image better illustrates the repressive role of the state in Paris after 1848 than *What Is Called Vagrancy* (Fig. **36.3**) by the Belgian painter Alfred Stevens (1823–1906) working in Paris. On a street in Vincennes [van-SEN], on the outskirts of Paris, troops of Napoleon III arrest for vagrancy a woman with a baby in her arms and a humiliated little boy at her skirt. A more elegantly dressed woman tries to intercede, but she is rebuffed by the threatening gesture of a soldier. An elderly disabled worker has already given up and turns away. Posters on the wall behind them emphasize the disparity between rich and poor—one announces a court auction of buildings (presumably for default) and the other a "*Bal*" [bahl] or dance. When Napoleon III saw this painting, he was outraged, believing such spectacles could stir up conflict. He ordered that vagrants should be transported to prison in closed coaches.

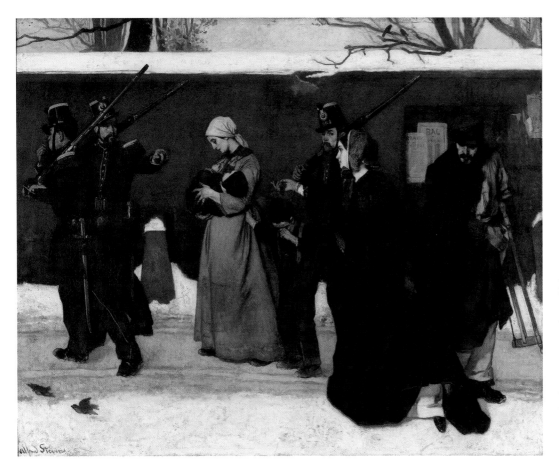

Fig. 36.3 Alfred Stevens. *What Is Called Vagrancy.* **1855 (1855 Exposition Universal).** Oil on canvas, 52″ × 63 ³/₄″. Musee d'Orsay, Paris, France. Photo: Hervè Hewandowski/Réunion des Musées Nationaux. Art Resource, NY. The painting was also known in the mid-nineteenth century by the telling title *The Hunters of Vincennes.*

Revolution across Europe: The Rise of Nationalism

The Paris uprising of February 1848 triggered a string of successive revolts in Austria, many of the lesser German states, and throughout Italy, spreading northward from Sicily, Sardinia, and Naples to the Papal States, Tuscany, and the northern regions under Austrian rule (see Map 36.1). One of the most important factors contributing to revolution was nationalism, the exaltation of one's home territory. National groups across Eastern Europe sought to replace the rule of the Prussian and the Austrian Habsburgs with smaller independent states. First, in Vienna, Magyar [MAG-yar] nationalists called for the independence of Hungary, even as Czech [chek] nationalists demanded the right to create an autonomous Slavic [SLAH-vik] state in Bohemia [boh-HEE-mee-uh] and Moravia [mor-AY-vee-uh]. In early June, the first Pan-Slavic Congress, including Poles, Croats [KROH-ats], Slovenes [SLOH-veenz], and Serbs, met in Prague [prahg] and issued a manifesto that protested the repression of all Slavic peoples. By June 12, as the Congress closed, an anti-government riot broke out, and the Habsburgs' military smashed the radicals, thus temporarily ending the drive toward a Pan-Slavic state.

Meanwhile, in Italy, revolution against Habsburg domination began in Milan and moved southward. In Rome, radicals rose up against papal control, forcing the pope to appoint a new ministry. Republican nationalists from across Italy, including Giuseppe Mazzini [mah-TZEE-nee] (1805–1872) and Giuseppe Garibaldi [gah-ree-BAHL-dee] (1807–1882), converged on the city hoping to unite the rest of Italy behind the example of this new Republic of Rome. But by June 1849, 10,000 French troops, sent by Louis-Napoleon, laid siege in support of continued papal control, and by the end of the month, the Roman Republic was dissolved. (To get a sense of what it felt like to witness this revolution firsthand, see *Voices,* page 1158.)

In mid-March 1848, popular disturbances also erupted in Berlin, forcing the Prussian king, Frederick William IV (r. 1840–1861), to install a liberal government. But again the forces of reform were thwarted, and in April 1849, the Prussian monarch forced the liberal assembly to resign and proclaimed his own constitution. Elsewhere in Germany, the liberal Frankfurt Parliament offered the crown of a united Germany to Frederick William IV, who refused it. The Frankfurt Parliament, hopelessly caught between its fear of the working classes and its dependence on the troops of conservative monarchs, dissolved.

Given the nationalists' opposition to the monarchist (and papal) governments that controlled most of the rebelling regions, it is hardly surprising that they often found themselves allied with liberals. But important differences existed between the two camps. In fact, on many questions nationalism was distinctly at odds with liberal political values. Nationalist groups

Voices

Italian Nationalists Struggle for Liberty

The Italian battle for nationhood gained a number of foreign allies, including American writer Margaret Fuller (1810–1858), who assumed charge of a Roman hospital while her Italian husband fought the French invaders in 1849. While individual Americans and British sympathized with the Italian nationalists, their governments remained frustratingly neutral, thereby dooming the new democracy. Fuller detailed her experiences during the French siege in letters to friends in the United States:

". . . [I]t gives us pain that our country, whose policy it justly is to avoid physical interference with the affairs of Europe, should not use a moral influence. Rome has—as we did—thrown off a government no longer tolerable; . . ."

May 6, 1849
I write you from barricaded Rome. The mother of nations is now at bay against them all. . . . The Americans here are not in a pleasant situation. Mr. Cass, the Charge of the United States, stays here without recognizing the government. . . . it gives us pain that our country, whose policy it justly is to avoid physical interference with the affairs of Europe, should not use a moral influence. Rome has—as we did—thrown off a government no longer tolerable; she had made use of the suffrage to form another; she stands on the same basis as ourselves [American democracy]. . . .

June 6, 1849
On Sunday . . . I witnessed a terrible, a real battle. It began at four in the morning: it lasted to the last gleam of light. The musket-fire was almost uninterrupted; the roll of the cannon, especially from St. Angelo, most majestic. I saw the smoke of every discharge, the flash of bayonets, with a glass [telescope] could see the men. The French could not use their heavy cannon, being always driven away by the legions of Garibaldi when trying to find positions for them. The loss on our side [the Italian nationalists] about three hundred killed and wounded; theirs must be much greater. In one casino [country house] have been found seventy dead bodies of theirs. . . . The French throw rockets into the town, one burst in the courtyard of the hospital just as I arrived there yesterday, agitating the poor sufferers very much; they said they did not want to die like mice in a trap.

often defined themselves in direct opposition to other ethnic groups whom they considered their cultural inferiors. The Hungarian Magyars, for instance, sought authoritarian control over all other ethnic groups living within the historical boundaries of Hungary, including Romanians, Croatians, and Serbs.

One group that appeared to benefit from the revolutions of 1848 was the Jews, who had historically been subject to great repression throughout Europe. In Scandinavia, Italy, Germany, Belgium, and Holland, Jews attained full rights of citizenship after 1848, and in 1867 Austria-Hungary extended them the same rights. By 1858, Jews were permitted to sit in Parliament in England. As a result, Jewish participation in European cultural life increased dramatically. For the first time, Jews were able to enter art and music schools, and subsequently they became leaders in science and education. From 1850 until about 1880, Jews lived their lives in relative freedom from persecution and discrimination.

Only in Russia and other parts of Eastern Europe did anti-Semitism continue unabated. In Russia, Jews were confined to designated ghettos, from which they could leave only with internal passports. They were banned from state service and most forms of higher education, and publication of Jewish texts was severely restricted. The police regularly led *pogroms* [POH-grums] (organized and violent riots) against Jewish neighborhoods and villages. As a result, hundreds of thousands of Jews emigrated from the East to Western Europe as well as the United States.

Despite the anti-Semitic atmosphere in Russia, a new transnational Jewish literature began to surface, written in Yiddish, a German dialect using the Hebrew alphabet. Among its most notable authors is Sholem Yakov Rabinovitsh [SHOH-lem YAH-kov rah-bin-o-vits], widely known as Sholem Aleichem [ah-LAY-khum] (1859–1916). His stories about Tevye the Milkman would later inspire the Broadway musical and film *Fiddler on the Roof*.

In Pursuit of Modernity: Paris in the 1850s and '60s

Soon after the stunning events of 1848, Pierre-Joseph Proudhon [proo-DOHN] (1809–1865), the French journalist who

Fig. 36.4 Nadar (Gaspard-Félix Tournachon). *Portrait of Charles Baudelaire*. 1863. Silver print. Caisse Nationale des Monuments Historiques et des Sites, Paris. Baudelaire was deeply suspicious of photography, believing that it supported the näive view that "Art is, and cannot be other than, the exact reproduction of Nature." He called Daguerre the "Messiah" of this point of view.

READING 36.3 **from Charles Baudelaire, "To the Bourgeoisie," in** *Salon of 1846* **(1846)**

The government of the city is in your hands, and that is just, for you are the force. But you must also be capable of feeling beauty; for as not one of you today can do without power, so not one of you has the right to do without poetry. . . .

Very well, you need art.

Art is an infinitely precious good, a draught both refreshing and cheering which restores the stomach and the mind to the natural equilibrium of the idea.

You understand its function, you gentlemen of the bourgeoisie—whether lawgivers or businessmen—when the seventh or eighth hour strikes and you bend your tired head towards the embers of your hearth or the cushions of your arm-chair.

This is the time when a keener desire and a more active reverie would refresh you after your daily labors.

first called himself an "anarchist" and famously coined the phrase "property is theft," wrote: "We have been beaten and humiliated . . . scattered, imprisoned, disarmed, and gagged. The fate of European democracy has slipped from our hands." Political and moral idealism seemed vanquished. In their place remained only the banal prosperity of the triumphant bourgeoisie. In fact, the political, moral, and religious emptiness of the bourgeoisie became the targets of a new realism, which critiqued what Proudhon called the "fleshy, comfortable" bourgeois lifestyle.

Even before the revolution, the poet Charles Baudelaire [boh-deh-LAIR] (1821–1867) (Fig. **36.4**) recognized the triumph of bourgeois culture in the opening dedication to his *Salon of 1846*, a text that is both a social critique and an art review of the official government-sponsored exhibition of painting and sculpture by living artists held biannually at the Louvre (**Reading 36.3**):

Baudelaire recognized the bourgeoisie as his audience, but their hypocrisy was his constant target. His admonitions that they should love art masks his feelings that they are incapable of understanding true artistic innovation.

Charles Baudelaire and the Poetry of Modern Life

Baudelaire's own sense of the beautiful and marvelous is nowhere more apparent than in his poetry, which was passionately attacked for its unconventional themes and subject

matter, chosen to shock bourgeois minds. When Flaubert's *Madame Bovary* first appeared in magazine installments in 1856 (see chapter 35), its author had been brought to trial, charged with giving "offense to public and religious morality and to good morals." Eight months later, in August 1857, Baudelaire, Flaubert's good friend, faced the same charge for his book of 100 poems, *Les Fleurs du mal* [lay fler doo mahl], usually translated "Flowers of Evil." Unlike Flaubert, Baudelaire lost his case, was fined, and was forced to remove six poems concerning lesbianism and vampirism, all of which remained censored . . . for the next century!

The poems in *Les Fleurs du Mal* unflinchingly confront the realities of this "underworld" and of life itself. In the poem "Carrion," for example, Baudelaire recalls strolling with his love one day (**Reading 36.4**):

READING 36.4 Charles Baudelaire, "Carrion," in *Les Fleurs du mal* (1857) (translation by Richard Howard)

Remember, my soul, the thing we saw
that lovely summer day?
On a pile of stones where the path turned off,
the hideous carrion—

legs in the air, like a whore—displayed
indifferent to the last,
a belly slick with lethal sweat
and swollen with foul gas.

the sun lit up that rottenness
as though to roast it through,
restoring to Nature a hundredfold
what she had here made one.

And heaven watched the splendid corpse
like flower open wide—
you nearly fainted dead away
at the perfume it gave off.

The poem is an attack on the Romanticized view of death that marks, for instance, Emma Bovary's illusory ecstasy (see chapter 35). To look at such reality unflinchingly, with open eyes is, for Baudelaire, the central requirement of modern life.

The lover in "Carrion" is Jeanne Duval [zhun doo-VAHL], Baudelaire's Haitian-born mistress with whom he had a tumultuous on-again-off-again relationship for 20 years. His painter friend Édouard Manet (1832–1883) would paint her in 1862 sitting on a sofa, her enormous crinoline (hoop-skirt) dress spread around her (Fig. **36.5**). In his 1863 essay, "The Painter of Modern Life," Baudelaire writes: "What poet, in sitting down to paint the pleasure caused by the sight of a beautiful woman, would venture to separate her from her costume?" Such sentiments define the

attitude that would soon create the Paris fashion industry, the tradition of *haute couture* [oht koo-TOOR] that has come down to the present day.

Many critics and scholars have objected to Manet's rather unflattering depiction of his sitter. The work suggests that the woman and the dress embrace a larger unity, incorporating both attraction and repulsion. Nevertheless, both the painting and the many poems Baudelaire wrote about Jeanne openly address the attractions of her sexuality (**Reading 36.5**):

READING 36.5 Charles Baudelaire, "The Head of Hair," in *Les Fleurs du mal* (1857) (translation by Richard Howard)

Ecstatic fleece, that ripples to your nape
And reeks of negligence in every curl!
To people my dim cubicle tonight
with memories shrouded in that head of hair,
I'd have it flutter like a handkerchief!

For torpid Asia, torrid Africa,
—the wilderness I thought a world away—
survive at the heart of this dark continent.
As other souls set sail to music, mine
O my love! embarks upon your redolent hair.

Take me, tousled current, to where men
as mighty as the trees they live among
submit like them to the sun's long tyranny;
ebony sea, you bear a brilliant dream
of sails and pennants, mariners and masts.

A harbor where my soul can slake its thirst,
for color, sound and smell—where ships that glide
among the seas of golden silk throw wide
their yardarms to embrace a glorious sky
palpitating in eternal heat.

Drunk, and in love with drunkenness, I'll dive
into this ocean where the other lurks,
and solaced by these waves, my restlessness
will find a fruitful lethargy at last,
rocking forever at aromatic ease.

Poetry has rarely addressed sexual pleasure more openly, but Baudelaire also acts out what we can recognize today as imperialist imagery: Jeanne Duval's body becoming at once China and Africa, her harbors open to the colonizing fleet of his desire.

Édouard Manet: The Painter of Modern Life

In 1863, Baudelaire called for an artist "gifted with an active imagination" to actively pursue a new artistic goal: describing the modern city and its culture. Édouard Manet most clearly embodies this new vision of the artist as a recorder of every-

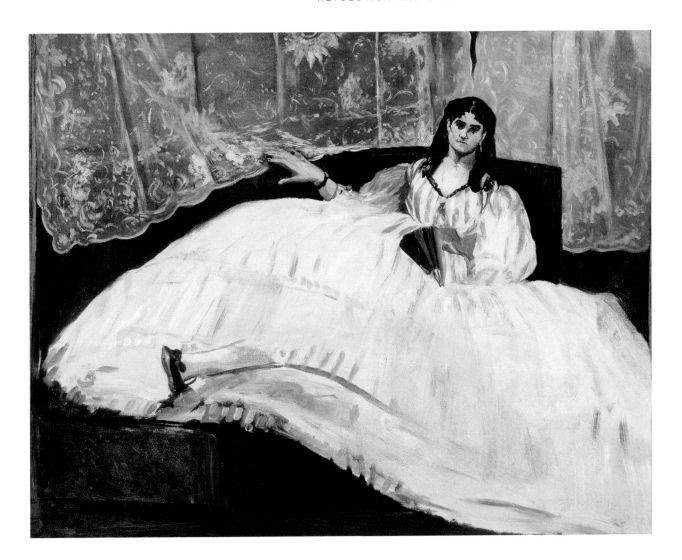

Fig. 36.5 Édouard Manet. *Baudelaire's Mistress Reclining* **(Study of Jeanne Duval). ca. 1862.** Oil on canvas, 35⅜″ × 44½″. Location: Museum of Fine Arts (Szépmuvészeti Muzeum), Budapest, Hungary. Giraudon/Art Resource, NY. Baudelaire referred to this dark-skinned actress, whom he first met in 1842, as his "Black Venus."

day city life, since he, like Baudelaire, was a *flâneur*. The *flâneur* was a man-about-town, with no apparent occupation, strolling the city, studying and experiencing it coolly, dispassionately. Moving among its crowds and cafés in fastidious and fashionable dress, the flâneur had an acute ability to understand the subtleties of modern life and the ability to create art, according to a definitive essay by Baudelaire (**Reading 36.6**):

READING 36.6 from Charles Baudelaire, "The Painter of Modern Life" (1863)

Be very sure that this man, such as I have depicted him—this solitary, gifted with an active imagination, ceaselessly journeying across the great human desert—[aims for] . . . something other than the fugi-

tive pleasure of circumstance. He is looking for that quality which you must allow me to call "modernity". . . By "modernity" I mean the ephemeral, the fugitive, the contingent. . . . This transitory, fugitive element, whose metamorphoses are so rapid, must on no account be despised or dispensed with. By neglecting it, you cannot fail to tumble into the abyss of an abstract and indeterminate beauty.

According to Baudelaire, the flâneur is distinguished by one other important trait: his attitude toward the bourgeoisie. He holds their vulgar, materialistic lifestyle in contempt, and his greatest devotion is to shocking them. "*Il faut épater le bourgeois*" [eel foh ay-pah-TAY leh boor-ZHWAH] ("One must shock the bourgeoisie"), he said. Thus, it came as no surprise to Manet when *Le Déjeuner sur l'herbe* [leh day-zhur-NAY sur lerb] (*Luncheon on the Grass*)

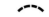

Fig. 36.6 Édouard Manet. *Le Déjeuner sur l'herbe (Luncheon on the Grass).* 1863. Oil on Canvas, 7' x 8'10". Musee d'Orsay, Paris. RMN Réunion des Musées Nationaux/Art Resource, NY. © 2008 ARS Artists Rights Society, NY. The model for the reclining young man on the right, whose gesture seems to point simultaneously at both female figures, was Manet's future brother-in-law.

was rejected by the jury for the Salon of 1863 (Fig. **36.6**). It was not designed to please them. The Salon drew tens of thousands of visitors a day to the Louvre and was the world's most prominent art event. The public also reacted with outrage when Manet's painting appeared at the Salon des Refusés [sah-LOHN day reh-foo-ZAY], an exhibition hurriedly ordered by Louis-Napoleon after numerous complaints arose about the large number of rejected artworks. While many of the paintings included in the Salon des Refusés were of poor quality, others, including *Le Déjeuner sur l'herbe* by Manet and *The White Girl, Symphony in White, No. 1* by American artist James McNeill Whistler, were vilified because of their supposedly scandalous content or challenging style. The Paris newspapers lumped them all together: "There is something cruel about this

exhibition: people laugh as they do at a farce. As a matter of fact it is a continual parody, a parody of drawing, of color, of composition."

Manet's painting evokes the *fêtes galantes* of Watteau (see Fig. 29.3) and a particular engraving executed by Marcantonio Raimondi [ray-MOHN-dee] (Fig. **36.7**) after a lost painting designed by Raphael, *The Judgment of Paris* (1520). Manet's three central figures assume the same poses as the wood nymphs seated at the lower right of Raimondi's composition, and so Manet's painting can be understood as a "judgment of Paris" in its own right—Manet judging Paris the city in all its bourgeois decadence. It was, in fact, the discord between the seated female's frank nudity—and the fact that she appears to confront directly the gaze of the viewer—and her fully clothed male companions, who seem

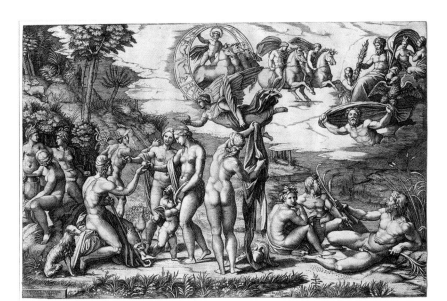

Fig. 36.7 Marcantonio Raimondi after Raphael. *The Judgment of Paris.* **ca. 1520.** Engraving. Inv. 4167LR. Rothschild Collection. Musée du Louvre/RMN Réunion des Musées Nationaux, France. SCALA/Art Resource, NY. Paris judges which of the goddesses—Aphrodite, Hera, or Athena—is the most beautiful. His choice has profound impact, leading as it does to the Trojan War.

engaged in a conversation wholly at odds with the sexualized circumstances, that most discomfited the painting's audience. Manet's assault on his fellow Parisians' sensibilities continued in 1863 with *Olympia* (see *Focus*, pages 1164–1165), though the painting was not exhibited until the Salon of 1865, where once again it was the object of public scandal and ridicule.

Émile Zola and the Naturalist Novel

Early in 1867, the novelist Émile Zola [ay-MEEL zoh-LAH] (1840–1902) came to the defense of his friend Manet and *Olympia* in particular in a short book entitled simply *Édouard Manet*. Manet, he said, painted "in a way which is contrary to the sacred rules taught in schools." He continues (Reading 36.7):

READING 36.7 from Émile Zola, *Édouard Manet* (1867)

He has made us acquainted with Olympia, a contemporary girl, the sort of girl we meet every day on the pavements, with thin shoulders wrapped in a flimsy faded woolen shawl. The public as usual takes good care not to understand the painter's intentions. Some people tried to find philosophic meaning in the picture, others, more lighthearted, were not displeased to attach an obscene significance to it. . . . But I know that you have succeeded admirably in doing a painter's job, the job of a great painter; I mean to say you have forcefully reproduced in your own particular idiom the truths of light and shade and the reality of objects and creatures.

A year after Zola's defense, Manet painted his friend's portrait (Fig. 36.8). On the wall behind him is a black-and-white reproduction of *Olympia*—perhaps a subtle tribute to Zola's claim that Manet was interested in portraying "the truths of light and shade." Zola himself was anything but disinterested in the gritty realities of modern life. He practiced a brand of literary realism called *naturalism*—that is, in his words, "nature seen through a temperament." It is distinct from realism because it does not pretend to objective reporting. Zola was, in other words, completely aware that the artist's own personality definitively influenced the work and his view of the world (Reading 36.8):

READING 36.8 from Émile Zola, "The Moment in Art" (1867)

There are, in my opinion, two elements in a work: the element of reality, which is nature, and the personal element, which is man. The element of reality, nature, is fixed, always the same; it is given equally to all men. . . . The personal element, man, is, on the other hand, infinitely variable; there are as many possible works as there are different minds. . . . The word "realist" means nothing to me, since I am determined to subordinate the real to temperament. . . . For it is equally ridiculous to believe that in matters of artistic beauty, there is one absolute and eternal truth. The single and whole truth is no good for us, since we construct new truths each morning and have worn them out by the evening. . . . This means that the works of tomorrow cannot be the same as those of today. . . .

Focus

Critics particularly criticized Manet's treatment of this hand, its fingers smudged and unformed, seeming to lack joints. Its rendering appeared simply incompetent to them, but it announces that Manet's realism is something other than photographic. He is more interested in the social realities that inform the scene.

Manet's *Olympia*

Manet's Olympia is a courtesan, or, more properly, not quite a courtesan. For she possesses the slightly stocky body of the working class—a *petite fabourienne* [puh-TEET fah-boor-ee-EN], one critic of the day called her, a "little factory girl." Perhaps she is one of the many factory girls who, in 1863, found themselves out of work in Paris, a casualty of the American Civil War. Unable to get raw cotton from the South, the cotton mills of Paris had to shut down. Many girls turned to prostitution in order to survive. Viewers at the Salon of 1865 were disturbed by her class—a courtesan satisfied upper-class tastes, prostitutes did not—by the position of her left hand, and, above all, by her gaze. Not only is her gaze as direct as the nude in *Le Déjeuner* (Manet used the same model in both); it is confidently directed downward toward us, the viewers. It is as if we have just arrived on the scene, bringing flowers that we have handed to the black maid. We are suddenly Olympia's customers. And if her body is for sale, then we have entered as well into the economy in which human beings are bought and sold—the economy of slavery.

We know that Manet was acutely aware of the politics of slavery. At age 16, in 1848, he set sail for Brazil aboard a merchant marine ship. From Rio de Janeiro, he wrote his mother:

> In this country all the Negroes are slaves; they all look downtrodden; it's extraordinary what power whites have over them; I saw a slave market, a rather revolting spectacle for people like us. The Negresses are generally naked to the waist, some with a scarf tied at the neck.

Here, in all likelihood, is the original contact with slavery that 15 years later would be realized in *Olympia* itself.

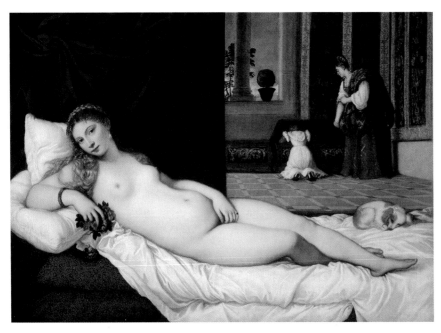

Titian. *Reclining Nude (Venus of Urbino)*. ca. 1538. Oil on canvas, 47″ × 65″. Galleria degli Uffizi, Florence.

In the 1980s this very bracelet and medallion were found in France. In the medallion was a lock of hair and a note, apparently written by Manet's niece, Julie Manet. The note claimed that the hair was Édouard Manet's at the age of 15 months.

Manet's painting mirrors the structure of Titian's *Reclining Nude* (left), but where Titian portrays two ladies-in-waiting in the deep architectural space of the right side, Manet paints a single, barely lit window. This suggests that where Titian's painting takes place in daylight, Manet's takes place at night in a room lit by artificial light and may be a comment on the nature of love and beauty in Manet's Paris. In Titian's *Venus of Urbino* a dog, symbolizing fidelity, lies at the nude's feet. Here a black cat, symbolizing promiscuity, arches its back as if to hiss in protest at the viewer's arrival.

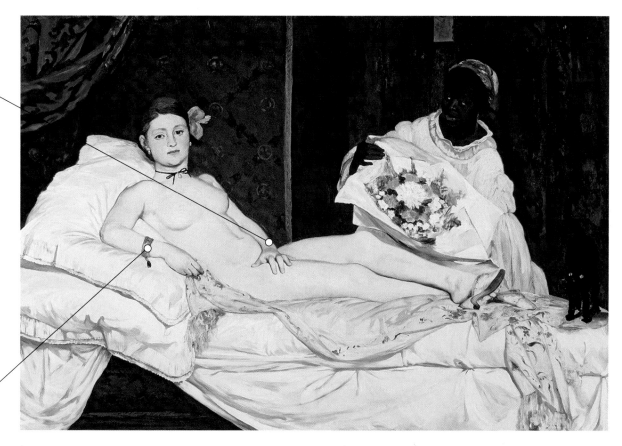

Édouard Manet. *Olympia.* 1863 (Salon of 1865). Oil on canvas, 51″ × 74³⁄₄″. Inv. RF 2772. Hervè Lewandowski/Musée d'Orsay, Paris, France. RMN Réunion des Musées Nationaux/Art Resource, NY. © 2008 Édouard Manet/Artists Rights Society (ARS), NY.

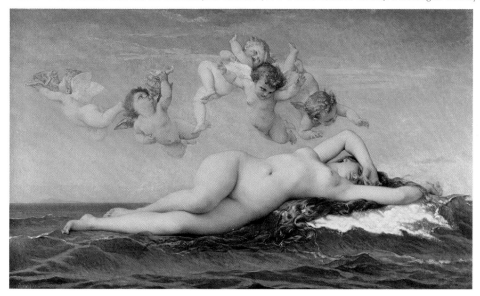

Alexandre Cabanel. *The Birth of Venus.* Salon of 1863. Oil on canvas, 52″ × 90″. P. Selert/Musée d'Orsay, Paris, France. Réunion des Musées Nationaux/Art Resource, NY. Just how radical Manet's painting must have seemed in 1865 can be understood by comparing it to this painting. The notoriously prurient Napoleon III, who had called Manet's *Le Déjeuner* "immodest," purchased it at the Salon of 1863. Cabanel's nude passively invites the gaze of the viewer, but does not meet it. The flock of cupids busy blowing conch shells above her head establishes the propriety of her nudity. She exists in mythological space, unlike Olympia, who rests firmly in the real.

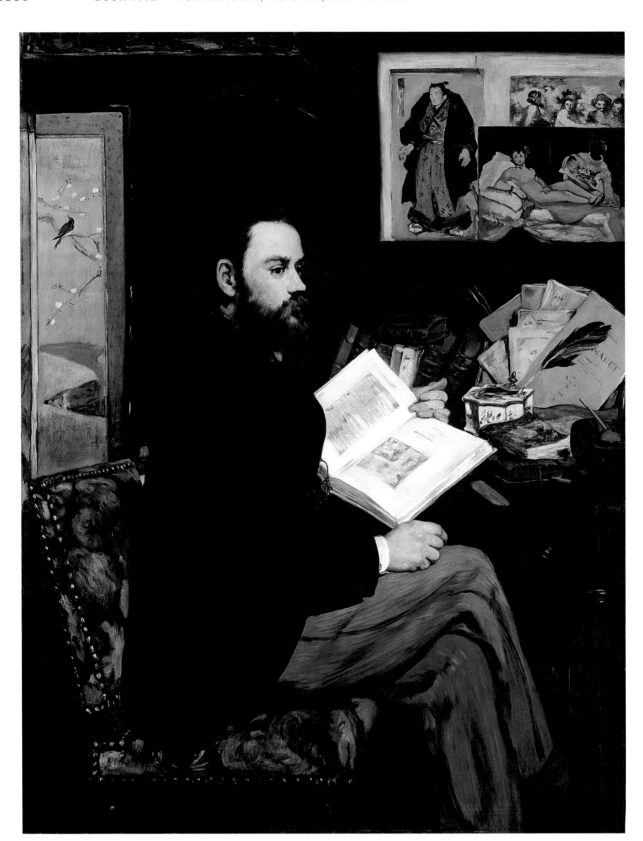

Fig. 36.8 Édouard Manet. *Portrait of Émile Zola.* **1868.** Oil on canvas, $56\frac{5}{8}''\times44\frac{7}{8}''$ RF2205. Musée d'Orsay, Paris, France. Photo: Hervè Lewandowski. Reunion des Musées Nationaux/Art Resource, NY. The Japanese woodblock print in the painting, has been identified as a portrait of a sumo wrestler by Kuniaki II. Japanese culture was strongly represented at the Universal Exposition in Paris in 1867, and the growing interest of Western artists including Manet, become increasingly interested in Japanese art.

Zola also believed that all human beings (including authors and artists) are products of hereditary and environmental factors over which they have no control but which very much determine their lives. He applied this belief in such novels as *Thérèse Raquin* [tay-REZ rah-KEHN] (1867). The Thérèse of the title begins a love affair with a friend of her husband. The lovers drown the husband, only to find that their guilt makes life together intolerable, leading them to plot each other's murder. Zola described his strategy in the novel's preface (**Reading 36.9**):

READING 36.9 **from Émile Zola, Preface to *Thérèse Raquin*, 2nd edition (1868)**

I set out to study, not characters, but temperaments. Therein lies the whole essence of the book. I chose to portray individuals existing under the sovereign dominion of their nerves and their blood, devoid of free will and drawn into every act of their lives by the inescapable laws of their physical nature. Thérèse and Laurent are human animals, nothing more. I have endeavored to follow these animals through the devious working of their passions, the compulsion of their instincts, and the mental unbalance resulting from a nervous crisis. . . . I had only one desire: given a highly-sexed man and an unsatisfied woman, to uncover the animal side of them and see that alone, then throw them together in a violent drama and note down with scrupulous care the sensations and actions of these creatures. I simply applied to two living bodies the analytical method that surgeons apply to corpses.

Such realism reached its most powerful expression in Zola's 1885 novel *Germinal* [zher-mee-NAHL], about the lives of France's coal miners (see **Reading 36.10**, page 1181 for an extended passage). Permanently fatigued, anemic, emaciated by the coal dust they ceaselessly breathe, the miners live their lives in perpetual gloom (**Reading 36.10a**):

READING 36.10a **from Émile Zola, *Germinal* (1885)**

They all hammered away, and nothing could be heard but these irregular blows, muffled, seemingly far-off. The sounds took on a harsh quality in the dead, echoless air, and it seemed as if the shadows created a mysterious blackness, thickened by the flying coal dust and made heavier by the gas which weighed down their eyes. The wicks of their lamps displayed only glowing red tips through their metal screens. You couldn't make out anything clearly. The work space opened out into a large chimney, flat and sloping, on which the soot of ten winters had created a profound night. Ghostly forms moved about, random light beams allowing a glimpse of the curve of a thigh, a brawny arm, a savage face, blackened as if in preparation for a crime. . . .

Zola experienced these brutal realities firsthand when, in researching the novel, he descended into a mineshaft and took detailed notes. The scene could also be summed up as Zola's effort to capture "the truths of light and shade and the reality of objects and creatures," as he had written of Manet's *Olympia*. But it is the novel's intense documentary-like exposé of the living conditions his characters must endure that is most notable. The plight of the proletariat had never been so clearly depicted.

Nationalism and the Politics of Opera

Popular taste in Napoleon III's Second Empire was antithetical to the realism of a Courbet (see chapter 35) and the naturalism of artists like Manet and Zola. It preferred the Romanticism of an earlier generation, as illustrated by Emma Bovary's voracious consumption of romantic novels. The dynamics of this confrontation between bourgeois taste and what we have come to call the **avant-garde** [ah-vunt-GARD]—artists on the cutting edge—played itself out in the Second Empire most surprisingly at the opera. As a musical form favored by the aristocracy, and increasingly by the bourgeoisie, opera played an important social as well as musical role in Paris. Established by Louis XIV in 1669, the *Académie Nationale de Musique* (National Academy of Music) encompassed opera, music, and ballet. The opera was at once a state institution, a symbol of French culture and sovereignty, and a reminder of the country's royal heritage. In a period of rapid change during a century when the aristocracy lost its hold on power throughout Europe, the opera house seemed to be an oasis of conservative stability and aristocratic values. Or it should have been, thought its long-time aristocratic patrons and the *nouveau riche* (newly rich) bourgeois audience.

Yet change did arrive at the opera in the form of the most creative composers of the period, many of whom were associated with the revolutions of 1848 and the fervent nationalism sweeping the Continent. Since the aristocracy and the bourgeoisie shared a sense of hostility toward liberal nationalism and its notions of social equality and individual rights, a clash between opera's practitioners and audience was bound to happen.

Ever since Beethoven stopped writing his dynamic and tempo directions in Italian, replacing them with German, nationalism had become a growing force in music. Frédéric Chopin (see chapter 34), a native of Poland, wrote many mazurkas and polonaises—traditional Polish folk dance forms—while living in Paris as part of a group of Poles forced into exile after the Russians had taken control of their country. The composer Robert Schumann immediately recognized Chopin's works as political compositions. If the Russian czar "knew what a dangerous enemy threatened him in Chopin's works," Schumann wrote, "in the simple tunes of his mazurkas, he would forbid this music. Chopin's works are cannons buried in flowers."

The confrontation between nationalism and the aristocracy played out, in Paris, at the new Paris Opéra [oh-pay-RAH], designed by Charles Garnier and constructed

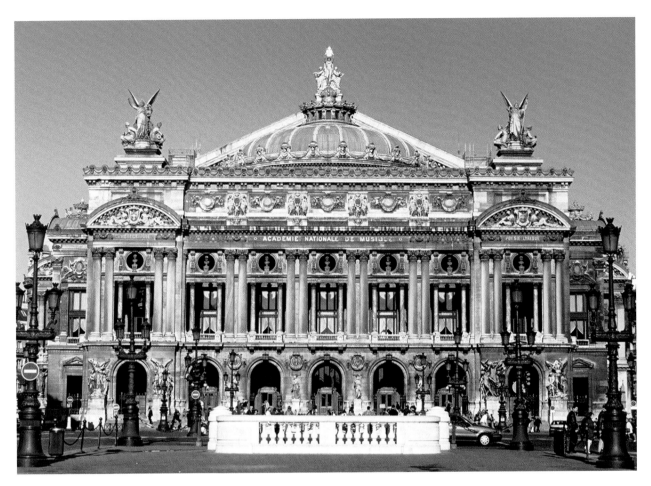

Fig. 36.9 Charles Garnier. Facade of the Opéra, Paris. 1860–1875. Construction of the opera building started in 1862, but was slowed because of the high water table under the gigantic stage and fly tower. The water was drained, a massive concrete well was built to carry the stage and fly tower, and it was filled with water to counter the water pressure. This is the underground lake made famous in Paul Leroux's famous play *The Phantom of the Opera.*

between 1860 and 1875 (Fig. **36.9**). Its facade is a unique marriage of the Neoclassical and the Baroque, conceived to reflect a new imperial style. A Corinthian colonnade of paired columns tops a closed arcade of arches at the entrance, the whole embellished with exotic carved decorations. At the head of the new, broad Avenue de l'Opéra running at a diagonal from the rue de Rivoli and the Louvre, the Opéra literally commanded the center of Paris. Its Grand Staircase, rising to a height of 98 feet, is itself a theater within the theater, designed to allow the aristocrats and the bourgeoisie to display themselves (Fig. **36.10**). So too were the loges, multi-seat boxes where women typically sat forward, in their finest evening wear, to show off their social position and wealth.

Giuseppe Verdi and the Grand Opera The Italian composer Giuseppe Verdi [VER-dee] (1813–1901) led the way in politicizing opera compositions. Verdi believed that opera should be, first of all, dramatically realistic. No longer were arias, duets, or quartets merely displays of the singers' technical virtuosity; rather, they dramatically expressed the characters' temperament or situation in magnificent sustained melodies. A case in point is Verdi's *Rigoletto* [ree-goh-LET-toh], a tragic opera in three acts, first performed in Venice in 1851, in which the womanizing duke of Mantua [MAHN-too-ah], disguised as a student, pays court to Gilda, who, unknown to him is the daughter of his hunchbacked court jester, Rigoletto. When Rigoletto learns that the duke has seduced her, he conspires to have him killed by a professional assassin, but the plan goes awry when the assassin's sister, Maddalena [mad-uh-LEH-nah], pleads for the duke's life. Because the assassin needs a victim in order to justify his payment, Gilda, who has overheard their conversation, sacrifices her own life to save the duke. For Act III, Verdi composed a quartet in which each of the characters conveys contrasting emotions (**CD-Track 36.1**). Two scenes are presented simultaneously. The duke tries to seduce Maddalena inside the inn while Rigoletto and Gilda watch from the outside. Rigoletto is demonstrating to the innocent Gilda the duke's moral depravity, and she reacts with shock and dismay. Here a wide range of human emotion occurs in a single scene.

As Italy struggled to achieve national unity, Verdi's operas came to symbolize Italian nationalism. Any time a female lead in his operas would yearn for freedom, the audience

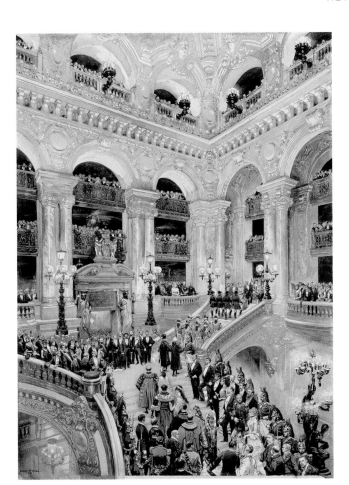

Fig. 36.10 Édouard Detaille, *Inauguration of the Paris Opera House, January 5, 1875: Arrival of Lord Maire (with entourage) from London, Greeted by Charles Garnier.* Gouache on paper. Photo: Gerard Blot. Châteaux de Versailles et de Trianon, Versailles, France. Réunion des Musées Nationaux/Art Resource, NY. At the staircase's base, the two bronze *torchères,* large female figures brandishing bouquets of light, were illuminated by the new technological innovation of gaslight, as were the large sconces in front of the marble columns.

would understand her as a symbol of Italian unification, and it would erupt in a frenzy of applause. Even Verdi's name came to be identified with nationalist politics, as an acronym for the constitutional monarchy established in 1861 of Victor Emanuel—V[ictor], E[manuel], R[e] d'I[talia], "Victor Emanuel, King of [a unified] Italy."

To have his operas produced in Paris, Verdi was forced to make changes to satisfy the censors, who were sensitive to nationalist references. He had to accommodate French taste as well. Since all Paris operas traditionally included a second-act ballet, he inserted a gypsy dance around a campfire at an appropriate spot in *Il Trovatore* [eel troh-vah-TOR-eh] (*The Troubadour*). *Il Trovatore* (originally premiered in Rome in 1853) was set in Spain and centered on the Count di Luna's young brother, kidnapped and brought up by a gypsy woman, whose own mother had been burned as a witch by the count's father. The second-act ballet was a requirement of the Jockey Club, an organization of French aristocrats who came to the opera after dinner, long after the opera had begun, and expect-

ed a ballet when they arrived. As the French journalist Alfred Delvau [del-VOH] explained: "One is more deliciously stirred by the sight of the ballet corps than by the great arias of the tenor in vogue or the reigning prima donna." So Verdi, the most popular opera composer of the day, who also viewed himself as a pragmatist, went along with the idiosyncratic Paris tradition. Considering the large number of Verdi performances in Paris in the 1850s, his changes must have met with success. (In the 1856–1857 season, the Théâtre des Italiens in Paris offered 87 performances—54 of them Verdi operas.)

Wagner's Music Drama Meets the Jockey Club The Jockey Club's ability to dictate taste and fashion—which the bourgeoisie anxiously copied—extended, in a notorious example, to Richard Wagner's opera *Tannhäuser* [than-HOY-zur] in March 1861. Declaring that his was "the art of the future," Richard Wagner [VAHG-ner] (1813–1883) had arrived in Paris in 1859, where Wagner reported that the press found him "arrogant" and guilty of "repudiating all existing operatic music." Nonetheless, he managed to secure Louis-Napoleon's support for a production of *Tannhäuser*, an opera in three acts. Because of the Paris Opéra's rule that foreign works be presented in French, Wagner set about having the opera translated into French.

Tannhäuser's protagonist is a legendary knight minstrel (*Minnesinger*), the German equivalent of a medieval troubadour. When other minstrels gather for a tournament of song in the great hall of the Wartburg [vart-boorg] castle, near the Venusberg [VEH-noos-berg], a hill in which Tannhäuser has taken refuge for a year under the magic spell of Venus, goddess of love, he insists on returning to Earth in order to compete. Once again he meets his beloved, Elisabeth, who sings to him the famous aria *Dich, teure Halle* [dikh toy-ruh hah-leh] ("Thou, Beloved Hall") (**CD-Track 36.2**), welcoming him back to the great hall where he formerly sang. She is excited that this beautiful space will once again resonate with music.

Traditionally, the operatic voice carries the melody and the orchestra provides accompaniment. As a result, Wagner felt, the music overwhelmed the text. So, in order to make the text understandable, Wagner shifted the melodic element from the voice to the orchestra. Elisabeth thus sings in a declamatory manner that lies somewhere between aria and recitative, and the orchestra carries the melody, following Elisabeth's shift in mood from ecstatic welcome to sad remembrance of her year-long loss. So radical was this change, the orchestra more or less taking over from the vocalist the primary responsibility for developing the melodic character of the work, that French audiences found Wagner's music almost unrecognizable as opera.

For a French audience, the music was too new to appreciate fully, and the plot, derived directly from German folklore, was hopelessly foreign. The opera seemed aimed at inflaming French/German hostility. Wagner was informed, furthermore, of the necessity of writing a ballet for the opening of the second act. He refused, though he did agree to *begin* the opera with a ballet. Already unhappy that an expensive production of a German work was to be staged in *their* opera, the Jockey Club was doubly outraged that its composer refused to

insert the ballet in its traditional place. Wagner seemed nothing short of a liberal nationalist deliberately trying to provoke his conservative French audience.

As rehearsals progressed, the Jockey Club provided its members with silver whistles engraved with the words "*Pour Tannhaeuser*." They used these whistles in defense of their aristocratic privileges on opening night, March 13, 1861. With Louis-Napoleon present in his box, the Jockey Club interrupted the music for as much as 15 minutes at a time as they hissed and whistled. "The Emperor and his consort stoically kept their seats throughout the uproar caused by their own courtiers," Wagner noted. The opera received the same reception at both its second and third performances. Paris was divided. The composer Berlioz found no virtue in the music, while Baudelaire admired it. After the third performance, which included several lengthy fights and continued whistling from the Jockey Club, Wagner demanded that the opera be withdrawn from performance. The French government accepted their financial losses and agreed.

Wagner's Music Drama The theme of *Tannhäuser*—the conflicting claims of sexual pleasure and spiritual love—is hopelessly Romantic, which might have appealed to bourgeois and aristocratic French taste, but its music and its approach to the opera as a form did not. Like Verdi, Wagner sought to convey realism, so that his recitatives, arias, and choruses made dramatic sense. And he considered his work a new genre—**music drama**—in which the actions acted out on stage are the visual and verbal manifestations of the drama created by the instruments in the orchestra, "deeds of music made visible," as he put it. This he accomplished by the **leitmotif** [LITE-moh-teef], literally a "leading motive." For Wagner this meant a brief musical idea connected to a character, event, or idea that recurs throughout the music drama each time the character, event, or idea recurs. However, as characters, events, and ideas change throughout the action, so do the leitmotifs, growing, developing, and transforming. Berlioz's *idée fixe* is a similar device in Romantic orchestral music (see chapter 34).

A clear example of the leitmotif is in the Prelude to Wagner's 1865 opera in three acts, *Tristan and Isolde* (**CD-Track 36.3**). The opera is based on the medieval legend of the ill-fated love of the Cornish knight Tristan and the Irish princess Isolde, whom Tristan's uncle, King Mark, wishes to marry against her will and for which purpose he has sent Tristan to Ireland to bring her back to Cornwall. Tristan's allegiance to King Mark is compromised by the fact that many years earlier Isolde, not knowing his identity as the man who had killed her fiancé and suffered wounds in the battle, had saved his life by nursing him back to health. When she did learn his identity, she could not bring herself to take vengeance. And so, as their ship sails for Cornwall, the two, unable to admit their mutual attraction but acknowledging the debt owed to Isolde, agree to drink poison before the ship lands. However, Isolde's maid substitutes a love potion for the poison, which frees the pair to admit their love. The leitmotif asso-ciated with drinking the love potion constitutes the first phrases of the Prelude:

At the first sounding of this leitmotif—known as both the "love potion" motif and the "yearning" motif—the audience does not understand its significance. The motif repeats throughout the Prelude in various forms and pitches. Not until it recurs, in Act I, as Tristan and Isolde are about to drink what they believe to be poison, does its full significance become clear (Fig. **36.11**). The longing that the leitmotif conveys is largely dependent on harmonic dissonance of the opening chord, which, as the very first harmony of the work, audiences found particularly disconcerting. The chord does not resolve itself, but rather changes into an equally dissonant harmony followed by a long silence. This refusal to resolve the leitmotif represents the lovers' unresolved longing.

Wagner's greatest realization of the leitmotif idea occurs in four music dramas dating from 1848 to 1874, titled collectively *Der Ring des Nibelungen* [der ring des nee-beh-LOONG-un] (*The Ring of the Nibelung*). The "*Ring*" forms an epic cycle based on Norse mythology involving the quest for a magical but accursed golden ring, the possessor of which can control the universe. Collectively, it represents Wagner's dream of composing a ***Gesamtkunstwerk*** [geh-SAHMT-koonst-verk], or total work of art, synthesizing music, drama, poetry, gesture, architecture, and painting (the latter two through stage design). The *Ring* features more than 20 leitmotifs that Wagner weaves into an intricate web, the four music dramas being performed over the course of four days. For instance, the hero Siegfried is associated with his famous horn call, and other leitmotifs represent objects like the Rhine gold and Valhalla (home of the gods), emotional states like love's awakening, and concepts like redemption. The cycle premiered in 1876 in Bayreuth, a small city in Bavaria. Here, with the help of his patron Ludwig II of Bavaria, Wagner oversaw the building of a *Festpielhaus* [FESHT-peel-hows], or "festival drama house," that he hoped might help to unify Germany both culturally and politically (Fig. **36.12**). In his appeal for funds to underwrite construction, Wagner makes the political motives of his project plain:

> In Hellas [ancient Greece], the supreme flowering of the State went hand in hand with that of Art; so too the resurrection of the German Empire should be accompanied by a massive artistic monument to the German intellect. In the field of politics, the German mission in the history of the world has recently enjoyed its second triumph [the victory over France in the 1870 Franco-Prussian war]—now its spiritual victory is to be celebrated, through the German Festival in Bayreuth.

Fig. 36.11 Bill Viola. *The Fall into Paradise (Act I, Scene 5—Tristan and Isolde drink the potion).* 2004. Still photo by Kira Perov from *The Tristan Project,* a collaborative semi-staging of Wagner's *Tristan und Isolde* by video artist Bill Viola, conductor Esa-Pakka Salonen, and director Peter Sellars. 2004. The video images echo rather than illustrate the inner story of the opera in much the same way as the music. Here in the new rapture of the confessed love, Tristan and Isolde caress each other as they float under water.

It was this spirit of German nationalism that would lead Adolf Hitler to lionize Wagner's music during the Third Reich [rykh] 60 years later.

Operetta: Jacques Offenbach and Musical Satire

As Wagner's experience suggests, serious opera was not particularly well received in Paris, the center of the art and music world during the 1860s. But the comic operas that played at the Opéra-Comique [oh-pay-RAH-koh-MEEK] were widely popular, enjoyed by Baudelaire and almost everyone else in Paris, aristocrats, the bourgeoisie, and the working class alike. Far and away the most admired of those writing comic operas was Jacques Offenbach [OFF-un-bahk] (1819–1880), a Jewish composer.

This fact must have appalled the virulently anti-Semitic Richard Wagner, who in 1850 had composed a polemic entitled "Jewry in Music," the chief target of which was composer Felix Mendelssohn.

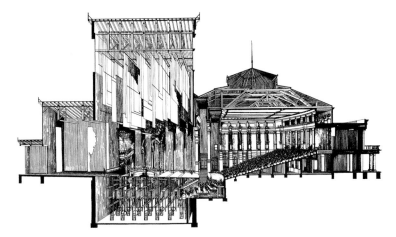

Fig. 36.12 Richard Wagner. Cross-section of the Bayreuth Festspielhaus. 1872–1876. From Frederic Spotts, *Bayreuth: A History of the Wagner Festival* (New Haven: Yale University Press, 1994). © 2003 Yale University Press/Spotts, BAYREUTH: A History of the Wagner Festival (1994), image p. 9. The design puts the orchestra beneath the stage, thus drawing the audience closer to the performance and projectizng the orchestra's music directly toward it, all resulting in acoustics ideal for the integration of orchestral and vocal parts.

The tract makes clear that Wagner's feelings were driven largely by his nationalism. As a speaker of German he is offended by Yiddish, which he calls "intolerably jumbled blabber." From Wagner's point of view, Jewish speech necessarily rendered the Jews incapable of producing music. Of Offenbach's music in particular, Wagner would simply say that it "gives off the heat of the manure in which all the pigs of Europe have come to wallow."

Born in Germany, Offenbach did not care what Wagner thought of his music. After all, Wagner was a failure in Paris, while he, Offenbach, was a success. He dominated the fashionable music scene of the Second Empire, satirizing the politics of Louis-Napoleon's reign and capturing its cosmopolitan atmosphere and loose morals in light operas that he called **operettas**. This genre of musical theater usually mixed spoken dialogue with sung numbers that might include rowdy music from the dance halls of the day, including the "can-can." His hit of 1866, *La Vie Parisenne* [lah vee pah-ree-zee-EN] (*The Parisian Life*), has a baron and baroness bamboozled by two veterans of the boulevards as they enjoy the plays, cafés, and amorous entertainments the city has to offer. His hit of the following year, *The Grand Duchess of Gérolstein* [zhay-roll-SHTINE], was originally entitled simply *The Grand Duchess*, but censors objected on the grounds that Russia might take offense, thinking that Offenbach was satirizing Catherine II, which in fact he was. (Grand Duchess was her title upon marrying Grand Duke Peter.) At one point, the duchess lines up her troops for inspection: "Oh, how I love the military," she sings, "Their sexy uniforms, / Their mustaches and their plumes." Upon seeing a handsome young soldier named Fritz, she promotes him to sergeant, then lieutenant, captain, and ultimately commander-in-chief to replace General Boum [boom], a man who, instead of taking snuff, shoots off his pistol periodically and inhales the smoke from its barrel. In an amusing way, and under the guise of mindless entertainment, Offenbach effectively mocked the political and military authorities. Indeed, within three years the farcical war that Fritz wages—no one gets killed because he gets the enemy drunk—would suddenly become a reality in Paris, but no longer a farce, this time a tragedy led by the tyrant Louis-Napoleon, who precipitated the Franco-Prussian War (see chapter 37). In later life Offenbach tried to bridge the gulf between serious and light opera that he had helped to create in the five-act opera, *The Tales of Hoffmann*.

Verdi, Wagner, and Offenbach all played an important role in transforming opera from a staid bastion of aristocrats and conservative values to a popular art form. By the end of the century, Verdi and Wagner were firmly placed in the pantheon of national heroes of their countries alongside leaders and revolutionaries such as Garibaldi, Mazzini, and Bismarck. And by the end of the nineteenth century, aristocrats, bourgeoisie, and workers across Europe were enthralled by a nationalist ideology that would, little more than a decade

later, lead to an epochal conflict that would kill 10 million—World War I.

The American Civil War

There was a great cultural and geographical distance between Paris and the rural South of the United States, yet as the nineteenth-century world became increasingly interdependent, there were also important connections between the two areas. Cotton textiles were enormously important to Europeans, and much of their supply came from the American South. So there was great consternation in Britain, France, Germany, and other European states when, in 1860, the Civil War loomed. From the European point of view, the causes that led to that war (1861–1865) seemed all too familiar. On the one hand, it appeared that the Union (Northern) states were insisting on the abolition of slavery in the tradition of liberal ideology. On the other hand, the Confederate (Southern) states, a predominantly agricultural society based on slavery, desired, in typical nationalist ideological form, to become a sovereign state of its own.

Both the British and French textile industries, and indeed, the entire economies of both nations, depended heavily on the imports of Southern cotton. As a result, they sided with the South insofar as it fought, in the antebellum [an-tee-BELL-um] [prior to the Civil War] Congress, to uphold free-trade policies while the North pushed for protective tariffs. The South felt confident that out of economic necessity Britain, and possibly France, would side with it in any conflict. But abolitionist sentiment ran high in Europe. Harriet Beecher Stowe's *Uncle Tom's Cabin* (see chapter 35) was a bestseller across the Continent, and, besides, both the British and French governments were not disposed to support an uprising that appeared even vaguely nationalist. Both nations were busily acquiring colonial possessions in Asia and Africa, and were uncomfortable with nationalist sentiment. To the South's surprise, both maintained neutrality throughout the conflict, despite continued Confederate attempts to draw Europeans to their side.

Romanticizing Slavery in Antebellum American Art and Music

Many in Europe across the globe were surprised that war erupted in the United States, believing that some sort of compromise was likely. In no small part, this delusion resulted from a romanticized view of slavery embedded even in abolitionist literature such as *Uncle Tom's Cabin*. For every Simon Legree there is an Augustine Saint Clare and his daughter, Little Eva; for every abused slave, a grateful Christian convert.

Eastman Johnson: The Ambiguity of *Negro Life in the South* A prime example of blindness to the full implications of slavery in antebellum America is evident in the painting *Negro Life in the South* by Eastman Johnson (1824–1906)

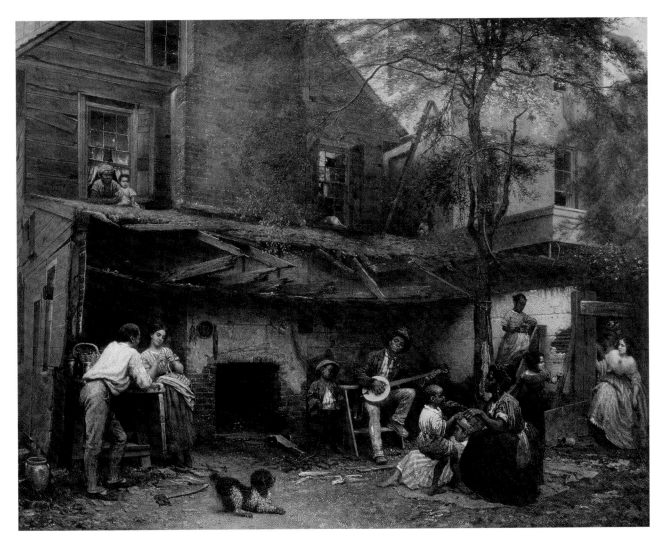

Fig. 36.13 Eastman Johnson. *Negro Life in the South (Kentucky Home).* 1859. Oil on canvas, 36″ × 45″.
© Collection of the New-York Historical Society, USA/The Bridgeman Art Library. Johnson studied in Europe from
1849 to 1855, culminating in Paris in the studio of Thomas Couture, where Édouard Manet was also a student.

(Fig. **36.13**). The painting achieved instant success when
exhibited in 1859 in New York. Much of its realism was con-
tributed by the models Johnson employed—the household
slaves owned by his father in Washington, DC.

Negro Life in the South was a curious painting in that it
was highly ambiguous—it could be read as either for or
against slavery. For some, Johnson's painting seemed to
depict slaves as contented with their lot. A banjo-picker
plays a song for a mother and child who are dancing togeth-
er. A young man and woman flirt at the left, while another
woman and child look out on the scene from the window
above. The white mistress of the house steps through the
gate at the left as if to join in the party. However, to an abo-
litionist, the contrast between the mistress's gown and the
more ragged clothing of the slaves, between the dilapidated
shed and the finer house behind, demonstrates the sorry
plight of the slaves.

Stephen Foster and the Minstrel Song Of all representa-
tions of African Americans before the Civil War, perhaps
the most popular was the **minstrel show**, a theatrical event
that presented black American melodies, jokes, and imper-
sonations, usually performed by white performers in black-
face. It evolved out of two types of common entertainment
in the early nineteenth century: theatrical or circus skits in
which white actors impersonated black banjo-playing street
musicians. In 1828, Thomas Dartmouth "Daddy" Rice, a
white man, began performing as an old slave named Jim
Crow, and his song-and-dance show soon had many imita-
tors. By the 1840s, a group of white performers in New York
were performing in blackface as the Virginia Minstrels. The
instruments they used to accompany themselves—bone cas-
tanets, violin, banjo, and tambourine—quickly became stan-
dard. *The Virginia Minstrels'* success led to the formation of
the Christy Minstrels, headed by white actor Edwin P.

Christy, whose show included songs, often referred to as "Ethiopian" melodies, usually set in the South and rendered in black dialect, as well as crude, racist jokes. The stereotypes perpetrated by the minstrel shows—African Americans as fun-loving, carefree people likely to break out in joyful song but also as ignorant, lazy, and superstitious buffoons—became a staple of American entertainment. And by the 1850s, songs about escaped slaves longing to return to their kindly masters were standard fare.

In 1848, the Christy Minstrels performed a song that quickly became a national hit: "Oh! Susanna," written by Stephen Foster (1826–1864), a young Pittsburgh bookkeeper. Foster realized that the minstrel stage was the key to securing an audience for his songs, but he also wanted to write a new kind of music for it. Rather than trivializing the hardships of slavery, he wanted to humanize the characters in his work and create songs that communicated to all people. Foster was also a music business pioneer, becoming a professional songwriter in an era when selling sheet music through a publisher was the only way to earn money from his wildly popular tunes.

In the next several decades, Foster wrote all kinds of songs, including "Camptown Races" (1850) (see **CD-Track 36.4**). The near-nonsense dialect of "Camptown Races" reinforces the portrayal of the black as a fool. Foster's so-called **plantation melodies** were also written in dialect but were quite different—depicting blacks as capable of a full range of human emotion. His 1849 song "Nelly Was a Lady," for instance, made popular by the Christy Minstrels, portrays a black man and woman as loving husband and wife. In "Nelly," Foster did something previously unheard of, allowing the husband to call his wife a "lady," a term heretofore reserved for well-born white women. Other famous Foster tunes included "Old Folks at Home" (Swanee River) (1851) and "My Old Kentucky Home" (1853). Finally, Foster wrote a number of parlor songs—so-called because they were to be performed in parlors—including "Jeanie with the Light Brown Hair" (1854) and "Beautiful Dreamer" (1862).

Eastman Johnson's *Negro Life in the South* was so closely associated with Foster's music that the painting quickly became known by another name—*Kentucky Home*. Together they sum up the complexities of antebellum attitudes about slavery. What they make apparent is how America before the Civil War was dominated by the mythologized, unrealistic, and romanticized view of slavery.

Representing the War

On October 16, 1859, relations between whites and slaves in America changed dramatically when John Brown (1800–1869), a white abolitionist, led 21 followers, five of them African American, on a raid to capture the federal arsenal at Harpers Ferry, West Virginia. Their intention was to set off a revolt of slaves throughout the South, but two days

later Lieutenant Colonel Robert E. Lee (1807–1879) recaptured the arsenal. Ten of Brown's men were killed in the battle, and he and the rest were hanged.

The prospect of a general slave insurgency, aided and abetted by abolitionists, convinced many in the South that the North was intent on ending slavery, a belief that the election of Abraham Lincoln (1809–1865) as president in November 1860 seemed to confirm. The images of contented slaves such as Eastman Johnson had painted in his *Negro Life* seemed to vanish instantly. After the war began in the spring of 1861, Johnson himself began to accompany Union troops to the front. His *A Ride for Liberty: The Fugitive Slaves*, which Easton painted in 1862–1863 from an incident he had witnessed, is entirely different in mood and handling from his earlier painting (Fig. **36.14**). The previous summer the Confederate army had soundly defeated the North at Bull Run, a stream near Manassas [man-ASS-uss], Virginia. Ever since that defeat the Northern and Confederate armies had stood their ground between Manassas and Washington, DC, with only minor skirmishes between the two forces. This delay gave Union commander George B. McClellan the opportunity to train a new Army of the Potomac. His intention in the spring of 1862 was to press on to Richmond, Virginia, and capture the Southern capital. In fact, in late June, before Johnson's painting was completed, now General Robert E. Lee would drive McClellan away from Richmond, back through Manassas, defeating him once more at Bull Run and moving forward to the outskirts of Washington.

In Johnson's painting, smoke fills the darkening sky. Under the muzzle of the horse, reflections flash off the barrels of the rifles of the advancing Union army. The myth of happy slave families living on Southern plantations is nowhere to be seen as the father urges his horse on, desperate to save his wife and children from the battle. Their drive for liberty, Johnson seems to say, made possible by McClellan's advance, is what the war is all about.

The American Civil War changed the nature of warfare and in response the nature of representing war. It was an intensely modern event, mechanized and impersonal in a way that no previous war had been—with hand-to-hand battles, face-to-face, bayonet-on-bayonet being the exception, not the rule. The traditional pageantry of war, "long lines advancing and maneuvering, led by generals in cocked hats and by bands of music," as one contemporary put it, were soon a thing of the past. When in the summer of 1861 the Union and Confederate armies clashed at Manassas, across the Potomac from Washington, DC, ladies and gentlemen from the capital drove out to the battleground to picnic and observe the conflict in their carriages. They quickly realized their mistake as the Union army retreated in panic, forcing its way through the wagons and buggies of the terror-stricken civilians. Still, a deep desire to know what was happening at the front consumed Americans. In response, a number of

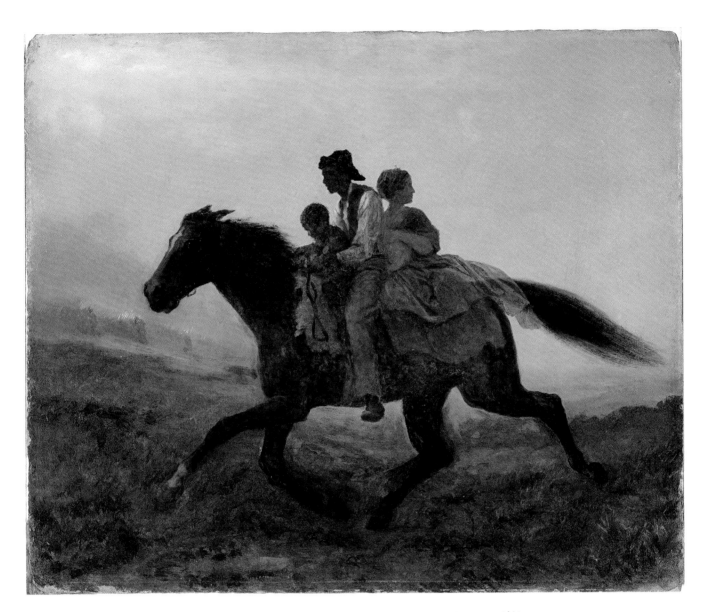

Fig. 36.14 Eastman Johnson. *A Ride for Liberty: The Fugitive Slaves.* ca. 1862–1863. Oil on board, 22″ × 26¼″.
© Brooklyn Museum of Art, New York, USA/The Bridgeman Art Library Nationality. Gift of Gwendolyn O. L. Conkling. The image of a family in flight inevitably evoked associations in viewers' minds with the flight of Mary, Joseph, and the baby Jesus into Egypt, though this is a family of four, not three. (Barely visible is a small child in the arms of its mother.) During the Civil War, over half a million slaves fled from the South, though 4 million remained.

newspapers and journals began to send "special artists" to the battlegrounds to picture events. One of these was a 25-year-old illustrator for *Harper's Weekly*, Winslow Homer (1836–1910).

Winslow Homer's Magazine Illustrations Homer immediately understood that this new war presented unique challenges. The battlefields were large—too large to represent—and death arrived not from near at hand but from the distance, from some cannon or rifle beyond the range of normal vision. The wood engraving *The Army of the Potomac—A Sharpshooter on Picket Duty* depicts this reality, with snipers hidden in the branches atop pine trees and using a telescopic sight capable of hitting a target more than a mile away (Fig. **36.15**). Death came without warning: "Our loss of officers," a Union officer said in 1862, ". . . has been awfully disproportioned, and indeed entirely unprecedented; and it may be attributed wholly to the presence of sharpshooters, who, by the brilliant uniforms which our generals wore, were enabled to pick them off like so many partridges." "Brilliant uniforms," like so many other traditional accoutrements of war, soon were relics of the past.

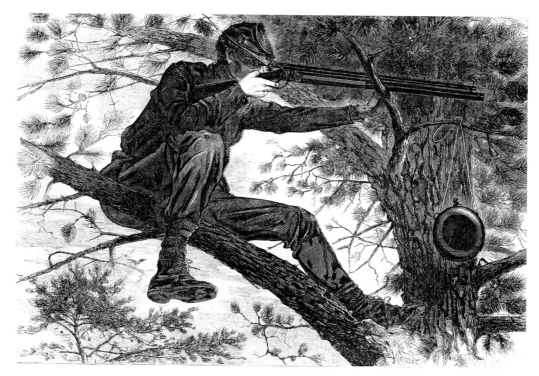

Fig. 36.15 After Winslow Homer. *The Army of the Potomac—A Sharpshooter on Picket Duty.* **1862.** Wood Engraving on paper, 9 1/8″ × 13 13/16″. Gift of International Machines Corp. Location: Smithsonian American Art Museum, Washington, DC. Art Resource, NY. This is the first of many wood engravings published in *Harper's Weekly* that were based on paintings that Homer would sometimes execute first, as is the case with Fig. 36.17 (on page 1178). More often the engravings were done before the painting was completed, as in this instance, serving as advertisements for the paintings to come.

Once, in April 1862, at Yorktown, Homer looked through the scope of a sharpshooter's rifle, and the image he saw, of an officer in the rifle's sights, "struck me as being as near murder as anything I could think of." This wood engraving, then, is for the artist an icon of murder and horror. It resonates with a particular irony through the near classical formality of Homer's setting: the sharpshooter in a visual square defined by the vertical trunk of the tree opposite his back and the horizontal line of his rifle and boot. The calm structure of the composition is a dramatic contrast with the terrible violence it describes.

Mathew Brady's Photographers It was the terror of war that increasingly impressed itself upon the American national consciousness. Given the mechanistic nature of modern warfare, this fear was, appropriately and accurately, captured by yet another machine—the camera. On September 19, 1862, Alexander Gardner, an employee of the photographer Mathew Brady (1823–1896), visited the battlefield at Antietam [an-TEET-um], Maryland. Twenty-six thousand Northern and Southern troops had just died in a battle that had no particular significance and decided nothing. Until that day, no American battlefield had ever been photographed before the dead were properly buried, but Gardner took many photographs of the scene. He even

rearranged the bodies of the dead for photographic effect—in part a necessity created by the technical limitations of photographing on a smoky battlefield. Gardner's manipulation of scenes for the camera was understood as an attempt to record a more accurate sense of the whole. Brady displayed Gardner's photographs in his New York gallery on Broadway in October—and took full credit for them, to Gardner's dismay. Within a month Brady was selling the pictures in both album-card size and stereoscopic views.

In July 1863, Gardner, now working on his own, went to the site of the Battle of Gettysburg with an assistant, Timothy O'Sullivan, who shot the most famous photograph to come out of the war, *A Harvest of Death, Gettysburg, Pennsylvania.* (Fig. **36.16**). It was published after the war in 1866 in *Gardner's Photographic Sketchbook of the War,* probably the first book-length photo essay. It is a condemnation of the horrors of war, with the Battle of Gettysburg at its center. O'Sullivan's matter-of-fact photograph is accompanied by the following caption:

The rebels represented in the photograph are without shoes. These were always removed from the feet of the dead on account of the pressing need of the survivors. The pockets turned inside out also show that appropriation did not cease with the coverings of the feet. Around is scattered the litter of the battle-field, accoutrements, ammu-

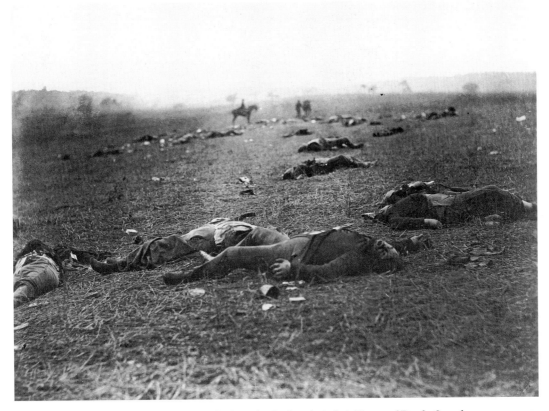

Fig. 36.16 Timothy O'Sullivan (negative) and Alexander Gardner (print). *A Harvest of Death, Gettysburg, Pennsylvania, July 1863,* from Alexander Gardner's *Gardner's Photographic Sketchbook of the War.* **1866.** Albumen silver print (also available as a stereocard), $6^{1}/_{4}$" × $7^{13}/_{16}$". Location: The New York Public Library, New York, NY/Art Resource, NY. The battle of Gettysburg was the decisive land battle of the American Civil War. O'Sullivan's photograph is meant to show something of the human cost of a battle that left 51,000 casualties—dead, wounded, captured, or missing—in three days of fighting.

nitions, rags, cups and canteens, crackers, haversacks, and letters that may tell the name of the owner, although the majority will surely be buried unknown by strangers, and in a strange land.

In O'Sullivan's photograph, both foreground and background are purposefully blurred to draw attention to the central corpses. Such focus was made possible by the introduction of albumen paper, which retained a high degree of sharpness on its glossy surface. "Such a picture," Gardner wrote, "conveys a useful moral: It shows the blank horror and reality of war, in opposition to the pageantry. Here are the dreadful details! Let them aid in preventing such another calamity falling upon the nation." These sentiments were echoed in Abraham Lincoln's famous Gettysburg Address, one of the most powerful, and short, speeches ever made (see **Reading 36.11,** page 1183).

Reconstruction Because most of the war was fought in the South, the region was devastated physically, economically, and socially. So the next decade became known as the era of Reconstruction. It also was home to nearly 4 million African Americans who suddenly found themselves free. The federal government established the Freedmen's Bureau to provide food, clothing, and medical care to refugees in the South, especially freed slaves. It also set up schools for African Americans, and teachers from the North and South worked to help young and old become literate. Additionally, Congress passed two amendments to the Constitution to give blacks equal rights with whites. The Fourteenth Amendment gave African Americans citizenship and struck down discriminatory state laws. Before they could be readmitted to the union, Southern states were ordered to ratify the amendment. The second amendment to the Constitution, the Fifteenth, gave African-American men the right to vote. Meanwhile, to maintain order, Union troops remained in the South.

African American emancipation, which advanced rapidly in the years immediately following the Civil War, would soon suffer setbacks, eliminating whatever gains had been made until the civil rights movement arose during the 1950s and 1960s. In 1877, Union troops withdrew from the South, and Southern whites who had never accepted African Americans as equals quickly restored their control of the region. Groups such as the Ku Klux Klan openly terrorized the African American community, and lynching became commonplace.

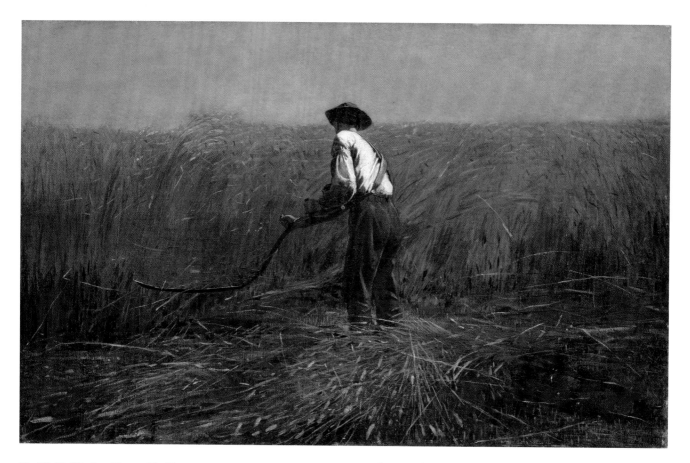

Fig. 36.17 Winslow Homer. *The Veteran in a New Field.* **1865.** Oil on canvas, 24 1/8″ × 38 1/8″. The Metropolitan Museum of Art, NY. Bequest of Adelaide Milton de Groot (1876–1967), 1967 (67.187.131). Image copyright © The Metropolitan Museum of Art. In the "New Field" of Homer's title, the veteran leaves behind the "field of battle." Homer was thinking of the biblical passage from Isaiah 2:4: "they shall beat their swords into plowshares, and their spears into pruning hooks," a theme also informing Jean-Antoine Houdon's famous statue of George Washington (see Fig. 31.13).

In 1883, the Supreme Court nullified the Civil Rights Act, and in 1896 the courts allowed segregation in the railroads, and thus, by extension, in all public services. These new laws that destroyed the legality of the postwar constitutional amendments for freed blacks were called Jim Crow laws. By 1900, African Americans were once again almost totally disenfranchised from American life.

The postwar North, where hundreds of thousands of Union soldiers returned home, was a region of almost unfettered optimism. As Mark Twain and Charles Dudley Warner described it in *The Gilded Age,* their bestseller of 1873, "the air [was] full of money, nothing but money,

money floating through the air." One of the first painted images of the Reconstruction era—Winslow Homer's *The Veteran in a New Field* (1865)—also points to the possibilities of a prosperous future (Fig. **36.17**). It depicts a Union soldier at work in his agricultural field and so recently returned home that his canteen and army uniform jacket are visible at the lower right. The painting glows with golden light, the promise of a harvest of plenty. But the veteran is also the grim reaper with his scythe, and his harvest is the same harvest of death that O'Sullivan and Gardner recorded at Gettysburg. It is as if the veteran is slashing, not so much at grain as at his memories.

READINGS

READING 36.1

Karl Marx and Friedrich Engels, *The Communist Manifesto*, Part I, from "Bourgeois and Proletarians" (1848; English edition 1888; trans. Samuel Morse)

Marx and Engels began their collaboration in 1844 in Paris. In 1847, they were invited by a left-ist group in London to write their program for them, which they did during December 1847 and January 1848. The group changed its name to the Communist League and adopted Marx and Engels's 12,000-word program as their manifesto. The following is the first part, which describes the tensions between the proletariat (working class) and the modern bourgeoisie:

The history of all hitherto existing society is the history of class struggles.

Freeman and slave, patrician and plebeian, lord and serf, guild-master and journeyman, in a word, oppressor and oppressed, stood in constant opposition to one another, carried on uninterrupted, now hidden, now open fight, a fight that each time ended, either in a revolutionary reconstitution of society at large, or in the common ruin of the contending classes.

In the earlier epochs of history we find almost everywhere a complicated arrangement of society into various orders, a manifold gradation of social rank. In ancient Rome we have patricians, knights, plebeians, slaves; in the Middle Ages, feudal lords, vassals, guild-masters, journeymen, apprentices, serfs; in almost all of these classes, again, subordinate gradations.

The modern bourgeois society that has sprouted from the ruins of feudal society has not done away with class antagonisms. It has but established new classes, new conditions of oppression, new forms of struggle in place of the old ones.

Our epoch, the epoch of the bourgeoisie, possesses, however, this distinctive feature; it has simplified the class antagonisms. Society as a whole is more and more splitting up into two great hostile camps, into two great classes directly facing each other: Bourgeoisie and Proletariat.

From the serfs of the Middle Ages sprang the chartered burghers of the earliest towns. From these burgesses the first elements of the bourgeoisie were developed.

The discovery of America, the rounding of the Cape, opened up fresh ground for the rising bourgeoisie. The East Indian and Chinese markets, the colonization of America, trade with the colonies, the increase in the means of exchange and in commodities generally, gave to commerce, to navigation, to industry, an impulse never before known, and thereby, to the revolutionary element in the tottering feudal society, a rapid development.

The feudal system of industry, under which industrial production was monopolized by close guilds, now no longer sufficed for the growing wants of the new market. The manufacturing system took its place. The guild-masters were pushed on one side by the manufacturing middle class; division of labor between the different corporate guilds vanished in the face of division of labor in each single workshop.

Meantime the markets kept ever growing, the demand ever rising. Even manufacture no longer sufficed. Thereupon, steam and machinery revolutionized industrial production. The place of manufacture was taken by the giant Modern Industry, the place of the industrial middle-class, by industrial millionaires, the leaders of whole industrial armies, the modern bourgeois.

Modern industry has established the world-market, for which the discovery of America paved the way. This market has given an immense development to commerce, to navigation, to communication by land. This development has, in its turn, reacted on the extension of industry; and in proportion as industry, commerce, navigation, railways extended, in the same proportion the bourgeoisie developed, increased its capital, and pushed into the background every class handed down from the Middle Ages.

We see, therefore, how the modern bourgeoisie is itself the product of a long course of development, of a series of revolutions in the modes of production and of exchange.

Each step in the development of the bourgeoisie was accompanied by a corresponding political advance of that class. An oppressed class under the sway of the feudal nobility; an armed and self-governing association in the medieval commune, (here independent urban republic, as in Italy and Germany, there taxable "third estate" of the monarchy, as in France); afterwards, in the period of manufacture proper, serving either the semi-feudal or the absolute monarchy as a counterpoise against the nobility, and in fact cornerstone of the great monarchies in general—the bourgeoisie has at last, since the establishment of modern industry and of the world-market, conquered for itself, in the modern representative state, exclusive political sway. The executive of the modern state is but a committee for managing the common affairs of the whole bourgeoisie.

The bourgeoisie, historically, has played a most revolutionary part.

The bourgeoisie, wherever it has got the upper hand, has put an end to all feudal, patriarchal, idyllic relations. It has pitilessly torn asunder the motley feudal ties that bound man to his "natural superiors," and has left no other nexus between man and man than naked self-interest, than callous "cash payment." It has drowned the most heavenly ecstasies of religious fervor, of chivalrous enthusiasms, of philistine sentimentalism, in the icy water of egotistical calculation. It has resolved personal worth into exchange value, and in place of the numberless indefeasible chartered freedoms, has set up that single, unconscionable freedom—Free Trade. In one word, for exploitation, veiled by religious and political illusions, it has substituted naked, shameless, direct, brutal exploitation.

The bourgeoisie has stripped of its halo every occupation hitherto honored and looked up to with reverent awe. It has converted the physician, the lawyer, the priest, the poet, the man of science, into its paid wage laborers.

The bourgeoisie has torn away from the family its sentimental veil, and has reduced the family relation to a mere money relation. . . .

The need of a constantly expanding market for its products drives the bourgeoisie over the whole surface of the globe. It must elbow-in everywhere, settle everywhere, establish connections everywhere.

The bourgeoisie has through its exploitation of the world-market given a cosmopolitan character to production and consumption in every country. To the great chagrin of reactionists, it has drawn from under the feet of industry the national ground on which it stood. All old-established national industries have been destroyed or are daily being destroyed. They are dislodged by new industries, whose introduction becomes a life and death question for all civilized nations, by industries that no longer work up indigenous raw material, but raw material drawn from the remotest zones; industries whose products are consumed, not only at home, but in every quarter of the globe. In place of the old wants, satisfied by the productions of the country, we find new wants, requiring for their satisfaction the products of distant lands and climes. In place of the old local and national seclusion and self-sufficiency, we have intercourse in every direction, universal interdependence of nations. And as in material, so also in intellectual production. The intellectual creations of individual nations become common property. National onesidedness and narrowmindedness become more and more impossible, and from the numerous national and local literatures there arises a world-literature. . . .

In proportion as the bourgeoisie,—that is, as capital, is developed, in the same proportion is the proletariat, the modern working class, developed, a class of laborers who live only so long as they find work, and who find work only so long as their labor increases capital. These laborers, who must sell themselves piece-meal, are a commodity, like every other article of commerce, and are consequently exposed to all the vicissitudes of competition, to all the fluctuations of the market

The various interests and conditions of life within the ranks of the proletariat are more and more equalized, in proportion as machinery obliterates all distinctions of labor, and nearly everywhere reduces wages to the same low level. The growing competition among the bourgeois, and the resulting commercial crises, make the wages of the workers ever more fluctuating; the unceasing improvement of machinery, ever more rapidly developing, makes their livelihood more and more precarious; the collisions between individual workmen and individual bourgeois take more and more the character of collisions between two classes. Thereupon the workers begin to form combinations (trade unions) against the bourgeois; they club together in order to keep up the rate of wages; they found permanent associations in order to make provision beforehand for these occasional revolts. Here and there the contest breaks out into riots.

Now and then the workers are victorious, but only for a time. The real fruit of their battle lies not in the immediate result, but in the ever expanding union of workers. . . .

The first step in the revolution by the working class is to raise the proletariat to the position of ruling class, to win the battle of democracy.

The proletariat will use its political supremacy to wrest, by degrees, all capital from the bourgeoisie, to centralize all instruments of production in the hands of the state,—that is, of the proletariat organized as a ruling class; and to increase the total productive forces as rapidly as possible. . . .

When, in the course of development, class distinctions have disappeared, and all production has been concentrated in the hands of a vast association of the whole nation, the public power will lose its political character. Political power, properly so called, is merely the organization power of one class for oppressing another. If the proletariat during its contest with the bourgeoisie is compelled, by the force of circumstances, to organize itself as a class, if, by means of a revolution, it makes itself the ruling class, and, as such, sweeps away by force the old conditions of production, then it will, along with these conditions, have swept away the conditions for the existence of class antagonisms, and of classes generally, and will thereby have abolished its own supremacy as a class.

In place of the old bourgeois society, with its classes and class antagonisms, we shall have an association in which the free development of each is the condition for the free development of all. ■

Reading Question

What leads Marx and Engels to believe that the conflict between the bourgeoisie and the proletariat will have a different result from history's previous class conflicts?

READING 36.10

from Émile Zola, *Germinal* (1885)

Germinal is an unflinching depiction of life among the coalminers of northern France in the 1860s. It is generally considered Zola's masterpiece. In the following scene, the novel's central character, Étienne Lantier, is taken through the mine by the miner Maheu, who works with his teenage daughter, Catherine. Each of the mining disasters described here actually happens in the course of the novel, and almost every character dies in one or the other of them. Despite its uncompromising condemnation of life in the mines, Germinal is, in the end, a hopeful book. Its title, Germinal, was the name of the seventh month of the French Revolutionary calendar, which occurred in the spring, as new life began to germinate and with it the possibility of hope.

"Damn! It's not warm here," muttered Catherine, shivering.

Etienne simply nodded. He found himself before the shaft, in the center of a huge hall swept by drafts. Of course he thought of himself as brave, yet an unpleasant emotion caused his throat to contract among the thundering of the carts, the clanking of the signals, the muffled bellowing of the megaphone, facing the continuously flying cables, unrolling and rolling up again at top speed on the spools of the machine. The cages rose and fell, slithering like some noctur- 10 nal animal, continually swallowing men that the hole seemed to drink down. It was his turn now. He was very cold. He kept silent out of nervousness which made Zacharie and Levaque snicker, for both disapproved of the hiring of this stranger— Levaque especially, hurt because he had not been consulted. So Catherine was happy to hear her father explaining things to the young man.

"Look, up on top of the cage; there's a parachute and iron hooks that catch in the guides in case the cable breaks. It works . . . most of the time. . . . Yes, the shaft is divided into three ver- 20 tical compartments, sealed off by planks from top to bottom. In the center are the cages; on the left the ladder-well."

But he broke off to complain, without daring to speak very loudly, "What the hell are we doing waiting here, for God's sake? How can they let us freeze here like this?"

Richomme, the foreman, who was also going down, his open miner's lamp hanging from a nail in his leather cap, heard him complaining.

"Be careful; the walls have ears!" he muttered paternalis- tically, as a former miner who still sided with the workers. 30

"They've got to make the adjustments . . . See? Here we are, get in with your team."

And in fact, the cage, banded with sheet iron and covered by a fine-meshed screen, was waiting for them, resting on its catches. Maheu, Zacharie, Levaque, and Catherine slid into a cart at the back; and since it was supposed to hold five people, Étienne got in as well; but all the good places were taken and he had to squeeze in beside the young girl, whose elbow poked into his belly. His lamp got in his way; he was advised to hang it from a buttonhole of his jacket. He didn't hear this advice 40

and kept it awkwardly in his hand. The loading continued, above and below, a jumbled load of cattle. Couldn't they get going? What was happening? It seemed as if he'd been waiting for a long time. Finally a jolt shook him and everything fell away, the objects around him seemed to fly past while he felt a nervous dizziness that churned his guts. This lasted as long as he was in the daylight, passing the two landing levels, sur- rounded by the wheeling flight of the timbers.

Then, falling into the blackness of the pit, he remained stunned, no longer able to interpret his feelings. 50

"We're off," said Maheu tranquilly.

They seemed relaxed. He, however, wondered at moments whether he was going down or up. There were moments at which they seemed immobile, when the cage was dropping straight down without touching the guides; then brusquely there were shudders, a sort of dancing between the planks, which made him fear a catastrophe was going to happen. In addition, he couldn't make out the walls of the shaft behind the grill to which his face was pressed. The lamps only dimly lit the heap of bodies at his feet. Alone, the open lamp of the 60 foreman shone from the next cart like a beacon.

"This one is fifteen feet wide," continued Maheu, instruct- ing him. "The casing needs to be redone; water's leaking everywhere. . . . Listen, we're down at the water level. Can you hear it?"

Étienne had just been asking himself what this sound of a downpour could be. A few big drops had splashed first on the roof of the cage, like at the beginning of a storm; and now the rain grew, streamed, was transformed into a real deluge. The roof must have had a hole in it, for a trickle of water, flowing onto 70 his shoulder, was soaking him to the skin. The cold became glacial; they entered a damp blackness, then there was a blind- ing flash and a glimpse of a cave where men were moving about. But already they were plunging back into nothingness.

Maheu said:

"That's the first landing. We're a hundred feet down now . . . Look how fast we're going."

Lifting his lamp, he lit up a guide timber flying past like the rail beneath a train running full steam ahead; beyond that, nothing else could be seen. Three other platforms flew 80 out of the shadows.

"How deep it is!" murmured Étienne.

The fall seemed to have lasted for hours. He was suffering because of the awkward position he was in, not daring to move, above all tortured by Catherine's elbow. She didn't say a word; he only felt her pressed against him, warming him. When the cage finally halted at the bottom, at 12,828 feet, he was astonished to learn that the descent had lasted just one minute. But the sound of the catches taking hold and the feeling of something solid underneath him suddenly cheered him up. . . . 90

The cage was emptying; the workers crossed the landing dock, a room carved out of the rock vaulted over with bricks lit by three huge lamps with open flames. The loaders were violently shoving full carts across the cast-iron floor. A cellar-like odor seeped from the walls, a chilly smell of saltpeter traversed by warm gusts from the stable nearby. Four galleries gaped into the opening.

"This way," said Maheu to Étienne. You're not there yet. We have another good mile and a quarter to go. . . ."

The miners were separating, disappearing by groups into 100 these black holes. Some fifteen of them had just entered the one on the left; and Étienne walked behind them following Maheu, who led Catherine, Zacharie and Levaque. It was a good tunnel for hauling the carts, cutting through a layer of rock so solid that only partial timbering had been necessary. They walked single file, walking always onward, without a word, led by the tiny flames in their lamps. The young man stumbled at every step, catching his feet in the rails. Suddenly a muffled sound worried him, the distant noise of a storm whose violence seemed to grow, coming from the bowels of 110 the earth. Was it the thunder of a cave-in which would crush down onto their heads the enormous mass cutting them off from the light of day . . .?

The further they went, the more narrow the gallery became, lower, with an uneven ceiling forcing them constantly to bend over.

Étienne bumped his head painfully. If he hadn't been wearing a leather cap, his skull would have been cracked. Yet he had been following closely the smallest movements of Maheu ahead of him, his somber silhouette created by the 120 flow of the lamps. None of the workers bumped into anything; they must have known every hump in the ground, every knot in the timbers, every protrusion in the rock. The young man was also bothered by the slippery ground, which was getting more and more damp. Sometimes he passed through virtual seas which he discovered only as his feet plunged into the muddy mess. But what surprised him the most were the abrupt changes in temperature. At the bottom of the shaft it was very cold, and in the haulage tunnel, through which all the air in the mine flowed, a freezing wind 130 was blowing, like a violent storm trapped between narrow walls. Further on, as they gradually traveled down other passageways which got less ventilation, the wind dropped and the warmth increased, creating a suffocating, leaden heat.

Maheu had not said another word. He turned right into a new gallery saying only to Étienne, without turning around, "The Guillaume vein."

This was the vein whose coal face they were to work. After a few steps Étienne bruised his head and elbows. The 140 sloping roof descended so far that they had to walk doubled over for fifty or a hundred feet at a time. The water reached his ankles. They went on in this way for more than 600 feet when suddenly, Levaque, Zacharie and Catherine disappeared, seemingly swallowed by a tiny crack that opened in front of him.

"You have to climb up," said Maheu. "Hang your lamp from a buttonhole and hang on to the timbers."

He too disappeared. Étienne had to follow him. This chimney was left for the miners to allow them to reach all the 150 secondary passageways, just the width of the coal vein, barely two feet. Fortunately the young man was thin: still clumsy, he drew himself up with a wasteful expense of strength, pulling in his shoulders and buttocks, hand over hand, clinging to the timbers. Fifty feet higher up they came to the first secondary passageway, but they had to go on; the work area of Maheu and his team was at the sixth level, "in Hell" as they said, and every fifty feet there was another passageway to be crossed. The climb seemed to go on forever, through this crack which scraped against his back and chest. Étienne 160 gasped as if the weight of the rocks were crushing his limbs; his hands were skinned, his legs bruised. Worst of all, he was suffocating, feeling as if the blood was going to burst out through his skin. He could vaguely see down one of the passageways two animals crouched down, one small and one large, shoving carts ahead of them: Lydie and La Mouquette, already at work. And he still had to clamber up two more levels! Sweat blinded him, he despaired of catching up to the others whose agile legs he could hear constantly brushing against the rock. 170

"Come on; here we are!" said Catherine's voice. . . .

Little by little the veins had filled, the faces were being worked at each level, at the end of each passageway. The all-devouring mine had swallowed its daily ration of men, more than 700 workers laboring now in this giant ant heap, burrowing through the earth in every direction, riddling it like an old piece of wood infested by worms. And in the midst of this heavy silence, under the crushing weight of these deep layers of earth, could be heard—if you put your ear to the rock—the movement of these human insects at work, from the flight of the 180 cable raising and lowering the extraction cage to the bite of the tools digging into the coal at the bottom of the mine. . . .

The four cutters had stretched out one above the other across the sloping coal face. . . . Maheu was the one who suffered most. High up where he was, the temperature was as high as 95°, the air did not circulate, and eventually you would suffocate. In order to see clearly he had had to hang his lamp on a nail near his head; but this lamp broiled his skull, making his blood seethe. His torture was worsened above all by the damp. Water kept flowing over the rock above him a 190 few inches from his face; and huge drops kept rapidly, continuously, in a maddening rhythm, falling, always on the same spot. It was no use twisting his neck or bending his head, the drops fell on his face, beating at him, splattering endlessly.

After a quarter of an hour he was soaked, covered with his own sweat, steaming like a laundry tub. He didn't want to stop cutting and gave huge blows which jolted him violently between the two rocks, like a flea caught between the pages of a book, threatened by being completely crushed. 200

Not a word was spoken. They all hammered away, and nothing could be heard but these irregular blows, muffled, seemingly far-off. The sounds took on a harsh quality in the dead, echoless air, and it seemed as if the shadows created a mysterious blackness, thickened by the flying coal dust and made heavier by the gas which weighed down their eyes. The wicks of their lamps displayed only glowing red tips through their metal screens. You couldn't make out anything clearly. The work space opened out into a large chimney, flat and sloping, on which the soot of ten winters had created a pro- 210 found night. Ghostly forms moved about, random light beams allowing a glimpse of the curve of a thigh, a brawny arm, a savage face, blackened as if in preparation for a crime. Sometimes blocks of coal stood out, suddenly lit up, their facets glinting like crystals. Then everything was plunged back into darkness, the picks beating out their heavy, dull blows; and there was nothing but the sound of heavy breathing, groans of pain and fatigue beneath the weight of the air and the showers from the underground streams. ■

Reading Question

In his research of the coalmining industry, Zola had taken careful notes about the elevator, or cage, in which workers were lowered into and raised out of the shaft. His description is thus meticulously realistic. But how does his writing exceed mere realistic description?

READING 36.11

from Abraham Lincoln, Address Delivered at the Dedication of the Cemetery at Gettysburg (1863)

Abraham Lincoln became president of the United States on March 4, 1861, just over a month before fighting between the Union and the Confederacy commenced, on April 12, 1861, when Confederate troops attacked the federal military installation at Fort Sumter, South Carolina. Lincoln exercised executive authority in a manner unprecedented in American history, an authority achieved, in no small part, by the persuasiveness of his rhetoric. At once lofty and colloquial, eloquent and down-to-earth, his speeches, which appeared within days of their delivery in almost every newspaper in the North, served to unite Northerners in their fight against the South. The Gettysburg Address was delivered on November 19, 1863, at the site of the decisive Battle of Gettysburg in which the Union's 90,000 men defeated 70,000 Southern troops in a three-day battle that ended in General Robert E. Lee's retreat to Virginia on July 3, 1863. The Union dead totaled 3,155, the Confederate dead 4,708. With combined wounded and missing soldiers standing at 46,000, Lincoln delivered his address at the Union Cemetery.

Four score and seven years ago our fathers brought forth on this continent, a new nation, conceived in Liberty, and dedicated to the proposition that all men are created equal.

Now we are engaged in a great civil war, testing whether that nation, or any nation so conceived and so dedicated, can long endure. We are met on a great battlefield of that war. We have come to dedicate a portion of that field, as a final resting place for those who here gave their lives that that nation might live. It is altogether fitting and proper that we should do this. 10

But, in a larger sense, we can not dedicate—we can not consecrate—we can not hallow—this ground. The brave men, living and dead, who struggled here, have consecrated it, far above our poor power to add or detract. The world will little note, nor long remember what we say here, but it can never forget what they did here. It is for us the living, rather, to be dedicated here to the unfinished work which they who fought here have thus far so nobly advanced. It is rather for us to be here dedicated to the great task remaining before us—that from these honored dead we take increased devotion to that cause for which they gave the last full measure of devotion—that we here highly resolve that these dead shall not have died in vain—that this nation, under God, shall have a new birth of freedom—and that government of the people, by the people, for the people, shall not perish from the earth. ■ 20

Reading Question

Part of the power of this speech rests in its brevity. How does that serve to make it more forceful?

 Summary

■ The Revolutions of 1848: From the Streets of Paris to Vienna

By the middle of the nineteenth century, living conditions in Paris and across Europe had deteriorated to an intolerable point. In 1848, in Paris, workers revolted with their battle cry "the right to work," and across Europe other revolutions quickly followed. Karl Marx and Friedrich Engels had anticipated these uprisings in the *Communist Manifesto*. In Paris, the bourgeois middle class was convinced that it had barely survived the complete collapse of the social order, and so it elected the nephew of Napoleon I, Charles-Louis-Napoleon Bonaparte, president and subsequently proclaimed him Emperor Napoleon III.

One of the most important factors contributing to revolutions elsewhere in Europe was nationalism, as ethnic groups tried to assert their independence from monarchist governments. Jews as the most transnational minority benefited from the revolutions of 1848 as liberal concerns for equality and freedom helped them attain the full rights of citizens almost everywhere in Europe except Russia.

■ In Pursuit of Modernity: Paris in the 1850s and '60s

Even before the revolution of 1848, French intellectuals had begun attacking the bourgeois lifestyle. While his *Salon of 1846* was a plea to the bourgeoisie to value art, the poet Charles Baudelaire was certain that they would ignore him. In his poems, he sought to shock them, using imagery that ranged from exotic sexuality to the grim reality of death in the modern city. Baudelaire styled himself a *flâneur*, and so did his friend, the painter Édouard Manet. Manet was Baudelaire's "Painter of Modern Life," a man who held the vulgar and materialistic lifestyle of the bourgeoisie in contempt. Manet's paintings of the 1860s, particularly *Le Déjeuner sur l'herbe* and *Olympia*, shocked his bourgeois audience, but the novelist Émile Zola championed them. He believed that all human beings are products of hereditary and environmental factors over which they

have no control but which determine their lives.

In music, the nationalist tendencies of the era played themselves out in the Paris opera. Giuseppe Verdi's *Rigoletto* and other works by him came to symbolize Italian nationalism, and the Parisian Jockey Club ostracized the German composer Richard Wagner on nationalist grounds when he tried to produce his opera *Tannhäuser*. Wagner shifted the melodic element from the voice to the orchestra and organized his opera dramas around the leitmotif, literally a "leading motive," changes so radical that French audiences found his music almost unrecognizable as opera. The Opéra Comique was, however, the most popular form of opera in Paris and the Jewish composer Jacques Offenbach its most popular artist.

■ The American Civil War

From Europe, the American Civil War appeared to be a contest between liberal Northern values and nationalist Southerners. Until the outbreak of hostilities, compromise seemed possible, especially in light of the mythologized and romanticized view of slavery of antebellum America. Especially popular were the songs of Stephen Foster, which gained a wide audience in the Northern states.

The outbreak of the Civil War in 1861 quickly extinguished all romanticized views of slavery or warfare. The war was an intensely modern event, mechanized and impersonal as no other war had been, and the nature of representation changed with it. Artists like Eastman Johnson and Winslow Homer followed troops into the field, as did photographers, who documented what Americans had never before witnessed—the battlefield before the dead had been properly buried. After the war, nearly 4 million African Americans in the South suddenly found themselves free as the federal government inaugurated a process of reconstruction, reforms that by 1900 were almost completely abandoned until the late1950s and 1960s.

 Glossary

avant-garde Literally the "advanced guard," this military term is used to describe artists on the cutting edge.

flâneur A French version of the aristocratic English dandy. A man-about-town, with no apparent occupation, strolling the city, studying and experiencing it dispassionately.

Gesamtkunstwerk A total work of art, one that synthesizes music, drama, poetry, gesture, architecture, and painting.

leitmotif In opera, a brief musical idea connected to a character, event, or idea that recurs throughout the work.

minstrel show A theatrical event presenting a program of black American melodies, jokes, and impersonations, usually performed by white performers in blackface.

music drama A musical genre in which the actions on stage are the visual and verbal manifestations of the drama created by the instruments in the orchestra.

operetta Light musical drama usually incorporating spoken dialogue.

plantation melody A type of song written in dialect, the lyrics of which depicted blacks as capable of a full range of human emotion.

 Critical Thinking Questions

1. What new European audience for culture emerged after the revolutions of 1848?

2. What makes Parisian opera in the mid-nineteenth century "political"?

3. How did American artists and composers deal both romantically and realistically with the Civil War and slavery?

Impressionist Paris

In the early 1870s, Édouard Manet befriended a number of young painters whom he would deeply influence and who would in turn come to be known as the Impressionists. Chief among his new, younger colleagues were Claude Monet, Pierre Renoir [ruh-NWAHR], Gustave Caillebotte [ky-BOTT], Edgar Degas, and Berthe Morisot [bert moh-ree-ZOH], who was married to Manet's brother. Starting in 1874, the Impressionists organized their own group exhibitions, in which Manet politely declined to participate, choosing instead to pursue recognition in the official Salons. Nevertheless, he came to be widely regarded as a pre-Impressionist if not the first Impressionist.

Manet never abandoned the complex social commentary that informs his earlier painting. In his *The Gare Saint-Lazare* [gahr san-luh-ZAHR] (Fig. **36.18**), his model is the same woman as in *Le Déjeuner sur l'herbe* and *Olympia*. The little girl is the daughter of Manet's friend Alphonse Hirsch, in whose garden the scene is set; she gazes through the fence at the tracks, obscured by the smoke of a passing train in the new train station of Saint-Lazare. The station was the work of the Baron Georges Eugène Haussmann [ohss-MAHN], who was appointed prefect of the Seine by Napoleon III on June 22, 1853, and charged with the task of "modernizing" the city by broadening its avenues, demolishing its worst neighborhoods, and building vast gardens and railway stations. By 1868, the station was receiving more than 13 million passengers a year, many of whom were workers, clerks, and laborers commuting

in from the suburbs. The station and the bridge above the surrounding streets would become a favorite subject of the Impressionist painters. The front door to Manet's own studio from 1872 to 1878 can be seen through the railings behind the woman's head. In 1877, Claude Monet rented a studio nearby in order to paint a series of views of the station itself.

Manet's painting is a bouquet of contrasts. The little girl is dressed in white with blue trim, while the older woman, posed here as her mother, or perhaps her nanny, is in blue with white trim. The one sits, regarding us; the other stands, gazing through the fence railing. The nanny's hair is down, the little girl's up. The nanny's angular collar is countered by the soft curve of the little girl's neckline. The black choker around the one's neck finds its way to the other's hair. The older woman sits with her puppy on her lap, a symbol of her contentment. The little girl is eating grapes (beside her on the ledge), which have bacchanalian associations. The older escapes into her novel, perhaps a Romantic one, while the younger looks out at the trains leaving the station, possibly dreaming of adventure.

Manet's painting suggests that the little girl will grow up into the woman beside her. The painting implicitly portrays the limits of women's possibilities in French society. As the nineteenth century progressed, women like the Impressionist painters Mary Cassatt and Berthe Morisot would strive to eliminate those limitations as they increasingly demanded equality and respect, not only in their work, but also in their lives. ■

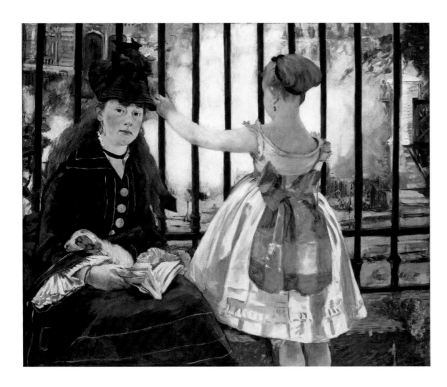

Fig. 36.18 Édouard Manet. *The Gare Saint-Lazare.* **1873.** Oil on canvas, 36³⁄₄″ × 45¹⁄₈″. Gift of Horace Havemeyer in memory of his mother, Louisine W. Havemeyer. 1956.10.1. Image © 2007. Board of Trustees, National Gallery of Art, Washington, DC © 2008 ARS Artists Rights Society, NY.

37 The Rise of Bourgeois Culture

Living the Good Life

| The Haussmannization of Paris
| The 1870s: From the Commune to Impressionism
| Russian Realism and the Quest for the Russian Soul
| Britain and the Design of Social Reform

" The more I go on, the more I see that I must work a lot to succeed in rendering what I am looking for: 'instantaneity' . . . more than ever I'm disgusted by easy things that come without effort. "

Claude Monet

◄ **Fig. 37.1 Camille Pissarro.** *Avenue de l'Opera, Sunlight, Winter Morning.* **ca. 1880.** Oil on canvas, 28¾″ × 35⅞″. Musée Saint-Remi, Reims, France. Noticeably absent in this view of the avenue, looking northwest from the Hôtel de Louvre toward Charles Garnier's Opéra at the other end of the street, are the trees that line the other Grand Boulevards of Paris. The Baron Georges-Eugène Haussmann forbade planting any in order to maintain what he called the "dignity" of the avenue, his monument to Louis-Napoleon's Second Empire.

N JULY 1853, FRENCH EMPEROR NAPOLEON III CHOSE BARON

Georges-Eugène Haussmann (1809–1891) to supervise a daunting task—planning the modernization of Europe's most celebrated city, Paris. They shared a dream: to rid Paris of its medieval character, transforming it into the most beautiful city in the world.

By 1870, their reforms were largely completed, resulting in improved housing, sanitation, and increased traffic flow, all of which encouraged growth in the city's shopping districts. The vast renovation also served to prevent the possibility of out-of-control street riots leading to revolutions—like those of 1830 and 1848—from ever happening again.

By widening the streets, Haussmann made it harder to build barricades. By extending long, straight boulevards across the capital, he made it easier to move troops and artillery rapidly within the city. And he integrated each project into a larger-scale city planning strategy. After demolish-

ing the labyrinth of ancient streets and dilapidated buildings that were home to the rebellious working class, for example, the government installed enormous new sewer lines before extending impressively wide boulevards atop them. Although many residents of the demolished areas were subsequently moved to new working-class suburbs, Haussmann's plan linked the new boulevards to enormous railway stations, providing easy access to transportation (Map **37.1**).

These gigantic projects ultimately reshaped Paris into a lively and expansive modern city with updated transportation networks and a worldwide reputation for innovative urban

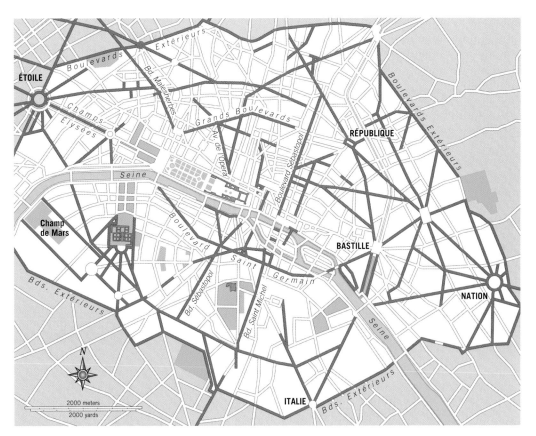

Map 37.1 Paris. ca. 1870. The map shows (in red) the street work done by Haussmann between 1850 and 1870.

design. The renovations and their social and cultural effects on France comprise the initial focal point of this chapter. Like Paris, the rest of the world also underwent rapid and massive urbanization during the nineteenth century. Tens of millions of people moved into crowded cities in search of better prospects, all of which lacked adequate infrastructure. Now, in France, someone was doing something about it on a grand scale—and on an ambitiously quick timetable.

As powerful as they were, Emperor Napoleon III and Haussmann could not have succeeded without the large bourgeois population's ready acceptance of their plans. And the bourgeoisie remained central to the Parisian economy as it boomed in the decades after 1860. The art and literature that reflected the lifestyle of this growing affluent class comprise the first theme of this chapter. Other European capitals did not duplicate the economic and social progress evident in Paris. In Russia, the issue of serfdom clouded the nation's art and literature, even as its writers and artists sought to express the uniqueness of their cultural identity. The second part of the chapter therefore focuses on Slavic nationalism and the very different artistic styles that emerged in mid-nineteenth-century Russia, characterized by an emphasis on realism. The chapter concludes by examining the social reform movement in Britain, led by artists and designers who sought to reshape and revitalize English society by emphasizing beauty and utility as well as harmony and restraint.

The Haussmannization of Paris

When a group of young and rebellious painters, later dubbed the Impressionists, organized their first Paris exhibition in 1874, they installed it directly across the street from the Grand Hôtel, the luxurious building erected a dozen years earlier on the Place de l'Opéra. They may have been cultural rebels, but they too wanted to share in the prosperity established during Napoleon III's Second Empire. Haussmann's new parks, avenues, and boulevards, along with the cafés and racetracks where the bourgeoisie promenaded, were often their subjects (Fig. **37.1**). Not even war with Prussia in 1870–1871 and a German siege that brought the city to the edge of famine could halt the oncoming tide of art and commerce.

One of Haussmann's pet projects was construction of a broad Avenue de l'Opéra connecting the Louvre to Charles Garnier's new Paris Opéra (see Fig. 36.9). The project was not completed until 1877, but the vista Haussmann created was of stunning scale, inspiring many artists, such as Camille Pissarro [pee-SAH-roo], to paint it (see Fig. 37.1). The Opéra was itself carefully placed just above Paris's *grands boulevards* [grahn bool-uh-VAHR], the center of his modernization plans (Map **37.2**). The greatest wealth of the city was concentrated along these promenades, and so was the city's best shopping. In a memoir of his visit to the Paris Exposition of 1867, Edward King, an American, described how those seeking the trappings of bourgeois life were drawn to these new public venues:

> The boulevards are now par excellence the social centre of Paris. Here the aristocrat comes to lounge, and the stranger to gaze. Here trade intrudes only to gratify the luxurious. . . . On the grands boulevards you find porcelains, perfumery, bronzes, carpets, furs, mirrors, the furnishings of travel, the copy of Gérome's latest picture, the last daring caricature in the most popular journal, the most aristocratic beer, and the best flavored coffee.

Haussmann understood full well that the boulevards appealed to tourists, and so in 1860, as he was busy adding sidewalks, gas streetlights, and trees to the boulevard des Capucines, he facilitated the demolition of old buildings to

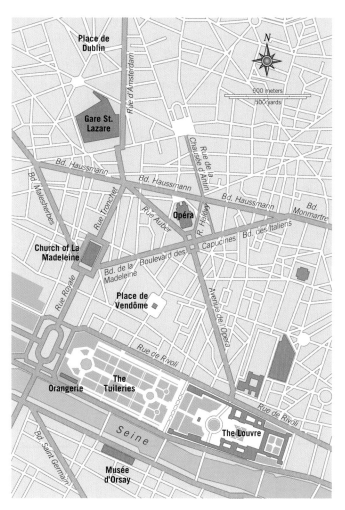

Map 37.2 The Grand Boulevards of Paris. The Grand Boulevards are composed of a continuous arc that changes its name every few blocks, running across the front of the Opéra. They begin in the west at the Church of La Madeleine with the boulevard de la Madeleine, then the boulevard des Capucines, then the Boulevard des Italiens, and finally bending eastward to become the Boulevard Montmartre.

Voices

Where Are the Roses?

Haussmann's transformation of Paris included the construction of large-scale plant nurseries and hothouses within the parks. As Anthony North Peat, the Paris correspondent of the London newspaper The Morning Star *writes in a letter, revolutionary workers and violent criminals were not the only threat to the city during the height of the Second Empire under Louis-Napoleon:*

"There are few roses cultivated here, for the simple reason that their flowers are invariably robbed during the night by lovers anxious to win a smile from their various lady-loves by the offering of a rose."

The nursery gardens of Paris are well worth the attention of the visitor. The most interesting, however, is that belonging to the city . . . in the Bois de Bologne. This vast horticultural laboratory contains about forty hothouses, some of which are of colossal proportions. . . . One hundred gardeners alone are occupied in the task of multiplying these plants whose number this year amounted to 3 million. . . . There are few roses cultivated here, for the simple reason that their flowers are invariably robbed during the night by lovers anxious to win a smile from their various lady-loves by the offering of a rose. It required at least three *sergents de ville* [policemen] in each square, and several more in such open gardens as the Champs-Élysées and the Parc Monceaux, to defend the roses. This being considered a somewhat superfluous duty by M. le Prefet de Police [chief of police], who required his men for different work, roses are but sparingly bestowed on the inhabitants of Paris.

make way for the 700-room Grand Hôtel [grahnd-oh-TEL]. Occupying a full block, it was a short walk to the city's most famous cafés, restaurants, and theaters.

Baron Haussmann's grand project became the model for cities around the world as they struggled to accommodate the demands of burgeoning populations and modern technology. In fact, his approach to urban redevelopment and its widescale destruction of existing structures is often simply called **Haussmannization**. Central to the plan was not only the widening of the city's arteries but also the development of a series of great public parks. Before 1848, there were perhaps 47 acres of parkland in Paris, most of it along the Champs-Élysées [shahnz-ay-lee-ZAY], but Emperor Louis-Napoleon soon opened to the public all the previously private gardens, including the Jardin des Plantes [zhar-DEHN deh plahnt], the Luxembourg [luks-om-BOOR] Gardens, and the royal gardens. Haussmann amplified this gesture by creating a series of new parks, squares, and gardens (see *Voices*, below). These included the massive redesign of the Bois de Boulogne [bwah deh boo-LOHN] on the city's western edge and the conversion of the old quarries in the working-class neighborhoods into a huge park with artificial mountains, streams, waterfalls, and a lake, all overlooked by new cafés and restaurants. By 1870, Haussmann had increased the total land dedicated to parks in the city by nearly 100 times, to 4,500 acres.

To create the new system of Parisian parks, the government demolished over 25,000 buildings between 1852 and 1859, and after 1860, another 92,000 (Fig. **37.2**). The system of new streets that resulted is depicted in *Paris Street, Rainy Day* (Fig. **37.3**), painted in 1877 by the youthful Gustave Caillebotte [cai-BOTT] (1848–1894), who was associated with the Impressionists, had grown up in Haussmann's Paris, and took its broad avenues and squares for granted. The casual elegance of the painting, the rhythms of the curved umbrellas and rounded shoulders of its pedestrians, play off the complex perspective of the scene. Here it seems as though Haussmann has bequeathed the good life—even on rainy days—to the city's inhabitants. Citizens and tourists alike enjoyed miles of new sidewalks with over 100,000 trees planted beside them. The eight new bridges that spanned the river Seine and pathways and roads along its banks further expanded the scenic vistas of the city's architectural treasures.

One of the jewels of Paris architecture, Notre Dame, and the island on which it was located was also part of Haussmann's grand design. Enlarging the open area in front of the great Gothic cathedral considerably, he replaced most of the housing on the Île de la Cité [eel deh la see-TAY] with public buildings symbolizing law, order, and civic well-being.

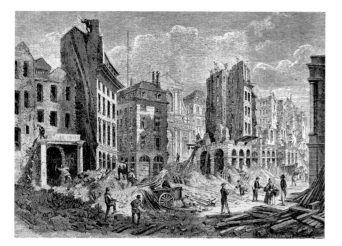

Fig. 37.2 Felix Thorigny. *Demolition of the rue de la Barillerie to allow for construction of the Boulevard Sebastopol, Paris, 1st arrondissement.* 1859. **Engraving.** Bibliothèque Nationale, Paris. Here thirteenth- and fourteenth-century streets and houses on the Right Bank are shown being cleared away.

CULTURAL PARALLELS

The Modernization of Tokyo

While Haussmann directed the renovation of Paris, Japan was also experiencing urbanization and a major shift in social and political policies. The Meiji Restoration in 1868 ended the rule of the *shoguns* (military dictators) and regional warlords (*daimyo*), replacing them with an oligarchy led by the emperor. The Restoration was a major catalyst for the rapid industrialization of Japan, the shift of the national capital to Tokyo, and a series of efforts at urban modernization.

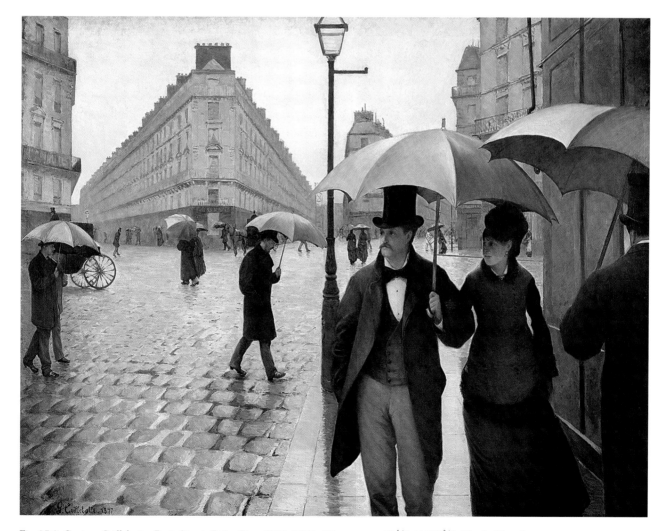

Fig. 37.3 Gustave Caillebotte. *Paris Street, Rainy Day.* 1876–1877. Oil on canvas, 83$\frac{1}{2}$″ × 108$\frac{3}{4}$″. Charles H. and Mary F. S. Worcester Collection, 1964.336. Photograph © 2006, The Art Institute of Chicago. All Rights Reserved. This view of the place de Dublin, near the Saint-Lazare railroad station, shows one of Haussmann's favorite devices, the so-called *places-carrefours*, or "crossroad-squares," where multiple boulevards converge.

Haussmann truthfully claimed that he built more new housing than he demolished. However, almost all of the less expensive housing for workers was erected on the outskirts of the city. As much as he wanted to open the city to air and light, he wanted to rid it of crowding, crime, and political disaffection. "Rue Transnonain," he bragged, referring to the site of Daumier's famous lithograph of 1834 (see Fig. 35.14), "has disappeared from the map of the city." The working-class exodus to the outskirts of Paris resulted in a city inhabited almost exclusively by the bourgeoisie and the upper classes. To further facilitate the exodus of the working class, Haussmann banned large-scale industry (as opposed to artisan workshops) from the city altogether. By the last quarter of the nineteenth century Paris became a city of leisure, of the good life, surrounded by a ring of industrial and working-class suburbs, as it remains to the present day.

The 1870s: From the Commune to Impressionism

A new era of French history and politics dawned in 1870. Haussmann was dismissed by Louis-Napoleon in January of that year, having become a political liability because of his questionable financing schemes for the massive reconstruction of Paris. While the complex accounting procedures and investment incentives proved unfathomable to most observers, no evidence has ever emerged that would prove extensive corruption. The pioneering urban planner was, in fact, a scapegoat of political opponents who despised Louis-Napoleon. Their displeasure mostly focused on the emperor's humiliating imperial adventure in Mexico, where he had sent 10,000 French troops in 1862 to depose the first indigenous president ever elected, Benito Juarez [hwar-EZ] (1806–1872). Louis-Napoleon seethed at Juarez's independent policies, then placed Maximilian (1832–1867), brother of the Austrian emperor, on the throne as a puppet ruler. Under severe criticism at home in 1867, Louis-Napoleon withdrew all French forces from Mexico, abandoning Maximilian, who was captured by Juarez's troops and summarily executed.

The painter Édouard Manet illustrated his displeasure with Louis-Napoleon's autocratic reign by depicting the scene in three full-scale paintings, an oil sketch, and a lithograph, none of which the government allowed to be exhibited at the time. The largest and most ambitious of these works is *The Execution of Maximilian* (Fig. **37.4**). The painting's most obvious influence is Francisco Goya's *The Third of May, 1808* (see Fig. 34.10), which Manet had probably seen in person in his August 1865 visit to Spain. Like the quasi-religious light shining on Goya's victims, the emperor's sombrero encir-

Continuity & Change
p. 1098

The Third of May, 1808

cles his head like a halo, an iconic symbol of martyrdom. The crowd leaning over the wall to observe the execution is reminiscent of many of Goya's bullfighting illustrations, lending the scene an aura of a bullfight's ritualistic death. But it is the point-blank range of the execution that most startles viewers, together with the evident coldness of the soldier in the red hat, who loads his rifle to deliver the final, mortal shot. (Manet read reports that the initial fusillade had failed to kill Maximilian, with two more shots required to finish him off.) Here Manet paints death as the matter-of-fact outcome of the emperor's own imperial ambitions.

Louis-Napoleon's ambitions would soon result in even greater disaster. In July 1870, Otto von Bismarck (1815–1898), prime minister of the kingdom of Prussia, goaded the increasingly vulnerable French emperor into declaring war. Two months later, at the Battle of Sedan, the Germans soundly defeated the French army. Louis-Napoleon was imprisoned and exiled to England, where he died three years later. Meanwhile Bismarck marched on Paris, setting siege to the city, forcing its government to surrender in January 1871 after four months of ever-increasing famine during which most of the animals in the Paris zoo were killed and consumed by the public.

The Commune

The new French National Assembly elected in February 1871 was dominated by monarchists. The treaty it negotiated with Bismarck concluding the Franco-Prussian war required France to pay its invader a large sum of money and give up the eastern provinces of Alsace and part of Lorraine. Most Parisians felt that the assembly had betrayed the true interests of France. In March, they elected a new city government, which they dubbed the Paris Commune [KOM-yoon], with the intention of governing Paris separately from the rest of the country. In a prelude to civil war, the National Assembly quickly struck back, ordering troops, led by General Lecomte [leh-KOHNT], to seize the armaments of the Commune. By the end of the day angry Paris crowds seized Lecomte and summarily shot him (Fig. **37.5**). By nightfall the National Assembly's troops, and the Assembly itself, had withdrawn to Versailles.

But the assembly was not about to let Paris go. Their troops surrounded the city and on May 8 bombarded it. Paris remained defiant, even festive. Edmond de Goncourt [ed-MOHN deh gohn-KOOR] (1822–1896), a chronicler of Parisian life, recalled: "I go into a café at the foot of the Champs-Élysées; and while the shells are killing up the avenue . . . men and women with the most tranquil, happy air in the world drink their beer and listen to an old woman play songs by Thérésa on a violin." Finally, on May 21, as hundreds of musicians entertained crowds in the Tuileries, 70,000 of the assembly's troops stormed the city. Caught unawares, the Communards began erecting barricades, only to discover that Haussmannization allowed the army to outflank them and clear the broad streets with artillery. By May 22, the city

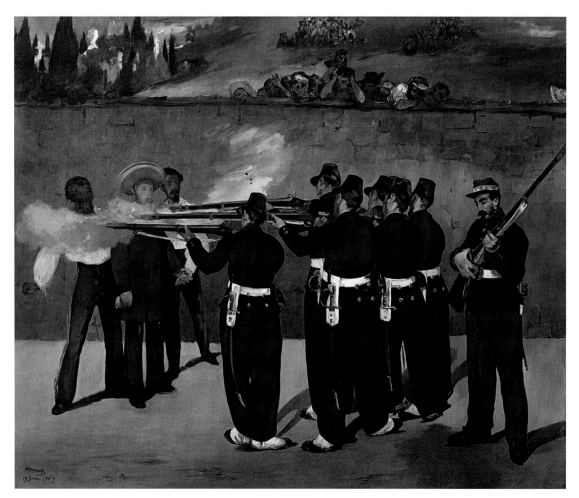

Fig. 37.4 Édouard Manet. *The Execution of Maximilian.* **1868–1869.** Oil on canvas, $99\frac{1}{4}''$ × 120″. Stadische Kunsthalle, Mannheim, Germany. This painting was never exhibited in France until 1905.

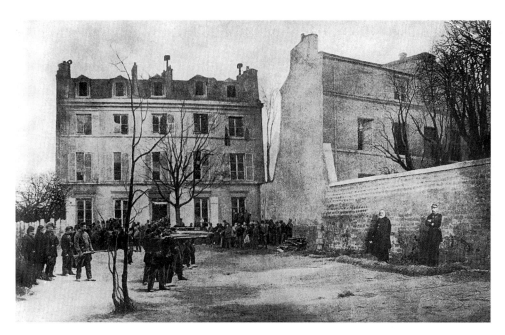

Fig. 37.5 The Execution of General Thomas and General Lecomte in the rue des Rosiers in Montmartre. March 18, 1871. Lecomte's troops easily seized the Communards' cannons, but they neglected to arrange for harnesses to haul them away. Over the course of the day, large crowds surrounded Lecomte's troops, and the Communard National Guard arrived. Three times Lecomte ordered his men to fire on their fellow Frenchmen. When they refused, Guards and Assembly troops cheered. Lecomte's execution quickly followed.

was ablaze, and a series of executions began as government troops arrested and killed anyone who seemed even vaguely sympathetic to the Commune. In what become known as "the bloody week," approximately 20,000 to 25,000 Parisians died. The Commune was crushed, and with it, the dreams of an independent Paris.

Impressionism

The painters of the Second Empire (Napoleon III's reign—1852–1870) struggled to respond to the rapidly changing circumstances. Courbet, who was president of the Commune's Art Commission, was arrested and jailed for six months. When he was released he moved to Switzerland. Manet fled the city for the Pyrenees after the siege, but he returned for at least the last days of the Commune and could not help but feel that his *Execution of Maximilian* had in some way foretold the execution of General Lecomte and subsequently the Paris Communards. He traveled to Bordeaux, the seat of the National Assembly, and attended a session with a friend who had been elected as a delegate. Manet was amazed: "I never imagined France could be represented by such doddering old fools, not excepting that little twit Thiers who I hope will drop dead one day in the middle of a speech and rid us of his wizened little person."

After the events of "the bloody week," Manet wrote despairingly: "What an encouragement all these bloodthirsty caperings are for the arts! But there is at least one consolation in our misfortunes: that we're not politicians and have no desire to be elected as deputies," a sentiment shared by many younger painters. Yet they also saw the entire apparatus of the French art world—the École des Beaux Arts [ay-KOHL deh bohz-AHR], the Salon, and the Salon des Refusés—as hopelessly mired in the politics that had led to the disaster of the Commune. Determined to begin anew, many writers called for the arts to lead the way in rebuilding French culture: "Today, called by our common duty to revive France's fortune," the editor of the *Gazette des Beaux-Arts* wrote, "we will devote more attention to . . . the role of art . . . in the nation's economy, politics, and education." Moved by such rhetoric, these young artists founded the *Société anonyme* [soh-see-ay-TAY ah-noh] for painters, sculptors, and other artists in December 1873. Membership was open to anyone who contributed 60 francs per year (about $12 when a dollar purchased the equivalent of 15 cents today). Among the founders were the painters Claude Monet (1840–1926) and Camille Pissarro (1830–1903); Pierre-Auguste Renoir [ruh-NWAHR] (1841–1919); Edgar Degas [deh-GAH] (1834–1917); and Berthe Morisot [moh-ree-SOH] (1841–1895), the lone woman in the group. Many of them had served in the military, and their close friend and fellow painter Frédéric Bazille [bah-ZEEL] (1841–1870) had been killed during the war with Prussia. On April 15, 1874, they held the first of eight exhibitions. The last was held in 1886, by which time the Société had forever changed the face of French painting. In fact, it had transformed Western painting altogether.

Monet's *Plein-Air* Vision From the outset, critics recognized that a distinguishing feature of this new group of painters was its preference for painting out-of-doors, in *plein air* [plen-air] ("open air"). The availability of paint in metallic tubes, introduced between 1841 and 1843, is in part responsible. Now paints could be easily transported out-of-doors without danger of drying. It was the natural effects of light that most interested these younger painters, which they depicted using new synthetic pigments consisting of bright, transparent colors. Before they were ever called "Impressionists," they were called the "École de Plein Air," although the term *Impressionist* was in wide use by 1876, when poet Stéphane Mallarmé [mahl-ar-MAY] (1842–1898) published his essay "Impressionism and Édouard Manet." (Manet, as noted in chapter 36, was generally considered the leader of the Impressionists, although he repeatedly denied invitations to exhibit with them.)

Plein-air painting implied, first of all, the artist's abandonment of the traditional environment of the studio. Of all the Impressionists, Claude Monet was the most insistent that only *en plein air* could he realize the full potential of his artistic energy. In rejecting the past, the painters of the Société cultivated the present moment, emphasizing improvisation and spontaneity. Each painting had to be quick, deliberately sketchy, in order to capture the ever-changing, fleeting effects of light in a natural setting. Although Monet habitually reworked his paintings in the studio, he would tell a young American artist: "When you go out to paint, try to forget what objects you have before you—a tree, a house, a field, or whatever. Merely think, here is a little square of blue, here an oblong of pink, here a streak of yellow, and paint it just as it looks to you, until it gives you your own naïve impression of the scene before you." It is not surprising, then, that in Monet's *The Regatta at Argenteuil* [ar-zhan-TOY-eh] the reflection of the landscape in the water disintegrates into a sketchy series of broad dashes of paint (Fig. 37.6). On the surface of the water, the mast of the green sailboat seems to support a red and green sail, but this "sail" is really the reflection of the red house and cypress tree on the hillside. Monet sees the relationship between his painting and the real scene as analogous to the relationship between the surface of the water and the shoreline above. Both of these surfaces—canvas and water—reflect the fleeting quality of sensory experience.

Two paintings by Monet in the first Impressionist exhibition offer different perspectives on this new approach to art. The first, *Impression: Sunrise*, went a long way toward giving Impressionism its name (Fig. 37.7). The artist applied the paint in brushstrokes of pure, occasionally unmixed, color that evoke forms in their own right. He rendered waves in staccato bursts of horizontal dashes, the reflection of the rising sun on the water in swirls of orange brushstrokes highlighted with white. Violets and blues contrast with yellows and oranges as if to capture the prismatic effects of light. Most of all, one feels the very presence of the painter at work, his hand racing across the surface of the canvas before the morning light vanished. Although Monet would often work

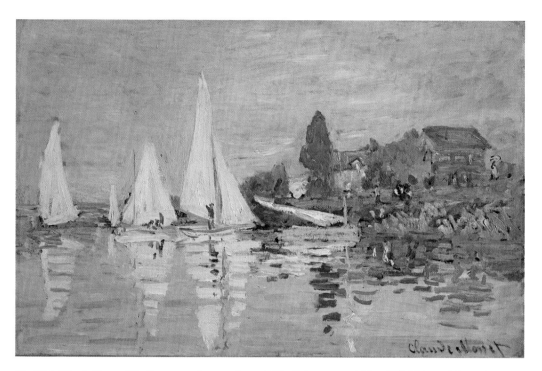

Fig. 37.6 Claude Monet. *The Regatta at Argenteuil.* **ca. 1872.** Oil on canvas, 19″ × 29¹⁄₂″. Musée d'Orsay, Paris, France. Erich Lessing/Art Resource, NY. Monet moved to Argenteuil, a suburb on the Seine just north of Paris, in December 1871, perhaps to leave memories of the Commune behind.

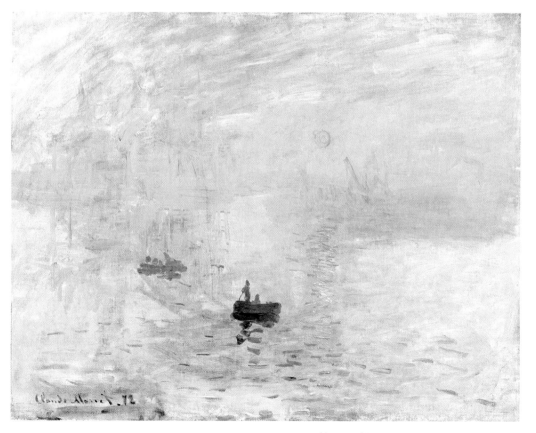

Fig. 37.7 Claude Monet. *Impression: Sunrise.* **1873.** Oil on canvas, 19⁵⁄₈″ × 25¹⁄₂″. Musée Marmottan-Claude Monet, Paris, France. Erich Lessing/Art Resource, NY. The painting is a view of the harbor in Le Havre, France, on the English Channel.

Japonisme An important influence on Impressionist imagery came from an unexpected location—Japan. After a period of more than 200 years of self-imposed isolation, Japan reached several agreements with the United States in the 1850s that heralded cultural and economic transformations in Asia and the West (see chapter 39). Two treaties signed in the 1850s opened diplomatic and trade relations between Japan and the West, and large quantities of Japanese goods began to arrive in Europe. Among the most distinctive items were **ukiyo-e**, or Japanese woodblock prints (literally, "pictures of the transient world of everyday life," commonly translated as "pictures of the floating world"), as well as fans, kimonos, bronzes, and silks. The Japanese Pavilion at the *Exposition Universelle* in Paris in 1867 highlighted the *ukiyo-e* along with other cultural artifacts, attracting much attention from the public and inaugurating the style known as *Japonisme*, the imitation of Japanese art.

The Impressionists were fascinated by the multilayered complexity of the *ukiyo-e*, which nevertheless remained commercial products rather than the artistic masterpieces that we consider them today. Claude Monet, it was said, spotted the engravings being used as wrapping material in a shop in

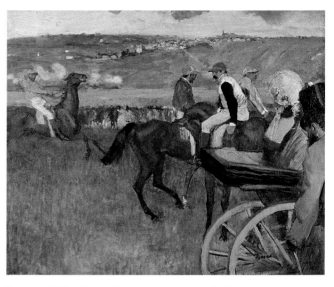

Fig. 37.16 Edgar Degas. *Racecourse, Amateur Jockeys.* **ca. 1877–1880.** Oil on canvas, 26" × 31⅞". Musée d'Orsay, Paris, France. The Bridgeman Art Library.

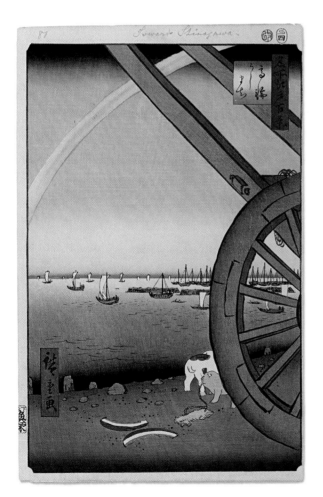

Fig. 37.15 Ando Hiroshige. *Ushimachi, Takanawa,* **from the series One Hundred Famous Views of Edo. 1857.** Woodblock print, 13¼" × 8⅜". Gift of Anna Ferris. Brooklyn Museum of Art.

Amsterdam in 1871 and walked out with the first of a collection that eventually numbered over 200. Édouard Manet's friend Zacahrie Astruc [ah-STROOK] summarized the sensation that Japanese woodblock printmaking caused in their circle: "Japanese art, which wrestles bodily with nature, which isn't at all like European art, prepared laboriously as a matter of absolute transmission (repetition) . . . simply astonished us." When Camille Pissarro saw prints by Hiroshige, he wrote "the Japanese artist Hiroshige is a marvelous Impressionist." In Manet's *Portrait of Émile Zola* (see Fig. 36.8), we glimpse a Japanese woodcut by the nineteenth-century artist Kuniaki II.

What so impressed the Impressionists about Japanese prints? Most important, the Impressionists recognized in Japanese prints a common interest in everyday urban life, an urban world of courtesans, actors, and dancers. However, the prints fascinated them for more than just their thematic celebration of everyday life. These *ukiyo-e* images represented space in a novel way. Ever since the Japanese had been introduced to Western linear perspective in the late 1730s, woodblock print artists had copied the Western technique while transforming it. Because it was difficult to create consistent space from near to far, many *ukiyo-e* printmakers exploited the possibilities of rendering banal things that happened to be near at hand quite large and of making more important things in the distance much smaller. So in Hiroshige's view of *Ushimachi, Takanawa*, a wagon wheel, watermelon rinds, and a couple of pigs dominate the harbor (Fig. **37.15**). Degas similarly cropped the right foreground of his *Racecourse, Amateur Jockeys*, with its carriage wheels, advancing gentleman, and jockeys, into a similarly vast and empty landscape (Fig. **37.16**). Degas also exploits the Japanese sense of dramatic juxtapositions of color. Note how the jockeys' red hats and jackets are set against the green grasses of the landscape, echoing the red and green chop mark (seal) at the top right of Hiroshige's print.

Continuity & Change
p. 870

The Kermis

and Flemish paintings like Rubens's *The Kermis* (see Fig. 27.7), which Renoir would have seen at the Louvre.

Edgar Degas was as dedicated as Renoir to the careful construction of his paintings. *Dance Class* depicts 21 dancers awaiting their turn to be evaluated by the ballet master, who stands leaning on a tall cane in the middle ground watching a young ballerina making her salute to an imaginary audience (Fig. **37.13**). The atmosphere is unpretentious, emphasizing the elaborate preparations and hard work necessary to produce a work of art that will appear effortless on stage. The dancers form an arc, connecting the foreground to the middle ground and drawing the eye quickly through the space of the painting. Degas draws the viewer's attention to the complex structure of his composition—that is, to the fact that he too has *worked* long and hard at it.

Work is, in fact, one of Degas's primary themes, and it is no accident that the ballet master leans on a cane—as a former dancer, he is understood to be physically impaired from a dance injury. Degas understood that the young women he depicted were, in fact, full-time child workers. Almost all were from lower-class families and normally entered the ballet corps at age seven or eight when their schooling ceased, leaving most of them illiterate. They had to pass examinations, such as the one Degas depicts here, in order to continue. By the time they were nine or ten, they might earn 300 francs a year (approximately 60 U.S. dollars in 1870, with a buying power of about 400 U.S. dollars today). If and when they rose to the level of performing brief solos in the ballet, they might earn as much as 1,500 francs—more than most of their fathers, who were shop clerks, cab drivers, and laborers. Should they ever achieve the status of *première danseuse* [pruh-mee-YAIR dahn-SUZ], in their late teens, they might earn as much as 20,000 francs, a status like today's richly compensated professional athlete that few reached but all dreamed of. Thus, Degas's *Dance Class* presents young women in a moment of great stress, struggling in a Darwinian world in which only the fittest survived.

Degas was the most radical of the Impressionists in experimenting with new media. He was especially stimulated by **pastels**—sticks of powdered pigment bound with resin or gum. The soft effects of pastel could simulate the gaslit atmosphere of Paris's café-concerts in the outdoor pavilions behind cafés such as the Café des Ambassadeurs , in the park at the base of the Champs-Élysées. Degas's *Aux Ambassadeurs*, displayed at the 1877 Impressionist exhibition, places the viewer in the audience close to the orchestra and behind three ladies and a gentleman (Fig. **37.14**). Onstage is the *chanteuse* ("singer"), her arm extended toward the audience as she sings. Behind her is the *corbeille* [kor-BAY], a term meaning "flowerbed" or "basket" but used figuratively to refer to the dress circle at the theater. In fact, the *corbeille* was composed of women of questionable repute hired to sit on the stage and look attractive and who communicated with admirers in the audience with a sign language, visible in Degas's pastel. Degas's taste for depicting such pleasure-seekers—on the stage and in the audience—is similar to Manet's earlier "judgments" of Paris.

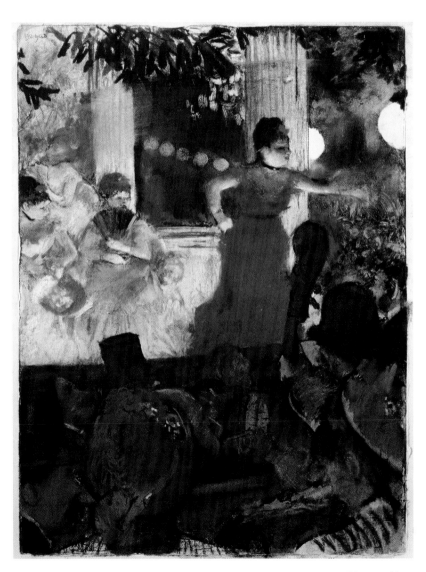

Fig. 37.14 Edgar Degas. *Aux Ambassadeurs*. 1877. Pastel over monotype, $14\frac{1}{2}'' \times 10\frac{5}{8}''$. Musée des Beaux-Arts, Lyons, France. Erich Lessing/Art Resource, NY. The questionable quality of the performance is captured in the unkempt hair and unstylish hat of the orchestra members, positioned between the four figures in the foreground and the stage.

Japonisme An important influence on Impressionist imagery came from an unexpected location—Japan. After a period of more than 200 years of self-imposed isolation, Japan reached several agreements with the United States in the 1850s that heralded cultural and economic transformations in Asia and the West (see chapter 39). Two treaties signed in the 1850s opened diplomatic and trade relations between Japan and the West, and large quantities of Japanese goods began to arrive in Europe. Among the most distinctive items were **ukiyo-e**, or Japanese woodblock prints (literally, "pictures of the transient world of everyday life," commonly translated as "pictures of the floating world"), as well as fans, kimonos, bronzes, and silks. The Japanese Pavilion at the *Exposition Universelle* in Paris in 1867 highlighted the *ukiyo-e* along with other cultural artifacts, attracting much attention from the public and inaugurating the style known as *Japonisme*, the imitation of Japanese art.

The Impressionists were fascinated by the multilayered complexity of the *ukiyo-e*, which nevertheless remained commercial products rather than the artistic masterpieces that we consider them today. Claude Monet, it was said, spotted the engravings being used as wrapping material in a shop in

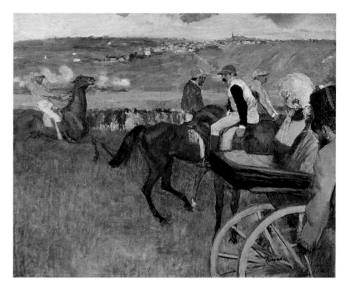

Fig. 37.16 Edgar Degas. *Racecourse, Amateur Jockeys.* ca. 1877–1880. Oil on canvas, 26″ × 31⅞″. Musée d'Orsay, Paris, France. The Bridgeman Art Library.

Amsterdam in 1871 and walked out with the first of a collection that eventually numbered over 200. Édouard Manet's friend Zacahrie Astruc [ah-STROOK] summarized the sensation that Japanese woodblock printmaking caused in their circle: "Japanese art, which wrestles bodily with nature, which isn't at all like European art, prepared laboriously as a matter of absolute transmission (repetition) . . . simply astonished us." When Camille Pissarro saw prints by Hiroshige, he wrote "the Japanese artist Hiroshige is a marvelous Impressionist." In Manet's *Portrait of Émile Zola* (see Fig. 36.8), we glimpse a Japanese woodcut by the nineteenth-century artist Kuniaki II.

What so impressed the Impressionists about Japanese prints? Most important, the Impressionists recognized in Japanese prints a common interest in everyday urban life, an urban world of courtesans, actors, and dancers. However, the prints fascinated them for more than just their thematic celebration of everyday life. These *ukiyo-e* images represented space in a novel way. Ever since the Japanese had been introduced to Western linear perspective in the late 1730s, woodblock print artists had copied the Western technique while transforming it. Because it was difficult to create consistent space from near to far, many *ukiyo-e* printmakers exploited the possibilities of rendering banal things that happened to be near at hand quite large and of making more important things in the distance much smaller. So in Hiroshige's view of *Ushimachi, Takanawa,* a wagon wheel, watermelon rinds, and a couple of pigs dominate the harbor (Fig. **37.15**). Degas similarly cropped the right foreground of his *Racecourse, Amateur Jockeys,* with its carriage wheels, advancing gentleman, and jockeys, into a similarly vast and empty landscape (Fig. **37.16**). Degas also exploits the Japanese sense of dramatic juxtapositions of color. Note how the jockeys' red hats and jackets are set against the green grasses of the landscape, echoing the red and green chop mark (seal) at the top right of Hiroshige's print.

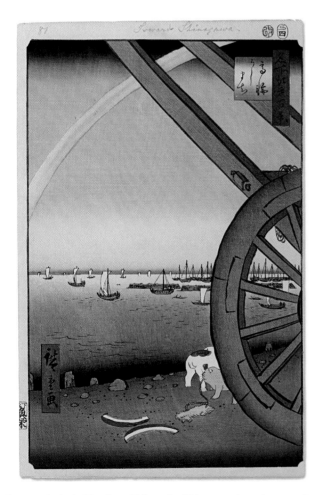

Fig. 37.15 Ando Hiroshige. *Ushimachi, Takanawa,* from the series *One Hundred Famous Views of Edo.* 1857. Woodblock print, 13¼″ × 8⅜″. Gift of Anna Ferris. Brooklyn Museum of Art.

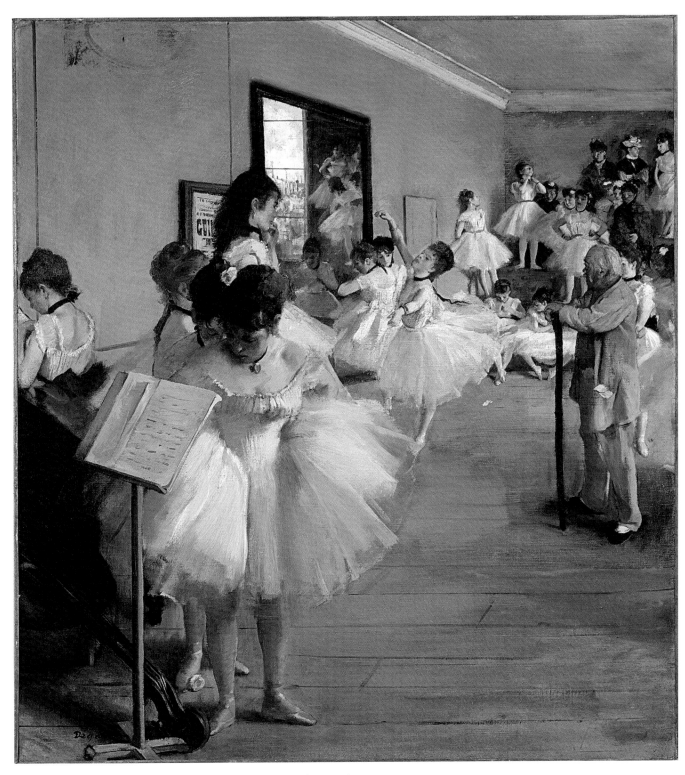

Fig. 37.13 Edgar Degas. *Dance Class*. ca. 1874. Oil on canvas, $32\frac{3}{4}'' \times 30\frac{1}{4}''$. The Metropolitan Museum of Art.
Bequest of Mr. and Mrs. Harry Payne Bingham, 1986 (1987.47.1). Image copyright © The Metropolitan Museum of Art.
The dance instructor is Jules Perrot, the most famous male dancer of the middle third of the century, whose likeness Degas
took from a photograph of 1861.

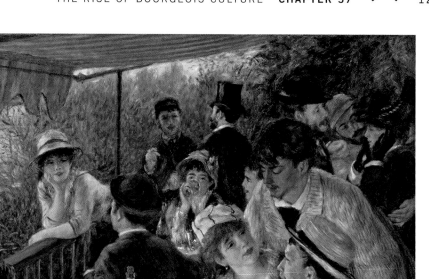

Fig. 37.12 Auguste Renoir. *Luncheon of the Boating Party.* **1881.** Oil on canvas, 51″ × 68″. Phillips Collection, Washington, DC. The woman leaning on the railing is Alphonsine Fournaise, the restaurant proprietor's daughter, and leaning against the rail at the left is Alphonse Fournaise, his son. Just below, about to kiss her little dog, is Aline Charigot, Renoir's future wife. The figure leaning over the table at the right—the only one without a hat—is Renoir's friend, the journalist Maggiolo. He addresses an actress by the name of Angèle and the painter Gustave Caillebotte, himself an avid sailor. The man in the top hat at the back of the painting is Charles Euphussi, editor of the *Gazette des Beaux-Arts.*

Renoir, Degas, and the Parisian Crowd While Monet and Pissarro concentrated on landscape painting, August Renoir and Edgar Degas preferred to paint the crowd in the cafés and restaurants, at entertainments of all kinds, and in the countryside, to which the middle class habitually escaped on weekends via the ever-expanding railroad lines. Renoir was especially attracted to Chatou [shah-TOO], a small village on the Seine frequented by rowers. No longer reserved for the upper class, Chatou and other riverside towns became retreats for a diverse crowd of Parisian artists, bourgeoisie, and even workers. Weekend escapes centered on cafés, dance halls, boating, and swimming. Renoir was particularly fond of the Maison and Restaurant Fournaise [foor-NEZ], a lodging house and restaurant on an island in the river, which served as the setting of *Luncheon of the Boating Party* (Fig. **37.12**). Through the foliage at the back of the painting we can make out two sailboats on the river and, just under the awning, a railroad bridge. We can identify many of the figures from his circle of friends and acquain-

tances at Chatou, including members of the Fournaise family. To represent such recognizable figures, Renoir had to abandon the gestural brushwork of Monet and Pissarro except in the background landscape. He composed his figures with firm outlines and modeled them in subtle gradations of light and dark, which clearly define their anatomical and facial features. And he carefully structured the group in a series of interlocking triangles, the largest of which is made up of Aline Charigot [shah-ree-GOH], Renoir's future wife, sitting at the table holding her dog. Scholars believe that the painting, begun in the summer of 1880, may represent Renoir's response to Émile Zola's critique in his review of the 1880 Salon charging the Impressionists with selling "sketches that are hardly dry" and challenging them to make more complex paintings that would be the result of "long and thoughtful preparation." For this reason, the theory goes, Renoir assimilates into this single work landscape, still life, and genre painting in a manner probably intentionally recalling seventeenth-century Dutch

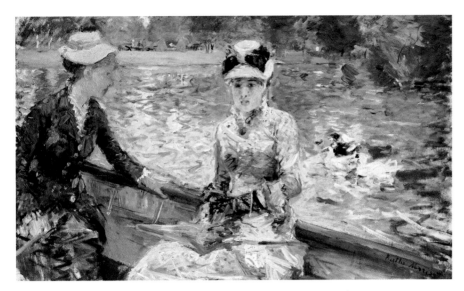

Fig. 37.10 **Berthe Morisot.** *Summer's Day.* **1879.** Oil on canvas, 18″ × 29 ³/₄″. National Gallery, London. Note the almost arbitrary brushwork that defines the bottoms of the dresses worn by both women, one a set of zigzags, the other a patchwork of straight strokes, emphasizing the distance and difference between the two.

Morisot and Pissarro: The Effects of Paint Monet's willingness to break his edges with feathery strokes of paint was even more radically developed in the work of Berthe Morisot. Born to a socially connected bourgeois family (she was the granddaughter of the Rococo painter Fragonard, noted for his rapid brushwork) (see Fig. 29.7), Morisot received an education that included lessons in drawing and painting from the noted landscape artist Camille Corot. She became a professional painter, and a highly regarded colleague to male artists of her generation. Morisot was the sister-in-law of Manet, and it was she who convinced him to adopt an Impressionist technique of his own. But no one could match her "vaporous and barely drawn lines," as one critic put it. "Here are some young women rocking in a boat," writes a critic of her painting *Summer's Day*, ". . . seen through fine gray tones, matte white, and light pink, with no shadows, set off with little multi-colored daubs . . ." (Fig. 37.10). She drapes her bourgeois figures, out for a little recreation, in clothing that is often barely distinguishable from the background, like those worn by the woman in the middle of the boat. She shuns outline altogether—each of the ducks in the water is realized in several broad, quick strokes.

If Morisot's paintings seem to dissolve into a uniform white light, Camille Pissarro's landscapes give us the impression of a view never quite fully captured by the painter. In *Red Roofs*, a random patchwork of red and green, orange and blue appears through a veil of tree branches that interrupt the viewer's vision (Fig. **37.11**). Pissarro was deeply interested in the new science of color theory, and he paid close attention to the 1864 treatise of Michel-Eugène Chevreul [shev-RULL] (1786–1889), *On Colors and their Applications to the Industrial Arts.* Chevreul argued that complementary colors of pigment (that is, colors directly opposite each other on the traditional color wheel)—like red and green, yellow and violet, blue and orange—intensify each other's hue when set side by side. Pissarro adopted a later scheme by American physicist Ogden Rood, in which the primary colors of light, rather than pigment, were red, green, and blue-violet. In this he anticipated the color theories that would stimulate Neo-Impressionist painters of the next generation like Georges Seurat [suh-RAH] and Paul Signac [seen-YAK] (see chapter 40).

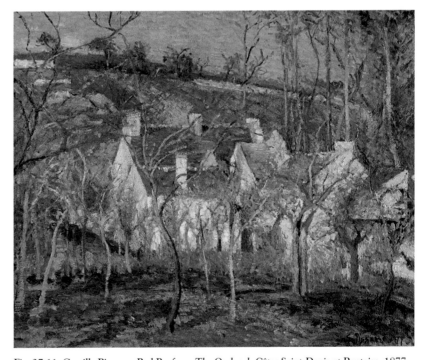

Fig. 37.11 **Camille Pissarro.** *Red Roofs, or The Orchard, Côtes Saint-Denis at Pontoise.* **1877.** Oil on canvas, 21 ¹/₂″ × 25 ⁷/₈″. Musée d'Orsay, Paris, France. Erich Lessing/Art Resource, NY. When Bismarck advanced on Paris, Pissarro abandoned his home in Louveciennes, on the outskirts of the city, and Bismarck's forces moved in. On rainy days, they created a path across the courtyard with Pissarro's paintings to keep their feet from getting wet. As a result, few of his paintings before 1871 survive.

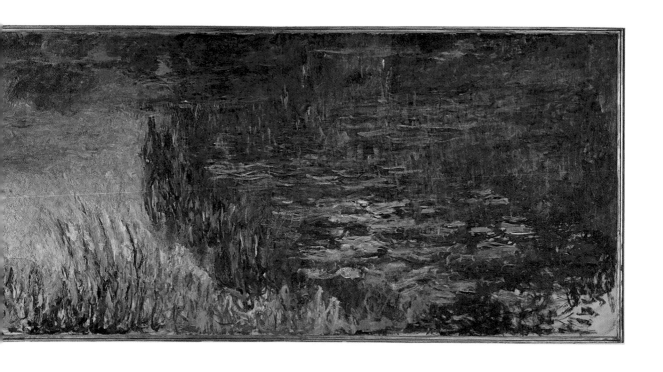

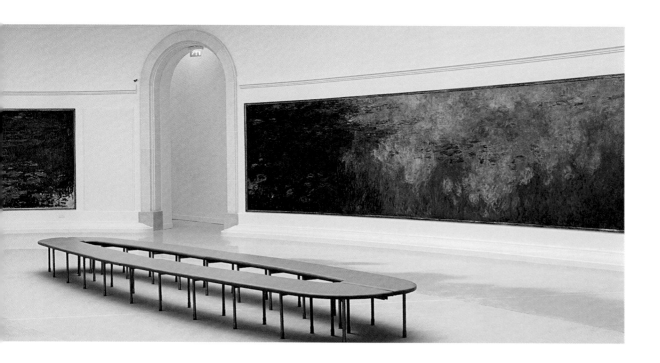

Focus

Monet's *Water Lilies*

In 1893, Claude Monet bought the tract of land that included a pond across the railroad tracks from his property in Giverny, adjacent to the river. He proceeded to expand the pond, plant it with water lilies, and build a Japanese bridge after the model found in any number of Japanese prints, which he had collected for years. Then he began to paint the ensemble repeatedly. The garden at Giverny became a sort of dream world for him, its reflections a metaphor for his own thoughts, his own self-reflections.

Beginning the series in 1902, Monet often repainted the canvases, destroying some in frustration. But in 1909, he exhibited 48 *Water Lilies* paintings in Paris. And in 1914, encouraged by his friend and neighbor Georges Clemenceau (1841–1929), prime minister of France, he began a series of mural-sized versions of the paintings, which he agreed to donate to the state. He worked on them continuously until his death. In 1927 they were finally installed, encircling the viewer in two rooms of the Orangerie [or-ohn-zhuh-REE], a building at the top of the Tuileries gardens.

Standing in the midst of Monet's panoramic cycle, the viewer's eye is driven randomly through the space of the paintings. It is as if one were standing on an island in the middle of the pond itself. Without a single focal point, the viewer organizes the visual experience through personal acts of perception and movement.

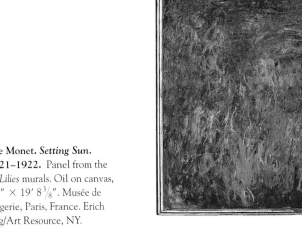
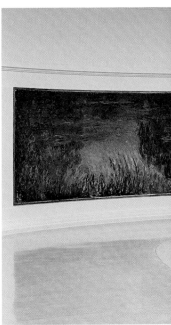

Claude Monet. *Setting Sun.* ca. 1921–1922. Panel from the *Water Lilies* murals. Oil on canvas, 6′ 6³⁄₄″ × 19′ 8³⁄₈″. Musée de l'Orangerie, Paris, France. Erich Lessing/Art Resource, NY.

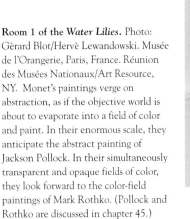

Room 1 of the *Water Lilies.* Photo: Gèrard Blot/Hervè Lewandowski. Musée de l'Orangerie, Paris, France. Réunion des Musées Nationaux/Art Resource, NY. Monet's paintings verge on abstraction, as if the objective world is about to evaporate into a field of color and paint. In their enormous scale, they anticipate the abstract painting of Jackson Pollock. In their simultaneously transparent and opaque fields of color, they look forward to the color-field paintings of Mark Rothko. (Pollock and Rothko are discussed in chapter 45.)

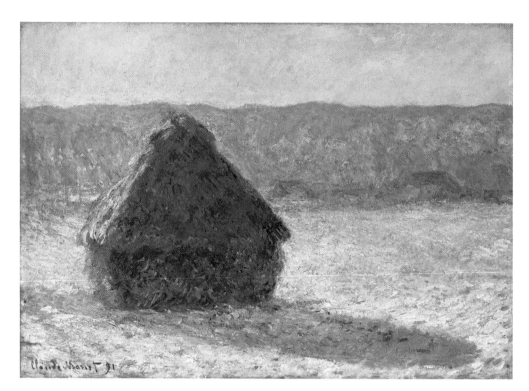

Fig. 37.9 Claude Monet.
Grainstack (Snow Effect). **1891.**
Oil on canvas, 25 ¾″ × 36 ⅜″.
Museum of Fine Arts, Boston. Gift of
Misses Aimee and Rosamond Lamb
in memory of Mr. and Mrs. Horatio
A. Lamb, 1970.253. Photograph
© 2008 Museum of Fine Arts,
Boston. This painting has a simple
geometric structure—a triangle set
on a rectangle, both set on a
rectangular ground.

Monet had continually sought to escape the city for the pleasures of the countryside. In December 1871, he had moved to Argenteuil, an idyllic little village on the Seine downriver from Paris and where he lived for seven years. Then, faced with the suburb's increasing industrialization and urbanization, he moved farther downriver to Vétheuil [vay-TOY], another little town with a tiny population, no railroads, no industry, no pollution, and no weekend Parisian crowds. Finally, in April 1883, he moved farther downriver again, to Giverny [zhee-vair-NEE]. Monet's determined flight from the distraction of crowds is an announcement of the rapid growth of suburbs and outlying towns surrounding Paris (and every other growing metropolis) in the last quarter of the century.

Monet did not begin painting at Giverny immediately. Instead, he traveled—to the south of France, to the Côte d'Azur [koht dah-ZOOR], to Brittany and the Normandy coast, and to locations all across France. Monet's sojourn through the countryside points to the increased opportunities for leisurely travel afforded by the ever-expanding railroad networks in France. Indeed many of the towns and scenes he painted were tourist locales, frequented by the prosperous Parisian middle class that the Impressionists sought to cultivate. Many of his contemporaries attacked the master of Impressionism for the shallowness of his themes and his apparent instantaneous rendering of light effects. But the painting was anything but instantaneous. "The more I go on," Monet wrote in a letter to a friend, "the more I see that I must work a lot to succeed in rendering what I am looking

for: 'instantaneity' . . . more than ever I'm disgusted by easy things that come without effort."

In the autumn of 1888, Monet began using a different series format than before, painting the same subject at different times of day and in different atmospheric conditions. In addition to a series on a line of poplar trees and on Rouen Cathedral, he painted a series of grainstacks in the nearby farmer's field. In May 1891, he exhibited 15 grainstack paintings in Paris. They were a spectacular success (Fig. **37.9**). In a preface to the catalog for the exhibition, art critic and Monet friend's Gustave Geffroy describes their effect on the viewer:

> These stacks in this deserted field are transient objects whose surfaces, like mirrors, catch the mood of the environment, the states of the atmosphere with the errant breeze, the sudden glow. Light and shade radiate from them, sun and shadow revolve around them in relentless pursuit; they reflect its dying heat, its last rays; they are shrouded in mist, soaked with rain, frozen with snow, in harmony with the distant horizon, the earth, the sky. . . .

Each painting in the series, then, becomes a fragment in the duration of the whole, and Geffroy's reading of the works transforms Monet into an artist who in rendering nature also depicts his own interior landscape. As he continued to work—almost daily until his death in 1926—he turned his attention to his gardens at Giverny, creating some of the most monumental paintings in the history of art (see *Focus*, pages 1198–1199).

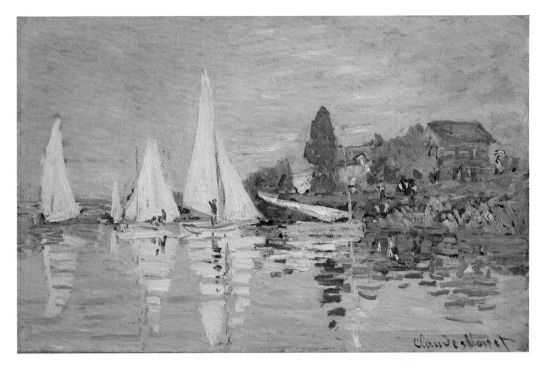

Fig. 37.6 Claude Monet. *The Regatta at Argenteuil.* **ca. 1872.** Oil on canvas, 19″ × 29 ½″. Musée d'Orsay, Paris, France. Erich Lessing/Art Resource, NY. Monet moved to Argenteuil, a suburb on the Seine just north of Paris, in December 1871, perhaps to leave memories of the Commune behind.

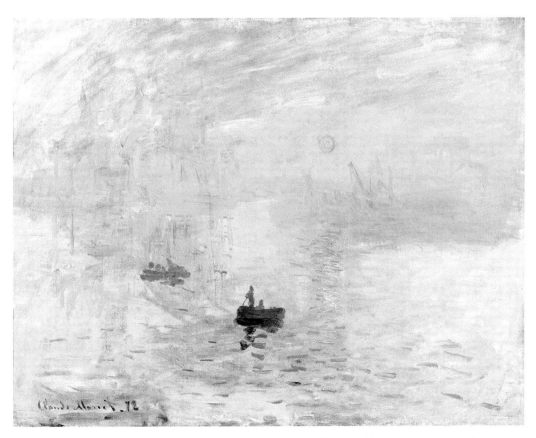

Fig. 37.7 Claude Monet. *Impression: Sunrise.* **1873.** Oil on canvas, 19 ⅝″ × 25 ½″. Musée Marmottan-Claude Monet, Paris, France. Erich Lessing/Art Resource, NY. The painting is a view of the harbor in Le Havre, France, on the English Channel.

and rework his paintings, they seem "of the moment," as immediate as a photograph.

In the second painting, *Boulevard des Capucines*, we look out over the *grands boulevards* with the two top-hatted men who lean forward out the window at the right (Fig. **37.8**). The building at the left is the Grand Hôtel, and between it and the next building, the space compressed by Monet's perspective, is the Place de l'Opéra. We are, in fact, standing in the exhibition space of the first Impressionist show, and this is a work of art about its own marketplace. Monet's brushwork, capturing the play of light on the leaves on the trees and the crowds in the street, is even looser and freer than in *Impression: Sunrise*. Writing in *Paris-Journal* in May 1874, the critic Ernest Chesneau [shay-noh] recognized the painting's significance:

> The extraordinary animation of the public street, the crowd swarming on the sidewalks, the carriages on the pavement, and the boulevard's trees waving in the dust and light—never has movement's elusive, fugitive, instantaneous quality been captured and fixed in all its tremendous fluidity as it has in this extraordinary, marvelous sketch. . . . At a distance, one hails a masterpiece in this stream of life, this trembling of great shadow and light, sparkling with even darker shadows and brighter lights. But come closer, and it all vanishes. There remains only an indecipherable chaos of palette scrapings. . . . It is necessary to go on and transform the sketch into a finished work. But what a bugle call for those who listen carefully, how it resounds far into the future!

Chesneau failed to understand that this "sketch" was already "finished." But he was right that it was a painting of the future. It would not take long for the public to understand that this "chaotic" brushwork was the very mark of a new sensibility, one dedicated to capturing what the French call *le temps* [tahn], a word that refers to the "time of day," "the weather," and "the age" all at once.

Monet's Escape to Giverny After the Commune, except for a brief stint in Paris in 1876–1877 when he painted a series of works on the *Gare Saint-Lazare* train station,

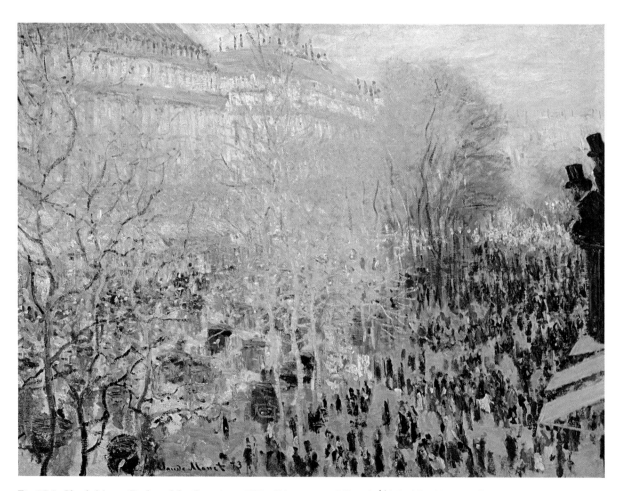

Fig. 37.8 Claude Monet. *Boulevard des Capucines.* **1873.** Oil on canvas, 24″ × 31½″. Pushkin Museum of Fine Arts, Moscow, Russia. Scala/Art Resource, NY. There are two paintings by this name, both executed in 1873. The other is a winter scene. It is unclear which of these two was exhibited at the first Impressionist exhibition, but Chesneau's description points toward this one.

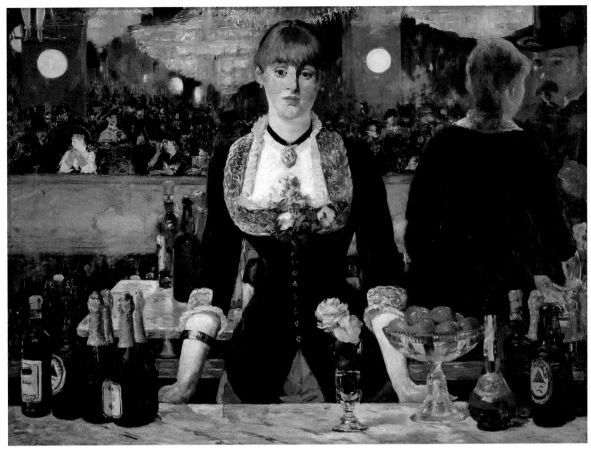

Fig. 37.17 Édouard Manet. *A Bar at the Folies-Bergère*. **1881–1882.** Oil on canvas, 37³/₄″ × 51¹/₈″. Courtauld Institute Galleries, London. Manet's model was actually a waitress at the Folies-Bergère named Suzon.

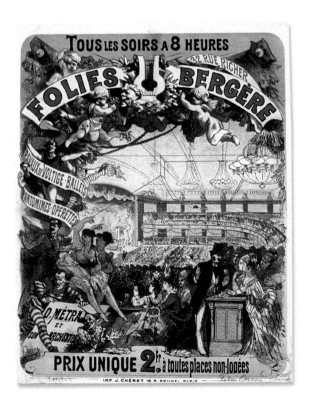

Fig. 37.18 Jules Chéret. *Aux Folies-Bergère*. 1875. Poster. Mention obligatoire Les Arts Decoratifs, Paris (Inv. 7972); Musée de la Publicité (Inv. 10531); Photo: Laurent Sully Jaulmes. Tous droits reserves. The Folies-Bergère opened as a department store specializing in bedding in 1860, but a "salle des spectacles" at the back of the store became so successful that by 1869 the store gave up the bedding business to concentrate solely on entertainment.

Manet's Impressionism Throughout the 1870s the influence of Manet's sister-in-law, Berthe Morisot, caused Manet increasingly to adopt the Impressionist techniques of the younger generation, particularly the loose application of paint and the emphasis on capturing the effects of light. But whereas the Impressionists tended to celebrate the good life, Manet never gave up his penchant for critiquing it in terms much more direct than the subtle "judgments" offered by Degas. Manet's *A Bar at the Folies-Bergère* [foh-LEE-ber-ZHER], the last major painting he finished before his death in 1883, situates the viewer in a higher-class environment than Degas's café-concert (Fig. **37.17**). The viewer faces a barmaid standing behind her marble counter on a balcony in front of a mirror reflecting the Folies theater in front of her. She is more or less in the same position as the barmaid at the lower right of Jules Chéret's [shay-RAYS] 1875 poster for the Folies, which reveals the entertainment of the moment: a trapeze artist flying across the space (Fig. **37.18**). The same trapeze artist's feet are visible at the top left of Manet's painting.

What really captures viewer attention in this painting is the barmaid's eyes. Instead of gazing directly at the viewer, as in *Le Déjeuner sur l'herbe* (see fig. 36.6) or *Olympia* (see the Focus, chapter 36), the eyes look past us, perhaps even inward in thought. In the midst of the crowd, the barmaid seems totally alone. The oddity of this is compounded by the barmaid's reflection in the mirror, improbably shifted to the right. For, in fact, the barmaid is facing a gentleman, who stands before her in the place we occupy as viewers. She is the object of his gaze (and our own), and he affirms her status, in his own eyes at least, as a server of consolation. Manet's Impressionism, then, incorporates the viewer into its "atmosphere," which like the illusion of depth provided by the mirror is actually impenetrable.

Russian Realism and the Quest for the Russian Soul

Ever since Catherine the Great made French the official language of the Russian court in the eighteenth century, unabashed Francophiles [FRANK-oh-files]—lovers of all things French—dominated cultural life in Saint Petersburg. By the turn of the century, Moscow merchants Sergei Shchukin (1854–1936) and Ivan Morozov (1871–1921) had amassed important collections of Impressionist paintings. Shchukin purchased Camille Pissarro's *Avenue de l'Opéra* (see Fig. 37.1) as well as paintings from Claude Monet's *Grainstacks*, *Rouen Cathedral*, and *Water Lilies* series. Morozov purchased Monet's *Boulevard des Capucines* (see Fig. 37.8) and several important Renoirs. Such collecting was motivated, at least in part, by political beliefs. Those who turned to France and Germany for inspiration, known as Westernizers, believed that Russia was hopelessly backward, epitomized by the continuation of serfdom. They believed that only by adopting Western values could the nation be saved.

But many Russians disagreed, arguing that the country possessed a spirit uniquely its own. These so-called Slavophiles [SLAHV-oh-files]—Russian nationalists—rejected the West as a source of inspiration in favor of Old Russian traditions and the Orthodox Church. They prided themselves on their spirituality. These values were shared by Russian writers like Pushkin and Gogol (see chapter 35), as well as by Fyodor Dostoyevsky [dust-uh-YEF-skee] (1821–1881) and Leo Tolstoy (1828–1910). Russian nationalism found expression in art and music too. Underlying all Russian culture—Francophile and Slavophile alike—was the plight of the Russian serfs, 22 million souls who were essentially slaves who worked the fields of their landlords for their entire lives with little or no compensation.

The Writer and Artist under the Tsars

Under the rule of Nicholas I (1825–1855), literary culture in Russia was severely stifled. Constantly on guard against rebellion, the tsar exercised strict control over education, publishing, and all public entertainment. He might have laughed at Gogol's *Dead Souls* (see chapter 35), but he was by no means tolerant of liberal thinkers like Gogol and Pushkin, whom he kept under constant surveillance by government censors. Nicholas's successor, Alexander II (r. 1855–1881), was as autocratic as his father, but he instituted a series of reforms, including the emancipation of the serfs in 1861. This act would profoundly affect the cultural life of his country.

The Psychological Realism of Dostoyevsky Troubled by the European revolutions of 1848, Nicholas abolished the study of philosophy at the University of Saint Petersburg and arrested members of a radical discussion group called the Petrashevsky Circle. One of those detained was the 27-year-old novelist Fyodor Dostoyevsky. Found guilty of subversive activities, he, like his colleagues, was sentenced to death. On December 22, 1849, Dostoyevsky and the others were led before the firing squad, but at the last minute the tsar issued a reprieve. Dostoyevsky was sentenced to four years in a Siberian labor camp, followed by six years in the army in Mongolia. He would describe his experiences in prison in the short novel *The House of the Dead* (1862) as "A period of burial alive, I was put in a coffin. The torture was unutterable and unbearable."

However, Dostoyevsky slowly came to admire his fellow inmates—murderers, thieves, and social outcasts. And the question he began to contemplate, which would occupy him for the rest of his life, was this: Can we love the damned? Are we not obligated to face the horrors of life to which the damned are condemned? As one of his characters in *The Insulted and Injured* (1861) puts it: "It thrills the heart to realize that the most downtrodden man, the lowest of the low, is also a human being and is called your brother."

Dostoyevsky was not allowed to return to Saint Petersburg until 1859, four years after the death of Nicholas I. Two years later, in 1861, when the new tsar, Alexander II, ordered the emancipation of Russia's serfs, Dostoyevsky felt the impact personally. His domineering and alcoholic father, a retired military surgeon and doctor at a hospital for the poor in Moscow, may have been murdered by his own serfs in 1839. Dostoyevsky's greatest and last novel, *The Brothers Karamazov* (1880), would have as a central figure an abusive father who is killed by his sons.

The complexity of psychological guilt is the theme of his 1866 novel, *Crime and Punishment*, as is the basic question: "Can immoral means justify worthy ends?" Its hero, Rodion Petrovich Raskolnikov—Rodya, for short—is tormented by his senseless axe murder of a despised pawnbroker and her more likable sister. Prior to the murder, Raskolnikov, an intellectual, had written an article dividing the world into ordinary people and gifted heroes (like Napoleon) who are above the law (see **Reading 37.1**, page 1215). Like all of Dostoyevsky's heroes, Raskolnikov is driven by an idea, not by hereditary or environmental causes. Dostoyevsky called his style a "higher realism," because it is so infused with the anxieties, conflicts, and tensions that comprise modern consciousness. Raskolnikov believes himself to be the embodiment of his idea, as a gifted hero above the law. It was, in fact, a misguided attempt to assert individual freedom and to escape humanity's enslavement to scientific rationalism, capitalism, and industrialism. Dostoyevsky's hero, then, has damned himself—like Goethe's Faust

(see chapter 34). In a bold gambit the author asks you, the reader, to comprehend that Raskolnikov is also "your brother."

After the murder, Raskolnikov barely escapes detection at the pawnbroker's home, then makes his way through the streets of Saint Petersburg. A short excerpt captures the drama that characterizes Dostoyevsky's style (**Reading 37.1a**):

READING 37.1a **from Fyodor Dostoyevsky, _Crime and Punishment_, Part I, Chapter 7 (1866)**

No one was on the stairs, nor in the gateway. He passed quickly through the gateway and turned to the left in the street.

He knew, he knew perfectly well that at that moment they were at the flat, that they were greatly astonished at finding it unlocked, as the door had just been fastened, that by now they were looking at the bodies, that before another minute had passed they would guess and completely realise that the murderer had just been there, and had succeeded in hiding somewhere, slipping by them and escaping. They would guess most likely that he had been in the empty flat, while they were going upstairs. And meanwhile he dared not quicken his pace much, though the next turning was still nearly a hundred yards away. "Should he slip through some gateway and wait somewhere in an unknown street? No, hopeless! Should he fling away the axe? Should he take a cab? Hopeless, hopeless!"

At last he reached the turning. He turned down it more dead than alive. Here he was half way to safety, and he understood it; it was less risky because there was a great crowd of people, and he was lost in it like a grain of sand. But all he had suffered had so weakened him that he could scarcely move. Perspiration ran down him in drops, his neck was all wet. . . .

He was only dimly conscious of himself now, and the farther he went the worse it was. . . . He was not fully conscious when he passed through the gateway of his house! he was already on the staircase before he recollected the axe. And yet he had a very grave problem before him, to put it back and to escape observation as far as possible in doing so. He was of course incapable of reflecting that it might perhaps be far better not to restore the axe at all, but to drop it later on in somebody's yard. . . . Scraps and shreds of thoughts were simply swarming in his brain, but he could not catch at one, he could not rest on one, in spite of all his efforts. . . .

The drama continues to heighten as the detective, Porfiry Petrovich, persistently pecks away at Raskolnikov and as Sonya, a young woman driven to prostitution by her alcoholic father, tries to persuade him to confess. He does finally confess his guilt and is sentenced to imprisonment in Siberia, where Sonya faithfully accompanies him. By the novel's end, Raskolnikov realizes he is not a superhuman hero above the law, and he dreams that his nihilism was a deadly plague advancing on Russia and Europe. Rejecting his former beliefs, Raskolnikov undergoes a spiritual rebirth, accepting the necessity of religion as well as love:

> Life had stepped into the place of theory and something quite different would work itself out in his mind. . . . He did not know that the new life would not be given him for nothing, that he would have to pay dearly for it, that it would cost him great striving, great suffering. But that is the beginning of a new story—the story of the gradual renewal of a man, the story of his gradual regeneration, of his passing from one world into another, of his initiation into a new unknown life.

In this renewal, Raskolnikov discovers his connection with the common people and so the essence of his Russian soul.

The Historical Realism of Tolstoy If Dostoyevsky's realism turned inward to the psychology of his tormented Russian heroes, Leo Tolstoy's realism turned outward, to the epic stage of Russian history. Slightly younger than Dostoyevsky, Tolstoy was born to privilege and wealth, and he began publishing short stories in the mid-1850s, while serving in the army. These dealt with childhood memories and his military career and helped him establish a literary reputation. Yet no one anticipated the two great novels he would write after his return to the family estate, 100 miles south of Moscow: _War and Peace_ (1869) and _Anna Karenina_ [kuh-REN-ih-nuh] (1877). Although both novels focus on the lifestyle of the Russian aristocracy, they also critique it.

War and Peace surveys Russian life in the early nineteenth century, telling the story of five aristocratic families as they come to terms with Napoleon's 1812 invasion of their country. Two major male characters, the intellectual but pessimistic Prince Andre Bolkonsky and the spiritual, questing Pierre Bezukhov, represent conflicting moral positions: the Romantic desire to fully realize the self versus dedication to others. Against the backdrop of war, each falls in love with Natasha Rostov, the young daughter of a noble Moscow family whose fortunes are failing. Andre is prevented from marrying her by his father, while Pierre, after having been taken prisoner by the French, finally succeeds. Their story illustrates the triumph of the Russian soul over the logical Western mind of Napoleon, whose disastrous decision to invade Russia initiates his downfall.

There are scores of characters in _War and Peace_, but Natasha Rostov is one of the great characters in all of fiction. Along with his brilliant accounts of war, Tolstoy's depiction of her is the hallmark of his realist style. We first meet her in chapter 11 of the novel as a 13-year-old who, on her nameday (the day of the year associated with her name), bursts into the sitting room where her parents, the count and countess, have been receiving guests (**Reading 37.2**):

READING 37.2　from Leo Tolstoy, *War and Peace*, Part I, Chapter 11 (1869)

The countess looked at her callers, smiling affably, but not concealing the fact that she would not be distressed if they now rose and took their leave. The visitor's daughter was already smoothing down her dress with an inquiring look at her mother, when suddenly from the next room were heard the footsteps of boys and girls running to the door and the noise of a chair falling over, and a girl of thirteen, hiding something in the folds of her short muslin frock, darted in and stopped short in the middle of the room. It was evident that she had not intended her flight to bring her so far. . . .

The count jumped up and, swaying from side to side, spread his arms wide and threw them round the little girl who had run in. "Ah, here she is!" he exclaimed laughing. "My pet, whose name day it is. My dear pet!"

"Ma chere, there is a time for everything," said the countess with feigned severity. "You spoil her, Ilya," she added, turning to her husband.

"How do you do, my dear? I wish you many happy returns of your name day," said the visitor. "What a charming child," she added, addressing the mother.

This black-eyed, wide-mouthed girl, not pretty but full of life—with childish bare shoulders which after her run heaved and shook her bodice, with black curls tossed backward, thin bare arms, little legs in lace-frilled drawers, and feet in low slippers—was just at that charming age when a girl is no longer a child, though the child is not yet a young woman. Escaping from her father she ran to hide her flushed face in the lace of her mother's mantilla—not paying the least attention to her severe remark—and began to laugh.

The exuberance of the young girl, her ability to dominate any room into which she walks, is immediately established. From this moment, Natasha lives life boldly, determined to enjoy it to the fullest, and over the course of the novel she grows into a woman of real wisdom and understanding.

The scope of Tolstoy's next novel, *Anna Karenina* (1877), is narrower than in *War and Peace*, even as its representation of human feeling and emotions is more

fully realized. It tells the story of the adulterous love affair of Anna, who is married to a government official in Saint Petersburg, and Count Vronsky [VRON-skee], a dashing young cavalry officer. Anna's "double" in the book is Constantine Levin. He shares her intensity and passion, but unlike Anna does not easily fit into Saint Petersburg's social swirl and so chooses to live instead on his country estate, dedicating himself to farming and the lives of the peasants who work for him. Tortured by doubts about the meaning of his life throughout most of the book, he experiences a spiritual revelation at the novel's end that reveals his reason for being. By contrast, Anna's more carnal passion leads to her destruction, the inevitable victim of her society's double standards.

It is possible to see Tolstoy's own spiritual autobiography in Levin's struggle with God. Tolstoy experienced many religious crises in his life, struggling to find a way of living religiously without endorsing the hypocrisies and greed of the Russian Orthodox Church, from which he was eventually excommunicated. Most of his writing after *Anna Karenina* consisted of educational articles and pamphlets, the ideas of which are most clearly formulated in his 1886 *What Then Must We Do?* In the interest of leading an exemplary life, he gave up smoking and drinking alcohol, became a vegetarian, dressed in peasant clothes, engaged in hard labor (Fig. **37.19**), and renounced sexual relations with his wife, with whom he had fathered 13 children. Yet all of Tolstoy's spiritual striving and rationally constructed religious doctrine could not ensure a happy family life. Arguments continually flared between his wife and the leader of a group of his followers. Finally, in 1910, he determined to leave society altogether and lead a hermit's life. He died of pneumonia a few days after leaving his ancestral estate.

The Travelers: Realist Painters of Social Issues Dostoyevsky's and Tolstoy's rigorous examination of Russian society was sustained by 13 visual artists who organized a society known as the Travelers dedicated to presenting art exhibitions throughout the country in 1870. All were students at the Saint Petersburg Academy, which emphasized traditional European standards of beauty and the production of painting and sculpture depicting

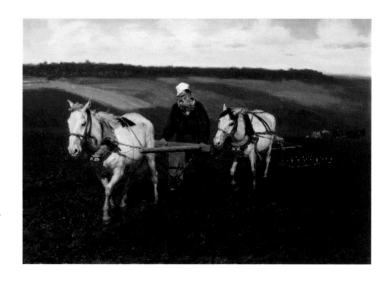

Fig. 37.19 Ilya Repin. *Leo Tolstoy Ploughing.* 1887. Oil on canvas. Photo: Roman Beniaminson. Tretyakov Gallery, Moscow, Russia. Bildarchiv Preussischer Kulturbesitz/Art Resource, NY. This portrait of Tolstoy by his friend and admirer Ilya Repin shows the writer and landowner engaged in the kind of manual labor that he believed it was his duty to perform so as not to take advantage of others.

mythological subjects in Neoclassical style. Several of the students were from peasant or working-class families and were more interested in addressing social issues than pursuing the Academy's more traditional, and less threatening, artistic agenda. Realism, they believed, was the only stylistic choice available to them. Like their literary predecessors, they addressed the inequities of Russian society in their paintings, often depicting peasants at work.

Ilya Repin (1844–1930), who painted the portrait of *Tolstoy ploughing* (see Fig. 37.19), visited Europe many times over the course of his career, and the fluid brushwork of the Impressionists is evident in his paintings. Ivan Kramskoy's [KRAM-skoys] portrait of another member of the group, landscape painter Ivan Shishkin [SHIS-kin], achieves a virtually photographic realism (Fig. **37.19**). In every detail, from the links in Shishkin's watch chain to the curls in his beard and hair, we feel as if we are looking at something more than a painting or a photograph—we are gazing into the eyes of an actual man.

The real force of the work of the Travelers group, however, lies in their means of exhibiting it. Previously, art exhibitions had been restricted to Saint Petersburg and Moscow, but as their name suggests, the Travelers "traveled," taking their paintings across the country for the peasantry to see and

Fig. 37.20 Ivan Nikolaevich Kramskoy. *Ivan I. Shishkin*. 1880. Oil on canvas, 46″ × 33½″. © 2009. State Russian Museum, St. Petersburg. As a young man, Kramskoy worked as a retoucher for a traveling photographer.

appreciate. Their desire to spread the message of social reform to the Russian countryside would be emulated by the Russian revolutionary movement in the twentieth century.

Russian Nationalist Music and Ballet

The quest to express the fundamental essence of Russia was reflected in the nation's music as well. Here too, a group of five musicians known as "the Mighty Handful" led the way, finding strength in unified action. The primary method by which they expressed their Slavic pride was through the incorporation of Russian folklore, folk songs, and native instruments like the balalaika into their compositions. The most ardent of these nationalists was Modest Mussorgsky [moos-ORG-skee] (1839–1881), whose 1869 opera *Boris Godunov*, about a sixteenth-century tsar of Russia who ascended the throne after murdering the rightful heir and who eventually died of guilt, was based on a play by Pushkin (see chapter 35).

Never included in their number—because they considered him too cosmopolitan—was Pyotr Ilyich Tchaikovsky [chy-KOF-skee] (1840–1893). However, influenced by the example of "the Mighty Handful," in 1880 he wrote *The 1812 Overture*, a work commemorating Napoleon's retreat from Moscow. It is one of the most nationalistic works ever composed, capturing in music the same drama as Tolstoy's *War and Peace* (see **CD-Track 37.1**). The work opens with a Russian hymn, "God Preserve Thy People." As horns and drums imitate Napoleon's march on Moscow, strains of the French national anthem, "The Marseillaise," are heard. After a day of battle, there is a traditional Russian lullaby and folk song, then, after a more furious battle, the "Tsar's Hymn," as bells chime to rifle and cannon fire. When the *Overture* was first performed in 1882 in front of Moscow's Cathedral of Christ the Redeemer, built by Tsar Alexander I to celebrate his victory over Napoleon, tsarist troops fired off actual rifles and cannons for the finale. (The church, later destroyed by the twentieth-century Communist leader Josef Stalin and replaced with an outdoor swimming pool, was rebuilt in 1997, an almost exact replica of the original.)

Tchaikovsky's real fame came from his ballet music, a very popular form in Europe, particularly in France. After dancing *en pointe* [on pwahnt] (on the tips of one's toes) was introduced early in the nineteenth century, costumes became skimpier, even skintight, showcasing the human form. Tchaikovsky's lyrical melodies and rich orchestrations in *Swan Lake* (1876), *Sleeping Beauty* (1889), and *The Nutcracker* (1892) raised ballet music to a new level, matching the groundbreaking choreography of Marius Pepita (1818–1910), ballet master of the Imperial Ballet in Saint Petersburg. (Pepita is often called the father of classical ballet.) In *The Nutcracker*, based on a story by Prussian writer E.T. A. Hoffmann, a young girl named Clara receives a magical nutcracker in the form of a soldier as a Christmas present. At night it comes to life and leads an army of toy soldiers into battle with an army of mice. When Clara saves the Nutcracker's life, he is transformed into a handsome youth. He takes her on a magical journey to the Land of the Sugar Plum Fairy, where she

encounters a variety of exotic dance images, including a French café, an Arabian dance, a Chinese tea party, and the Waltz of the Flowers, all culminating in her meeting the Sugar Plum Fairy herself. For this dance, Tchaikovsky contrasts the delicate sound of the celesta, a keyboard instrument similar to a glockenspiel, and the rich depth of a bass clarinet. So memorable is *The Nutcracker* that its music has found a permanent place in modern consciousness, with annual performances scheduled at Christmastime throughout the Western world.

Britain and the Design of Social Reform

In Great Britain, Haussmann's modernization of Paris did not go unnoticed. Nor did the revolution in painting that Impressionism represented escape the British. Yet the Impressionist interest in depicting light had been heralded by the work of J. M.W. Turner, and its looseness in depicting landscape by John Constable (see chapter 33). In fact, both had influenced the Impressionist approach to painting. As for Haussmann, experience had taught the British that public works had little power to effect social reform. London, after all, had rebuilt itself after the Great Fire of 1666 (see chapter 28), and that had done little to alleviate social suffering, perhaps even exaggerated it, until the early nineteenth century, when a program of reconstruction began. Aided by an ongoing series of sanitary improvements, along with accelerated clearing of slums and new building projects in the 1850s, London rivaled

Paris in setting the standard upon which European cities were judged. British thinkers like Thomas Carlyle and A.W. N. Pugin argued, however, that the problems inherent in industrialization, mechanization, and materialism could also be solved through increased attention to moral values connected with Christianity. And there were other more secular approaches to reform as well.

The answer appeared to many to lie in the question of design itself—so that as civil servant Henry Cole (1808–1882) argued, the "harmony of beauty and utility" would help the public understand the virtue of moderation and restraint. Cole argued for the creation of government-sponsored design schools—of which he became the director—and for the creation of the *Journal of Design*. Finally, in order to demonstrate the *lack* of standards in British design, he proposed an Exhibition of the Art and Industry of All Nations in London, which was held in 1851. To house the more than 14,000 exhibitors, half of whom were from outside Britain, a remarkable new type of building, designed by Joseph Paxton (1801–1865), was constructed in Hyde Park. Known as the Crystal Palace, it was made of glass and cast and wrought iron (Figs. **37.21**, **37.22**). Distinctly modern, the Crystal Palace seemed to reflect the lack of standards that Cole ascribed to British design in general. Nevertheless, it revolutionized architectural design.

Resembling a horticultural greenhouse but of gigantic dimensions, the Crystal Palace called for 900,000 square feet of glass (about one-third of Britain's annual production). All its components were standardized, modular, and factory-made,

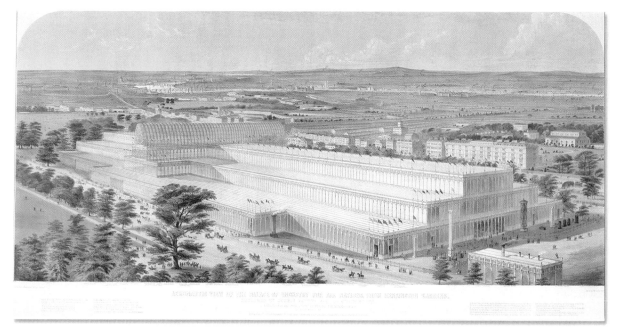

Fig. 37.21 Joseph Paxton's Crystal Palace. 1851. Iron, glass, and wood. Lithograph by Charles Burton with *Aeronautic View of the Palace of Industry for All Nations*, from *Kensington Gardens*, published by Ackerman (1851). Guildhall Library, City of London. The Bridgeman Art Library. Paxton described the roof as a "table and cloth"—the cast- and wrought-iron trusses providing a rigid "table" over which an external lightweight "cloth" of glass was draped. In summer the roof was covered by retractable canvas awnings which were sprayed with cool water.

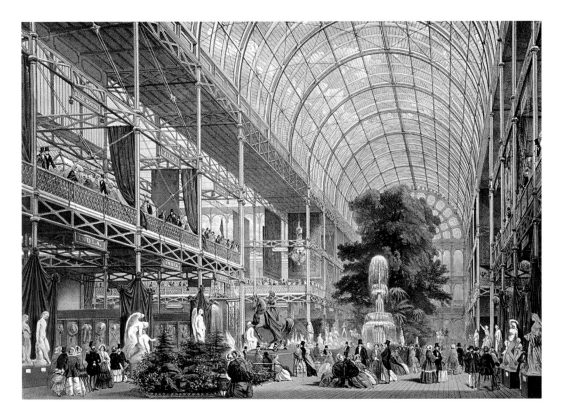

Fig. 37.22 The interior of Joseph Paxton's Crystal Palace. 1851. Institut für Theorie der Architektur an der ETH, Zürich. The vault was high enough to allow for elm trees on the Hyde Park site to remain in place.

brought together on site and required a minimum of traditional building skills to assemble. The three-story structure, 1,848 feet long (the length of about six football fields) and 408 feet wide, was built over a period of months. Its vast expanses of glass solved the problem of lighting individual exhibits and aisles (an especially difficult issue in the era before electricity). It even incorporated the park's trees into its wide, open interiors. Above all, Paxton's design made clear that industrial mass production, prefabrication, and systematic site assembly had the potential to revolutionize architecture and construction.

Morris, the Guild Movement, and the Pre-Raphaelites

Although the Great Exhibition, as it became known, was a roaring success, not everyone appreciated its implications. If it bred confidence in the speed and utility of technological innovation, it also demonstrated, in the words of Owen Jones, an architect who was the director of the Fine Arts exhibits, "no principles, no unity . . . novelty without beauty, beauty without intelligence, and all work without faith."

A young student preparing for the clergy at Oxford University named William Morris (1834–1896) conceived of a different way to attack the problem of design. Morris was deeply affected by the writings of John Ruskin [RUSS-kin] (1819–1900), who argued in his essay "On the Nature of Gothic" that the benefits of mass production were illusory (**Reading 37.3**):

READING 37.3 **from John Ruskin, "On the Nature of Gothic," in *The Stones of Venice* (1851–1853)**

[I]n mass manufacture people were deprived of the satisfaction of making a thing from start to finish. "We have much studied and much perfected, of late, the great civilized invention of the division of labor . . . It is not, truly speaking, the labor that is divided; but the men: divided into mere segments of men—broken in small fragments and crumbs of life. . . . All the stamped metals, and artificial stones, and imitation woods and bronzes, over the invention of which we hear daily exaltation—all the short, and cheap, and easy ways of doing that whose difficulty is its honor—are just so many new obstacles in our already encumbered road. They will not make one of us happier or wiser—they will extend neither the pride of judgment nor the privilege of enjoyment. They will only make us shallower in our understandings, colder in our hearts, and feebler in our wits.

To rectify this situation, in 1855 Morris and a group of friends created a new design firm, the first task of which was to

Fig. 37.23 Morris and Company. *The Woodpecker.* **1885.** Wool tapestry designed by Morris. William Morris Gallery, Walthamstow, England. The great contradiction in Morris and Company is that its beautifully crafted furnishings were beyond the means of the workers who made them.

produce the furnishings for Morris's new home in Kent, the Red House, designed by Philip Webb. "At this time," Morris wrote, "the revival of Gothic architecture was making great progress in England. . . . I threw myself into these movements with all my heart; got a friend [Webb] to build me a house very medieval in spirit . . . and set myself to decorating it." Morris longed to return to a handmade craft tradition, in which workers, as with the medieval craft guilds, would no longer be alienated from their labor. In effect, he was declaring war on the Industrial Revolution. The firm soon was turning out high-quality tapes-

tries, embroideries, chintzes, wallpapers, ceramic tiles and bowls, stained-glass windows, and furniture of all kinds.

In his designs, Morris constantly emphasized two principles: simplicity and utility. However, it is difficult to see "simplicity" in work such as *The Woodpecker*, a wool tapestry meant to decorate a wall and keep out drafts as they had in medieval palaces (Fig. **37.23**). For Morris, however, the natural and organic were by definition simple. Thus the pattern possesses, in Morris's words, a "logical sequence of form, this growth looks as if it could not have been otherwise." Anything, according to Morris, "is beautiful if it is in accord with nature." And just as Henry Cole believed that "harmony of beauty and utility" would transform public taste, Morris argued that "simplicity of taste" worked hand in hand with "simplicity of life"—all in accord with nature.

To assist him in creating the most beautiful designs possible, Morris hired many of his artist friends, among them Dante Gabriel Rossetti [roh-SET-tee] (1828–1882) and Edward Burne-Jones (1833–1898). Rossetti had been leader and spokesperson of a group at the Royal Academy named the Pre-Raphaelite Brotherhood, who denounced contemporary art as well as all painting done after the early work of Raphael—including the work of Leonardo da Vinci and Michelangelo, whose techniques they found appalling. (The Pre-Raphaelites knew Michelangelo primarily through the unrestored, grimy painted ceiling of the Sistine Chapel.) Instead, they admired the work of fifteenth-century Flemish artist Jan van Eyck, whose texture and clarity of detail they tried to emulate (see chapter 20), and the linear contours of fifteenth-century Italian painter Sandro Botticelli (see chapter 17), whose work had been almost entirely forgotten until they rediscovered him.

Continuity & Change
p. 561

Botticelli, *Primavera*

Although the Pre-Raphaelite Brotherhood officially dissolved by 1860, Rossetti continued to champion the spiritual values of medieval and early Renaissance culture, values that he imparted both to Morris and his friend Edward Burne-Jones. Modernity intruded, however, in the form of an undercurrent of erotic tension in Rossetti's work. The subject of his painting *Mariana*, for example, is a minor character in Shakespeare's play *Measure for Measure* who has been spurned by Angelo, her fiancé, because her dowry was lost in a shipwreck (Fig. **37.24**). Unbeknownst to Angelo, Mariana substitutes herself, in the darkness of Angelo's bedroom, for Isabella, whom Angelo has convinced to sleep with him. Rossetti's model in the painting is Jane Morris (1839–1914), William Morris's wife. Janey, as she was known, and her sister Bessie were the preeminent embroiderers at Morris's design company, producing many of the finest pieces themselves, as well as supervising the other workers. Rossetti portrays her here at work on a piece of embroidery of the kind that would be sold by the firm. Rossetti was obsessed with Jane, and there is good reason to believe that the two were romantically involved. In her role as Mariana, Jane's gaze directly addresses the painter. Behind her a boy, playing a lute, sings to her, a moment from the opening of Act 4 of Shakespeare's play:

Take, oh take those lips away,
that so sweetly were forsworne,

Rossetti inscribed these words on the frame of the painting, suggesting the undercurrent of sexual tension that informs the scene.

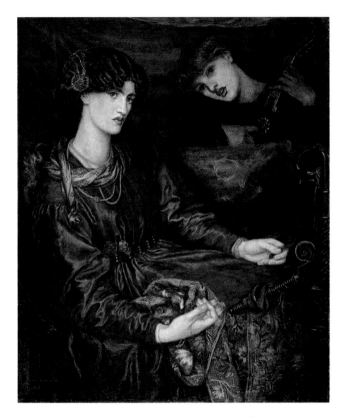

Fig. 37.24 Dante Gabriel Rossetti. *Mariana.* **1870.** Oil on canvas, 43¼″ × 35⅝″. Aberdeen Art Gallery and Museums, Aberdeen, Scotland. Acc. No. ABDAG002900. The richness of the fabrics in this painting are typical of Morris and Co.'s own production.

Burne-Jones, who regularly illustrated many of the books produced by Morris's press, including the famous *Kelmscott Chaucer*, was even more devoted to medieval culture than Rossetti. *Laus Veneris* (*In Praise of Venus*) depicts a scene from the legend of Tannhäuser, the hero of Wagner's opera (see chapter 36), who falls in love with Venus and lives with her, seduced by carnal pleasures, which he comes to understand as sinful (Fig. **37.25**). At this point, Tannhäuser has abandoned Venus, but the four maidens on the left, flute and clavichord in hand, are about to sing her praises, as she slumps in her chair on the right. The painting was inspired by a poem of the same name written four years earlier, in 1866, by the English poet Algernon Charles Swinburne (1837–1909). Swinburne describes Venus in terms that Burne-Jones captures in the painting (**Reading 37.4**):

READING 37.4 **from Algernon Charles Swinburne, "Laus Veneris" (1866)**

Her little chambers drip with flower-like red,
Her girdles, and the chaplets of her head,
Her armlets and her anklets; with her feet
She tramples all that wine-press of the dead.

Her gateways smoke with fume of flowers and fires,
With loves burnt out and unassuaged desires;
Between her lips the steam of them is sweet,
The languor in her ears of many lyres.

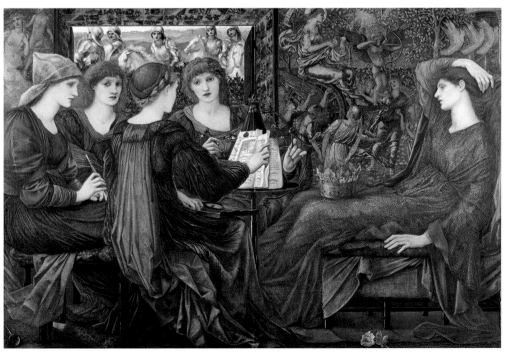

Fig. 37.25 Edward Burne-Jones. *Laus Veneris (In Praise of Venus),* **1873–1878.** Oil on canvas, 48¾″ × 74¼″. Laing Art Gallery, Newcastle-upon-Tyne, England. The design of the tapestry on the right of the painting was created in 1861 by Burne-Jones as a design for tiles produced by Morris and Co. and in 1898 realized as an actual tapestry by the firm.

Venus's languorous sexuality has evidently captivated the knights outside the window, who gaze in longingly. The tapestry behind her shows her mounted on a chariot with Cupid, whose arrow is aimed at another victim. Like Rossetti's works, Burne-Jones's painting seethes with repressed sexuality and longing.

The influence of Morris's design company was enormous, fostering a guild movement throughout England intent on producing quality handcrafted goods. A socialist, Morris dreamed of a society "in which all men would be living in equality of condition." But despite the fact that female sexuality was something of an obsession of the company's designers—or perhaps precisely because they were so obsessed and thus unable to see women as anything more than sexual beings—this equality did not extend to women. Morris and Company employed women, but only to make embroidered wall hangings. As already noted, the embroidery workshop was at first managed by Morris's wife, Jane, and then, after 1885, by their daughter, May, then 23 years old. (Many of the designs attributed to her father after 1885 were actually her own. Apparently, she thought it important, at least from a commercial point of view, to give her father the credit.) May Morris would continue to practice her craft (Fig. **37.26**), helping to found the

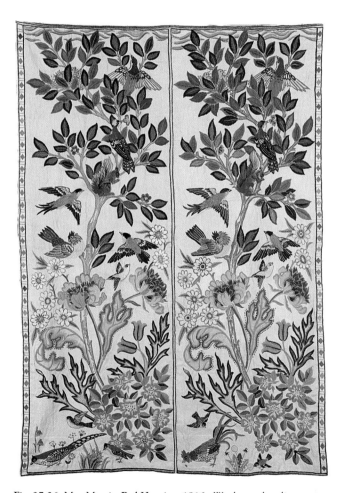

Fig. 37.26 May Morris. Bed Hanging. 1916. Wool crewel on linen, cotton lined, 76 3/4″ × 54″. Collection of Cranbrook Art Museum, Bloomfield Hills, Michigan. Gift of George Gough Booth and Ellen Scripps Booth. Photo: R. H. Hensleigh. (CAM 1955.402). The two halves of the embroidery are identical except for the birds at the lower left.

Women's Guild of Art in 1907, the purpose of which was to create a "centre and a bond for the women who were doing decorative work and all the various crafts." A successful businesswoman, author, and lecturer, she became an important role model for women in early twentieth-century England.

The Fight for Women's Rights: Mill's *Subjection of Women*

That socialists were not so liberal in their thinking about women was common. Many reformers felt that women were inherently conservative, unduly controlled by the clergy. So, too, upper-class women, sensitive to their own economic interests, often lacked the inclination to support feminist causes. But some liberals and reformers did provide intellectual support for women's causes. An essential text in this regard was *The Subjection of Women*, an 1860 essay by John Stuart Mill (1806–1873).

Mill was an advocate of **utilitarian** theory—believing that the goal of any action should be to achieve the greatest good for the greatest number. By that logic, it was evident that in assigning an inferior role to women, society was wasting an enormous resource. Thus, the essay opens with the following argument (**Reading 37.5**):

READING 37.5 **from John Stuart Mill, *The Subjection of Women* (1869)**

The principle which regulates the existing social relations between the two sexes—the legal subordination of one sex to the other—is wrong itself, and now one of the chief hindrances to human improvement; and . . . it ought to be replaced by a principle of perfect equality, admitting no power or privilege on the one side, nor disability on the other.

Mill further points out that for centuries women have been subordinate to men, excluded from the kinds of individual choices that naturally follow from the principle of liberty, which decrees "over himself, over his own body and mind, the individual is sovereign."

Mill wrote *The Subjection of Women* in collaboration with his wife, Harriet Taylor Mill, and after his wife's death in 1854, her daughter from an earlier marriage, Helen Taylor. Scholars are divided as to how much Mill relied on these women—some go so far as to suggest that the work was actually "ghost-written" by them. Although Mill never accepted his wife's contention that women should be able to work outside the home after marriage, there is no question that she and her daughter's ideas greatly influenced Mill's version of feminism. Whatever the case, the feminist sensibility defined by Mill reflects not only the spirit of reform that has been the focus of this chapter, but also the evolving lifestyle of the increasingly affluent class populating Europe's capitals. In an age demanding freedom, it is hardly surprising that women should take up the call.

READINGS

READING 37.1

from Fyodor Dostoyevsky, *Crime and Punishment*, Part 3, Chapter 5 (1866)

Dostoyevsky's novel describes the actions of a poor, young student, Raskolnikov, who is driven by the idea that extraordinary individuals, such as himself, have the right to commit immoral acts in the pursuit of greatness. As a result, he rationalizes the murder of an old woman and her younger sister. His crime goes unsolved, but a Saint Petersburg detective, Porfiry Petrovich, suspects him. The following scene demonstrates Dostoyevsky's fondness for developing character through dialogue. Note the way that Porfiry's "innocent" questions allow Raskolnikov to say more than he intends. Even more important, in explaining his "thesis" Raskolnikov exposes its very absurdity.

"All these questions about crime, environment, children, recall to my mind an article of yours which interested me at the time. 'On Crime' . . . or something of the sort, I forget the title, I read it with pleasure two months ago in the *Periodical Review*."

"My article? In the *Periodical Review*?" Raskolnikov asked in astonishment. "I certainly did write an article upon a book six months ago when I left the university, but I sent it to the *Weekly Review*."

"But it came out in the *Periodical*." . . . 10

Raskolnikov had not known.

"Why, you might get some money out of them for the article! What a strange person you are! You lead such a solitary life that you know nothing of matters that concern you directly. It's a fact, I assure you." . . .

"How did you find out that the article was mine? It's only signed with an initial."

"I only learnt it by chance, the other day. Through the editor; I know him. . . . I was very much interested."

"I analysed, if I remember, the psychology of a criminal 20 before and after the crime."

"Yes, and you maintained that the perpetration of a crime is always accompanied by illness. Very, very original, but . . . it was not that part of your article that interested me so much, but an idea at the end of the article which I regret to say you merely suggested without working it out clearly. There is, if you recollect, a suggestion that there are certain persons who can . . . that is, not precisely are able to, but have a perfect right to commit breaches of morality and crimes, and that the law is not for them." 30

Raskolnikov smiled at the exaggerated and intentional distortion of his idea. . . .

"No, not exactly because of it," answered Porfiry. "In his article all men are divided into 'ordinary' and 'extraordinary.' Ordinary men have to live in submission, have no right to transgress the law, because, don't you see, they are ordinary. But extraordinary men have a right to commit any crime and to transgress the law in any way, just because they are extraordinary. That was your idea, if I am not mistaken?" . . .

Raskolnikov smiled again. He saw the point at once, and 40 knew where they wanted to drive him. He decided to take up the challenge.

"That wasn't quite my contention," he began simply and modestly. "Yet I admit that you have stated it almost correctly; perhaps, if you like, perfectly so." (It almost gave him pleasure to admit this.) "The only difference is that I don't contend that extraordinary people are always bound to commit breaches of morals, as you call it. In fact, I doubt whether such an argument could be published. I simply hinted that an 'extraordinary' man has the right . . . that is not an official 50 right, but an inner right to decide in his own conscience to overstep . . . certain obstacles, and only in case it is essential for the practical fulfilment of his idea (sometimes, perhaps, of benefit to the whole of humanity). . . ."

"Thank you. But tell me this: how do you distinguish those extraordinary people from the ordinary ones? Are there signs at their birth? I feel there ought to be more exactitude, more external definition. . . ."

"Oh, you needn't worry about that either," Raskolnikov went on in the same tone. "People with new ideas, people 60 with the faintest capacity for saying something *new*, are extremely few in number, extraordinarily so in fact. . . . The man of genius is one of millions, and the great geniuses, the crown of humanity, appear on earth perhaps one in many thousand millions. . . ."

"Yes, yes." Porfiry couldn't sit still. "Your attitude to crime is pretty clear to me now. . . ." ■

Reading Question

Dostoyevsky sets up this exchange between Raskolnikov and Porfiry in the form of a Socratic dialogue (see chapter 7), with Raskolnikov taking the part of Socrates. What is the author's purpose in doing this?

 ## Summary

■ **The Haussmannization of Paris** From 1853 to 1870, under the direction of the Baron Haussmann, Paris was transformed, as working-class districts of the city were replaced with *grands boulevards* and promenades. Serving both practical and aesthetic purposes, the new parks, boulevards, and infrastructure drew worldwide acclaim. The French government increased the space dedicated to parks by 100 times, lined the streets with sidewalks and trees, and laid miles of sewer pipes, displacing the working class and the industry they supported to new suburbs.

■ **The 1870s: From the Commune to Impressionism** The renovation of the city came to a temporary halt in 1870 during the Franco-Prussian war. Embarrassed by the failure of his imperial adventuring in Mexico, where his hand-picked leader was executed by revolutionaries, Louis-Napoleon entered into war with Prussia. He was soundly defeated by Otto von Bismarck and exiled to England. After Bismarck laid siege to Paris, which surrendered in January 1871, the newly declared Third Republic was far too generous in granting concessions to its citizens. In March they created their own municipal government, the Commune. The National Assembly's army attacked, and after a bloody week the Commune was crushed.

Meanwhile, France's younger generation of painters believed that by rejecting the Second Empire's art institutions they could reestablish French cultural dominance. Many of these young artists, who came to be known as Impressionists, preferred painting out-of-doors to capture the natural effects of light. Monet, Pissarro, Renoir, Degas, and Morisot were the founders of the group. Although he never exhibited with them, Manet was considered by many to be their leader.

■ **Russian Realism and the Quest for the Russian Soul** In Russia, Francophiles followed developments in Paris carefully, but Slavophiles rejected the pro-Western bias and those Westernizers who believed that Russia was hopelessly mired in the medieval past. Slavophiles tended to be nationalists and saw Russian culture and its spirituality (or "soul") as essentially different from that of the West. Fyodor Dostoyevsky probed the psychological depths of the Russian personality in *Crime and Punishment*, and Leo Tolstoy delved into the epic scope of the country's history in his *War and Peace*. In painting, a group of young Russian painters called the Travelers created highly realistic works that celebrated peasant life. In music, the nationalist spirit manifested itself in the use of folklore and folk songs, particularly in the compositions of Modest Mussorgsky. Tchaikovsky's *1812 Overture* commemorated Napoleon's retreat from Moscow.

■ **Britain and the Design of Social Reform** The lack of standards of beauty in British industrial design was symptomatic of the country's social inequities, according to English civil servant and designer Henry Cole. In proposing a Universal Exposition for London's Hyde Park in 1850, Cole sought to set a new and progressive course for his country. The Exposition took place at Joseph Paxton's Crystal Palace, a prefabricated glass and iron structure that revolutionized architecture and construction.

William Morris took a different approach to the problem. With a group of friends he founded the design firm, Morris and Company in 1855. Modeled on the medieval guilds, the company made everything from tapestries and ceramic tiles to stained glass and furniture, all handcrafted. In his employ were the Pre-Raphaelite painters Daniel Gabriel Rossetti and Edward Burne-Jones, whose work was both medieval in spirit and highly charged with erotic tension. Morris's exclusion of women from higher-level production and design positions in his firm illuminates the importance of John Stuart Mill's 1869 essay *The Subjection of Women*, which argued against the continued subjugation of women in Western society.

 ## Glossary

Haussmannization The term used to describe Baron Haussmann's approach to urban redevelopment. He favored the destruction of existing structures to produce something for the betterment of society.

Japonisme The imitation of Japanese art.

pastel Sticks of powdered pigment bound with resin or gum.

plein air French for "open air" and referring to painting out of doors in front of the subject rather than in the studio.

ukiyo-e Japanese woodblock prints ("pictures of the floating world").

utilitarian A person who believes that the goal of any action should be to achieve the greatest good for the greatest number.

 ## Critical Thinking Questions

1. Which bourgeois values were the basis of Haussmannization?

2. How did Impressionism undercut conventional assumptions about the style and content of painting?

3. How do the Crystal Palace and Pre-Raphaelite artists express British values of social reform?

The Prospect of America

One of Edgar Degas's closest friends in Paris was the American expatriate painter Mary Cassatt (1824–1926), who began exhibiting with the Impressionists in 1867. Cassatt, like Monet and Degas, was fascinated with Japanese prints. She was especially impressed with its interest in the intimate world of women, the daily routines of domestic existence. Consciously imitating works like Utamaro's *Shaving a Boy's Head* (Fig. **37.27**), her *The Bath* exploits the same contrasts between printed textiles and bare skin (Fig. **37.28**). One of ten prints inspired by an April 1890 exhibition of Japanese woodblock prints at the École des Beaux-Arts in Paris, *The Bath* is a set of flatly silhouetted shapes against a bare ground, devoid of the traditional shading and tonal variations that create the illusion of depth in Western art.

American tastes were, in fact, deeply attracted to all things exotic, and France itself seemed attraction enough. Certainly, France appeared to offer Americans a kind of liberation from the cramped Puritan morality they found at home. And so creative people in particular were drawn to work and study there. The painter Theodore Robinson (1852–1896) went to France in 1884 to study with Monet at his home in Giverny. Other Americans came to sit at Monet's feet as well—Phillip Leslie Hale (1865–1931), who stayed at Giverny for four or five summers beginning in 1888, Lilla Cabot Perry, who spent nine summers there, and Theodore Earl Butler (1861–1936), who married Monet's stepdaughter.

These painters as well as more famous ones—including Cassatt, James Abbott McNeill Whistler (1834–1903), and John Singer Sargent (1856–1925)—as well as writers like Henry James (1843–1916) and Henry Adams (1838–1918), grandson of President John Quincy Adams—all came to Europe in the last half of the nineteenth century intent on immersing themselves in its cultural fervor. They admired what they saw in Europe. By comparison, when they turned their eyes back upon their own country, they saw only vulgarity and superficiality, moneymaking and materialism, boss-ridden politics, sanctimonious hypocrisy, and blind acceptance of social convention and conformity. It was Mark Twain who named this era in America the "Gilded Age", as opposed to a utopian Golden Age, and the name stuck.

The gilt covered, among other things, deep social unrest among the working poor, the continuing subjugation of women, the gradual elimination of all rights that African Americans had gained in the Civil War (see chapter 36), the removal of Native Americans to reservations, and, under the guise of enlightening the backward peoples of the world, the vast territorial theft of Africa and Asia by the imperial powers of Europe. But Europe offered many artists a way to ignore these realities, just as to those who stayed at home the thriving American economy offered a sense of well-being that enabled them to ignore the darker realities beneath the gilt. ∎

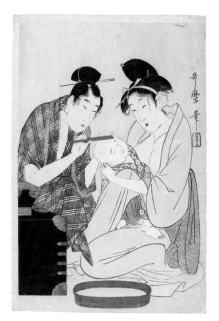

Fig. 37.27 Kitagawa Utamaro. *Shaving a Boy's Head.* ca. 1795. Color woodblock print, 15 1/8" × 10 1/4". Signed Utamuro hitsu. Bequest of Richard P. Gale. The Minneapolis Institute of Arts. Utamaro was noted for his depictions of beautiful women, especially his 1793 *Ten Physiognomies of Women.*

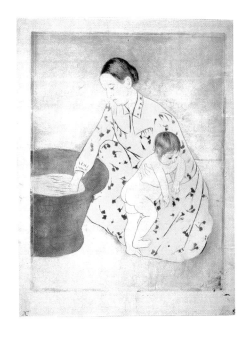

Fig. 37.28 Mary Stevenson Cassatt. *The Bath.* 1890–1891. Drypoint and aquatint on laid paper, plate: 12 3/8" × 9 3/4"; sheet: 17 13/16" × 12". Rosenwald Collection. Photograph © Board of Trustees, National Gallery of Art, Washington, D.C. Photo: Dean Beasom.

F rom 1870 to 1900, New York City was a boomtown of extraordinary diversity. The population of the old city—the boroughs of Manhattan and the Bronx—doubled. When, in 1898, it was proposed that the city annex Queens, Brooklyn, and Richmond (Staten Island), Brooklyn's social elite opposed it, fearing the immigrants who were sure

to cross the East River from the old city (Map 38.1). Nevertheless, the consolidation took place, the city's area increased more than tenfold to 299 square miles, and its population doubled to 3.4 million. New York's port handled most of America's imports and roughly 50 percent of the country's exports. As the nation's financial center, the city teemed with lawyers, architects, engineers, and entrepreneurs of every nationality.

In 1892, 30 percent of all millionaires in the United States lived in Manhattan and Brooklyn, side by side with millions of the nation's working-class immigrants. By 1900, fully three-quarters of the city's population was foreign-born, having arrived via Ellis Island, which opened in 1892. Italians, Germans, Poles, and waves of Jews from Hungary, Rumania, Russia, and Eastern Europe sought the unlimited opportunities they believed were to be found in America. Many stayed in New York City. As the twentieth century dawned, these immigrants, and their descendents, would dramatically change American culture.

New York was the epicenter of a new kind of culture and economy in which poor immigrants, wealthy industrialists, ambitious merchants, and flagrantly corrupt politicians struggled to gain a share of the American Dream. This dream— usually expressed in dollars and the things those dollars could buy—was so often built on a framework of fraud and exploitation that Mark Twain gave this era the compelling name "The Gilded Age." The unprecedented expansion of New York was matched in the country as a whole as agricultural and industrial production, economic growth, and population soared.

As much as the Gilded Age signified prosperity and opportunity, it was also a byword for deceit, corruption, and financial manipulation at every level of government and business. This was especially true of large corporations and trusts (a holding company that controlled many other companies). During the era, an entire class of ultra-rich businessmen emerged, termed "robber barons" because of their use of unethical and anticompetitive methods to gain wealth and power. The rich were notable for their conspicuous consumption and self-indulgent excess, which became fodder for the gossip-hungry press and public. Wealth was on display at every turn. In 1904, Mrs. Stuyvesant Fish, a leader of New York society, threw a dinner party honoring her dog, who wore a $15,000 diamond collar for the occasion. At the time, more than 90 percent of America's families survived on less than $1,200 a year.

This chapter will survey America in the Gilded Age, the glittering facade of New York society as well as the very different and more representative experience of working-class Americans, both native-born and immigrants. These less-celebrated Americans can be glimpsed in artist George Bellows's [BELL-ohz] (1882–1925) painting *Cliff Dwellers* (Fig. 38.1). On a hot summer afternoon on the Lower East Side of Manhattan, teeming multitudes of working-class city dwellers crowd the cramped tenements and grimy streets.

In examining the nation's promise and comparing it to the often crushing reality, this chapter will illustrate how the working class, as well as disenfranchised women, began to assert themselves. African Americans, however, were increasingly oppressed, as their legal rights disappeared and they were systematically excluded from participating in civil affairs across the country. Only in New Orleans, where the new musical idiom of jazz developed, did African Americans participate significantly in the nation's cultural life. With all of these contradictions, America still saw fit to congratulate itself on the occasion of the four-hundredth anniversary of Columbus's expedition to the New World at the 1893 World Columbian Exposition in Chicago, probably the fastest-growing city in the country. The nation's mastery of the American continent, as well as its increasingly prominent place in the world economy, culture, and politics, were celebrated. Meanwhile, a new generation of expatriate American writers and artists in Europe looked back at their country with a mixture of admiration, frustration, and dismay.

Walt Whitman's America

There is no better human symbol for the restless, ambitious American spirit in the nineteenth century than the poet Walt Whitman (1819–1892), who revolutionized American literature as he linked the Romantic, Transcendental, and Realist movements. Born into a working-class Brooklyn household (his father was a carpenter), Whitman went to work full time as an office boy at age 11. Within a year he was a printer's devil (an apprentice who did odd jobs around print shops), soon contributing the occasional story.

After an unhappy five-year stint as a teacher beginning in his late teens, Whitman spent the next two decades working in

38 The Gilded Age in America

Expansion and Conflict

> *Thrive, cities—bring your freight, bring your shows, ample and sufficient rivers, Expand. . . .*
>
> Walt Whitman, *"Crossing Brooklyn Ferry"*

← **Fig. 38.1 George Bellows. *Cliff Dwellers*. 1913.** Oil on canvas, $40 \frac{3}{16}'' \times 42 \frac{1}{16}''$. Los Angeles County Museum of Art. Los Angeles County Fund. Photograph © 2007 Museum Associates/LACMA. A preparatory drawing for this painting in *The Masses*, a socialist magazine published in New York from 1911 to 1917, was entitled "Why Don't They All Go to the Country for Vacation?" The painting's name comes from a remark reportedly made by a Fifth Avenue socialite observing the scene.

From 1870 to 1900, New York City was a boomtown of extraordinary diversity. The population of the old city—the boroughs of Manhattan and the Bronx—doubled. When, in 1898, it was proposed that the city annex Queens, Brooklyn, and Richmond (Staten Island), Brooklyn's social elite opposed it, fearing the immigrants who were sure

to cross the East River from the old city (Map 38.1). Nevertheless, the consolidation took place, the city's area increased more than tenfold to 299 square miles, and its population doubled to 3.4 million. New York's port handled most of America's imports and roughly 50 percent of the country's exports. As the nation's financial center, the city teemed with lawyers, architects, engineers, and entrepreneurs of every nationality.

In 1892, 30 percent of all millionaires in the United States lived in Manhattan and Brooklyn, side by side with millions of the nation's working-class immigrants. By 1900, fully three-quarters of the city's population was foreign-born, having arrived via Ellis Island, which opened in 1892. Italians, Germans, Poles, and waves of Jews from Hungary, Rumania, Russia, and Eastern Europe sought the unlimited opportunities they believed were to be found in America. Many stayed in New York City. As the twentieth century dawned, these immigrants, and their descendents, would dramatically change American culture.

New York was the epicenter of a new kind of culture and economy in which poor immigrants, wealthy industrialists, ambitious merchants, and flagrantly corrupt politicians struggled to gain a share of the American Dream. This dream—usually expressed in dollars and the things those dollars could buy—was so often built on a framework of fraud and exploitation that Mark Twain gave this era the compelling name "The Gilded Age." The unprecedented expansion of New York was matched in the country as a whole as agricultural and industrial production, economic growth, and population soared.

As much as the Gilded Age signified prosperity and opportunity, it was also a byword for deceit, corruption, and financial manipulation at every level of government and business. This was especially true of large corporations and trusts (a holding company that controlled many other companies). During the era, an entire class of ultra-rich businessmen emerged, termed "robber barons" because of their use of unethical and anticompetitive methods to gain wealth and power. The rich were notable for their conspicuous consumption and self-indulgent excess, which became fodder for the gossip-hungry press and public. Wealth was on display at every turn. In 1904, Mrs. Stuyvesant Fish, a leader of New York society, threw a dinner party honoring her dog, who wore a $15,000 diamond collar for the occasion. At the time, more than 90 percent of America's families survived on less than $1,200 a year.

This chapter will survey America in the Gilded Age, the glittering facade of New York society as well as the very different and more representative experience of working-class Americans, both native-born and immigrants. These less-celebrated Americans can be glimpsed in artist George Bellows's [BELL-ohz] (1882–1925) painting *Cliff Dwellers* (Fig. **38.1**). On a hot summer afternoon on the Lower East Side of Manhattan, teeming multitudes of working-class city dwellers crowd the cramped tenements and grimy streets.

In examining the nation's promise and comparing it to the often crushing reality, this chapter will illustrate how the working class, as well as disenfranchised women, began to assert themselves. African Americans, however, were increasingly oppressed, as their legal rights disappeared and they were systematically excluded from participating in civil affairs across the country. Only in New Orleans, where the new musical idiom of jazz developed, did African Americans participate significantly in the nation's cultural life. With all of these contradictions, America still saw fit to congratulate itself on the occasion of the four-hundredth anniversary of Columbus's expedition to the New World at the 1893 World Columbian Exposition in Chicago, probably the fastest-growing city in the country. The nation's mastery of the American continent, as well as its increasingly prominent place in the world economy, culture, and politics, were celebrated. Meanwhile, a new generation of expatriate American writers and artists in Europe looked back at their country with a mixture of admiration, frustration, and dismay.

Walt Whitman's America

There is no better human symbol for the restless, ambitious American spirit in the nineteenth century than the poet Walt Whitman (1819–1892), who revolutionized American literature as he linked the Romantic, Transcendental, and Realist movements. Born into a working-class Brooklyn household (his father was a carpenter), Whitman went to work full time as an office boy at age 11. Within a year he was a printer's devil (an apprentice who did odd jobs around print shops), soon contributing the occasional story.

After an unhappy five-year stint as a teacher beginning in his late teens, Whitman spent the next two decades working in

One of Edgar Degas's closest friends in Paris was the American expatriate painter Mary Cassatt (1824–1926), who began exhibiting with the Impressionists in 1867. Cassatt, like Monet and Degas, was fascinated with Japanese prints. She was especially impressed with its interest in the intimate world of women, the daily routines of domestic existence. Consciously imitating works like Utamaro's *Shaving a Boy's Head* (Fig. **37.27**), her *The Bath* exploits the same contrasts between printed textiles and bare skin (Fig. **37.28**). One of ten prints inspired by an April 1890 exhibition of Japanese woodblock prints at the École des Beaux-Arts in Paris, *The Bath* is a set of flatly silhouetted shapes against a bare ground, devoid of the traditional shading and tonal variations that create the illusion of depth in Western art.

American tastes were, in fact, deeply attracted to all things exotic, and France itself seemed attraction enough. Certainly, France appeared to offer Americans a kind of liberation from the cramped Puritan morality they found at home. And so creative people in particular were drawn to work and study there. The painter Theodore Robinson (1852–1896) went to France in 1884 to study with Monet at his home in Giverny. Other Americans came to sit at Monet's feet as well—Phillip Leslie Hale (1865–1931), who stayed at Giverny for four or five summers beginning in 1888, Lilla Cabot Perry, who spent nine summers there, and Theodore Earl Butler (1861–1936), who married Monet's stepdaughter.

These painters as well as more famous ones—including Cassatt, James Abbott McNeill Whistler (1834–1903), and John Singer Sargent (1856–1925)—as well as writers like Henry James (1843–1916) and Henry Adams (1838–1918), grandson of President John Quincy Adams—all came to Europe in the last half of the nineteenth century intent on immersing themselves in its cultural fervor. They admired what they saw in Europe. By comparison, when they turned their eyes back upon their own country, they saw only vulgarity and superficiality, moneymaking and materialism, boss-ridden politics, sanctimonious hypocrisy, and blind acceptance of social convention and conformity. It was Mark Twain who named this era in America the "Gilded Age", as opposed to a utopian Golden Age, and the name stuck.

The gilt covered, among other things, deep social unrest among the working poor, the continuing subjugation of women, the gradual elimination of all rights that African Americans had gained in the Civil War (see chapter 36), the removal of Native Americans to reservations, and, under the guise of enlightening the backward peoples of the world, the vast territorial theft of Africa and Asia by the imperial powers of Europe. But Europe offered many artists a way to ignore these realities, just as to those who stayed at home the thriving American economy offered a sense of well-being that enabled them to ignore the darker realities beneath the gilt. ∎

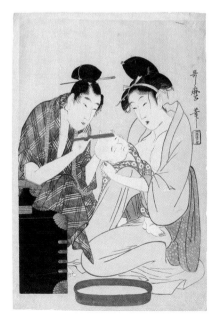

Fig. 37.27 Kitagawa Utamaro. *Shaving a Boy's Head.* ca. 1795. Color woodblock print, 15 1/8" × 10 1/4". Signed Utamuro hitsu. Bequest of Richard P. Gale. The Minneapolis Institute of Arts. Utamaro was noted for his depictions of beautiful women, especially his 1793 *Ten Physiognomies of Women*.

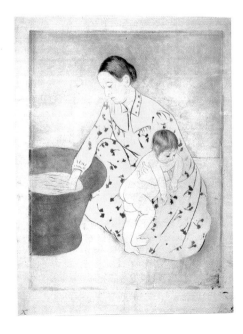

Fig. 37.28 Mary Stevenson Cassatt. *The Bath.* 1890–1891. Drypoint and aquatint on laid paper, plate: 12 3/8" × 9 3/4"; sheet: 17 13/16" × 12". Rosenwald Collection. Photograph © Board of Trustees, National Gallery of Art, Washington, D.C. Photo: Dean Beasom.

the newspaper trade as a printer and journalist, refining his writing skills. He also sharpened his powers of observation, as he gained a thorough knowledge of New York and its surrounding regions. Whitman became an ardent opponent of slavery in this period—even getting fired at one point by a conservative newspaper publisher who could not tolerate his views.

During a brief but memorable residence in New Orleans in 1846, where he helped set up a new newspaper, Whitman encountered a kaleidoscope of colorful characters and immersed himself in the city's exotic mixture of Indian, French, and African American culture. He liked the French market and the amazing variety of people and goods, and he enjoyed the strong coffee he purchased from a "Creole mulatto woman." Near his lodging house, Whitman also witnessed a less pleasant spectacle—slave auctions, which were a common occurrence in the American South. He would never forget the sight, and he kept an auction poster displayed in his room for years afterward to remind him of the degrading scene. More than a decade later, Whitman would make a slave auction the setting of one of his most famous poems, "I Sing the Body Electric."

As much as he appreciated the dynamism and unique appeal of New Orleans, Whitman was a confirmed New Yorker. He eventually gained fame with his portraits of the city's environment and people. He celebrated the sense of urgency and vigor conveyed by the urban atmosphere in "Crossing Brooklyn Ferry" (**Reading 38.1**):

Map 38.1 New York City and its Boroughs, ca. 1900.

READING 38.1 **from Walt Whitman, "Crossing Brooklyn Ferry" (1856)**

Come on, ships from the lower bay! pass up or down,
 white-sail'd schooners, sloops, lighters!
Flaunt away, flags of all nations! be duly lower'd at sunset!
Burn high your fires, foundry chimneys! cast black shadows at
 nightfall! cast red and yellow light over the tops of the
 houses! . . .
Thrive, cities—bring your freight, bring your shows, ample
 and sufficient rivers,
Expand. . . .

New York City was the very embodiment of the vast American possibilities Whitman celebrated in *Leaves of Grass*, the long and complex volume of poems that he self-published in 1855 and continuously revised until 1892. It started out as a slim volume of 12 poems and grew to more than 400 as the author's life changed and as he grew into his self-defined role as "the American poet," speaking for the common man. In the first few years, *Leaves* was not received favorably and it did not sell many copies. But within a decade new editions would become a commercial success and the foundation of his growing reputation as the nation's most important poet. In "Song of Myself," the first and eventually longest of the poems, Whitman

spoke to his own and the country's diverse experiences (Reading 38.2a):

READING 38.2a **from Walt Whitman, "Song of Myself," in *Leaves of Grass* (1867)**

I am large, I contain multitudes. . . .
Of every hue and cast am I, of every rank and religion,
A farmer, mechanic, artist, gentleman, sailor, quaker,
Prisoner, fancy-man, rowdy, lawyer, physician, priest.

Whitman openly embraced all Americans in "Song of Myself," from immigrants to African Americans and Native Americans, from male to female, and heterosexual to homosexual. He celebrated all forms of sexuality, a fact that shocked many readers. One early reviewer called *Leaves* "a mass of stupid filth" and its author a pig rooting "among a rotten garbage of licentious thoughts." And in 1865, Whitman, who worked at the U.S. Interior Department as a clerk, was fired by his boss, the Secretary of Interior, for having violated in that work "the rules of decorum and propriety prescribed by a Christian Civilization."

"Song of Myself" consists of 52 numbered sections with the "I" of the narrator serving as a literary device for viewing the experiences of one man as representative of multitudes. *Leaves of Grass* is therefore a subjective epic. "Remember," Whitman would tell a friend late in his life, "the book arose out of my

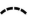

Fig. 38.2 Childe Hassam.
The Manhattan Club
(The Stewart Mansion). ca. 1891.
Oil on canvas, $18\frac{1}{4}''\times 22\frac{1}{8}''$. Santa
Barbara Museum of Art, California. Gift
of Mrs. Sterling Morton to the Preston
Morton Collection. 1960.62. At the
northwest corner of 34th Street and
Fifth Avenue, the Manhattan Club was
originally the home of A. T. Stewart,
owner of a department store on
Broadway specializing in "feminine
attire." It was the largest iron structure
in the United States and contained 55
rooms, most with 19-foot ceilings.

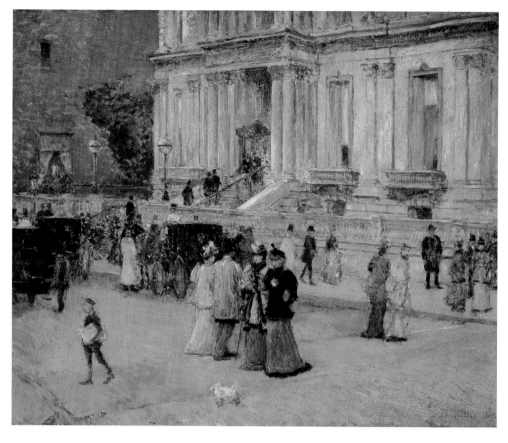

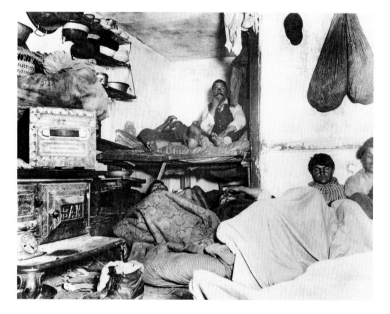

Fig. 38.3 Jacob A. Riis. *Five Cents a Spot.* ca. 1889. Photograph. Museum of the City of New York, NY. Jacob A. Riis Collection. Riis described this photo, taken on Bayard Street in Manhattan's Lower East Side, as follows: "In a room not thirteen feet either way slept twelve men and women, two or three in bunks set in a sort of alcove, the rest on the floor. A kerosene lamp burnt dimly in the fearful atmosphere, probably to guide other and later arrivals to their 'beds,' for it was only just past midnight."

life in Brooklyn and New York. . . . absorbing a million people for fifteen years, with an intimacy, an eagerness, an abandon, probably never equaled." (See **Reading 38.2**, page 1242, for a lengthy excerpt.)

Whitman loved equally the finery of New York's upper classes and the city's "newly-come immigrants." He appreciated the elegant lifestyle depicted by the American Impressionist painter Childe Hassam [child HASS-um] (1859–1935) in such works as *The Manhattan Club* (Fig. **38.2**) and how it contrasted with the impoverished lifestyle of the city's working class, accurately captured by photographer Jacob Riis [reess] in his book, *How the Other Half Lives* (1890) (Fig. **38.3**). "The pleasures of heaven are with me," Whitman writes in "Song of Myself," "and the pains of hell are with me, / the first I graft and increase upon myself, the latter I translate into a new tongue."

Whitman developed a **free-verse** style of writing poetry, based on irregular rhythmic patterns as opposed to conventional meter. Rhymes are rare in his work, but the "song" of the poems derives from his liberal use of alliteration, assonance (similar, repeated vowel sounds in successive words), and other forms of repetitive phrasing.

The style owes much to the opera arias that Whitman admired so much. As he wrote in "Song of Myself" (**Reading 38.2b**):

READING 38.2b **from Walt Whitman, "Song of Myself," in *Leaves of Grass* (1867)**

I hear the sound I love, the sound of the human voice,
I hear sounds running altogether, combined, fused or
 following,
Sounds of the city and sounds out of the city, sounds of the
 day and night . . .
I hear the chorus, it is a grand opera,
Ah this indeed is music—this suits me.

By the time Whitman issued his final ("deathbed") edition of *Leaves of Grass*, the work had grown from 96 printed pages in the 1855 edition to 438. He would come to anguish over the personal suffering of the soldiers who fought in the Civil War in "Drum Taps," and mourn the death of Abraham Lincoln in "When Lilacs Last in the Dooryard Bloom'd," both added to the 1867 edition. To celebrate the opening of the Suez Canal, he added to the 1876 edition the long "Passage to India." *Leaves of Grass*, in other words, was as expansive and as ever-changing as its author.

But it is finally in Whitman's feelings for New York City that we can best understand the complexity of his feelings for America. In a paragraph from a lengthy pamphlet in 1871 that argued for the necessity of reinvigorating American democracy, he tells of his feelings for the city (**Reading 38.3**):

READING 38.3 **from Walt Whitman, *Democratic Vistas* (1871)**

After an absence, I am now again (September, 1870) in New York City and Brooklyn, on a few weeks' vacation. The splendor, picturesqueness, and oceanic amplitude and rush of these great cities, the unsurpass'd situation, rivers and bay, sparkling sea-tides, costly and lofty new buildings, facades of marble and iron, of original grandeur and elegance of design, with the masses of gay color, the preponderance of white and blue, the flags flying, the endless ships, the tumultuous streets, Broadway, the heavy, low, musical roar, hardly ever intermitted, even at night; the jobbers' houses, the rich shops, the wharves, the great Central Park, and the Brooklyn Park of hills (as I wander among them this beautiful fall weather, musing, watching, absorbing)—the assemblages of the citizens in their groups, conversations, trades, evening amusements, or along the by-quarters—these, I say, and the like of these, completely satisfy my senses of power, fulness, motion, &c., and give me, through such senses and appetites, and through my esthetic conscience, a continued exaltation and absolute fulfilment. Always and more and more,

. . . I realize . . . that not Nature alone is great in her fields of freedom and the open air, in her storms, the shows of night and day, the mountains, forests, seas—but in the artificial, the work of man too is equally great—in this profusion of teeming humanity—in these ingenuities, streets, goods, houses, ships—these hurrying, feverish, electric crowds of men, their complicated business genius, . . . and all this mighty, many-threaded wealth and industry concentrated here.

In the Interest of Liberty: An Era of Contradictions

Whitman's essential optimism, his genuine belief in the egalitarian promise of democracy, was put to the test during Reconstruction. As he wrote in *Democratic Vistas*, the promise that he saw in New York's streets and harbors remained unfulfilled: "With such advantages at present fully, or almost fully, possess'd—the Union just issued, victorious, . . . and with unprecedented materialistic advancement—society, in these States, is canker'd, crude, superstitious, and rotten." As if to prove his point, the Supreme Court nullified the Civil Rights Act in 1883. Lynchings of African Americans became almost commonplace across the South as white-controlled state legislatures passed laws designed to rob blacks of their civil rights. Legally sanctioned segregation ("Jim Crow" laws) prevented blacks from using public facilities such as restrooms, hotels, and restaurants, and attending school with whites.

The Statue of Liberty and Tammany Hall Even as African Americans were losing their freedoms, the nation celebrated liberty when wealthy businessmen and politicians raised the necessary funds for a pedestal to support a French gift to the American people sculpted by Frédéric-Auguste Bartholdi [bar-tohl-DEE] (1834–1904), *Liberty Enlightening the World*. Known simply as the Statue of Liberty—a broken chain under Liberty's foot alludes to the emancipation of the slaves—it was positioned on an island in New York Harbor and dedicated in 1886. At the ceremony, President Grover Cleveland (held office 1885–1889) noted, with no irony intended, "Instead of grasping in her hand the thunderbolts of terror and death, she holds aloft the light that illumines the way to man's enfranchisement." Former slaves and their descendents along with all American women might have objected to the grand sentiments, since the prospect of gaining the vote or a voice in democracy was far in the future.

However it was perceived, democracy was a complicated and imperfect process of self-governance, and especially so in large urban areas with diverse populations. Organizations like the Tammany [TAM-uh-nee] Society, founded in the eighteenth century for social purposes, now used working-class and immigrant votes to gain and keep power indefinitely. By offering those at the bottom of society's ladder assistance in gaining citizenship, jobs, and housing, Tammany leaders such as William "Boss" Tweed (1823–1878) were able to create a

CULTURAL PARALLELS

Famine in India

As the Gilded Age began in America, India was experiencing a nationwide famine. The catastrophe, which claimed 25 million lives between 1875 and 1902, had several causes. Supporters of British imperialism liked to say that it modernized India by introducing railroads and the civil service system, but the introduction of low-cost British imports systematically undermined India's native industries. Also, British policies supported seizure of local farmlands and their conversion to foreign-owned plantations, and local trade was heavily taxed.

self-sustaining system of patronage, whereby favors would be traded in return for political loyalty.

By the 1860s the Tammany Society, which was closely aligned with the Democratic Party, completely controlled the city's political life. Under the leadership of Boss Tweed, City Hall became known as Tammany Hall. In his role as commissioner of public works, Tweed not only helped workers and immigrants, but also enriched himself and his cronies through swindling the city government. He purchased 300 benches for $5 each, which he turned around and resold to the city for $600 apiece. Tweed commissioned his friends to do work for the city. One carpenter received $360,747 for a month's labor, and a supplier of furniture and carpets was paid over $5 million.

Boss Tweed was not alone in helping to corrupt democratic government. President Ulysses S. Grant (held office 1868–1876) and his cabinet were implicated in a number of dubious schemes, leading to notorious scandals. It was just such corruption that led Mark Twain to remark in a *New York Tribune* newspaper column in 1871: "What is the chief end of man?—to get rich. In what way?—dishonestly if we can; honestly if we must."

Economic Depression, Strikes, and the Haymarket Riot

Widespread fraud and corruption contributed to the impoverishment of the working class, but so did the profit motive that drove the industrial sector of the economy. By 1890, 11 million of the nation's 12 million families had an average annual income of $380, well below the poverty line ($380 would buy about the same as $7,600 in today's dollars). Sudden, unexpected events also precipitated widespread economic hardship, as occurred in September 1873, when a Philadelphia banking firm failed, causing investors to panic, banks to shut down, and the New York Stock Market to close for ten days. The "Panic of 1873" triggered the "Long Depression," which lasted four years. In this period, over 20,000 American businesses failed and a quarter of the nation's 364 railroads went bankrupt. (The downturn also affected other countries, particularly Europe and Britain.)

Millions of American workers found themselves without jobs in the 1870s, while business owners began cutting wages—an oversupply of employees meant cheaper labor. Many lost their savings as well as their jobs when unregulated banks, insurance companies, and investment firms went out of business and federal and state governments stood by. As the unemployment rate in New York and other cities passed 25 percent, famine and starvation in the land of opportunity became a reality.

It should not be surprising that workers developed new forms of collective action in this harsh economic environment. Impromptu strikes, walkouts, and the beginnings of organized labor unions signaled the changing economic and social climate. When the Baltimore & Ohio Railroad cut wages in 1877, its workers staged spontaneous strikes, which spread rapidly to other railroads. In Baltimore, the state militia shot and killed 11 strikers and wounded 40 others. In Pittsburgh, the head of the Pennsylvania Railroad wryly suggested that strikers be given "a rifle diet for a few days and see how they like that kind of bread." Perhaps in response to his suggestion, troopers began firing at the unarmed crowd—leaving at least 20 dead. In Philadelphia, strikers burned down much of the downtown before federal troops stepped in. But despite the widespread strikes and development of labor organizations, workers were largely unsuccessful because of the power and wealth of those united against them.

Owners of railroads and other corporations together with the political leaders they supported made sure wage reductions remained in place. The federal government aided them when the U.S. War Department created the National Guard as a quick reaction force to put down future disturbances. It was an era of unparalleled political unrest, and *The Strike* by Robert Koehler [KOH-lur] (1850–1917) suggests something of the mood of the workers and their bosses, as well as the grim environment of industrial-age America (Fig. **38.4**). The painting depicts an angry crowd confronting an employer, demanding a living wage from the stern top-hatted man and a worried younger man standing behind him. An impoverished woman with her children looks on at the left, another woman, more obviously middle class, tries to talk with one of the workers, but behind him a striker bends down to pick up a stone to throw. Koehler's realism is evident in the diversity of his figures, each possessing an individual identity. But the background of the work, with its smoky, factory-filled landscape on the horizon, owes much to the Impressionist style.

The May 1, 1886, issue of *Harper's Weekly* included the painting as its central feature. On the same day a national strike called for changing the standard workday from 12 hours to 8. More than 340,000 workers stopped work at 12,000 companies across the country. In Chicago, a bomb exploded as police broke up a labor meeting in Haymarket Square. A police officer was killed by the blast and police retaliated, firing into the crowd of workers, killing one and wounding many more. Four labor organizers were charged with the policeman's death and subsequently hanged, demoralizing the national labor movement and energizing management to resist labor's demands.

Fig. 38.4 Robert Koehler. *The Strike.* **1886.** Oil on canvas, 71 ⅝" × 9' ⅝". Deutsches Historisches Museum, Berlin, Germany/The Bridgeman Art Library, NY. Koehler's father was a machinist, and he identified with the plight of the working class. The painting was exhibited at the National Academy of Design in 1886, to general approval.

The American Woman

Women as well as working-class whites and blacks felt the contradictions and limitations of American democracy. In the post–Civil War years, women became the public face of social reform as they led the suffrage movement, aimed at gaining the right to vote, and the Temperance movement, which sought to moderate (or cease) the consumption of alcohol. Both movements met formidable opposition. At the dedication of the Statue of Liberty, officials barred the New York State Woman Suffrage Association from participating. The New York "suffragettes" sailed out to Bedloe's Island anyway and invited the public onboard their ship, where their president, Lillie Devereux Blake, spoke: "In erecting a Statue of Liberty embodied as a woman in a land where no woman has political liberty, men have shown a delightful inconsistency which excites the wonder and admiration of the opposite sex."

Yet women were making *some* gains. After the Civil War, they had assumed a growing role in education, as state-run schools trained women as teachers. And during the war, many had followed the lead of England's Florence Nightingale (1820–1910), who established nursing as an honored

profession during the Crimean War in the 1850s. By the end of the century, nursing schools, usually associated with the nation's medical schools, had opened across the country, although physician training was still reserved for men. By 1900, fully 80 percent of the nation's colleges, universities, and professional schools were admitting women, though in small numbers. And the literacy rate of white women equaled that of white men.

If women were the symbols of social reform in Gilded Age America, they increasingly embodied education and literacy in art and literature as well. In *A Reading* by Thomas Dewing (1851–1938), created by a painter who worked with his wife, also an artist, in a professional partnership, we see women in the act of reading (Fig. **38.5**). It is even fair to say that women became the favorite subject of American painters in the last decades of the nineteenth century.

Formal portraits of society women were an important source of income for many painters, but artists also showed women in more relaxed settings. Thomas Dewing, for example, painted women almost exclusively, bathing them in a gauzy light, as in *A Reading*, a technique that he learned from the Impressionists during his training at the Académie Julian

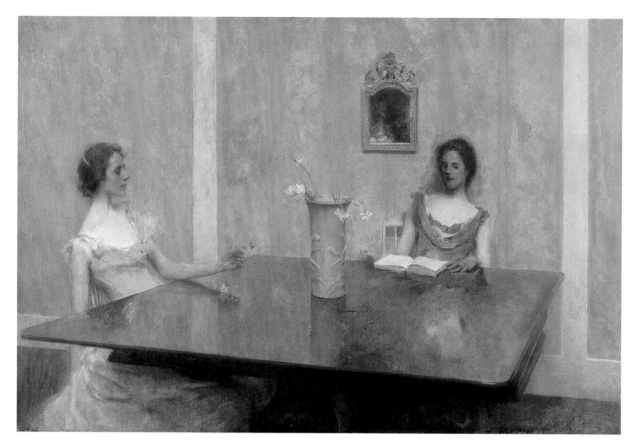

Fig. 38.5 Thomas Wilmer Dewing. *A Reading.* **1897.** Oil on canvas, 20¼″ × 30¼″. Bequest of Henry Ward Ranger through the National Academy of Design. Smithsonian American Art Museum, Washington, DC/Art Resource, NY. For Dewing and many of his contemporaries, repose was therapeutic. His paintings were intended to evoke that state in the viewer.

[ah-kah-day-MEE zhoo-lee-AHN] in Paris in the 1870s. Such scenes are double-edged since on one hand, they celebrate the intellectual capacity of women, but on the other, they insulate these same women from the harsh world of labor and business by showing them sitting comfortably in their home, safely domestic. In short, nothing about such artworks challenged the status quo. Male painters of the Gilded Age depicted women as almost always passive—sitting, lounging, reading, writing a letter—and rarely physically active. Flowers are often present in these images, with the women sometimes contemplating a bloom, as in Dewing's painting. The ever-present cut rose might symbolize fallen virtue, while daffodils were associated with the innocence of spring. Or women might be depicted strolling in a garden, as in a view of Prospect Park by the American painter William Merritt Chase (1849–1916) (Fig. **38.6**). Chase's views of New York's parks were among the first fully Impressionist canvases to be painted in the United States. Monet's paintings of his wife Camille in their garden at Argenteuil influenced paintings like this, but the contrast between female passivity and male action was much more pronounced in American painting than in European art. Almost all of Chase's park views are populated exclusively with women. In his eyes, the park was their particular environment, a feminine space as nurturing

as the mother Chase depicts here, sitting with her baby in its pram, as opposed to the male world of business.

With the possible exception of Thomas Eakins's [AY-kinz] *Agnew Clinic* (see *Focus*, pages 1228–1229), no painting embodies the tension between genders more than Winslow Homer's *The Life Line* (Fig. **38.7**). Immediately recognized as a masterpiece when exhibited at the National Academy in 1884, it depicts a woman's rescue from a ship wrecked in a storm. A review in the *New York Times* summarizes the painting's attraction to its New York audience:

> The coast guard is a well-drawn muscular figure with face hidden. . . . The hiding of his features concentrates the attention very cleverly on his comrade, who has fainted or is numb with fright. She has nothing on but her shoes, stockings, and dress, while the skirt of the latter has been so torn that her legs are more or less shown above the knees. Then, the drenching she has received makes her dress cling to bust and thighs, outlining her whole form most admirable. She is a buxom lassie, by no means ill-favored in figure and face. Her disordered hair, torn skirt, drenched dress, and set face call for sympathy; a redness of the skin, above the stockings hints at a cruel blow, and puts the climax on one's pity; at the same time, one cannot forget her beauty.

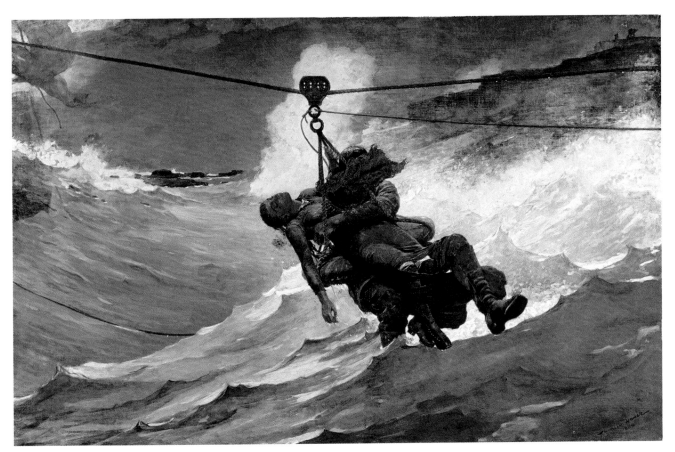

Fig. 38.7 Winslow Homer. *The Life Line.* **1884.** Oil on canvas, $28\frac{5}{8}'' \times 44\frac{3}{4}''$. The George W. Elkins Collection, 1924. The Philadelphia Museum of Art, Philadelphia/Art Resource, NY. In the first days that the painting was exhibited, the rescuer's face was visible. However, Homer apparently felt that it detracted from the composition, so he painted in the windblown red shawl to cover him while the exhibition was in progress.

Focus

Eakins's *Gross Clinic* and *Agnew Clinic*

Thomas Eakins (1844–1916) was an American Realist who began teaching at the Pennsylvania Academy of Fine Art in Philadelphia in 1876 and became its director in 1882. Always controversial, he was dismissed from the Academy in 1886 for removing a loincloth from a nude male model in a studio where female students were present. Among his most notable—and controversial— works are two portraits of surgeons, *The Gross Clinic* and *The Agnew Clinic*, painted 14 years apart, in 1875 and 1889 respectively. Although anticipated in seventeenth-century European paintings such as Rembrandt's *Anatomy Lesson of Dr. Tulp* (see *Focus*, chapter 26), the subject was relatively unknown in American art and so not considered an appropriate subject for a painting. In addition, Eakins's graphic realization of both surgeries shocked the public.

The Gross Clinic is the product of the painter's own desire to paint Dr. Samuel D. Gross (1805–1884) in his surgical clinic, which he had attended when he studied anatomy a year before at the Jefferson Medical College in Philadelphia. It shows Dr. Gross standing in his surgical amphitheater, scalpel in hand, explaining a procedure to his students. Like Rembrandt's *Anatomy Lesson*, the composition is pyramidal in structure, with Dr. Gross at its apex. Light bathes the surgeon's head and hand and the surgery itself, emphasizing the intellectual capacity and physical dexterity of the surgeon. He and his colleagues are in the process of removing a piece of

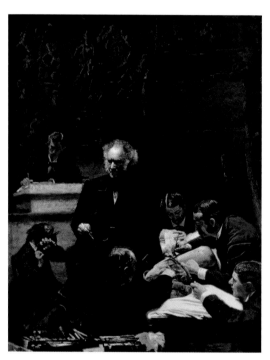

Thomas Eakins. *The Gross Clinic*. 1875. Oil on canvas, 96″ × 78¹⁄₂″. Philadelpia Museum of Art on loan from the University of Pennsylvania School of Medicine. The brightest color in this painting is the red of oozing blood on the patient's wound and on the surgeon's hands and linens.

dead bone from the leg of a patient suffering from osteomyelitis, a bone disease that until the nineteenth century had been treated by amputation. Eakins evidently understood the shock the scene would cause his viewers because behind Dr. Gross he has depicted a woman, probably a relative of the patient, recoiling in horror from the scene. The era's prototypical weak woman, she is a far cry from the stoic nurse who watches Dr. Agnew's surgery in *The Agnew Clinic*.

The Agnew Clinic was a commission from the students of Dr. D. Hayes Agnew (1818–1892), who expected merely a portrait of their retiring mentor. Eakins, however, wanted to survey advances in medicine since his last effort and offered to paint all of Agnew's students and colleagues into a work echoing *The Gross Clinic*. The painting, the largest Eakins ever painted and depicting surgery on a young woman, was rejected by the Pennsylvania Academy—it had asked him to submit it to their annual exhibition—and then subsequently by the Society for American Artists. It was finally displayed at the Chicago World's Columbian Exhibition in 1893. Oblivious to the fact that Eakins was celebrating American medical advancement, one critic wrote: "It is impossible to escape from Mr. Eakins's ghastly symphonies in gore and bitumen. Delicate or sensitive women or children suddenly confronted by the portrayal of these clinical horrors might receive a shock from which they would never recover." Nevertheless, in *The Agnew Clinic* Eakins had replaced the fear and blood of *The Gross Clinic* with professionalism and detachment.

The doctors wear white coats, unlike the surgeons in *The Gross Clinic*. This indicated that in the 14 years separating the two paintings, principles of *antisepsis*—the destruction or minimization of germs and other microorganisms—had been introduced into the surgical arena. The figures are also much better lit by artificial lighting, whereas in *The Gross Clinic* the light enters the auditorium through skylights above.

The figure of Eakins himself stands in the doorway, listening as a colleague of Agnew's whispers to him, possibly explaining the procedure. Eakins's wife Susan added his likeness to the painting.

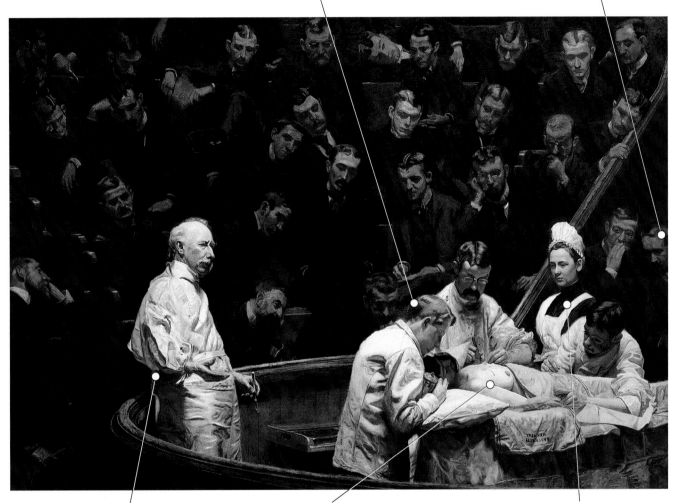

Dr. Agnew was professor of surgery at the University of Pennsylvania School of Medicine. His students described him, according to the Latin motto carved on the finished work's frame, as "the most experienced surgeon, the clearest writer and teacher, the most venerated and beloved man." At Dr. Agnew's request there is no blood shown on him or his patient.

The female patient is undergoing a mastectomy, or breast removal—still an experimental procedure—to combat her breast cancer. The doctor at her head administers chloroform as an anesthetic, another experimental technique. Poor men and women from almshouses were regularly recruited to undergo such experimental procedures in return for free medical care.

The nurse is Mary V. Clymer, at the top of her nursing class at the University of Pennsylvania. She serves a double function: overseeing the propriety of the male doctors' handling of the female patient and representing the new profession of nursing as a whole. While women were still not admitted to medical schools (an exclusion strongly supported by Dr. Agnew), the University of Pennsylvania was one of the first American universities to inaugurate a school of nursing. It was only three years old at the time of Eakins's painting.

Thomas Eakins. *The Agnew Clinic.* 1889. Oil on canvas, $84\frac{3}{8}'' \times 118\frac{1}{8}''$. Jefferson College, Philadelphia, PA, USA/The Bridgeman Art Library. Today, this painting is reproduced on the diplomas of all graduates of the University of Pennsylvania School of Medicine.

This is the very image of the strong, active male in whose embrace the weak, passive female is rescued. And part of her attractiveness is her passivity and vulnerability. That the painting appealed to the prurient interests of its audience—in some other context the couple might be seen as lovers embracing—sealed its success. But above all, the painting positions woman in a condition of total dependency on a man, which is precisely where the American male, in the last quarter of the nineteenth century, thought she should be.

Emily Dickinson: The Poetry of Enigma As a result of the broadly condescending attitude toward women and the fierce resistance to the fledgling women's rights and suffrage movements, the achievements of women in the nineteenth century were often individual ones. A remarkable example is the work of Emily Dickinson (1830–1886), who lived in her father's Amherst, Massachusetts, home almost her entire life. Here she gardened, baked bread—her chief talent in her father's eyes—and read voluminously. Dickinson also wrote continuously, corresponding with a small circle of friends and composing some of the most remarkable poetry in the history of American literature. Her work is characterized by passion, simplicity, and an economy and concentration of style. She summarized her life in 1862, at age 31, when she wrote a letter to Thomas Higginson, at *Atlantic Monthly* magazine, responding to his published essay that offered advice to young authors:

> You ask of my Companions Hills—Sir—and the Sundown—and a Dog—large as myself, that my Father bought me—They are better than Beings—because they know—but do not tell—and the noise in the Pool, at Noon—excels my Piano. I have a Brother and Sister—My Mother does not care for thought—and Father, too busy with his Briefs—to notice what we do—He buys me many Books—but begs me not to read them—because he fears they joggle the Mind. They are religious—except me—and address an Eclipse every morning—whom they call their "Father." But I fear my story fatigues you—I would like to learn—Could you tell me how to grow—or is it unconveyed—like Melody—or Witchcraft?

Higginson could not, in fact, tell her how to grow as an author. He found her unconventional verse curious, and even powerful, but decidedly unorthodox. It was in this lack of orthodoxy, however, that Dickinson found her own form of freedom and her resemblance to Whitman. Even in the isolation of her Amherst home, her poetry awakened her senses, as she explained, in a poem: "I am alive—because / I am not in a Room— / The Parlor . . ." (In the New England parlor one met with one's visitors, and Dickinson studiously avoided visiting.) Dickinson so avoided the parlor (and the visitors in them) that she remained something of a mystery to her neighbors—and to us. In fact, there are only two known photographs of her (Fig. **38.8**).

Yet one day in 1882, in that dreaded parlor, Emily's mother read some of her daughter's poems to a young neighbor, Mabel Loomis Todd, who found them "full of power."

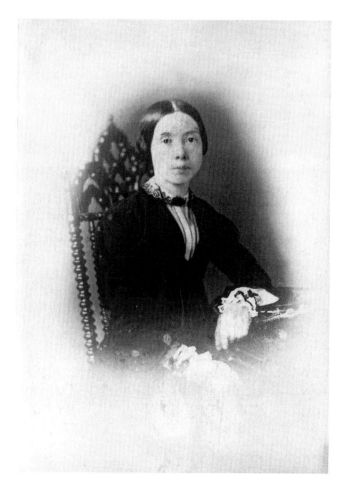

Fig. 38.8 Emily Dickinson. ca. 1848–1853. Mid-1860s. Albumen photograph copy of an original daguerreotype, $5\frac{1}{2}" \times 3\frac{7}{8}"$. Until Professor Gura of the University of North Carolina purchased this photograph on eBay, only one other photograph of the reclusive Dickinson was known to exist. Asked at age 31 to supply a photograph of herself, she replied, "Could you believe me—without? I had no portrait, now, but am small, like the Wren, and my Hair is bold, like the Chestnut Bur—and my eyes, like the Sherry in the Glass, that the Guest leaves—Would this do just as well?"

Encouraged by Emily's sister, Todd undertook the task of transcribing them. By letter, Dickinson and Todd developed "a very pleasant friendship," even though they never actually met. In 1890, four years after Dickinson's death, Todd persuaded Thomas Higginson to publish a collection of Dickinson's poems, followed by a second series in 1891, and a third in 1896. They seemed to embody the pent-up imagination of the nineteenth-century American woman, and they became popular almost immediately.

The crisp, sharp imagery and economy of statement in poems like Dickinson's "Wild Nights" contrasts dramatically with its great emotional intensity. As is typical of Dickinson's work, her brevity seems to charge the poem, fuel its ambiguity, and contribute to the fierceness of her vision (**Reading 38.4**):

READING 38.4 **Emily Dickinson,
"Wild Nights" (as published
in 1953)**

Wild Nights—Wild Nights!
Were I with thee
Wild Nights should be
Our luxury!

Futile—the Winds—
To a Heart in port—
Done with the Compass—
Done with the Chart!

Rowing in Eden

Ah, the Sea!
Might I but moor—Tonight—
In Thee!

The poem contrasts the safety and repose of a port and the wildness of the open seas, which are metaphors for the poet's emotional state. It opens with the poet longing for the "wild nights" that would evidently be assured if she were with "thee." The second stanza seems to describe the circumstances of a heart safely harbored in port. It has no need of compass or chart and the winds do not stir it. She is "Rowing in Eden," in a paradise-like calm. But she rejects such calm, for it is "wildness" that the poet desires. The peace of Eden offers no risk, none of the passion represented by the wild seas.

The poem can also be read in terms of sexual encounter, adding to the ambiguity. We know that Dickinson used an 1844 dictionary that linked *luxury* with its Latin origins in wantonness, sexual desire, and riotous living. However, the poem remains enigmatic and suggestive rather than clear and detailed. The reader's imagination is as free to play as Dickinson's own. (See **Reading 38.5**, page 1243, for several other Dickinson poems.)

Kate Chopin and the New Feminist Novel Unlike the writings of Emily Dickinson, which were almost unknown in her lifetime, the works of writer Kate Chopin [shoh-PAN] (1851–1904), of St. Louis, Missouri, were well known. Having taken up writing in 1884 after the death of her husband, Chopin's first two books of stories, *Bayou Folk* (1894) and *A Night in Arcadie* (1897), were praised for their attention to local custom and dialect. *Vogue* magazine and other commercial publications featured her work. But when her short novel *The Awakening* (1899) appeared, she was harshly criticized for its frank treatment of female marital infidelity.

In its celebration of sensuality and its positive attitude toward the sexual desire of its central character, Edna Pontellier [pohn-tell-ee-AY], *The Awakening* owes much to Walt Whitman, whose work Chopin greatly admired. Set in New Orleans and Grand Isle, a summer resort on the Louisiana coast, *The Awakening* opens as Edna is falling in love with Robert Lebrun [luh-BRUHN], a young Creole [KREE-ohl]

whose family owns the resort. From the story's very first moments it becomes apparent that the author intends to challenge the viability of Edna's marriage. In the following passage, Mr. Pontellier watches her return from the beach with her new object of affection (**Reading 38.6a**):

READING 38.6a **from Kate Chopin,
The Awakening,
Chapter I (1899)**

Mr. Pontellier finally lit a cigar and began to smoke, letting the paper drag idly from his hand. He fixed his gaze upon a white sunshade that was advancing at snail's pace from the beach. He could see it plainly between the gaunt trunks of the water-oaks and across the stretch of yellow camomile. The gulf looked far away, melting hazily into the blue of the horizon. The sunshade continued to approach slowly. Beneath its shelter were his wife, Mrs. Pontellier, and young Robert Lebrun. . . .

"What folly! to bathe at such an hour in such heat!" exclaimed Mr. Pontellier. . . . "You are burnt beyond recognition," he added, looking at his wife as one looks at a valuable piece of personal property which has suffered some damage.

Edna is as seduced by the sea as she is by young Robert Lebrun. When he takes her to the beach a few chapters later, Edna begins to experience the "awakening" that will free her from her marriage (**Reading 38.6b**):

READING 38.6b **from Kate Chopin,
The Awakening,
Chapter VI (1899)**

A certain light was beginning to dawn dimly within her,—the light which, showing the way, forbids it. . . .

In short, Mrs. Pontellier was beginning to realize her position in the universe as a human being, and to recognize her relations as an individual to the world within and about her. . . .

But the beginning of things, of a world especially, is necessarily vague, tangled, chaotic, and exceedingly disturbing. How few of us ever emerge from such beginning. How many souls perish in its tumult!

The voice of the sea is seductive; never ceasing, whispering, clamoring, murmuring, inviting the soul to wander for a spell in abysses of solitude; to lose itself in mazes of inward contemplation.

The voice of the sea speaks to the soul. The touch of the sea is sensuous, enfolding the body in its soft, close embrace.

And so Edna learns to swim, both literally and figuratively, to fend for herself, free of her husband, in a newfound world of sensual, even carnal pleasure. No other writer of the era even tried to describe the feelings a woman experiences as she discovers her own sexual being and, more important, her own identity. The novel's commercial and critical failure, in fact, mirrored Edna's own inability, once she has in fact fully awakened to herself, to fit into her society. The author fared better than her character, and Chopin turned to writing more commercially acceptable short stories. Illustrating the changing social and literary environment, Kate Chopin was recognized in the first edition of Marquis *Who's Who* (1900), which includes concise biographies of "distinguished Americans."

Ragtime and the Beginnings of Jazz

Edna Pontellier was not the kind of woman that Americans were used to encountering personally. But Chopin had carefully chosen New Orleans as Edna's place of awakening. New Orleans was still a French city, but it was also African American, Spanish, Haitian, Creole, and Caucasian. At the end of the nineteenth century, it was probably the most cosmopolitan city in America. Out of this mixture a thriving musical culture developed, which included opera and chamber music, as well as a new form of music that evolved in the city's bars, dance halls, streets, and brothels. The bands that played at festivals, dances, and weddings, in the bars and in parades, at political rallies and funerals gained inspiration from African and Caribbean dance and drumming traditions.

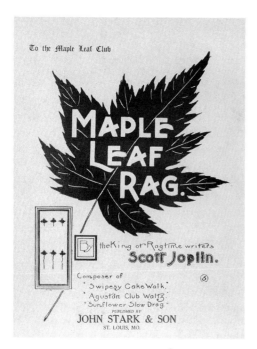

Fig. 38.9 Title page to an early edition of Scott Joplin's *Maple Leaf Rag.* **ca. 1899.** Joplin received $50 plus royalties for the work.

Combining these traditions with the brass bands and syncopated musical tunes that gained popularity in the 1880s, New Orleans gave birth to a new musical tradition that has come to be known as **jazz**.

Jazz is characterized by a steady rhythm that plays off against a rhythmic **syncopation**—the accentuation of "off-beats." (Off-beats are not generally stressed in other forms of music.) **Ragtime** piano music is one of the earliest manifestations of this principle. A musician "rags" by playing a classical or popular melody in a syncopated style. The left hand maintains a steady marchlike tempo, while the right plays the melody in syncopated rhythm. The most famous ragtime pianist was Scott Joplin, whose *Maple Leaf Rag* (Fig. 38.9) sold hundreds of thousands of copies after 1899 (see **CD-Track 38.1**).

To many, more puritanical Americans, the loose rhythms of ragtime suggested loose morals, and ragtime was subjected to the same harsh criticisms as Chopin's novel, published in the same year that Joplin's tune was released. One American music critic, for instance, urged readers: "take a united stand against the Ragtime Evil. . . . In Christian homes, where purity of morals is stressed, ragtime should find no resting place. . . . Let us purge America and the Divine Art of Music from this polluting nuisance." Such sentiments, which would later also be aimed at jazz (in the 1920s and 1930s) and rock-and-roll (in the 1950s and 1960s), were often motivated by racism. However, more open-minded white audiences were attracted to the music's fresh spontaneity. Ragtime—and, later, jazz in general—represented a new, authentic form of American expression, a synthesis of diverse traditions that transcended the classical symphony, ballet, and opera musical forms that originated in Europe.

The American Abroad

As much as New Orleans offered Americans the prospect of a colorfully complex urban atmosphere, the rest of the world also beckoned, available as never before for exploration. Novelist Henry James remarked, "The world is shrinking to the size of an orange." He meant that it had become easy for Americans to travel to and live in London, Paris, and Rome. In fact, by the end of the nineteenth century there were 17 companies with over 173 steamships regularly sailing between New York and Europe. With the advent of steam turbine engines, screw propellers, and steel hulls, it took less than a week to cross the Atlantic. (Fifty years earlier it had taken two to three weeks, and in Benjamin Franklin's time it took from six weeks to three months.)

Another innovation that made international travel even more inviting was the development of ocean liners, ships that measured up to a thousand feet long with lavish accommodations for (some of) its passengers. Ocean liners had three classes of rooms for its customers, with the third or "steerage" class (originally referring to those housed in cargo holds of ships) comprising the greatest number, and the first and second class supplying the majority of profits. European immi-

grants moving westward with dreams of a better life filled the steerage compartments, while newly rich Americans traveled eastward toward Britain and the Continent. In Europe, wealthy Americans, who would sometimes stay for months and years, took in the history and culture, spent their money freely, sometimes married (or dallied with) aristocrats, and generally indulged in behavior that would draw scorn from their more puritanical families and friends as well as from the scandal-seeking press in the United States.

Henry James and the International Novel

Perhaps the best-traveled and most cosmopolitan American writer in the nineteenth century was Henry James (1843–1916). His first years were spent in Paris—his first memory, he claimed, was of the Place Vendome [vahn-DOME] with its Napoleonic column—and he was educated there as well as in Geneva, Switzerland, and Bonn, Germany. American schooling was not up to his father's high standards. On his first European tour, undertaken when he was 26 years of age in 1869–1870, James met the intellectual elite of England: William Morris, Dante Gabriel Rossetti, Edward Burne-Jones, John Ruskin, and Charles Darwin. He then traveled on to Paris, to Switzerland, and from there he hiked into Italy, then on to Milan, Venice, and Rome. He took his aunt and sister on a second tour in 1872–1874, returned to Paris in 1875, meeting writers Gustave Flaubert and Émile Zola among others, and then settled in England in 1876. "My choice is the Old World," he wrote in his diary, "my choice, my need, my life."

James often depicted the drama of American innocence confronting European experience in his novels. In *Portrait of a Lady* (1881), for instance, Isabel Archer, a young woman freed by her inheritance to travel wherever she pleases, follows in James's footsteps to England and France, marrying a morally bankrupt American expatriate. Her relationship with him tests every fiber of her innocence and moral being. In *The Ambassadors*, Lambert Strether is sent to Europe to free Chad Newsome, his fiancée's son, from the perceived clutches of the older, more experienced Madame de Vionnet [vee-oh-NAY]. Yet he himself is transformed by his acquaintance, in London and Paris, with Maria Gostrey, an American émigré, and by Chad's new circle of friends. Over a period of weeks, Strether recognizes that Chad has in fact "improved," gaining new sophistication, and knows that something similar has occurred to himself.

James's prose style is distinctive and not easygoing for many contemporary readers. For example, he is often cited for his tendency to write paragraph-length sentences, which all college students are taught to avoid. The protagonists in his dialogues often circle around their subject rather than state it, as if its meaning is forever just out of their reach, and the same could be said of his elongated sentences. In chapter 11, Strether accidentally meets Chad and Madame de Vionnet at a country inn and finally discovers their relationship is a romantic one (**Reading 38.7**):

READING 38.7 from Henry James, *The Ambassadors*, Chapter 11 (1903)

What he saw was exactly the right thing—a boat advancing round the bend and containing a man who held the paddles and a lady, at the stern, with a pink parasol. It was suddenly as if these figures, or something like them, had been wanted in the picture, had been wanted more or less all day and had now drifted into sight, with the slow current on purpose to fill up the measure. . . .The air quite thickened, at their approach, with further intimations; the intimation that they were expert, familiar, frequent—that this wouldn't at all events be the first time. They knew how to do it, he vaguely felt, and it made them but the more idyllic, though at the very moment of the impression, their boat seemed to have begun to drift wide, the oarsman letting it go. It had by this time none the less come much nearer—near enough for Strether to dream the lady in the stern had for some reason taken account of his being there to watch them. . . . She had taken in something as a result of which their course had wavered, and it continued to waver while they just stood off. . . . He too within the minute had taken in something, taken in that he knew the lady whose parasol, shifting as to hide her face, made so fine a pink point in the shining scene. It was too prodigious, a chance in a million, but, if he knew the lady, the gentleman, who still presented his back and kept off, the gentleman, the coatless hero of the idyll, who had responded to her start, was, to match the marvel, none other than Chad.

The manner in which James teases out the last sentence, as if holding the identity of the boatman for as long as the reader can bear it, is characteristic of James. So is the impressionistic description—the way the lady is "a pink point in the shining scene"—so that the reader feels that for all its detail, the vision remains vague. We take an impression, rather than something sharply delineated. Like Emily Dickinson, whose brevity of statement contrasts with James's drawn-out sentences, James approached the world and its people as essentially enigmatic.

Painters Abroad: The Expatriate Vision

Henry James was as socially active as a hardworking writer could be. His network of friends and acquaintances included many British and European artists, as well as dozens of American expatriates. *The Ambassadors* began from a germ of an idea that the author captured in his notebook in October 1895 when he recorded how fellow American author William Dean Howells (1837–1920), standing in a Paris

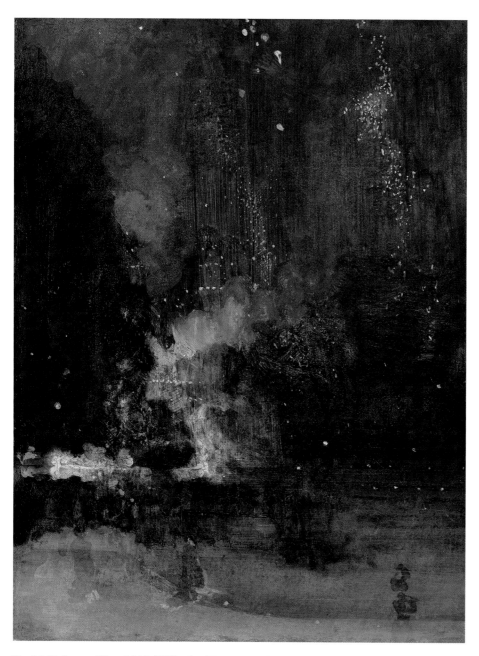

Fig. 38.10 James Abbott McNeill Whistler. *Nocturne in Black and Gold: The Falling Rocket.* **ca. 1874.** Oil on oak panel, 23⅜″ × 18⅜″. The Detroit Institute of Arts. Gift of Dexter M. Ferry, Jr. 46.309. The Bridgeman Art Library. The painting depicts fireworks falling over Cremorne Gardens, the popular resort on the banks of the Thames.

verged on high comedy, as the jury was shown the offending picture upside down, and "experts" of all persuasions testified to the painting's worth. Whistler eventually won but was awarded only a farthing (the least valuable English coin), a far cry from the cost of the legal action, which eventually drove him into bankruptcy.

The painting at the center of the controversy is a kind of radical impressionistic illustration of a seaside fireworks display, so deeply atmospheric that its subject matter is hard to fathom. Whistler was an admitted **aesthete**—someone who valued art for art's sake, for its beauty not for its content. In an 1890 collection of essays called *The Gentle Art of Making Enemies*, he explained the philosophy behind **aestheticism**:

[Art] should be independent of all clap-trap—should stand alone and appeal to the artistic sense of ear or eye, without confounding this with emotions entirely foreign to it, as devotion, pity, love, patriotism and the like. All these have no kind of concern with it, and that is why I insist on calling my works "arrangements" and "harmonies."

Whistler wanted the public to understand that the painter had a right to alter objective truth in order to conform to his or her own subjective standards of beauty. A work created in this way was not incompetent. It was, rather, of the highest order of art.

Another American painter who spent much of his life in Europe was John Singer Sargent (1856–1924). Born in Florence and trained in Italy and France, Sargent was Whistler's rival, though 22 years his junior. He took Whistler's old studio in London after Henry James convinced the young artist to leave Paris in 1886, and it was there that Sargent did most of his work. Sargent specialized in portraits of the aristocracy and the wealthy, and he was noted for his stylish, bravura brushwork. James and Sargent moved in similar social circles, becoming fast friends after James's review of the 26-year-old painter's work in *Harper's Weekly*.

In the *Harper's* article, James took special note of Sargent's *The Daughters of Edward Darley Boit*, exhibited in Paris at the Salon of 1883 (Fig. **38.11**). The painting depicts the four

garden, sermonized to a young man that he must live to the fullest while young. The Parisian home where the garden was located belonged to American expatriate painter James Abbott McNeill Whistler (1834–1903), who maintained a friendship with James for almost two decades.

The painter had notoriously sued English critic John Ruskin for libel after Ruskin published a scathing review of Whistler's *Nocturne in Black and Gold: The Falling Rocket* (Fig. **38.10**). In his review Ruskin berated the artist for asking "two hundred guineas for flinging a pot of paint in the public's face." The trial

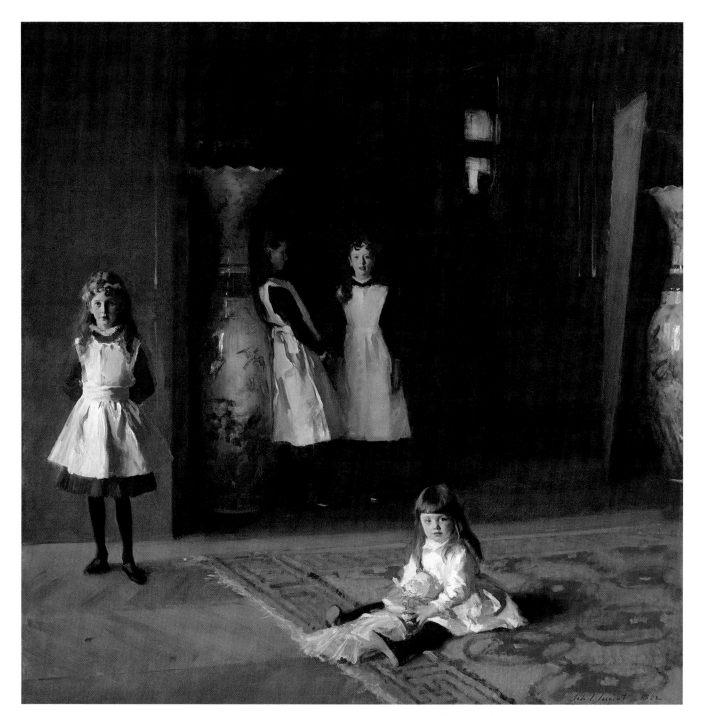

Fig. 38.11 John Singer Sargent. *The Daughters of Edward Darley Boit.* 1882. Oil on canvas, $87\frac{3}{8}''\times 87\frac{5}{8}''$. Gift of Mary Louisa Boit, Julia Overing Boit, Jane Hubbard Boit, and Florence D. Boit in memory of their father, Edward Darley Boit, 19.124 Photograph © 2008 Museum of Fine Arts, Boston. The unusual, almost square canvas is probably something of a pun on the "Boit" name since *boîte*, in French, means "box."

daughters of an expatriate patrician couple from Boston, Edwin Darley Boit and Mary Louisa Cushing Boit, in the entry to their apartment in Paris. In the foreground, Julia, the youngest child, aged four, sits on the floor with her doll between her legs. To the left, facing the viewer forthrightly, but gazing just to the viewer's left, is Mary Louisa, aged eight. In the shadows of the doorway, Jane, aged 12, looks directly at us, while Florence, the eldest, aged 14, leans, as if unwilling to cooperate with the painter, against one of two enormous Chinese vases that lend the scene something of an "Alice in Wonderland" effect.

James first described this painting as "a rich, dim, rather generalized French interior (the perspective of a hall with a shining floor, where screens and tall Japanese vases shimmer

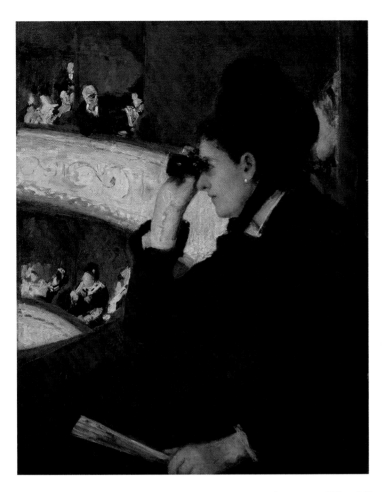

Fig. 38.12 Mary Stevenson Cassatt. *In the Loge.* 1879. Oil on canvas, 32″ × 26″. Museum of Fine Arts, Boston. The Hayden Collection - Charles Henry Hayden Fund, 10.35. Photograph © Museum of Fine Arts, Boston. This was the first of Cassatt's Impressionist paintings to be displayed in the United States. American critics thought the picture a promising sketch, but not, as the Impressionist Cassatt intended, a finished painting.

Opéra society (Fig. **38.12**). A woman respectfully dressed all in black peers through her binoculars in the direction of the stage. Across the way, a gentleman in the company of another woman leans forward to stare through his own binoculars in the direction of the woman in black. Cassatt's woman, in a bold statement, becomes as active a spectator as the male across the way. Cassatt continually explored new styles and methods of painting. She even created a series of colored lithograph prints in 1891 inspired by Japanese woodblock prints that had also influenced Degas, Renoir, van Gogh, Monet, and many other European artists (see Fig. 37.28).

Chicago and the Columbian Exposition of 1893

An influential artist in Europe and America, Mary Cassatt played an integral part in the 1893 Columbian Exposition (an early world's fair) in Chicago to which she contributed a large mural entitled *Modern Woman* for the Hall of Honor in the Woman's Building. The exposition marked the four-hundredth anniversary of the arrival of Christopher Columbus in the Americas, after Congress selected Chicago as the site for a massive exhibit that demonstrated the economic, technological, and cultural progress of the country. Chicago was a logical choice, since it had grown from a village of 250 people in 1833 to the nation's second-largest city in 60 years with a population of almost one million, most of them foreign-born. West Coast cities like San Francisco, though also growing swiftly in population, were still too rough, too much like frontier towns, to make the right impression (see *Voices*, page 1238).

Cassatt designed her mural as an allegorical triptych (three-paneled work of art). The left and right panels depicted *Young Girls Pursuing Fame* and *Arts, Music, Dancing.* She represented the allegorical figure of Fame as a flying female figure, her nudity emblematic of the necessity of abandoning conventional social constraints. Three girls chase Fame, and a gaggle of geese chase them in turn. The three self-confident and assured women at the other side of the central panel demonstrated that women are accomplished in their own right, not just the creative muses of men.

The central panel, entitled *Young Women Plucking the Fruits of Knowledge or Science,* drew the most attention. Here Cassatt offers a positive reinterpretation of the theme of Eve in the Garden of Eden, as women pass on knowledge, imaged as fruit, from one generation to the next. Although the mural does not survive, we know it from reproductions in contemporary periodicals (Fig. **38.13**). In *Gathering Fruit,* a print from the same era as the mural, Cassatt combined the primary theme of the central panel with a baby, an element from the mural's border, which was decorated with several plump infants (Fig. **38.14**).

and loom), which encloses the life and seems to form the happy play-world of a family of charming children." But gradually he perceived in this work the same mysterious depth that he tried to convey in his own fiction—"the sense," he called it, "of assimilated secrets." At least at some level, the painting is a parable of the coming of age of young women in late nineteenth-century society, from the innocence of youth to the privacy and alienation of adolescence. As in James's fiction, there is always more than meets the eye, and this is the lesson that James continually impressed upon Americans who traveled or lived abroad.

One of the most successful of the American expatriate painters was Mary Cassatt, who moved to Paris in 1874 and was befriended by one of the founders of Impressionism, Edgar Degas. Participating in the Impressionist exhibitions in 1879, 1880, and 1881, Cassatt was a figure painter, concentrating almost exclusively on women in domestic and intimate settings. Among her most famous works are paintings of women at the Paris Opéra. *In the Loge* is a witty representation of

Fig. 38.13 **Mary Stevenson Cassatt.** *Modern Woman,* **central panel, in the Hall of Honor, Woman's Building, World's Columbian Exposition, Chicago, 1893 (destroyed).** Mural, 13' × 58'. Reproduced in *Harper's New Monthly Magazine,* Vol. 86, Issue 516, May 1893, p. 837. At the opposite end of the Hall of Honor was a mural entitled *Primitive Woman,* painted by Mary Fairchild Macmonnies, an American artist who had moved to Paris in 1888 and spent each summer near Monet at Giverny.

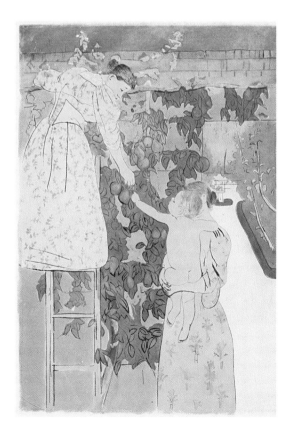

Fig. 38.14 **Mary Stevenson Cassatt.** *Gathering Fruit.* ca. 1893.
Drypoint, softground etching, and aquatint printed in color from three plates, 16⅞″ × 15⅜″. Gift of William Emerson and The Hayden Collection— Charles Henry Hayden Fund, 41.813. Photograph © 2008 Museum of Fine Arts, Boston. This is one of several prints by Cassatt related to the theme of the Hall of Honor mural.

Cassatt's murals coincided with the early development of the women's movement in America and Europe. The 1878 International Congress of Women's Rights, held in Paris, advocated for free and compulsory education for women through secondary school, a measure that the French in fact implemented in the 1880s. The meeting also focused on the important role women play in nurturing and educating their children—the theme, indeed, of Cassatt's central panel at the Chicago Exposition and one that she would paint continuously in her domestic scenes of mothers tending their children.

As plans for the Columbian Exposition were being made, the all-male World's Columbian Commission appointed a "Board of Lady Managers," headed by a Chicago socialite, to design a building where women could meet at the fair. When it became apparent that women would have difficulty exhibiting elsewhere, the project was transformed into the pavilion where Cassatt's painting and other women's artwork was displayed. Designed by the first female graduate of the Massachusetts Institute of Technology to earn a degree in architecture,

Voices

Saturday Night in San Francisco

In the 1860s and 1870s, California and its largest city, San Francisco, were growing, spurred by new discoveries of silver and gold, the building of the transcontinental railroad, and the expansion of such profitable and long-lasting businesses as Wells Fargo, Levi Strauss, and others. Albert S. Evans, a visitor from New Hampshire, provides an atmospheric tour of the Barbary Coast (nowadays covering parts of Chinatown, North Beach, and the Financial district) on an evening in 1871:

It is Saturday evening, in the middle of the rainy season, when no work is doing upon the ranches, and work in the placer mines is necessarily suspended, and the town fairly swarms with "honest miners" and unemployed farmhands, who have come down from the mountains and "the cow counties" to spend their money, and waste their time and health in "doing" or "seeing life" in San Francisco. The Barbary Coast is now alive with "jay-hawkers" [thieves], "short-card sharps," "rounders," pickpockets, prostitutes and their assistants and victims; we cannot find a better night on which to pay a visit to the locality. Half a dozen of us, more or less, make up the party, and we start out. The evening is pleasant, and Montgomery and Kearny streets are filled with the beauty, fashion, and wealth of San Francisco. A military company, in brilliant uniform, with a full and very superior band, returning from a target excursion, pass up the street, attracting the attention of the throng for a moment; and then come, in turn, a party of horsemen and horsewomen, gaily mounted, coming in from the Cliff House at Point Lobos, or just starting out for a night-ride, who dash down the street at a gallop, are glanced at, criticised, and forgotten.

> **"The Barbary Coast is now alive with 'jay-hawkers' [thieves] , short-card sharps,' 'rounders,' pickpockets, prostitutes and their assistants and victims. . ."**

Three men come up the street as we stand on the sidewalk looking and listening, and two of them eye our friend the policeman uneasily as they pass. These two are unmistakably of the Algerine pirate class, and the third evidently a middle-aged greenhorn from the mining country. The officer comprehends the situation at a glance, and stepping forward, says emphatically, "Look here, Jack; I told you once before to get out of the jayhawking [thieving] business, and not let me catch you on the Coast again. And you, Cockeye; when did you come back from over the Bay? I'll bag you both, as sure as I'm a living man, if I catch either of you on my beat again. . . ." The young fellows slink away without a word, like renegade curs caught in the act of killing sheep, and the officer addresses himself to their intended victim. "Look here, old fellow; those fellows picked you up at the wharf, or around the What Cheer, and pretended they used to know you at home. They are two State Prison thieves, and would have robbed you before daylight, sure. Now, you go back to your hotel, put your money in the safe, and go to bed, or I'll lock you up for a drunk; do you hear?" The countryman stares a moment with blank astonishment, and then, with many thanks, tells the officer just what the latter had already told him, and leaves the Barbary Coast in all haste.

Sophia Hayden (1868–1953), the two-story Women's Building was of Neoclassical design, with a central arcade flanked by pavilions at each end and a two-story pediment over the main entrance (Fig. **38.15**). Hayden, sadly, would never design another building. Constant interference by the all-male Board of Architects, a meager budget, and confused guidance led to a nervous breakdown and Hayden's withdrawal from her profession.

The fair was situated on 700 acres of swampland at the edge of Lake Michigan planned to resemble a Venetian park, complete with waterways and gondolas. Like all of the other buildings, the Woman's Building was steel-framed, with its plaster-of-Paris facade painted white, an effect that lent the fairgrounds their nickname—the White City. It was a white city in more ways than one. Although African Americans tried mightily to be represented at the fair, actively seeking membership on the planning committees and employment at its venues, they were systematically

excluded from participation. They could attend the fair only on select days, even though on the mile-long Midway Plaisance [play-ZAHNSS] the fair's official Department of Ethnology created simulated African, Laplander, Turkish, Chinese, Pacific Island, and Japanese villages. Men from Dahomey [dah-HOH-may] populated the African village, brought to the fair by an eccentric French entrepreneur. Other indigenous peoples from America, Asia, and North Africa were also included in this "outdoor museum" of "primitive peoples." (Such ethnographic exhibits were already standard at European world fairs.) Frederick Douglass, appalled by the fair's segregationist admission policies, its indifference to African American job-seekers, and its representation of "the Negro as a repulsive savage," joined Ida B. Wells in writing a scathing review of the exposition, "The Reason Why the Colored American Is Not in the World's Columbian Exposition."

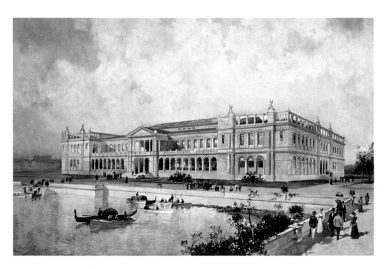

Fig. 38.15 Charles Graham. *Sophia Hayden's Woman's Building,* **World's Columbian Exposition, Chicago. 1893.** Watercolor, 17″ × 27½″. The Granger Collection, New York. Graham included a gondola in the lake to express the fair's Venetian theme.

Louis Sullivan and the Chicago School of Architecture

One of the main reasons Chicago was so attractive as a venue for the Columbian Exposition was the sheer volume and impressiveness of its original, contemporary architecture. Ironically, the origin of the city's vast expanse of modern buildings was due to a catastrophic accident. On Sunday evening, October 8, 1871, a fire began in the cow barn at the rear of the Patrick O'Leary cottage on Chicago's West Side. By midnight the city's business district was in flames. By Monday evening, as rains helped to douse the blaze, 300 residents of Chicago were dead, 90,000 homeless, and the property loss was estimated at $200 million. The entire central business district of Chicago was leveled.

While devastating, the fire also contributed substantially to Chicago's economic boom as the city raced to rebuild. This provided an extraordinary opportunity for architectural innovation. Four factors contributed to what became known as the Chicago School of architecture. First, there was an urgent need to rebuild with fireproof materials. Second, Chicago was a world leader in the manufacture and production of steel. Third, the hydraulic elevator was invented the same year as the fire. And fourth, there was a growing conviction that because land in the downtown district was so expensive, buildings should be built higher.

Until the 1880s, the height of buildings was restricted to 10 stories because of the structural limitations of masonry-bearing walls, even with cast iron built into them. The solution was metal-frame construction, first developed for building bridges in

England (see Fig. 28.9). The frame supported the entire load of the building, with the **curtain wall** (a non-load-bearing wall applied to keep out the weather) carried on the structural skeleton. In Chicago, where the bearing capacity on soil at the edge of Lake Michigan was extremely poor and could not support the weight of a brick building over 10 stories high, the lightness of iron and then steel-frame construction became a driving force in rebuilding the downtown after the great fire of 1871.

Continuity & Change
p. 912

Iron Bridge

Iron- and steel-frame construction also opened the curtain wall to ornamentation and large numbers of exterior windows. One of the leading proponents of this new method of design and construction was the Chicago architect Louis H. Sullivan (1856–1924). For Sullivan, the building's identity lay in its ornamentation. As he put it in his satirically titled 1901–1902 *Kindergarten Chats,* ornamentation was the "spirit" that enhanced the architectural idea. Inorganic, rigid, and geometric lines of the steel frame would flow through the ornamental detail that covered it into "graceful curves," and angularities would "disappear in a mystical blending of surface." So at the top of Sullivan's Bayard Building in New York, the vertical columns that rise between the windows blossom in an explosion of floral decoration (Fig. **38.16**).

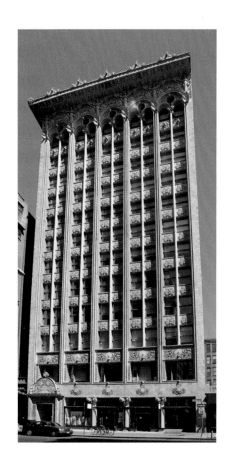

Fig. 38.16 Louis H. Sullivan. Bayard (Condict) Building, New York. 1897–1898. For Sullivan, the foremost problem that the modern architect had to address was how the building might transcend the "sinister" urban conditions out of which, of necessity, it had to rise.

Such ornamentation might seem to contradict the aphorism that Sullivan is most famous for: "Form follows function." If the function of the urban building is to provide a well-lighted and ventilated place in which to work, then the steel-frame structure and the abundance of windows on the building's facade make sense. But how does the ornamentation follow from the structure's function?

Down through the twentieth century, Sullivan's original meaning has largely been forgotten. He was not promoting a notion of design akin to the sense of practical utility found in the first mass-produced automobile, the Model T Ford. For

Sullivan, "the function of all functions is the Infinite Creative Spirit," and it could be revealed in the rhythm of growth and decay that we find in nature. Thus the elaborate organic forms that cover his buildings were intended to evoke nature and the creative impulse. For Sullivan, the primary function of a building was to elevate the spirit of those who worked in it. No architect would have a greater influence on modern architecture in the twentieth century. He is at once the father of the skyscraper, and, perhaps most important, the teacher of one of the twentieth century's most influential architects, Frank Lloyd Wright.

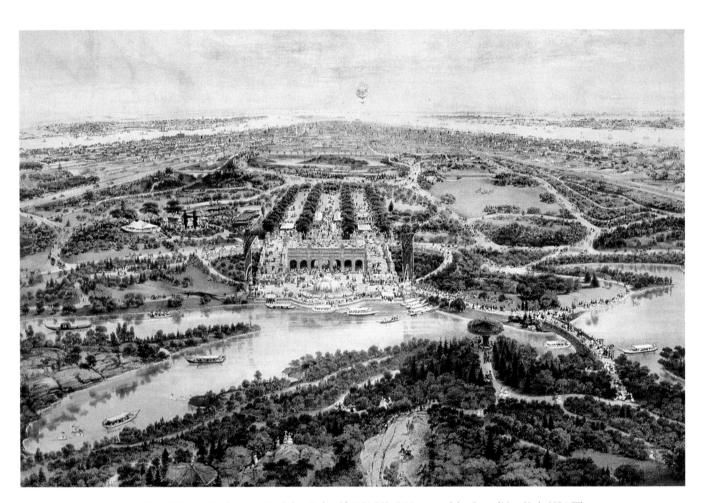

Fig. 38.17 John Bachman. *View of Central Park.* ca. 1870. Colour Litho. (fl.1850-77). © Museum of the City of New York, USA/The Bridgeman Art Library. Frederick Law Olmsted and Calvert Vaux designed the park, and construction began in 1857. For Olmsted, the park was an educational environment in which poor immigrants could mingle freely with the upper classes and learn how to properly "comport" themselves.

Frederick Law Olmsted and the Invention of Suburbia

Sullivan's buildings reflect the same motivation that inspired the parks movement inaugurated by Central Park in New York City and other parks throughout the country—the desire to bring the spirit of nature to the urban environment. In order to allow the rapidly growing population to escape the rush of urban life, New York City in 1856 acquired an 840-acre tract of land for a park in the still largely undeveloped regions north of 59th Street. It hired Frederick Law Olmsted [OLM-sted] (1822–1903) and Calvert Vaux [voh] (1824–1895) to effect the transformation (Fig. **38.17**). The two men modeled what is now known as Central Park on the English garden (see chapter 29) with, in Olmsted's words, "gracefully curved lines, generous spaces, and the absence of sharp corners, the idea being to suggest and imply leisure, contemplativeness, and happy tranquility." Here, immigrants from the hundreds of blocks of tenement housing in Manhattan could stroll side by side with the wealthy ladies and gentlemen whose homes lined Fifth Avenue facing the park. Sheep grazed in one area of the park, and in another, the Dairy, children could sip milk fresh from the cows that grazed nearby. In this artificial rural environment city dwellers could forget that they were even *in* the city.

So successful was Central Park that, in 1866, Olmsted and Vaux collaborated on the design of Prospect Park, across the East River, in Brooklyn (see Fig. 38.6). And after Vaux's dissolution of their partnership in 1872, Olmsted went on to design many other public commons, including South Park in Chicago, the parkway system of the City of Boston, Mont Royal in Montreal, and the grounds at Stanford University and the University of California at Berkeley. Moreover, Olmsted was able to foresee that the increasing population density of cities required the growth of suburbs, a residential community within commuting distance of the city. "When not engaged in business," Olmsted wrote, "[the worker] has no occasion to be near his working place, but demands arrangements of a wholly different character. Families require to settle in certain localities which minister to their social

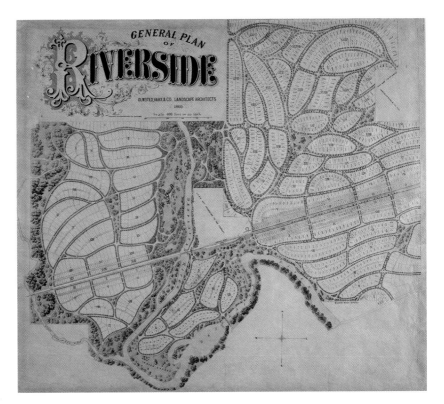

Fig. 38.18 Olmsted, Vaux, & Co., landscape architects. General plan of Riverside, Illinois. 1869. Francis Loeb Library, Graduate School of Design, Harvard University. In the Preliminary Report for Riverside, Olmsted remarks, "The city [of Chicago] as yet has no true suburb in which rural and urban advantages are agreeably combined."

and other wants, and yet are not willing to accept the conditions of town-life . . . but demand as much of the luxuries of free air, space and abundant vegetation as . . . they can be enabled to secure."

As early as 1869, Olmsted and Vaux laid out a general plan for the city of Riverside, Illinois, situated nine miles outside Chicago and one of the city's first suburbs (Fig. **38.18**). The plan incorporated the railroad as the principal form of transportation into the city, making it one of the very first commuter suburbs in America. The plan provided for the best-engineered streets of the time, with cobblestone gutters for proper drainage, sewers, water lines, gas lines, and gas street lamps. Olmsted strove to create a communal spirit by subdividing the site into small "village" areas linked by drives and walks, all intended to have "the character of informal village greens, commons and playgrounds." Together with Forest Hills in New York, Llewellyn Park in New Jersey, and Lake Forest, also outside Chicago, Olmsted's design for Riverside set the standard for suburban development along with a new pattern of living for Americans.

READINGS

READING 38.2

from Walt Whitman, "Song of Myself," in *Leaves of Grass* (1867)

From the time of its first edition in 1855, Leaves of Grass *constantly changed over the course of Whitman's lifetime. Its many revisions and additions reflect the changing course of American democracy, including the tragedy of the Civil War, the expansion of the nation into the West, and the industrialization of the eastern seaboard. At the center of the book is Whitman's "Song of Myself." It consists of 52 parts, reflecting the 52 weeks of the year. In the following passages, something of the range of Whitman's vision can be understood: his individualism in part 1, his sexuality in part 2, the development of his central metaphor, the grass, in part 6, and his all-encompassing inclusiveness in part 15.*

1

I CELEBRATE myself, and sing myself,
And what I assume you shall assume,
For every atom belonging to me as good belongs to you.

I loafe and invite my soul,
I lean and loafe at my ease observing a spear of summer grass.

My tongue, every atom of my blood, form'd from this soil, this air,
Born here of parents born here from parents the same, and their parents the same,
I, now thirty-seven years old in perfect health begin, 10
Hoping to cease not till death.

Creeds and schools in abeyance,
Retiring back a while sufficed at what they are, but never forgotten,
I harbor for good or bad, I permit to speak at every hazard,
Nature without check with original energy.

2

Houses and rooms are full of perfumes, the shelves are crowded with perfumes,
I breathe the fragrance myself and know it and like it,
The distillation would intoxicate me also, but I shall not let it. 20

The atmosphere is not a perfume, it has no taste of the distillation, it is odorless,
It is for my mouth forever, I am in love with it,
I will go to the bank by the wood and become undisguised and naked,
I am mad for it to be in contact with me. . . .

6

A child said *What is the grass?* fetching it to me with full hands,
How could I answer the child? I do not know what it is any more than he. 30

I guess it must be the flag of my disposition, out of hopeful green stuff woven.

Or I guess it is the handkerchief of the Lord,
A scented gift and remembrancer designedly dropt,
Bearing the owner's name someway in the corners, that we may see and remark, and say *Whose?*

Or I guess the grass is itself a child, the produced babe of the vegetation.

Or I guess it is a uniform hieroglyphic,
And it means, Sprouting alike in broad zones and narrow zones, 40
Growing among black folks as among white,
Kanuck, Tuckahoe, Congressman, Cuff, I give them the same, I receive them the same.

And now it seems to me the beautiful uncut hair of graves. . . .
All goes onward and outward, nothing collapses,
And to die is different from what any one supposed, and luckier. . . .

15

The pure contralto sings in the organ loft,
The carpenter dresses his plank, the tongue of his foreplane 50
whistles its wild ascending lisp,
The married and unmarried children ride home to their Thanksgiving dinner,
The pilot seizes the king-pin, he heaves down with a strong arm,
The mate stands braced in the whale-boat, lance and harpoon are ready,

The duck-shooter walks by silent and cautious stretches,
The deacons are ordain'd with cross'd hands at the altar,
The spinning-girl retreats and advances to the hum of the 60
big wheel,
The farmer stops by the bars as he walks on a First-day loafe and looks at the oats and rye,

The lunatic is carried at last to the asylum a confirm'd case,
(He will never sleep any more as he did in the cot in his
mother's bedroom;)
The jour printer with gray head and gaunt jaws works at his
case,
He turns his quid of tobacco while his eyes blurr with the
manuscript; 70
The malform'd limbs are tied to the surgeon's table,
What is removed drops horribly in a pail;
The quadroon girl is sold at the auction-stand, the drunkard
nods by the bar-room stove,
The machinist rolls up his sleeves, the policeman travels his
beat, the gate-keeper marks who pass,
The young fellow drives the express-wagon, (I love him,
though I do not know him;)
The half-breed straps on his light boots to compete in the race,
The western turkey-shooting draws old and young, some 80
lean on their rifles, some sit on logs,
Out from the crowd steps the marksman, takes his position,
levels his piece;
The groups of newly-come immigrants cover the wharf or levee,
As the woolly-pates hoe in the sugar-field, the overseer
views them from his saddle,

The bugle calls in the ball-room, the gentlemen run for their
partners, the dancers bow to each other,
The youth lies awake in the cedar-roof'd garret and harks to
the musical rain, 90
The Wolverine sets traps on the creek that helps fill the Huron,
The squaw wrapt in her yellow-hemm'd cloth is offering
moccasins and bead-bags for sale,
The connoisseur peers along the exhibition-gallery with
half-shut eyes bent sideways. . . .

The city sleeps and the country sleeps,
The living sleep for their time, the dead sleep for their time,
The old husband sleeps by his wife and the young husband
sleeps by his wife;
And these tend inward to me, and I tend outward to them, 100
And such as it is to be of these more or less I am,
And of these one and all I weave the song of myself. ■

Reading Question

In the selection from part 6, Whitman refers to the grass as
"the flag of my disposition, out of hopeful green stuff woven."
How does part 15 develop that sentiment?

READING 38.5

from Emily Dickinson, *Poems* (as published in *The Complete Poems of Emily Dickinson*, ed. T. H. Johnson, 1953)

Dickinson wrote almost 2,000 poems in her lifetime. It was not until 1953 that all of her known poems were published—and for the first time as she wrote them, without editorial changes. The following three poems circulate around the theme of death, that greatest of all enigmas. Even in so small a selection they give a fair idea of the scope of her mind.

465

I heard a Fly buzz—when I died—
The Stillness in the Room
Was like the Stillness in the Air—
Between the Heaves of Storm—

The Eyes around—had wrung them dry—
And Breaths were gathering firm
For that last Onset—when the King
Be witnessed—in the Room—

I willed my Keepsakes—Signed away
What portion of me be 10
Assignable—and then it was
There interposed a Fly—

With Blue—uncertain stumbling Buzz—
Between the light—and me—

And then the Windows failed—and then
I could not see to see—

712

Because I could not stop for Death—
He kindly stopped for me—
The Carriage held but just Ourselves—
And Immortality. 20

We slowly drove—He knew no haste
And I had put away
My labor and my leisure too,
For His Civility—

We passed the School, where Children strove
At Recess—in the Ring—
We passed the Fields of Gazing Grain—
We passed the Setting Sun—

Or rather—He passed Us—
The Dews drew quivering and chill— 30
For only Gossamer, my Gown—
My Tippet—only Tulle—

We paused before a House that seemed
A Swelling of the Ground—
The Roof was scarcely visible—
The Cornice—in the Ground—

Since then—'tis Centuries—and yet
Feels shorter than the Day
I first surmised the Horses' Heads
Were toward Eternity – 40

754

My Life had stood—a Loaded Gun—
In Corners—till a Day
The Owner passed—identified—
And carried Me away—

And now We roam in Sovereign Woods—
And now We hunt the Doe—
And every time I speak for Him—
The Mountains straight reply—

And do I smile, such cordial light
Upon the Valley glow— 50
It is as a Vesuvian face
Had let its pleasure through—

And when at Night—Our good Day done—
I guard My Master's Head—
'Tis better than the Eider-Duck's
Deep Pillow—to have shared—

To foe of His—I'm deadly foe—
None stir the second time—
On whom I lay a Yellow Eye—
Or an emphatic Thumb— 60

Though I than He—may longer live
He longer must—than I—
For I have but the power to kill,
Without—the power to die— ■

Reading Question

**One of Dickinson's preferred thematic forms was the riddle.
How do these three poems reflect that preference?**

Summary

■ **Walt Whitman's America** As New York City grew to over 3 million people in the last decades of the nineteenth century, poet Walt Whitman celebrated the city's as well as the nation's sense of energy, excitement, and unlimited possibility. As his often-updated volume *Leaves of Grass* grew in the decades between 1855 and 1892, Whitman continued to embrace all aspects of the Gilded Age in his country, both good and bad. The quintessential New Yorker, he fully recognized the corruption that characterized New York's Tammany Hall and the plight of the working class, which in 1877 erupted in a series of strikes across the country, precipitated by economic depression and wage cutbacks.

Women of the era continued to be disenfranchised, but they did make gains, as state-run schools trained women as teachers and nurses. In the last decades of the century, women became one of the favorite subjects of male American painters, who generally represented them as passive and removed from the real business of American culture. Women often made significant individual contributions to the culture, in the arts as well as in the fledgling women's rights movement. Emily Dickinson's poetry, although little known in her lifetime, was widely read and admired by century's end. But whenever women challenged their traditional place in American society, as Kate Chopin did in her novel exploring a woman's marital infidelity, *The Awakening*, they were harshly criticized.

■ **Ragtime and the Beginnings of Jazz** New Orleans by the end of the century was one of the nation's most cosmopolitan cities. In the city's bars and dance halls, at its political rallies, weddings, and funerals, a new kind of music developed that has come to be known as jazz. Characterized by a steady rhythm that plays off against a rhythmic syncopation, its first manifestation was in the ragtime piano music popularized by Scott Joplin. In the minds of many Americans, the loose rhythms of ragtime were equated with loose morals, but ragtime—and later jazz—represented a new, authentic form of American expression.

■ **The American Abroad** Many Americans, seeking to escape the perceived hypocrisy and limitations of the Gilded Age, traveled to Europe for lengthy sojourns. The novelist Henry James was the most famous of these, and his novels detail the experiences of Americans abroad. He was friendly with many expatriate painters, including James McNeill Whistler and John Singer Sargent. Whistler valued art for art's sake, for its beauty, not its content. Sargent specialized in portraiture, but he often found ways to lend his subjects a mysterious quality that hinted at similar uncertainties in the works of Henry James. Another important expatriate painter of the day was Mary Cassatt, who exhibited with the Impressionists in Paris. Specializing in domestic scenes and Parisian society, Cassatt grew as an artist throughout her long and productive career.

■ **Chicago and the Columbian Exposition of 1893** Cassatt advocated that women take an equal place in modern society alongside men. In 1892 she created a large mural entitled *Modern Woman* for the Woman's Building at the Columbian Exposition in Chicago. Its central panel depicted *Young Women Plucking the Fruit of Knowledge or Science*, and it spoke to Cassatt's dedication to women's education and advancement. Sophia Hayden, the first female graduate of the Massachusetts Institute of Technology to earn a degree in architecture, designed The Woman's Building.

Part of what attracted the fair's organizers to Chicago was its advanced architecture, represented particularly in the skyscrapers of Louis Sullivan. Sullivan used metal-frame construction to create structural skeletons that could be faced with light curtain walls, thus opening the facade of the building to ornamentation. Sullivan's love of ornamentation, in which he believed rested the true "spirit" of architecture, was reflected in the parks movement inaugurated by Frederick Law Olmsted and Calvert Vaux in New York's Central Park, begun in 1857. Olmsted and Vaux also designed Riverside, Illinois, one of the very first commuter suburbs in the nation, creating a parklike city with "informal village greens, commons and playgrounds."

 # Glossary

aesthete One who values art for art's sake, for its beauty rather than its content.

aestheticism A devotion to beauty in art.

curtain wall A non-load-bearing wall applied in front of a framed structure, often for decorative effect.

free-verse Poetry based on irregular rhythmic patterns as opposed to conventional meter.

jazz A uniquely American form of music characterized by a steady rhythm that plays itself off against a rhythmic accentuation of the "off-beats."

ragtime A type of music in which the musician takes a classical or popular melody and plays it in a syncopated way; see syncopation.

syncopation The accentuation of "off-beats."

Critical Thinking Questions

1. What characteristics make jazz a uniquely American type of music?

2. How do the contrasting styles and content of Whitman's and Dickinson's verse define the American culture of their era?

3. Based on their life and works, why do you think Henry James, James McNeill Whistler, Mary Cassatt, and John Singer Sargent chose to be expatriates?

4. Summarize the ideal of America as exhibited at the Columbian Exposition. Do the buildings of Sullivan and the parks of Olmstead help to express this ideal?

The "Frontier Thesis" of Frederick Jackson Turner

Continuity & Change

Coinciding with the Columbian Exposition of 1893 was the American Historical Association's yearly convention, where Frederick Jackson Turner (1861–1932) presented one of the most influential essays on the American West ever written. Entitled "The Significance of the Frontier in American History," Turner argued that the frontier was "the meeting point between savagery and civilization." He further contended that "the existence of an area of free land, its continuous recession, and the advance of American settlement westward explain American development." Twenty years earlier, painter John Gast had essentially illustrated this argument in his widely popular painting *American Progress* (Fig. **38.19**). As trains, a covered wagon, a stagecoach, riders, miners, trappers, and farmers push westward driving bear, buffalo, and Indians before them, the frontiersmen are inspired by the allegorical figure of Progress. So when, in 1890, the U.S. Census Bureau proclaimed the frontier closed, Turner understood that a defining era in American history had passed. The frontier, according to Turner, had produced a "dominant individualism," men "of coarseness and strength . . . acuteness and inquisitiveness, [of a] practical and inventive turn of mind . . . [with] restless and nervous energy . . . [and the] buoyancy and exuberance which comes with freedom." From the beginning, he continued, this "frontier individualism . . . promoted democracy." Yet he also warned that

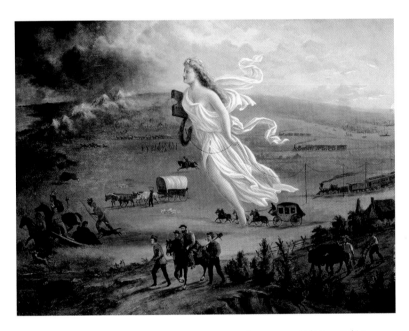

Fig. 38.19 John Gast. *American Progress*. 1872. Oil on canvas, 20¼″ × 30¼″. (fl.1872). Private Collection. Photo © Christie's Images/The Bridgeman Art Library. The allegorical figure of Progress unravels telegraph wire as Indians and buffalo flee before her. At the right is Manhattan Island, the twin towers of the Brooklyn Bridge just visible over the East River. Construction on the suspension bridge, designed by engineer John Augustus Roebling, had begun in 1869 but would not be completed until 1883.

the democracy born of free land, strong in selfishness and individualism, intolerant of administrative experience

and education, and pressing individual liberty beyond its proper bounds, has its dangers as well as its benefits. Individualism in America has allowed a laxity in regard to governmental affairs which has rendered possible the spoils system and all the manifest evils that follow from the lack of highly developed civic spirit. In this connection may be noted also the influence of frontier conditions in permitting lax business honor, inflated paper currency and wildcat banking. . . . He would be a rash prophet who should assert that the expansive character of American life has now entirely ceased . . . [but] now, four centuries from the discovery of America, at the end of a hundred years of life under the Constitution, the frontier has gone, and with its going has closed the first period of American history.

Turner ignored the important role women played in settling the West, the role of slave labor in creating a productive economy, and perhaps most of all, the price Native Americans paid for the "free" land that Americans claimed as their own. Nevertheless, even as Buffalo Bill was performing his "Wild West Show" to tens of thousands of people just outside the Columbian Exposition's gates, Turner had articulated the seminal American myth. True or false, his "frontier thesis" affirmed the role that most people thought individualism would have to play if the nation were to continue to progress forward and meet the challenges of its increasing global presence. ■

39 Global Confrontations

The Challenge to Cultural Identity

The Native American in Myth and Reality

The British in China and India

The Opening of Japan

Africa and Empire

" *. . . we will, imitating the clemency of Heaven, Who tolerates all sorts of fools on this globe, condescend to allow a limited amount of trading through the port of Canton.* "

Chinese emperor Ch'ien-lung in a letter to
King George III of England

← Fig. 39.1 George Catlin. *Big Bend on the Missouri River, 1,900 Miles above St. Louis,* detail. 1832. Oil on canvas, 29″ × 24″. Smithsonian American Art Museum, Washington, DC / Art Resource, NY. 1985.66.390. The Big Bend is some 30 miles southeast of present-day Pierre, South Dakota. Catlin was one of the first artists to capture the vast expanses of the Louisiana Purchase and to document the peoples of the region, whose way of life, he very well understood, was doomed by the advance of a civilization he himself represented.

BEFORE THOMAS JEFFERSON PURCHASED THE LOUISIANA Territory from the French in 1803, it would not have occurred to the Native Americans who inhabited the region (see Map **39.1**) that it was either France's to sell or Jefferson's to buy. This massive expanse of land extending from Canada to the Gulf

of Mexico and from the Mississippi River to the Rocky Mountains cost Jefferson a mere $15 million, or about four cents an acre. The nation's third president had effectively doubled the size of the United States of America and greatly accelerated the opening of the Western frontier, which now extended to the Pacific coast. In setting the stage for the ensuing century of expansion, Jefferson was only dimly aware of the hundreds of Native American tribes that would be obliterated or forever changed as European-American settlers moved westward, staking their claim on the "empty" land (Fig. **39.1**).

The true extent of the devastation of Native American cultures was little understood at the time because invisible microbes that spread infectious diseases for which indigenous peoples had no immunity caused much of the damage. So too, the brutal nineteenth-century policy of "Indian Removal," the subsequent Indian Wars, and attempts to "civilize" Native Americans stemmed from the lack of awareness by Americans like Jefferson and his successors of the ancient

preliterate cultures of indigenous Americans. Yet much of America's nineteenth-century westward growth was driven by the desire for land and the determination to prevail over any obstructions posed by indigenous peoples, whether through legal means (agreements and treaties) or extralegal methods (ignoring those same treaties and agreements). And so the North American conflicts between Natives and Europeans echoed the global encounters between Western and non-Western cultures in the nineteenth century in which the West's aggressive military and economic policies combined with unintended consequences to produce momentous historical changes.

Revitalized by effective new military, communication, and naval technologies, Western nations sought to expand their influence and reap new economic and political power in far-distant lands during the nineteenth century. This chapter will explore the confrontation of Western civilization with the cultures of others whose values were often dramatically opposed to those of Western cultures. It suggests that by the dawn of the twentieth century the tradition and sense of centeredness that had defined indigenous cultures for hundreds, even thousands, of years was either threatened or in the process of being destroyed. Worldwide, non-Western cultures faced fundamental challenges to their cultural identities—not so much a *recentering* of culture but a *decentering* of culture.

In China, what had been the world's richest economy was increasingly dependent on manufacturing goods for export to Western countries, and a war instigated by England further damaged the economy. Soon large numbers of poor Chinese accepted the prospect of long periods of indentured servitude in both the United States and the Caribbean in order to survive. India's manufacturing economy had also been overwhelmed by British exploitation of its resources, coupled with an increased emphasis on low-cost exports that offered little profit. As with its Chinese neighbor, millions of people from the Indian subcontinent accepted indentured servitude in foreign lands. Japan, which had been closed to trade with the West and to almost all international contact since the 1630s, was forced to open its ports in 1854 when the U.S. Navy threatened military action. Japan subsequently underwent a rapid process of industrialization, even as it found ways to protect its cultural traditions. While the Japanese enthusiastically engaged in "Westernization," fasci-

Map 39.1 Major Native American tribes of the West.

nated by the technological progress and artistic accomplishments of Europe and America, Westerners were similarly captivated by Japan's ancient cultural traditions, from woodblock prints to silk fans.

In Africa, European countries vied with one another for control of the continent, motivated by both a sense of their own superiority to African peoples and competition for the region's vast natural resources. Large numbers of Africans worked in the diamond mines of South Africa as well as the copper mines and rubber plantations of Central Africa where European overseers exploited them. The slave trade, which had shipped around 20 million Africans to the Americas against their will, declined in the nineteenth century after more than 300 years of intensive activity. At the same time, Westerners began to penetrate into the African interior, developing trading posts and eventually colonies after the initial phases of exploration. By the beginning of the twentieth century, Westerners also began to remove large quantities of art and artifacts—Africa's cultural heritage—to museums and private collections around the world. It is not inaccurate to say that the African diaspora—the dispersion of its people and its culture across the globe—was an involuntary one prior to the twentieth century.

The Native American in Myth and Reality

The first consistent interactions between Native peoples and Europeans in North America occurred during the seventeenth century and were confined mostly to the eastern part of the continent. In the aftermath of the Revolutionary War and the Louisiana Purchase the movement westward accelerated, first into the Ohio Valley, then the Midwest and South Central regions (Indiana, Illinois, Kentucky), and last, the Great Plains, Rocky Mountain, and Pacific regions. Images such as *The Rocky Mountains, Lander's Peak* (Fig. **39.2**) by Albert Bierstadt [BEER-shtaht] (1830–1902) reinforced in the national consciousness the wisdom of Jefferson's purchase. First exhibited in New York in April 1864 at a public fair, the painting's display was accompanied by performances by Native Americans, who danced and demonstrated their sporting activities in front of it. However, the scenes depicted by the painting were almost entirely fictional. Although commonly believed at the time to be a representation of Lander's Peak in the Wind River Range, the mountain rising in the center of the painting does not bear even a vague resemblance to any Rocky Mountain, let alone

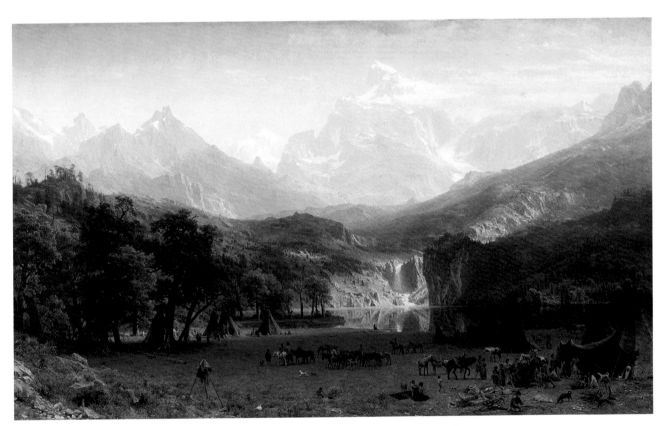

Fig. 39.2 Albert Bierstadt. *The Rocky Mountains, Lander's Peak*. 1863. Oil on panel, 73 ½″ × 120 ¾″. The Metropolitan Museum of Art, Rogers Fund, 1907 (07.123). Image copyright © The Metropolitan Museum of Art. This painting established a visual rhetoric that Bierstadt applied in painting after painting—the bucolic foreground with a clear lake at the base of a waterfall that drops from the heights of the mountains beyond. It presented a myth of landscape and of the Native American presence within it. In China, India, Japan, and Africa, cultural confrontation with the West in the nineteenth century was not nearly so peaceful.

 Voices

A Choctaw Festival

English merchant Adam Hodgson traveled throughout the United States and Canada from 1819 to 1821, providing a rich chronicle of people and landscapes. He offers an interesting perspective on the lives of indigenous Americans in the Eastern, Southern, and Midwestern states when they still maintained viable cultural traditions. He encountered the Choctaw tribe in northern Mississippi and visited for several days, describing an Indian festival.

About sunset we arrived at Smallwood's . . . in order to see a grand Indian dance and ball play, which was to take place in the neighbourhood. . . . On joining them [the Choctaw] . . . in an open space which they had partially cleared in the middle of the wood, we found them lying or sitting round fifteen or twenty fires, the ball poles erected at the distance of 200 yards from each other, serving, in some degree, as two common centres for the rival parties and their friends. There appeared to be altogether about 200.

The men were elegantly dressed in cotton dresses of white, or red, or blue, with belts, handsomely embroidered, and moccasins of brown deer skin. Several of them had circular plates of silver, or silver crescents, hanging from their necks, while others had the same round their arms, and others silver pendants attached to the cartilage of the nose. Some of them had cotton turbans, with white feathers in front, and others black plumes nodding behind. The women, too, were in their gala dress; and we had now, for the first time, the satisfaction of seeing them elevated to their proper rank, the companions, and not the abject slaves, of their husbands. . . . Gowns of printed calico formed the common dress, and some had, in addition, a loose red cloak, which they folded round them with an elegant negligence, which would have done no discredit to a duchess. Their long black hair, tied up behind, shone as brightly as if it had had the advantage of the highly vaunted Macassar Oil. They were, however, overloaded with necklaces and silver ornaments . . .

"the game . . . extremely resembles cricket. . . ."

Soon after our arrival, a tall Indian . . . went round to the different fires, making a singular noise, to induce the dancers to take their places; . . . At last, six women approached the ball poles, standing opposite each other three and three; and then about forty men of the same side gathered into a little crowd, at a short distance. A small drum, made of a deer skin, stretched upon a gourd, then beat, the women gradually mingling their voices with its sound, and dancing slowly in the same place, with eyes fixed upon the ground. In a minute or two, the men set up a hideous yell, brandished their ball sticks in the air, and ran with vehemence to a fire about forty paces distant, when they repeated their shrieks and vociferations, and then ran with impetuosity to their former places. This was repeated, with little intervals . . . till after midnight; the same thing going on in the other party, at the opposite ball poles. . . .

I forgot to say, that the men stripped, previous to the dance, retaining only their girdle, and a long white tail, like that of a wild colt, which gave them a most whimsical and savage appearance . . .

I was informed . . . that the dance, which always takes place on the eve of a celebrated ball play, is significant of the great feats they intend to perform the next day; and that the song of the women, which rather resembles a funeral dirge, is an encouragement to the men to dance, being literally, "Come to the dance—come follow the dance" . . . About eight o'clock [the next day], they all assembled in the ball-ground; the men again stripped. . . . The rival parties then met half-way between the ball-poles—their ball sticks laid on the division line; they then shook hands and joked with each other, while some went round to collect the stakes; . . . They then proceeded to the game, which I will not attempt to describe farther, than by saying it extremely resembles cricket. . . .

Lander's Peak. It is instead an illustration of a mountain from the Alps, a none-too-disguised version of the Matterhorn. Bierstadt presents the American West through a European lens, perhaps because he both understood that view was what his audience expected and saw the world through that lens himself. As Bierstadt wrote in 1859, describing a journey to the American Rockies:

The mountains are very fine; as seen from the plains, they resemble very much the Bernese Alps, one of the finest ranges of mountains in Europe, if not in the world. . . . The color of the mountains and of the plains, and, indeed of the entire country, reminds one of the color of Italy; in fact, we have here the Italy of America in primitive condition.

By "primitive," Bierstadt means pure, untainted, and unfallen, as if it were another biblical Garden of Eden before Eve ate of the apple of knowledge. The Native Americans in the foreground are similarly "primitive," the "noble savages" that Rousseau so admired (see chapter 30), at peace in a place as yet untouched by white settlement. But in the pamphlet accompanying the painting's exhibition as it toured the country, Bierstadt wrote that he hoped that, one day in the area occupied by the Native American encampment, "a city, populated by our descendants, may rise, and in its art-galleries this picture may eventually find a resting-place."

The onslaught of Western settlers is epitomized by Emanuel Leutze's [LOYT-zuh] (1816–1868) painting *Westward the Course of Empire Takes Its Way* (*Westward Ho!*) (Fig. **39.3**). Leutze, a German painter specializing in American subjects, conveys the expansion into the Louisiana Territory as a matter of national pride. Commissioned by Congress, the mural for which the painting was a precursor decorates a stairwell of the Capitol building in Washington, giving it a kind of official seal of approval from the U.S. government. *Westward Ho!* depicts miners, trappers, scouts, and families in wagon trains converging on the golden promise of the sun setting in the West. (See Fig. 38.19 for a similar image.) At the base of the painting is a panorama depicting the end of the trail, Golden Gate Bay and San Francisco harbor, flanked by portraits of two original American pioneers, Daniel Boone and explorer William Clark, dressed in a buckskin jacket and animal-fur headdress.

The trickle of settlers moving west at the beginning of the nineteenth century soon became a torrent: From 1790 to 1860 the population density of nonnative-born Americans increased from 4 million to 31 million, with nearly half of them moving

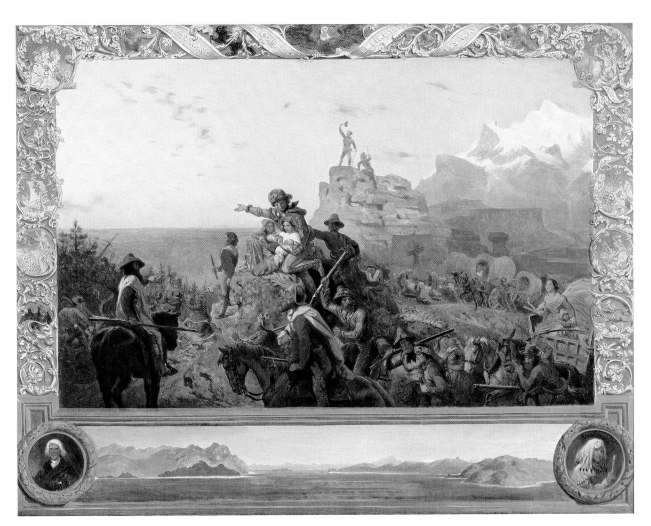

Fig. 39.3 Emanuel Leutze. Study for *Westward the Course of Empire Takes Its Way* (*Westward Ho!*). 1861. Oil on canvas, 33 1/4″ × 43 3/8″. Smithsonian American Art Museum, Washington, DC / Art Resource, NY. When Leutze transferred this image to the wall of the Capitol in 1862, he added, in the center foreground, a black man leading a white woman and child on a mule. Although Leutze's abolitionist sentiments were well known, he probably meant to suggest that blacks as well as whites might enjoy freedom in the West. It is notable, however, that the black man remains in a subservient position to the mother and child.

to territory west of the Atlantic coast states (see Map **39.2**). America's frontier shifted into regions where the possibilities (and natural resources) seemed limitless. It was as if America's future lay somewhere out past the pointing finger of Leutze's trapper. "Go West, young man, and grow up with the country," the Indiana journalist John Soule had advised in 1851. The influential New York journalist Horace Greeley (1811–1872) took up the first part of the refrain, and soon it became obvious that the American West would be central to America's self-identity. Unfortunately, the original inhabitants of the lands were only an afterthought to the artists, the political leaders in Washington, and most of all the settlers themselves. Native American culture and tribal identities were almost entirely ignored and disparaged in the process of "going West."

Conflict with Native Americans was therefore inevitable during the course of expansion. The most visible dimension of a multifaceted clash of cultures was the fight over land—who owned it and who had the right to live on it. The settlers thought of the land as something to organize, control, and own. (As early as 1784, Thomas Jefferson had proposed surveying public lands in the West in geographic units that were 10 miles

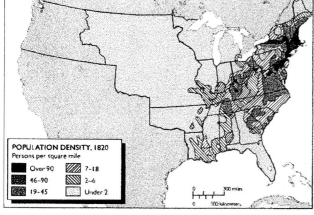

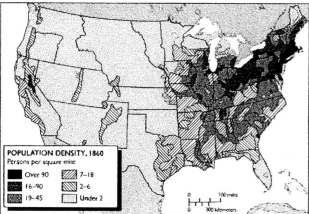

Map 39.2 **Population density of nonnative peoples in the United States in 1820 (a) and 1860 (b).** After G. B. Tindall and D. E. Shea, *America: A Narrative History.*

square, based on the decimal system. This was later replaced by townships of 6 miles square.) They saw the land as central to their own economic well-being and as a resource to exploit to their own benefit. Land was also fungible, like money—that is, it could be traded like any other commodity, and disposed of as well. The Native Americans, on the other hand, saw themselves as one element in the whole of nature, not privileged in relation to the natural world but part of its delicate balance. Their primary responsibility was to live in harmony with nature rather than transforming, trading, or altering it in a fundamental way.

The Indian Removal Act

In 1830, at the request of President Andrew Jackson (in office 1829–1837), Congress passed "An Act to provide for an exchange of lands with the Indians residing in any of the states or territories, and for their removal west of the river Mississippi." Jackson had provided Congress with the rationale in a speech the previous year:

> Their present condition, contrasted with what they once were, makes a most powerful appeal to our sympathies. Our ancestors found them the uncontrolled possessors of these vast regions. By persuasion and force they have been made to retire from river to river and from mountain to mountain, until some of the tribes have become extinct and others have left but remnants to preserve for awhile their once terrible names. Surrounded by the whites with their arts of civilization, which by destroying the resources of the savage doom him to weakness and decay, the fate of the Mohegan, the Narragansett, and the Delaware is fast overtaking the Choctaw, the Cherokee, and the Creek. That this fate surely awaits them if they remain within the limits of the states does not admit of a doubt. Humanity and national honor demand that every effort should be made to avert so great a calamity.

Jackson's apparent concern for the Native Americans' well-being was insincere, to put it mildly. As a military leader during the War of 1812, he had brutally suppressed the Creek tribal nation, which occupied much of the Southeast United States, then afterward negotiated a treaty that took more than half of Creek lands. He also spearheaded the movement to grant Native Americans individual ownership of land, inciting competition, and breaking down ancient traditions of communal landholding.

Jackson's presidential policies mirrored George Washington's idea of "civilizing" the Native Americans by teaching them to farm and build homes, educating their children, and helping them embrace Christianity. But many Americans viewed indigenous cultures more negatively, drawing from a wealth of lurid images that depicted them as morally depraved and violent. One of the most revealing of these portrayals was prompted by President Jefferson's envoy to France, Joel Barlow, who commissioned John Vanderlyn [VAN-der-lin] to paint *The Murder of Jane McCrea* (1803–1804), which occurred in 1777 (Fig. **39.4**). The painting depicts Jane McCrea, daughter of a Presbyterian minister in upstate New York, who followed her Loyalist fiancé to

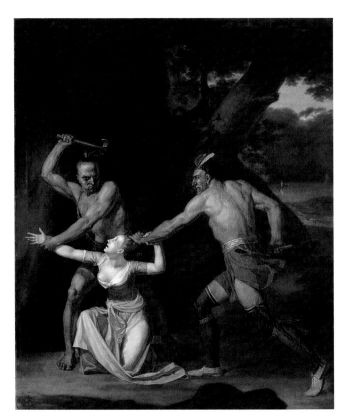

Fig. 39.4 John Vanderlyn. *The Murder of Jane McCrea.* **1803–1804.** Oil on canvas, 32″ × 26½″. Courtesy Wadsworth Atheneum Museum of Art, Hartford, Connecticut. Purchased by Supscription. Jane McCrea's plight symbolized colonial vulnerability, but also warned about the fate of women who disobeyed the wishes of their families.

Canada against the wishes of her pro-Revolutionary brother and was captured, killed, and scalped by Native Americans fighting for the British. Jane became an instant symbol of vulnerable colonials preyed upon by diabolical and savage Native Americans, and her story helped galvanize American colonists to resist the British troops and Native American allies.

Such images, etched on the national consciousness, provoked the likes of Henry Clay, who served as secretary of state (1824–1828) under John Quincy Adams and who was nearly elected president 20 years later, to contend that the Native American's "disappearance from the human family would be no great loss to the world." Even a "civilized" tribe like the Cherokee in Georgia was subject to Jackson's Removal Act. An 1825 census revealed that the tribe, with a population of little over 13,000, owned 2,486 spinning wheels, 2,923 plows, 69 blacksmith shops, 13 sawmills, and 33 grist mills, and 1,277 black slaves—signs of Western acculturation—but the Cherokee made the fatal mistake of insisting on their sovereignty. Jackson therefore assented to the eviction of the Cherokee and the other "civilized" tribes of the Southeast—the Choctaw, Chickasaw, Creek, and Seminole [SEM-ih-nohl]—from their homes and farms. The Cherokee were forced to march across the country to their newly assigned homes in Oklahoma on a journey that would become known as the Trail of Tears because of the 4,000 who died en route.

The Fate of the Native Americans: Cooper's *Leatherstocking Tales*

The disappearance of Native Americans and those who were sympathetic to their plight was the subject of the first successful American novelist, James Fenimore Cooper. In five historical novels collectively known as *The Leatherstocking Tales*, Cooper follows the career of Nathanial "Natty" Bumppo, a white hunter and woodsman who lives his entire life near the northeast Native American tribal lands. The order of the publications was by no means chronological. In the first book, *The Pioneers* (1823), Natty is in his seventies. In the third, *The Prairie* (1827), he is in his eighties. In the second and fourth books, *The Last of the Mohicans* (1826) and *The Pathfinder* (1840), he is in his forties. And in *The Deerslayer* (1841), the last of the series, he is in his mid-twenties.

In *The Pioneers*, Natty Bumppo witnesses the wholesale slaughter of passenger pigeons by the residents of Otsego, in central New York (see **Reading 39.1**, page 1273, for the complete episode). What Cooper's villagers saw to inspire their shooting spree was probably similar to the scene described by the American naturalist and wildlife artist John James Audubon [aw-duh-BON] (1785–1851), who authored *Birds of America* (1851–1859). (Fig. **39.5** shows an illustration from the book.) In 1813, in Kentucky, Audubon calculated that he viewed more than a billion birds pass over him in about three hours. "The air was literally filled with Pigeons," he wrote. "The light of noon-day was obscured as by an eclipse." Natty Bumppo looks on silently at the slaughter, as "the birds lay scattered over the field in such profusion, as to cover the very ground with the fluttering victims," until he is angered into speech by the introduction of a cannon into the fray, designed to bring thousands down at a time (**Reading 39.1a**):

READING 39.1a **from James Fenimore Cooper, *The Pioneers* (1823)**

"This comes from settling a country" he said—"here I have known the pigeons to fly for forty long years, and, till you made your clearings, there was nobody to scare or to hurt them. I loved to see them come into the woods, for they were company to a body; hurting nothing; being, as it was, as harmless as a garter-snake. But now it gives me sore thoughts when I hear the frighty things whizzing through the air, for I know it's only a motion to bring out all the brats in the village at them. Well! the Lord won't see the waste of his creatures for nothing, and right will be done to the pigeons, as well as others, by and by.

Natty clearly equates the fate of the pigeons with the fate of the Native Americans. From Cooper's point of view, the native peoples, so at home in the natural world, must inevitably succumb to the same destructive "civilizing" forces as nature itself. Yet he is not happy about it.

Focus

Howling Wolf's *Treaty Signing at Medicine Lodge Creek*

In 1875, Howling Wolf, son of the Cheyenne chief Eagle Head, was taken, together with his father and 70 others considered ringleaders of an Indian uprising, to Fort Marion in Saint Augustine, Florida, and imprisoned for 3 years. At Fort Marion, Howling Wolf and others engaged in ledgerbook drawing, a practice Howling Wolf had already undertaken in order to record in the traditional manner his own narrative history, particularly his military exploits. Encouraged by the officer in charge of Fort Marion, the interred Native Americans sold their ledger art to buy things for themselves and to support their families back on the reservations.

Howling Wolf was one of the most innovative artists at Fort Marion. He abandoned most of the old pictographic style and composed colorful, decorative drawings with a strong sense of balance, symmetry, and rhythm. He carefully

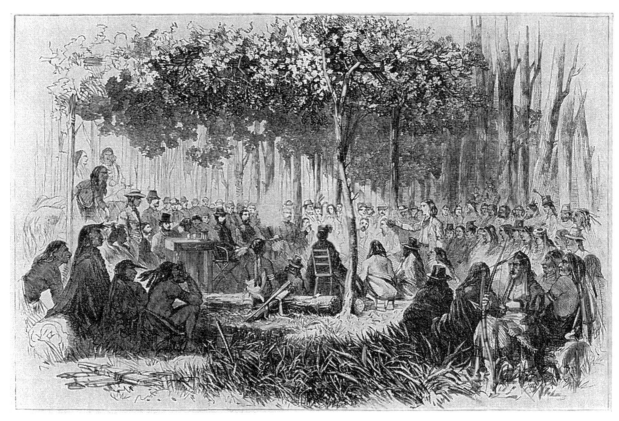

John Taylor. *Treaty Signing at Medicine Lodge Creek.* **1867.** Drawing for *Frank Leslie's Illustrated Gazette*, September–December 1867, as reproduced in Douglas C. Jones, *The Treaty of Medicine Lodge*, after page 144, Oklahoma University Press, 1966. Taylor's view of the treaty signing, produced at the time of the event, contains only one woman, Mrs. Margaret Adams, interpreter for the Arapaho. The daughter of a French-Canadian trapper and an Arapaho mother, she was the object of great fascination to the journalists present, especially when she arrived on the opening day in a red velvet dress and matching red bonnet.

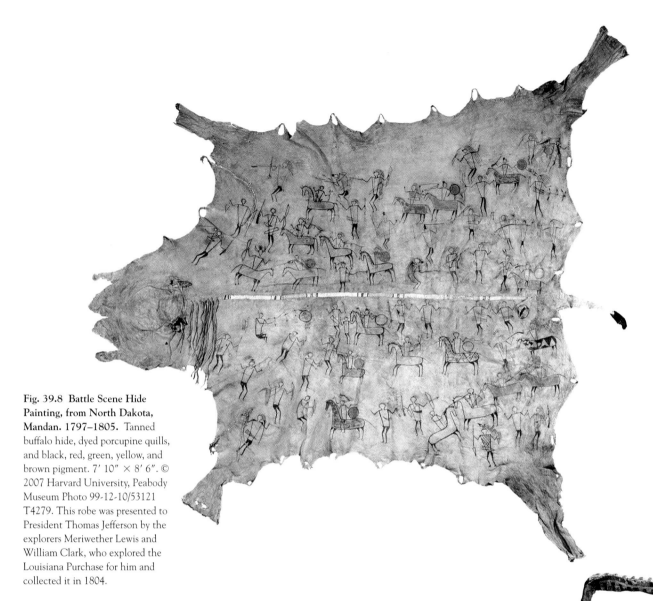

Fig. 39.8 Battle Scene Hide Painting, from North Dakota, Mandan. 1797–1805. Tanned buffalo hide, dyed porcupine quills, and black, red, green, yellow, and brown pigment. 7′ 10″ × 8′ 6″. © 2007 Harvard University, Peabody Museum Photo 99-12-10/53121 T4279. This robe was presented to President Thomas Jefferson by the explorers Meriwether Lewis and William Clark, who explored the Louisiana Purchase for him and collected it in 1804.

At first the artists used the typical pictographic conventions familiar from hide painting and depicted wars between their own and other tribes. But once they were imprisoned or forced to live on reservations, they began also to depict pre-reservation scenes of battles with Westerners as well as illustrating the cultural changes they were experiencing (see *Focus*, pages 1260–1261). In addition, as the buffalo disappeared in the last decades of the nineteenth century, Plains artists sought larger formats, turning to drawing on cloth.

Women's Arts on the Plains: Quillwork and Beadwork

The artwork of women was greatly respected in the Plains and Intermountain tribal cultures. Among the Cheyenne, women who worked on the construction, design, and decoration of teepees held some of the most prestigious positions in the tribe.

However, the two main art forms practiced by women were quillwork and beadwork. Quillwork, first practiced by Eastern Woodlands tribes, spread to the Plains, where it was considered a sacred art (Fig. **39.9**). Using porcupine quills that range from $2\,^{1}/_{2}$ to 5 inches in length, quillworkers sorted them according to size, dyed them in batches, then softened and made them flexible for use by the artist, who repeatedly pulled the quills through her teeth as she stitched them into hides. Among the Lakota, a woman received an ornamented stick for each

Fig. 39.9 Baby Carrier, from the Upper Missouri River area, Eastern Sioux. 19th century. Board, buckskin, porcupine quill, length 31″. Smithsonian Institution Libraries, Washington, DC. Woven into the carrier are three bands of thunderbirds, symbols of protection capable of warding off supernatural harm as well as human adversaries.

Focus

Howling Wolf's *Treaty Signing at Medicine Lodge Creek*

In 1875, Howling Wolf, son of the Cheyenne chief Eagle Head, was taken, together with his father and 70 others considered ringleaders of an Indian uprising, to Fort Marion in Saint Augustine, Florida, and imprisoned for 3 years. At Fort Marion, Howling Wolf and others engaged in ledgerbook drawing, a practice Howling Wolf had already undertaken in order to record in the traditional manner his own narrative history, particularly his military exploits. Encouraged by the officer in charge of Fort Marion, the interred Native Americans sold their ledger art to buy things for themselves and to support their families back on the reservations.

Howling Wolf was one of the most innovative artists at Fort Marion. He abandoned most of the old pictographic style and composed colorful, decorative drawings with a strong sense of balance, symmetry, and rhythm. He carefully

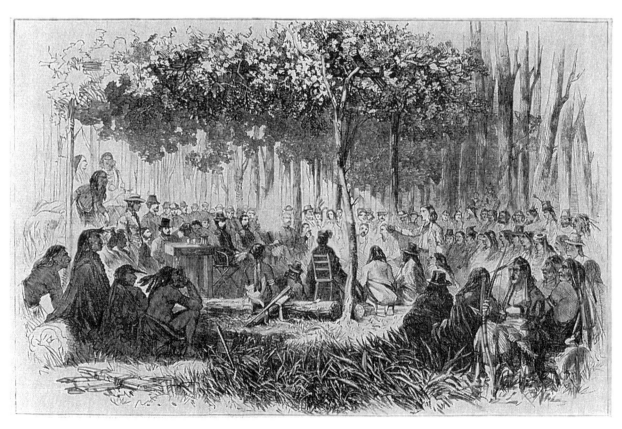

John Taylor. *Treaty Signing at Medicine Lodge Creek.* **1867.** Drawing for *Frank Leslie's Illustrated Gazette*, September–December 1867, as reproduced in Douglas C. Jones, *The Treaty of Medicine Lodge*, after page 144, Oklahoma University Press, 1966. Taylor's view of the treaty signing, produced at the time of the event, contains only one woman, Mrs. Margaret Adams, interpreter for the Arapaho. The daughter of a French-Canadian trapper and an Arapaho mother, she was the object of great fascination to the journalists present, especially when she arrived on the opening day in a red velvet dress and matching red bonnet.

Their ceremonial life revolved around the "Old Woman Who Never Dies," keeper of the corn seed, who oversees the agricultural well-being and hunting success of the tribe. Performed each year, before and after the summer buffalo hunt, the Okipa Ceremony was designed to dramatize the tribe's myths and to provide an opportunity for young men to be initiated into manhood. The young men of the village fasted for a prolonged period, then suspended themselves from a central platform in the ceremonial lodge by thongs attached to the pierced skin of the back or chest. In the "last race" of the ceremony, they ran around outside the lodge pulling buffalo skulls similarly attached to the skin of their legs and arms, a ritual clearly depicted in the foreground of Catlin's painting.

Catlin's paintings of the Mandan are remarkable not only in their depiction of the ceremony but also for their careful depiction of the village itself with its hemispherical earthen lodges. This fidelity to detail was, he believed, the hallmark of his art. He took especially great pride in his portrait of *Mah-To-Toh-Pa*, or Four Bears, the Mandan Chief (Fig. **39.7**). Yet Catlin brings his own classical associations to bear on the portrait, as his description of the sitting in his 1841 *Letters and Notes*, makes clear. As the chief arrived for his portrait, Catlin writes, "No . . . gladiator ever entered the Roman Forum with

more grace and manly dignity. . . . He took his attitude before me . . . with the sternness of a Brutus and the stillness of a statue." If Catlin's intention was to record the chief's costume with ethnographic fidelity, we know from his *Letters and Notes* that he left several important details out—namely, a belt containing a tomahawk and scalping knife, a buffalo-hide robe, on which was painted the history of the chief's military exploits, and a bear-claw necklace. He claimed that these "interfered with the grace and simplicity of the figure."

Catlin has "pacified" the warrior, made him presentable to a white audience. Such gestures undermine the authority of his attempts to convey a realistic view of natives. Indeed, for the frontispiece of *Letters and Notes*, Catlin depicted himself painting this portrait, the chief standing among his people before a group of tepees [TEE-pees]. "The Author painting a Chief at the base of the Rocky Mountains," the caption reads. The Mandan villages on the Missouri River were far distant from the Rocky Mountains, and the Mandan did not live in teepees, the conical shelters of nomadic Plains tribes such as the Sioux. So Catlin helped create the myth of the Native American—highly inaccurate—while being intensely sympathetic to their plight.

Plains Narrative Painting: Picturing Personal History and Change

By choosing not to paint the buffalo-skin hide Mah-To-Toh-Pa wore to the sitting, Catlin ignored the most crucial part of the chief's character, his personal history. Unlike almost all other Native American tribes in North America, the Native Americans of the Great Plains developed a strong sense of history. They recorded their history as a narrative in relatively flat semiabstract images on buffalo-hide robes, the exterior hides of teepees, and shields, and in their highly detailed oral narratives (Fig. **39.8**). The wearer of a Plains robe owned all the designs on it, though he could sell or give them away. So each robe was doubly personal in being both autobiographical and aesthetically unique. In these designs, humans are generally stick figures, and events are described in selective detail. Both served as memory aids that would help the wearer in relating his history through the traditional art of storytelling.

Some tribes, particularly the Lakota and Kiowa, recorded family or band history in what are known as "winter counts."

Continuity & Change p. 78

Palette of Narmer

Marking the passing of years in winters, tribal artists created pictographic images, such as those found on the Egyptian *Palette of Narmer*, one for each year, which would, in effect, stir the collective memory of what else happened in the year. They then arranged the pictographs in a pattern, often circular, reading from the center outward. By the mid-nineteenth century, encounters with artists such as George Catlin and the introduction of paper and pencils and inks by explorers and traders influenced the pictographic style of the Plains tribes. They began to use discarded recordkeeping ledgers from trading posts, and this genre of Plains tribal history painting became known as "ledgerbook art."

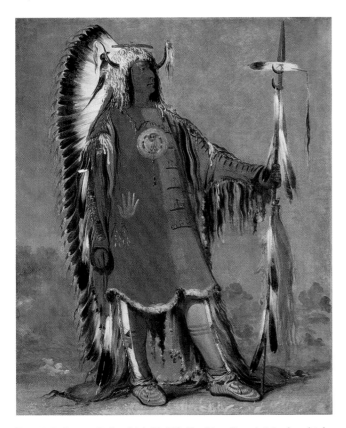

Fig. 39.7 George Catlin. *Mah-To-Toh-Pa (Four Bears),* **Mandan chief. 1832–1834.** Oil on canvas, 29" × 24". Smithsonian American Art Museum, Washington, DC/Art Resource, NY. War bonnets were worn only by those warriors who could claim the special ability to match bravery with cunning. The wearer could never ask for mercy in battle.

Recording and Mythologizing Native Americans: Catlin's Ethnographic Enterprise

In 1830, George Catlin (1796–1872), a successful portrait painter from the east coast, headed west to St. Louis from which he would make five trips in six years into the territory west of the Mississippi to record the costumes and practices of the Native Americans. On Catlin's historic but unheralded journeys, he encountered cultures of vast diversity and represented over 40 different tribes in 470 portraits and portrayals of daily life: Osage [OH-sage], Kickapoo, Iowa, Ojibwa [oh-JIB-wah], Pawnee [PAW-nee], and Mandan [MAN-dan], to name just a few. In 1832 Catlin discussed his reasons for painting the Native American peoples that he encountered:

> I have, for many years past, contemplated the noble races of red men who are now spread over these trackless forests and boundless prairies, melting away at the approach of civilization, their rights invaded, their morals corrupted, their lands wrested from them, their customs changed,

and therefore lost to the world; and they at last sunk into the earth, and the ploughshare turning the sod over their graves, and I have flown to their rescue—not of their lives or of their race (for they are "doomed" and must perish), but to the rescue of their looks and their modes, at which the acquisitive world may hurl their poison . . . and trample them down and crush them to death; yet, phoenix-like, they may rise from the "stain on a painter's palette," and live again upon canvas, and stand forth for centuries yet to come, the living monuments of a noble race.

While Catlin assumes too much power for his art to resurrect the vanishing tribes, his contribution to Native American ethnography—the scientific description of individual cultures—is indisputable. His depiction of *The Last Race, Part of Okipa Ceremony* is one of several representing a four-day Mandan ceremony linking all of creation to the seasons (Fig. **39.6**). According to legend, the Mandan sprang from the earth like corn, the mainstay of their diet.

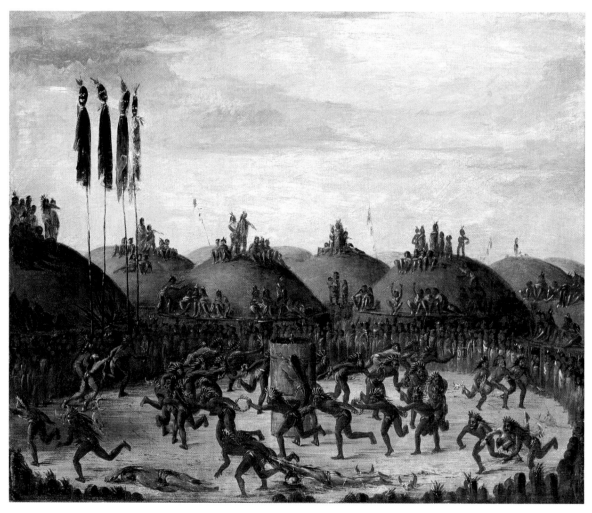

Fig. 39.6 George Catlin. *The Last Race, Part of Okipa Ceremony (Mandan).* **1832.** Oil on panel, 23 3/8" × 28 1/8". Smithsonian American Art Museum, Washington, DC/Art Resource, NY. Beginning in 1837, Catlin toured with his paintings, including a trip in 1839 to London and Paris. The Okipa Ceremony paintings were especially popular, but even as he began his tour, a plague of smallpox almost completely wiped out the Mandan themselves.

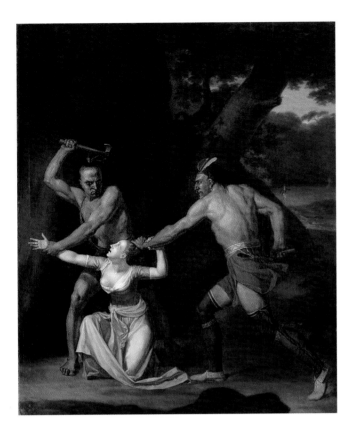

Fig. 39.4 John Vanderlyn. *The Murder of Jane McCrea.* 1803–1804. Oil on canvas, 32″ × 26½″. Courtesy Wadsworth Atheneum Museum of Art, Hartford, Connecticut. Purchased by Supscription. Jane McCrea's plight symbolized colonial vulnerability, but also warned about the fate of women who disobeyed the wishes of their families.

The Fate of the Native Americans: Cooper's *Leatherstocking Tales*

The disappearance of Native Americans and those who were sympathetic to their plight was the subject of the first successful American novelist, James Fenimore Cooper. In five historical novels collectively known as *The Leatherstocking Tales*, Cooper follows the career of Nathanial "Natty" Bumppo, a white hunter and woodsman who lives his entire life near the northeast Native American tribal lands. The order of the publications was by no means chronological. In the first book, *The Pioneers* (1823), Natty is in his seventies. In the third, *The Prairie* (1827), he is in his eighties. In the second and fourth books, *The Last of the Mohicans* (1826) and *The Pathfinder* (1840), he is in his forties. And in *The Deerslayer* (1841), the last of the series, he is in his mid-twenties.

In *The Pioneers*, Natty Bumppo witnesses the wholesale slaughter of passenger pigeons by the residents of Otsego, in central New York (see **Reading 39.1**, page 1273, for the complete episode). What Cooper's villagers saw to inspire their shooting spree was probably similar to the scene described by the American naturalist and wildlife artist John James Audubon [aw-duh-BON] (1785–1851), who authored *Birds of America* (1851–1859). (Fig. **39.5** shows an illustration from the book.) In 1813, in Kentucky, Audubon calculated that he viewed more than a billion birds pass over him in about three hours. "The air was literally filled with Pigeons," he wrote. "The light of noon-day was obscured as by an eclipse." Natty Bumppo looks on silently at the slaughter, as "the birds lay scattered over the field in such profusion, as to cover the very ground with the fluttering victims," until he is angered into speech by the introduction of a cannon into the fray, designed to bring thousands down at a time (**Reading 39.1a**):

READING 39.1a **from James Fenimore Cooper, *The Pioneers* (1823)**

"This comes from settling a country" he said—"here I have known the pigeons to fly for forty long years, and, till you made your clearings, there was nobody to scare or to hurt them. I loved to see them come into the woods, for they were company to a body; hurting nothing; being, as it was, as harmless as a garter-snake. But now it gives me sore thoughts when I hear the frighty things whizzing through the air, for I know it's only a motion to bring out all the brats in the village at them. Well! the Lord won't see the waste of his creatures for nothing, and right will be done to the pigeons, as well as others, by and by.

Natty clearly equates the fate of the pigeons with the fate of the Native Americans. From Cooper's point of view, the native peoples, so at home in the natural world, must inevitably succumb to the same destructive "civilizing" forces as nature itself. Yet he is not happy about it.

Canada against the wishes of her pro-Revolutionary brother and was captured, killed, and scalped by Native Americans fighting for the British. Jane became an instant symbol of vulnerable colonials preyed upon by diabolical and savage Native Americans, and her story helped galvanize American colonists to resist the British troops and Native American allies.

Such images, etched on the national consciousness, provoked the likes of Henry Clay, who served as secretary of state (1824–1828) under John Quincy Adams and who was nearly elected president 20 years later, to contend that the Native American's "disappearance from the human family would be no great loss to the world." Even a "civilized" tribe like the Cherokee in Georgia was subject to Jackson's Removal Act. An 1825 census revealed that the tribe, with a population of little over 13,000, owned 2,486 spinning wheels, 2,923 plows, 69 blacksmith shops, 13 sawmills, and 33 grist mills, and 1,277 black slaves—signs of Western acculturation—but the Cherokee made the fatal mistake of insisting on their sovereignty. Jackson therefore assented to the eviction of the Cherokee and the other "civilized" tribes of the Southeast—the Choctaw, Chickasaw, Creek, and Seminole [SEM-ih-nohl]—from their homes and farms. The Cherokee were forced to march across the country to their newly assigned homes in Oklahoma on a journey that would become known as the Trail of Tears because of the 4,000 who died en route.

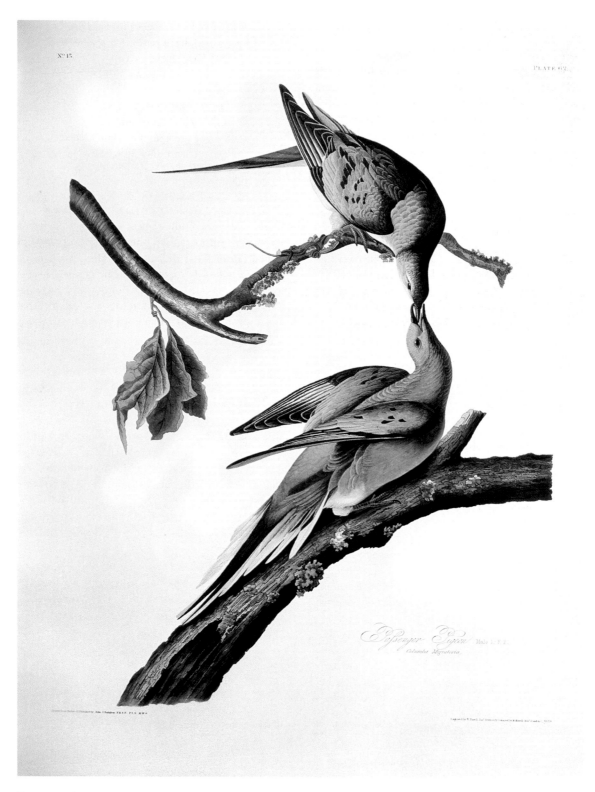

Fig. 39.5 John James Audubon. *Passenger Pigeon.* **ca. 1824.** Watercolor, pastel, and graphite on paper, 40″ × 30″ with mat. Collection of the New York Historical Society, Havell LXII. As a result of events such as Cooper describes in *The Pioneers*, the passenger pigeon was extinct by 1914, when the last one died at the Cincinnati Zoological Gardens.

outlined his figures in ink, then colored them with crayon, colored pencils, or watercolors. He also identified himself and others through signifying adornment and decoration. One of the most significant works he created at Fort Marion is *Treaty Signing at Medicine Lodge Creek*. It depicts the signing of a peace treaty in October 1867 between Cheyenne [SHY-an], Arapaho [uh-RAP-uh-ho], Kiowa [KY-uh-wah], and Comanche [kuh-MAN-chee] peoples and the U.S. govern-ment at the intersection of Elm Creek and Medicine Lodge Creek in Kansas. Medicine Lodge Creek was named for a shelter shared by the Plains tribes beside the creek that they believed to possess magical healing powers. But the terms of the treaty were anything but healing. In requiring their children to go to school and learn to speak English, and restricting the movements of the tribes, it signaled the end of their traditional way of life.

The women's braided hair is decorated with red paint in the part. Traditionally, when a Plains warrior committed himself to a woman, he ceremonially painted her hair in this manner to confirm his affection.

The grove of cottonwoods and elms where the treaty was negotiated with government agents in place.

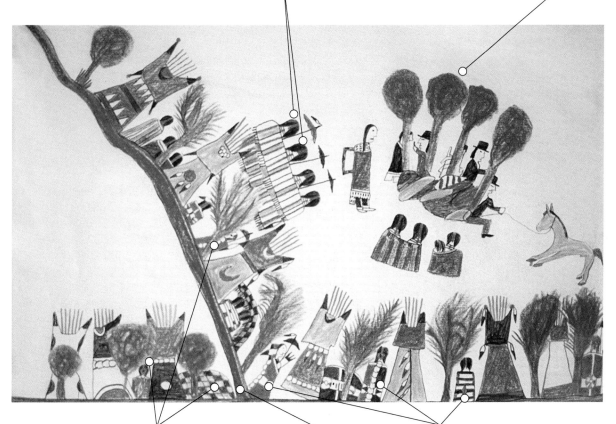

Compared to John Taylor's illustration of the treaty signing, Howling Wolf's representation seems näive, but he has notably adopted some techniques of traditional Western representation, for instance depicting deep space by means of overlapping. He also abandoned the Plains pictographic style and created full-bodied, if not fully modeled, figures. The most startling difference is his depiction of the events as dominated by women, while Taylor completely ignores them.

The intersection of Elm Creek and Medicine Lodge Creek.

Each figure is identifiable by the decoration on garments and tepees. Most are women, who sit with their backs to the viewer, in formal attire, suggesting the importance of women in Plains society. In this drawing, it is they who establish identity.

Howling Wolf, *Treaty Signing at Medicine Lodge Creek*. 1875–1878. Pencil, crayon, and ink on ledger paper, 8″ × 11″. Courtesy, New York State Library, Albany, NY.

piece of work quilled, and the four women with the greatest num-ber of sticks were honored by being seated in places of honor and being served food before all others. This reward system, in which valued accomplishments were often signified in elevated status rather than in material goods, was emblematic of many aspects of Native American social and economic life. It was a major differ-ence from the value system of white settlers and colonists.

Quillwork design was quickly adapted to beadwork after the introduction of glass beads by explorers and traders. Before large numbers of whites came to the region, glass beads were so valuable that 100 of them were approximately equivalent to the value of a horse. Their bright, permanent colors were believed by many to be preferable to the softer tones attain-able in quillwork. Nonetheless, artists imitated the quillwork stitch by creating what is known as a "lazy stitch," stringing about seven beads on each thread. Another seven beads are strung on the thread and laid parallel to the first seven, back and forth until a complete band is realized. In both quillwork and beadwork—and in the textile arts as well—Native tribes believed that artistic skill coexisted with divine and supernat-ural powers. This belief lent the artist a unique and immeasur-able authority. Like the indigenous system of rewards, this power was largely invisible to Westerners.

The End of an Era

The ultimate fate of Plains tribes was inextricably linked to the fate of the buffalo. By the 1870s the military was pursuing an unofficial but effective policy of Native American extermina-

tion, and it encouraged the slaughter of the buffalo as a short-cut to this end. Echoing President Andrew Jackson 40 years ear-lier, General Philip Sheridan (1831–1888) urged that white settlers hasten the killing of buffalo herds, thereby undercutting the Native American supply of food. The effort to build a transcontinental railroad helped Sheridan's wish to be realized, as over 4 million buffalo were slaughtered by meat hunters for the construction gangs, by hide hunters, and by tourists. In the late summer of 1873, railroad builder Granville Dodge reported that "the vast plain, which only a short twelvemonth before teemed with animal life, was a dead, solitary, putrid desert." It was as if George Catlin had predicted the demise of the buffalo, and with it the demise of the Indian, when forty years earlier he had painted his lone Indian overlooking a Missouri River val-ley empty of game (Fig. 39.10). The end of the buffalo signaled the end of Native American culture. A Crow warrior named Two Legs put it this way: "Nothing happened after that. We just lived. There were no more war parties, no capturing horses from the Piegan (tribe) and the Sioux [soo], no buffalo to hunt. There is nothing more to tell." History had come to an end.

The painter Albert Bierstadt was, by his own account, deeply affected by the buffalo's demise. But there is never, in any of his work, the slightest indication of his own, or white, complicity in the buffalo's fate. By 1889, about when Bierstadt painted *The Last of the Buffalo* (Fig. 39.11) showing a Native American spearing a perfect specimen, he declared: "I have endeavored to show the buffalo in all his aspects and depict the cruel slaughter of a noble animal now almost extinct."

Such duplicity is also apparent in laws passed affecting Native Americans such as the Dawes Act (1887), which attempted to estab-lish private ownership of Native Amer-ican lands by initiating government partitions of reservations. Under the act, each Native American family head was to receive 160 acres, and all other Indians over the age of 18 were to receive 80 acres each. Officially, it was a gesture dedicated both to "civilizing" the tribes by giving them private prop-erty and to protecting their property from settlers during the Oklahoma Land Rush. However, to receive the allotment, Native Americans had to "anglicize" their names, so that Rolling Thunder, for instance, would hence-forth be known as Ron Thomas. Many refused, but the requirement allowed government agents to register their own family and friends as "Indians"— and so grab more land. Who would be able to tell a white "Ron Thomas" from a Native American one back in Wash-ington? In essence the Dawes Act was a land grab—Native American lands, which totaled 138 million acres at the

Fig. 39.10 George Catlin. *Big Bend on the Missouri River, 1,900 Miles above St. Louis.* 1832. Oil on canvas, 29″ × 24″. Smithsonian American Art Museum, Washington, DC/Art Resource, NY. Catlin's lone Indian contemplating the vastness of the landscape is symbolic of a vanishing people and a vanishing wilderness.

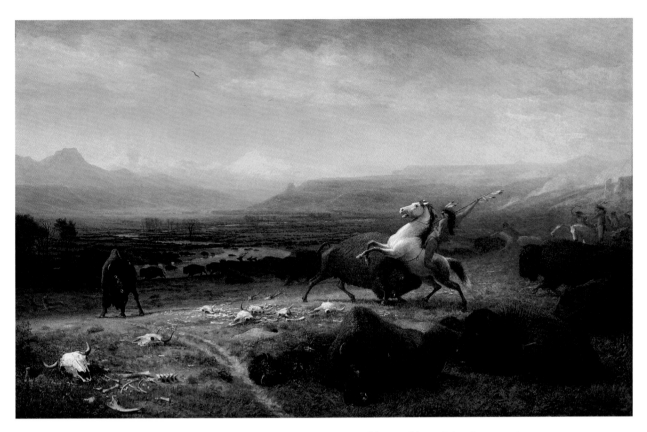

Fig. 39.11 Albert Bierstadt. *The Last of the Buffalo*. ca. 1888. Oil on canvas, $60\frac{1}{4}'' \times 96\frac{1}{2}''$. Buffalo Bill Historical Center, Cody, WY. Gertrude Vanderbilt Whitney Trust Fund, 2.60. Bierstadt was a charter member of the Boone and Crockett Club, an organization of big-game hunters ostensibly dedicated to conservation.

time the Dawes Act was signed into law, were reduced to 47 million acres of land by 1934 when the act was repealed. Similarly, in the Western states and territories inhabited by the Nez Perce [nez pers], Yakima [YAK-uh-muh], Cayuse [ky-YOOS], and other tribes, Native Americans lost nearly 500 million acres of tribal land to settlement by white farmers.

The British in China and India

Westerners also posed dire threats to the two most populous and culturally influential Asian nations during the course of the eighteenth and nineteenth centuries. While not posing a threat to the actual existence of China and India, Western nations sought to dominate them through aggressive military and economic policies aimed at transferring wealth to their own countries and limiting their sovereignty. During the eighteenth century, both the English East India Company and the French Compagnie des Indes [kohm-pahn-YEE dayz-ahnd] (French East India Company) vied for control of trade with India and the rest of Asia even as they engaged in ruthless competition in Europe and North America. In fact, India's trade was seen as the stepping-stone to even larger markets in China, whose silks, porcelains, and teas were

highly valued throughout Europe and America. Rather than being mutually beneficial, however, trade with the West was a profound threat to local, regional, and national leaders in both China and India. Before the end of the nineteenth century, both countries would become outposts in new colonial empires developed by Europeans, resulting in the weakening of traditional cultural practices, political leadership, and social systems.

China and the Opium War

From the seventeenth century onward, the Chinese tolerated Western traders while also imposing strict controls on the people they called *fanqui* ("foreign devils"). By 1793, the tide was beginning to shift in favor of the West, with proud emperor Ch'ien-lung [chee-EN-loong] (r. 1735–1796) sending a defiant message to the English king George III (r. 1760–1820) concerning this trade:

> Our Empire produces all that we ourselves need. But since our tea, rhubarb and silk seem to be necessary to the very existence of the barbarous Western peoples, we will, imitating the clemency of Heaven, Who tolerates all sorts of fools on this globe, condescend to allow a limited amount of trading through the port of Canton.

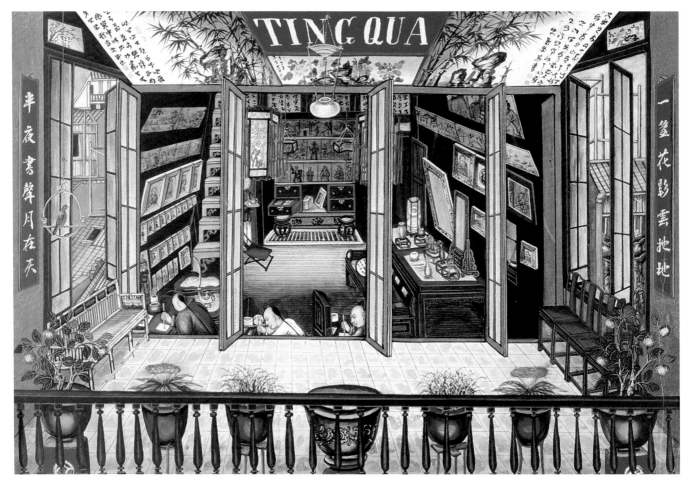

Fig. 39.12 Attributed to Tingqua. *Shop of Tingqua, the Painter.* ca. 1855. Watercolor on paper, $10\frac{1}{2}'' \times 13\frac{3}{4}''$.
Photograph courtesy Peabody Essex Museum. Note that Tingqua depicted his shop in Western perspective.

The Chinese policy of admitting foreign ships to Canton [kant-ON] (modern Guangzhou [gwahng-JOE]) and confining traders to a narrow strip of land where they lived and did business in buildings or factories dated from the early eighteenth century. Chinese entrepreneurs quickly set up shops in the narrow lanes between the factories, selling silks, teas, porcelains, lacquerware, screens, chessboards, carvings, boxes, and pictures to satisfy the European taste for *chinoiserie* (see chapter 30). The shops of Lampqua and his younger brother Tingqua were famous for copying European engravings and for producing paintings of the daily life and ceremonies of the Chinese, along with scenes of Macao and Canton for export (Fig. **39.12**).

More important to the Westerners than these wares was the opium trade. In order to compensate for the gold and silver spent on the purchase of tea, porcelains, and silks, the British East India Company began selling to the Chinese large quantities of opium, which it grew in India. Produced at a very low cost, opium was a very profitable trade item for the British. Unfortunately for the Chinese, opium addiction rapidly became a severe social problem. In 1839, after the emperor's son died an opium-related death, the Chinese moved to ban the drug.

However, by this time, the British were increasingly impatient with the traditional trade restrictions in China as well as the new attempts to limit the opium trade. Since the English military and naval technologies were far superior to that of the Chinese, the nineteenth-century aphorism "Might makes right" can summarize the ensuing British course of action. The parallel with the antagonistic policies of the American government toward indigenous Americans during this period is clear.

A Chinese official, Commissioner Lin Zexu (1785–1850), even sought the help of Queen Victoria (r. 1837–1901) in a plea that invoked ethical and moral principles:

Let us ask, where is your conscience? I have heard that the smoking of opium is very strictly forbidden by your country; that is because the harm caused by opium is clearly understood. Since it is not permitted to do harm in your own country, then even less should you let it be passed on to the harm of other countries—how much less to China! Of all that China exports to foreign countries, there is not a single thing which is not beneficial to people. . . . Suppose there were people from another country who carried opium for sale to England and seduced your people into

buying and smoking it; certainly you honorable ruler would deeply hate it and be bitterly aroused. . . . Now after this communication has been dispatched and you have clearly understood the strictness of the prohibitory laws of the Celestial Court, certainly you will not let your subjects dare again to violate the law.

Whether the Queen read the letter is unknown, but in fact, opium addiction was rampant in London during her reign. She certainly supported British merchants in their refusal to cooperate with the Chinese prohibition after Lin confiscated all the opium he could find and destroyed it in the spring and summer of 1839.

Curiously, the British acknowledged that Lin had the right to prohibit the Chinese from using opium, but they considered his ban on trading it an unlawful violation of the freedom of commerce. They declared war and subsequently crushed China, attacking most of its coastal and river towns. In the resulting Treaty of Nanjing [nan-JING], China ceded Hong Kong to Britain and paid an indemnity of 21 million silver dollars (roughly equivalent to $2 billion today). Chinese ports and markets were opened to Western merchants, and by 1880 the import of cheap machine-made products resulted in the collapse of the Chinese economy. It would not recover for over a century.

Indentured Labor and Mass Migration

While the coffers of British government and merchants were enriched, the declining Chinese economy produced a number of unforeseen consequences, typical of the interactions between Westerners and indigenous peoples during this period. First, ever-worsening economic conditions drove many Chinese to emigrate in order to earn a living. Tens of thousands were attracted to California after gold was discovered there in 1849. Mostly single men, many worked for several years in the mines and then returned home. By 1852, 20,000 Chinese a year arrived in California, although that number declined in the ensuing decades. San Francisco, the port of entry to most Asian immigrants, soon boasted a growing "Chinatown," which offered further employment opportunities as immigrant entrepreneurs built new businesses. America's "melting pot" of cultures was continuing to grow.

The Chinese were also an important source of labor for the Central Pacific Railroad as it constructed railroad lines across the Western United States. By 1867, 90 percent of the workers on the railroad were Chinese. Hired for 30 percent less than the cost of hiring whites, they soon organized and struck for better wages. After the Burlingame Treaty of 1868, in which the United States and China established friendly relations, Chinese immigration to the United States increased to approximately 16,000 a year. By 1882, however, the threat to the American workforce posed by immigrant Chinese labor in a time of economic downturn led to the passing of the Chinese Exclusion Act, which outlawed further immigration and denied citizenship to those already in the country.

The Chinese did not emigrate only to the United States (see Map **39.3**), and they generally encountered much worse treatment elsewhere. They were technically indentured workers—laborers working under contract, generally for from 5 to 8 years, to pay off the price of their passage, usually for no pay, just food and accommodation. In 1873, the Chinese government conducted an investigation of Chinese emigration to Cuba. There it discovered horrific conditions as a Chinese plantation worker testified: "We labor 21 hours out of 24 and are beaten. . . . On one occasion I received 200 blows, and though my body was a mass of wounds I was still forced to continue labor. . . . A single day becomes a year. . . . And our families know not whether we are alive or dead."

East Indian indentured workers faced similarly harsh conditions. In the 1860s and 1870s, more than 50,000 Indians were shipped to French colonies in the Caribbean, where they were kept in "perpetual servitude." Just a century earlier, India had been one of the most productive economies in the world. In the 1760s, for instance,

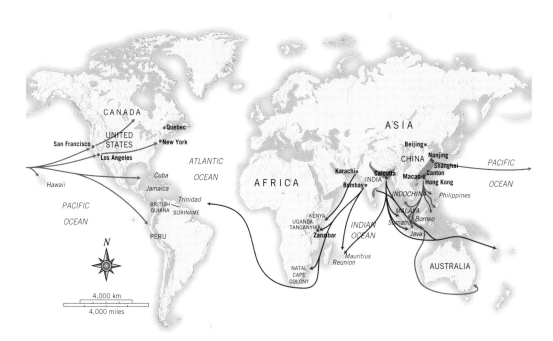

Map 39.3 The movement of indentured labor in the late nineteenth century.

Britain imported most of its best cast steel from India, where hundreds of thousands were employed in mills and mines. But by the end of the eighteenth century, India lost its European markets for finished goods after the British East India Company bought Indian raw materials at exploitatively low prices and then undercut Indian manufacturers by selling finished textiles in India at low prices. Backed by the force of the British Army and increasingly efficient mechanized factories in Britain, English merchants profited handsomely at the expense of traditional economic production in India. So, instead of manufacturing cast steel, India found itself producing only iron ore; instead of manufacturing finished textiles, it exported raw cotton. In this economy, from which manufacturing had been almost completely eliminated, work became a scarce commodity. As its population increased in the second half of the nineteenth century, India experienced an unprecedented series of intensive famines, as well as widespread unemployment and poverty. As a result, over the course of the late nineteenth and early twentieth centuries, nearly 1.5 million Indians sold themselves into indentured servitude. Having produced 25 percent of the world's industrial output in 1750, India by 1900 contributed only 2 percent.

Company School Painting in India

In the early seventeenth century, the Mogul court in India had already expressed an interest in Western art, especially the degree of realism that could be accomplished through modeling and perspective (see chapter 30). Yet most Indian artists considered European art an exotic oddity, and well into the nineteenth century traditional modes of picture making almost completely dominated Indian artistic production. Gradually, as the British Westernized India, they commissioned and purchased Indian art, and the subcontinent's artists responded by incorporating Western techniques and pictorial traditions.

The British East India Company employed Indian artists as draftspersons, instructing them in European techniques, with others assigned to work as assistants to European artists. In art schools, Indians began to study and copy European prints. Thus encouraged and employed by the East India Company, they soon became known as the Company School.

The subjects favored by their European patrons tended to be images featuring Indian costumes and dress, and depictions of Indians at work—a weaver at his loom or a potter at his wheel. Europeans were also fascinated by the "curiosities" of Indian culture, particularly religious practices, which seemed exotically foreign. Indian artists also specialized in depicting the domestic lives of the British themselves. Among the greatest of the Company School painters was Sheikh Muhammad Amir of Karraya (a suburb of Calcutta [kal-CUT-tuh]). In depicting horses with their grooms, Sheikh Muhammad added newly adopted Western techniques—shading, texture, and accurately depicted anatomy—to the traditional subject matter (Fig. 39.13). By the last decades of the century, the British were able to document their lives in India more effectively by means of photography, and so the Company School came to an end.

The Opening of Japan

As India was rapidly changing under the British colonial regime in the mid-nineteenth century, Japan sought to accommodate Western industrialization while maintaining the most important aspects of its cultural traditions. Until the American Commodore Matthew Perry sailed into Tokyo Bay on July 8, 1853, the archipelago had been closed to the West for 250 years (see Map 23.4). Seeking to gain the Japanese government's assistance in opening trade as well as providing safe havens for stranded sailors, Perry demanded and received concessions. His expedition ultimately led to the Treaty of Kanagawa (1854) and the Harris Treaty (1858) between the United States and Japan, which opened diplomatic and trade relations between the two countries and brought large quantities of Japanese goods to the West for the first time. The Japanese realized that they had to accommodate Perry, the immediate threat, as well as cope with the longer-term challenge from Western nations. Their goal was to modernize along Western lines but maintain sovereignty as well as their ancient cultural traditions. Visitors arriving in Japan in the late nineteenth and early twentieth centuries had to follow carefully laid out itineraries if they wished to venture beyond the "treaty ports" of Yokohama [yoh-koh-HAH-mah], just south of Tokyo; Kobe [KOH-bee], just outside Osaka; and Nagasaki

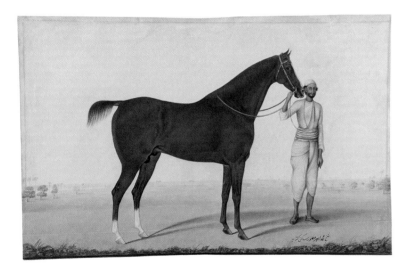

Fig. 39.13 Sheikh Muhammad Amir. *A Horse and Groom.* 1830–1850. Calcutta, India. Pencil and opaque watercolor with touches of white and gum arabic, 11″ × 17 1/2″. Arthur M. Sackler Gallery. Smithsonian Institution, Washington, DC. Purchase, S1999.121. Note the carefully realized rocks and grasses in the foreground and the way the trees occupy perspectival space.

[nah-gah-SAH-kee]. The Japanese by this means tried to control the image of their country that visitors took home.

Industrialization: The Shifting Climate of Society

At first, Japan focused on closing the technology gap between its army and navy and Western military powers. Samuel Williams, the Perry expedition's interpreter, described the Japanese army as it appeared to him in July 1853: "Soldiers with muskets and drilling in close array," but also, "soldiers in petticoats, sandals, two swords, all in disorder." But pressure for change was growing, and by 1868 a historic shift occurred, as the Tokugawa Shogunate, which had held power since 1603, was replaced by a new coalition led by leaders of the Satsuma and Choshu provinces, who aimed to restore direct imperial rule. A new emperor, Meiji, had ascended the throne the year before, and the new government took his name, despite the fact that his role was largely symbolic. The new rulers, however, were determined to centralize power and decrease the influence of the previous shogun's clan, the daimyo (regional provincial leaders and warlords) and the samurai class, the military nobility that had little practical purpose in a modern society. In order to modernize their society, the new Meiji government had to industrialize, which they commenced without delay.

Exports of traditional Japanese products—raw silk (which accounted for more than a third of Japan's export trade), tea, cotton yarn, buttons (before 1853 unknown in Japan), and even woodblock prints—financed the industrialization process. The state took an active role, developing the railway lines within several years of the replacement of the Tokugawa Shogunate in order to, first, expand and speed up food distribution networks throughout the mountainous terrain of the country and, second, assist in centralizing political power. By 1872, the emperor presided over the opening of the first long-distance railway from Tokyo to Yokohama (Fig. **39.14**), and by 1900, the nation boasted 5,000 miles of track. Shipyards used to build warships in the 1850s and 1860s were converted to the production of iron and steel for other industries. Many of the large corporations that still dominate Japanese economic life, such as Mitsui and Mitsubishi, originated in this period as co-partners with the Japanese state.

Eiichi Shibusawa (1840–1931) was the father of Japanese capitalism. Founder of the National Bank of Japan and in charge of national industrialization until 1873, he admitted that he first believed that only the military and political classes could lead the nation. Traditionally, merchants had always been at the bottom of the Japanese social hierarchy, but Shibusawa changed his mind when he visited the 1867 World Exposition in Paris as a member of the Japanese delegation. "Then," Shibusawa wrote, "I realized that the real force of progress lay in business." Born to a poor farming family, Shibusawa rose to enormous political and economic power, and embodied the shifting climate of Japanese society.

Japanese Printmaking

By the late nineteenth century, the Japanese economy was booming, as was the art of woodblock printing, called *ukiyo-e*

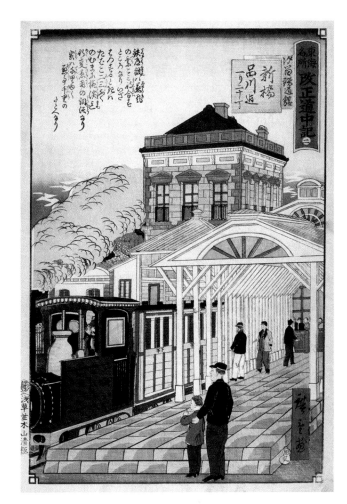

Fig. 39.14 *Shimbashi Station, Tokyo.* From *Famous Places on the Tokaido: A Record of the Process of Reform.* 1875. The Tokyo–Yokohama railway, the first long-distance railway in the country, was built in 1872 with the aid of foreign engineers.

[oo-kee-oh-ay] ("pictures of the floating world"), a tradition that had developed steadily since the beginning of the Tokugawa era (1603–1868). The export trade in prints was a vital part of the economy, and Western artists, particularly the Impressionists, were captivated by the effects Japanese printmakers were able to achieve (see chapter 37). Very popular among the urban classes in Edo (Tokyo) since the 1670s, *ukiyo-e* had gained new potential a century later when a Chinese painting manual, *The Mustard Seed Garden*, accelerated the shift to polychrome printing, which produced multicolored woodblock prints. Woodblock prints were mass produced and thus affordable to artisans, merchants, and other city dwellers. They depicted a wide range of Japanese social and cultural activity, including the daily rituals of life, the theatrical world of actors and geisha, sumo wrestlers, and artisans along with landscapes and nature scenes. Incorporating traditional themes from literature and history, the prints were also notable for introducing contemporary tastes, fads, and fashions, thus forming an invaluable source of knowledge on

the Japanese culture over the more than two centuries of its development.

One of the leading artists of the era, Kitagawa Utamaro [oo-tah-MAH-roh] (1753–1808), illustrated the process of developing color printing in a triptych entitled *Utamaro's Studio* (Fig. **39.15**). Traditionally, the creation of a Japanese print was a team effort, and the publisher, the designer (such as Utamaro), the woodblock carver, and the printer were all considered equal in the process. The publisher conceived of the ideas for the prints, financing individual works or series of works that the public would, in his estimation, be likely to buy. In *Utamaro's Studio* the process begins, at the left, with the workers preparing paper. The paper itself was traditionally made from the inside of the bark of the mulberry tree mixed with bamboo fiber, and it was dampened for 6 hours before printing.

In the middle section of the print, the block is actually prepared. In the foreground, a worker sharpens her chisel on a stone. Behind her is a stack of blocks with brush drawings by Utamaro stuck face down on them with a solution of rice starch dissolved in water. The woman seated at the desk in the middle rubs the back of the drawing to remove several layers of fiber. She then saturates what remains with oil until it becomes transparent. At this point, the original drawing looks as if it were drawn on the block.

Next, in the middle section, workers carve the block, and we see large white areas being chiseled out of the block by the woman seated in the back. Black-and-white prints of this design are made and then returned to the artist, who indicates the colors for the prints, one color to a sheet. The cutter then carves each sheet on a separate block. The final print is, in essence, an accumulation of the individually colored blocks, each color requiring a separate printing.

Utamaro's depiction of *The Fickle Type*, from his series *Ten Physiognomies of Women*, embodies the sensuality of the urban world that *ukiyo-e* prints often reveal (Fig. **39.16**). But probably the most famous series of Japanese prints is *Thirty-Six Views of Mount Fuji* by Katsushika Hokusai [HO-koo-sigh] (1760–1849). The print in that series known as *The Great Wave* has achieved almost iconic status in the art world (Fig. **39.17**). It depicts two boats descending into a trough beneath a giant crashing wave that hangs over the scene like a menacing claw. In the distance, above the horizon, rises Mount Fuji [FOO-jee], symbol to the Japanese of immortality and of Japan itself, framed in a vortex of wave and foam. Though the wave is visually larger than the distant mountain, the viewer knows it will imminently collapse and that Fuji will remain, illustrating both the transience of human experience and the permanence of the natural world. The print also juxtaposes the perils of the

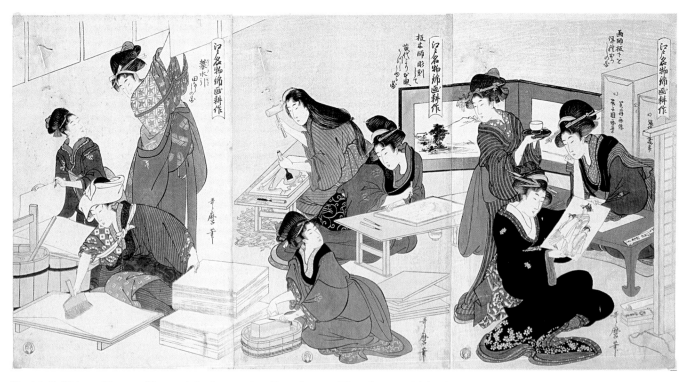

Fig. 39.15 Kitigawa Utamaro. *Utamaro's Studio*. ca. 1790. From the series *Edo meibutsu-e nishiki kosaku*. Ink and color on paper, Oban triptych, 24³/₄″ × 96³/₈″. Published by Tsuraya Kiemon. Clarence Buckingham Collection. 1939.2141. © The Art Institute of Chicago. All rights reserved. Each of the workers is pictured as a pretty girl—which gives the print its status as a *mitate*, or "fanciful picture"—workers in print shops were not normally pretty young women. To further the fancifulness of the image, Utamaro depicts himself at the right, holding a finished print and dressed in women's clothing. His publisher, also dressed as a woman, looks on from behind his desk.

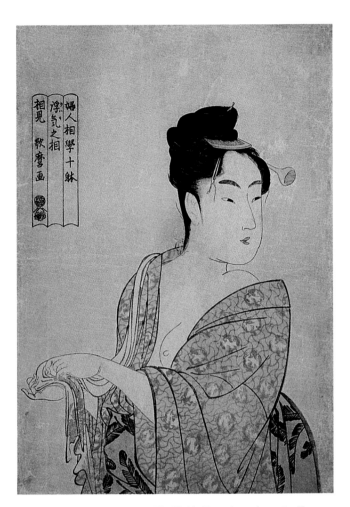

Fig. 39.16 Kitigawa Utamaro. *The Fickle Type,* from the series *Ten Physiognomies of Women.* ca. 1793. Color woodblock print with mica, 14 13/16″ × 9 3/4″. Miriam and Ira D. Wallach Division. The New York Public Library/Art Resource, NY. Utamaro captures the woman's fickleness by having her glance over her shoulder as she returns from the bath, evidently hoping to catch the interested eye of her suitor.

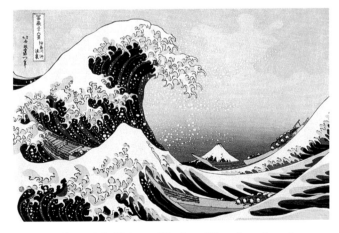

Fig. 39.17 Katsushika Hokusai. *The Great Wave,* from the series *Thirty-Six Views of Mount Fuji.* ca. 1823–1839. Color woodblock print, 10 1/8″ × 14 1/4″. © Historical Picture Archive/CORBIS. The boatsmen can be understood as working in harmony with the powers of nature, something like samurai of the sea.

CULTURAL PARALLELS

The Rise of the Zulu

While European countries projected their economic, military, and technological power worldwide, the southernmost region of Africa had its own strong ruling force, led by Zulu leader Shaka (1787–ca. 1827). Shaka established a large, highly disciplined fighting force aimed at destroying tribal enemies. After 1812, when he assumed full leadership, Shaka used brute force, diplomacy, and patronage to conquer or assimilate other tribes, gaining control of what is today South Africa. It took Europeans more than half a century after Shaka's death to defeat the Zulu nation. Today, the Zulu are South Africa's largest ethnic group.

moment, as represented by the dilemma of the boatmen, and the enduring values of the nation, represented by the solidity of the mountain. Those values can be understood to transcend the momentary troubles and fleeting pleasures of daily life.

Africa and Empire

During the second half of the nineteenth century, European nations competed with each other in acquiring territories in Asia, Africa, Latin America, and elsewhere around the world. In some cases, their management of these areas was direct, with a colonial political structure supervising the governance of the territory. In other cases, control was indirect, focusing on economic domination. In either case this effort to increase the power of nation-states was termed **imperialism**, and the world is still living with the consequences more than a century later. There is probably no more overt statement of the principle than when the British, in 1858, declared Queen Victoria to be the empress of India.

By the beginning of the twentieth century, Western powers had established cultural, political, and economic hegemony (control or domination) over much of the world. They were motivated by economic and strategic self-interest—that is, the control of natural resources and trade routes. Fierce nationalism, and a Europe-centered belief in the superiority of Western culture (as well as the white race), also fueled imperialism. Another important facet of the imperialist philosophy emphasized the humanitarian desire to "improve the lot" of indigenous peoples everywhere. By the last quarter of the century, the African continent was the focal point of imperialist competition.

European Imperialism

A quick glance at a map of Africa illustrates the spread of European domination of the continent after 1880 (Map **39.4**). The scramble for control of the continent began with

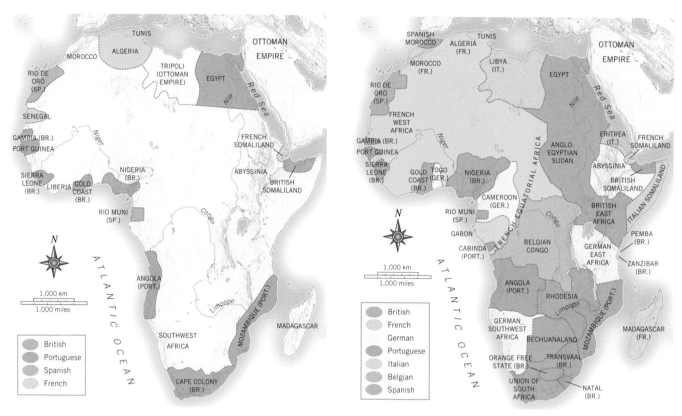

Map 39.4 Imperial expansion in Africa to 1880 (a) and from 1880 to 1914 (b). Until 1880, European occupation of Africa was limited to a few colonies that facilitated shipping along the coast. Between 1880 and 1914, European countries came to control almost the entire continent, with only Liberia and Abyssinia (present-day Ethiopia) remaining independent.

the opening of the Suez Canal in 1869, the shortest route to India, long England's most important and profitable colony. When internal squabbles threatened Egypt's stability in the 1880s, Britain stepped in to protect its interest in the canal, in which it had a major economic investment. Then, to further protect Egypt, it advanced into the Sudan. Beyond Africa's key strategic placement, its vast land area and untapped natural resources proved an irresistible lure for European nations.

France's direct control of Algeria in North Africa dated from 1834, when it formally annexed much of the region. Originally motivated by the desire to thwart piracy in the Mediterranean, France added Tunisia [too-NEE-zhuh], much of West Africa, and Madagascar [mad-uh-GASS-kar] (a large island nation off the east coast of Africa) to its colonies by the 1880s. Not to be left behind, and motivated by a desire to appear at least as powerful as Britain and France, Belgium, Portugal, Spain, and Italy all began to expand previous colonies or acquire new ones. To counter this expansion, and to protect trade routes around the Cape of Good Hope, Britain expanded into present-day Zimbabwe [zim-BAH-bway] and Zambia [ZAM-bee-uh].

Looking at the situation in Africa, Germany's Chancellor Bismarck decided to acquire Southwest Africa (Namibia [nam-IB-ee-uh]), Togoland [TOH-goh-land], the Cameroons [kam-uh-ROONZ], and East Africa (Tanzania [tan-zuh-NEE-

uh]). His motives were purely political, designed to improve his relations with Britain in his never-ending struggles with France and Russia. "My map of Africa lies in Europe," he said. "Here is Russia, and there is France, and here in the middle are we. That is my map of Africa." By and large, European imperial expansion in Africa and Southeast Asia was the nationalist expression of the desire of European countries to assert and expand their own political power.

Economic wealth was also at stake, for the exploitable resources of the African continent made Europe wealthy. France extracted phosphates from Morocco; Belgium acquired gems, ivory, and rubber from the Congo; and England obtained diamonds from South Africa. In this way, Europe's African colonies became (like India) primarily focused on producing large quantities of raw materials—a commodity-based export economy that left most Africans in dire poverty. The social dislocation created by the South African diamond mines is a case in point. In 1866, an African shepherd found a massive diamond of 83.5 carats, quickly dubbed the Star of Africa, on the Orange River. As news of the find spread, Europeans arrived in droves to Kimberley, South Africa, seeking their fortune. Mining was focused around the farm of Diederik Arnoldus de Beer, an Afrikaner [af-rih-KAHN-ur] (Dutch emigrant to South Africa). Gradually, these small, individual plots were bought up by Cecil Rhodes [roads] (1853–1902), and in 1880 he

founded the DeBeers Mining Company. By 1914, Rhodes's Kimberley mine was the largest artificial crater on earth, and he controlled as much as 80 percent of the world's diamonds.

The diamond mines required huge amounts of labor, and native Africans supplied it. Between 1871 and 1875 an estimated 50,000 Africans arrived every year at the diamond mines, replacing roughly the same number that left each year. In a newspaper article published in 1874, Reverend Tyamzashe, an African clergyman, described the scene:

> There are San, Khoikhoi, Griquas, Batlhaping, Damaras, Barolong, Barutse . . . Bapedi, Baganana, Basutu, Maswazi, Matonga, Matabele, Mabaca, Mampondo, Mamfengu, Batembu, Maxosa etc. many of these [people] can hardly understand each other. . . . Those coming from far up in the interior . . . come with the sole purpose of securing guns. Some of them therefore resolve to stay no longer here than is necessary to get some six or seven pounds for the gun. Hence you will see hundreds of them leaving the fields, and as many arriving from the North almost every day.

So the peoples of southern Africa were diffused and reunited around a diamond mine in the South African Central Plateau, before dispersing, presumably with enough money to buy Western weapons to deal with their enemies. Laborers lived in closed compounds designed to control theft but actually closer to prisons. Workers left the compound each morning and returned to it each evening after work, when they were searched for diamonds hidden on their person. These European-designed structures were also a sure way to control potentially unruly Africans. Christian missionaries such as Reverend Tyamzashe were encouraged to start congregations in the compounds to aid in the same policy of control. Their task, as Cecil Rhodes saw it, was to educate and prepare Africans for a future within British colonial society, however limited that might be. These compounds also effectively separated black Africans from the white residents of Kimberley, an enforced separation that in many respects marks the beginning of South African **apartheid** [uh-PAR-tite] (literally "separateness" in Afrikaans [af-rih-KAHNZ], the dialect of Dutch spoken by Afrikaners).

Social Darwinism: The Theoretical Justification for Imperialism

In the extended title of the groundbreaking work *On the Origin of Species by Means of Natural Selection, or the Preservation of Favored Races in the Struggle for Life* (see chapter 35), Charles Darwin's use of the word "race" became a critical ingredient in the development of a new nineteenth-century ideology, **social Darwinism**. To those who desired to validate imperialism and the colonial regimes it fostered in Africa and Asia, social Darwinism explained the supposed social and cultural evolution that elevated Europe (and the white race) above all others nations and races. Europeans, it was argued, were the "fitter" race, and thus were destined not merely to survive but to dominate the world. While still a student at Oxford, Cecil Rhodes had written a "Confession of Faith" in

which he clearly articulated the imperialists' faith in their ability to dominate the world:

> Why should we not form a secret society with but one object, the furtherance of the British Empire and the bringing of the whole civilized world under British rule for the recovery of the United States, for making the Anglo-Saxon race but one Empire? What a dream, but yet it is probable, it is possible.

Such grandiose thinking would later characterize the demented ambitions of Adolf Hitler in Germany. Social Darwinism seemed to overturn traditional Judeo-Christian and Enlightenment ethics, especially those pertaining to compassion and the sacredness of human life. It seemed at once to embrace moral relativism, the belief that ethical positions are determined not by universal truths but by social, political, or cultural conditions (such as the imperial imposition of its values upon another culture) and to support the superior evolutionary "fitness" and superiority of the Aryan [AR-ee-un] (or Anglo-Saxon) race.

Darwin himself meant nothing of the kind. Recognizing the ways in which his theories were being misapplied to social conditions, he published *The Descent of Man* in 1871. In it, he offered a theory of conscience that had a distinctly more ethical viewpoint. Darwin contended that our ancestors, living in small tribal communities, and competing with one another ruthlessly, came to recognize the advantages to successful propagation of the tribe. Over generations, the tribe whose members exhibited selfless behavior that benefited the whole group would tend to survive and prosper over tribes whose members pursued more selfish and individualistic goals. "There can be no doubt," he wrote, "that a tribe including many members who, from possessing in a high degree the spirit of patriotism, fidelity, obedience, courage, and sympathy, were always ready to give aid to each other and to sacrifice themselves for the common good, would be victorious over most other tribes, and this would be natural selection." This is not the ethical philosophy that motivated imperialism.

Darwin's ideas were not the last word on the issue, however, and social Darwinism continually evolved. English philosopher and political theorist Herbert Spencer (1820–1903) offered extensive interpretations of social evolution that were influenced by Darwin but that equated change with constructive progress. Francis Galton (1822–1911) advocated human intervention in evolution, through selective breeding. His theory of **eugenics** focused on eliminating undesirable and less fit members of society by encouraging the proliferation of intelligent and physically fit humans. Galton's theories emphasized eliminating "inferior" humans through increased breeding of the most fit members of society by means of such state intervention as tax and other incentives. Later his theories mutated into the dark ideologies that developed into Nazism in the twentieth century.

Imperialism and the Arts

European imperial involvement in Africa had a substantial impact on the arts over the last half of the nineteenth century

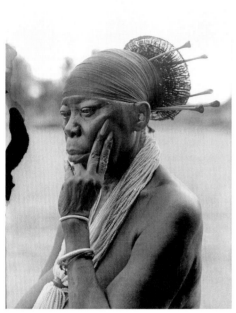

Fig. 39.18 Herbert Lang. Queen Nenzima in her husband Chief Okondo's village. 1910. Mangbetu, Kongo. Courtesy Department Library Services, American Museum of Natural History, NY. Note the length of the nails on the queen's left hand.

Fig. 39.19 Necklace presented to Herbert Lang by Queen Nenzima. 1910. Mangbetu, Kongo. Cord, beads, fingernails, length 12³⁄₈″. American Museum of Natural History, NY. 90.1/4180. Each year the queen cut off the fingernails of her left hand, and sometimes her toenails as well, and gave them away as a very important gift.

One of the most fascinating types of sculpture that came into prominence after the invasion of colonial forces into the Kongo were magical figures known as *minkisi* ("sacred medicine"), which whites termed **fetishes**. *Minkisi* were made by the Kongo tribes for their own use, and they played a central role in symbolizing resistance to the imposition of foreign culture. Throughout Central Africa, all significant human powers are believed to result from communication with the dead. Certain individuals can communicate with the spirits in their role as healers, diviners, and defenders of the living. They are believed to harness the powers of the spirit world through *minkisi*. Among the most formidable of *minkisi* is the type known as *minkonde*, which are said to pursue witches, thieves, adulterers, and wrongdoers by night. The communicator activates a *minkonde* by driving nails, blades, and other pieces of iron into it so that it will deliver similar injuries to those worthy of punishment.

Minkonde figures usually stand upright (Fig. 39.20). One arm is raised and holds a knife or spear (often missing, as here), suggesting that it is ready to attack. A hole in the figure's stomach contained magical "medicines," often kaolin, a white clay believed to be closely linked to the world of the dead, and red ocher, linked symbolically to blood. Such figures—designed to evoke awe in the spectator—were seen by European missionaries as evidence of witchcraft, and the missionaries destroyed many of them. In fact, the *minkonde* represented a form of **animism**, a foundation to many religions, including that of Native Americans, and referring to the belief in the existence of souls and the conviction that nonhuman things can also be endowed with a soul. European military commanders saw them as evidence of an aggressive native opposition to colonial control. Despite their suppression during the colonial era, such figures are still made and used by the peoples of the Kongo.

as European and American collectors supplanted the royal courts of Africa as the major collectors of African art. In essence, foreigners replaced indigenous leaders as interpreters and authorities on the cultural heritage of the African continent. Also at this time the major European ethnographic museums were founded, furthering the ascent of European influence. In the United States, the American Museum of Natural History opened in New York in 1869, although its African collection was not significant until one of its scientists, Herbert Lang (1879–1957), organized a collecting trip in 1909. Over the course of 6 years, Lang and his assistant traveled throughout the Kongo River basin region of central Africa collecting over 54 tons of specimens and a large number of artifacts, requiring 38,000 porters and assistants. Among the most remarkable works brought back by Lang was a necklace made from the fingernails of Nenzima, the reigning queen of the Mangbetu (Figs. **39.18**, **39.19**). Possession of a part of the queen's body conferred her power on the owner, and Lang was evidently given the necklace as a sign of trust. He returned the favor by leaving the queen his thumbnail.

Fig. 39.20 Magical figure, *nkisi nkonde*, Kongo (Muserongo), Zaire. Late nineteenth century. Wood, iron nails, glass, resin, height 20″. The Stanley Collection. X1986.573. The University of Iowa Museum of Art, Iowa City, IA. The number of nails and blades driven into this figure indicates the number of clients who sought the aid of its magical powers.

READING

from James Fenimore Cooper, *The Pioneers*, Chapter XXII (1823)

The Pioneers was the first of a series of five novels that came to be known as The Leather-stocking Tales. *The series derives its name from the nickname of Natty Bumppo, a character who is both frontiersman and Native American, and who thus embodies the tension between civilization and the untamed wilderness that is at the heart of Cooper's fiction. No moment in* The Pioneers *underscores this tension more than when Natty and villagers of Oswego confront the massive migration of passenger pigeons in chapter 22.*

> "Men, boys, and girls.
> Desert th' unpeopled village; and wild crowds
> Spread o'er the plain, by the sweet frenzy driven."
> —Somerville

From this time to the close of April, the weather continued to be a succession of great and rapid changes. One day, the soft airs of spring would seem to be stealing along the valley, and, in unison with an invigorating sun, attempting, covertly, to rouse the dormant powers of the vegetable world; while on the next, the surly blasts from the north would sweep across the lake, and erase every impression left by their gentle adversaries. The snow, however, finally disappeared, and the green wheat fields were seen in every direction, spotted with the dark and charred stumps that had, the preceding season, supported some of the proudest trees of the forest. Ploughs were in motion, wherever those useful implements could be used, and the smokes of the sugar-camps were no longer seen issuing from the summits of the woods of maple. The lake had lost all the characteristic beauty of a field of ice, but still a dark and gloomy covering concealed its waters, for the absence of currents left them yet hid under a porous crust, which, saturated with the fluid, barely retained enough of its strength to preserve the contiguity of its parts. Large flocks of wild geese were seen passing over the country, which would hover, for a time, around the hidden sheet of water, apparently searching for an opening, where they might obtain a resting-place; and then, on finding themselves excluded by the chill covering, would soar away to the north, filling the air with their discordant screams, as if venting their complaints at the tardy operations of nature.

For a week, the dark covering of the Otsego was left to the undisturbed possession of two eagles, who alighted on the centre of its field, and sat proudly eyeing the extent of their undisputed territory. During the presence of these monarchs of the air, the flocks of migrating birds avoided crossing the plain of ice, by turning into the hills, and apparently seeking the protection of the forests, while the white and bald heads of the tenants of the lake were turned upward, with a look of majestic contempt, as if penetrating to the very heavens, with the acuteness of their vision. But the time had come, when even these kings of birds were to be dispossessed. An opening had been gradually increasing, at the lower extremity of the lake, and around the dark spot where the current of the river had prevented the formation of ice, during even the coldest weather; and the fresh southerly winds, that now breathed freely up the valley, obtained an impression on the waters. Mimic waves begun to curl over the margin of the frozen field, which exhibited an outline of crystallizations, that slowly receded towards the north. At each step the power of the winds and the waves increased, until, after a struggle of a few hours, the turbulent little billows succeeded in setting the whole field in an undulating motion, when it was driven beyond the reach of the eye, with a rapidity, that was as magical as the change produced in the scene by this expulsion of the lingering remnant of winter. Just as the last sheet of agitated ice was disappearing in the distance, the eagles rose over the border of crystals, and soared with a wide sweep far above the clouds, while the waves tossed their little caps of snow into the air, as if rioting in their release from a thralldom of five months duration.

The following morning Elizabeth was awakened by the exhilarating sounds of the martins, who were quarrelling and chattering around the little boxes which were suspended above her windows, and the cries of Richard, who was calling, in tones as animating as the signs of the season itself—

"Awake! Awake! My lady fair! the gulls are hovering over the lake already, and the heavens are alive with the pigeons. You may look an hour before you can find a hole, through which, to get a peep at the sun. Awake! awake! lazy ones! Benjamin is overhauling the ammunition, and we only wait for our breakfasts, and away for the mountains and pigeon-shooting."

There was no resisting this animated appeal, and in a few minutes Miss Temple and her friend descended to the parlour. The doors of the hall were thrown open, and the mild,

balmy air of a clear spring morning was ventilating the apartment, where the vigilance of the ex-steward had been so long maintaining an artificial heat, with such unremitted diligence. All of the gentlemen, we do not include Monsieur Le Quoi, were impatiently waiting their morning's repast, each being equipt in the garb of a sportsman. Mr. Jones made many visits to the southern door, and would cry—

"See, cousin Bess! see, 'duke! The pigeon-roosts of the south have broken up! They are growing more thick every instant. Here is a flock that the eye cannot see the end of. There is food enough in it to keep the army of Xerxes[1] for a month, and feathers enough to make beds for the whole county. Xerxes, Mr. Edwards, was a Grecian king, who—no, he was a Turk, or a Persian, who wanted to conquer Greece, just the same as these rascals will overrun our wheat-fields, when they come back in the fall.—Away! away! Bess; I long to pepper them from the mountain."

In this wish both Marmaduke and young Edwards seemed equally to participate, for really the sight was most exhilarating to a sportsman; and the ladies soon dismissed the party, after a hasty breakfast.

If the heavens were alive with pigeons, the whole village seemed equally in motion, with men, women, and children. Every species of fire-arms, from the French ducking-gun, with its barrel of near six feet in length, to the common horseman's pistol, was to be seen in the hands of the men and boys; while bows and arrows, some made of the simple stick of a walnut sapling, and others in a rude imitation of the ancient cross-bows, were carried by many of the latter.

The houses, and the signs of life apparent in the village, drove the alarmed birds from the direct line of their flight, towards the mountains, along the sides and near the bases of which they were glancing in dense masses, that were equally wonderful by the rapidity of their motion, as by their incredible numbers.

We have already said, that across the inclined plane which fell from the steep ascent of the mountain to the banks of the Susquehanna, ran the highway, on either side of which a clearing of many acres had been made, at a very early day. Over those clearings, and up the eastern mountain, and along the dangerous path that was cut into its side, the different individuals posted themselves, as suited their inclinations; and in a few moments the attack commenced.

Amongst the sportsmen was to be seen the tall, gaunt form of Leather-stocking, who was walking over the field, with his rifle hanging on his arm, his dogs following close at his heels, now scenting the dead or wounded birds, that were beginning to tumble from the flocks, and then crouching under the legs of their master, as if they participated in his feelings, at this wasteful and unsportsmanlike execution.

The reports of the fire-arms became rapid, whole volleys rising from the plain, as flocks of more than ordinary numbers darted over the opening, covering the field with darkness, like an interposing cloud; and then the light smoke of a single piece would issue from among the leafless bushes on the mountain, as death was hurled on the retreat of the affrighted birds, who would rise from a volley, for many feet into the air, in a vain effort to escape the attacks of man. Arrows, and missiles of every kind, were seen in the midst of the flocks; and so numerous were the birds, and so low did they take their flight, that even long poles, in the hands of those on the sides of the mountain, were used to strike them to the earth.

During all this time, Mr. Jones, who disdained the humble and ordinary means of destruction used by his companions, was busily occupied, aided by Benjamin, in making arrangements for an assault of a more than ordinarily fatal character. Among the relics of the old military excursions, that occasionally are discovered throughout the different districts of the western part of New-York, there had been found in Templeton, at its settlement, a small swivel,[2] which would carry a ball of a pound weight. It was thought to have been deserted by a war-party of the whites, in one of their inroads into the Indian settlements, when, perhaps, their convenience or their necessities induced them to leave such an encumbrance to the rapidity of their march, behind them in the woods. This miniature cannon had been released from the rust, and mounted on little wheels, in a state for actual service. For several years, it was the sole organ for extraordinary rejoicings that was used in those mountains. On the mornings of the Fourth of July, it would be heard, with its echoes ringing among the hills, and telling forth its sounds, for thirteen times, with all the dignity of a two-and-thirty pounder; and even Captain Hollister, who was the highest authority in that part of the country on all such occasions, affirmed that, considering its dimensions, it was no despicable gun for a salute. It was somewhat the worse for the service it had performed, it is true, there being but a trifling difference in size between the touch-hole and the muzzle. Still, the grand conceptions of Richard had suggested the importance of such an instrument, in hurling death at his nimble enemies. The swivel was dragged by a horse into a part of the open space, that the sheriff thought most eligible for planting a battery of the kind, and Mr. Pump proceeded to load it. Several handfuls of duck-shot were placed on top of the powder, and the Major-domo soon announced that his piece was ready for service.

The sight of such an implement collected all the idle spectators to the spot, who, being mostly boys, filled the air with their cries of exultation and delight. The gun was pointed on high, and Richard, holding a coal of fire in a pair of tongs, patiently took his seat on a stump, awaiting the appearance of a flock that was worthy of his notice.

So prodigious was the number of the birds, that the scattering fire of the guns, with the hurling of missiles, and the cries of the boys, had no other effect than to break off small flocks from the immense masses that continued to dart along the valley, as if the whole creation of the feathered tribe were pouring through that one pass. None pretended to collect the

[1]Xerxes, King of Persia, led his vast army against the Greeks in 480 BCE, and was finally defeated in the naval battle at Salamis by Themistocles (see chapter 6).

[2]A small cannon that can be swung right or left.

game, which lay scattered over the fields in such profusion, as to cover the very ground with the fluttering victims. [180]

Leather-stocking was a silent, but uneasy spectator of all these proceedings, but was able to keep his sentiments to himself until he saw the introduction of the swivel into the sports.

"This comes of settling a country" he said—"here have I known the pigeons to fly for forty long years, and, till you made your clearings, there was nobody to scare or to hurt them. I loved to see them come into the woods, for they were company to a body; hurting nothing; being, as it was, as harmless as a garter-snake. But now it gives me sore thoughts when I hear the frighty things whizzing through the air, for I [190] know it's only a motion to bring out all the brats in the village at them. Well! the Lord won't see the waste of his creaters for nothing, and right will be done to the pigeons, as well as others, by-and-by.—There's Mr. Oliver, as bad as the rest of them, firing into the flocks as if he was shooting down nothing but the Mingo[3] warriors."

Among the sportsmen was Billy Kirby, who, armed with an old musket, was loading, and, without even looking into the air, was firing, and shouting as his victims fell even on his own person. He heard the speech of Natty, and took upon [200] himself to reply—

"What's that, old Leather-stocking!" he cried; "grumbling at the loss of a few pigeons! If you had to sow your wheat twice, and three times, as I have done, you wouldn't be so massyfully[4] feeling'd to'ards the devils.—Hurrah, boys! scatter the feathers. This is better than shooting at a turkey's head and neck, old fellow."

"It's better for you, maybe, Billy Kirby," returned the indignant old hunter, "and all them as don't know how to put a ball down a rifle-barrel, or how to bring it up ag'in with a true [210] aim; but it's wicked to be shooting into flocks in this wastey manner; and none do it, who know how to knock over a single bird. If a body has a craving for pigeon's flesh, why! it's made the same as all other creaters, for man's eating, but not to kill twenty and eat one. When I want such a thing, I go into the woods till I find one to my liking, and then I shoot him off the branches without touching a feather of another, though there might be a hundred on the same tree. But you couldn't do such a thing, Billy Kirby—you couldn't do it if you tried." [220]

"What's that you say, you old, dried cornstalk! you sapless stub!" cried the wood-chopper. "You've grown mighty boasting, sin[5] you killed the turkey; but if you're for a single shot, here goes at that bird which comes on by himself."

The fire from the distant part of the field had driven a single pigeon below the flock to which it had belonged, and, frightened with the constant reports of the muskets, it was approaching the spot where the disputants stood, darting first from one side, and then to the other, cutting the air with the swiftness of lightning, and making a noise with its wings, not [230]

unlike the rushing of a bullet. Unfortunately for the wood-chopper, notwithstanding his vaunt, he did not see his bird until it was too late for him to fire as it approached, and he pulled his trigger at the unlucky moment when it was darting immediately over his head. The bird continued its course with incredible velocity.

Natty had dropped his piece from his arm, when the challenge was made, and, waiting a moment, until the terrified victim had got in a line with his eyes, and had dropped near the bank of the lake, he raised his rifle with uncommon [240] rapidity, and fired. It might have been chance, or it might have been skill, that produced the result; it was probably a union of both; but the pigeon whirled over in the air, and fell into the lake, with a broken wing. At the sound of his rifle, both his dogs started from his feet, and in a few minutes the "slut"[6] brought out the bird, still alive.

The wonderful exploit of Leather-stocking was noised through the field with great rapidity, and the sportsmen gathered in to learn the truth of the report.

"What," said young Edwards, "have you really killed a [250] pigeon on the wing, Natty, with a single ball?"

"Haven't I killed loons before now, lad, that dive at the flash?" returned the hunter. "It's much better to kill only such as you want, without wasting your powder and lead, than to be firing into God's creaters in such a wicked manner. But I come out for a bird, and you know the reason why I like small game, Mr. Oliver, and now I have got one I will go home, for I don't like to see these wasty ways that you are all practysing, as if the least thing was not made for use, and not to destroy."

"Thou sayest well, Leather-stocking," cried Marmaduke, [260] "and I begin to think it time to put an end to this work of destruction."

"Put an ind, Judge, to your clearings. An't the woods his work as well as the pigeons? Use, but don't waste. Wasn't the woods made for the beasts and birds to harbour in? and when man wanted their flesh, their skins, or their feathers, there's the place to seek them. But I'll go to the hut with my own game, for I wouldn't touch one of the harmless things that kiver the ground here, looking up with their eyes at me, as if they only wanted tongues to say their thoughts." [270]

With this sentiment in his mouth, Leather-stocking threw his rifle over his arm, and, followed by his dogs, stepped across the clearing with great caution, taking care not to tread on one of the hundreds of the wounded birds that lay in his path. He soon entered the bushes on the margin of the lake, and was hid from view.

Whatever might be the impression the morality of Natty made on the Judge, it was utterly lost on Richard. He availed himself of the gathering of the sportsmen, to lay a plan for one "fell swoop"[7] of destruction. The musket-men were drawn up [280] in battle array, in a line extending on each side of his artillery, with orders to await the signal of firing from himself.

[3]In Cooper's novels the Mingo (Iroquois) are depicted as enemies of the white settlers.
[4]Mercifully.
[5]Since.

[6]A female dog, or "bitch."
[7]A quotation from Shakespeare's *Macbeth*, Act 4, Scene 3, as Macduff mourns the loss of his wife and children.

"Stand by, my lads," said Benjamin, who acted as an aid-de-camp on this momentous occasion, "stand by, my hearties, and when Squire Dickens heaves out the signal for to begin the firing, d'ye see, you may open upon them in a broadside. Take care and fire low, boys, and you'll be sure to hull the flock."

"Fire low!" shouted Kirby—"hear the old fool! If we fire low, we may hit the stumps, but not ruffle a pigeon." 290

"How should you know, you lubber?"[8] cried Benjamin, with a very unbecoming heat, for an officer on the eve of battle—"how should you know, you grampus? Havn't I sailed aboard of the Boadishy for five years? and wasn't it a standing order to fire low, and to hull your enemy? Keep silence at your guns, boys, and mind the order that is passed."

The loud laughs of the musketmen were silenced by the authoritative voice of Richard, who called to them for attention and obedience to his signals.

Some millions of pigeons were supposed to have already 300 passed, that morning, over the valley of Templeton; but nothing like the flock that was now approaching had been seen before. It extended from mountain to mountain in one solid blue mass, and the eye looked in vain over the southern hills to find its termination. The front of this living column was distinctly marked by a line, but very slightly indented, so regular and even was the flight. Even Marmaduke forgot the morality of Leather-stocking as it approached, and, in common with the rest, brought his musket to his shoulder.

"Fire!" cried the Sheriff, clapping his coal to the priming 310 of the cannon. As half of Benjamin's charge escaped through the touch-hole, the whole volley of the musketry preceded the report of the swivel. On receiving this united discharge of small-arms, the front of the flock darted upward, while, at the same instant, myriads of those in their rear rushed with amazing rapidity into their places, so that when the column of white smoke gushed from the mouth of the little cannon, an accumulated mass of objects was gliding over its point of direction. The roar of the gun echoed along the mountains, and died away to the north, like distant thunder, while the 320 whole flock of alarmed birds seemed, for a moment, thrown into one disorderly and agitated mass. The air was filled with their irregular flights, layer rising over layer, far above the tops of the highest pines, none daring to advance beyond the dangerous pass; when, suddenly, some of the leaders of the feathered tribe shot across the valley, taking their flight directly over the village, and the hundreds of thousands in their rear followed their example, deserting the eastern side of the plain to their persecutors and the fallen.

"Victory!" shouted Richard, "victory! we have driven the 330 enemy from the field."

"Not so, Dickon," said Marmaduke; "the field is covered with them; and, like the Leather-stocking, I see nothing but eyes, in every direction, as the innocent sufferers turn their heads in terror, to examine my movements. Full one half of those that have fallen are yet alive: and I think it is time to end the sport; if sport it be."

"Sport!" cried the Sheriff; "it is princely sport. There are some thousands of the blue-coated boys on the ground, so that every old woman in the village may have a pot-pie for 340 the asking."

"Well, we have happily frightened the birds from this pass," said Marmaduke, "and our carnage must of necessity end, for the present.—Boys, I will give thee sixpence a hundred for the pigeons' heads only; so go to work, and bring them into the village, when I will pay thee."

This expedient produced the desired effect, for every urchin on the ground went industriously to work to wring the necks of the wounded birds. Judge Temple retired towards his dwelling with that kind of feeling, that many a 350 man has experienced before him, who discovers, after the excitement of the moment has passed, that he has purchased pleasure at the price of misery to others. Horses were loaded with the dead; and, after this first burst of sporting, the shooting of pigeons became a business, for the remainder of the season, more in proportion to the wants of the people. Richard, however, boasted for many a year, of his shot with the "cricket;"[9] and Benjamin gravely asserted, that he thought that they killed nearly as many pigeons on that day, as there were Frenchmen destroyed on the memorable occa- 360 sion of Rodney's victory.[10] ∎

Reading Question

The destructiveness of civilization is made abundantly clear in this narrative. How does Cooper's military metaphor underscore it?

[8]Landlubber, a landsman or untrained seaman.

[9]A little cannon.
[10]In April 1782, the British admiral George Bridges, Baron Rodney, defeated the French in a naval battle in the West Indies.

 Summary

■ **The Native American in Myth and Reality** The confrontation between white settlers and indigenous Americans accelerated after the Louisiana Purchase in 1803, effectively doubling the size of the United States. With the population of nonnative Americans rising from 4 million in 1790 to 31 million in 1860, the pressure was relentless on Native American tribes seeking to maintain their traditional hunting and gathering lifestyles. While American presidents like Washington, Jefferson, and Jackson emphasized the importance of "civilizing" Native Americans by converting them to Christianity, teaching them to farm, and educating their children, settlers on the frontier often ran roughshod over native rights, breaking treaty agreements and ignoring Indian land rights.

American artists of the nineteenth century offered a range of mythic interpretations of the frontier experience. Albert Bierstadt emphasized the "primitive" landscape, untainted by human civilization, and Emanuel Leutze offered heroic depictions of white American pioneers moving westward to build a new destiny. Other popular artists, such as John Vanderlyn, represented Native Americans as depraved and violent or, in the unique case of George Catlin, as a noble, disappearing race of innocents. America's first successful novelist, James Fenimore Cooper, also took the disappearance of Native Americans and their lands as one of his main subjects in the five novels comprising *The Leatherstocking Tales*.

Native American artists offered unique testament to their cultures and the rapid changes that overtook them by the end of the century. Families, bands, and tribes illustrated their histories by painting semiabstract figures on buffalo-hide robes, tepees, and shields, which they then used as memory aids for oral narratives, often regarded as "storytelling." Indigenous women artists used quillwork and beadwork to decorate tepees, shields, and implements, offering evidence of history and tribal myths in their work.

■ **The British in China and India** The European-American conflict with indigenous Americans mirrored encounters between Westerners and non-Western peoples and cultures during the eighteenth and nineteenth centuries. With their scientific and technological advances providing a decided edge in military and economic competition, Western nations began a concerted effort to dominate Asian and African nations with abundant resources or productive economies in order to transfer the wealth to their own countries. Britain proved the most successful at this through the policy of imperialism, which included using aggressive military and economic policies to take control either directly or indirectly of non-Western nations. Colonists played a major role by establishing plantations, other economic enterprises, and colonial governments in order to effectively transfer sovereignty to Britain and other colonial powers, such as France, Germany, and Belgium.

China fell victim to Britain's aggressive imperialist tactics in the late 1830s. Resisting the British effort to import massive quantities of opium in their country, the Chinese struggled to impose trade restrictions on this addictive drug. British merchants, supported by their government and the British military, forced the Chinese to back down in the "Opium War" of 1840–1842.

India, having fallen under control of Britain in the late-eighteenth century, also was negatively affected by imperialism. Its economy was seriously damaged by the British policies that forced Indians to sell raw materials at exploitatively low prices, and then undercut Indian manufacturers by selling finished textiles at below-market prices.

■ **The Opening of Japan** Japan was one of the few major Asian nations not overwhelmed by the West's aggressive military and economic policies. After the forced "opening" of Japan by American Commodore Matthew Perry in 1853, Japan embarked on new trade and diplomatic relationships with Europe and the United States, while also beginning a rapid effort to modernize its economy and government. After 1868, Japanese industrialization quickened, and a flood of manufactured products reached the West for the first time.

Among the most distinctive of those products were woodblock prints, or *ukiyo-e*, which depicted the "floating world" of urban Japan—the rituals of everyday life, the theatrical world, artisans, as well as landscapes and nature scenes.

■ **Africa and Empire** Beginning with the opening of the Suez Canal in 1869, Africa proved an irresistible lure for European colonial and imperialist interests, particularly for Britain, France, Germany, and Belgium. At stake were the exploitable natural resources of the African continent, including phosphates, gems, ivory, and rubber. Europe's African colonies were mostly used to produce large quantities of raw materials at the lowest possible price, which left most Africans in dire poverty.

Europe's imperialists justified their policies through the philosophy of social Darwinism, which explained social and cultural evolution as a part of Charles Darwin's theory of biological evolution. "Survival of the fittest" was the explanation for the supposed superiority of Europeans over Africans (and all other races and ethnicities). By extension, Europeans theorized that their culture, government, and institutions were likewise superior.

 # Glossary

animism Belief in the existence of souls and that nonhuman things can also be endowed with a soul.

apartheid A policy that promotes or is founded on racial segregation, especially as occurred in South Africa.

eugenics A theory focused on eliminating undesirable and less fit members of society by encouraging the proliferation of intelligent and physically fit humans.

fetish A figure or object with magical properties.

imperialism The extension of one nation's authority over another by the exercise of its military, economic, and/or political power.

social Darwinism An extension of Darwin's theory of evolution positing that nations and societies advance according to the rule of "the survival of the fittest."

 # Critical Thinking Questions

1. What single event do you think was most responsible for the *decentering* of culture in each of the following: Native Americans, Japan, India, and Africa?

2. How would you describe the difference between Native American attitudes about the land and those of the white settlers of North America?

3. What factors motivated European imperialism? Were they the same for each nation or group of colonizers?

4. Compare and contrast *Japonisme* with Europeans' interest in African arts.

The African Mask

When Westerners first encountered African masks in the ethnographic museums of Europe in the late nineteenth and early twentieth centuries, they saw them in a context far removed from their original settings and purposes. Pablo Picasso first saw such masks sometime in 1907 at the Musée d'Ethnographie de Trocadéro (later the Museum of Man) in Paris as he was working on the painting that many think of as announcing the birth of modern art, *Les Demoiselles d'Avignon*, a painting of prostitutes in the red-light district of Barcelona (see chapter 41). He was strongly affected by the experience. The masks seemed to him imbued with power that allowed him, for the first time, to see art, he said, as "a form of magic designed to be a mediator between the strange, hostile world and us, a way of seizing power by giving form to our terrors as well as our desires." As a result, he quickly transformed the faces of three of the five prostitutes in his painting into African masks (Fig. **39.21**).

Picasso's appropriation of African masks neglects their ritual, often celebratory social function in African society. Even Africans, it would appear, recognize that in a Western context, their masks lose their ritual power. A mask from Zaire (Fig. **39.22**) is a case in point. This mask was used in initiation dances among the hunters and fishers of the Ngbandi peoples in northwest Zaire around 1920, before the arrival of an invading column of the Belgian *Force Publique* [forss poo-BLEEK]. Since the 1880s, the Belgian troops had conscripted millions of tribal members throughout the Kongo region into virtual slave labor in order to meet rubber quotas, sometimes burning whole villages. Women were often captured, flogged, and raped by the Belgian troops in order to force their husbands to collect rubber. This time, the Ngbandi defeated the colonial army, which fled, leaving behind pails of green and white camouflage paint. So the Ngbandi adorned this mask with camouflage and placed it on an altar to celebrate their victory. But the mask could never be danced in an initiation rite again because it was tainted by its European coloration. ■

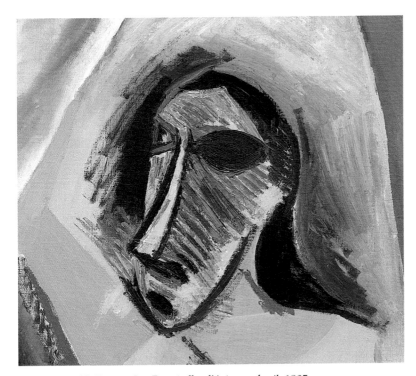

Fig. **39.21** Pablo Picasso. *Les Demoiselles d'Avignon,* detail. 1907. Oil on canvas, 8′ × 7′ 8″. Acquired through the Lille P. Bliss Bequest. (333.1939). The Museum of Modern Art, New York, NY, U.S.A. Digital Image © The Museum of Modern Art/Licensed by SCALA/Art Resource, NY. © Estate of Pable Picasso/ARS Artists Rights Society, NY.

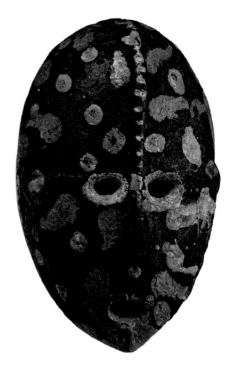

Fig. **39.22** **Mask. ca. 1915–1920. Ngbandi, Zaire.** Wood, European paint, height 11″. The Stanley Collection, The University of Iowa Museum of Art, Iowa City, IA. X1986.591.

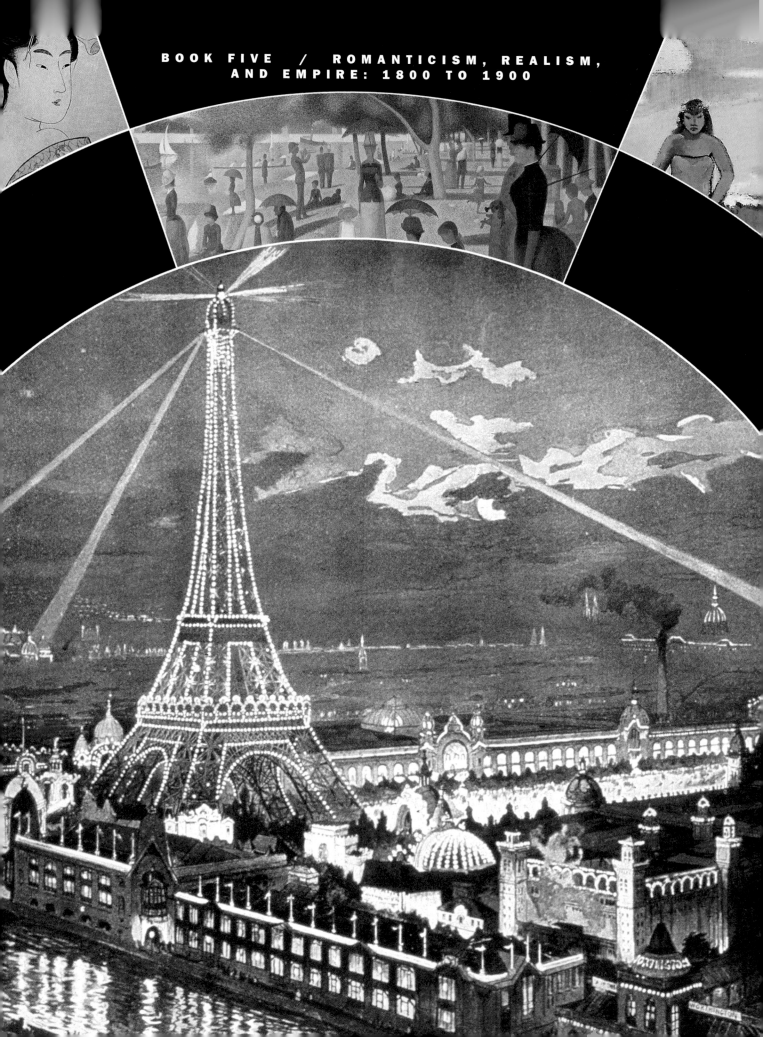

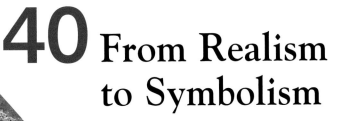

40 From Realism to Symbolism

The Fin de Siècle

" *One epoch of history is unmistakably in its decline, and another is announcing its approach. . . . Men look with longing for whatever new things are at hand . . .* **"**

Max Nordau

◄ Fig. 40.1 *Les Fêtes de Nuit à la Exposition.* **1900.** From *L'Exposition de Paris* (1900). Smithsonian Institution, Washington, DC. The 1889 and 1900 expositions in Paris drew visitors from around the world to celebrate the centennial of the French Revolution and the beginning of a new century. In 1900, Paris was lit for the first time by electric light, and the Eiffel Tower, erected for the Exposition of 1889, was the centerpiece of "les fêtes de nuit," the nighttime celebrations at the fair. It was as if darkness were evaporating, both literally and figuratively, and that a new light was about to dawn.

PARIS'S *EXPOSITION UNIVERSELLE* OF 1889 (MAP 40.1) WAS A fitting postscript to the nineteenth century as well as a precursor to the twentieth. It commemorated imperial supremacy, modern technology, and national pride one century after the beginning of the French Revolution. Further, the exposition

showcased France's cultural heritage and confirmed the status of Paris as one of the world's great centers of art. As he opened the fair, French President Sadi Carnot hailed the "new era in the history of mankind" that the revolutionary events of 1789 initiated, and the "century of labor and progress" that had unfolded since then.

But Carnot had little inkling of the darker side of technology and nationalism that would be unleashed over the next 50 years when two world wars killed over 60 million people with unparalleled efficiency. Ideologies also grew more strident and dangerous in the ensuing decades, becoming virulently transnational in scope and as dangerous as technology if unrestrained. France's president himself would become a victim of a new ideology 5 years later when an Italian anarchist assassinated him to avenge the execution of several

French anarchists who had participated in bombings. It seems that while nationalism held an increasing, often irrational sway over human behavior, political theories such as anarchism and, later, fascism and communism would also lead to violent and destructive actions by individuals and groups aiming to reshape society to their own standards.

This chapter surveys the era just before and after the 1889 Exposition, now labeled the *fin de siècle* [fen duh see-EKL], or "end of the century," but implying much more. The 1890s were characterized by an atmosphere of opulence, decadence, and anticipation as Europeans prepared to enter the twentieth century. Paris was widely acknowledged as the center of the fin de siècle spirit and one of the centers of artistic and literary innovation. The progression of Western cultural movements and styles

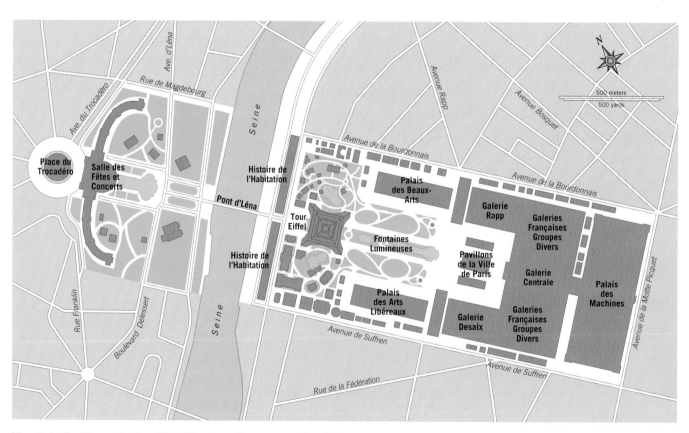

Map 40.1 **The Champs de Mars, World Exposition, Paris. 1889.** The Eiffel Tower is at left.

chronicled in this chapter—Art Nouveau, Symbolism, and Post-Impressionism—reveal a deeper mood of uncertainty about the world. Doubts about human rationality and about positivism—the belief that the scientific approach could explain and solve problems of the individual and society, were key elements of this uncertainty. In the realm of politics, revolution after revolution had promised a brighter future, but the rise of the bourgeois middle class proved unsettling, for its values seemed crassly materialistic, self-centered, and hypocritical. Even as scientific and technological innovation was everywhere apparent, artists found it difficult to reflect that spirit of innovation in their own work. A "new" modern art was struggling to be born, seemingly against the tide of popular culture and opinion.

A Fair to Remember: The Paris Exposition of 1889

The social and political problems of the next century were certainly not in the minds of the 28 million people who visited the Paris fair in 1889. They excitedly circulated among the artistic, commercial, and engineering marvels displayed by more than 6,000 exhibitors on over 235 acres and thought about a future embodied by that marvel of architecture and technology unveiled at the fair—the Eiffel Tower (Fig. **40.1**). The past was also represented at the fair in the form of a village of 400 native Africans and similar displays of numerous

other indigenous peoples from Asia and Africa in a "colonial" section. Together with reproductions of housing from around the world, the fair's "colonies" attested to the seemingly limitless ambition and power of imperial nations such as France to command the world's resources and peoples (Fig. **40.2**). A decade later, *Exposition Universelle* of 1900 (see Fig. 40.1) would reaffirm another decade of cultural progress, imperial power, and rapid technological advances.

The future was the chief attraction of the Paris Exposition, and *invention* was the key word of the day. In the Palace of Machines, Thomas Edison exhibited 493 new devices, including a huge carbon-filament electric lamp made from many smaller lamps. The magic of electricity made it possible to illuminate all 235 acres of the exposition. His phonograph was also a great attraction as thousands of visitors lined up each day to hear the machine. Other inventions fascinated the public—in the Telephone pavilion, one could listen to live performances of the Comédie Française through two earphones that created a convincing stereo effect.

The most popular "exhibit," however, was Gustav Eiffel's [EYEful] Tower (see Fig. 40.1), a 984-foot-high open-frame structure at the entrance of the fair that dominated the city. Almost twice the height of any other building in the world, the tower was meant "to raise to the glory of modern science and to the greater honor of French industry, an arch of triumph,"

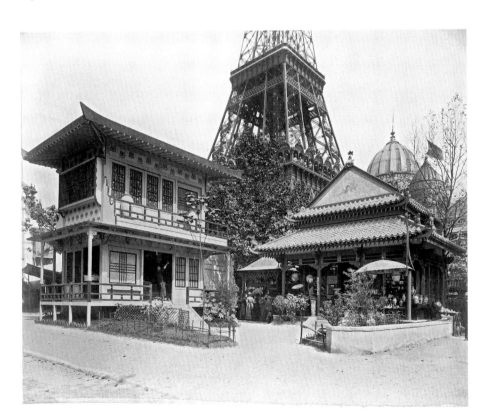

Fig. 40.2 **Japanese house (left) and Chinese house (right) in the History of Habitation exhibit,** *Exposition Universelle,* **Paris. 1889.** Library of Congress, Washington, DC. LC-US262-106562. The juxtaposition of East and West underscores the growing decentralization of culture discussed in chapter 39.

according to Eiffel. One of the main challenges he faced was how to protect the tower from the wind, which he solved by designing three levels of wrought-iron piers to provide efficient wind resistance. Once the tower was completed, spotlights positioned on the third level illuminated various Paris monuments. One of the world's first electric beacons on the top of the tower flashed a brilliant light, visible for more than a 100 miles, into the night sky. Electricity also allowed fair visitors to ascend almost a thousand feet to an observation platform at the top of the tower in a hydraulic elevator designed by the Otis Elevator Company.

Not everyone was pleased with the project. From the early 1880s, when the tower was under consideration, to 1887, when construction began, a fusillade of angry resistance issued forth from architects, artists, and people who lived in the vicinity of the project. Three hundred prominent artists and writers submitted the *Protestation des artistes* [pro-tes-tah-see-OHN dayz-ar-TEEST] to the Minister of Public Works, forcefully arguing that the erection of the tower was a violation of the city's beauty:

> Writers, painters, sculptors, architects, passionate lovers of the heretofore intact beauty of Paris, we come to protest with all our strength, with all our indignation, in the name of betrayed French taste, in the name of threatened French art and history, against the erection in the heart of our capital of the useless and monstrous Eiffel Tower.

Charles Garnier, the designer of the Paris Opera (chapter 36) and spokesperson for traditional architecture, was one of the key opponents because of the tower's bold new style and high profile as well as the fact that it eclipsed his own buildings at the fair. With his "History of Habitation" exhibit Garnier attempted to portray the progressive evolutionary history of humans through the buildings they lived in. The 33 buildings he carefully built to exacting historical standards illustrated how humans had improved their habitats over time through ingenious technology and architectural planning. However, Garnier's admiration for progress only went so far—and certainly did not include approval of the Eiffel Tower's mere "framework," as he ridiculed it.

If a writer like Guy de Maupassant [moh-pah-SOHN] lunched at the restaurant in the tower, it was not because he liked the food—he didn't—but because "It's the only place in Paris where I don't have to see it." Nevertheless, the tower quickly became one of the city's landmarks. Gradually, through the last decade of the century the Eiffel Tower came to symbolize not only Paris itself, but modernity. It was a very popular symbol of "the new."

The Fin de Siècle: From Naturalism to Symbolism

Although its meaning was never exact, *fin de siècle* came to refer to the last decade of the nineteenth century's climate of decadence, world-weariness, and dawn of a new kind of modernism in art. It was against the prevailing, popular spirit of progress and optimism as represented in the bourgeois values of the era. Max Nordau [NOR-dow], a Hungarian-born physician and Jewish leader, offered an eloquent and elaborate identification of the term in 1892:

> *Fin de siècle* is French, for it was in France that the mental state so entitled was first consciously realized . . . and Paris is the right place in which to observe its manifold expressions. . . . It means a practical emancipation from traditional discipline. . . . To the voluptuary, this means unbridled lewdness, the unchaining of the beast in man; . . . to the sensitive nature yearning for aesthetic thrills, it means the vanishing of ideals in art, and no more power in its accepted forms to arouse emotion. . . .
>
> One epoch of history is unmistakably in its decline, and another is announcing its approach. . . . Things as they are totter and plunge, and they are suffered to reel and fall, because man is weary, and there is no faith that it is worth an effort to uphold them. . . . Men look with longing for whatever new things are at hand . . .

While Nordau's popular essay bemoans the loss of "traditional views of custom and morality" and openly deplores the art of the era, it accurately captures European society's sense of being trapped between the end of one era and the start of another. The art of the era seems similarly caught in a state of "in between"—between a tradition whose values it rejects and a future that it cannot quite see but is struggling to define.

Art Nouveau

One of the most pervasive and influential new artistic styles beginning in the 1880s was Art Nouveau ("new art"), the name of which was derived from the Paris interior design shop of Siegfried Bing (1838–1905), named *Maison de l'art nouveau*. As with most artistic styles, Art Nouveau was associated with a number of contemporary trends, from the Arts and Crafts movement in England (chapter 37) to Symbolism, which endeavored to elevate feelings, imagination, and the power of dreams as creative inspiration. While Bing saw his galleries as displaying a wide range of art of the future, from fabrics by William Morris, to jewelry, glassware, and furniture, not everyone agreed. A Norwegian visitor put it this way:

> Rather than the rising sun of the coming century, this "new art" appears to symbolize the evening twilight of refinement, which has settled over French intellectual life and which, with a worn but still not worn out catch-word, calls itself "fin de siècle."

In fact, Art Nouveau was a transitional style, one caught between fin de siècle decadence and the innovations of modernity; between the nineteenth century's dedication to complex decorative designs and more abstract visions of the twentieth.

The fin de siècle era itself was transitional, and as an entrepreneur Bing, realized that he could take advantage of the mate-

with decorative items from Bing's workshop, where he supervised every aspect of the design and production.

As an international movement, Art Nouveau included architecture, glassware, textiles, furniture, and painting, and its practitioners could be found almost everywhere in Europe as well as in America's major cities. In one of the most important early innovations, Belgian architect Victor Horta [HOR-tuh] (1861–1947) incorporated the Art Nouveau style into architecture. Commissioned to design the Brussels home of scientist Emile Tassel, the traditionally trained Horta used floral patterns and designs resembling the tendrils and shoots of young plants to decorate the ironwork, walls, and floor tile of the house (Fig. 40.4). Such decorative effects spread rapidly across Europe, manifest in the long, flowing locks of female figures on posters, the peacock feathers on vases designed by Tiffany, budding flowerlike forms of glasswork, and the designs of furniture and metalwork.

Fig. 40.3 **Louis Comfort Tiffany. Stained-glass window. ca. 1894.** Glass, 43″ × 27½″. Mention obligatoire Les Arts Decoratifs, Paris (Inv. 7972); Musee de la Publicite (Inv. 10531); Photo: Laurent Sully Jaulmes. Tous droits reserves. Tiffany's stained-glass and iridescent favrile glass vases, made by mixing different colors of glass together while hot (a process Tiffany patented in 1894), were widely popular in France. The Musée des Art Décoratifs purchased this window soon after it arrived at Bing's galleries in 1895.

rialistic desires of the middle class by selling them a fashionable *art nouveau*. He was already the chief dealer of Japanese prints in Paris when he traveled to the United States in 1894 at the request of the French government to report on American art. While there, he visited the New York studios of Louis Comfort Tiffany (1848–1933), son of the founder of the famous New York jewelry house. Tiffany's decorative stained glass, Bing felt, might provide a model for French design (Fig. **40.3**). Bing began to import Tiffany's designs and sell them, along with furniture by Émile Gallé and Eugène Gaillard [guy-YAHR], and ceramics by Georges de Feure [fehr], among others, in his new showrooms. So successful was his enterprise that he built his own pavilion at the 1900 *Exposition Universelle*, entitled *L'art nouveau Bing*. Consisting of six rooms—dining room, bedroom, sitting room, lady's boudoir, parlor, and foyer—this new, modern house was filled

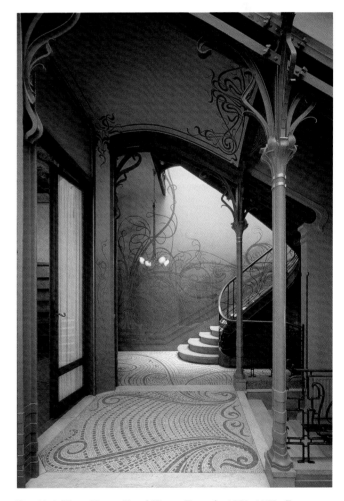

Fig. 40.4 **Victor Horta. Tassel House, Brussels. 1892–1893.** From a calyx like capital (calyxes are green and leaflike parts of a flower that enclose the petals), the iron columns sprout slender iron strips to support the floor above.

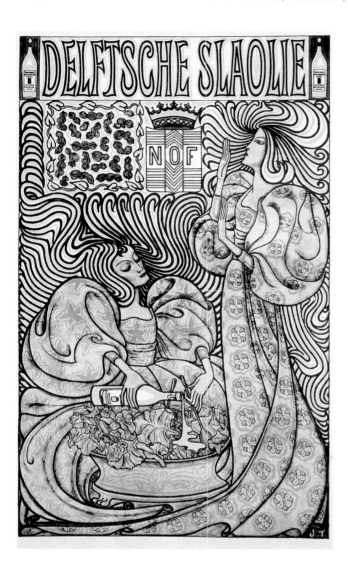

Fig. 40.5 Jan Toorop. *Delftsche Slaolie.* 1894. Lithograph, 37³⁄₄″ × 21¹⁄₄″. Dutch advertisement poster. Scala/Art Resource, NY. The undulating curvilinear rhythms of this poster advertising salad oil were widely emulated across Europe.

When viewing the poster design for Delftsche Slaolie salad oil (Fig. **40.5**) by Belgian painter Jan Toorop (1858–1928), one can easily understand how the whiplike tendrils, buds, and flowers of Art Nouveau could be interpreted not as a celebration of growth and rebirth but as decadent and suggestively sexual. The two women are preparing a salad, but in the undulating rhythms of their flowing robes and hair they elevate the mundane task "to the level of almost mystic rite," according to the Rijksmuseum in Amsterdam. As the best-known example of Dutch Art Nouveau, this commercial poster is now considered a masterpiece in the collection of one of Europe's greatest museums. Toorop's use of dynamic flowing lines, organic forms, color, and abstract designs to celebrate and enliven everyday life highlights an important aspect of the Art Nouveau movement. Rather than being confined to either the sphere of fine art or the practical applied designs of household objects and furniture, Art Nouveau encompassed a wide range of types of design.

Exposing Society's Secrets: The Plays of Henrik Ibsen

In the world of literature, the fin de siècle spirit was apparent in the later works of Norwegian playwright Henrik Ibsen (1828–1906), whose plays were performed across Europe in the last decades of the century. French author Émile Zola [zoh-LAH] introduced Ibsen's work to Paris and considered the playwright a naturalist (see chapter 36), who saw his world through an intensely acute and realistic lens. Ibsen's 1879 play *A Doll's House* was a sensation for its scathing depiction of Victorian marriage, with its oppression of women and cruelty of men. The heroine of the story, Nora, finally awakens to the truth of her existence, for although she lives a pampered, sheltered life, she is continually patronized and humiliated, treated like a child—or a doll—by her husband, Torvald (**Reading 40.1**):

READING 40.1 **from Henrik Ibsen,**
A Doll's House, **Act III (1878)**

NORA: . . . While I was still at home I used to hear Father airing his opinions and they became my opinions; or if I didn't happen to agree, I kept it to myself—he would have been displeased otherwise. He used to call me his doll-baby, and played with me as I played with my dolls. Then I came to live in your house . . . from Father's hands I passed into yours. You arranged everything according to your tastes, and I acquired the same tastes, or I pretended to—I'm not sure which—a little of both, perhaps. Looking back on it all, it seems to me I've lived here like a beggar, from hand to mouth. I've lived by performing tricks for you, Torvald. But that's the way you wanted it. You and Father have done me a great wrong. You've prevented me from becoming a real person. . . . Our home has never been anything but a play-room. I've been your doll-wife, just as at home I was Papa's doll-child. And the children, in turn, have been my dolls. I thought it fun when you played games with me, just as they thought it fun when I played games with them. And that's been our marriage, Torvald.

In her weariness and her despair, Nora found a symbolic image—the doll's house—that offers expression to her previously inarticulate feelings. When, at the end of the play, she leaves home forever with a slam of the door, she has become the symbol of individual freedom, a whole person who declares as she leaves: "I cannot be satisfied any longer with what most people say, and with what is in books. I must think over things for myself, and try to get clear about them."

In Ibsen's play, Nora represents the future, Torvald the past, and the reaction of European audiences to the play reveals just how resistant nineteenth-century European society was to the

possibility of meaningful social change. Like the American audiences who reacted negatively to Kate Chopin's *The Awakening* (see chapter 38), Europeans were outraged. To admit that a woman might reject her familial duties to satisfy her own needs was unthinkable. In fact, the actress who played Nora in the first German production refused to play the final scene of the play, as Nora says to Torvald, "I'm sure I'll think of you often, and about the children and the house here." The German actress loudly protested, "*I* would never leave *my* children," abruptly ending the play with Nora unable to leave her children, sinking to the floor of their room in despair.

Ibsen was a realist, and he presented the hidden truths of European society as no one before had ever dared. In *Ghosts* (1881), which followed *A Doll's House*, he took on the problematic issues of children born out of wedlock, venereal disease, infidelity, and incest. Again the reaction was outrage for what was perceived as Ibsen's affront to public decency. In *Hedda Gabler* (1890) he explored the world of a neurotic woman at the edge of insanity, who successfully schemes to sabotage an academic rival to her husband. By destroying her husband's rival, however, Hedda also destroys herself, illuminating the powerful influence of irrational, sometimes unconscious motivations and values upon our lives. Ibsen, in short, revealed the lies behind the seemingly upright facade of contemporary European society, lies that many of his critics clearly wished he had kept secret. While Ibsen's work heralded new cultural trends that would come to fruition in the twentieth century, it also had many attributes of popular nineteenth-century literary styles, particularly realism. His emphasis on realistic dramas with complex moral questions would become central to the world of drama (and eventually film) in the new century.

The Symbolist Imagination in the Arts

With *The Master Builder* (1892), Ibsen began a series of four interrelated plays that explored the lives of powerful men who come to recognize their failures and shortcomings. Culminating with *When We Dead Awaken* (1899), they abandon the realism of his earlier work and explore the dreams and fantasy worlds of their protagonists. This focus on the subjective experience and the often irrational impulses that rule human behavior signaled a new emphasis on introspection and the realization that human behavior was difficult, if not impossible, to

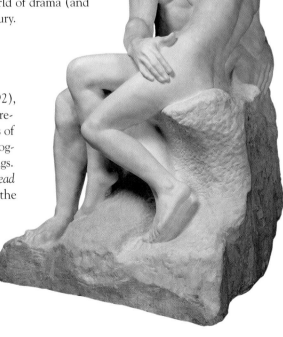

Fig. 40.6 Auguste Rodin. *The Kiss*. 1888–1889. Marble, 54½" × 43½" × 46½". Musée Rodin, Paris. The sculpture was originally conceived as a depiction of Paolo and Francesca, the adulterous lovers whom Dante encounters in the Second Circle of Hell in *The Divine Comedy*.

quantify. Increasingly, Ibsen reflected the Symbolist aesthetic that in the last decade came to dominate the European imagination. The Symbolists aimed to "objectify the subjective . . . instead of subjectifying the objective," according to the poet Gustave Kahn (1859–1936). By describing transitory feelings of people through symbolic language and images, Symbolists hoped to convey the essential mystery of life.

Symbolism distinguished itself from naturalism as practiced by Émile Zola by downplaying the need to convey meaning through direct and accurate representation. Instead, it favored *suggesting* the presence of meaning in order to express the inexpressible. This movement away from the physical world and into the realm of impressionistic experience lays the groundwork for the modern in art because, detached as it is from tangible reality, it takes a first step toward abstraction.

The Sculpture of Rodin The transition from realism to Symbolism is notable in the expressive sculptures of Auguste Rodin [roh-DAN] (1840–1917), whose style matured in the years after 1877. In many ways, Rodin was an intense realist, identifiable in the fact that many people thought some of his pieces must have been the result of a mold being applied to a living model. Like the Impressionist painters who were his contemporaries, Rodin depended on the play of light upon surfaces for the energy of his works. And just as they worked *en plein air* [ahn plen air], Rodin based his sculpture on direct observation, which accounted for its smooth realization and considerable impact on critics and the public at large.

However, *The Kiss* (1888–1889), one of Rodin's most famous sculptures, is more than simply a sharply realistic portrayal of two bodies embracing (Fig. **40.6**). It is the very embodiment of ecstatic abandon in which the woman is clearly as active a participant as the man. The work was a purposeful homage to the opposite sex, according to Rodin. When it was exhibited at the Salon of 1886, viewers found it immodest and shocking. At the 1893 Columbian Exposition in Chicago (see chapter 38), a bronze version of *The Kiss* was considered too scandalous for public display.

Rodin's monumental homage to Balzac, a full-length representation of the writer in his dressing gown, also depicts a source

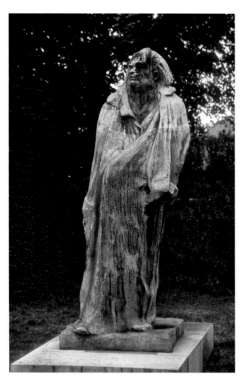

Fig. 40.7 Auguste Rodin. *Monument to Balzac.* **1898.** Bronze, 106 1/4" × 47 1/4" × 50 3/8". Garden of the Museum, Musée Rodin, Paris. When a model of the sculpture was first exhibited, it was dismissed as a "colossal fetus," a "colossal clown," and a "snowman." The Society of Men of Letters refused to accept it, and Rodin was forced to return payments for it that had already been made.

of creative power, in this case artistic (Fig. **40.7**). Rodin was grateful for the commission from the French literary organization of which Zola, an admirer of Rodin, was president. He immediately proceeded to study his subject in as much depth as Zola had studied the French mining industry for *Germinal* (see chapter 36). He traveled to Balzac's hometown of Tours in order to study the physical types of the city's inhabitants. He tracked down Balzac's tailor to find out his measurements so that he could model the artist's dressing gown to exact specifications. He viewed portraits, lithographs, and daguerreotypes of the writer. He modeled an imaginary Balzac nude so that he would know the body that he was to fit under the robe. But the finished nine-foot-high work is not realistic, although its "phallic, upward-thrusting form," as New York's Museum of Modern Art's catalog described it, is certainly memorable. It is recognizably Balzac, but a Balzac whose features have been exaggerated in the quest to illustrate the process of artistic creativity, enfolded in its robes. It is finally, as one contemporary critic has noted, as much Rodin's portrait as Balzac's, "the symbolic celebration, through Balzac, of the vigour and heroism of prolific genius."

Rodin, Lautrec, and the World of Montmartre In the early 1890s, a number of artists residing in Paris engaged in artistic experiments that combined music, dance, painting, and the new electrical lighting technology. Rodin was at the center of this community. He had always been attentive to the move-

ment of the human body, and he allowed his models—often dancers—to wander around the studio, striking poses at will (Fig. **40.8**). Gustav Kahn described Rodin's technique:

> She can sit, stand, lie down, stretch, and, according to her fancy or fatigue, propose a movement, an attitude, a letting go, and one of these images will be stopped by Rodin and captured in a drawing that seems to emerge almost instantaneously. Sometimes he does not even make her stop, but makes a cursive notation, for the rare movement he seeks is a transition between two movements.... The series of drawings furnishes him with an encyclopedia of human movements.... The huge sketchbook consulted by the artist takes on full meaning when he seeks the confirmation of a freshly-sprouted idea. The simplest movement, or observation of a physical attitude can give rise to an idea too.

Rodin's ideas inspired a close friend, the American dance sensation Loïe Fuller (1862–1928). She had arrived in Paris in 1892, bringing with her electricians skilled at devising dramatic lighting techniques. Within a short time, she was dazzling audiences at the Folies-Bergère [foll-EE-bair-ZHAIR] with a juxtaposition of colored lighting and dances marked by long, flowing, transparent fabrics swirling around her body. In 1893, French painter and printmaker Henri de Toulouse-Lautrec [too-LOOZ-loh-TREK] (1864–1901) executed a

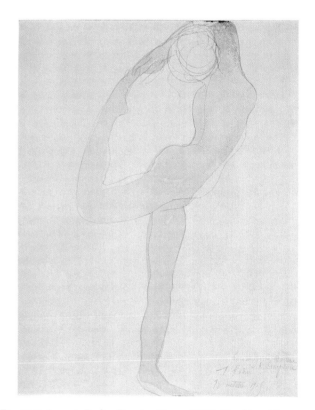

Fig. 40.8 Auguste Rodin. *Dancing Figure.* **1905.** Graphite with orange wash, 12 7/8" × 9 7/8". Gift of Mrs. John W. Simpson. 1942.5.36. Image © 2007 Board of Trustees, National Gallery of Art, Washington, DC. Rodin's drawings are characterized by their extreme simplicity, the outline of the body flowing continuously, without shadow or modeling. Broad bands of wash create a sense of volume.

Fig. 40.9 Henri de Toulouse-Lautrec. *Miss Loïe Fuller*. 1893.
Color lithograph, sheet: 15 1/8″ × 11 1/16″. Rosenwald Collection.
1947.7.185 Image © 2007 Board of Trustees, National Gallery of Art,
Washington, DC. Each of the approximately 60 impressions in the
series is unique. Toulouse-Lautrec used five different lithographic
stones in the process, inking them in a wide range of colors. He dusted
some of the prints, including this one, with gold or silver powder,
attempting to imitate the play of electric light on Fuller's dance.

series of 60 lithographs of Fuller dancing, each hand-colored
in order to capture the full effect of her inventive show (Fig.
40.9). An early champion of Rodin, Fuller helped organize
the first exhibition of his work in New York in 1903.

Another popular dance of the era was the can-can, made
infamous in 1890s Paris by La Goulue [goo-LEW] ("The
Greedy One"), the stage name of Louise Weber
(1866–1929). She was named La Goulue after her habit of
dancing past café tables and quickly downing the drinks of
the seated customers. When she danced the can-can, she
lifted her skirts to reveal a heart embroidered on her
panties. Then with a high kick she would flip a man's hat off
with her toe. She performed regularly at the Moulin Rouge
(Red Windmill), a cabaret in the Parisian red-light district
in the Montmartre section of the city.

Such places and the people in them—gamblers, prosti-
tutes, and circus performers—were Toulouse-Lautrec's
favorite subjects. Severely deformed, the victim of a rare
bone disease, Toulouse-Lautrec depicts himself walking
with a tall cousin in the background of *At the Moulin Rouge*
(Fig. **40.10**). Behind the two, La Goulue herself adjusts her
red hair. At the table, a coterie of cabaret regulars, includ-
ing the entertainer La Macarona, her face powdered in stark
white makeup, and the dancer Jane Avril [ah-VREEL],
noted for her long, red hair, share a drink. Toulouse-
Lautrec's portrayals of the nightlife of Paris—in many ways
a counterpart to Tokyo's "floating world" of courtesans,
actors, and artists—helped define the fin de siècle era in
lithographs and paintings. Although generally considered a
Post-Impressionist (see page 1291), Toulouse-Lautrec is
hard to categorize. He influenced the Art Nouveau movement

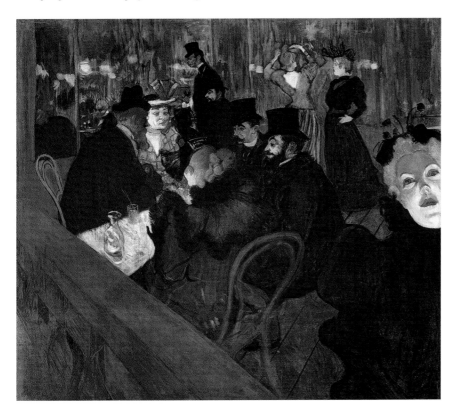

**Fig. 40.10 Henri de Toulouse-Lautrec. *At the
Moulin Rouge*. 1892–1895.** Oil on canvas,
4′ 3/8″ × 4′ 7 1/4″. Helen Birch Bartlett Memorial
Collection, 1928.610. Photograph © 2006, The
Art Institute of Chicago. All Rights Reserved.
The faces of Toulouse-Lautrec's figures border on
caricature, as if to mock traditional canons of
beauty.

with his posters and lithographs, and also impacted the Symbolists. Perhaps the clearest assessment of Toulouse-Lautrec came from a German art historian who affirmed that "in his skilled hands, the denizens of Montmartre . . . are transformed into symbols of themselves. Toulouse-Lautrec's art is simultaneously realistic and symbolic. The figures are stripped of accidental detail and reduced to the essence of character. They are an essence distilled from reality by a great artist."

Mallarmé's Poetry Like Rodin and Toulouse-Lautrec, the Symbolist poet Stéphane Mallarmé [mah-lar-MAY] (1842–1898) was immediately enraptured by Loïe Fuller. She is "at once an artistic intoxication and an industrial achievement," he wrote, referring to her lighting effects, "fusing the swift changes of color that vary their limelit phantasmagoria of twilight and grotto with rapidly changing passions—delight, mourning, anger." If, for Mallarmé, to name a thing was to destroy it and to suggest it was to bring it to life, it was the dancer, not the lighting, that was the most important ingredient in Fuller's colorful show. "The dancer," he wrote,

> . . . does not dance, but suggests, by prodigies of bending and of leaping, by a corporeal writing, what would require paragraphs of prose, both dialogue and description, to express in words: a poem freed from all the machinery of the writer.

Because Mallarmé believed that a poem was somehow hindered by the writer's words and syntax—and that poetry might be freed of the necessity of words—it is not surprising that in his own works what is said is less important than how the poems evoke feelings. Their mysterious suggestions and overtones take precedence over the logic of grammar, replaced by a sensual web of free association. In one of his most famous poems, "L'Après-midi d'un faune" [lah-pray-mee-DEE duh fohn] ("The Afternoon of a Faun"), the faun—part-man, part-goat—wakes from a dream to remember his afternoon tryst with a group of nymphs (female goddesses, spirits of nature). The poem was inspired by the Ovidian myth of the god Pan's attempt to seduce the beautiful nymph Syrinx [SUR-inks], who is rescued from his clutches. Regretting his loss, Pan discovers the beauty of music by blowing air through the reeds into which Syrinx has been transformed. While Mallarmé takes many liberties with the myth, he maintains most of the core elements, and leaves the ending ambiguous (**Reading 40.2a**):

READING 40.2a **from Stéphane Mallarmé, "L'Après-midi d'un faune" ("Afternoon of a Faun") (1876)**

Ah well, towards happiness others will lead me
With their tresses knotted to the horns of my brow:
You know, my passion, that, purple and just ripe,

The pomegranates burst and murmur with bees;
And our blood, aflame for her who will take it,
Flows for all the eternal swarm of desire.
At the hour when this wood's dyed with gold and with ashes
A festival glows in the leafage extinguished:
Etna! 'tis amid you, visited by Venus
On your lava fields placing her candid feet,
When a sad stillness thunders wherein the flame dies.
I hold the queen!

It is clear that this passage is charged with sexual symbolism. The juxtaposition of "passion," "purple," and "just ripe" seems to suggest physical as well as imaginative readiness, and the pomegranate is a traditional symbol of fertility, bursting with seed. Above all, the poetry is suggestive, not definitive, creating a mood, an impression, an atmosphere, more than a clear image. (See **Reading 40.2**, page 1307, for the entire poem.)

The Music of Debussy The most notable missing element in any translation of Mallarmé's poetry is the sound of the French language—the music of his words. Something of their effect, however, was translated into instrumental music by the composer Claude Debussy [duh-boo-SEE] (1862–1918), who began attending Mallarmé's Tuesday salons in about 1892, when he was 30 years old. Mallarmé's friends and associates—the international cast of artists and intellectuals who met on Tuesdays (*mardi* in French) became known as *les Mardistes*. They included the Irish poet William Butler Yeats, the German poet Rainer Maria Rilke, and French poet Paul Verlaine. Two years later, Debussy composed one of his most famous and important pieces, *Prélude à l'après-midi d'un faune*, which many consider a defining moment in the history of music (see **CD-Track 40.1**).

Before its first performance on December 22, 1894, Debussy invited Mallarmé to attend: "I need not say how happy I would be if you were kind enough to honour with your presence the arabesque which, . . . I believe to have been dictated by the flute of your faun." Mallarmé was evidently delighted and responded with a short poem:

> If you would know with what harmonious notes
> Your flute resounds, O sylvan deity,
> Then harken to the light that shall be breathed
> There unto by Debussy's magic art.

Music's ability to bring to mind a torrent of images and thoughts without speech is almost perfectly realized in Debussy's composition, first by an opening flute solo that is shaped as a series of rising and falling arcs and then later by oboes, clarinets, and more flutes that develop the theme further. Debussy adds textures to this melody with harp, muted horns, the triangle, and lightly brushed cymbals, backed by orchestral accompaniment that provides atmospheric tone. The use of **chromatic scales**, which move in half-steps through all the black and white keys on a keyboard, lends *Prélude à l'après-midi d'un faune* a sense of aimless wandering.

As with other efforts by the fin de siècle artists, *Prélude* [pray-LOOD] was a controversial work. More than 20 years after the

premiere, another major French composer, Camille Saint-Saëns (1835–1921), declared: "The *Prelude to the Afternoon of a Faun* has a pleasing sonority, but one finds in it scarcely anything that could properly be called a musical idea. It is to a work of music what an artist's palette is to a finished painting." Indeed, because Debussy's music lacks clear-cut cadences and tonal centers, it has often—and somewhat erroneously—been labeled Impressionist, which he disagreed with at the time. His 1905 composition *La Mer* [mair] (*The Sea*) seems to be a clearly impressionistic evocation of water. It consists of three sections. They illustrate the play of light on the surface of the water in the first, the movement of waves in the second, and the sound of wind on the water in the third. Superficially, it seems similar to the observation of the shimmering effects of water in Monet's *Regatta at Argenteuil* (see Fig. 37.6).

Some have made the point that Debussy's music is more Symbolist than Impressionist in nature because of the subtle but important difference between the words *impression* and *suggestion*. *Impression* is a received image and *suggestion* is a created effect. If *La Mer* were Impressionist, it would recreate the way in which the composer literally viewed the sea. But it is Symbolist, suggesting the way that Debussy feels about the sea, expressing the profound mysteries of its unseen depths.

Post-Impressionist Painting

As we have seen, Toulouse-Lautrec has been labeled a Post-Impressionist, which refers to the generation of painters who followed the eight Impressionist Exhibitions in Paris, which ended in 1886. The other painters we think of as Post-Impressionists include Paul Cézanne, Paul Gauguin, and Georges Seurat, all of whom exhibited at various Impressionist shows. Rather than creating Impressionist works that captured the optical effects of light and atmosphere and the fleeting qualities of sensory experience, they sought to capture something transcendent in their act of vision, something that captured the essence of their subject. This is similar to the goal of Symbolist artists. The Post-Impressionists saw themselves as inventing the future of painting, of creating art that would reflect the kind of sharply etched innovation that, in their eyes, defined modernity.

Pointillism: Seurat and the Harmonies of Color

One of the most talented of the Post-Impressionist painters was Georges Seurat [suh-RAH] (1859–1891), who exhibited his masterpiece, *A Sunday on La Grand Jatte*, in 1886 when he was 27 years old (Fig. **40.11**). It depicts a Sunday crowd of Parisians

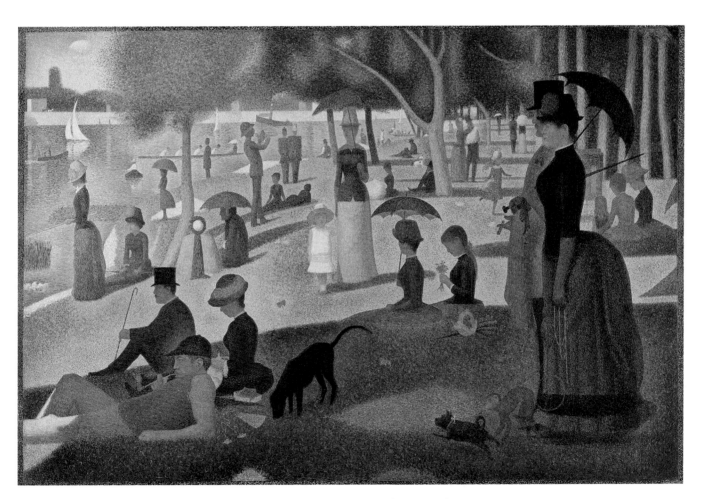

Fig. 40.11 Georges Seurat. *A Sunday on La Grande Jatte*. 1884. Oil on canvas, 5′ 11¾″ × 10′ 1¼″. Helen Birch Bartlett Memorial Collection, 1926.224. Combination of quadrant captures F1, F2, G1, G2. Photograph © 2006, The Art Institute of Chicago. All Rights Reserved. Capuchin monkeys like the one held on a leash by the woman on the right were a popular pet in 1880s Paris.

enjoying the weather on the island of La Grand Jatte in the Seine River just northeast of the city. The subject matter is typically Impressionist, but it lacks that style's sense of spontaneity and the immediacy of its brushwork. Instead, *La Grand Jatte* is a carefully controlled, scientific application of tiny dots of color—***pointilles*** [pwahn-TEE], as Seurat called them—and his method of painting became known as pointillism [POIN-tih-lizm] to some, and neo-impressionism to others.

Seurat tried to incorporate systematically the theories of Michel Eugène Chevreul's *Principle of Harmony and Contrast of Colors* (1839) and Ogden N. Rood's *Modern Chromatics* (1879) into his paintings to better utilize combinations of colors. Chevreul, in particular, had established the value of employing red, yellow, and blue as primary colors, through which most other colors can be mixed, and orange, green, and violet as secondary colors, produced by the mixing of two primaries. Rood's ideas were more sophisticated than Chevreul's and more useful to the painter, because he recognized that there was a significant difference between colored light and colored pigments. Not only did light possess a different set of primary and secondary colors—red, blue, and green—but the laws governing the mixture of these colors were dissimilar as well. Mixing together the colors of pigment is a *subtractive* process—that is, mixing together all three primary pigments ultimately creates black, the absence of color. But mixing light is an *additive* process—when all the primary colors of light are mixed, they create white, which has all colors in it. This is illustrated when light refracting through the moisture in the air becomes a rainbow.

One of the most difficult tasks Seurat and other painters faced was imitating in the subtractive medium of pigments the additive effects of colored light observed in nature. In Rood's observation, placing "a quantity of small dots of two colors very near each other . . . allowing them to be blended by the eye placed at the proper distance. . . . [produces] true mixtures of colored light." The theory, it turns out, was not quite right, so while some found Seurat's painting to be luminous, others complained that "one could hardly imagine anything dustier or more dull." Ultimately, in pointillist paintings, dots of yellow-orange, meant to create a sensation of bright sunlight, will appear to be gray from a distance of even 15 feet.

Nevertheless, in setting his "points" of color side by side across the canvas, Seurat determined that color could be mixed, as he put it, in "gay, calm, or sad" combinations. Lines extending upward could also reflect these same feelings, he explained, imparting a cheerful tone, as do warm and luminous colors of red, orange, and yellow. Horizontal lines that balance dark and light, warmth and coolness, create a sense of calm. Lines reaching in a downward direction and the dark, cool hues of green, blue, and violet evoke sadness.

With this symbolic theory of color in mind, we can see much more in Seurat's *La Grand Jatte* than simply a Sunday crowd enjoying a day at the park. There are 48 people of various ages depicted, including soldiers, families, couples, and singles, some in fashionable attire, others in casual dress. A range of social classes is present as well, illustrating the mixture of diverse people on the city's day of leisure. Although overall the painting balances its lights and darks and the horizontal dominates, thus creating a sense of calm, all three groups in the foreground shadows are bathed in the melancholy tones of blue, violet, and green. With few exceptions—a running child, and behind her a couple—almost everyone in the painting is looking either straight ahead or downward. Even the tails of the pets turn downward. This solemn feature is further heightened by the toy-soldier rigidity of the figures.

Like a Symbolist poem, Seurat's painting *suggests* more than it portrays—and his intentions are even more clearly revealed in *Les Poseuses* [pose-URZ] (*The Models*) (1888), a painting of his studio in which *La Grande Jatte* functions as a sort of painting-within-the-painting (Fig. **40.12**). A critic of the time had written of *La Grande Jatte*, "one understands then the rigidity of Parisian leisure, tired and stiff, where even recreation is a matter of striking poses." *Les Poseuses* affirms this view. Some of the clothes in the foreground—notably the hats, the red umbrella, and the blue gown—are recognizably costumes used in the *La*

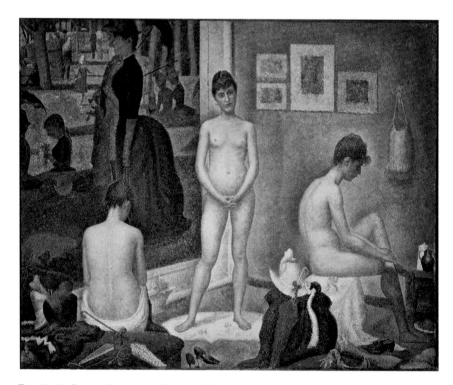

Fig. 40.12 Georges Seurat. *Les Poseuses* (*The Models*). 1886–1888. Oil on canvas, 6′ 6¾″ × 8′ 2⅜″. The Barnes Foundation, Merion, Pennsylvania. Seurat unites the elements of this painting through color. Note, for instance, how the green stockings and green bag hanging on the wall echo the greens of *La Grande Jatte*, the huge painting on the wall to the left of the models, while the red umbrella, lying against a polka-dot dress, echoes the little girl in red running in the painting.

Grande Jatte, and Seurat's models seem to be changing out of them into their street clothes. But the key element here is the title itself. As art historian Linda Nochlin has pointed out, *poseuse* is not the usual term employed by the French to describe an artist's model—*modèle* [moh-DELL] is. *Poseuse* rather means "one who seeks to attract attention by an artificial or affected manner." Seurat, then, in *Les Poseuses*, calls attention to the artificiality and affectation of the figures in *La Grande Jatte*.

Symbolic Color: Van Gogh

Seurat's influence on French painting was profound. Indeed many, including prominent critics of his era, considered him the founder of "neo-impressionism." Even Impressionist Camille Pissarro (see chapter 37) would take up the style for a time. Seurat's student Paul Signac would advance his theories by making his *pointilles* larger—passing on this innovation to twentieth-century painters such as Henri Matisse [mah-TEES] (see chapter 41). And perhaps the most famous of the nineteenth-century artists, Dutch painter Vincent van Gogh (1853–1890), also studied Seurat's paintings while living in Paris in 1886–1887. (He worked there for Siegfried Bing selling Japanese prints [see *Japonisme*—chapter 37].) Van Gogh experimented extensively with Seurat's color combinations and pointillist technique, which extended even to his drawings, as a means to create a rich textural surface.

Van Gogh was often overcome with intense and uncontrollable emotions, an attribute that played a key role in the development of his unique artistic style. Profoundly committed to discovering a universal harmony in which all aspects of life were united through art, van Gogh found Seurat's emphasis on contrasting colors appealing. It became another ingredient in his synthesis of techniques. He began to apply complementary colors in richly painted zones using dashes and strokes that were much larger than Seurat's *pointilles*. In a letter to his brother Theo in 1888, van Gogh described the way the complementary colors in *Night Café* (Fig. **40.13**) work to create visual tension and emotional imbalance:

> In my picture of the *Night Café* I have tried to express the idea that the café is a place where one can ruin oneself, run mad, or commit a crime. I have tried to express the terrible passions of humanity by means of red and green. . . . Everywhere there is a clash and contrast of the most alien reds and greens. . . . So I have tried to express, as it were, the powers of darkness in a low wine shop, and all this in an atmosphere like a devil's furnace of pale sulphur. . . . It is a color not locally true from the point of view of the stereoscopic realist, but color to suggest the emotion of an ardent temperament.

Color, in van Gogh's paintings, becomes symbolic, charged with feelings. Added to the garish conflict of colors is van Gogh's peculiar point of view, elevated above the room that sweeps away from the viewer in exaggerated and unsettling perspective. *Night Café* in this regard reflects not just a mundane view of the interior of a café lit by lamps, but van Gogh's "ardent" reaction to it.

For many viewers and critics, van Gogh's paintings are the most personally expressive in the history of art, offering unvarnished insights into the painter's unstable psychological state. As he was painting *Night Café*, van Gogh was living in the southern French town of Arles, where, over the course of 15 months, he produced an astounding quantity of work: 200 paintings, over 100 drawings and watercolors, and roughly 200 letters. Many of these letters, especially those addressed to his brother Theo, help us to interpret his paintings, which have become treasured masterpieces, each selling for tens of millions of dollars. Yet at the time he painted them, almost no one liked them, and he sold almost none of his art.

To viewers at the time, the dashes of thickly painted color, a technique known as *impasto*, seemed thrown onto the canvas as a haphazard and unrefined mess. And yet, the staccato rhythms of this brushwork seemed to van Gogh himself deeply autobiographic, capturing almost stroke by stroke the pulse of his own volatile personality.

Fig. 40.13 Vincent van Gogh. *Night Café.* **1888.** Oil on canvas, 28½″ × 36¼″. Yale University Art Gallery, 1961.18.34. New Haven, Connecticut/Art Resource, NY. Van Gogh frequented this café on the place Lamartine in Arles. Gas lighting, only recently introduced, allowed it to stay open all night. Drifters and others with no place to stay would frequent it at night. Notice how many patrons seem to be asleep at the tables.

What I learned in Paris is leaving me and I am returning to the ideas I had . . . before I knew the impressionists. And I should not be surprised if the impressionists soon find fault with my way of working. . . . Because instead of trying to reproduce exactly what I have before my eyes, I use color more arbitrarily, in order to express myself forcibly.

Although his work grew ever bolder and more creative as the years passed, van Gogh continued to suffer from the emotional instability and depression that tormented him most of his adult life. In July 1890, after a number of stays in hospitals and asylums, he committed suicide in the fields outside Auvers-sur-Oise, where he was being treated by Dr. Paul Gachet, who was the subject of several of the great artist's last portraits.

The Structure of Color: Cézanne

The French painter Paul Cézanne [say-ZAHN] (1839–1906) might have written the same words as van Gogh with respect to Impressionism. He certainly had similar thoughts regarding the colors of the south of France. Writing in 1876 to another Impressionist painter, Camille Pissaro, he described the village of L'Estaque [less-TAHK] on the Gulf of Marseilles [mar-SAY]:

> It's like a playing card. Red roofs against the blue sea. . . . The sun here is so tremendous that it seems to me that the objects are defined in silhouette, not only in black, but in blue, in red, in brown, in violet. I may be mistaken, but it seems to me to be the antithesis of modeling.

So it seems hardly accidental that Cézanne's *The Gulf of Marseilles, Seen from l'Estaque* (Fig. **40.16**) uses the same colors van Gogh used in *Patience Escalier*. Nevertheless, Cézanne did not much care for van Gogh's work. Indeed, there is little of the symbolism of van Gogh's colors in Cézanne's painting, since he was more interested in the way that color structures the space of the canvas.

Of all the Post-Impressionists, Cézanne was the only one who continued to paint *en plein-air*. In this regard, he remained an Impressionist, and he continued to paint what he called

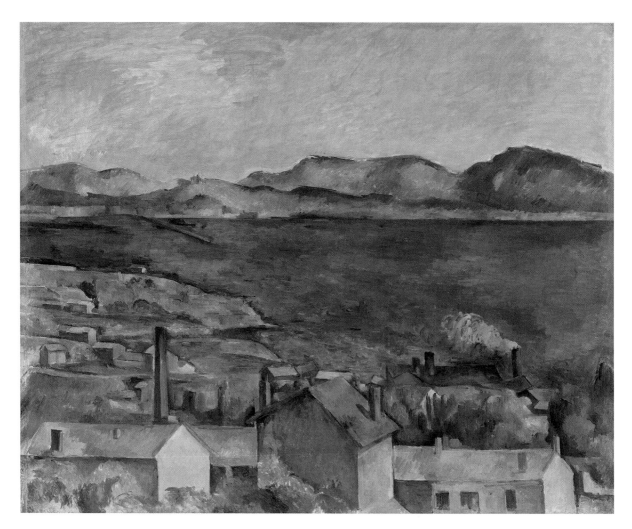

Fig. 40.16 Paul Cézanne. *The Gulf of Marseilles, seen from l'Estaque*. ca. 1885. Oil on canvas, 31 ½″ × 39 ¼″.
Mr. and Mrs. Martin A. Ryerson Collection. 1933.1116. Reproduction, The Art Institute of Chicago. All Rights Reserved.
Note the way in which the brightly lit side wall of the building at the lower right seems to parallel the picture plane rather than recede at an angle away from it.

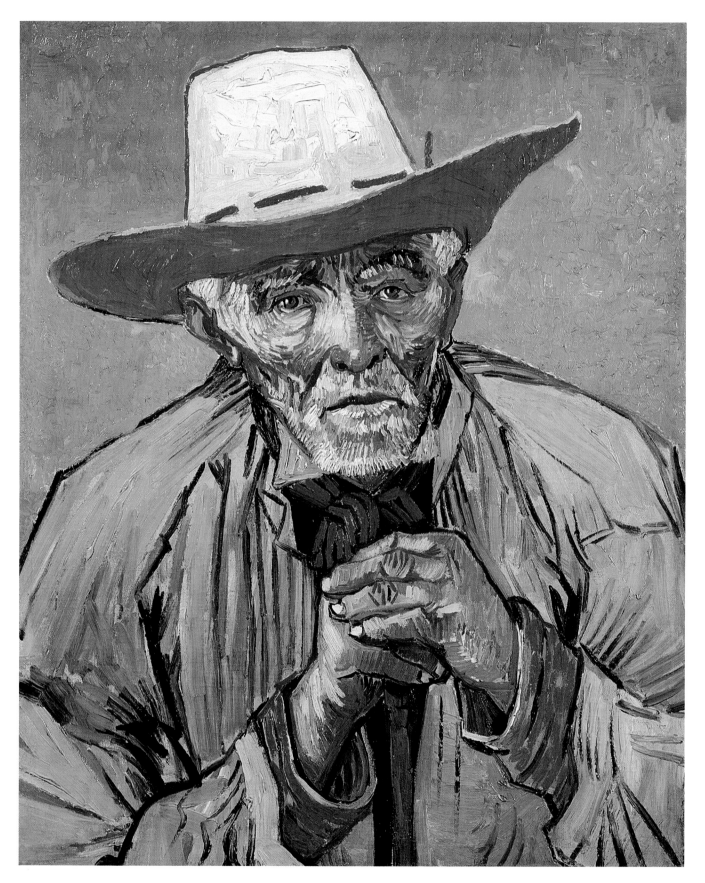

Fig. 40.15 Vincent van Gogh. *Portrait of Patience Escalier.* **August 1889.** Oil on canvas, 27 1/8″ × 22″. Private
Collection/Photo © Lefevre Fine Art, Ltd., London/The Bridgeman Art Library. Van Gogh would comment on the

What I learned in Paris is leaving me and I am returning to the ideas I had . . . before I knew the impressionists. And I should not be surprised if the impressionists soon find fault with my way of working. . . . Because instead of trying to reproduce exactly what I have before my eyes, I use color more arbitrarily, in order to express myself forcibly.

Although his work grew ever bolder and more creative as the years passed, van Gogh continued to suffer from the emotional instability and depression that tormented him most of his adult life. In July 1890, after a number of stays in hospitals and asylums, he committed suicide in the fields outside Auvers-sur-Oise, where he was being treated by Dr. Paul Gachet, who was the subject of several of the great artist's last portraits.

The Structure of Color: Cézanne

The French painter Paul Cézanne [say-ZAHN] (1839–1906) might have written the same words as van Gogh with respect to Impressionism. He certainly had similar thoughts regarding the colors of the south of France. Writing in 1876 to another Impressionist painter, Camille Pissarro, he described the village of L'Estaque [less-TAHK] on the Gulf of Marseilles [mar-SAY]:

> It's like a playing card. Red roofs against the blue sea. . . . The sun here is so tremendous that it seems to me that the objects are defined in silhouette, not only in black, but in blue, in red, in brown, in violet. I may be mistaken, but it seems to me to be the antithesis of modeling.

So it seems hardly accidental that Cézanne's *The Gulf of Marseilles, Seen from l'Estaque* (Fig. **40.16**) uses the same colors van Gogh used in *Patience Escalier*. Nevertheless, Cézanne did not much care for van Gogh's work. Indeed, there is little of the symbolism of van Gogh's colors in Cézanne's painting, since he was more interested in the way that color structures the space of the canvas.

Of all the Post-Impressionists, Cézanne was the only one who continued to paint *en plein-air*. In this regard, he remained an Impressionist, and he continued to paint what he called

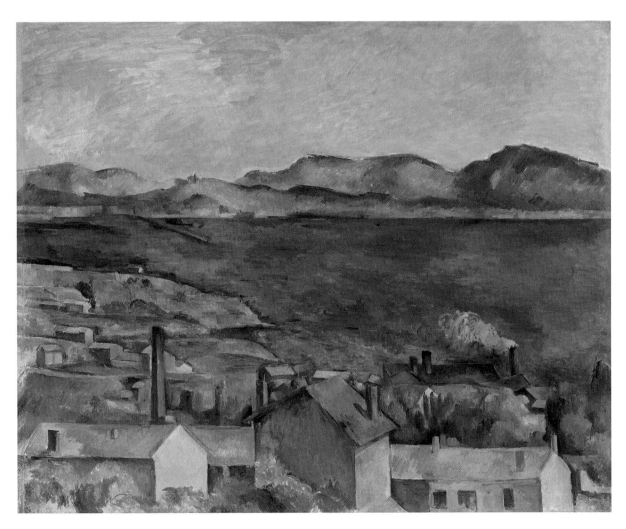

Fig. 40.16 Paul Cézanne. *The Gulf of Marseilles, seen from l'Estaque.* ca. 1885. Oil on canvas, 31 $\frac{1}{2}$ʺ × 39 $\frac{1}{4}$ʺ. Mr. and Mrs. Martin A. Ryerson Collection. 1933.1116. Reproduction, The Art Institute of Chicago. All Rights Reserved. Note the way in which the brightly lit side wall of the building at the lower right seems to parallel the picture plane rather than recede at an angle away from it.

Grande Jatte, and Seurat's models seem to be changing out of them into their street clothes. But the key element here is the title itself. As art historian Linda Nochlin has pointed out, *poseuse* is not the usual term employed by the French to describe an artist's model—*modèle* [moh-DELL] is. *Poseuse* rather means "one who seeks to attract attention by an artificial or affected manner." Seurat, then, in *Les Poseuses*, calls attention to the artificiality and affectation of the figures in *La Grande Jatte*.

Symbolic Color: Van Gogh

Seurat's influence on French painting was profound. Indeed many, including prominent critics of his era, considered him the founder of "neo-impressionism." Even Impressionist Camille Pissarro (see chapter 37) would take up the style for a time. Seurat's student Paul Signac would advance his theories by making his *pointilles* larger—passing on this innovation to twentieth-century painters such as Henri Matisse [mah-TEES] (see chapter 41). And perhaps the most famous of the nineteenth-century artists, Dutch painter Vincent van Gogh (1853–1890), also studied Seurat's paintings while living in Paris in 1886–1887. (He worked there for Siegfried Bing selling Japanese prints [see *Japonisme*—chapter 37].) Van Gogh experimented extensively with Seurat's color combinations and pointillist technique, which extended even to his drawings, as a means to create a rich textural surface.

Van Gogh was often overcome with intense and uncontrollable emotions, an attribute that played a key role in the development of his unique artistic style. Profoundly committed to discovering a universal harmony in which all aspects of life were united through art, van Gogh found Seurat's emphasis on contrasting colors appealing. It became another ingredient in his synthesis of techniques. He began to apply complementary colors in richly painted zones using dashes and strokes that were much larger than Seurat's *pointilles*. In a letter to his brother Theo in 1888, van Gogh described the way the complementary colors in *Night Café* (Fig. **40.13**) work to create visual tension and emotional imbalance:

> In my picture of the *Night Café* I have tried to express the idea that the café is a place where one can ruin oneself, run mad, or commit a crime. I have tried to express the terrible passions of humanity by means of red and green. . . . Everywhere there is a clash and contrast of the most alien reds and greens. . . . So I have tried to express, as it were, the powers of darkness in a low wine shop, and all this in an atmosphere like a devil's furnace of pale sulphur. . . . It is a color not locally true from the point of view of the stereoscopic realist, but color to suggest the emotion of an ardent temperament.

Color, in van Gogh's paintings, becomes symbolic, charged with feelings. Added to the garish conflict of colors is van Gogh's peculiar point of view, elevated above the room that sweeps away from the viewer in exaggerated and unsettling perspective. *Night Café* in this regard reflects not just a mundane view of the interior of a café lit by lamps, but van Gogh's "ardent" reaction to it.

For many viewers and critics, van Gogh's paintings are the most personally expressive in the history of art, offering unvarnished insights into the painter's unstable psychological state. As he was painting *Night Café*, van Gogh was living in the southern French town of Arles, where, over the course of 15 months, he produced an astounding quantity of work: 200 paintings, over 100 drawings and watercolors, and roughly 200 letters. Many of these letters, especially those addressed to his brother Theo, help us to interpret his paintings, which have become treasured masterpieces, each selling for tens of millions of dollars. Yet at the time he painted them, almost no one liked them, and he sold almost none of his art.

To viewers at the time, the dashes of thickly painted color, a technique known as *impasto*, seemed thrown onto the canvas as a haphazard and unrefined mess. And yet, the staccato rhythms of this brushwork seemed to van Gogh himself deeply autobiographic, capturing almost stroke by stroke the pulse of his own volatile personality.

Fig. 40.13 Vincent van Gogh. *Night Café.* **1888.** Oil on canvas, 28½″ × 36¼″. Yale University Art Gallery, 1961.18.34. New Haven, Connecticut/Art Resource, NY. Van Gogh frequented this café on the place Lamartine in Arles. Gas lighting, only recently introduced, allowed it to stay open all night. Drifters and others with no place to stay would frequent it at night. Notice how many patrons seem to be asleep at the tables.

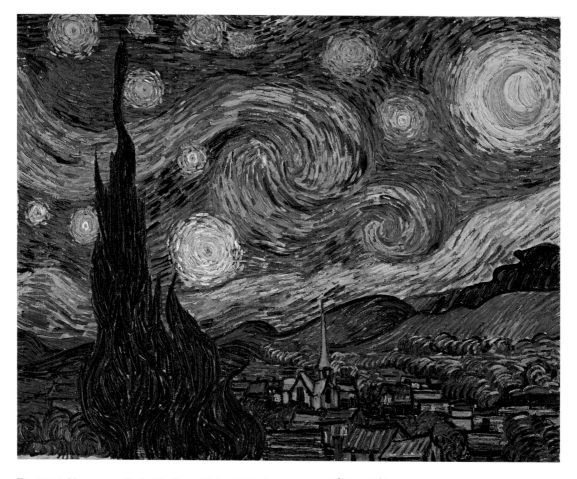

Fig. 40.14 Vincent van Gogh. *The Starry Night.* **1889.** Oil on canvas, $28\frac{3}{4}'' \times 36\frac{1}{4}''$. Acquired through the Lillie P. Bliss Bequest. (472.1941). Digital Image © The Museum of Modern Art/Licensed by Scala/Art Resource, NY. Saint-Rémy, where van Gogh painted this work, lies at the foot of a small range of mountains between Arles and Aix-en-Provence. This part of France is plagued in the winter months by the mistral, strong winds that blow day after day out of the Alps down the Rhone River valley. The furious swirls of van Gogh's sky and the blowing cypress trees suggest that he might be representing this wind known to drive people mad, in contrast to the harmonies of the painting's color scheme.

In December 1888, van Gogh's personal emotional turmoil reached a fever pitch when he sliced off a section of his earlobe and presented it to an Arles prostitute as a present. After a brief stay at an Arles hospital, he was released, but by the end of January the city received a petition signed by 30 townspeople demanding his committal. In early May, he entered a mental hospital in Saint-Rémy, not far from Arles, and there he painted *Starry Night*, perhaps his most famous composition (Fig. **40.14**). Unlike the violent contrasts that dominate the *Night Café*, here the swirling cypresses (in which red and green lie harmoniously side by side) and the rising church steeple unite earth and sky. Similarly, the orange and yellow stars and moon unite with the brightly lit windows of the town. Describing his thoughts about the painting in a letter to his brother, van Gogh wrote, "Is it not emotion, the sincerity of one's feeling for nature, that draws us?"

Another work of van Gogh's, the *Portrait of Patience Escalier* [ess-kah-lee-AY], is not just a portrait, but the embodiment of van Gogh's feeling for nature (Fig. **40.15**). The painting, the artist wrote, is "a sort of 'man with a

Continuity & Change
p. 1136

The Sower

hoe'"—that is, a peasant in the tradition of Millet (see Fig. 35.17). But if the painting recalls realist subject matter, its color is anything but. Escalier's blue coat, though traditional peasant garb, evokes the deep blue skies of the south of France, and the orange background reproduces what van Gogh described as "the furnace of the height of harvest time . . . orange colors flashing like lightning, vivid as red-hot iron." He further explained that ". . . although it does not pretend to be the image of a red sunset, [it] may nevertheless give a suggestion of one." Through color, van Gogh calls to mind not just the landscape of southern France, but also the enduring lifestyle and nobility of the peasants who live in it.

Van Gogh understood that in paintings like *Portrait of Patience Escalier*, he was actively abandoning Impressionism. In so doing, he established not only his signature style, but also a vigorous and modern aesthetic sense. As he wrote while working on the painting:

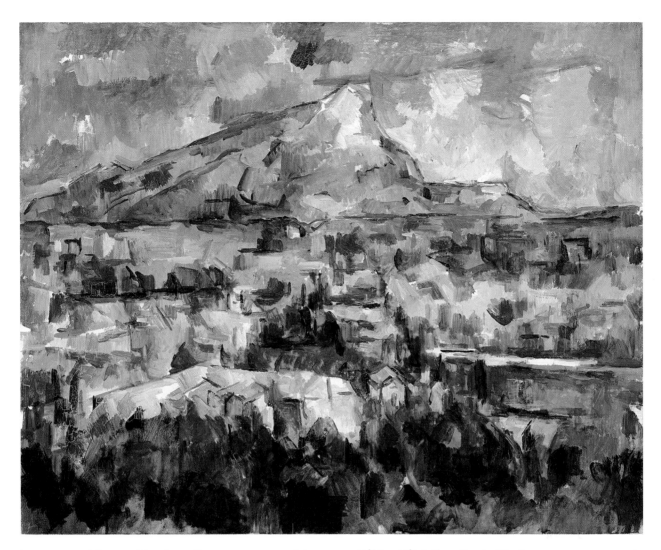

Fig. 40.17 Paul Cézanne. *Mont Sainte-Victoire*. 1902–1904. Oil on canvas, 28³/₄″ × 36³/₁₆″. Photo Graydon Wood. Philadelphia Museum of Art: The George W. Elkins Collection, 1936. E1936-1-1. Cézanne painted this from the top of the steep hill known as Les Lauves, just north of Aix-en-Provence but within walking distance of the city center. He built his own studio on a plot of land halfway up the hill, overlooking the city.

"optics." The duty of the painter, he said, was "to give the image of what we see," but innocently "forgetting everything that has appeared before." The result of this vision is a representation of nature as a series of patches of color that tend to flatten the surface of his paintings. (For an examination of this topic in regard to Cézanne's still-life paintings, see *Focus*, pages 1298–1299.) In *The Gulf of Marseilles*, for instance, the roofs and walls of the houses seem to lose the sense of having been drawn in proper perspective as swathes of yellow, orange, red, and green lie against one another. The uniform saturation of the blue color of the sea contradicts the illusion of spatial recession into deep space, causing the sea to hang like a curtain over the village.

Similar to Monet at Giverny [zhee-ver-NEE], Cézanne returned to the same theme continually—Mont Sainte-Victoire, the mountain overlooking his native Aix-en-Provence [eks-ahn-proh-VAHNSS] in the south of France (Fig. **40.17**). In the last decade of his life, the mountain became something of an obsession, as he climbed the hill

behind his studio to paint it day after day. He especially liked to paint after storms when the air is clear and the colors of the landscape are at their most saturated and uniform intensity. Cézanne acknowledges the illusion of space of the mountain scene by means of three bands of color. Patches of gray and black define the foreground, green and yellow-orange the middle ground, and violets and blues the distant mountain and sky. Yet in each of these areas, the predominant colors of the other two are repeated—the green brushstrokes of the middle ground in the sky, for instance—all with a consistent intensity. The distant colors possess the same strength as those closest. Together with the uniform size of Cézanne's brushstrokes—his patches do not get smaller as they retreat into the distance—this use of color makes the viewer very aware of the surface qualities and structure of Cézanne's composition. It is this tension between spatial perspectives and surface flatness that would become one of the chief preoccupations of modern painting in the forthcoming century.

Focus

Cézanne's *Still Life with Plaster Cast*

In the late nineteenth century, few artists challenged the traditions of Western painting more dramatically than Paul Cézanne. In no painting is that challenge more explicit than *Still Life with Plaster Cast*, painted in about 1894. While the painting includes a plaster copy of a Cupid sculpted by Pierre Puget [poo-ZHAY] (1620–1694), it is also a commentary on the natural and artificial worlds. Since the Renaissance, Western art had been dedicated to representing the world as the eye sees it—that is, in terms of perspectival space. But Cézanne realized that we see the world in far more complex terms than just the retinal image before us. We see it through the multiple lenses of our lived experience. This multiplicity of viewpoints, or perspectives, is the dominant feature of Cézanne's paintings.

Cézanne consciously manipulates competing points of view in *Still Life with Plaster Cast*. Nothing in the composition is spatially stable. Instead we wander through the small space in the corner of Cézanne's studio just as the painter's eye would do. His viewpoint constantly moves, contemplating its object from this angle, then that one. In *Still Life with Plaster Cast* as well as other Cézanne still lifes, we experience the very uncertainty of vision. These still lifes consistently abandon Renaissance certainties about the position of objects in space in favor of a new, uncertain view, in which even a still life is animated. In French, the term for a "still life" is *nature morte* [nah-TOOR mort], literally "dead nature." Cézanne sought to reanimate vision, to bring "still life" back to life.

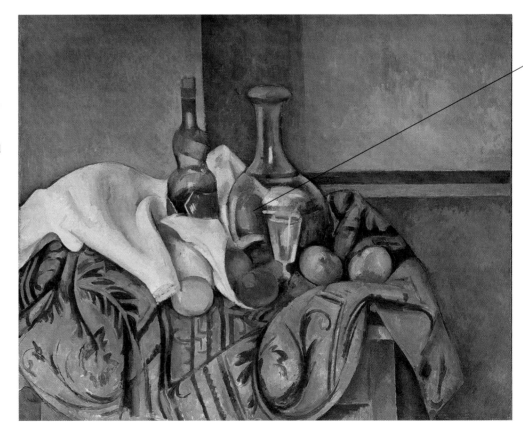

Paul Cézanne. *The Peppermint Bottle*. 1893–1895. Oil on canvas, 26″ × 32⅜″. Image © 2007 Board of Trustees, National Gallery of Art, Washington. Chester Dale Collection. This is one of several paintings stacked against the wall of the painter's studio in *Still Life with Plaster Cast* that contribute to the visual complexity of that work. At the left side of *Still Life with Plaster Cast* a blue cloth, under the plate of apples, seems to rise up off the table to support what we can now see are actually two apples in the right side of *The Peppermint Bottle*, where they appear ready to fall forward into the lap of the viewer. They are in motion, like Cézanne's eye and mind, and perhaps our frenetic modern lives.

The edges of a canvas behind the statue visually reinforces the Cupid's posture, even as it seems to position him in the space of that canvas. This heightens the spatial confusion of the composition. What is in back seems to come forward. What is in front seems to fall back. Nothing is spatially stable.

If this is a green apple in the corner of the studio, it is far too large, larger than a grapefruit. Although we know that objects in the distance appear smaller than objects close at hand, Cézanne represents the apple not how it appears to us, but how we know it to be—the same size as the apple on the table directly below it.

The studio floor seems oddly to angle away to the left and also to tilt up. In fact, to the left of the Cupid, Cézanne appears to be looking at the floor from across the table, whereas to the right of the Cupid, he seems to be looking down at the floor from above. Although the painting seems disjointed left to right, Cézanne seems to be suggesting that we never view the world from a single point of view. So he presents two different points of view here.

The two red onions are of radically different size, echoing the difference in size of the green apple on the floor at the corner of the room and the apples on the table. Yet, since both onions are on the same plane, it seems likely that this difference in size is real, which highlights Cézanne's manipulation of scale.

The Cupid is a highly ironic element. It has associations with traditional art and the Western ideal of love, which derives from Greco-Roman classical tradition. However, in the context of the apples that surround it, the Cupid also alludes to Christian tradition and Eve's eating of the fruit of knowledge.

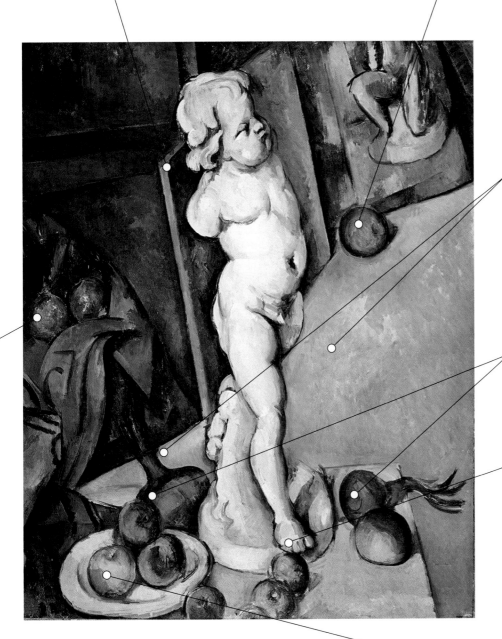

Paul Cézanne. *Still Life with Plaster Cast.* ca. 1894. Oil on paper on board, 26½″ × 32½″. The Samuel Courtauld Trust, Courtauld Institute of Art Gallery, London.

The apple is modeled by radical shifts in color rather than gradations from light to dark (traditional chiaroscuro). The shaded areas are red, the lighted areas yellow. Furthermore, this apple and the other objects are outlined, which tends to flatten them, emphasizing their two-dimensional shape rather than their three-dimensional mass.

Escape to Far Tahiti: Gauguin

Cézanne's self-exile from Paris to the solitude of his native Aix-en-Provence is also characteristic of the Symbolists, who valued the comparative quiet of the countryside over the turmoil of cities. The belief that silence allowed for contemplation of the essence of things and that solitude further enhanced this introspection provided the Symbolists with a reason to escape, an urge to retreat from the hectic pace of modern life.

In 1891, the painter Paul Gauguin [goh-GAN] (1848–1903) left France for the island of Tahiti, part of French Polynesia, in the South Pacific. A frustrated businessman and father of five children, he had taken up art with a rare dedication a decade earlier, studying with Camille Pissarro and Paul Cézanne. Gauguin was also a friend of van Gogh, with whom he spent several months painting in Arles during the Dutch artist's most productive period. He had also been inspired by the 1889 *Exposition Universelle*, where indigenous peoples and housing from around the world were displayed. "I can buy a native house," he wrote his friend Émile Bernard, "like those you saw at the World's Fair. Made of wood and dirt with a thatched roof." To other friends he wrote, "I will go to Tahiti and I hope to finish out my life there . . . far from the European struggle for money . . . able to listen in the silence of beautiful tropical nights to the soft murmuring music of my heartbeats in loving harmony with the mysterious beings in my entourage."

Between the last Impressionist exhibition in 1886 and leaving for Tahiti, Gauguin divided his time between Paris and Brittany (in northwestern France), interrupted only by his visit to van Gogh in Arles in late 1888. "I like Brittany," he wrote, "it is savage and primitive." The landscape there was not heavily impacted by civilization, but more important, the people seemed "*primitif*" in their beliefs—a far cry from the *poseuses* of Seurat. In French, the word *primitif* suggests the primal, original, or irreducible. Gauguin believed that "primitive" ways of thinking offered an entry into the primal powers of the mind. (In some ways it resembles the eighteenth-century idea of the "noble savage.") Nonetheless, the *primitif* theme is an important ingredient in one of the most innovative paintings he executed in Brittany, *The Vision after the Sermon (Jacob Wrestling with the Angel)* (Fig. **40.18**). It depicts a group of Breton women and a priest envisioning a scene from the Bible—Jacob wrestling with a mysterious angel (Genesis 32), who is sometimes interpreted as God, Satan, or himself. In a letter to van Gogh, Gauguin offered his thoughts on the work:

> Breton women in a group, praying: very intense black clothes—yellow-white bonnets, very luminous. The two bonnets at the right are like monstrous helmets—an apple tree, which is dark violet, spreads across the canvas. . . . I think I have achieved great simplicity in the figures, very rustic, very superstitious—the overall effect is very severe—the cow under the tree is tiny in comparison with reality, and is rearing up—for me in this painting the landscape and the fight only exist in the imagination of the people praying after the sermon, which is why there is a contrast between the people, who are natural, and the struggle going on in a landscape which is non-natural and out of proportion.

Fig. 40.18 Paul Gauguin. *The Vision after the Sermon (Jacob Wrestling with the Angel).* **1888.** Oil on canvas, 28 3/4″ × 36 1/4″. The National Galleries of Scotland, Edinburgh, Scotland. When the painting was exhibited in Paris in 1889, it provoked a scandal, which did not surprise Gauguin. "I know quite well," he wrote in October 1888, "that I shall be *less and less* understood. . . . For most I shall be an enigma, but for a few I shall be a poet and sooner or later what is good wins recognition."

Gauguin's *Vision*, then, is a testament to the primal power of faith, the ability of the primitive mind to envision the spiritual world as palpable. Originally intending to give the painting to the church of the Breton village where he painted it, Gauguin was rebuffed when the church refused it, possibly because of its radical and innovative space and color. Another interesting facet of the composition is its similarity to the café-concerts paintings of Degas (see Fig. 37.14), in which the audience and orchestra occupy the foreground and look up at the stage. However, Gauguin would probably say the *Vision* depicts the *real* theater of existence.

Gauguin's first trip to Tahiti was not everything he dreamed it would be, since by March 1892 he was penniless. When he arrived back in France, he had painted 66 pictures but had only four francs (about $12 today) to his name. He spent the next two years energetically promoting his work and writing an account of his journey to Tahiti, entitled *Noa Noa* (*noa* means "fragrant" or "perfumed"). It is a fictionalized version of his travels and bears little resemblance to the details of his journey that he honestly recorded in his letters. But *Noa Noa* was not meant to be true so much as sensational,

with its titillating story of the artist's liaison with a 13-year-old Tahitian girl, Tehamana, offered to him by her family. He presents himself as a *primitif* and his paintings as visionary glimpses into the primal forces of nature.

Gauguin arranged for two exhibitions at a Paris gallery in November 1893 and another in December 1894. He opened a studio of his own, painted olive green and a brilliant chrome yellow, and decorated it with paintings, tropical plants, and exotic furnishings. He initiated a regular Thursday salon where he lectured on his paintings and regaled guests with stories of his travels, as well as playing music on a range of instruments.

In this studio he painted *Mahana no atua* (*Day of the God*) of 1894 (Fig. **40.19**). Based on idealized recollections of his escape to Tahiti, the canvas consists of three zones. In the top zone or background, figures carry food to a carved idol, representing a native god, a musician plays as two women dance, and two lovers embrace beside the statue of the deity. Below, in the second zone, are three nude figures. The one to the right assumes a fetal position suggestive of birth and fertility. The one to the left appears to be day-dreaming or napping, possibly an image of

reverie. The middle figure appears to have just emerged from bathing in the water below that constitutes the third zone. She directs her gaze at the viewer and, so, suggests an uninhibited sexuality. The bottom, watery zone is an irregular patchwork of color, an abstract composition of sensuous line and fluid shapes. As in van Gogh's work, color is freed of its representational function to become an almost pure expression of the artist's feelings.

Gauguin returned to Tahiti in June 1895 and never came back to France, completing nearly 100 paintings and over 400 woodcuts in the eight remaining years of his life. He moved in 1901 to the remote island of Hivaoa [hee-vah-OH-uh], in the Marquesas [mar-KAY-suz], where in the small village of Atuona [aht-uh-WOH-nuh] he built and decorated what he called his House of Pleasure. Taking up with another young girl, who like Tehamana gave birth to his child, Gauguin alienated the small number of priests and colonial French officials on the islands but attracted the interest and friendship of many native Marquesans, who were fascinated by his nonstop work habits and his colorful paintings. Having suffered for years from heart disease and syphilis, he died quietly in Hivaoa in May 1903.

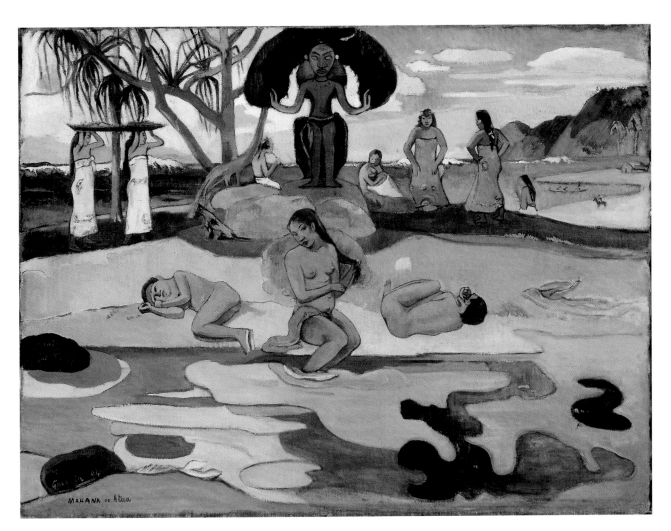

Fig. 40.19 Paul Gauguin. *Mahana no atua* (*Day of the God*)**. 1894.** Oil (possibly mixed with wax) on canvas, $26\frac{5}{8}"\times 35\frac{5}{8}"$.
The Art Institute of Chicago. Helen Birch Bartlett Memorial Collection (1926.198). Photograph © 2007, The Art Institute of Chicago.
All Rights Reserved. There is no record of Gauguin ever exhibiting this work. It was first exhibited at the Boston Art Club in 1925.

Toward the Modern

As a turn-of-the-century artistic movement, Symbolism was in many ways a revolt against reason, for to describe the world as it appears is to ignore the subjective experience of human beings—everything from belief and faith to intuition, the creative impulse, and the dream world. Symbolism represented a sort of return to spirituality, but without formalized religion, and especially its attendant moral rules. Symbolists practiced a kind of religion of the self, freed of social constraint. What further distinguishes that self from the Romantic self is that it does not merely seek the truth, even subjective truth—it attempts to *create* it.

Outside of Paris, artists and writers quickly adopted Symbolism as the style of the day. In Oslo, Norway, Henrik Ibsen's friend Edvard Munch [moongk] (1863–1944) adopted to his own explorations of the primordial forces of the human psyche the brushwork of Vincent van Gogh, whose paintings he had viewed in the early 1890s. In Vienna, Gustave Klimt (1862–1918) founded a movement dedicated to liberating art from the bonds of conventional morality. Perhaps the most influential thinker of the day was the German philosopher Friedrich Nietzsche [NEE-chuh] (1844–1900) (Fig. **40.20**), whose new moral philosophy served to support the Symbolist movement.

The New Moral World of Nietzsche

Nietzsche's first important work was the *Birth of Tragedy from the Spirit of Music* (1872), which he dedicated to German composer Richard Wagner. Here he challenged Socrates' appeal for rationality in human affairs and outlined the turbulent conflict between what he called the "Apollonian" and "Dionysian" forces at work in Greek art and in the tragedies of Aeschylus and Sophocles (see chapter 7). The Apollonian leads to the art of sculpture, the beautiful illusion of the ideal form, while the Dionysian expresses itself in music and dance, with their ability to excite the senses (**Reading 40.3**):

READING 40.3 **from Friedrich Nietzsche, *The Birth of Tragedy*, section 1 (1872)**

In song and in dance man expresses himself as a member of a higher community; he has forgotten how to walk and speak and is on the way toward flying into the air, dancing. His very gestures express enchantment. Just as the animals now talk, and the earth yields milk and honey, supernatural sounds emanate from him too: he feels himself a god, he himself now walks about enchanted, in ecstasy, like the gods he saw walking in his dreams. He is no longer an artist, he has become a work of art.

Apollonian and Dionysian tendencies usually run parallel to each other, but when they join together they generate Athenian dramatic tragedies, with the Dionysian "spirit of music" in the chorus supplemented by Apollonian dialogue. Socratic philosophy, particularly in the plays of Euripides, eliminated the Dionysian from the stage (by reducing the use of the chorus), destroying the delicate balance between Dionysus and Apollo that is fundamental to Athenian tragedy. *The Birth of Tragedy*, then, is a call to bring the Dionysian back into art and life, something Nietzsche sees occurring in the operas of Wagner, whose *gesamtkunstwerks* bring together song, music, dance, theater, and art (see chapter 36).

In his subsequent books, including *The Gay Science* (1882—the title refers to the medieval troubadour art of writing poetry), *Beyond Good and Evil* (1886), *The Genealogy of Morals* (1887), *Twilight of the Idols* (1888), and *Thus Spoke Zarathustra* (1882–1893), Nietzsche would reject organized religion for subjecting humanity to "slave morality." In *The Gay Science*, he announces the death of God, and in *Beyond Good and Evil* he defines the greatest men as those "who can be the loneliest, the most hidden, the most deviating," and the philosopher as one who seeks to live where everyone else is "least at home." (For excerpts from these two texts, see **Reading 40.4**, page 1308.) Democracy, according to Nietzsche, was a pretense, no more than a guarantee of mediocrity.

Following in the footsteps of Hegel's "Great Man" theory of history (see chapter 34), Nietzsche called for a society led by an *Übermensch* [oo-ber-MENCH], or "higher man," a hero of

Fig. 40.20 Curt Stoeving. *Friedrich Nietzsche*. 1894. Oil on canvas. Stiftung Weimarer Klassik und Kunstsammlungen, Weimar, Germany. Bilderchiv Preussischer Kulturbesitz/Art Resource, NY. By the time this picture was painted, Nietzsche was virtually insane. In 1889, he had suffered a mental breakdown and never recovered. The critical moment occurred in Turin, Italy, where he collapsed embracing the neck of a horse that had just been cruelly whipped by a coachman.

singular vision and courage who could produce a new "master" morality. Nietzsche's ideas were bold, but in many ways they were also dangerous. For in empowering the individual in an industrial society, they left open the possibility of catastrophic evil being unleashed upon the world in a way that would be difficult to stop. In the twentieth century, Adolph Hitler would misconstrue Nietzsche's ideas to justify his notion of a master race of Germans, leading to mass genocide and a world war that killed more than 50 million people.

Nietzsche also argued that God was dead and that conventional morality was life-denying rather than life-affirming. In an argument directed particularly at social Darwinists that also echoes the sentiments of English reformers like A. W. N. Pugin (see chapter 35), he argued that progress was an illusion: "Mankind does not represent a development toward something better or stronger or higher in the sense accepted today. . . . The European of today is vastly inferior in value to the European of the Renaissance."

On the Cusp of Modern Music: Mahler and Brahms

Viennese composers and conductors Gustave Mahler [MAH-lur] (1860–1911) and Johannes Brahms (1833–1897) dominated the music scene of Vienna in the last years of the nineteenth century. Although temperamentally somewhat different, the two men recognized each other's genius, and enjoyed each other's company and friendship. Mahler was an avid student of Nietzsche's, and the influence of *The Birth of Tragedy* and the philosopher's other writings on Mahler's work was extensive. The first movement of his lengthy 95-minute Symphony No. 3 is a Dionysian procession, and the fourth movement is vocal, based on a song written by Nietzsche, the so-called "Drunken Song," from *Thus Spoke Zarathustra*. In fact, Mahler named the whole symphony *The Gay Science—A Summer Morning's Dream*, after Nietzsche's 1882 book. Though Mahler's symphonies are in many ways traditional nineteenth-century orchestral works, inspired by Beethoven, they are also evocations of Nietzsche's Dionysian spirit and so are clear assertions of modernity.

Mahler's Symphony No. 1 is a case in point. Originally called *Titan*, after Nietzsche's observation in *The Birth of Tragedy* that "the effects wrought by the Dionysian also seemed 'titanic,'" the symphony moves from struggle to triumph across its four movements. The third movement is a funeral march in the manner of the second movement of Beethoven's *Eroica* (see chapter 34), but it is a parody, based on the French children's song "Frère Jacques" (see **CD-Track 40.2**). As Mahler explained in his program notes:

> The composer found the external source of inspiration in the burlesque picture of the hunter's funeral procession in an old book of fairy tales known to all children in South Germany. The animals of the forest escort the dead forester's coffin to the grave. Hares carry flags; a band of gypsy musicians, accompanied by cats, frogs, crows, all making music, and deer, foxes, and other four-footed and feathered creatures of the woods, leads the procession in farcical postures.

Mahler introduces the movement with a solo double bass playing the march at a high range, one that challenges all double bass players to this day. The melody soon shifts to a minor mode in a variation of the "Frère Jacques" tune. This is followed in turn by so-called **klezmer music**, of Eastern European Jewish origin, characterized by its notable bass sound—"like a parody," Mahler indicates in the score—and the shrill sound of a clarinet. Soon the march metamorphoses into a lyrical song of great beauty, "The Two Blue Eyes of My Beloved," written by Mahler a few years earlier, and accompanied by a harp. Such contrasts were jarring to Mahler's audience, but the sense of conflict and tension he evoked by this means anticipated the modern and its rapid-fire juxtapositions of sensory images.

In both composing and conducting, Brahms at first seems more conservative than Mahler. For one thing, he was absolutely dedicated to building on the classical example of Beethoven and Mozart, and he reached even further back into Western musical tradition to the examples of Bach, Handel, and even Palestrina. So his works are rich in musical allusions. His lushly lyric Symphony No. 4 of 1885 is a case in point, with its many references to Beethoven's compositions. The fourth and final movement, marked *allegro energico e passionato* ("energetically fast and passionate"), reaches even further back to an old-fashioned Baroque form (see **CD-Track 40.3**). Its basic structure is a series of 30 variations in triple time, each eight measures long and of increasing intensity, based on a theme in the finale of Bach's Cantata No. 150 that is clearly stated by trombones in the first eight notes of the movement. The next variation makes only minor changes on the first, but as the movement progresses, each variation seems to grow increasingly complex, as they seem to explore the entire range of human emotion and feeling.

Despite its traditional sources—the triple-time variation form was very popular among Baroque composers in Bach's time—the Fourth Symphony is startlingly modern, full of a wide variety of harmonies and dissonances, competing rhythms and meter changes. For this reason many critics found Brahms's work as difficult to understand—and as modern—as Mahler's. But the final movement of the symphony is, above all, distinctly fin de siècle in tone, world-weary and pessimistic even as it seems to yearn for—and discover—the new.

The Painting of Isolation: Munch

By the time the Norwegian painter Edward Munch arrived in Paris in the early 1890s, he was deeply immersed in the writings of both Fyodor Dostoyevsky (see chapter 37) and Friedrich Nietzsche. (After Nietzsche's death in 1900, Munch was commissioned to paint a portrait of the philosopher.) Their writings captured the sense of extreme isolation that seemed the inevitable fate of people of genius in the materialist world of bourgeois European culture. Equally moved by the paintings of Gauguin and van Gogh, Munch expressed his debt to his artistic heroes in *The Scream*,

Voices

A Visitor in Vienna

Although it was not on the tourist circuit the way that Paris and London were, Mahler and Klimt's Vienna was one of the cultural capitals of nineteenth-century Europe. James Huneker's portrait of the Austrian city around 1909 is an affectionate tribute, filled with praise about the city's food, beverages ("But the Pilsner in Vienna! That would need a complete chapter."), tobacco, restaurants, cafés, and beer taverns, as well as its people.

The Viennese man is an optimist; he regards life not so steadily, or as a whole, but as a gay fragment. Clouds gather, the storm breaks, then the rain stops and the sun floats once more in the blue. Let tomorrow take care of itself, today we go to the Prater and watch the wheels go round. This irresponsibility is confined to no class. Whether all the folk you see in the restaurants, cafes, and gardens can afford to spend money as they indubitably do, I cannot pretend to know. They eat and drink the best, and as a native said to me, if they were without a roof they would still go to the restaurants. Well fed, with good flavoured food . . . the Viennese are seemingly contented; they look so, and they are always cheerful. . . . Coffee is the magnet late in the afternoon, and it is difficult to get a seat after five o'clock in any of the numerous places. I remember one café . . . called the Guckfenster from the windows of which you may stare at the passing show. Every afternoon I went there early so as to secure my favourite seat, and there I sipped and stared, and stared and sipped, and in the dolce far niente I marveled over the futility of life, especially the futility of American life, its

> **"They eat and drink the best, and as a native said to me, if they were without a roof they would still go to the restaurants."**

hurry, bustle, money-making. . . . Oh, how mistaken I was! No one works harder than the Vienna business man and woman; their hours are at least a third longer than an American, yet they contrive so to space them that they appear to have limitless leisure. The climate is soft, which allows of open-air life . . . It gives Vienna its primal charm, it hums in the air. No wonder Johann Strauss composed his music, no wonder the otherwise ponderous Johannes Brahms preferred this spot to his birthplace, Hamburg; no wonder Beethoven here wrote the scherzi of his symphonies. Vienna inspired these composers as it inspired Mozart and Schubert.

. . . There is an earnest intellectual and artistic life. In one week last winter I attended conferences by Gerhart Hauptmann [German writer and Nobel Prize winner], Georg Brandes—the latter dealt with Goethe and Strindberg—and I heard Morz Rosenthal, Eugen D'Albert, Godowsky, and the Rose quartet, and attended a performance by the greatest of orchestras, the Vienna Philharmonic under Felix Weingartner . . . Then there is the opera, there are the theatres, and to jump to the other side of the scale, there are the medical schools and surgeons and physicians who have not their equal anywhere. And the University life.

painted in 1893 after moving to Berlin (Fig. **40.21**). From Gauguin he took the sensuous curvilinear patterning of color and form that distinguished the Brittany paintings (see Fig. 40.18). From van Gogh's work, he took the Dutch artist's intense brushwork and color, as well as his disorienting perspective. Compare, for instance, the uptilted walkway in *The Scream* to the floor of van Gogh's *Night Café* (see Fig. 40.13).

Munch's depiction of the horrifying anxiety of modern life is unmatched in the work of any previous painter. His grotesquely contorted figure in *The Scream* clasps its skull-like head as if to close its ears to its own anguished cry, which funnels out and sweeps across the landscape behind it. The blood-red sky elevates this cry to a fever pitch. Ironically, the two figures walking farther down the way and the single ship moored in the bay intensify rather than diminish the figure's isolation, as if distancing themselves from the scene.

There is good reason to believe that the color of the scene was prompted by the 1883 eruption of the Indonesian volcano Krakatoa, which could be heard for 1,500 miles, and the ashes of which circled the globe, creating brilliant red sunsets

for many months afterward. On a gouache version of the painting, Munch wrote:

> I was out walking with two friends—the sun began to set—suddenly the sky turned blood red—I paused, feeling exhausted, and leaned on the fence—there was blood and tongues of fire above the blue-black fjord and the city—my friends walked on, and I stood there trembling with anxiety—and I sensed an endless scream passing through nature.

Munch would later include the painting in a series entitled *The Frieze of Life*, designed to occupy four walls of a Berlin exhibition in 1902. Each of the four walls, hung with four or five paintings, had its own title: *Love's Awakening*, *Love Blossoms and Dies*, *Fear of Life* (where he hung *The Scream*), and, finally, *Death*. He called *Frieze* "a poem of love, anxiety, and death." The trajectory of Munch's series is the opposite of a Mahler symphony. Where Mahler, like Beethoven, moves from struggle to triumph, Munch sees triumph as fleeting, and his work moves, always, toward despair. In fact, *Despair* was *The Scream*'s original title.

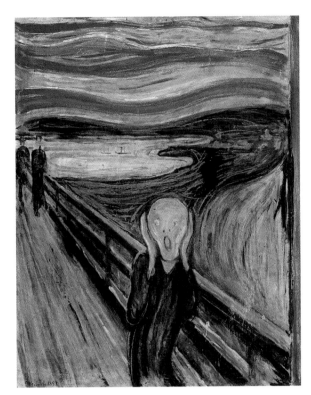

Fig. 40.21 Edvard Munch. *The Scream.* 1893. Tempera and casein on cardboard, 36″ × 29″. Nasjonalgalleriet, Oslo. Photo: J. Lathion © 2008 Artists Rights Society (ARS), New York/ADAGP, Paris. The painting was stolen from the museum in August 2004, then recovered, severely damaged, in August 2006. It is now undergoing restoration.

The Vienna Secession: Klimt

The painters of Mahler's Vienna, another European capital city with a high concentration of artists and intellectuals (see *Voices*, page 1304), largely avoided the pessimism of Munch. They turned toward a frank investigation of human sexuality in their work. One of the most important Viennese painters, Gustav Klimt (1862–1918), was a master of the erotic. Even his society portraits, such as the exquisite *Portrait of Emilie Flöge*, seemed charged with sexual energy by virtue of a color palette that can only be described as sensual (Fig. **40.22**). Like Nietzsche, Klimt sought to liberate art from the confines of conventional morality, believing that human life was driven by sexual desire. His paintings therefore seek to explore not only the sexual instincts of his sitters and models, but his own—and the viewer's.

By 1897, at age 35, Klimt, a traditionally trained academic painter, had led a group of mostly younger artists out of the established art academy in order to form an organization they called the Secession. They called themselves *die Jungen*, "the Youth," and the journal they founded called *Vers Sacrum* (*Sacred Spring*) was named after the Roman ritual of consecrating youth in times of national danger. In 1898 they had built themselves a new exhibition space, designed by Josef Olbrich

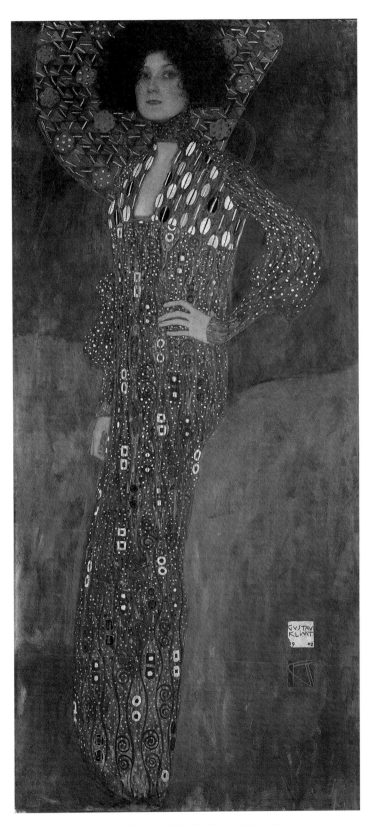

Fig. 40.22 Gustav Klimt. *Portrait of Emilie Flöge.* 1902. Oil on canvas, 71 ¼″ × 33″. Österreichische Galerie, Vienna. Flöge and her sister owned a dress shop not far from the Secession building. Klimt frequently designed dresses for them, like the one Emilie wears here.

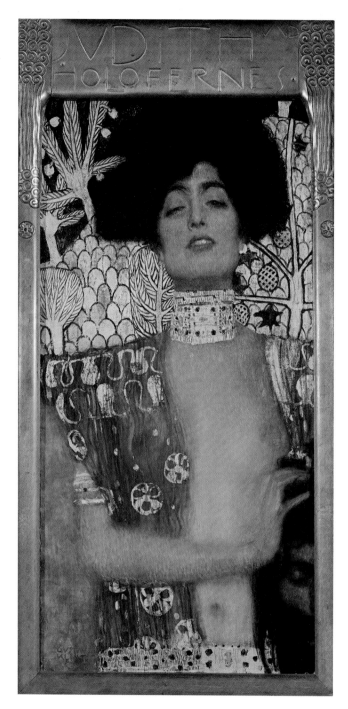

Fig. 40.23 Gustav Klimt. *Judith I*. 1901. Oil on canvas, 33″ × 16½″. Österreichische Galerie, Vienna. The frame identifies the subject of Klimt's painting as the biblical figures Judith and Holofernes.

[OHL-breekh] (1867–1908), called the House of the Secession. It was to serve as a retreat from daily life, a sanctuary that, in Olbrich's words, "would offer the art-lover a quiet place of refuge." Over the portal of the building these words were inscribed:

TO THE AGE ITS ART,
TO ART ITS FREEDOM.

The Secession would be dedicated, it proclaimed, to the proposition of showing "modern man his true face."

Continuity & Change
p. 819

Judith and Maidservant

Klimt's *Judith I*, based on the biblical story of the Jewish heroine Judith and the Assyrian general Holofernes [hoh-luh-FER-neez], is the very embodiment of the Secessionist revolt (Fig. **40.23**). Klimt's Judith, caressing with her right hand Holofernes's head, which she has just severed, is no biblical heroine. She is a contemporary wealthy Viennese woman, clothed— or half-clothed—in the same sort of costume as Emilie Flöge [FLER-guh], her neck adorned in a gold and jewel-studded version of Emilie's broad necklace. She is at once the malevolent femme fatale, a danger to any male who might desire her, as well as a symbol of the liberation of the newly emancipated woman of the twentieth century. Klimt's painting suggests that behind the facade of social decorum, and underneath the fine dresses worn by modern women, lies the earthy, elemental spirit of the heroic Judith. It also shows the continuing power of a theme that had been explored for many centuries.

Through his paintings, Klimt believed, he had begun to set society free of its inhibitions. This Secessionist spirit of liberation mirrored earlier artistic gestures of rebellion, such as Courbet's establishment of his own exhibit across the street from the 1855 *Exposition Universelle* (see Fig. 35.18), the Salons des Refusés established in the 1860s, and the Impressionist Exhibitions of the 1870s and 1880s. It would become a dominant theme of the arts in the century to come. This spirit of rebellion—and the artist's Nietzschean self-definition as one who lives where everyone else is "least at home," pushing the bounds of accepted taste and tradition—would come to dominate not just the dawning century's visual arts, but its music, literature, and philosophy as well.

READINGS

READING 40.2

Stéphane Mallarmé, "L'Après-midi d'un faune" ("Afternoon of a Faun") (1876)

Mallarmé's poetry is experimental, combining words and images that are mysterious and ambiguous. "Afternoon of a Faun" was set to music by Claude Debussy and as a result is one of Mallaré's most famous poems. It is the monologue of a faun (a minor rural deity that possesses an animal's ears, horns, tail, and hind legs) who tries to seduce two nymphs. The poem begins with the faun waking up, and ends with him returning to the dream world, wine by his side.

These nymphs I would perpetuate.
So clear
Their light carnation, that it floats in the air
Heavy with tufted slumbers.
Was it a dream I loved?
My doubt, a heap of ancient night, is finishing
In many a subtle branch, which, left the true
Wood itself, proves, alas! that all alone I gave
Myself for triumph the ideal sin of roses.
Let me reflect 10
. . .if the girls of which you tell
Figure a wish of your fabulous senses!
Faun, the illusion escapes from the blue eyes
And cold, like a spring in tears, of the chaster one:
But, the other, all sighs, do you say she contrasts
Like a breeze of hot day in your fleece!
But no! through the still, weary faintness
Choking with heat the fresh morn if it strives,
No water murmurs but what my flute pours
On the chord sprinkled thicket; and the sole wind 20
Prompt to exhale from my two pipes, before
It scatters the sound in a waterless shower,
Is, on the horizon's unwrinkled space,
The visible serene artificial breath
Of inspiration, which regains the sky.
Oh you, Sicilian shores of a calm marsh
That more than the suns my vanity havocs,
Silent beneath the flowers of sparks, relate
That here I was cutting the hollow reeds tamed
By talent, when on the dull gold of the distant 30
Verdures dedicating their vines to the springs,
There waves an animal whiteness at rest:
And that to the prelude where the pipes first stir

This flight of swans, no! Naiads, flies
Or plunges . . .
Inert, all burns in the fierce hour
Nor marks by what art all at once bolted
Too much hymen desired by who seeks the Ia:
Then shall I awake to the primitive fervour,

Straight and alone, 'neath antique floods of light, 40
Lilies and one of you all through my ingenuousness.
As well as this sweet nothing their lips purr,
The kiss, which a hush assures of the perfid ones,
My breast, though proofless, still attests a bite
Mysterious, due to some august tooth;
But enough! for confidant such mystery chose
The great double reed which one plays 'neath the blue:
Which, the cheek's trouble turning to itself
Dreams, in a solo long, we might amuse
Surrounding beauties by confusions false 50
Between themselves and our credulous song;
And to make, just as high as love modulates,
Die out of the everyday dream of a back
Or a pure flank followed by my curtained eyes,
An empty, sonorous, monotonous line.
Try then, instrument of flights, oh malign
Syrinx, to reflower by the lakes where you wait for me!
I, proud of my rumour, for long I will talk
Of goddesses; and by picturings idolatrous,
From their shades unloose yet more of their girdles: 60

So when of grapes the clearness I've sucked,
To banish regret by my ruse disavowed,
Laughing, I lift the empty bunch to the sky,
Blowing into its luminous skins and athirst
To be drunk, till the evening I keep looking through.
Oh nymphs, we diverse memories refill.
My eye, piercing the reeds, shot at each immortal
Neck, which drowned its burning in the wave
With a cry of rage to the forest sky;
And the splendid bath of their hair disappears 70
In the shimmer and shuddering, oh diamonds!
I run, when, there at my feet, enlaced. Lie (hurt by the
 languor they taste to be two)
Girls sleeping amid their own casual arms; them I seize, and
 not disentangling them, fly
To this thicket, hated by the frivolous shade,
Of roses drying up their scent in the sun
Where our delight may be like the day sun-consumed.

I adore it, the anger of virgins, the wild
Delight of the sacred nude burden which slips 80
To escape from my hot lips drinking, as lightning
Flashes! the secret terror of the flesh:
From the feet of the cruel one to the heart of the timid
Who together lose an innocence, humid
With wild tears or less sorrowful vapours.
"My crime is that I, gay at conquering the treacherous
Fears, the dishevelled tangle divided
Of kisses, the gods kept so well commingled;
For before I could stifle my fiery laughter
In the happy recesses of one (while I kept 90
With a finger alone, that her feathery whiteness
Should be dyed by her sister's kindling desire,
The younger one, naïve and without a blush)
When from my arms, undone by vague failing,
This pities the sob wherewith I was still drunk.

Ah well, towards happiness others will lead me
With their tresses knotted to the horns of my brow:
You know, my passion, that, purple and just ripe,
The pomegranates burst and murmur with bees;

And our blood, aflame for her who will take it, 100
Flows for all the eternal swarm of desire.
At the hour when this wood's dyed with gold and with ashes
A festival glows in the leafage extinguished:
Etna! 'tis amid you, visited by Venus
On your lava fields placing her candid feet,
When a sad stillness thunders wherein the flame dies.
I hold the queen!
O penalty sure . . .
No, but the soul
Void of word and my body weighed down 110
Succumb in the end to midday's proud silence:

No more, I must sleep, forgetting the outrage,
On the thirsty sand lying, and as I delight
Open my mouth to wine's potent star!
Adieu, both! I shall see the shade you became. ■

Reading Question

It is not entirely clear whether the faun is describing real events, memories, or dreams. Can you locate passages where this ambiguity is highlighted?

READING 40.4

from Friedrich Nietzsche, *The Gay Science*, "The Madman" (1882), and *Beyond Good and Evil*, section 212 (1888)

Nietzsche composed both of these works as a series of several hundred aphorisms the typical lengths of which range from a line or two to a page or two. The selection from The Gay Science *is a parable entitled "The Madman," in which Nietzsche announces the possibility that God is dead. Written in 1888,* Beyond Good and Evil *was designed to give the reader an overview of Nietzsche's philosophy as it had developed to this point. Subtitled* Prelude to a Philosophy of the Future, *it projects the terms of a new philosophy that has gotten rid of blind acceptance of Christian values and morality.*

The Madman

Have you not heard of that madman who lit a lantern in the bright morning hours, ran to the market place, and cried incessantly: "I seek God! I seek God!"— As many of those who did not believe in God were standing around just then, he provoked much laughter. Has he got lost? asked one. Did he lose his way like a child? asked another. Or is he hiding? Is he afraid of us? Has he gone on a voyage? emigrated?—Thus they yelled and laughed.

The madman jumped into their midst and pierced them with his eyes. "Whither is God?" he cried; "I will tell 10 you. *We have killed him*—you and I. All of us are his murderers. But how did we do this? How could we drink up the sea? Who gave us the sponge to wipe away the entire hori- zon? What were we doing when we unchained this earth from its sun? Whither is it moving now? Whither are we moving? Away from all suns? Are we not plunging contin- ually? Backward, sideward, forward, in all directions? Is there still any up or down? Are we not straying, as through an infinite nothing? Do we not feel the breath of empty space? Has it not become colder? Is not night continually 20 closing in on us? Do we not need to light lanterns in the morning? Do we hear nothing as yet of the noise of the gravediggers who are burying God? Do we smell nothing as yet of the divine decomposition? Gods, too, decompose. God is dead. God remains dead. And we have killed him.

"How shall we comfort ourselves, the murderers of all murderers? What was holiest and mightiest of all that the world has yet owned has bled to death under

our knives: who will wipe this blood off us? What water is there for us to clean ourselves? What festivals of atonement, what sacred games shall we have to invent? Is not the greatness of this deed too great for us? Must we ourselves not become gods simply to appear worthy of it? There has never been a greater deed; and whoever is born after us—for the sake of this deed he will belong to a higher history than all history hitherto."

Here the madman fell silent and looked again at his listeners; and they, too, were silent and stared at him in astonishment. At last he threw his lantern on the ground, and it broke into pieces and went out. "I have come too early," he said then; "my time is not yet. This tremendous event is still on its way, still wandering; it has not yet reached the ears of men. Lightning and thunder require time; the light of the stars requires time; deeds, though done, still require time to be seen and heard. This deed is still more distant from them than most distant stars—*and yet they have done it themselves.*"

It has been related further that on the same day the madman forced his way into several churches and there struck up his *requiem aeternam deo.* Led out and called to account, he is said always to have replied nothing but: "What after all are these churches now if they are not the tombs and sepulchers of God?"

Beyond Good and Evil, Section 212

We Scholars

More and more it seems to me that the philosopher, being *of necessity* a man of tomorrow and the day after tomorrow, has always found himself, and *had* to find himself, in contradiction to his today: his enemy was ever the ideal of today. So far all these extraordinary furtherers of man whom one calls philosophers, though they themselves have rarely felt like friends of wisdom but rather like disagreeable fools and dangerous question marks, have found their task, their hard, unwanted, inescapable task, but eventually also the greatness of their task, in being the bad conscience of their time.

By applying the knife vivisectionally to the chest of the very *virtues of their time,* they betrayed what was their own secret: to know of a *new* greatness of man, of a new untrodden way to his enhancement. Every time they exposed how much hypocrisy, comfortableness, letting oneself go and letting oneself drop, how many lies lay hidden under the best honored type of their contemporary morality, how much virtue was *outlived.* Every time they said: "We must get there, that way, where *you* today are least at home."

Facing a world of "modern ideas" that would banish everybody into a corner and "specialty," a philosopher—if today there could be philosophers—would be com-pelled to find the greatness of man, the concept of "greatness," precisely in his range and multiplicity, in his wholeness in manifoldness. He would even determine value and rank in accordance with how much and how many things one could bear and take upon himself, how *far* one could extend his responsibility.

Today the taste of the time and the virtue of the time weakens and thins down the will; nothing is as timely as weakness of the will. In the philosopher's ideal, therefore, precisely strength of the will, hardness, and the capacity for long-range decisions must belong to the concept of "greatness"—with as much justification as the opposite doctrine and the ideal of a dumb, renunciatory, humble, selfless humanity was suitable for an opposite age, one that suffered, like the sixteenth century, from its accumulated energy of will and from the most savage floods and tidal waves of selfishness.

In the age of Socrates, among men of fatigued instincts, among the conservatives of ancient Athens who let themselves go—"toward happiness," as they said; toward pleasure, as they acted—and who all the while still mouthed the ancient pompous words to which their lives no longer gave them any right, *irony* may have been required for greatness of soul, that Socratic sarcastic assurance of the old physician and plebeian who cut ruthlessly into his own flesh, as he did into the flesh and heart of the "noble," with a look that said clearly enough: "Don't dissemble in front of me! Here—we are equal."

Today, conversely, when only the herd animal receives and dispenses honors in Europe, when "equality of rights" could all too easily be changed into equality in violating rights—I mean, into a common war on all that is rare, strange, privileged, the higher man, the higher soul, the higher duty, the higher responsibility, and the abundance of creative power and masterfulness—today the concept of greatness entails being noble, wanting to be by oneself, being able to be different, standing alone and having to live independently. And the philosopher will betray something of his own ideal when he posits: "He shall be greatest who can be loneliest, the most concealed, the most deviant, the human being beyond good and evil, the master of his virtues, he that is overrich in will. Precisely this shall be called *greatness:* being capable of being as manifold as whole, as ample as full." And to ask it once more: today—is greatness *possible?* ■

Reading Question

It is important to recognize that the man who calls for the death of God is a "madman." But can you see a relation between this madman and Nietzsche's new philosopher as described in the section from *Beyond Good and Evil?*

Summary

■ A Fair to Remember: The Paris Exposition of 1889
When the *Exposition Universelle* opened in Paris in the spring of 1889, it heralded a new era of Western technological innovation and political and social superiority as displayed in the fair's thousands of exhibits. The most prominent exhibit was also the symbol of the exposition, and would soon become the embodiment of Paris itself—the Eiffel Tower. The fair's many exhibits displayed a wide range of technological innovations, including hundreds of inventions from Thomas Edison's laboratories, as well as an ambitious collection of houses from across the globe. France's imperial ambitions were represented by the inclusion of an exhibit of an entire African village and numerous other "exhibits" of indigenous peoples from Asia and the Pacific.

■ The Fin de Siècle: From Naturalism to Symbolism
The fin de siècle is the name given to the period just before and after the two great Paris expositions of 1889 and 1900 marked, from the point of view of those who looked at it with disfavor, by a degenerate abandonment in art and culture of the ideals of the past. It was also an era marked by a spirit of innovation. Art Nouveau embodied both points of view, its swirling tendrils and buds symbolizing rebirth and renewal, while its luxuriously curved female figures suggest decadent self-indulgence.

Henrik Ibsen's Realist drama presented the hidden realities of European social life as no one had ever before dared. *A Doll's House* showed a new kind of woman to European audiences, one capable of exercising her free will to leave behind an oppressive marriage. In his later work, Ibsen adopted a more dreamlike, experimental Symbolist approach to drama. Symbolism moves away from representations of the physical world into the realm of subjective experience, seeking to "objectify the subjective," to give the subjective form.

The transition from realism to Symbolism appears in the sculpture of Rodin, who came to value music and dance as the most Symbolist of art forms. The painter Toulouse-Lautrec loved dance's more earthy forms, such as the can-can. Dance also fascinated Mallarmé, whose elusive poems, such as "L'Après-midi d'un faune," suggest a mood by the presence of something that eludes meaning. The composer Claude Debussy put Mallarmé's poetry to music, creating a sense of mysterious ambiguity by means of chromatic scales.

■ Post-Impressionist Painting
The generation of painters that followed the Impressionist exhibitions was dedicated to advancing art in innovative directions. Seurat's Pointillist technique relied on colors blended in the viewer's eye. Van Gogh used color in much broader bands of paint to create deeply symbolic works. Cézanne assembled his canvases out of patches of color that tend to flatten the surface of the painting, thus exploiting the tension between the two-dimensional surface of the canvas and the representation of three-dimensional space. Finally, Gauguin reflected the *primitif*—the primal, irreducible base of existence—in paintings done first in Brittany and then in Tahiti.

■ Toward the Modern
The Symbolist spirit manifested itself outside of France as well. Leading the way was the German philosopher Friedrich Nietzsche. In *The Birth of Tragedy*, he argued for a return of the Dionysian spirit, long suppressed in Western civilization. In *The Gay Science* he announced—not in his own words, but in the words of a madman—the death of God. And in *Beyond Good and Evil* he argued that the true philosopher must live where everyone else is "least at home." Deeply influenced by Nietzsche, composer Gustave Mahler created music distinguished by its jarring contrasts of melody and mood. His contemporary, Johannes Brahms, composed lushly lyric works rich in allusions to classical and even earlier composers yet, at the same time, surprisingly modern. In Oslo, the painter Edvard Munch, influenced by van Gogh, Gauguin, and Nietzsche, captured the anguish of modern experience in works like *The Scream*, while in Vienna, Gustav Klimt revolted from tradition by painting deeply erotic works designed to set society free of its inhibitions.

Glossary

chromatic scales Scales that move in half-steps through all the black and white keys on a keyboard.

free association The practice developed by Sigmund Freud of directing patients to say whatever came to mind.

klezmer **music** A type of music of Eastern European Jewish origin characterized by its oompah, oompah bass sound and the shrill sound of a clarinet.

pointilles Tiny dots of color and the building blocks of the pointillist style.

Critical Thinking Questions

1. What qualities of Art Nouveau make it a "transitional" style?

2. How does the modern self "create" subjective truth?

3. The Vienna Secession was dedicated to showing "modern man his true face." What is the significance of this?

Continuity & Change

In 1910, having lost his virility upon discovering that his young wife, Alma Schindler Mahler, was having an affair, Mahler sought out the Viennese psychoanalyst Sigmund Freud (1856–1939) (Fig. **40.24**). On August 26, the two spent four hours walking through the streets of Leiden, Holland, discussing Mahler's "condition." Mahler recalled for Freud an "especially painful scene" between his parents, which caused him to run out of the house where he encountered a barrel organ playing the popular song, *Ach, du lieber Augustin* [akh doo LEE-bur OW-goos-ten]. According to Freud, the tension between the tragic episode between his parents and the banality of the organ grinder's song was permanently imprinted on Mahler's mind for life—the very stuff of the third movement of his Symphony No. 1.

If, by 1910, Freud was not the most famous man in Vienna, then he was one of the most notorious. He had opened a medical practice there in 1886, specializing in psychic disorders. Just a year earlier he had gone to Paris to study with the famous neurologist Jean-Martin Charcot [shar-KOH], and in his new practice he began using Charcot's techniques—hypnosis, massage, and pressure on the head to get patients to call up thoughts related to their symptoms. In 1895, in collaboration with Josef Breuer [BROY-ur], another Viennese physician, he published *Studies in Hysteria*. But even then he was changing his techniques. He began to ask his patients to say whatever crossed their minds, a practice he called **free association**. With free association he was able to abandon hypnosis, as he discovered that patients tended to relate their particular neurotic symptoms to earlier, usually childhood experiences when freed to talk spontaneously about themselves.

For Freud, free association required interpretation, and he came more and more to focus on the obscure language of the unconscious. By 1897 he had formulated a theory of infantile sexuality based on the proposition that sexual drives and energy already exist in infants. Childhood could no longer be considered innocent. One of the keys to understanding the imprint of early sexual feeling upon adult neurotic behavior was the interpretation of dreams. Freud was convinced that their apparently irrational content could be explained rationally and scientifically. He concluded that dreams allow unconscious wishes, desires, and drives that are censored by the conscious mind to exercise themselves. "The dream," he wrote in his 1900 *The Interpretation of Dreams*, "is the (disguised) fulfillment of a (suppressed, repressed) wish."

Freud's work would become enormously influential, as we will see in Book 6, but as much as Freud was one of the innovative thinkers of the twentieth century, he is also a product of the nineteenth century's growing obsession with self-knowledge. He is also, in some measure, a Symbolist. Like Mallarmé, van Gogh, and Gauguin, for Freud the symbol is a vehicle for indirect expression. It is suggestive, elusive. In a manner of speaking, the entire dream life of an individual could be thought of as a Symbolist poem. ■

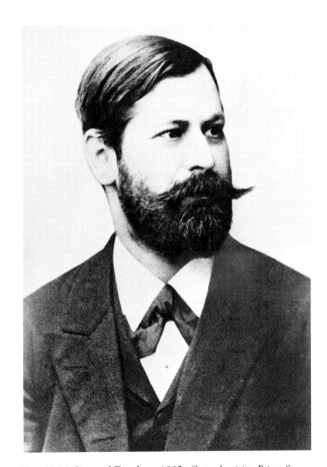

Fig. 40.24 *Sigmund Freud. ca. 1895.* Carte-de-visite. Prints & Photographs Division, Library of Congress, Washington, DC.

Index

Photo Credits

Chapter 33

Book Opener Erich Lessing/Claude Monet (1840–1926), "Regatta at Argenteuil". c.1872. Location: Musée d'Orsay, Paris, France. Erich Lessing/Art Resource, NY; **33-01** Roy Rainford/Robert Harding Picture Library Ltd; **33-02** Victoria & Albert Museum/Joseph Mallord William Turner (1775–1851), "Transept of Tintern Abbey". Exhibited 1794. Watercolor. 12-5/8 × 9-7/8″ (32.2 × 25.1 cm). Victoria and Albert Museum/Art Resource, NY; **33-03** National Portrait Gallery, London; **33-04** Courtauld Institute of Art Gallery, London; **33-05** John Constable (English, 1776–1837), "Stour Valley and Dedham Church". 1815. Oil on canvas, 55.6 × 77.8 cm (21 7/8″ × 30 5/8″). William Wilkins Warren Fund, 48.266. Photograph © 2008 Museum of Fine Arts, Boston; **33-06** The Natioal Gallery, London/The Bridgeman Art Library International; **33-07** Joseph Mallord William Turner (1775–1851), "Upper Falls of the Reichenbach". (w/c on paper). Yale Center for British Art, Paul Mellon Collection, USA. The Bridgeman Art Library; **33-08** Clore Collection/Tate Gallery, London/Joseph Mallord William Turner (1775–1851), "The Fall of an Avalanche in the Grisons". Exhibited 1810. Clore Collection, Tate Gallery, London/Art Resource, NY; **33-09** Clore Collection/Tate Gallery, London/Joseph Mallord William Turner (1775–1851) "Snow Storm-Steam-Boat off a Harbour's Mouth". Exhibited 1842. Oil on canvas, 91.4 × 121.9 cm. Clore Collection/Tate Gallery, London/Art Resource, NY; **33-10** Joerg P. Anders/Friedrich, Caspar David (1774–1840), "Monk by the Sea". 1809. Oil on canvas, 110 × 171,5 cm. Inv.: NG 9/85. Nationalgalerie, Staatliche Museen zu Berlin, Berlin, Germany. Joerg P. Anders/Bildarchiv Preussischer Kulturbesitz/Art resource, NY; **33-11** Elke Walford/Caspar David Friedrich (1774–1840), "Wanderer Above a Sea of Fog". ca. 1817. Oil on canvas, 94,8 × 74,8 cm. Inv.: 5161. On permanent loan from the Foundation for the Promotion of the Hamburg Art Collections. Photo: Elke Walford. Hamburger Kunsthalle, Hamburg, Germany. Bildarchiv Preussischer Kulturbesitz/Art Resource, NY; **33-12** Thomas Cole (American, 1801–1848), "View from Mount Holyoke, Nortampton, Massachusetts, after a Thunderstorm-The Oxbow". 1936. Oil on canvas, 51 1/2″ × 76″ (1.30.8 × 1.93 m). The Metropolitan Museum of Art, NY. Gift of Mrs. Russell Sage, 1908 (08.228). Photograph © 1995 The Metropolitan Museum of Art; **33-13** Frederic Edwin Church (1826–1900), "Twilight in the Wilderness". Oil on canvas. Cleveland Museum of Art, OH, USA. The Bridgeman Art Library; **33-14** © CORBIS. All Rights Reserved; **33-15** Joseph Mallord William Turner (English, 1775–1851), "The Whale Ship". ca. 1845. Oil on canvas, 36 1/8″ × 48 1/4″ (91.8 × 122.6 cm). The Metropolitan Museum of Art, Catherine Lorillard Wolfe Collection, Wolfe Fund, 1896 (96.29). Image © The Metropolitan Museum of Art; **33-16** Erich Lessing/Antoine Jean Gros (1771–1835), "Napoleon on the Battlefield at Eylau". 1808. Musée du Louvre/RMN Réunion des Musées Nationaux, France. Erich Lessing/Art Resource, NY; page 1059 Victoria & Albert Museum, London/John Constable (1776–1837), "Landscape and Double Rainbow". 1812. Inv.: 328-1888. Victoria and Albert Museum, London/Art Resource, NY.

Chapter 34

34-01 Historisches Museum Der Stadt Wein; **34-02** R.G. Ojeda/Jacques Louis David (1748–1825), "General Bonaparte". Unfinished oil study on canvas, 81 × 65 cm. Photo: R.G. Ojeda. Musée du Louvre/RMN Réunion des Musées Nationaux, France. SCALA/Art Resource, NY; **34-03** National Portrait Gallery, London, UK Thomas Phillips (1770–1845), "Portrait of George Gordon (1788–1824) 6th Baron Byron of Rochdale in Albanian Dress". 1813. Oil on canvas. National Portrait Gallery, London, UK. The Bridgeman Art Library; **34-04** Theodor M. von Holst (1810–44). "Illustration from 'Frankenstein' by Mary Shelley (1797–1851)". Engraving. Private Collection. The Bridgeman Art Library; **34-05** Kavaler/Tischbein, Johann Heinrich the Elder (1722–1789), "Goethe in the Roman Campagna". 1787. Location: Staedelsches Kunstinstitut, Frankfurt am Main, Germany. Kavaler/Art Resource, NY; **34-06** Eugene (Ferdinand Victor) Delacroix (1798–1863), "First Meeting between Faust and Mephistopheles: 'Why all this Noise?'". From Goethe's Faust, 1828. Illustration, Lithograph. Private Collection. The Stapleton Collection. The Bridgeman Art Library; **34-07** Erich Lessing/Carl Schuetz (1745–1800), "Neuer Markt (New Market) Vienna". 18th c. Mozart and Haydn lived nearby. Location: Wien Museum Karlsplatz, Vienna, Austria. Erich Lessing, Art Resource, NY; **34-08** Stieler, Joseph Carl (1781–1858), "Ludwig van Beethoven (1770–1827) Composing his 'Missa Solemnis'". 1819. Oil on canvas. Beethoven Haus, Bonn, Germany. The Bridgeman Art Library; **34-09** Andreas Geiger (1765–1856). "A Concert of Hector Berlioz (1803–69) in 1846". Engraving. Musée de l'Opera, Paris, France. The Bridgeman Art Library; **34-10** Oronoz-Nieto/Francisco de Goya, (Spanish, 1746–1828). "The Third of May, 1808". 1814–1815. Oil on canvas, approx. 8′8″ × 11′3″. Derechos reservados © Museo Nacional Del Prado-Madrid. Photo Oronoz; **34-11** Goya y Lucientes, Francisco Jose de (1746–1828). "A heroic feat! With dead men!, plate 39 of 'The Disasters of War', 1810–14, pub. 1863" Etching. Private Collection, Index. The Bridgeman Art Library; **34-12** Francisco de Goya y Lucientes (1746–1828), "The Sleep of Reason Produces Monsters (El sueño de la razon produce monstrous). Plate 43 of "The Caprices (Los Caprichos)", first edition; etching, aquatint, drypoint and burin; 87/16 × 57/8 in. (21.5 × 15 cm). The Metropolitan Museum of Art. Gift of Knoedler & Co., 1918 (18.64). Photograph © 1994. The Metropolitan Museum of Art; **34-13** Francisco de Goya y Lucientes (1746–1828), "Saturn Devouring One of His Sons", Mural transferred to canvas (146 × 83 cm). Derechos reservados © Museo Nacional Del Prado-Madrid; **34-14** Musée de Louvre/Géricault, Théodore (1791–1824), "The Wounded Cuirassie". 1814. Oil on canvas. Musée du Louvre/RMN Réunion des Musées Nationaux, France. Bridgeman Art Library, NY.; **34-15** Hervè Lewandowski/Théodore Géricault (1791–1824). "The Raft of the Medusa". First oil sketch. Oil on canvas. 37 × 46 cm. Louvre, Paris. Photo: Hervè Lewandowski. Inv.: RF 2229. © Réunion des Musées Nationaux/Art Resource, NY; **34-16** Le Mage/Eugene Delacroix (1798–1863). "Scene from the Massacre at Chios: Greek families awaiting death or slavery". 1824. Oil on canvas. 419 × 354 cm. Louvre, Paris, France. Photo: Le Mage. © Réunion des Musées Nationaux/Art Resource, NY; **34-17** Giraudon/Jean Auguste Dominque Ingres (1780–1867), "The Vow of Louis XIII (1601–43)". 1824. Oil on canvas. Montauban Cathedral, France, Lauros. Giraudon/The Bridgeman Art Library, NY.; **34-18** Ingres, Jean Auguste Dominique (1780–1867), "Madame Philibert Riviere". Oil on canvas, 116 × 90 cm. Musée du Louvre/RMN des Musées Nationaux, France. SCALA/Art Resource, NY.; **34-19** Eugène Delacroix (French 1798–1863), "Arab Hoseman Attacked by a Loin". 1849–50. Oil on panel, 17 1/4″ × 15″. Potter Palmer Collection. 1922.403. The Art Institute of Chicago. Photograph © 2008, The Art Institute of Chicago. All Rights Reserved; **34-20** Géricault, Théodore (1791–1824), "Kleptomania: Portrait of a Kleptomaniac". c. 1819–22. Museum voor Schone Kunsten, Ghent, Belgium. The Bridgeman Art Library; page 1100 Goya y Lucientes, Francisco Jose de (1746–1828), "193-0082155 Until death, plate 55 of 'Los caprichos', 1799". Etching. Private Collection, Index. The Bridgeman Art Library; page 1101 Arixiu Mas, Barcelona Francisco Goya, "The Family of Charles IV". 1800. Oil on canvas. 9′2″ × 11″. Museo del Prado, Madrid. Arixiu Mass, Barcelona/Derechos reservados © Museo Nacional Del Prado-Madrid.

Chapter 35

35-01 Anonymous, "Old Hetton Colliery, Newcastle". Beamish, North of England Open Air Museum, Durham, UK. The Bridgeman Art Library; **35-01 Map** Reprinted by permission of Harper Collins Publishers Ltd. © Hugh Cloud (Editor), "The Times History of London New Edition". 1991; **35-02** The New York Public Library, New York, NY USA/Art Resource, NY; **35-02 Map** Penguin Books Ltd. UK; **35-03** The Illustrated London News; **35-04** The Culture Archive; **35-05** Stewart McKnight/Alamy Images; **35-06** Erich Lessing/Joseph Mallord William Turner (1775–1851), "Rain, Steam, and Speed". Oil on canvas. 90.8 × 121.9 cm. National Gallery, London, Great Britain. Erich Lessing/Art Resource, NY; **35-07** The Image Works; **35-08** Robert Harding Picture Library Ltd./Alamy Images; **35-09** National Portrait Gallery, Smithsonian Institution/Art Resource, NY; **35-10** Sojourner Truth (c.1797–1883) (b/w photo), American Photographer, (19th century). Private Collection, Peter Newark American Pictures. The Bridgeman Art Library; **35-11** Robert Scott Duncanson (1821–72), "Uncle Tom and Little Eva". 1853. Oil on canvas. The Detroit Institute of Arts, USA. The Bridgeman Art Library; **35-12** Hervè Lewanski/Eugène Delacroix (1798–1863), "Liberty Leading the People". July 28, 1830. Painted 1830. Oil on canvas, 260 × 325 cm. Photo: Hervè Lewandowski. Musée de Louvre/RMN Réunion des Musées Nationaux, France. SCALA/Art Resource, NY; **35-13** Honoré Daumier (French, 1809–1879), "Gargantua" 1831. Lithograph. Fine Arts Museums of San Francisco, Museum purchase, Herman Michels Collection, Vera Michels Bequest Fund, 1993.48.1; **35-14** Erich Lessing/Honoré Daumier (1808–1879). "Rue Transnonain, 15 Avril 1834. A murdered family". 28.5 × 44.1 cm. Inv. A 1970–67. Kupferstichkabinett, Staatliche Kunstsammlungen, Dresden, Germany Erich Lessing/ Art Resource, NY; **35-15** Honoré Daumier, "The Third-Class Carriage". c. 1962. Oil on canvas. 25 3/4″ × 35 1/2″ (65.4 × 90.2 cm). Bequest of Mrs. H. O. Havemeyer, 1929. The Ho. O. Havemeyer Collection. © 1922 The Metropolitan Museum of Art, NY; **35-16** Gerard Blot/Rosa Bonheur, "Plowing in the Nivernais". 1849. Oil on canvas. 5′9″ × 8′8″ (1.75 × 2.64 m). Musée d'Orsay, Paris, Gerard Blot/Réunion des

Text Credits